i

t a man

Modeo

Blood stick

Biologic

model of the
oc or galtic
and infancy

what the body writes

Monument to the

Century

Sanctuary

Sanctuary

Britain's Artists and their Studios

Editor/interviews
Hossein Amirsadeghi

Executive Editor
Maryam Homayoun Eisler

Contributors
Iwona Blazwick
Richard Cork
Tom Morton

Photography
Robin Friend

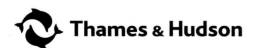 **Thames & Hudson**

Endpapers:
The artist's mind at work: Front endpapers
show Anish Kapoor's rough sketches on his
studio wall mixing art, doodles and homespun
philosophy, while on the back, Shirazeh
Houshiary's studio pinboard displays sketches
and digital renderings made for the London 2012
Olympic Park landmark design competition.

TransGlobe Publishing Limited
6 New Street Square
London EC4A 3LX
United Kingdom

info@tgpublishingltd.com

First published by
Thames & Hudson in association with
TransGlobe Publishing Limited
© 2012 TransGlobe Publishing

Text, captions and photographs
© 2011 Hossein Amirsadeghi

Distributed worldwide
(except in the United States and Canada) by
Thames & Hudson Ltd.
181A High Holborn
London WC1V 7QX
United Kingdom

ISBN: 978-0-500-97707-1

A CIP catalogue for this book is available from
the British Library.

Andrea Belloli: Managing editor
Roger Fawcett-Tang: Creative director
Anne Field: Project coordinator
Siobhan Loughran Mareuse: Project director

Designed by Struktur Design Limited
Printed in Singapore

To find out about all our publications, please visit
www.thamesandhudson.com
There you can subscribe to our e-newsletter,
browse or download our current catalogue,
and buy any titles that are in print.

Foreword
Hossein Amirsadeghi

Sanctuary: Britain's Artists and their Studios has been described as more of a cultural event than a mere book. Suits me fine, yet it's intriguing to think how a conversation between friends on a country walk can be transformed through iterative interpretations into a cultural event.

Sanctuary is the story of an extraordinary journey undertaken by intrepid explorers of the British art scene over the period of a year. December to December, season to season. This is how the book has been designed, walking with, talking to and picturing 120 of Britain's leading artists as they go about their lives through the seasons, pursue their daily practice under scrutiny through the keyhole of their studios.

The final list of artists featured in the book is based on two criteria: being British, and having practised art in this country. We've followed UK artists abroad, chasing them down in studios scattered across Europe and America, from Los Angeles to Abu Dhabi. Fifty names grew into 120, 286 pages into 600. We have filtered each name through the looking glass of experts: curators, institutional heads, critics, commentators and even artists.

At the end of the day, the choices came down to me, a total outsider penetrating hallowed sanctums within the British contemporary art scene. I'm ready to fall on my sword for my sins, but hold the thought for now, as the journey is yet to unfold. The embers of more than a hundred conversations with extraordinary creative minds are still glowing. Artists, despite their insecurities, are nothing if not firm in their beliefs; Eva Rothschild's assertion that 'art is a human impulse to make something that has no function except for looking and experiencing something that you can't express in any other way' still rings fresh in my ears. In nightly visions I'm still redirecting shoots: should I have teased my way into Frank Auerbach's cloistered studio after being invited to coffee at Mornington Crescent at 7.00 in the morning? The great man had agreed to be interviewed and photographed for the first time in many years. Surely posterity should have sight of his sanctum? He would have none of it, superstition offered as an excuse. Even looking back at us to make sure we were not following him to his one-room studio, which he has occupied these last fifty-seven years. He was rushing back to keep an appointment with a handyman. I'm good at fixing things, I said.

Remembering the hundred tortuous sessions spent with Roger Fawcett-Tang, the creative director, selecting images one by one – over 100,000 images in all. Helping design and redesign, and revise again. Having begun the book principally as a photographic record of the lives of artists in their element, I discovered the importance of their personalities coming through in the Q&As. Viewpoints mundane, comments controversial, words of wisdom (or otherwise), uttered in the thrall of meandering conversations held afresh with each individual. 'The best thing about art,' Yinka Shonibare said, 'is its superiority to the mundane.' Too true. *Sanctuary*, I was determined, was going to be anything but mundane.

The word *sanctuary* itself has endured a tortured existence in the context of the book. Why *sanctuary*? Why not just *studio*? I'll leave that to the reader's imagination. Perhaps the best explanation setting the tone for the idea behind the book is offered by Tom Morton, who observes in his essay that the word *sanctuary* suggests a place of refuge and of metaphysical transport. 'It follows,' he says, 'that the lands that abut it may be both dangerous and profane.'

Equally dangerous has been the invasion of art protectorates, bypassing self-appointed guardians and gatekeepers who make their living by trying to guard against anybody not cut from the same cloth, the veritable (and tiresome) priesthood of new art. There was, I determined from the outset, to be no *art-speak* in the book. Guarded statements, unguarded comments, often indisceet, were going to capture moments in this country's cultural history and the history of art in a broader sense.

The photography speaks for itself. Space, place, face, mood and neighbourhood all captured in time, for all time. Every profile helps to evoke the character of the artist, their life and environment. Captivating moments, each a revelation when combined with the incisive Q&As. Highlighting social nuance, encapsulating architectonics and tautology. Cityscapes as silent tributes to ordinary lives made extraordinary through the gift of art. The young artist-photographer chosen for the commission, off the walls of John Jones's gallery in North London, didn't even *do* people. Robin Friend was, is, a landscape artist. Our young friend has found sanctuary, and immortality, in this book.

The idea for the book first came to me almost three years ago served on a cold plate. Maryam Homayoun Eisler and Siobhan Loughran Mareuse (they of the country walks) accosted me with the thought of making a book on British artists. Not interested. There were too many such books. I was preoccupied at the time creating a series of contemporary art books from the periphery. The centre, as represented by British contemporary art, did not appeal. But I had not reckoned with Maryam and Siobhan's persistence. Daunting angels, the two of them. Maryam was to prove her executive mettle in subsequent collaborations. She came up trumps for *Sanctuary*, instrumental in helping make a better book. Relentless and untiring, she deserves high plaudits.

The challenges facing us were enormous. No-one believed that we could do it. Big galleries thought the idea too big. Smaller ones wondered who I was to be undertaking such a task. No doubt their big brothers thought the same, but they had other considerations in mind. There were many who went out of their way to help from the outset. They saw the vision, got the script, bought the book.

Once decided, everything had to be done to perfection in double-quick time. Attention deficit does wonders for one's drive to succeed. I appreciate art, even collected the great Impressionists in bygone days, and have always enjoyed a creative bent. But there's a greater passion involved here. I'm a firm believer in the social, political and economic transformative powers of art. The artist is the alchemist, the studio the laboratory. That's where it all starts.

Some contemporary art practice has done away with the studio altogether. Say hello to Liam Gillick, today's globetrotting artist constantly in transit between workspaces in London and New York. We caught up with Gillick in his Barbican home in London, chased the man back to his New York apartment overlooking the East River, looking for a studio. No studio, just the studio of the mind, and the

computer as his work tool. Funny thing? I met his wife Sarah Morris in Abu Dhabi by pure chance. Originally on our master list, Morris had fallen off the map but was chased back to New York for a last-minute shoot orchestrated by Gillick himself.

What fun, you think? But this kind of publishing is not all fun. The great art book is a dying species, yet nothing comes close. To create such books is really quite simple, if you don't mind being cast adrift on a rickety raft on the seas of creativity. You start the book with a concept as near as the distant horizon. Title and subtitle then frame its borders. Having decided to do the book, I waited in vain for a title, something I'm usually good at. No title, no work. No book. Then came a random dinner conversation with the Argentinian artist Varda Caivano, who is also featured in the book. Varda whispered the word *sanctuary*, and the wind was strong in my sail. There's another book waiting to be written around the journey of *this* book.

How does one glue such a creative monster together, anchor its ambitions, frame its perspectives? The direction we took with *Sanctuary* was never overly structured, allowing the process of creation to determine direction. Nothing of the sort has been done in nearly half a century. *Private View*, the last worthy contender in the genre, made by Robertson, Russell and Snowdon, was published in 1965.

The essay contributors were easy choices by virtue of their reputations and standing. Iwona Blazwick's extraordinary rendition of studio outtakes gives the reader eclectic insights into the practices and pitfalls around artists and their studios. Tom Morton's brilliant, quick-fire exposé of contemporary British art at the start of the third millennium allows the reader a fish-eye view of current trends. Richard Cork uncorks the greats, covering his own studio visits to British artists whom we failed through acts of Fate (Lucian Freud, Richard Hamilton), Circumstance (David Hockney, Bridget Riley) and Time (Francis Bacon) to include in the book.

Like all rooms, a studio has a life of its own. Many dimensions too, from the huge factory space of Anthony Gormley's North London, David Chipperfield-designed studio to the tiny, sometimes dingy spaces where artists labour in search of inspiration. Much

is revealed about human character, and the character of art, by a studio visit. With each inspiring in their own way, one can't help but reflect on the outlandishness of some of them. Raqib Shaw's large studio-living space filled to the rafters with fresh flowers and exotic plants, a florist in attendance at all times. Gustav Metzger's dilapidated surroundings, his house-studio filled to overflowing with the detritus of his art, rubbish bags stuffed with newspaper and magazine clippings gathered over the years, piled high towards the ceilings. The much younger Shaw enjoys excess and success, while the octogenarian Metzger chooses the life of the hermit, constantly fretting about the human condition without any regard for his own. Two creatives, different in their generational outlook, yet each living for art, use of a studio their only common ground.

The origins of the studio lie in the artisanal workshops of thirteenth-century Europe, particularly Italy, where artists employed craftsmen to fulfil commissions for the interiors of churches, palaces and public squares. In her essay Iwona quotes Ian Wallace to shed light on the important role of the studio: 'During the Renaissance there was a shift in the space of production from the craft workshop to the more literary *studium*, a shift that was essential to the intellectual liberation of the artist and the eventual repositioning of the visual arts as a branch of the humanities.' 'The privacy and freedom of the studio make it a forum for free expression and a weapon in the contestation of prevailing orthodoxies,' Iwona contends. 'The studio becomes a magical machine which transforms the "excreta" of these de-sublimated urges into objects of monetary value and aesthetic immortality.'

Having visited some hundred and twenty studios over twelve months, I can think of nothing that better describes the *studium* than Iwona's observation. But perhaps the last word belongs to artist Shirazeh Houshiary. 'The world is a chaotic place. When I come to my studio, it is a place where the chaos is unified. To me that's the most creative force in the universe.'

London December 1st, 2011

The Sanctuary Crew. From left: Hossein Amirsadeghi publisher and editor, Robin Friend photographer, Anne Field project coordinator, Roger Fawcett-Tang creative director, Siobhan Loughran Mareuse project director, Maryam Homayoun Eisler executive editor and Andrea Belloli managing editor (AWOL) photographed in the Old Vic Tunnels, under Waterloo Station, London October 2011.

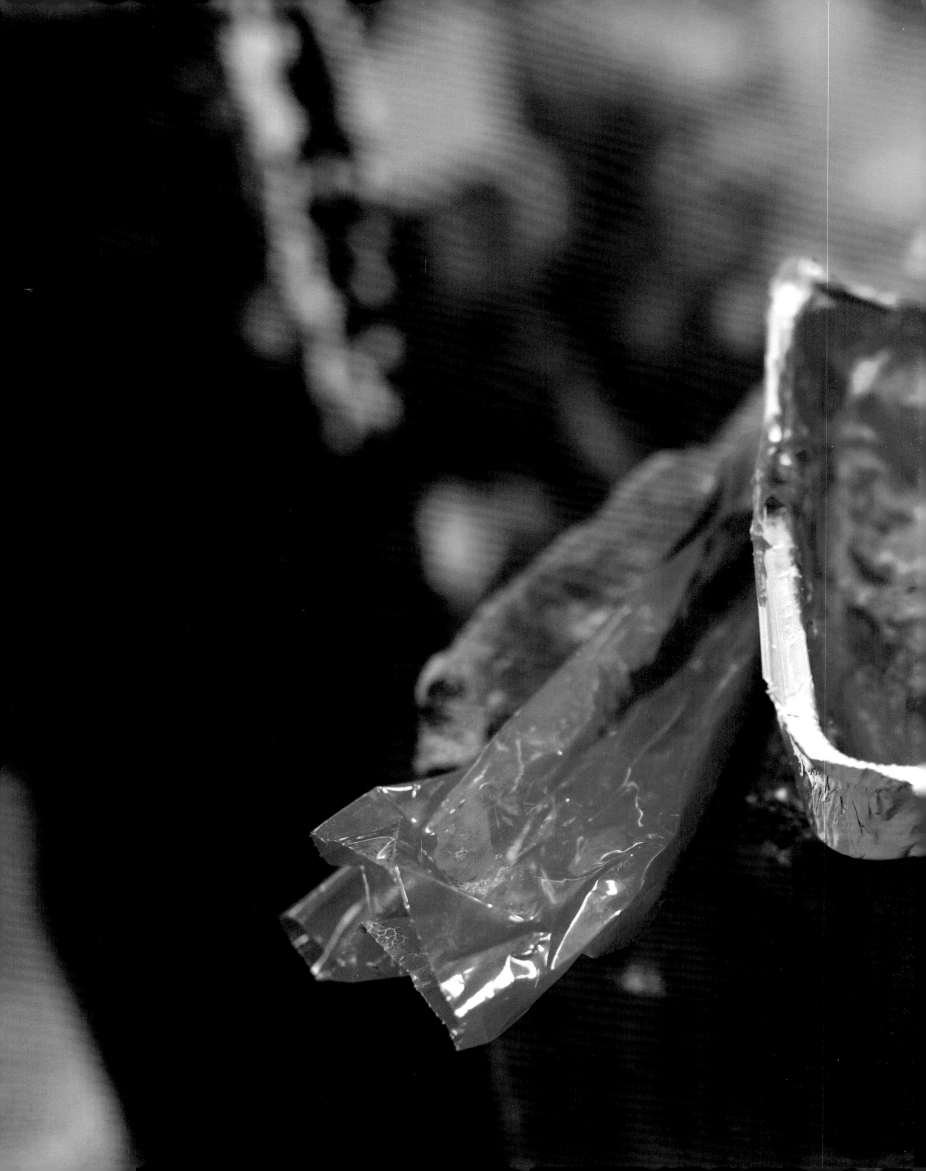

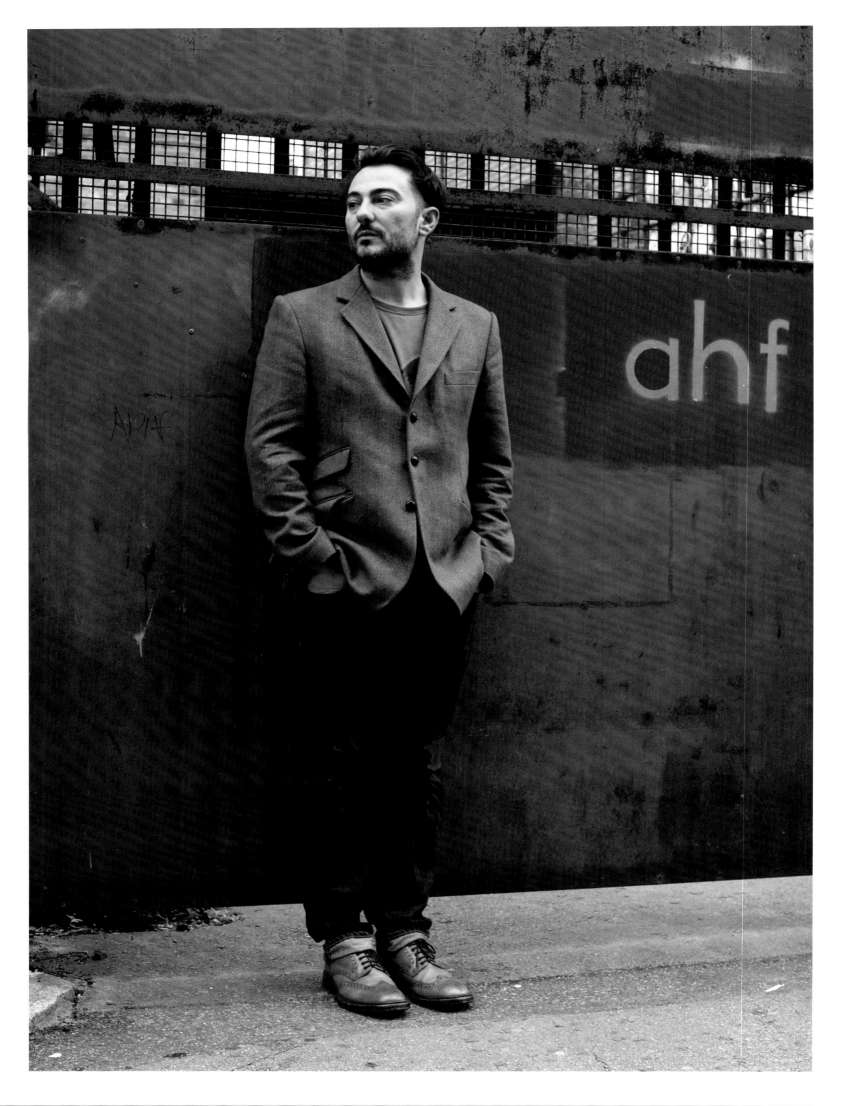

Field Notes On British Art In The Third Millennium
Tom Morton

1) The Past Is Now Part of My Future, or, Polyphony Wins Out

The word *sanctuary* suggests a place of refuge and of metaphysical transport. It follows that the lands that abut it may be both dangerous and profane. If the interviews collected in this volume are concerned with the studio practices of British artists active in the Third Millennium, these field notes sketch the passage of their work through the wider, wilder world.

Of course, it makes little sense to speak of 'British art', save perhaps as an administrative category. Britain, a nation forged largely by internal and external colonialism, has never been monocultural, and the global dimension of much contemporary art practice makes the notion of a 'British artist' – as opposed to, say, a 'British citizen' or 'British resident' – difficult to define or to defend. So widely recognised is this that even institutions founded on the fantasy of a national art now feel comfortable with calling that fantasy into question: we might think of Tate Britain's 2009 Triennial, in which the curator Nicolas Bourriaud invited ten international artists to take part in a recurrent group exhibition formerly reserved for Britons, or of the curator Nicholas Schafhaussen selecting British artist Liam Gillick to represent Germany in its pavilion at the 2009 Venice Biennale. (Instructively, the fact that these two projects flouted the customs of national participation was, if not peripheral to their concerns, then only a springboard to their wider arguments.) This is not to suggest that artists born, brought up or living in Britain do not make work that is touched by these islands' histories, cultures or contemporary realities, only that in the Third Millennium the terms *Britain* and *British* provide crude and sometimes misleading maps of a complex territory. Stand far enough away, and we might persuade ourselves that the art of the last decade has, like a constellation in the night sky, a coherent and readable shape. Move in more closely, however, and this quickly melts away, rendered liquid and ungraspable by the heat of hundreds of proximate suns.

These field notes might be considered (to invoke the half-playful, half-anxious subtitle of Hans Ulrich Obrist and Stéphanie Moisdon's 2007 Lyon Biennale) as episodes from a 'History of a Decade That Has Not Yet Been Named'. It feels almost superfluous to point out the impossibility of writing a comprehensive account of British art in the Third Millennium in a few thousand words. Much like the book of interviews within which they are published, these notes can only point to a small number of the significant artists at work over the last ten or so years, and even then shed only partial light on their practices and contexts. To represent the art of the recent past through a collection of its fragments rather than a continuous narrative, though, is to perhaps suggest something of its character. While there have been attempts to frame, or even manufacture, a new 'movement' in British art in the wake of the (anyway intellectually problematic) branding of the late 1980s/early 1990s generation

of Damien Hirst, Sarah Lucas, Mat Collishaw et al. as 'the YBAs', these have had little critical traction – we might think of the 1998 Saatchi Gallery exhibition *The New Neurotic Realism*, an implausible stab at presenting artists as different as Roger Hiorns, Cecily Brown and Tim Noble and Sue Webster as exponents of a sort of ill-defined high-fidelity disquiet. Far more indicative of the concerns of British art in the Third Millennium was *Heart and Soul* (1999), an artist-organised exhibition held at the studio complex 60 Long Lane in Southwark, South London, that featured works by many leading figures of the decade to come, among them Hiorns, Lucy McKenzie, Jim Lambie, Enrico David, Gillian Carnegie, Mark Titchner and Dexter Dalwood. Eschewing the 'last gang in town' approach to group shows of younger British artists favoured since the Hirst-curated *Freeze* in 1988, and taking its oblique title from the 1980 Joy Division track of the same name (sample lyric: 'the past is now part of my future'), this exhibition spoke of both a renewed interest in sorting through the rubble of cultural history and a broad generational refusal to be packaged and sold as a job lot, the latest products of the visual arts division of 'Cool Britannia'.

In short, these notes reflect on a phase of artistic production in which polyphony won out. They consist of detailed studies of single works (mostly, but not always, by the artists interviewed in this volume), and fleeting accounts of far-reaching socio-cultural shifts, of zoom and wide-angle shots. They are of different lengths, and may be read in or out of sequence. Here and there, under the banner 'Matters of Importance, Briefly Alluded To', they point to themes that demand far more space for discussion than we have here. As with all fragments, their jagged contours suggest a greater whole.

2) More More More

Some background, then: British art in the Third Millennium exists in the context of the rapid and unprecedented growth of almost everything that makes up what is customarily called the art world. Compared to even a decade ago, there are more curators, more arts institutions, more biennales, and bigger and more various audiences. There are more commercial galleries, more art collectors, and more art fairs. There is more press attention and more critical discourse (although perhaps not a corresponding increase in its quality), and there are more colleges and universities offering art education (although recent hikes in tuition fees are likely to make this largely the preserve of the rich). Perhaps the only measurable contraction has been in the vital area of government funding. The full force of this is yet to be felt.

The architectural totems of Britain's (or more accurately London's) shift from a relative art world backwater to one of its major centres are Tate Modern's Bankside building, opened in 2000, and the white tent of the Frieze Art Fair, which first took place in Regent's Park in 2003. However, the growth – even hypertrophy – described above not only has its roots in public and commercial

Tom Morton photographed outside the Art House Foundation, where he is writer in residence, in November 2011

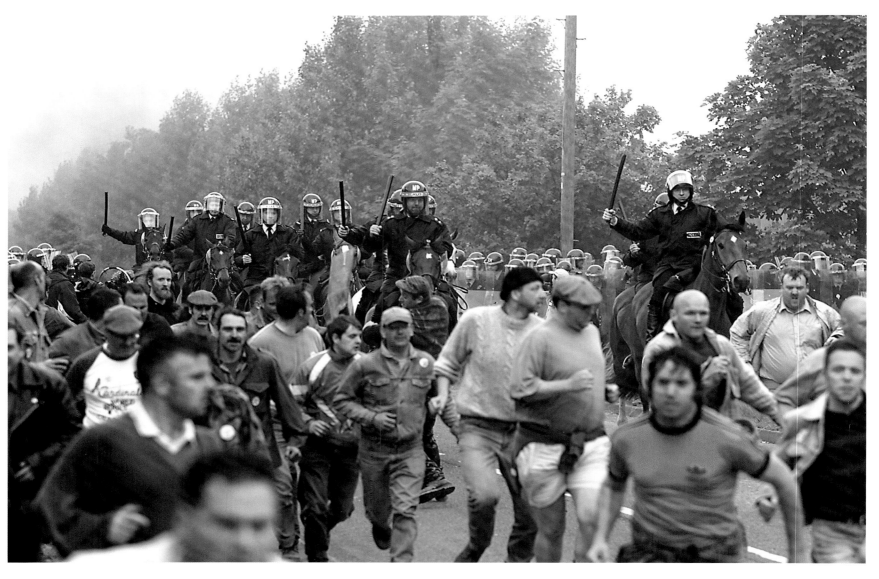

grands projets but is also the product of the more prosaic stuff of cheap airfares and the Internet. These have made possible not only the easier circulation of capital, people, ideas and even artworks but also the creation of new communities based not on location but on shared interests and sympathies. In terms of artistic practice, the effect of the Internet has been incalculable and goes far beyond the still shaky beginnings of 'web-based art' (it's hard to imagine the work of, for example, Ryan Gander or Helen Marten existing in a culture in which the search engine was not our primary portal to information and images). To put it in dramatically sci-fi terms, since the 1990s our species has grown a collective auxiliary brain, immediately accessible from almost any location on Earth.

3) This Is Hardcore

'British art in the Third Millennium' – which is to say in the period from the year 2000 to now – did not begin directly after Big Ben chimed midnight on New Year's Eve 1999 and the celebrity guests shuffled, underwhelmed, out of the Millennium Dome. First screened at the ICA, London, in the final year of the twentieth century, Mark Leckey's seminal video *Fiorucci Made Me Hardcore* (1999) pieces together found documentary footage of British youth tribes from the preceding twenty-five years, from fleet-footed '70s Northern Soul weekenders to '80s 'Casuals' sporting wedge haircuts and expensive Euro knitwear labels (Ellesse, Diadora, the titular Fiorucci), from roller-disco divas speeding down suburban streets to ravers dancing in fields and warehouses off the M25 during the Third Summer of Love. Leckey's sampling, editing and cut-up soundtrack removes the temporal gaps between these

moments, corralling them into a continuous bacchanal in which stylistic variation in dance moves, fashion and even the filmic language of the footage itself become mere details, somewhere between local colour and evolutionary mutations. In a telling sequence, a dancer appears to release an animated bird from his palm that floats across the screen before becoming a tattoo on the arm of a young man in a quite different scrap of footage. Generations blur one into the other, and, despite the tribes' disparities in dress and deportment, we begin to read them as part of a wider whole. *Fiorucci Made Me Hardcore* is, to a degree, about an ancient dream of escaping the physical realm (where we are obliged to work, and to die) into the free flow of music, or of image. It is also about a certain intensity of experience, or even of being, and how this may still be achieved in a world of reference, quotation and appropriation – *Hardcore*, in Leckey's title, nods to the word's use in street slang to describe a heightened existential pitch but also to a genre of British dance music in which '80s Chicago Acid House was re-imagined using cheap bedroom samplers. The importance of *Fiorucci* to British art in the Third Millennium should not be underestimated. We might read it as a move away from both the broad conventions of 1990s video (static or locked-on cameras, minimal narrative) and the increasingly laboured pseudo-punk-meets-commodity-fetishism shtick of late-period 'Britart' while also as a work that anticipates, perhaps more than anything else, the coming decade's renewed interest in lost, marginalised and mythologised histories. Oddly, its most lasting influence is perhaps to be found in its emotional tone. Leckey's video takes found footage of the recent past and turns it into an object of yearning.

4) Matters of Importance, Briefly Alluded To (Part I)

The parallel development of a) a market for feature films by a small number of high-profile British artists, among them Steve McQueen, Sam Taylor-Wood and Gillian Wearing, and b) a renewed interest in, and expansion of, the possibilities of (narrative) film and video by a new generation of British artists, among them Anja Kirschner & David Panos, Nathaniel Mellors, Emily Wardill and Ben Rivers. This to be read through the fact that the mainstream moving-image culture is in a state of utter flux.

5) Get Back

Tacita Dean's *Kodak* (2005) is a film about the death of film – or, rather, the death of film as a physical object. Focusing on the Kodak factory in Chalon-sur-Saône, France, in the final days before it discontinued production of the artist's favoured 16-mm stock, it speaks not only of the losses engendered by widespread adoption of new technologies but also of the more general mood of elegy that suffused a number of works by British artists made in the first few years of the Third Millennium. Perhaps the most extraordinary of these was Jeremy Deller's *The Battle of Orgreave* (2001), a project in which the residents of a Yorkshire pit village re-enacted one of the bloodiest episodes of the 1984–5 miners' strike in the manner of live role-play hobbyists re-enacting the battles of Hastings or Marston Moor. Just as Dean's film was shot on the stock we see being manufactured in the Kodak plant, many of the participants in Deller's *Battle* were the very people who fought against Margaret Thatcher's attempt to break the British trade-union movement in the early '80s. Contemplating the piece, in which the former pickets play both their younger selves and the riot police with whom they clashed, we get to thinking about enforced obsolescence and the afterlife of memory, about the frustrations and comforts of nostalgia.

Somewhat similar thoughts are prompted by the canvases of George Shaw, an artist who grew up in Tile Hill, a post-war council estate on the outskirts of Coventry. On a trip back to his parents' house during his studies at the Royal College of Art, London, Shaw began taking snapshots of the landscape of his '70s childhood, using them as the basis for an ongoing series of paintings which chart its litany of nowhere places and the transforming effects of time, nature and socio-political change. Revisiting the same sites over and over again – barren recreation grounds, rubbish-choked storm drains, the muddy track between two rows of dilapidated lock-up garages – the artist records the wearing away of one reality and its ad-hoc replacement by another. As with *Kodak* and *The Battle of Orgreave*, Shaw's paintings approach the Third Millennium not as a brave new world but as kind of graveside, a place to protest against forgetting.

6) Matters of Importance, Briefly Alluded To (Part II)

The renewed and widespread interest among British artists in movements of the modern age, among them Arts & Crafts, Symbolism, Aestheticism, Art Nouveau, Art Deco, the Bauhaus, Constructivism and Brutalism. This as a reaction to an atomised and apolitical artistic landscape? This as a reaction to the (somewhat vague but nevertheless tangible) feeling that Postmodernism had run its course? This as both a cause and an effect of an economy of quotation? Also, the emergence of what we might call an anti-populist, or at least unambiguously erudite and even perhaps scholarly, tendency in British art of the Third Millennium, sustained not by a broad local audience but by a narrow (although numerically sufficient) audience of specialists across the globe. Also, the fact that this shift is not reflected in the mainstream British media, which appear steadfastly reluctant to give up the Britart ghost.

George Shaw
Detail of Untitled, 2010
Humbrol enamel on board
Private collection, London
Courtesy Wilkinson Gallery,
London

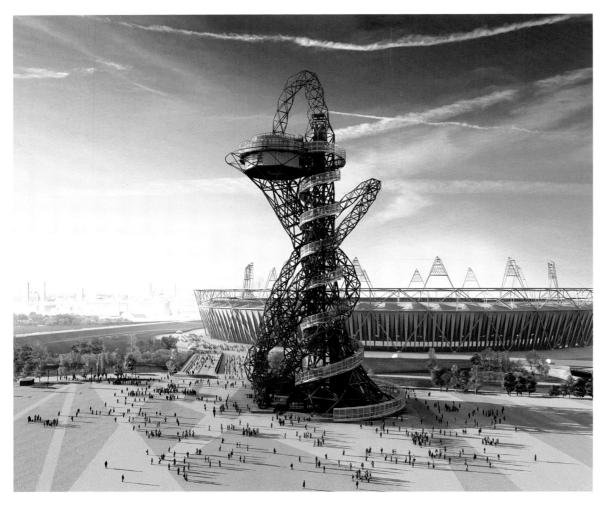

7) Iron Giants

While the last decade has seen an explosion in visitor numbers to museums and galleries (Tate Modern alone lays claim to an average of some 4.6 million visitors per year), it is still through that strange beast, 'public art', that British citizens are most likely to encounter the work of the artists of our time. As I write these words in the autumn of 2011, a few miles away from my desk Anish Kapoor's *ArcelorMittal Orbit* (2011–12) is being constructed in the Olympic Park, Stratford. Selected from a number of proposals submitted in response to the Conservative Mayor of London Boris Johnson's desire to build a major public artwork on the site, Kapoor's tower (designed in collaboration with engineer Cecil Balmond) was announced, like a Hollywood blockbuster, in a flurry of statistics: at 115 metres high, it will be Britain's tallest work of public art and, at a projected cost of £19.1 million, almost certainly its most expensive (Britain's richest man, steel tycoon and ArcelorMittal chairman Lakshmi Mittal, pledged to cover £16 million of the bill, reportedly following a chance encounter with Johnson in the cloakroom of the Davos Conference). Fabricated from steel painted the colour of flayed human flesh, the *ArcelorMittal Orbit* takes the form of a flared trumpet sheathed in helical lattice-work which gropes its way up into the grey London skies. Visitors are promised an internal spiral walkway, observation platforms and an onsite restaurant. With its monstrous scale, blood-smeared appearance and appetite for chewing over its art historical forebears, we might imagine the tower as public art's very own Godzilla, as though the vast red bugle of Kapoor's earlier work *Marsyas* (2002) had escaped the confines of Tate Modern's Turbine Hall and, having gorged itself on Trajan's Column (AD 113), the Eiffel Tower (1889) and Tatlin's planned *Monument to the Third International* (1919), had slumped down between Zaha Hadid's Olympic Aquatic Centre and the Westfield Stratford mega-mall to sleep its rampage off. Whatever meaning we might ascribe to the *ArcelorMittal Orbit* (its form points

vaguely and inoffensively towards DNA helixes and swirling galaxies, towards an insurance-ad sense of wonder at the connectedness of all things), its central narrative is its own giganticism. In this, it joins Anthony Gormley's *Angel of the North* (1998) in Gateshead, Thomas Heatherwick's *B of the Bang* (2005) in Manchester, and Ken Shuttleworth and MAKE Architects' *Aspire* (2008) in Nottingham. Sentinels of late capitalism, these structures stand vigil over what were once industrial cities, overseeing their redevelopment into spaces that are safe for shopping and spectating. An aside: Are such works a guy thing? Could we imagine, say, Rebecca Warren's fabulous clay sculpture *Croccioni* (2000) – the fat-calved, high-heeled progeny of a Robert Crumb drawing and Umberto Boccioni's *Unique Forms of Continuity in Space* (1913) – striding across a civic plaza, blown up to the size of a double-decker bus?

If some artworks have colluded in the doubtful business of post-Millennial regeneration, others take it as their subject. For his 2010 project *ELIS* at Herald Street, East London, Matthew Darbyshire clad the gallery's façade in aluminium Dibond panels, announcing the imminent arrival of a twenty-three-storey mixed-use development on the site, featuring a polyclinic, state-of-the-art gym, fifteen-faith chaplaincy, student digs, social and luxury housing, a lifelong-learning zone, a branch of Tesco Express and a community dance theatre. Inattentive viewers wandering through this 'up and coming' corner of Bethnal Green could have been forgiven for imagining that the gallery had been forced out of the area by skyrocketing rents, and what was once an edgy neighbourhood was about to become yet another candy-coloured, pseudo-modern, PFI-funded neo-ghetto, a future ruin awaiting the ferocious bite of pending government austerity measures. The title *ELIS* refers to the district of ancient Greece in which the first Olympic Games were held. In the contemporary Elis of East London, Darbyshire's intervention – at once subtle and absurd – felt like a dystopian prophecy.

8) Matters of Importance, Briefly Alluded to (Part III)

The appropriation of the outer trappings, if not the radical potential, of participatory art practices by gallery education programmes and community outreach initiatives, and how welcome this might be (as the critic Dan Fox has remarked, 'No one is demonstrating outside Tate Modern demanding more inclusivity'). Also, the appropriation of the same by marketeers. Here in late 2011, after a summer of riots, Absolut Vodka's 2007 advert in which a group of hipsters attack armoured police with pillows makes for oddly anachronistic viewing.

9) Three Works about Value (and Perhaps Values)

Michael Landy's 2001 project *Breakdown* saw the artist catalogue and publicly destroy his 7,227 personal possessions in a former branch of C&A on London's Oxford Street – from his car to his art collection, from his clothing to his correspondence, from his books to his studio kettle. Widely understood at the time as a critique of the way in which capitalism encourages us to define ourselves through commodities, *Breakdown* also had a semi-neglected mystical aspect, prompting dreams not only of monkish asceticism but also of escaping the bonds of the body itself. In September 2008, Landy's fellow Goldsmiths alumnus Damien Hirst initiated *Beautiful Inside My Head Forever*, a sale of 218 of his works at Sotheby's in nearby New Bond Street, bypassing his commercial galleries and in the process setting a record for a single-artist auction on the very evening that Lehman Brothers, then the world's fourth-largest investment bank, went bankrupt. Whatever else the sale proved (and there have been several not wholly successful attempts by critics to claim it as an artwork), it quickly became emblematic of the fact that the ongoing financial crisis has had little adverse impact on the international class of plutocrats who collect Hirst's work.

Beautiful Inside My Head Forever took place a year or so after Hirst's *For the Love of God* (2007), a platinum cast of the skull of an unknown eighteenth-century European barnacled with 8,601 diamonds, was first shown at White Cube, London. The experience of viewing this work was a highly choreographed affair in which visitors were escorted by a security guard into a darkened room where they could spend two minutes staring into the skull's spar-

kling, empty eye sockets before being ushered out, blinking, into the light of day. Two minutes, 8,601 gemstones, the well-publicised £15 million production costs and £50 million price tag: *For the Love of God* was about nothing if not numbers – indeed, if a buyer were to break it down into its raw materials for resale, he or she would see £35 million worth of pure 'art' disappear into the ether. And yet, while this work was deeply embedded in what we might call the decadent phase of the post-Millennial art-market boom, it also plays a much longer game. If traditional memento mori are about accepting the universal fact of death, Hirst's diamond skull is about leaving a beautiful corpse that, with its ineffable durability (all the clanking machinery of Landy's wreckers' yard couldn't hope to destroy it) might just witness our species' end.

10) Matters of Importance, Briefly Alluded To (Part IV):

The '(re)discovery' of neglected artists by critics, curators and gallerists at a later stage in their career (among them Phyllida Barlow, Marc Camille Chaimowicz, Gustav Metzger and John Stezaker), and what this might say about contemporary art's intellectual and commercial markets. Also, a not-unconnected art-world cult of youth, exemplified by the 2009 exhibition The Generational: Younger Than Jesus *at the New Museum, New York, which featured work by fifty international artists born before 1976, among them Britons Ruth Ewan, Luke Fowler, Ryan Gander, James Richards and Tris Vonna-Michell.*

11) The Art of War

On 15 February 2003, over a million people marched in London to protest against Britain's participation in the imminent invasion of Iraq. The Blair government ignored the march, and the nation duly went to war. In the months and years that followed, a number of British artists produced works that engaged with Iraq, among them the Otolith Group's film *Otolith I* (2003), in which footage of the London march is revisited in a distant sci-fi future; Steve McQueen's *Queen and Country* (2007), a set of unofficial postage stamps featuring portraits of British soldiers killed in the Gulf; and Jeremy Deller's *It Is What It Is* (2009), the burnt-out shell of a car

Michael Landy
Breakdown, 2001
Commissioned and
produced by Artangel

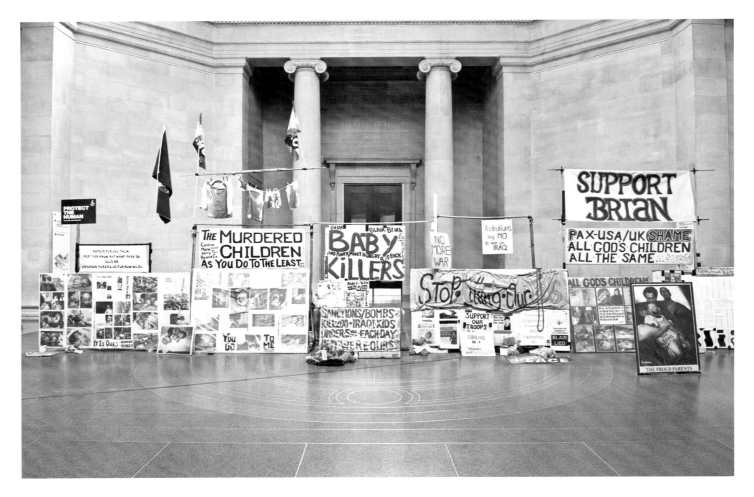

Mark Wallinger
State Britain (detail), 2007
Mixed-media installation
at Tate Britain
© Mark Wallinger
Courtesy Anthony Reynolds
Gallery, London

destroyed by the bombing of a Baghdad street. Presented in Tate Britain's Duveen Galleries in 2007, Mark Wallinger's *State Britain* was a life-size, near-perfect simulacrum of the 40-metre wall of banners, placards and rickety information boards erected by the peace campaigner Brian Haw in London's Parliament Square between June 2001, when he first began his protest against the economic sanctions imposed against Iraq, and May 2006, when police removed nearly all of his belongings from the site under Section 132 of the 2005 Serious Organised Crime and Police Act, which made it an offence to stage a public protest within 1 kilometre of Parliament Square without first obtaining permission. A few days before the police moved in, Wallinger took hundreds of photographs of Haw's ramshackle, hectoring, oddly splendid monument, and it was on these that *State Britain* was based. This in itself begs some knotty questions about authorship. Haw's protest, after all, was an organic thing, responding to the events surrounding the 'War on Terror' and constantly being added to by sympathetic parties. The specific form it took in Tate Britain, then, was not dictated so much by the protester, or the news headlines, or even by the artist, as by those who framed, passed and acted on Section 132. By drawing those who sought to silence Haw into an inadvertent act of image-making, Wallinger gave the some-times softcore stuff of participatory art a hard edge. The work only existed because the protest does not, just as the protest only existed because of other absences or erasures: of due process, of liberty, of, ultimately, life. No work of art wholly regrets its own being, but *State Britain* came close. It was both a continuation of Haw's protest and something like a wake for it, an expression of freedom of speech and a wry, sad meditation on the arts institution as a place in which dissent is contained and sanitised.

12) Matters of Importance, Briefly Alluded to (Part V)

The growth of postgraduate curating courses in the UK, and how this has (and hasn't) had an impact on UK institutions. Also, how the post-Millennial emphasis on the curator as an active and self-reflexive creator of discourse has had an impact on the practice of younger artists. Also, the increasing number of former curators of public institutions now working in the commercial sector. Also, the seeming replacement of the critic by the curator as the primary mediator of new art. Also, claims that criticism is 'in crisis'. Also, emailed e-flux announcements as news ticker and career accelerator.

13) Some Fleeting Thoughts on Painting

In the period between the invention of the daguerreotype in the late 1830s and Douglas Crimp's exhibition *Pictures* at Artists Space, New York, in 1977, the 'death of painting' was announced, as Belgian art historian and theorist Thierry de Duve has observed, 'about once every five years'. While suspicion persists in some quarters about the medium's popularity with collectors, there's little serious discussion of its demise in the Third Millennium, no apparent appetite for a burial without a corpse.

Painting's current vitality might be ascribed to its near-infinite variety, which might in turn be ascribed to the fact that it's been three decades since there was anything like a common trajectory to cleave to or deviate from. Even taking the painters interviewed in this book as a (not wholly necessarily representative) sample, the only thing that seems to unite them is an awareness of the deep history of their form, something present in the nineteenth-century-Academy-goes-Pop works of Dexter Dalwood as much as in the unsettled abstract surrealism of Varda Caivano or Maaike Schoorel's use of genre as an armature on which to build her bleached- or blacked-out studies in how pictorial information unfolds over time. In a world saturated with photographs, films and video, might we make an argument for the importance of painting on the grounds that it retains trace memories of a mode of image-making that prefigures mechanical reproduction (even or especially when it draws on the legacy of the lens), and see in its insistence on its own unique object-hood something precious that has nothing to do with monetary value?

14) Traces

In 2005, Scottish artist Simon Starling disassembled a shed on the banks of the Rhine and used its planks to build a boat. He then sailed the boat downriver to the Kunstmuseum Basel, where he turned it back into a shed. This work, *Shedboatshed (Mobile Architecture No. 2)*, is a study in traces – for all that its final form is architectural, its redundant bolt holes and curiously shaped panels attest to its brief life as a water craft, and make visible the labour involved in its double (or triple?) metamorphosis. In the same year as Starling set sail on the Rhine, Goshka Macuga bound a series of monographs on art historical heavy hitters (Marcel Duchamp, Martin Kippenberger, Francis Picabia, Sigmar Polke and Andy Warhol) between hand-tooled covers of her own design, highlighting aspects of the artists' works that had a particular bearing on her own practice. As an image of how art history might operate, Macuga's books are beguiling. The rebound monographs retain their scholarly integrity and disinterested 'balance', but they also bear the traces of a more subjective response, of a passion or idiosyncratic delight. If we were looking for a working model of how British artists of the Third Millennium have responded to art history, these volumes might just be it.

15) Matters of Importance, Briefly Alluded to (Part VI)

The undeniable fact that London is the centre of the British art world, and might be better imagined as a small state than as a city. Also, the distorting effect of this on the production and reception of art in the UK. Also, significant civic centres of British art outside of the capital, and the importance of artist-led space to these (Transmission, Glasgow; S1, Sheffield; Catalyst, Belfast). Also, a possible future in which London becomes simply unaffordable to any but the most privileged of young artists and there is a large-scale shift to another British city. Also, Berlin?

16) Dust

First shown at Corvi-Mora, London, in 2008, Roger Hiorns's *Untitled* is comprised of the atomised remains of an engine from a passenger aircraft. Scattered across the gallery floor, the powdery grey particles form a lunar topology, their constituent metals (nickel, stainless steel, cobalt, titanium) providing tonal range. We get to thinking of the post-apocalyptic landscape of Cormac McCarthy's *The Road* (2006) or the ancient desert in Percy Bysshe Shelley's 'Ozymandias' (1818) – here, 'boundless and bare, the lone and level sands stretch far away'. On one level, *Untitled* is a work concerned with universal entropy and the hopelessness of human effort in the face of time's infinite stretch. On another, it addresses a particular object, the commercial jet engine, which is implicated in irreversible climate change and our species' ongoing act of collective suicide. In the autumn of 2010, *Untitled* was shown in curator Peter Eeley's exhibition *September 11* at MoMA PS1, New York. The sculpture was not conceived as a piece about the World Trade Center attacks (indeed the work makes no explicit reference to anything outside of its own manufacture and ontology), but in this context few viewers could avoid interpreting it in terms of the dust that choked New Yorkers' lungs as they fled the falling towers in 2001, and the acts of atomisation the world over that would mark the decade to come. It is perhaps interesting to reflect on the degree to which *Untitled*'s formal and conceptual integrity depends upon the art institution. The museum or gallery, here, performs an almost placental or womblike role, nourishing and protecting a vision of inevitable collapse. In Hiorns's otherwise pitiless schema, does this provide a grey mote of hope?

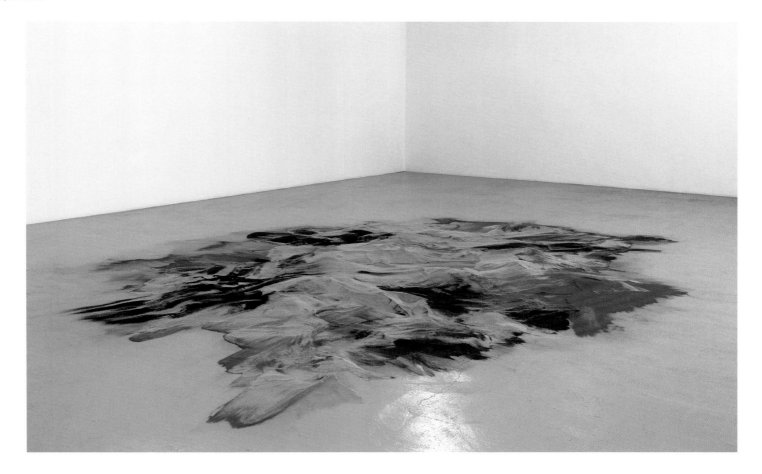

Roger Hiorns
Untitled, 2008
Atomised passenger
aircraft engine
Courtesy of the artist
and Corvi-Mora, London

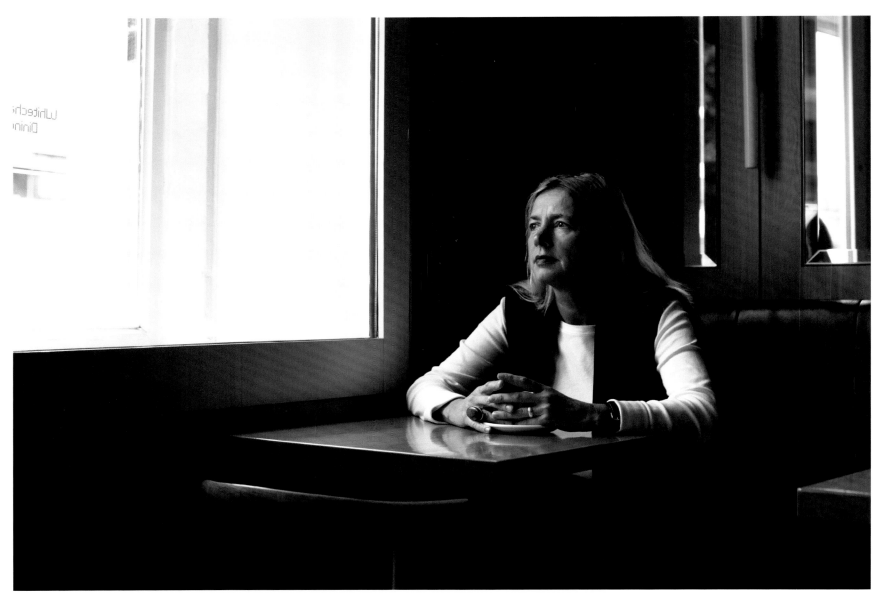

Iwona Blazwick
photographed in the Dining
Room of the Whitechapel
Gallery in November 2011

The Studio – An A To Z
Iwona Blazwick

Acme

ACME and SPACE studios are pioneering organisations that changed the face of studio provision in London in the late 1960s and early 1970s. SPACE was founded in 1968 by artists Bridget Riley, Peter Sedgley and Peter Townsend, who had been inspired by visiting artists' spaces in New York. Four years later, artists Jonathan Harvey and David Panton set up ACME; both organisations were responding to a severe lack of affordable studios in London. They recognised that the metropolitan economy was changing – the docklands and their magnificent wharves and warehouses were emptying in favour of deeper waters and container traffic. Manufacturing had also shifted to parts of the globe where labour and materials were cheaper. Factories and workers' cottages stood empty in working-class areas of the city, primarily on its periphery. What artists seized on in this post-industrial urban landscape was an opportunity for space. For Riley, Sedgley and Townsend, it was the warehouses of Butler's Wharf on the south bank of the Thames; for Harvey and Panton, two derelict shopfronts in Bow in the East End. With nothing to lose in an economic recession, local government authorities and private land-lords agreed to temporary occupation by artists.

It was the artists who then entered long-abandoned buildings and waded through the rubble, dead pigeons and excrement to turn the skills they had learned stretching canvases or building sculptures to installing plumbing or fixing leaking roofs. Gallerist and former artist Maureen Paley recalls occupying a small work-er's cottage in Mare Street through ACME and discovering that the garbage in her back garden which had been dumped by her neighbours towered the full height of the two-storey house. From these modest beginnings, ACME and SPACE now offer affordable working and living spaces to thousands of artists, as well as residencies, advisory services and exhibitions. Their work is supported by the Arts Council of England, local government agencies and property developers.

Boredom

The studio is a place in which to see what boredom can unleash. Intrinsic to the state of boredom is a hyper-awareness of time, slowed to the point of weariness. Although the studio does exert pressure to produce, it is not the boredom of the alienated worker that is relevant here. It is rather the absence of activity that sets the stage for a range of mental symptoms which might include a heightened awareness of the body and its ailments, the emergence of repressed anxieties and erotic fantasies, and the sudden appre-hension of the absurd. In a public situation, boredom is often the prelude to an onset of irrepressible hilarity. In the context of the studio, hysteria turns into doodling, face-pulling and serendipitous assemblage. Boredom triggers spontaneity and random actions; boredom is a mother of invention.

Cathedral of Erotic Misery

'A day comes when I realise I have a corpse on my hands – relics of a movement in art that is now passed. So what happens is that I leave them alone, only I cover them up either wholly or partly with other things, making clear that they are being downgraded.

As the structure grows bigger and bigger, valleys, hollows, caves appear, and these lead a life of their own within the overall struc-ture. The juxtaposed surfaces give rise to forms twisting in every direction, spiralling upwards. An arrangement of the most strictly geometrical cubes covers the whole, underneath which shapes are curiously bent or otherwise twisted until their complete dissolu-tion is achieved.' In 1943, the Allies bombed Hannover and so destroyed what was at once Kurt Schwitters's studio, his home, his archive and a work of art that, in the words of his friend Hans Arp, rivalled 'the masterpieces of the Louvre'. Schwitters's concept of 'Merz' stood for 'freedom from all fetters, for the sake of artistic creation'. From 1923 he set about Merzing his house, penetrating its floors with shafts and tunnels, and erecting a series of accre-tions intended to form grottos. Arp described them as 'soaring columns ingeniously constructed out of rusty old iron bars, mirrors, wheels, family portraits, bedsprings, newspaper, cement, paint, plaster and glue – lots and lots of glue – [which] forced their way upward through successive holes, gullies, abysses and fissures'. The Merzbau also incorporated clothing Schwitters had stolen from his friends – Sophie Tauber's bra, Moholy-Nagy's socks – and a vast panoply of other found objects, both organic and inorganic, which acted as psycho-sexual triggers.

Here, the studio ingested what it produced, absorbing the artist's experiments and failures in a geological layering of process, inspiration and influence. The studio recorded all that it had staged, its successive accretions of artistic fossils providing the perfect analogue for the artist's unconscious.

Discipline

In 2000, Anglo-Canadian artist Lisa Milroy translated a day in her life into forty-two individual scenarios in a painting called *A Day in the Studio*. This series of black-and-white pictograms is a tautology, a painting about the everyday routine of painting. Milroy left no stage undocumented. Getting up, getting washed and dressed, the commute by bike, the temptation of a pastry, are followed by entering the studio and then finding all the diversionary measures for not working: making a coffee, playing some music, checking out the view. The brush makes contact with the canvas, then stops. Another coffee, a phone call. Painting begins again. The day ends. Things must be washed up and put away. The commute home commences. From Velázquez's *Las Meninas* to Hans Namuth's photographs of Jackson Pollock, images of the studio have mythologised it as a stage set – for power plays between artist and patron; for articu-lating complex lines of vision between viewer, artist and model; and for staging the heroic, protean struggle of the male genius. Milroy dispelled the aura and illuminated the sheer ordinariness and the quiet discipline that is required for the daily act of making art.

Everyday Life

Paris in the 1900s attracted artists from all over the world. Drawn by a collective desire for the new, they rejected the history paint-ings and religious, allegorical or aristocratic subject matter of the Academy. Instead, they turned to the everyday, finding new subject matter in the humble objects that surrounded them in their studios,

Lisa Milroy
A day in the studio, 2000
Acrylic on canvas
© Lisa Milroy
Courtesy of Alan Cristea
Gallery

located in the impoverished environs of the Bateau-Lavoir in Montmartre. In his essay 'The Social Bases of Art' (1936), Meyer Schapiro observes that 'although painters will say… content doesn't matter, they are curiously selective in their subjects … his studio and his intimate objects, his model posing, the fruit and flowers on his table, his window and the view from it: symbols of the artist's activity, individuals practising other arts, rehearsing, or in their privacy; instruments of art, especially music, which suggest an abstract art and improvisation; isolated intimate fields, like a table covered with private instruments of idle sensation, drinking glasses, a pipe, playing cards, books, all objects of manipulation, referring to an exclusive, private world in which the individual is immobile, but free to enjoy his own moods and self stimulation … Thus elements drawn from the professional surroundings and activity of the artist; situations in which we are consumers and spectators; objects which we confront intimately, but passively or accidentally, or manipulate idly and in isolation – these are typical subjects of modern painting.' The detritus of everyday life in the studio became a protagonist in the development of Cubism and abstraction, in short in the story of modernism itself.

Factory

It was the demise of the hat in the early 1960s that led to an industrial loft at 231 East 47th Street in Manhattan being transformed into one of the most famous studios in the history of contemporary art. Andy Warhol and Billy Linich (who became Billy Name) transformed this fourth-floor hat factory into a cross between a film set, a place of mechanical reproduction and a salon. This space 30 metres long and 15 metres wide was covered in silver foil and filled with furniture found on the street. At once improvised and glamorous, utilitarian and theatrical, the space was large enough for groups of collaborators to both produce and star in a range of productions, from silk-screened paintings to home movies and impromptu bands. Although this model of production has raised disquiet about the detachment of the artist from the creation of art, its origins lie in the Italian and Northern European ateliers of the fourteenth, fifteenth and sixteenth centuries where artists would employ artisans and assistants to complete their commissions. The factory is also a

model used today by artists such as Damien Hirst, Jeff Koons and Takashi Murakami. The mass production of works of art that become signature pieces also sees the production of the artist as a persona, or brand, whose image becomes part of the media's global empire of signs. This mirroring of capitalism can also be understood as a kind of apolitical counterculturalism standing in opposition to avant-garde concepts of authenticity and political critique.

Gallery

If artists cannot attract institutional or commercial support, they can turn the studio into a gallery. This not only offers a way of showcasing their own work but also enables them to exhibit work by friends and artists they admire without asking their permission. Inspired by an artist working in Poznan who showcased foreign artists in his studio, thus disregarding the isolationist tendencies of Communist Poland, the London-based artist Robin Klassnik decided to offer his SPACE studio as a platform for other artists. The press release for his first exhibition of work by David Troostwyk in 1979 states, 'The studio of Robin Klassnik will become Matt's Gallery at two-monthly intervals when it will show new work for seven days. The gallery is seen as a brief but concentrated stopover for new work to be experienced or checked – as much by the artist as by anyone else who may be really interested. London does not return the more liberal views and interest offered by mainland Europe to British artists and Matt's will present the work of both European and British artists.'

In 1987, British artist Richard Wilson was allowed to flood this studio with 200 gallons of used sump oil. Visitors climbed onto a narrow platform that appeared to be hovering vertiginously above a void. In fact the oil created a perfect mirror and was simply reflecting the high ceiling above it. When it rained, drops of water would appear to rise up the windows reflected in the oil's surface. *20:50* was a paradigmatic installation only made possible by being staged in the space of a studio which operated without the physical and commercial constraints of the white cube or the health and safety obsessions of the institution. It was, however, subsequently acquired by the Saatchi Collection.

Hermeticism

For some artists, the studio is a social place of intellectual exchange, collaborative production and public display. For others, it is a private place of solitude, a place to externalise the life of the mind. In her short career, American photographer Francesca Woodman took hundreds of photographs entirely staged within the physical confines of her East Village loft. The rooms, cupboards, doorways and mirrors of her studio became an existential world where the camera caught glimpses of the artist in a series of fleeting self-portraits. She crouches naked in a glass display case or peers up from beneath a filthy windowsill like a ghost or mannequin. In the words of Margaret Sundell, 'Woodman's contiguity relates the individuation of the body to the seamlessness of its environment, the internal world of subjectivity to an external field that absorbs its uniqueness, so that at a certain point, it becomes impossible definitively to separate self from other.' Like many artists, Woodman lived in her studio. It was perhaps inevitable that, like Mark Rothko, she would also use the studio as the site of her death, throwing herself from the window when she was just twenty-two years old.

Jobs

Studios offer a vital source of employment. Outside of Britain, a typical tutelage for a young artist is to become a studio assistant to an established figure whose work they admire. This kind of job is a form of training and will tend to focus on research and production. It should, if the young artist finds independent success, be transitory. There are other permanent roles that are technical and administrative. Canvases need stretchers, sculptures may require armatures, and most objects will need to be packed, stored and conserved. With the rise of public art commissions, artists are also called upon to deploy the skill sets of engineers or architects, from creating computer designs to generating complex structures and understanding statutory requirements. Meanwhile, the rise of moving-image work requires an immersion in the fast-changing world of audiovisual technologies. These new directions require technicians with new kinds of expertise.

The increasingly global nature of the art world requires artists to travel constantly. The proliferation of art media must be fed by images and information, while the often volatile economics of investing in production and recouping through sales or grants needs careful financial planning. Administrators and studio managers act as travel agents, photographers, website managers, press officers and accountants, liaising with and also offering a protective barrier against the outside world. A crucial role is that of archivist. The tracking of works as they are sold or borrowed for exhibitions becomes an essential part of their provenance. Similarly, creating a curriculum vitae with a history of exhibitions, bibliography and record of collections is central to the historical understanding and dissemination of an artist's oeuvre. Sometimes, however, the studio assistant might just need to get the artist a coffee.

In 1990 a young British sculptor called Mike Smith decided that his future lay in realising the visions of other artists. The Mike Smith Studio became famous for fabricating all the works of Damien Hirst. The studio describes itself as 'a design and fabrication facility that … produces … creative and experimental exchanges … a symbiosis between the practical and the creative … The Studio incorporates a wide vocabulary of facilities, with an interdisciplinary staff from a diversity of backgrounds such as fine art, industrial design, graphic design and engineering'. This kind of specialised studio has become essential to artists who require bespoke industrial fabrication.

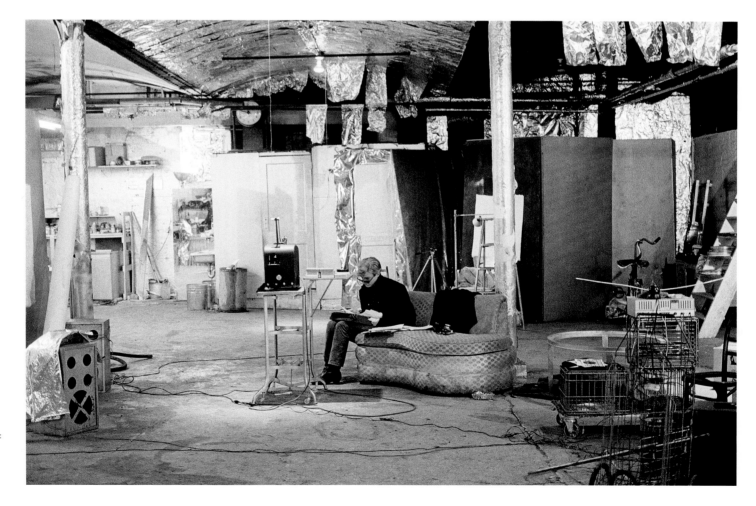

Andy Warhol in his factory:
Factory Panorama, c. 1965
© Nat Finkelstein
Courtesy The Estate
of Nat Finkelstein

Richard Wilson
20:50, 1987
Installation view
Courtesy the artist and
Matt's Gallery, London

Knowledge

In 2007, curators Jens Hoffman and Christina Kennedy made an exhibition at the Hugh Lane Gallery in Dublin to coincide with the city museum's display of Francis Bacon's studio, donated by his heir. The exhibition, entitled *The Studio*, included work by American artist Martha Rosler. In contrast with the paint-splattered accretions of Bacon's studio, Rosler's comprises a desk and neat rows of crowded bookshelves. Decoupling her library of some 8,000 books from her studio, she sent them off on a gallery tour to New York and Europe. The 'Martha Rosler Library' offers a portrait of the artist, a record of her intellectual interests and pursuits, and an insight into her working methods. The books also map the emergence of new ideologies through the nineteenth and twentieth centuries. Many of the titles focus on authors or activities marginalised by virtue of gender, race or geography. The books are rearranged at each venue to draw attention to particular fields of research that then trigger associative routes to adjacent areas of scholarship For example, '… the section with literature by women leads to books on feminism leads to gender studies leads to family studies leads to psychoanalysis leads to Jewish studies leads to books on the Holocaust which leads to German history, and so on'. Here the studio is presented as a source of knowledge production for both the artist and her audience. It also acknowledges the authorship of others, signifying the artist's dependency on an ontological corpus of thousands of voices.

Laboratory

A significant physical aspect of the studio is that it must be capable of withstanding serious injury, for it is a site for experimentation. The materials in play may parallel those of the physicist, the biologist or the chemist. Indeed the methods of artists such as Roger Hiorns, Damien Hirst (whose company is called Science), John Latham, Mike Kelley, Dieter Roth or Fischli & Weiss can be compared to those of the scientist. Fischli & Weiss's influential film *Der Lauf der Dinge* (*The Way Things Go*, 1987) is set in a gigantic studio/ warehouse and follows a series of chain reactions among delicately balanced domestic and industrial objects. Bin bags, oil cans or trays of foaming liquids advance, tip, explode and collapse into one another, triggered by chemicals, fire and gravity. Inert bits of rubbish come to life to combine knife-edge suspense with slapstick comedy. These absurd and pointless pyrotechnics make the film a masterpiece of the artistic laboratory. As opposed to the instrumentalist research of the science lab, of course, the studio offers pure research into the possibilities of poetry and aesthetics.

Mess

The legendary Francis Bacon studio is the prototypical repository of artistic messiness, what Bacon himself called 'a compost heap'. By contrast, the studio of German painter Gerhard Richter is a model of ascetic order, clinically clean and arranged with bureaucratic precision. In his definitive text on the studio, Brian O'Doherty comments, 'We are aware of the fields of force, as it were, that surround the artist in his studio whether it is the studio of accumulation or the studio of monastic bareness, which, according to Ernst Kris, descends from Plato through Christian saintliness. Why these extremes? Is it just a matter of housekeeping? If the studio reflects the mind of its occupant, is one mind an attic, the other a prison cell? Does one introduce us to the aesthetics of redundancy, the other to the aesthetics of elimination – the glutinous studio of ingestion and the anal studio of excretion, the fat and the slender, Laurel and Hardy seeing each other in the studio's distorting mirror? Are studios of accumulation indubitably secular? Do studios of elimination have a yearning for some absolute? Does each indicate a temperament and an aesthetic?' Perhaps we can also see the studio as offering a counterpoint to the world: where repressive order reigns, chaos becomes an expression of freedom. Where the traffic of people, objects, noise, dirt and commerce overwhelm, minimalism offers clarity and peace.

Night-Time

Like all rooms, the studio has a life of its own. Frustrated by not having any new ideas, Bruce Nauman decided to record what happened in his studio at night. It proved a lively place. An infestation of field mice, the predatory prowlings of his cat and a variety of bugs are the incidental stars of *Mapping the Studio (Fat Chance John Cage)*, shot in 2000 and made into a seven-screen video projection. Multiple soundtracks evoke ambient noises both inside the studio and in the surrounding countryside. The films were shot over successive nights from August to November. They also track the progress of works of art as they evolved by day. As if by magic, items move around the room, develop or disappear.

Darren Almond's *A Real Time Piece* (1996) was a live broadcast transmitted from his empty studio to a gallery on the other side of London. With the help of the BBC, Almond offered a view into his studio in real time, marked by the presence of a digital clock. Its numerical readings flipped down minute by minute, providing a curiously hypnotic focal point, the most dynamic element in an interior featuring a chair, a drawing board and two stationary fans. The movement of the clock heightened the viewer's awareness of a crepuscular movement of light and shadow as day became night.

Why are these works so compelling? Perhaps because they represent a combination of anticipation that something might eventually happen with the vicarious thrill of watching the private space of the studio as if through a peephole. Perhaps because they evoke the uncanny quality of an empty room haunted by the presence of an artist.

Origin

The origins of the artist's studio lie in the artisanal workshops of thirteenth-century Europe, in particular Italy, where artists

employed teams of craftspeople to fulfil commissions for public squares or the interiors of churches and palaces. However, as artist Ian Wallace has remarked, 'During the Renaissance there was a … shift in the space of production from the craft workshop to the more literary studium, a shift that was essential to the intellectual liberation of the artist and the eventual repositioning of the visual arts as a branch of the humanities.' Until the twentieth century, the atelier evolved around the practices of painting and of carved or cast sculpture. Facilities were required for grinding pigments and for the storage and maintenance of tools. The need for a steady source of daylight required skylights or large windows; furnishings could include a couch for a model and chairs for admirers and patrons so they might observe proceedings and acquire work. The studio might incorporate anatomical models, lay figures and – in the case of Thomas Gainsborough – broccoli, which offered a model for painting trees. Marcel Duchamp installed fittings and objects around his studio to perceptually transform the space, 'hanging' a coat rack, for example, on the floor.

The architecture and interior dynamic of the artist's studio changed radically in the second half of the twentieth century, when artists colonised industrial lofts, factories and warehouses. Wide spans supported by cast iron columns offered deep perspectival space; electricity replaced natural light; walls and partitions were made of plywood or brick. These environs were challenging rather than charming, and the ethos of artistic activity shifted towards a syntax of physical labour and manufacture. Recently, another shift has occurred. Artists will always require physical space even though their activities may be virtual. The contemporary studio might resemble an office, complete with desk and computer.

Politics

The studio can act as a refuge or an activist cell. Following the Nazi invasion of Prague in 1939, Czech photographer Josef Sudek withdrew into his studio, a ramshackle cottage on Ujezd Street. Curator Kate Bush beautifully describes the scope of his work: 'He brought his full attention to bear on the pane of his studio window observing minute seasonal and meteorological changes in the garden outside … Sometimes he decorated its sill with the detritus of lunch: egg shells, a glass of water, a braid of onions … A theme of chaos emerges … his still lives, which by the 1970s he titled *Labyrinths* – made from an amorphous confusion of paper, objects, letters, string or whatever he happened upon within its famously untidy interior. He countered Stalinist regulation and its prescribed art of socialist realism, with images of disorder and chaos – creating still lifes metaphoric of both personal loss and personal freedom.'

Set up in Senegal in 1974, the celebrated Laboratoire Agit-Art was a studio where groups of artists and intellectuals could meet under the official radar. In post-colonial Africa, numerous political leaders were imposing a culture of so-called Negritude. Craft-based and ostensibly authentic to pre-colonial African traditions, this was also a way of denying rural and urban communities access to social, cultural and political progress. The Laboratoire became a space where artists could present their own versions of the modern. Also in the 1970s, artist Mary Kelly used her London studio to bring together what became known as the History Group, where film maker Laura Mulvey discussed with writers Juliet Mitchell and Sally Alexander issues around the representation of women and their absence from the canon. The privacy and freedom of the studio make it a forum for free expression as well as a weapon in the contesting of prevailing orthodoxies.

Queue

As of September 2011, in London alone, there were approximately a thousand artists waiting for studio space.

Radio

In the corner of most studios there will be a paint-spattered radio, its aerial broken but still capable of receiving broadcasts. Silence is not a prerequisite for creativity; indeed there are many tasks other than the production of work that occupy the artist. In Britain most artists will admit to listening to BBC Radio 4 and, under pressure, its longest-running soap opera, *The Archers*.

American artist Roni Horn creates crystalline drawings in which straight and serpentine lines fracture and overlap. Playing around them are pencilled words: Iraq, news, crisis, morning – these have all slipped into the work from the radio that plays in her studio. The drawing is a net catching the radio's aural fragments. They evoke a political and social context mediated through the consciousness of the artist.

Studio Visit

Although the studio is a private site of production, the art created there is usually intended for an audience. Work might first be shared with peers while still in progress, but secondly it is presented to the art world's gatekeepers. The former might involve other artists or friends becoming collaborators, contributing expertise or skill. It might require a discussion or simply an opinion as to which is the right ending. Russian critic Ekaterina Degot wrote of the Moscow Conceptual artists of the 1970s that the presentation of works began and ended in the studio, as there was no public place of exhibition, no audience and no market. The artist was creator, audience and critic.

The second encounter, with the external world, is more formal: 'If the artist is the first viewer, the first stabilizing factor is the studio visitor … The visit has its etiquette and comic misunderstandings. The studio visitor is the preface to the public gaze. The visitor brings an environmental aura – collector, gallery, critic, museum, magazine. The studio visit can be a raging success or a disaster, a much desired "discovery" or an intrusion from hell.' At this stage the artist enters into a different relationship with the object of their creativity. The gaze of the outsider defines the work as complete and autonomous of its maker. A judgement is also made of the artist's persona.

British artists Tracey Emin and Sarah Lucas turned the second encounter into an act of defiance with their studio/shop on London's Bethnal Green Road in 1993, handing out painted T-shirts with slogans such as 'I'm so Fucky', 'Have you wanked over me yet?' or 'Complete Arsehole'. As Matthew Collings commented,

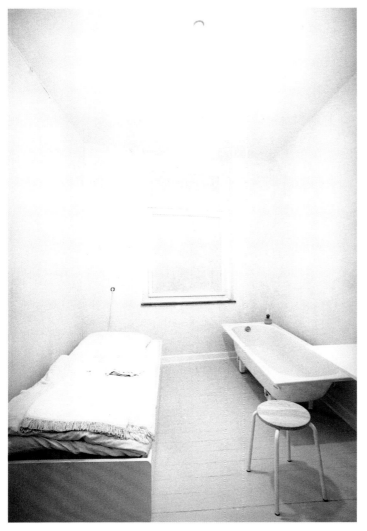

Gregor Schneider
*u r 19, LIEBESLAUBE,
Rheydt*, 1995
Room within a room,
construction made of
blockboard and wood, 1
window, 1 lamp, 1 tub, 1
radiator, 1 cupboard, grey
wooden floor, white plastered
walls and ceiling
Haus u r, Rheydt, Germany
© Gregor Schneider /
VG Bild-Kunst Bonn
Courtesy Sadie Coles HQ,
London

'Nothing … about the shop was positive or pleasant, except the atmosphere of creative energy – and this energy was all about rudeness. There was a kind of sneering to it, a punk-like self-contempt, combined with world-contempt as well as a punky drive to be always drawing attention to the hateful matter at hand and not just getting on quietly or in a solitary way.'

Trap

Just as Kurt Schwitters created an inner world inside his studio, German artist Gregor Schneider transforms his house in Rheydt, near Mönchengladbach, into a series of rooms within rooms, crawl spaces and vertical passages made out of different sculptural materials. Some spaces are empty while others contain photographs, dead animals, disco balls or abstract objects. One room is situated on casters and can rotate imperceptibly through 360 degrees. Visitors taken on a tour of what Schneider calls the Dead House returned to this room and became completely disorientated. When curator Ulrich Loock asked in an interview, 'What is behind the very last window?' Schneider replied, 'Everyone asks that question. You raise it and stare at a solid white wall. That makes most people scared and they want to get out. I'd love to stop someone getting away one time, but I have never dared to yet.'

Utopia

The fresh studio, yet to be occupied, is a utopian space. It is, at this point, a tabula rasa where ideals and aspirations have yet to find a form and, in this unrealised state, are untainted by failure.

Value

Perhaps the closest historical figure to the contemporary artist is the alchemist. Wikipedia's useful definition is as follows: 'Alchemy is an ancient tradition, the primary objective of which was the creation of the mythical "philosopher's stone", which was said to be capable of turning base metals into gold or silver, and also act as an elixir of life that would confer youth and immortality upon its user.' In psychoanalytic terms, the creative act can be understood as infantile, libidinous, fetishistic or scatological. Typically repressed by bourgeois society, these urges are unleashed by the artist. The studio becomes a magical machine which transforms the 'excreta' of these de-sublimated urges into objects of monetary value and aesthetic immortality.

Window

Dutch seventeenth-century painting often pictured domestic interiors, including the artist's studio. These pictures would include a view through a window. As well as providing a source of illumination within the image, the window signified a perspective onto the outside world. Conversely, contemporary artists offer a window from the outside world into their studios. American artist Paul McCarthy's *Box* (1999) is a full-sized room encased in a wooden container with a window. When it was installed on the pavement of Madison Avenue in New York City, members of the public could climb onto a step and peer inside. What they saw was McCarthy's studio turned carefully on its side, 'with all its furnishings and contents intact, present[ing] the image of a complex inner world "turned upside down" … In this, McCarthy is true to his project of carnivalesque overturning, of testing the limits through contrast, of upsetting the applecart of modern minimalism with perverse and sly outrageousness.' As we are enticed to climb the stair, stand on tiptoe and crane our necks to make sense of this vertiginous space, McCarthy transforms us into voyeurs, witnessing a workspace that has been detached from the possibility of labour and repositioned as a parallel universe.

Xenodochium

The prefix 'xeno' means 'foreigner, stranger or guest'; the xenodochium is a room for hosting passing strangers. Studio organisations such as Gasworks in London, DAAD in Berlin or MomaPS1 in New York offer studio space to foreign artists to take up temporary residencies. Unlike a tourist visit, living and working full-time in a foreign city can be at once lonely, disorientating and exhilarating. On moving to London, Italian artist Annie Ratti recreated her new surroundings inside her studio. Urban Landscape, Early Morning, in Autumn (2003) is made up of wooden pallets used for shipping crates, which provide a literal and metaphorical platform for natural and cultural artefacts. As Ratti has said, 'It's like the way you look at a city, a town, or urban space, but there is also the idea of home and of home life.' The pallets are arranged on the floor in a rectangle, like a raft. The climatic, phenomenal, material and olfactory elements of the landscape are represented by a whirring fan, recordings of birdsong, bags of autumn leaves, pots of rosemary. Coat stands and lamps provide a vertical axis that echoes the high-rise apartment blocks outside. These elements are composed alongside long cushions covered in richly decorated fabrics, carpets, an empty birdcage and a television set. Overlapping rugs and cushions create divans draped in patterned textiles from Africa and India, vestiges of a colonial past and emblems of London's multiculturalism. They are arranged so as to invite not sitting but lying down, in the manner of an odalisque.

They evoke a habitat – the artist's coat hangs on the stand – and the artist's consciousness and memories – we hear what she heard, early one morning. The studio is the locus for a voyager mapping her co-ordinates. Ratti offers a place of meditation and time travel to cultural and personal origins.

Year

Studios have significance not only as spatial but also as temporal environments. In 1980–1 Taiwanese artist Tehching Hsieh installed the sort of clocking-in machine found in a factory inside his studio. His performance, entitled *The Time Piece*, involved clocking in every hour, 24 hours a day, for the 365 days of one year. He made a still image of himself every time he punched in; put together, these images made a six-minute film. Viewers can track the passage of time through the growth of the artist's hair, which he shaved off completely at the beginning of the project. The studio here is analogous to a factory, a diary, a space of meditation, a place of endurance, discipline and obsession. It is also like a clock marking out a life with relentless precision.

Zone

In traditional usage, the floor space of a studio offers a zone for the figurative painter to explore figure/ground relations through the employment of a model. The easel is positioned offside, enabling the building of platforms where a figure can be arranged, standing, lying on a couch or daybed, or, as with some of Lucian Freud's subjects, sprawled directly on the floor. Drapery or memento mori can be at hand, part of a panoply of props. This theatrical zone becomes cinematic in the work of an artist such as Cindy Sherman who uses make-up, costumes and different backdrops to effect a breathtaking series of transformations of her own persona. A different zone operates in the creation of portraits, marking the distance between artist and sitter. This can give the subject of the portrait autonomy and composure. It might also open a libidinous space between a photographer and their model, as exemplified by the intimate nude photographs of Robert Mapplethorpe. The conceptual zone of the studio is however multivalent and constantly mutating.

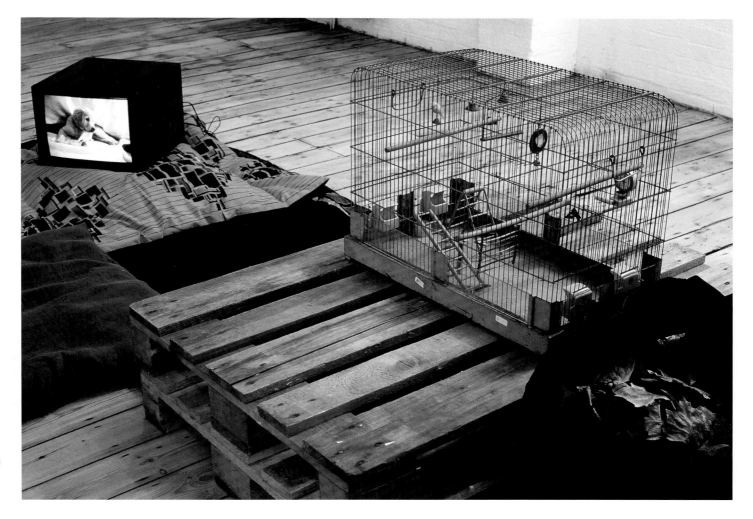

Annie Ratti
Urban landscape, early morning, in autumn, 2001–2
Pallets, cushions, crates, lamps, plants, fans, video
Photo: Claudio Abate

Richard Cork outside Francis
Bacon's studio in Reece
Mews, South Kensington,
London, November 2011.
Cork interviewed Bacon
in 1971 when the critic
was only tweny-four.
He found the experience
to be 'mesmerising'.

Studio Visits
Richard Cork

The first artist's studio I ever saw, in the autumn of 1971 when I was twenty-four years old, belonged to Francis Bacon. It was a mesmerising spectacle. The floor, heaped with layers of printed images as well as discarded, slashed canvases, testified to the intensity of the work he had made there. It was a very private space, and Bacon – although friendly and talkative – seemed reluctant to let me explore his sanctuary. But eventually, on a subsequent visit to this lair in a London mews near the Victoria and Albert Museum, he did allow me to investigate his most hallowed territory and find out what lay embedded there. After passing through a narrow kitchen lined with colour reproductions of his work, Bacon led me into his modestly proportioned studio. I noticed that one of his new paintings sat half-finished on an easel, showing a grey upper area leading down to a central section spattered with blood-coloured pigment. 'I was planning this year to do a series of paintings where murder had been committed,' Bacon explained with a troubled frown, describing how there would have been 'one in a field, one on a pavement, and one in a room. But I'm going to abandon the idea.' I told him that the unfinished painting on his easel had the rudiments of an authentically chilling image. But Bacon, an inveterate and ruthless destroyer of pictures he considered to be failures, replied that it was 'no good'.

The studio felt cold, probably because Bacon's anxiety about the risk of fire prompted him to leave unheated the rooms he was not currently using. The walls, like the door, were gaudily covered with paint-splashes of every conceivable colour. As for the floor, it was smothered in books, paint pots, squeezed-out tubes of pigment and smeared rags. How Bacon moved around in such a cluttered space remained unfathomable, but I did manage to bend down and retrieve a small, discarded canvas from the wreckage. The painted face it had once contained had been cut out with a few swift slashes of the knife, leaving only the tantalising vestige of a head behind.

In this cramped studio, illuminated by a skylight window which Bacon had inserted for the purpose, he somehow managed to work on even the largest of his triptychs. When assembled, they must have stretched across virtually the full width of the room, but Bacon found this constriction oddly stimulating. Here, hemmed in by detritus and a space which most artists would find claustrophobic, he worked indefatigably each morning. 'I get up very early and paint in here until one o'clock,' he told me. 'Then I'm finished, I've had it. I hate afternoons. I think they're absolutely revolting; they're a wash-out.'

Lucian Freud, by contrast, admitted me without hesitation to his far more spacious Holland Park studio one evening in 2005. He was engrossed in painting a picture of a female nude lying with her legs apart. His model, who had just finished posing, was standing by a well-lit bed in the middle of the room. The walls of the studio, situated right at the apex of a very tall Victorian house, were splattered with thick paint. I saw tubes of pigment stacked high and crushed paint-rags heaped on the floor. The whole space testified to the incessant activity of a man obsessively committed to painting at night. 'I work until midnight or half-past twelve,' he said in his soft, low voice. 'But then I get up at four. I've never been any good at sleeping. I think, What am I doing, lying here? I don't really need much sleep, but I feel quite ill some of the time.'

As far as possible, Freud did not allow physical ailments to get in the way of his overriding commitment to art. The truth is that he always wanted to be in his studio. Expending so much time and energy on work might well have defeated a lesser artist. But Freud was formidably resolute and knew how to pace himself. 'When I get weary,' he said, 'I put one cheek of my behind on this high chair.' During the years since he had acquired the top-floor flat and then spent eighteen months building a studio there, the long and lofty room had become layered with accumulated paint-marks from all the work carried out there. Several heaters ensured that 'I can make it very warm,' even though Freud wore a thin grey scarf round his neck 'because I get sore throats'. Without any warning, he pulled a white sheet off a big mirror opposite me. Now I could see my reflection in the space inhabited by so many of his models. It was like finding myself lodged, inexplicably and unnervingly, within one of Freud's own images.

The pigment heaped on the studio wall behind me was so thickly applied that Freud was even able to stick a pair of scissors into it. He explained that 'the paint on the walls is from my palette-knife. When working, I change the colours with every brushstroke, so I'm always wiping them off.' But he had left a space on one of the walls for handwritten inscriptions, one of which caught my eye: 'All systems tend towards disorder.' Was it a quotation? 'Yes,' Freud said. 'It's Newton. The anarchy of it was very appealing to me philosophically. People think that they're safe with a system, but they're not.'

Anthony Caro's studio in 1991 could hardly have been more different. After driving through the narrow archway leading to what had once been a piano factory in London's Camden Town, I found his ample parking space almost filled with colossal sheets and cylinders of rusted steel. Stacked alongside a mighty ship's anchor culled from a maritime scrapyard in Chatham, they all looked ready to be incorporated into a new sculpture. But they had endured a long wait, for he had spent most of the previous six months working on his tallest work to date: a 25-ton *Octagon Tower* spiralling 7 metres into the air, with twisting stairways and secret chambers. Poised halfway between sculpture and architecture, this spectacular work was about to form the centrepiece of Caro's exhibition at the Tate. 'It's taken up our lives this year,' he said, half rueful and half excited. 'We've had seventeen people working on it, and the noise has been unbelievable at times. Because this is a very residential area, I tried to minimise the disturbance and wrote letters to all the neighbours. But when we moved the tower outside, somebody started throwing eggs at us.'

White-bearded yet very spry, Caro remained undaunted by this outburst of local resentment. But neither international fame nor a knighthood prevented him from regarding the Tate show with apprehensiveness. Part of his concern centred on practical considerations. 'The tower contains six separate flights of steps, and a number of rooms on different levels,' he explained. 'I like the idea of people entering it, climbing up and walking round inside. The work can't be experienced properly otherwise. But I feel totally inhibited by the problem of public safety. Nick Serota said to me, "Don't worry, you're making a sculpture, so concentrate on that." But if

somebody falls, the steel will hurt them and it'd be awful. The Tate would have to close the tower at once.'

Despite his immense productivity, and the panache with which his sculpture is cut and welded into flamboyant form, Caro sounded surprisingly anxious. 'I'm very insecure, always worried,' he confessed. 'When I'm working, I don't have the confidence to say, "That's it!" I need a lot of confirmation from people whose opinions I respect, for instance my wife Sheila. She's an artist herself, and since her studio is above mine, we talk about each other's work the whole time.'

Suddenly, on the morning in 2003 when I visited Bridget Riley in her West London house, the entire city succumbed to a heatwave. At the front of a tall, white room on the ground floor, where her vibrant paintings shimmered in the light, we both gazed out of the window. The view was dominated by magnificent mature trees in the square beyond, and Riley clearly admired them. Then she darted through the luminous rooms with a vitality amazing for a woman in her seventies, explaining that long ago she had handed over the execution of her paintings to studio assistants because 'the visual experience' of her work would best come through 'unhampered by any

Francis Bacon, 1975
Cibachrome print
Photo: © Peter Stark
Courtesy of National
Portrait Gallery, London

kind of painterly handling or touch'. Her assistants work in her large house, where walls and bare floorboards are all painted white.

Riley spends a considerable amount of time with her highly trained team. She is utterly removed from the clichéd idea of the artist as a lazy, bohemian dissolute, forever tipsy and hopelessly unreliable. 'The English have a romantic image of the artist, and it's a cross we have to bear,' she said with a smile. 'It's a safe recipe, and I was always impatient with it. I love working. There's nothing like it, making something that didn't exist before. It's exciting.' Riley was certainly the focus of bitter controversy when she emerged in the early 1960s. Restricting herself to black and white, she launched a dazzling optical attack on the viewer with her dynamic, impeccably organised paintings. But precocious success did not make her complacent. She introduced greys and then coloured greys into her art before finally, in 1967, working with pure colour.

Talking to Riley, I soon became aware of the delight she derived from her intense, thoroughgoing involvement with art. The decision to use studio assistants was made as early as 1961. But she is closely concerned with production from beginning to end. 'The working process is very important,' she explained, 'and I enjoy it.' Like every artist, though, she also needs her solitude. 'To supervise work here is one thing,' she said, 'but obviously I have to be alone in order to concentrate properly.' She seemed committed to exploring emotions as celebratory as the joyful painted paper cut-out in the Matisse poster hanging on her wall. 'The spirit of this house is important,' she told me. 'It faces the sun, you see. Part of the job is to work, as far as is possible, for joy.'

Howard Hodgkin, on the other hand, often emphasised the importance of painting pictures all by himself. When he won the Turner Prize in 1985, Hodgkin intrigued many visitors by exhibiting a work called *A Small Thing but My Own*. The title could also have applied to the London flat he acquired, many years ago, in a nineteenth-century house bordering the British Museum. 'I went to the estate agent's office and said, "This is what I've been looking for all my life,"' he recalled. 'Although that's not exactly the cleverest thing for a prospective buyer to say, it was true. I'd wanted to live in Bloomsbury ever since I was a young man, when I had a map of it on the cupboard door in my Shepherd's Bush flat.' Eventually Hodgkin was able to acquire the whole house, and to have the British Museum on his doorstep was ideal for a painter unusually well versed in the art of the past.

His studio, however, is a truly spectacular, monumental space. Approached from the back of the house, via a courtyard containing a palm tree from Weymouth, this mighty Victorian building was once used by a dairy. Horses with milk-carts would enter it and move around on a turntable. Lit through a lofty glass roof, the studio now contains a superb all-white interior. The entire ceiling is transparent, giving the room an exceptional radiance even on a dull day in 1990. Everywhere I looked, this astonishing space bore witness to the all-consuming importance of painting in Hodgkin's life. 'It's the best studio I've ever had,' he explained, 'and it gives me tremendous freedom. I feel as if I'm working in an envelope of light.'

No paintings were visible in this luminous chamber. Hodgkin

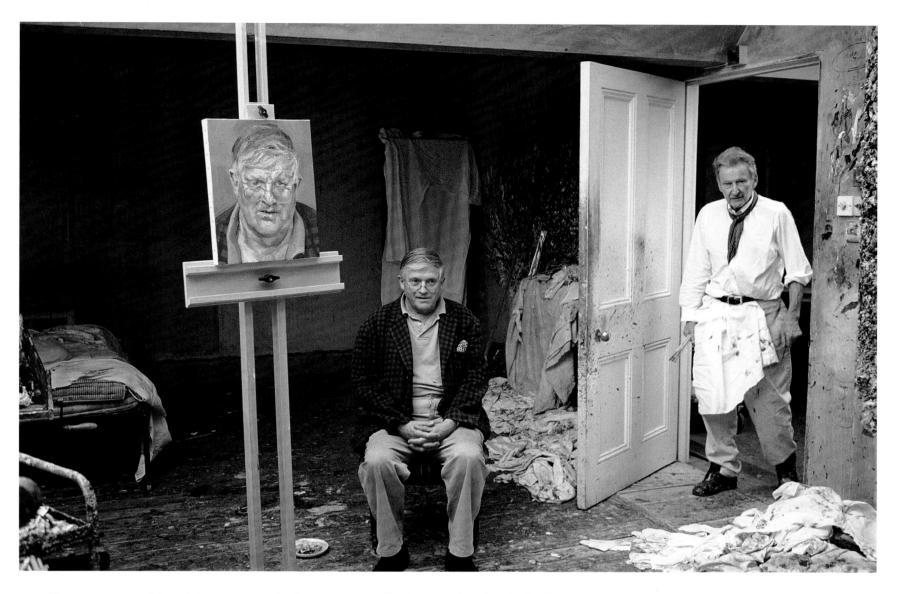

David Hockney and
Lucian Freud
Photo: © David Dawson
Courtesy of Hazlitt
Holland-Hibbert

never likes anyone to see his work-in-progress, and a dozen large stretchers were propped against the walls to hide the unfinished pictures behind them. He is a famously slow painter, sometimes taking years to bring an image to fruition. 'If I did show them to you,' Hodgkin said, 'they wouldn't mean a great deal yet. They're keeping each other company in here, and at best you can say they're in an interesting condition. Slowness is something I can't help, but it's extremely frustrating. My dream is to paint quickly.' Hence the feeling of effervescent freedom conveyed by his mark-making. There is never any sense of staleness or over-deliberation in the final work. On the contrary: freshness of touch is one of Hodgkin's greatest virtues as a painter, even though he is constantly building on what has gone before.

David Hockney's capacious house, at Bridlington in Yorkshire, seemed to have been uncannily preserved in a time capsule. Positioned near the seafront, in 2006 it still boasted the extensive decorative embellishments lavished on it back in 1924. 'It's like a set for an Agatha Christie play, isn't it?' said Hockney with a grin, greeting me in the elaborate central hall where a tanned young man busied himself hoovering the ample staircase. 'I bought it for my sister Margaret and my mother, who didn't do stairs and lived on the ground floor. She died at the age of ninety-one, after spending only three days in bed.' Since her death affected him deeply, Hockney's decision to leave Los Angeles and move into his mother's house may have been bound up with a sense of loss.

As if to prove how energetic he was, Hockney said, 'Come upstairs', racing away with prodigious speed. Dressed in a blue-and-white striped shirt with workmanlike braces and paint-spattered grey trousers, he looked ready for action. And when we entered the light-filled studio he had built at the top of the house, I could imme-

diately see just how busy he had been. While persistent seagulls cried outside the tall, sloping windows which Hockney has installed in the roof, he showed me canvas after canvas filled with his fresh, sensuous response to the Yorkshire countryside. Gesturing vigorously at a painting of an empty path leading through trees, he said, 'That one was done in about six hours – very intense, it knocks you out!'

What attracted him to this landscape, so different from the Californian terrain he used to favour? 'Well, I wasn't going to stay here,' he said, sitting back in a deep yellow armchair with stubbed-out cigarette butts scattered on the floor around it. 'But as things changed and the corn got golden, I realised there's a fucking good subject here. So why should I go back to LA? I'm very excited in Yorkshire. If you told me last summer what I'd be doing here, I'd have been surprised because I wouldn't have known how to paint these pictures. It's not just about landscape: it's about being in it, seeing it, it's about England. I'm painting the *real England*.'

On the way downstairs, Hockney darted into his bedroom to show me another Yorkshire landscape hanging on the end wall. It was a work-in-progress, and I noticed that his brushes and paint were placed near at hand. 'I go to sleep looking at my paintings, and when I wake up – wow! – I have a completely different response to them. I always have paper by the bed, because your mind is freer then, and it's in a special state.'

When Gilbert & George answered my ring on the doorbell of their early eighteenth-century house near Brick Lane in the East End of London, they seemed unaware of the summer heat. Dressed in their customary matching suits, with crisp white collars and well-laundered ties, they took me through to a small outdoor area at the back. A handsome carved and painted bench, by their favourite Victorian designer Christopher Dresser, glittered in the light. Over

the wall, Hawksmoor's architectural masterpiece, Christ Church Spitalfields, seemed to surge with startling force. When I marvelled at it, George murmured, 'It's rather terrifying, isn't it?'

But we soon disappeared into the coolness of a surprisingly extensive studio beyond, converted by the artists from a clothing factory built in the former back garden half a century ago. Tea was promptly served in plain white mugs. The pair admitted that 'we don't normally notice the weather. We're inside all the time working. In the winter months, we get up soon after six, go out for breakfast in Brick Lane and come back to start work before it even gets light.'

Despite their long-standing reputation as the bad boys of British art, the truth is that Gilbert & George are formidably disciplined and prolific. Ever since I first visited them in the early 1970s, when they were only renting two rooms on the ground floor of the same house and producing art in the kitchen, they have concentrated their energies on making a prodigiously inventive body of work. In 2001, this indefatigable duo were showing no sign of letting up. I inspected careful scale models on a nearby table of two museum-sized galleries where Gilbert & George were holding large exhibitions later that year. One was the Factory at the School of Art in Athens, the other at the enormous Centro Cultural de Belem in Lisbon. Judging by the miniature reproductions of their exhibits,

already fixed neatly in place on the walls of the scale models, Gilbert & George would pull no punches in either Greece or Portugal. One colossal, multi-panelled work was called *Blood, Tears, Spunk and Piss*, while the word *Cock* was prominently displayed in another, equally provocative picture. But Gilbert & George had not experienced any resistance from their hosts: 'Both Athens and Lisbon have recently come out of rather oppressive times, so they've gone to the other extreme now and haven't questioned any of our choices.' On our way out, Gilbert handed me a printed post-card. Signed by both of the artists with kisses, it read, 'We Are The *Most Disturbed* People We Ever Met.'

Driving through the entrance to Antony Gormley's spectacular London studio near King's Cross in 2004 was an unforgettable experience. The colossal building, custom-designed by David Chipperfield, reared up in front of me, culminating in a dramatic zigzag roof line. Suddenly, I heard a shout of greeting from above. It was Gormley, waving to me from the angular metal staircase jutting out from the studio's façade. Very tall and restlessly energetic, with close-cropped jet-black hair and circular glasses, he seemed thoroughly at home in his monumental workspace. And he wasted no time in coming down to join me.

When he began making sculpture, Gormley struggled to establish

Bridget Riley, 2004
Photo: © Eamonn McCabe

himself. He became obsessed with casting his own body, relying on help from his wife, the painter Vicken Parsons. Now Parsons is able to relish her own separate studio within the vast Chipperfield building, and Gormley's ever-growing international reputation means that he can employ many workshop assistants. One of them sat outside with a protective mask over his face, carefully dipping pieces of metal in vessels of liquid. The other men were all busy inside the great metal doors leading through to the main studio.

It was an awesome arena. Chipperfield designed an astoundingly lofty space where everything was enhanced by the luminosity of the immense skylights far above our heads. Only a few sculptures stood or crouched on the floor. All the rest dangled down from the beams spanning the roof, including an upside-down man suspended by chains from a pulley. But he was the only solid sculpture among the suspended pieces. Looking up at those whirling clusters of metal rods, I saw that contours of male figures could be detected inside them. 'It's like drawing in space,' said Gormley. 'I've released them from the burden of being self-supported.'

Clearly exhilarated by the fresh possibilities he had uncovered, Gormley took me through to a neighbouring darker space where his earlier sculpture was stored. A cluster of life-size figures stood in one corner, tightly wrapped in polythene and taped up. They looked like bandaged victims, melancholy and trapped. The contrast between these haunted men and the work in a nearby chamber could hardly have been more extreme, for here, the entire space was alive with looped, arching and tensely coiled lines of raw metal. They added up to an audacious and exuberant spectacle. 'This is my mock-up for *Clearing*, my new installation at White Cube,' Gormley explained with a quickening sense of anticipation. 'It's my attempt to liberate the room from Euclidean geometry, but you could also say it's a trapped trajectory, testing itself against the surfaces of the walls, floor and ceiling.' Either way, *Clearing* became a dramatic breakthrough in Gormley's work.

I visited Anish Kapoor's studio not long before his immense Tate Modern commission for the Turbine Hall, one of the most commanding art spaces in Britain, was unveiled in 2002. Kapoor wanted, from the outset, to work for the first time with the entire Hall. Everything, including the normally empty entrance ramp sloping down towards the information counters, would be engulfed in his unashamedly overwhelming sculpture. Not that Kapoor felt at all smug about his ability to perform such a colossal feat. He admitted with a rueful smile that 'there are so many decisions to make, and so much pressure, it's driving me crazy.'

Kapoor was quite willing to show me how he had arrived at his Turbine Hall sculpture. Upstairs in his South London studio, converted from an old brick building which used to house a company making shutters, tea was provided in a room hung with

preliminary drawings and photographs of the Tate project. Then, eager to reveal the models he had made subsequently, Kapoor took me down to a far larger room on the ground floor. Assistants, some with protective masks over their faces, could be seen in even bigger spaces beyond working on a monumental two-piece sculpture, where extremes of concavity and convexity were powerfully juxtaposed. Intense, concentrated activity was occurring there, with loud drilling and other noisy eruptions – not least in a closed-off section where a man was spray-painting an enormous dish. But Kapoor was able to focus on the array of models and computer graphics which gave me fascinating insights into the genesis of his audacious work for the Turbine Hall. In order to give me a more visceral idea of what it would be like, he lifted up a model and held the central cavity directly over my head. I could look straight up into its darkness. 'The middle ring will envelop you when you move underneath,' he said, before encouraging me to kneel in front of the final fibreglass model, covered with black felt-tip lines showing where the seams would be. Putting my head next to the floor, I was able to gauge the vastness and a sense of something suspended far above me, as if high in the Turbine Hall's upper reaches. But Kapoor also told me that the piece had to 'be intimate, and engage each viewer singly and personally'. He knows a lot about that kind of involvement. Although his reputation rests on his work as a sculptor, he spends as much time as possible on his own in a special room set aside for painting. He said that he liked exploring colour with the immediacy of a brush, contrasting it favourably with the frustration of knowing 'how long it takes to make big, technically demanding sculpture'. After walking round the entire studio, I was impressed above all by how this immense space had stimulated the range and inventiveness of a prolific artist arriving, now, at the fullness of his maturity.

Cecily Brown

Why did you choose to live and work in New York?

Because of the light, which we don't get at home. Funnily enough, this is quite a dark studio, but I had a beautiful studio for years, with fantastic daylight. I miss that.

One feels so tiny in London. I often think about cycling across Vauxhall Bridge when I was a student, with lorries thundering by, and rain. Everything's harder in England. When I came here, I was broke, but I found it very easy to live hand to mouth in a way that I hadn't in England.

So you arrived at the airport with a bag and an address?

Yes. I remember faxing my professor to say, 'Can I please finish my degree from New York, and I'll send you back some pictures?' They said absolutely not, so I finished my degree and moved back here the following year. At the time, the London art world was much smaller than it is now. I felt that the kind of gallery I wanted to show in would probably not be interested in me, and vice versa. Being a sort of old-fashioned painter, I didn't feel hip enough for London. Here, the art world was so much bigger. There was more room for different kinds of work.

You missed the YBA phenomenon by a year or two. Did you not want to be part of that?

The funny thing is that I've met a lot of the artists and know them as colleagues. But at the time, I felt like that was a very closed world. The other funny thing is that I feel that my work had quite a lot in common with the YBAs.

When I first came here, I stopped painting entirely. Then gradually, I went back to it. My efforts in other mediums were pretty unsuccessful. The only thing I'm proud of is the animated film I made. That was the thing that got me back into painting, because it reminded me why I started in the first place.

Why did you stop painting?

I had a strong awareness of how I didn't fit anywhere, and a lot of the art I was responding to wasn't painting. You want to feel like you're of your time. As much as I loved older painting, there was a desire to be in conversation with people whose work I saw for the first time here. I thought painting was very restricted. Also, what more can you say in painting? I still don't think there's more to say. Once you're aware of everything that happened in the last hundred years, it's conceptually hard to carry on. The attitude in London was, 'If you know all of this has happened, how can you possibly paint?' I agreed with the people who said that, even though I wanted to paint so much.

But you can't worry about the huge picture. I've come to believe that the kind of artist you are is something that you can't help. So it was a slow acceptance of 'Well, I am a painter' and, even more slowly, 'I'm this kind of painter'. Even once I started painting again, it took quite a few years to lose certain hang-ups. That's still going on.

You say you can't help being what you are, being a painter. Is being an artist an affliction?

It is when people want to go on holiday and you have absolutely no interest. It's an affliction in the sense that I'd rather be here than anywhere else. My life has changed a lot now I've got a husband and a child, so I have to work differently. But until now, it's been very hard to compete with the pleasures of being in the studio. Some people could argue that you're hiding yourself away, making your mind physical and living in that space.

Is that how you would describe a studio?

My studio, not everybody's. I know a lot of people now don't need a studio. But it's my favourite place. I think it's partly because of the medium. You're compelled to be around the paintings a lot more than you are with some other mediums. The more time you spend, the richer – the deeper – it becomes, and the more you look at what you've done, the more it's going to help with the next painting. You can never spend enough time in the studio.

How many hours do you spend per day?

It used to be twelve-ish.

Any breaks?

To get a coffee, maybe to see some shows. Now I'm trying to get used to a new model, which is to be very constructive in the hours I'm here. To any young artist, I'd say you have to be there all the time. A very good teacher of mine said you have to be there for the bad days, and that has stuck with me. She gave me my first studio by letting me paint in her garage when I was broke, before I got into the Slade. You just have to show up for painting. If it's a totally miserable day, you also have to know when to leave.

How has success affected you?

The first thing is that I can afford to do it all the time, which is obviously a great luxury. And I can use excellent materials. I don't have to worry if I work on a huge painting for two years and then I destroy it.

You destroy your paintings?

I do. Actually, my assistant does, usually on days when I'm not here.

So you hire an assassin?

I do! It's not that I don't want to do it; it's just the way it works out. The paint gets too old, it gets too worked, it gets too overcooked. Sometimes it gets to a stage where you're never going to be able to get it back.

It would be interesting to know what New York did to your painting …

It's hard to say because my whole painting life has been here since I left art school. One of the reasons I was so attracted to New York was that it struck a chord, the physicality of it and the energy. I'm very open to what's around me. I walk very fast and I love the rush of information that you get. It's very energising and inevitably feeds back in. But I've never consciously made a New York painting.

Your father is a recognised critic, your mother a published author. How much does family affect creative people?

One of my sisters is also a published author. I think my mum and stepfather were very open to us doing something we loved. I always loved drawing. I was never discouraged from being an artist.

How much is nature and how much is nurture?

So many of the great modern artists did not come from an artistic background. Think of Johns and Warhol and (I think) Twombly. They were poor Southern boys. Well, not Southern, but working class.

Is art a class-breaker?

Yeah, although class is so much less important here. It's one of the few things in England that is a class-breaker, up to a point.

Is art useless?

It improves life. It's a form of escape. When you walk into the National Gallery in London, you're transported.

You've talked about your art being voyeuristic. Is art voyeurism? And what has sex got to do with it?

Well, the first thing you need is a subject. You want to capture people's imaginations, and you want to talk about something that people care about, or are obsessed about, or are preoccupied with. Even if you're indifferent to sex, it's all around us. I feel like when I started painting, sex wasn't in one's face as much as it is now. I've actually become a bit of a prude, because I find there's so much of it every-where. It's one thing when you've chosen to go into a museum or gallery, but I think there's far too much sexual imagery on the street, or on the Internet. Violence is even worse. Violence is far more accepted than sex in this country.

But sex has always been one of the great subjects, beginning with Titian and Bosch, or even earlier. One of the things I love about the Old Masters is the way they had to deal with it because they couldn't do it directly. People focus on the sex in my work, but it's just there and part of life like everything else. Painting is an invented space where you can talk about a lot of things at once. You can have sex there at the same time as something pathetic, something violent, something sad, something nasty, something tender and so on. I've always felt like a voyeur with other people's paintings in the best possible way.

When did you feel that your art had been discovered?

Once it started happening, it was all quite quick. Getting a show at Jeffrey Deitch's gallery was huge for me, especially as I expected Jeffrey would be the last person to show work like mine. Around 2000 it felt like people really were interested and responding. You don't believe it at first. I carried on waitressing even after my paintings were selling; I didn't dare stop because I didn't want to have to go back. So the first two or three years I was exhibiting and selling work, I kept my job, gradually reducing the hours until I thought, Okay, maybe I can count on this. I certainly never expected to make a living, let alone do really well. A lot of it is luck and timing. I started showing at the beginning of a boom, a huge resur-gence of interest in painting.

Are De Kooning and Bacon influences on your work?

Everyone mentions De Kooning more than I'd like them to. I was thinking much more of Pollock and the Old Masters. And Bacon, but I always try to suppress Bacon. When I was at school in Britain, he was the painting god. That was another funny thing about coming here; it wasn't Bacon so much, it was more

De Kooning. Bacon was the one I was trying not to look like. In my early art-school things, it was so obvious that he was my favourite.

Now I don't care so much. Time's passed. When I was younger, I'd worry terribly that it showed if I was a fan of somebody. I think there's a kind of mash-up of influences. Over time, different influences come to the surface. That's why I'm not worried that I'll be remembered as 'She ripped off Gorky' or 'She ripped off Bacon'. People might say I ripped off everyone. I see it all as there to be used and understood.

I wouldn't mind being remembered as someone who is in conversation with the past. I'd like to keep the past alive. That sounds so ridiculous, because every artist – whatever they make – loves old art. I love Goya ... You have to have somewhere to put your figures. I never want there to be an overt reference to something in particular. It's more taking what is needed at that moment and using it, not worrying about where it comes from.

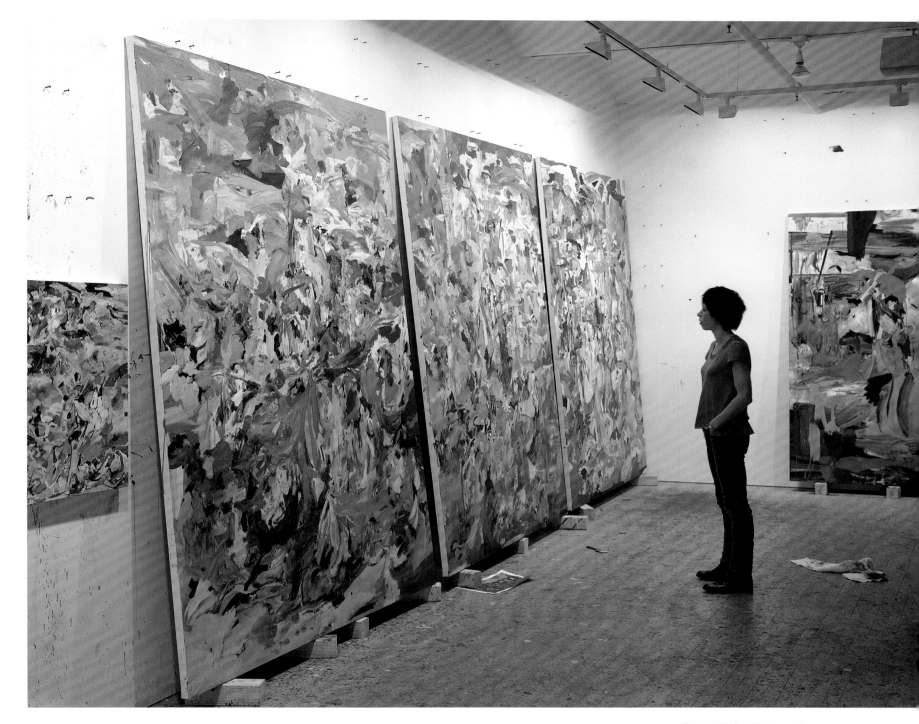

The artist's brushes (opposite page), some of which she has specially made with extra-long handles and squirrel and ox hair. The artist in her studio (above), viewing finished paintings. Brown will occasionally work on a painting for two years only for it to be destroyed. As she explains, 'If you're prolific, you have to be a good editor.'

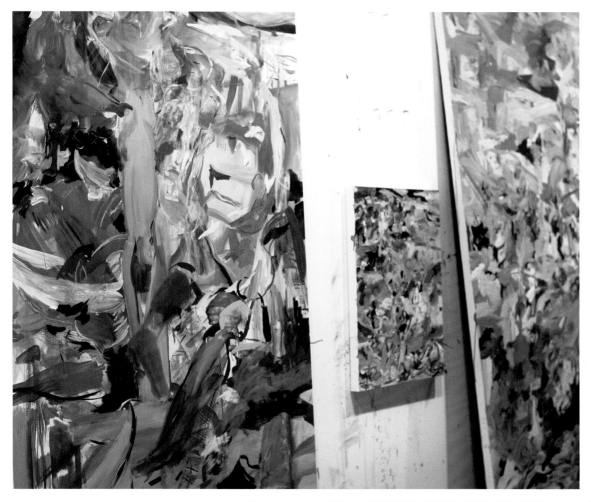

'I find a sense of oneself in the crowd in New York. You feel a part of it, and at the same time you can feel quite solitary,' Brown caught on camera holding up traffic in Union Square (left). 'One of the reasons I was so attracted to New York was that it struck a chord, the physicality of it and the energy.' Brown's canvases (above) leaning against her studio walls in preparation for major exhibitions in London and Rome. 'I've come to believe that the kind of artist you are is something that you can't help.' Brown engages her daughter (right) in artistic conversation on the walls of her studio, the child's toys mingle with artwork. 'I think a proximity to art improves life,' she says. 'I wouldn't mind being remembered as someone who is in conversation with the past.' Or with the future, it would seem.

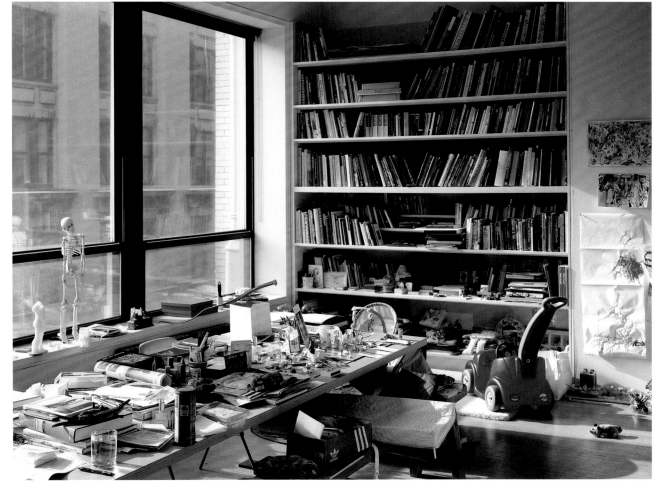

Shezad Dawood

What is the role of the studio in an artist's life?
I subscribe to the idea of the mansion of the mind that was originally put out by Cicero and later developed by Giordano Bruno. A kind of inner mansion where you have a number of connecting rooms. It's actually used as a memory device, but for me that becomes a way of reordering one's world. I spent a lot of time when I was younger reading about alchemy and memory techniques and devices, and it became an interesting way to resolve my relationship to my inner world and to the outer world.

My connections and my understanding are multiple, so for many years I worked without a studio. I worked in my front room and often on a plane or wherever I ended up. I have a big studio these days – I've succumbed – but I still like to keep that flexibility, that openness. Having the big studio allows me to go away more often. I spend about six months of my year in London; I'm very rarely there for more than a few weeks at a time.

You say you've 'succumbed' to having a large studio. What do you mean?
It's been a practical necessity because structurally I outgrew the previous one. The old space didn't work any more in terms of the storage of work, the creation of work, the level of things we were working on. It's interesting when you allow yourself to be led by the currents of life and to create – going back to this metaphor of mansions of the mind – little exit doors.

This exit door that you have now is a large studio in which you can delegate to some degree and out of which you can move?
Exactly.

Move out to where?
For the last few years I've been doing a lot of work and research in Morocco. I tend to work on ideas in a very slow way especially with larger projects which are less studio-based. I love this parallel of working in the studio and then stepping out into the wider world and working in a small, collaborative, networked way which often throws open its own challenges but also adds a certain richness and texture that feeds back into the studio. I feel it all as an open field of what the studio might represent.

Given your interpretation that the inner studio, the inner mind, can create what can be projected into history, how is it that one person's artistic or imagined realities can have a huge impact on millions of other people? What is art, in fact?
I always think of Georges Bataille ... Look where he roamed, without ever leaving France! To the point that even the Surrealists couldn't contain him ...

For me, art is this quasi-spiritual thing where the inner and the outer worlds are mirrors. It's like in Cocteau's film *Orpheus*, where you step through the mirror into the world of death, but which is the world of death and which is the world of life? It's almost a magical simulacrum, a portal for the artist between the outer world and the inner world. That's where I tend to roam.

So in effect this mystical element is a camera obscura projected on the outer world. And the little reflection in the mirror: is it art or is it reality?
That reflection is the reduced, or the obverse, gaze. A more open space. I love stepping out into the world. I love testing my ideas in collaboration with others. There's a continuum of ideas that moves me between what I make in the studio and my larger collaborative projects. Something happens in that process of taking ideas that are more intellectual, rarefied, reflective, in the studio and testing them against other people. Both are very important. I'm interested in mysticism, light, cultural play, political allegory. This layering of work is something that I can build a certain density into out in the world as well as in the studio. I see it all as my studio. Why would I want to restrict myself?

You've said that your practice is like a stream of consciousness – one text flows very much into another.
I love the intuitive or counter-intuitive relationship that's thrown up between working in different sites and spaces – and different conversations I might have. The context is shifting all the time. I'm the child of immigrants, I've lived in many countries – maybe there's a nomadic thing at my core which impels me to keep moving. A certain restlessness that is fundamental to my creative drive. Maybe that has something to do with cultural dislocation? One of the things I see as problematic is conceited nationalism which extends from politics to the art market. Hence I like to be able to roam. The word Hegel used for 'synthesis' actually embodies the idea of going beyond. Not a simple, relativistic resolution.

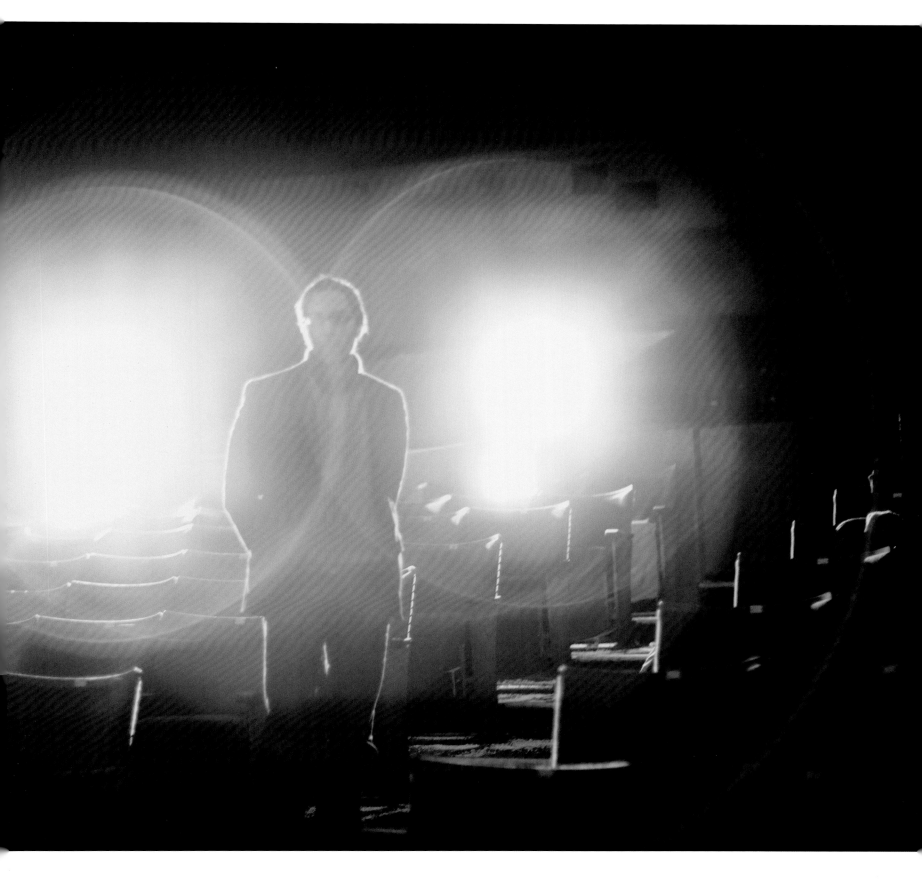

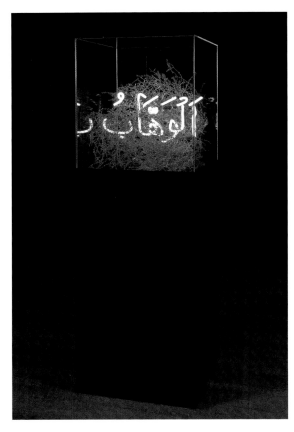

(above)
The Bestower, 2007
Neon and tumbleweed with enamelled aluminium plinth
Courtesy of the artist and Paradise Row, London

Shezad Dawood (previous page) photographed on a site visit to an abandoned cinema for a commission for the city of Preston, famous for its now defunct textile industry and home to a large ethnic Pakistani population. At the height of cinema-going in the 1930s, Preston had the greatest number of cinemas per person in England. 'Cultural dislocation serves me, or perhaps I live in my own utopian dream.'

Dawood, who has lived in many countries, was influenced by the neon signs in his father's homeland of Pakistan: 'I love allowing something to develop in my painted works or the neon sculptures ... an interest in ideas of mysticism, ideas of light, ideas of cultural play, ideas of political allegory.'

Dawood's studio (below) also functions as his home. In 2005 he collaborated with an architect and curator to convert a heritage building in East London into an installation consisting of a studio along with a living and exhibition space: 'I live above my studio and always have done since I've had a studio. I love to be that close to my work, but also I see my studio and home as a continuum, a social space.' Dawood (opposite page) in Victoria Park, East London, in December 2010. 'I like to take walks to clear my thoughts or interrogate myself further about what I'm doing.'

So what you're doing is synthesising society?

No, almost the opposite. There's a two-tiered process. One where I have a fascination for the way in which art acts as a mirror. In certain film makers' work there's an attempt to mirror the world, not neatly like in a Hollywood film, but as a kind of rupture. It's not about synthesis. Once you've stepped out of the synthesis/antithesis duality, you start to see more of the organic structure, the structure behind the outward form. That's where art starts to operate. For me, that's where the studio can't just be these four walls. The artist is like a raggedy Scarecrow circumambulating the world, perpetually seeking the Wizard.

What about the gastro-intestinal juices that drive human emotions?

Fear and desire play a part, of course. What drives me to be an artist? Is it something transcendent? No. Sometimes it's far more of a gut instinct. Maybe somewhere between those two poles exists intuition. Intuitive faculties are not easily reduced to the binary of head and gut.

Would you say that the head is the studio and the gut is the outside element?

What you put forward is a really interesting way to visualise it. It's my gut that's more challenged by the larger collaborative projects I do out in the world. My emotions are challenged; the rug is pulled out from beneath me. It's important to have the rug serially pulled out from under you to keep yourself fresh as an artist – to keep challenging your own comfort zones.

Does your sense of pulling the rug from underneath yourself translate to pulling the rug from underneath social mores?

I seem to be moving into that space where there needs to be more of an urgency to art rather than just to fulfil certain markets. There needs to be more social urgency. But I don't know if I would distinguish this from social mores. I get tired of the way in

which institutions and the art market become guilty of a neat, culturally relativistic reduction of artistic practice. There's a certain conceptual engagement that one could step into very easily when one is with another artist. You just slip into it. There's also a certain clarity, a need to communicate. The audience is also a factor. When that becomes secondary, it dilutes or limits the deeper thinking behind the work.

You've chosen to have your studio in the East End of London. Why is that?

It just happens to suit me. There are plenty of other artists around. I live above my studio and always have done since I've had a studio. I love to be that close to my work, but also I see my studio and home as a continuum, a social space. Many artists, curators and writer friends are local, and there's a healthy flow of people coming in and out.

If your studio was in Mayfair, how would that be reflected in your thinking?

I don't believe in setting up those oppositions, which are too easy. But creatively it would be more sterile. Around here you have, as I've said, numerous artists, and you've also got lots of hardware shops, wood places. It's where you can get things made and done. It's useful to be in this area because it's a site of production. Also, it's close to Victoria Park, and I like to take walks to clear my thoughts or interrogate myself further on what I'm doing.

You referred to the cross-cultural dialogue you like to engage in ...

I guess living in many different places leaves you without a fixed centre. I've learnt to rethink the way I see the world because I find it hard to believe in conservative nationalism. I'm a great believer in opening up spaces and dialogue and seeing points of connection between cultures. But central to the question is a divide in cultures.

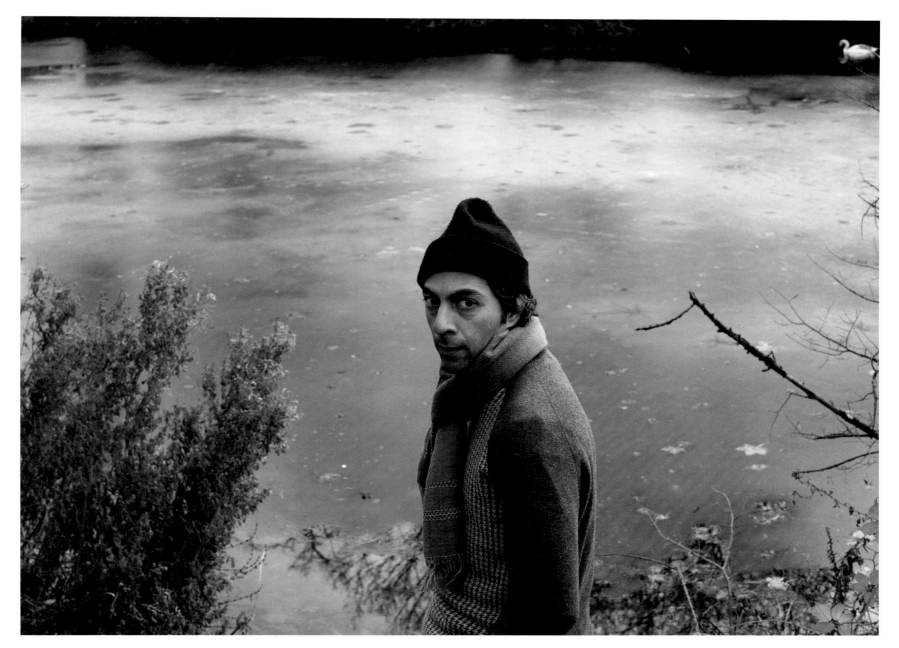

With your father being Pakistani and your mother Indian – you even have some Irish blood in you – are you looking for a centre?

No. Up until about the age of fourteen there was definitely a sense of dislocation. There was always a sense, even at school, that I was an immigrant, and yet if I went home to India or Pakistan, my English inflections when speaking Hindi or Urdu would give me away in a heartbeat. Then it was almost like I did a 180-degree turn in my thinking. I thought, Why do I have to conform, and to what? There was the idea of just feeling myself free to draw on all the things I'd grown up with. Maybe that's something I try to reflect in my studio today with this mix of people.

Are cultures an amalgam of social inflections?

Yes and no. There are deeper tendencies and continuums philosophically, metaphorically, but for me, often, there is the idea of seeing a connection where one isn't apparent. Cultural dislocation serves me, or perhaps I live in my own utopian dream. What I find intriguing is to make bold connections and assertions and then see where they lead.

Is the fact that you are the offspring of Indian and Pakistani immigrants the reason for your success in Western Europe?

Perhaps it was more apparent in my earlier work, where I was more aware of that binary. Getting a bit older, with more confidence in what I was doing, was like taking the stabilising wheels off the bicycle. You're asking about the contribution the work might make. What I hope my work might do is reveal something about the workings of the mind. The way in which we construct culture.

Around the time there was a lot of media-speak around the clash of civilisations, I was interested in going beyond that and looking at how this neat contrivance of Islam vs the West masked something quite similar. Both colourful trajectories, Islam and the myth of the American West, grew up in dustbowls. This idea of a frontier, of being surrounded by enemies on all sides, this kind of ideology, comes out of the desert. My work prior to that dealt more literally with the binary between Britain and India, Britain and Pakistan, or Britain and the Continent. That work evolved into a larger binary and then tried to look beyond it. The more recent work steps out into a more philosophical abstraction of space and time, while my films are becoming more of a political allegory.

For Conceptual artists, and for some other modern and contemporary artists, the studio is taking on more of a factory aspect. Is it still a studio, or is it a workshop?

It's whatever you want to make it. I know people who work alone, and I know people who have a factory set-up with assistants. I fall somewhere in the middle. A studio should be a place of calm and dialogue as well.

So the studio is not just a working space; it is part of an elaborative process.

Yes, more like a laboratory of ideas. Recently I've been more and more intrigued by how one can open up the studio even more, or the practice perhaps. How do you separate the studio and the practice? You can say that the studio is in this particular building, but I've never really seen that as the studio. The studio is in the mind and in the world.

Lucy Williams

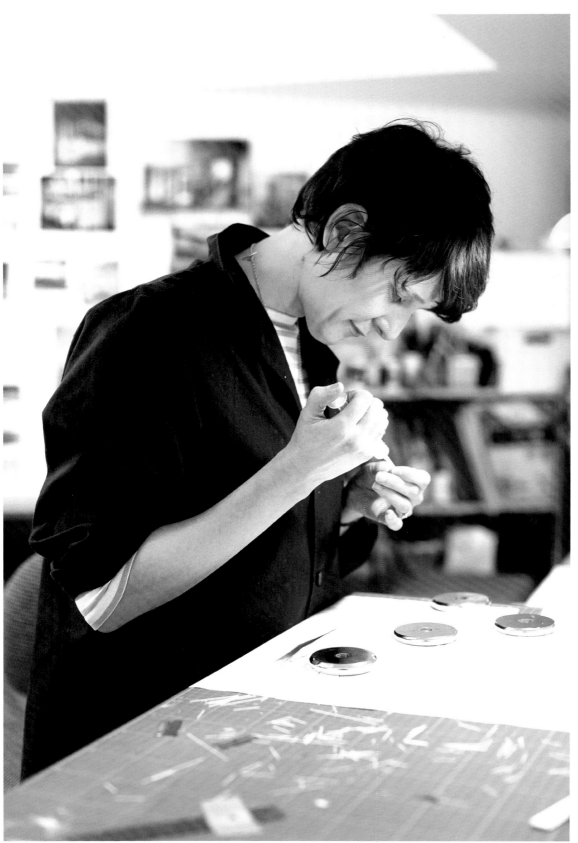

What is interesting about the artist's studio?
It is a secret, private world, and not that many people
see it. A lot of artists don't want anybody to see
certain phases of their work.

**Is that a proprietary thing? A concern that ideas
might be stolen?**
There must be a bit of that. People become artists
because there is that private part of you and then
there is a public part of you which shows the work.
A lot of artists are quite shy.

**Shy or not confident? When you see people
fine-tuned by the galleries' public-relations
machines …**
Most artists hate those moments.

What do you dislike most about them?
I don't like being on show. I recently had a show
at McKee Gallery in New York. At the private view,
people asked me lots of searching questions, and
that's tough. When you are working, all your ideas
are flowing. You are not necessarily having to explain
everything to yourself. You are just doing it. Then
people want an explanation. The worst thing to be
asked is: 'What is your work about?' Because it's a
sequence of ideas that go back in time to – you can't
even remember. It's like building blocks. But people
want a sound-bite; they want one answer.

Is this germane to art or the artist?
Both. Each work is a stage in an artist's trajectory.
When I was at art school in Glasgow, I always found
the idea of the Sublime, of reaching a higher level,
alienating, because I didn't know what it meant. It
sounded like a religion to me. I have a more prac-
tical point of view. I make things, and out of making
things other things are made. It is a cliché, isn't it,
that artists are shrouded in mystery? In a way we
perpetuate that myth by being private, so you think
that something exotic is going on in your studio,
when actually I'm just sticking bits of paper together!

Do you need a large space?
No. I currently work from home in a small space.
Before that, the bigger studio I had in Hoxton, I only
used half of it. The rest was for storage.

Why did you end up in Glasgow?
My art teacher told me that I should go there.

Did the environment affect your art?

I thought it was a serious place. I went to art school on someone's advice, not thinking that you could actually be an artist. Glasgow made me want to be an artist.

Have you changed your idea of what art is about, or is it something which is constant in your mind?

As I have got older, I've become more dedicated. I went along with it, but I didn't know whether it was fundamental to my life. I've realised that it is. During my four years between Glasgow and the Royal Academy Schools (where I did my post-grad), I got an administrative job in an architect's office. I could've sidestepped being an artist and done something else. That was when I realised how important it was to me.

Did things become easier when you chose to be an artist?

At the RA Schools I had this opportunity to concentrate on being an artist again. It felt like a more experimental time. It was at that point that I started making the work I am making now. I completely changed what I made, and it was almost like things were making themselves. I am still on that trajectory. Suddenly I didn't feel so worried. I'd always worried that I wouldn't be able to do it, that the odds were against me.

How were the odds against you?

Not being able to support myself, or make good work, or show it, or have a space in which to make it …

Not being good enough?

Yes, that too.

How important is that to an artist starting out?

Artists need time to find out what it is they are about. By the time I started making collages, I was nearly thirty, so it took a long time to find the thing I think I am good at. Before then I was just going from one thing to the next.

Do you remember exactly when this happened?

I was making a painting of circles, very graphic shapes. I think it was a couple of hours before a tutorial I was worried about, so I decided to attach some sticky-backed plastic to the painting. I took it in to my tutorial, and one of the tutors went, 'I think that is the most interesting thing you have made since you have been here.'

How long did your first collage take?

My early collages were made within a week or so.

You haven't had times when you've lacked inspiration and gone back to source, so to speak?

I maybe didn't engage in such vigorous research in the early years. Research has become a more important part of my practice; I continually look for new ideas. Inspiration comes from wanting to get to know a subject and inhabiting it.

Have you ever broken up a piece in anger?

No, but it is frustrating when you have to rip layers off, or something you have spent days making doesn't quite work. A horrible feeling, but you have to be brutal.

Your works are symmetrical; there's a great deal of order, measurement and precision. Is this a reflection of your mind, of your life?

As you might imagine, I am quite meticulous. But not inside. Inside it's a bit of a mess. The work is something to hold – a nice anchor.

Where does your nostalgia come from?

I look to a period in history that held ideals of optimism which no longer exist. I don't think nostalgia is a bad thing. I suppose that is why I like to use original photographs of the buildings that I end up recreating. They hold a kind of key.

This meticulousness in craft requires a great deal of patience and methodology. Is that something that you have learnt?

I am prepared to spend ages cutting something out. The materials I use and the way I make stuff have grown as I have needed to represent more complex things. It is something that I have become better at over time.

When that is in process, are you lost in your thoughts, or are there no thoughts?

There are a lot of thoughts. When you do one thing obsessively, it is hard not to drift into daydreaming. I use Radio 4 to tether me.

What is art?

It's a way of life.

How do you translate it to become part of my life?

The reason you are interested in art is not necessarily the reason that attracts me to making it. You bring your understanding to it. Whether you get something from it or not is up to you.

Adam Neate

What is art?

Art is one human expressing themselves in a language to another human or number of humans, a language that engages with them and gives a reaction to the other humans.

What reaction is elicited from art?

It could be anything. For example, music can follow an equation that makes sense as you listen to it, with its rhythm and how it's organised. If you break the universe down, it's like a mathematical equation. When you look at art, the equation the artist has used, the combination of elements – the other person looks at it and decodes it, and makes sense of it, and either likes it or doesn't like it. Even a composition in the frame of a painting is a mathematical equation. Your mind thinks, Well, that does look nice. It stimulates you, makes you feel something.

Is this a conscious or a subconscious process?

It's a subconscious thing. Even when you listen with an untrained ear and it doesn't make sense, if you listen between the notes you find music there. Even if it's the most abstract, chaotic painting, there's still a rhythm or a language within that to give it harmony and to explain why the onlooker has stopped doing what they were doing to engage with the work.

Is the language of art being invented and reinvented constantly and individually?

For certain artists, their life became art, but they could also exist as personalities. Warhol became an art form himself, the same as a musician. Art has become all media encompassed in one. You could make a film of your life and project it onto a sculpture, with a musical score, and it would all amalgamate, all join together as one thing. For the past hundred years, artists have been breaking down barriers and changing and inventing themes. Anything can be perceived as art now. Our hunger as the onlooker will change continuously, as with fashion. As hunger is always going to be there in human nature, there is always going to be that push to create the new, the unseen.

How much hunger drew you to art?

For some reason I've always wanted to paint and create images.

What does that mean? You woke up at the age of five and wanted to paint?

Yes. I was three or four. I enjoyed painting from a very early age. I'm not the most academic person; why would a child laboriously construct a sentence to describe something when they could just paint that moment or that feeling? It came naturally to me.

Would you call yourself a quiet or a reserved person, a shy boy who wanted to express himself?

As a child you don't have any of this baggage. You just go to school and have friends, and you are not thinking like that as such. You paint when you want to paint. It's only when I got older, I suppose ... especially when I was a teenager. You have so many questions about the world, and you have that anger or something inside you wanting to find reasons. I liked to paint the unexplained to express myself.

This hunger, is it hunger for fame or for the expression of emotions?

It's a kind of excited hunger. I want to create what hasn't been done before, which is a very difficult thing to do. I always thought the saying 'There is nothing new under the sun' was a negative outlook on creativity. There are loads of things that haven't been done before. You just have to think of them and strive for that newness. Imagine if that saying was applied to science to describe the chances of making new discoveries!

So you sit in a box at night and think up new things? Or do you start something and then it turns into something new?

The majority of it is hard work, constant work, the battle. You are forcing yourself not to make do with being satisfied.

Who tells you you can do better?

In here I know I can do better.

In your heart or in your head?

A bit of both.

Which is more important?

The heart, because my heart has been with me through everything, when I didn't have a job, didn't have anything going for me. It's been there when I've been lucky and had good times. For years when I was giving away paintings as gifts, I was trying to separate what art is worth as money from what art is worth as an image or as a feeling. I was very young, trying to find what it meant that I could paint for free, not necessarily to make money from it. I was painting what I wanted to paint for my own reasons; that was the most important lesson for me. I was painting not what other people wanted to see but what I wanted to show them.

And as a consequence your public profile suddenly ballooned?

I don't know. People who knew me knew I did it anyway, and those who didn't know, I guess they found out. But to do a big project in the street I needed to inform the public, so it made sense, conceptually, for people to go out and look for the work. But I am not interested in becoming a celebrity artist. I'd rather my paintings be seen than my face.

Adam Neate (above) in Elms
Lesters Painting Rooms,
which he uses when he is in
London (he lives in Brighton
and São Paulo, Brazil). 'I am
quite unorthodox; I'll have
materials with me, but I'll
never be psychologically
settled in one place which
will be my studio.'

Artworks (left) from his
Dimensional Paintings series
hanging in the Elms Lesters
Painting Rooms, London.

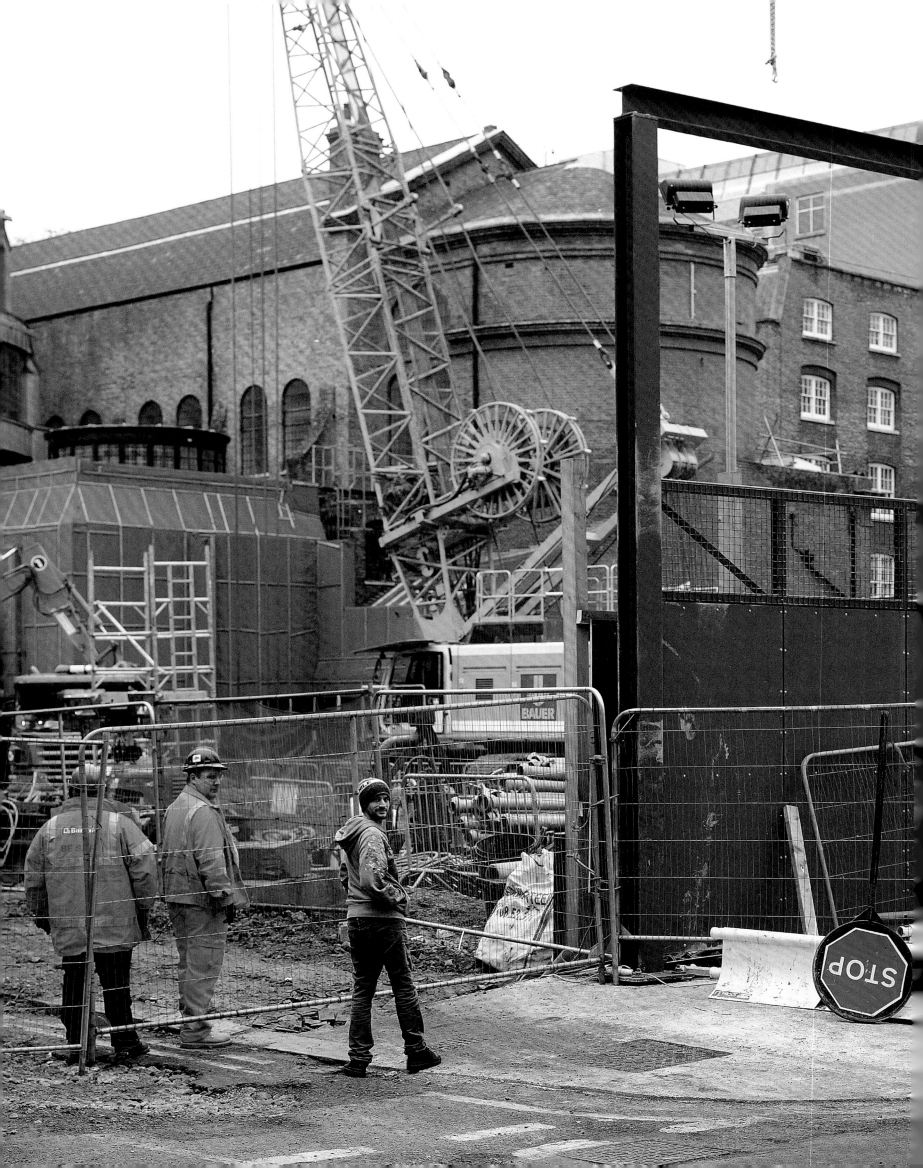

Neate (opposite) pictured near Tottenham Court Road, London, in January 2011 during the construction of the new Underground and Crossrail station. Self-taught, he left thousands of paintings on the streets of London over a period of ten years for people to take: 'For years when I was giving away paintings as gifts, I was trying to separate what art is worth as money from what art is worth as an image or as a feeling.'

Layers of paint and graffiti (right) cover the walls of Elms Lesters, a 1904 purpose-built scenic-painting studio used by London's theatre-set creators. 'As hunger is always going to be there in human nature, there is always going to be that push to create the new, the unseen.'

What does having a studio mean to you?

I don't need a massive studio. It's all within: the ideas and the thinking and the feeling. It's the environment I'm exposed to when the art comes out. You could have the biggest studio in, I don't know, the South of France, and you could be in this big studio drinking red wine all afternoon, painting pictures of whatever, but 80 per cent of that creativity is you going out into the world and experiencing things. Be it going to a chip shop and seeing somebody having a fight outside or going to a car-boot sale and seeing a load of crazy people standing in front of their crazy personal objects. You don't need a big studio for that. It all just goes into your head, and you maybe keep a sketch of it.

I spent some time when I was a teenager living in the middle of nowhere with my grandma because my parents had to move house. All I had to keep me entertained was books or drawing pictures. So I'd go into the garden. It would be all plant pots and old rusty objects. You absorb it if you're sensitive to the environment. While you are there drawing a rusty padlock, what's important is its meaning to you, your connection to it – the symbolism of the object.

So your studio is essentially your environment?

Yes. It's my ideas. I see other artists' studios where they get quite settled in; they've got their chair and their nice collection of stuff that they look at on the wall, their objects or their library or their organised pot of paintbrushes. It has become their environment in such a way that by sitting there they can be creative and start working. Whereas I am quite unorthodox; I'll have materials with me, but I'll never be psychologically settled in one place which will be my studio. If someone told me I had to leave that place and go and work somewhere else the next day, it wouldn't affect me in an emotional way. Mountains of randomly grouped objects (commonly known as chaotic mess) form after a time. For me, being too organised and tidy means wanting to be in control of your environment. I'm a great lover of chaos and everything it has to offer us. Chaos is the most beautiful maths equation/form of art there is.

Do you have a physical space that you call a studio?

I've got a place where I work; I guess it's a studio. It's a combination of places: here, São Paulo, my home near Brighton. It's wherever I've got my work with me.

Would you call yourself a street artist?

No. Maybe it's not wanting to be tied down to a certain thing or to be labelled.

You have not been a part of the standard art scene; you have not gone to art college. Do you feel yourself to be an outsider?

I always knew I wanted to be an artist, so the main anchor in my life is my art. I continued being an artist even without the fine-art world. I started from an outsider position, not having the classical training and what have you. It's like the music business. How many of the best-known musicians have gone to traditional music school? It's the kids who just want to express themselves, so they go and get a guitar.

You have been called a fearless painter. What does that mean?

I'm not afraid of changing. You want to take advantage of your time, your life on this planet, and do as many pretty things as possible.

That means that you don't much care what the market thinks of you. Or are you catering to the market?

No matter how you go about your creativity as an artist, you should never lose the initial reason why you started what you do: for the love of art.

Who determines what art is? The artist or the viewer?

It's a fifty-fifty thing. I always say there is no such thing as a good artist; there is no such thing as a bad painting. Everything that can be created is a plus. It is a positive thing to make something proactive, not destructive.

Is art presumptuous?

Art pushes the boundaries; it can be perceived as presumptuous. Without that, you wouldn't have the knock-on effect of someone using it in a different way with that eventually being seen as the norm and accepted.

So is questioning the essential factor that pushes the boundary for an artist?

For me, yes.

Is art elitist?

It depends. It has become more and more accessible over the past ten or twenty years; with the Internet it is a lot more accepted. More people like to be given questions when they see art, and then there are other people who don't want questions; they just want to look at it and enjoy it for what it is.

You've referenced some major influences in your work, from Hockney to Matisse to Bacon to Picasso. What elements have you drawn from them?

The drive to keep on creating and not be afraid of changing. To try different things, like Hockney, like a scientist who experiments with things to create the atom bomb or a new type of petrol or whatever.

Technology is effectively killing off that sort of art, isn't it?

I think the artist will adapt and take on board what is new. When photography was invented, they thought they no longer needed to paint traditional paintings so they decided to paint what the camera could not see. The same can be said of traditional film or 3D TV.

Is art a social experiment, then?

A dramatic answer would be: 'Yes, art can ask the questions and suggest the possible answers that can help form or change a society.' The less dramatic answer would be: 'Yes, in relation to our current society.'

What would you like to be remembered for?

Being a good father and a good husband. If I'm remembered for anything else, that's a bonus.

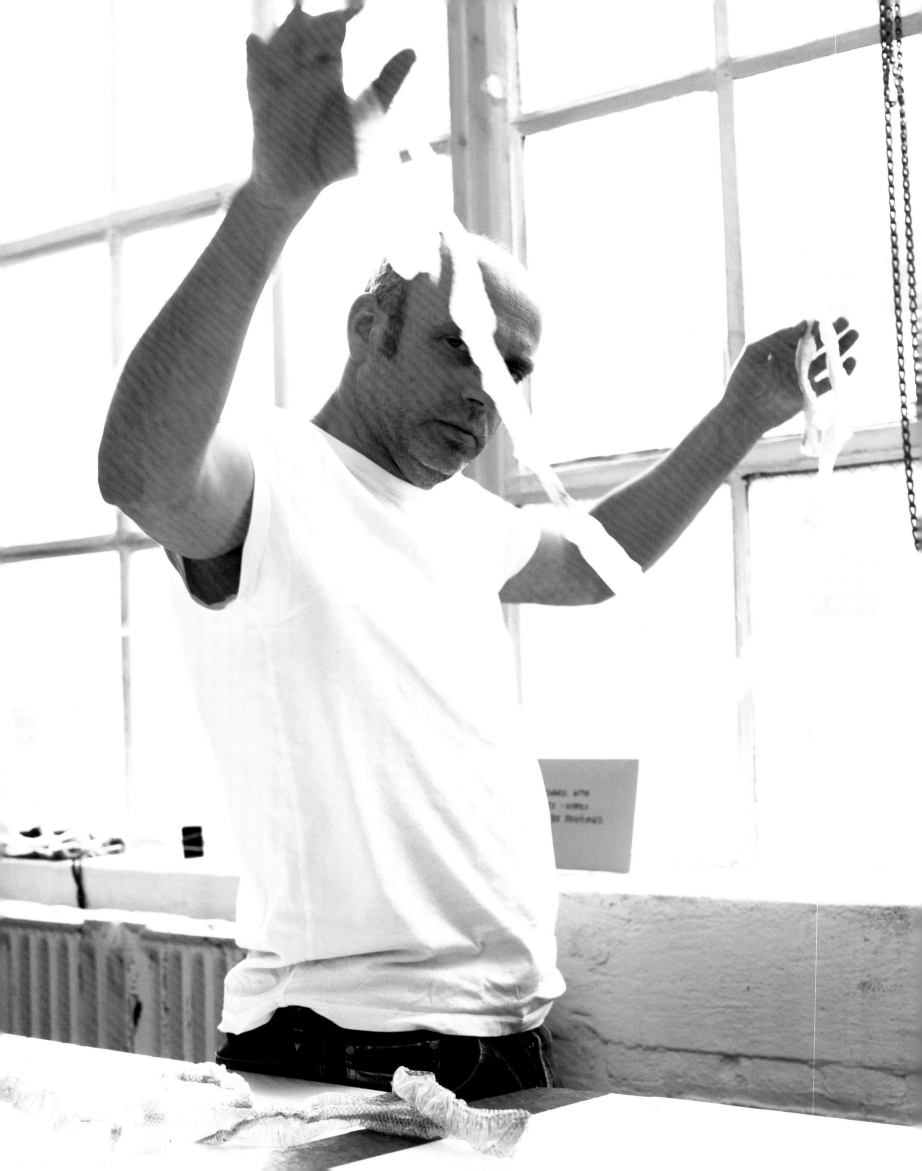

Adam Fuss

Where does your inspiration come from?

My work comes out of my childhood in England. I've made about 95 per cent of it in New York; the more I try to understand what I've done, the more it tells me that it's about my formative connections with the English landscape. If I was in England, I wouldn't need to reconceptualise my English experience. Being in New York has given me the opportunity to explore those themes.

I grew up in West Sussex. We lived in a semi-rural situation; I spent as much time as I could outside, in nature. The strong connection I had with nature pushed me as a child and adolescent towards science because science was explaining, cataloguing, recording. At some point I realised that the science of nature didn't address what I was interested in. It appeared to, when in fact it was the arts that seemed like a way to address the questions that were there. Photography ended up being a bridge. Part of photography is technical and scientific, and on the other side of photography is the world of the image, which is the world of painting, sculpture, film. I am walking from one side to the other.

Photography was also a way to challenge another thing, which was that photography as an art form is so interested in consumerism. In the old days, it was about sexy equipment. I ended up throwing that away, using a cardboard box to make one of my first groups of pictures. I chose to remove the technology. Photography is extremely simple, but you don't understand how simple it is because it arrives in such a sophisticated, complicated package from Germany or Japan. You can empower yourself by making your own camera. That was part of my process.

How do you empower yourself by making your own equipment?

When you make your own camera, you're bringing in a visual language that has its own character. When I realised that I could craft visual words, the pinhole camera became very attractive; it had such a strong vocabulary.

So I did that for a while and realised that I didn't even need a camera; I could *make* pictures rather than *take* pictures. I chose to make pictures that were related to nature. Where the materials are intimate with the photographic paper is what distinguishes my photographs from, for instance, Man Ray or Moholy-Nagy, because I like to work with organic materials: water, snakes, powder, smoke. The connection is quite intimate, whereas I think historically a lot of artists liked to use shadows from man-made objects. I have moved away from that; a lot of the patterning in my pictures is organic rather than man-made.

Can you elaborate on your concentration on natural elements, on the ephemeral quality of life as represented in your photography?

What is the universe, what is our life, what is nature if not ephemeral? When you have a picture in which the viewer experiences a sense of the ephemeral, that seems like a good way to hold someone's interest. It's key to my practice that I am looking at pictures I want to keep looking at. We all see billions of images which all have been generated in pretty much the same way. We don't need to keep looking at them; we consume them too quickly. I want a picture to stop my normal association of thoughts with a pause. That pause is holy. Or it's a doorway. It has power; it's unusual; it's having a moment of presence. Say you are walking in the countryside and you see a beautiful tree. You stop, not thinking about what's for dinner any more. That relationship of viewer to image is key. I don't think you get that kind of photography without changing some ground rules. You used to, but because of where we are in the consumption of photomechanical images, it's a different world now.

When you photograph people, do you think that, as the Native Americans used to think, they might not want to be photographed because their spirits would be taken away?

People all over the world are credited with saying that. I think it has as much to do with the people taking the pictures. Think of images of American Indians; those people have incredible dignity and presence. They are looking into the lens and they don't give a shit about their souls being captured. You get to see that they are very proud. So I don't completely buy this story of capturing souls. But it does address the magic of photography, how it can keep memories and moments and give access to parts of our brain that we don't have easy access to. There's also the idea that in photography you have light, and when you make photographs you are controlling light and dark. What happens in the dark? We go to sleep, we dream, we give our fantasies space … we have nightmares. How photography happens is connected to how we dream and how we deal with the dark.

Speaking of dark forces, the snake is a motif you've been concentrating on. Is there a connection between the underworld and the snake?

The snake's a connection between the underworld and all of us. It's their physicality and their uncanny nature. They sit in a zone that is dangerous. When I'm working with snakes, I keep them here in my studio. They are not hurt; I just work with them making

(above)
Medusa, from the series
Home and the World, 2010
Gelatin silver-print
photogram
© Adam Fuss
Courtesy Timothy Taylor
Gallery, London

Adam Fuss (left) in his New York studio holding the skin of one of the snakes he uses in his work. 'It's a depiction of energy, the energy to be free, to fly where you want, to crawl where you want, to eat what you want, to do what you want.' The live reptiles are kept with him in his studio.

pictures. People come in, and, even if the snakes are in the other room and locked up in boxes, the people can't talk because there are snakes in the room. They can't deal with whatever the snake represents.

Why did I start working with snakes? I don't know. The snake just wants to be free. Forget it's a snake; it's a depiction of energy, the energy to be free, to fly where you want, to crawl where you want, to eat what you want, to do what you want. I think the snake is very positive.

Who, in your opinion, has managed to capture the essence of a soul in a contemporary picture?
One of the photographers I respect, because I feel he's got closer than anyone else to the idea of abstraction in photography, is Roger Newton.

When you see his work, what comes to mind?
What comes to mind is a question: 'What is that?'

I'm interested in abstraction, in the absence of the hand. For example, Jackson Pollock's hand is here and then the paint is moving through the air and hits the canvas … Pollock is over here, and the canvas is over there, with nature in between. That way of making a mark really attracts me. De Kooning has it. Abstraction is the most energetic art of my time. Pollock's art is really about energy.

The space that you have here: do you consider this a sanctuary or a studio?
It's the place where I work. It's where I get to come out of my head. It doesn't feel like a sanctuary, but

I do feel protective of it. I don't like people coming in whom I don't really know, so yeah, maybe it has aspects of a sanctuary. But it's too disconnected from the earth to be a real sanctuary. My real sanctuary is in Sussex; I have a cottage there.

What's the longest period that you haven't worked?
I work all the time, but I don't make pictures all the time. This is not interesting to your readers, but the business of being a successful artist is such that it takes you away from the creative part. So I can be busy, busy, busy … I'm busy now. People are waiting for me to tell them which picture I'm going to give them; that means I have to open boxes, and make a selection, and do this, and say that, and organise the other thing. That's going on continuously.

So success is not such a good thing?
It's mixed. It's not all that it seems to be. There's a price, absolutely.

Does success cut down on your creativity?
I haven't found a way to balance them.

And why New York?
I didn't plan it; I just felt at home here. New York was very energetic; it felt wild to me, and dangerous. I am relieved not to be in the midst of English culture. I love England; I love being there, I love the landscape. It's where I feel at home. But I'm not comfortable with the culture.

The artist (above) walking in Central Park, New York in early March 2011. 'New York was very energetic; it felt wild to me, and dangerous.'

Fuss (below) in the small orchard at his home in Sussex, England, early April 2011.

The darkroom (above) where the artist creates work with traditional camera equipment: 'I chose to remove the technology. Photography is extremely simple, but you don't understand how simple it is because it arrives in such a sophisticated, complicated package from Germany or Japan. You can empower yourself by making your own camera.'

'A lot of my work is personally therapeutic because in making a picture it allows me to take something out of me, to externalise it.'

Shirazeh Houshiary

What does your studio mean to you?

When you're in the outside world, you are busy with domestic or everyday events. Here you leave all that behind; it's a place where you are free, without any involvement with the outside world. Yet everything about the outside world exists within, and is absorbed inside this space. Here everyday thoughts are art: it is a place to let go. Sometimes you have these experiences when you see a great piece of art: you let go of everything you know. At that moment you become unified.

So is art religion, in your opinion?

Art and religion have something in common; both try to free you from your anxieties, your everyday concerns, your limitation, and show you something else, which perhaps has an infinite quality. But I wouldn't say art is religion.

Would you describe yourself as a spiritual person?

I don't know what it means to be 'spiritual'. I call myself a person who is concerned with state of mind; I seek a state of mind that is beyond everyday events or problems. I know it is a strange thing because today it is fashionable to be involved with everyday events. The world is a chaotic place. When I come to my studio, it is a place where the chaos is unified. To me that's the most creative force in the universe.

So that moment is almost like a window onto another world?

Yes. It is a window onto another world because as humans we are limited. Our perception is limited. We are limited by three-dimensional space. We are limited by time. So this is a moment that frees us. That is why I fell in love with art. I am not limited any more by three-dimensional space; I am not limited by time. All these concepts seem to have dissolved. Sometimes great art shows you another possibility; it changes your perception.

What I am trying to say is that for me, the studio as a place is very important. For some artists, it's not. Some artists find their material in the world, in the streets, at home, in society or in particular places. I find my inspiration in the studio and the nature around it.

Where was your first studio?

The first studio I had, when I started art school, was a room a bit like Kurt Schwitters's. I made a room with collages. That room became an installation. It was very important to me. Suddenly I was expressing myself in that small space, and that space was my whole world. I realised that the studio was almost my self-portrait.

At that point I was making installation work, and

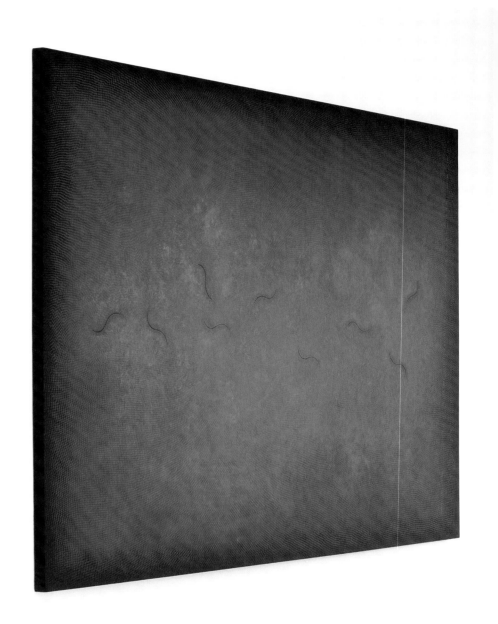

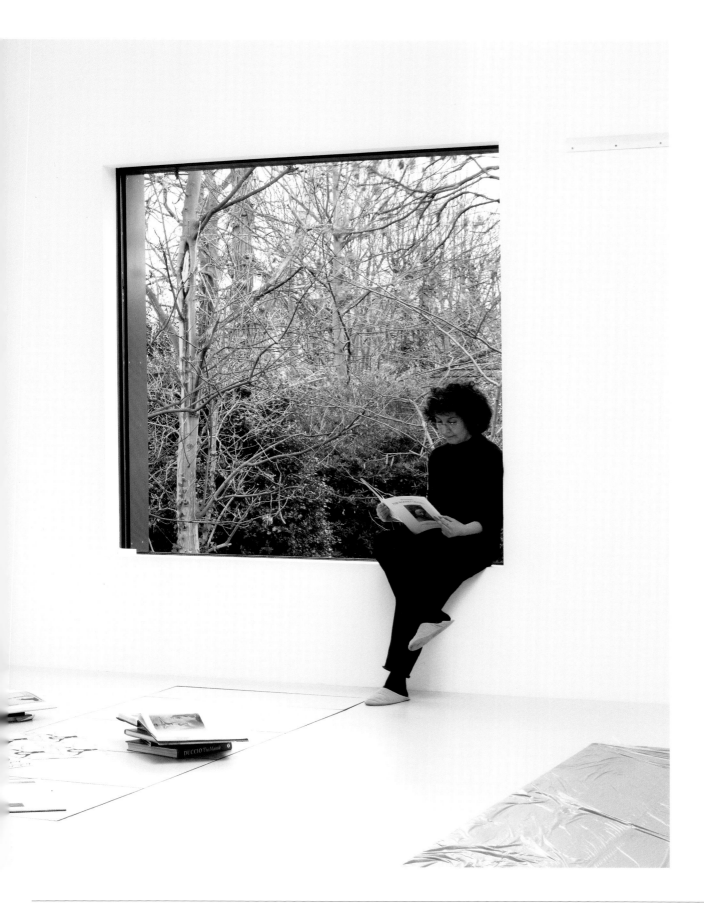

'For me, making art is a way of life. It is a measure of my journey,' Shirazeh Houshiary says. She feels most at ease in her studio in London. The building was designed by her architect husband and collaborator Pip Horne. 'His architecture has managed to bring the outside world inside the space so you are not enclosed and not locked away.'

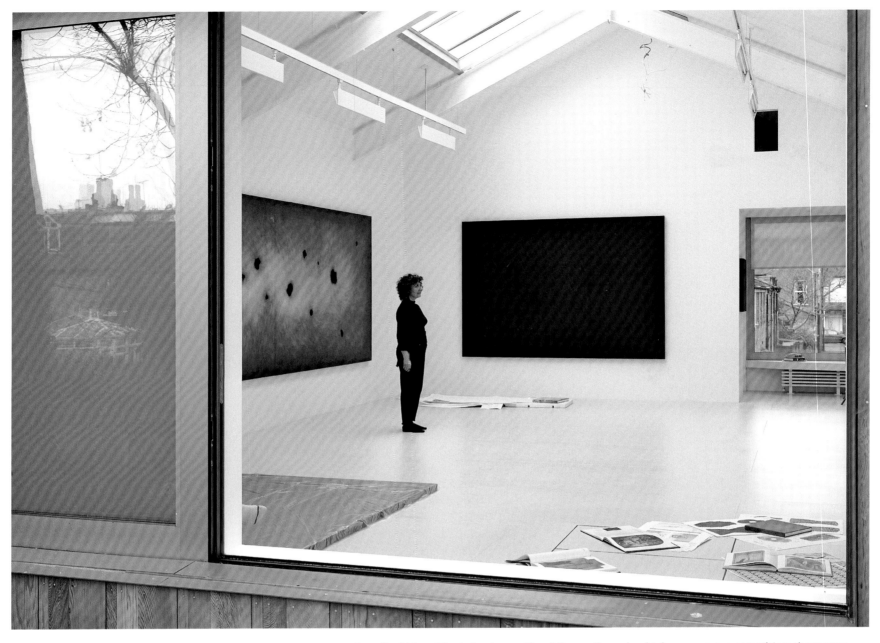

my space described ideas I had about myself and the world around me. Art teaches you what the world is *about*. It teaches you your limitations; it teaches you that what you see and think can be wrong. It teaches you to have doubts. It teaches you that the world is a very uncertain place.

And the role of the artist is to make it certain or reinterpret it?

No. The role of art is to show how vulnerable we are. The universe is full of doubt, and what we know is not reality, so next time we think we know something, we have to think twice. What we know always has an opposite that teaches us something completely different.

Are you reinterpreting reality?

No. I am trying to find the nature of the limitation of perception.

What do people see when they observe your art outside of the studio?

Every person has their own universe, their own vision. So any two people are not seeing the same thing. My paintings are like pulses and rhythms that make you aware of your own presence. They are intended to evoke something about you, a medium

through which you can see something about your own perception. I am not trying to pass messages, because there is no message.

Are you not seeking some kind of reaction?

I am seeking some kind of reaction, but that reaction is your reaction.

Isn't it manipulated by you, the artist?

It's not manipulated. It's offered as a perspective. It is up to you to make that perspective real or not real, or go against it, or enjoy it, or find something meaningful. Jacopo da Pontormo said something very beautiful, that 'painting consists of material hellishly woven, ephemeral and of little worth, because if the superficial coating is removed nobody any longer pays any attention to it'. It's an illusion. If this image disappears, who cares? It is just canvas on a piece of wood or aluminium.

Does criticism affect you?

It can affect me if it has *meaning* for me, if it teaches me to look deeper into myself.

Is your art more for you or for the outside world?

First it's for me. Then it goes out and has meaning for others – it becomes independent from me.

How much satisfaction do you get from people's responses to your work?

If you manage to evoke something in somebody, there is a pleasure in that. I think it was Rumi who said that when we look into somebody's eyes we see our own reflection.

Life and breath and death are factors that you have discussed a great deal as reflected in your paintings. Can you talk about them?

I am interested in things that you can't see. To me form is an illusion. Reality is what you cannot perceive with the eyes, something which is like the wind, the air, the breath. That is why I became involved with breath, with trying to make something as if it is living, as if it is breathing. Breath is fascinating to me because it is not something you can perceive. It's air, it's almost invisible, yet when we lose our breath, in a second we are no longer there. So its power is immense. This was the beginning of my fascination with a rhythm or pulse that I cannot perceive with my eyes. I have realised that perhaps even death is not final. I used to think that once the breath is gone, there is nothing. But even if the form is not real, the breath carries on. What you see is actually your limitation in life. What you don't see is what you have to seek. I found this difficult because I am a visual artist. Yet I am talking about subjects that you cannot visualise because the unseen and the uncanny are powers in our lives.

I have come to believe that painting is the flowering of all the arts because in painting you can go against common sense. Sculpture is limited in being dependent on three-dimensional space, on gravity, on materiality, but in a painting you can transcend that.

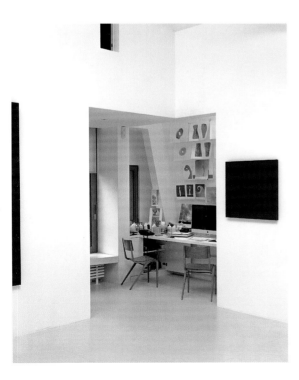

Does painting throw you into a parallel universe? Is it a form of trance?

It is a difficult thing to talk about, and can be dangerous to talk about. I think there are parallel universes. Physics and quantum theory teach us that the world we perceive is not reality. What fascinates me about quantum theory is that by looking at the small-small-small, we have come to see that the universe has many more dimensions than the ones we experience. So our limitation is even more apparent. And this is *science* telling us that our perception is limited.

This question of moving to a European world from a Middle Eastern, Persian context ... you've been quoted as saying that you are not 'religion-specific'. What does that mean?

I am an individual who tries to understand the nature of who I am in relation to the universe and my place within it. Nationality is problematic. In ancient times we were tribal, so the tribe would fight with another tribe. Then the tribe became a village, and a village became a city, and then for instance you had war between Florence and Siena, and then we grew a bit more intelligent and we had countries, so now we have Italy and in the same way India and Iran. Now perhaps we realise that we are connected to Planet Earth. To define myself as Middle Eastern or American or European is an outdated limitation of perception. Art is the only place where we can transcend these boundaries.

I don't have revolutionary ideas. What I am trying to show is that your perception or my perception is *limited*. Then I try to transcend our perception because we might have access to something more beautiful. Great art always transcends limitations. Rumi asked why, if you can discover the beauty of the world in the ocean, you are looking at a jug of water?

If your art was not satisfying a market appetite, would you change it to match other people's expectations?

No, because for me making art is a way of life. It is a measure of my journey. I am not going to change it because the world wants something else from me.

You've said that your paintings represent three words that you never reveal. You lock in your meaning, don't you?

This has always been a problem for people, and maybe I am becoming a bit tired of it. The words are very powerful, and I don't want to reveal them because it might distort the experience of the painting. It would become more about the *meaning* than about an *experience*. For me, experience is more powerful than meaning.

But words express experience ...

They do. But when you shatter the word ... that is what I am trying to do. Once shattered, you can experience the word, the real word. There is a beautiful story written by Rumi. A teacher wants to teach the word *snake*, so he writes 'snake' on the chalkboard in a classroom. A child gets up and says, 'A snake doesn't look like that! What a ridiculous thing!' So the teacher draws the shape of a snake. The child says, 'No, the snake doesn't look like this either! This is just a harmless line! I'll tell you what a snake is.' He opens a bag and a *real* snake comes out. That is the real snake. Snake is not the word, is not the shape; it's the *feel*. It's an experience of fear. Experience is more powerful than any word.

School can kill the creativity of the child because he forgets to experience. He learns to manipulate with his mind: 'Okay, I know what a snake is. I read this, I know the word, and that's it. That's enough for me.'

But classification is necessary to bring order to society.

But art does not need order like that.

Speaking about society, there is something shared by religion and art, but they are also very different. Art at its best can express the nature of reality. Religion is dogmatic. It doesn't really deal with the nature of reality. Artists have broken through dogma throughout the centuries. Look at Malevich. He is someone I admire very much because he broke the convention of his time. He emerged from a difficult period under Communism and all those paintings of workers for freedom and social upheaval. Art has always tried to break through common sense and dogma, always.

Fifty years, or five hundred years, down the line, what will people be thinking about Shirazeh Houshiary?

I don't know if people will be around! That is what my work is about: the nature of vulnerability. We are not even defined; it is almost like a moment that is there and the next minute is not there. Why am I worried about five hundred years from now?

Liam Gillick

How much has confidence got to do with good art?
The issue is not so much good art or bad art; it is to do with finding how closely my ideas can match material reality. I am not led by materials; I think in a completely theoretical way. I think about ideal situations, so I want the artwork to match my ideas. That's confidence. When you know that what you are thinking can be produced or can have a material reality, it gives you the feeling of a very fast connection between your head and the world.

If I have a problem, I lie down and close my eyes and start to sleep and think about the problem. When I wake up, it's usually been solved. Because then I can relate this idea to material reality. Some artists – very good artists, great artists – will have an image in their head, and then they will see if there is a way to reproduce this image, this idea. I need to have a connection between the idea and something that exists. That is confidence: when you can connect what is in your head with what could exist.

When you are in a period of doubt, the connection is broken between the ideas in your head and the way they could exist in reality. That is when you can't work. That's a disaster. Usually I don't worry about it. I just read. Like a lot of artists, I am uneducated, or under-educated. So I tend to read the things that would be good for me, that I feel I have missed. Right now I am reading a lot of economic theory, books about how the financial system works, how things acquire value and why. Then I'll stop and I won't touch that again for a long time. I don't know if there is a direct relation to any work, but somehow it frees your mind again.

I am interested in cars, but mainly for the idea of the journey, not for their engineering. There is a type of car they used to call a Grand Touring car, which is designed to drive a fairly long distance with ease. I was fascinated by this lost British moment, this idea of being able to drive at speed for a long time in comfort. I am of the generation that benefited from the fall of the Berlin Wall and easy travel, but I am old enough to remember the border between France and Italy and doing exhibitions in Milan or the South of France. I used to like to drive there from London. In the South of France there is a border you have to wait to cross – it is like a scene from *Day of the Jackal*. It was always the image of the journey, not the thing itself.

I am much more interested in production than consumption. So my interest in these cars was to do with what they could produce. One thing they could produce was a *day*, which became a *movie*, which became an *event*. Which is why my cars never lasted. I wore them out.

Is there inspiration to be had from all this journeying?
Absolutely yes. From the day I left art school, I decided I couldn't work in a studio. I love going to other people's studios; it is a pleasure to see the way they work and see all their things. But I decided that the place to work would be the exhibition itself; the exhibition would become the place of production. It wouldn't be the place where you brought things from outside; it would be the place where you made stuff. So of course, the journey was the place where you would think.

At the beginning, I found this incredibly liberating. It had nothing to do with the way art was taught in school, nothing to do with the idea that you have to think of something, make something, show it to people, see what they think, refine it, change it, do it again, have another meeting, show the next development … That kind of thing was too depressing. I wanted to develop in public. I wanted to have the mistakes or the real ideas be visible in the moment that they would happen, not wait to see if they were good or not, just to *be* them. In retrospect, I think it was quite precocious; I am amazed by what I used to ask for.

But you've mentioned that you got annoyed with people watching you …
Exactly. So there were two problems about this way of working. One was the drama of improvisation, which of course we know from music. When you're young, you have a good instinct about what to do; you are developing, and you are developing new ideas. After a while, you become symbolic of an artist working in a space, so you start to become a spectacle. In Zurich around 2000 or 2001, I was still working that way. I would arrive at the gallery and start to build everything. People would come every day, and of course you could say, 'Why not just throw them out?' But I didn't really want them out; I wanted to speak to people. I couldn't win either way; if I threw them out, I would be the artist who throws people out, and that is also a cliché.

The idea of improvising has become problematic. I didn't like the way that improvising seemed to have politics attached to it. Improvising seemed to be the perfect analogy to the new (in the late '90s) informal economy of consultancy and software and technologies. To go into an empty space and work on ideas for a week was too close to things in the world that I was critical of, so I thought I'd steal the idea of planning and see if you could use it in a way that could be creative instead of uncreative. I started to plan every exhibition precisely, down to the last detail.

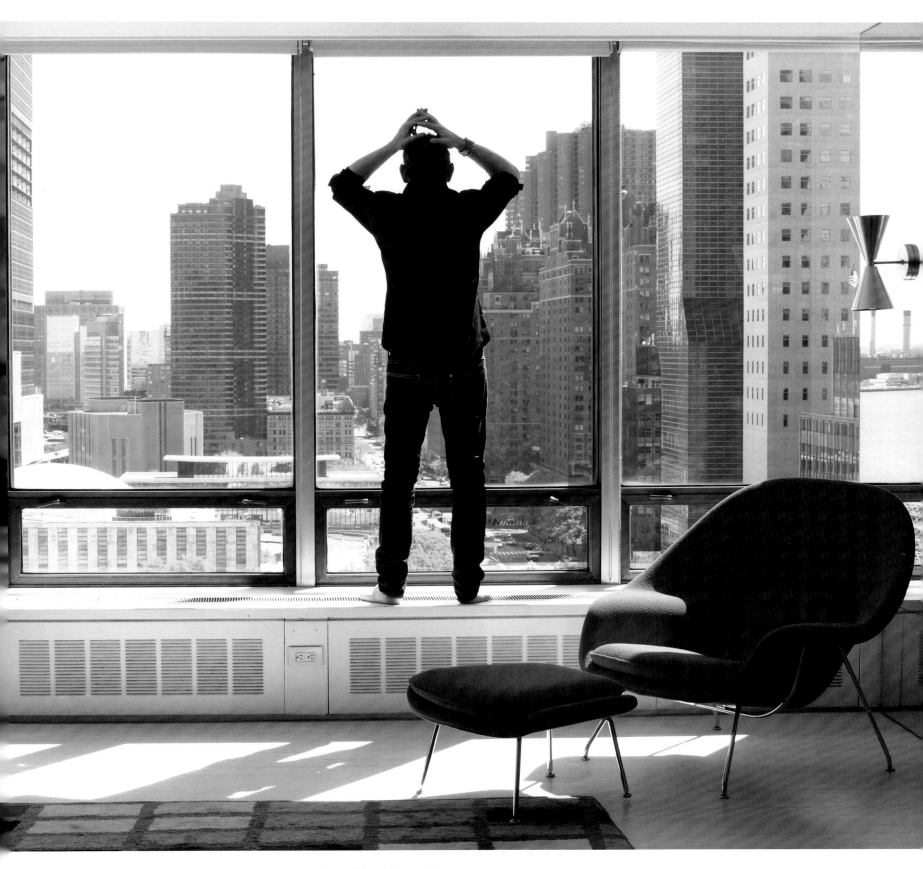

Liam Gillick at his home in
New York looking out over
the East River and the United
Nations Headquarters.
Gillick has a home in both
London and New York and
alternates between the two.
He doesn't own a studio:
'If I am surrounded every day
by a reminder of my own
personality, by a reflection
of my own labour or by
evidence of my own failure,
I can't think. I am either not
that confident or the ideas
I want to pursue can easily
be killed.'

Gillick (opposite) who creates
site-specific works for
exhibition spaces, makes
precise plans and computer
models of these spaces. He is
shown here in his New York
apartment seated next to
a photograph by his friend
Darren Almond.

Gillick (following spread)
in his London flat in the
Barbican: 'Nothing is better
than my private space at
3.00 in the morning, whether
it is on this table or in the
kitchen or in a hotel room.'
He believes that an artist is
simply an ordinary person
who has found something:
'My obligation to society is
somehow to remain in the
condition of an artist in this
time, and my way of doing
it is to not enter into the
same relationships that other
people have.'

I changed the way I worked, started to work in a three-dimensional computer space, building a perfect model of every building I would work in. Then I could get to know that building in private. I could spend time with the building on my own and also waste time.

Are you saying that if you don't do a three-dimensional computer-generated plan of where you are going to be working, you will not be as inspired?

Not at the moment. I am very sympathetic to curators and gallery people and other artists, and I'll often say, 'Sure, see what you think about how you should do everything.' I'll listen, but usually they come back to my plan.

If I had started out this way, it would have been a disaster because I would have started to make art about the experience of synthetic space, which I don't think is interesting. But if you come to it the way I did, through necessity, it has a kind of logic. It means I am free when I do an exhibition. I don't have to do anything; it is all finished. Everything was precisely planned at another moment; all the frustration and all the irritation happened somewhere else. It means I'll be free to talk and think and see the exhibition, because of course this is the problem for an artist: to be able to see your own work. It is almost the only problem, really; everything else is easy. Being able to see your work is really hard. See what it is doing, what its possibilities are. See what it has really produced. With important artists, you can tell that they can always see their own work. We have to find new ways to do that.

When you see your own art, is it a surprise or a confirmation?

I always think it is not finished yet. I see everything still heading towards something.

So will you ever be complete as an artist or as a human being?

No. The question of completion is a legalistic concept – you complete the deal, or you finish the job, or the building is signed off. The only difference between me and an architect is the fact that there is no moment of exchange or handing off or completion. My obligation to society is somehow to remain in the condition of an artist in this time, and my way of doing it is to not enter into the same relationships that other people have.

Art is always based on a paradox, or even a tautology. At some level you want to do something that is not like everything else, but on another level you want to communicate. There is this constant battle in my head over a kind of abstraction which keeps things universal in a way that doesn't require language.

I am interested in the failure of abstraction. The act of making an abstract object is always a failure because you just create another thing which points towards another abstraction. I want to help keep the idea of abstraction alive because many things in the world try and crush it or kill it or steal it or reduce it. At least I can keep the corpse alive. Sometimes I feel like I am just performing CPR on this corpse. It is like when they realise someone's not really dead, realise they are still breathing. It's like being a person who discovers something. I think an artist is an ordinary person who has found something.

Talking about the studio, isn't that an abstraction in your case, since you always work outside?

Yes. I don't want to be surrounded by evidence of my own work because that will stop me looking at other people's things or other people or other effects. If I am surrounded every day by a reminder of my own personality, by a reflection of my own labour or by evidence of my own failure, I can't think. I am either

not that confident or the ideas I want to pursue can easily be killed. So I need to somehow stay in the same state of mind as the day I decided to become an artist, which means that at that point there was no studio and there was no art. I have to wake up every day with the possibility that tomorrow I could become an artist.

Artists often compromise more quickly than other people. So I have to create systems to prevent myself from compromising, because I can doubt myself like everyone else. One of my systems is to make sure I'm surrounded by other people who will see things through. Some artists' studios are big, and they have assistants and espresso machines and bars and stuff. A lot of studios have become second homes. It is not necessarily about producing art, but it teaches artists about life; it's a place where you can do brainstorming and socialising and hanging out. That has always been true. Traditionally in France, the grand history of the studio was about time with other people.

Is there such a thing as a studio of the mind?

Absolutely. The geography of my studio is like this: when I'm in a good mood and everything is going well, it's enormous, because it is not restricted to one location. In many different places there are different things happening and I know they are being done or worked on or talked about or discussed. So it is literally this expanded geography. In another way it means there is potential, there are always possibilities. This is very common with writers, for example. And film producers do it. They have this nomadic life where you have this temporary location where you can produce ideas.

It is interesting to talk about the freedom of no studio and the studio of the mind, but also this way of working means I don't have to work. The biggest thing I have to fight is work, because work, for

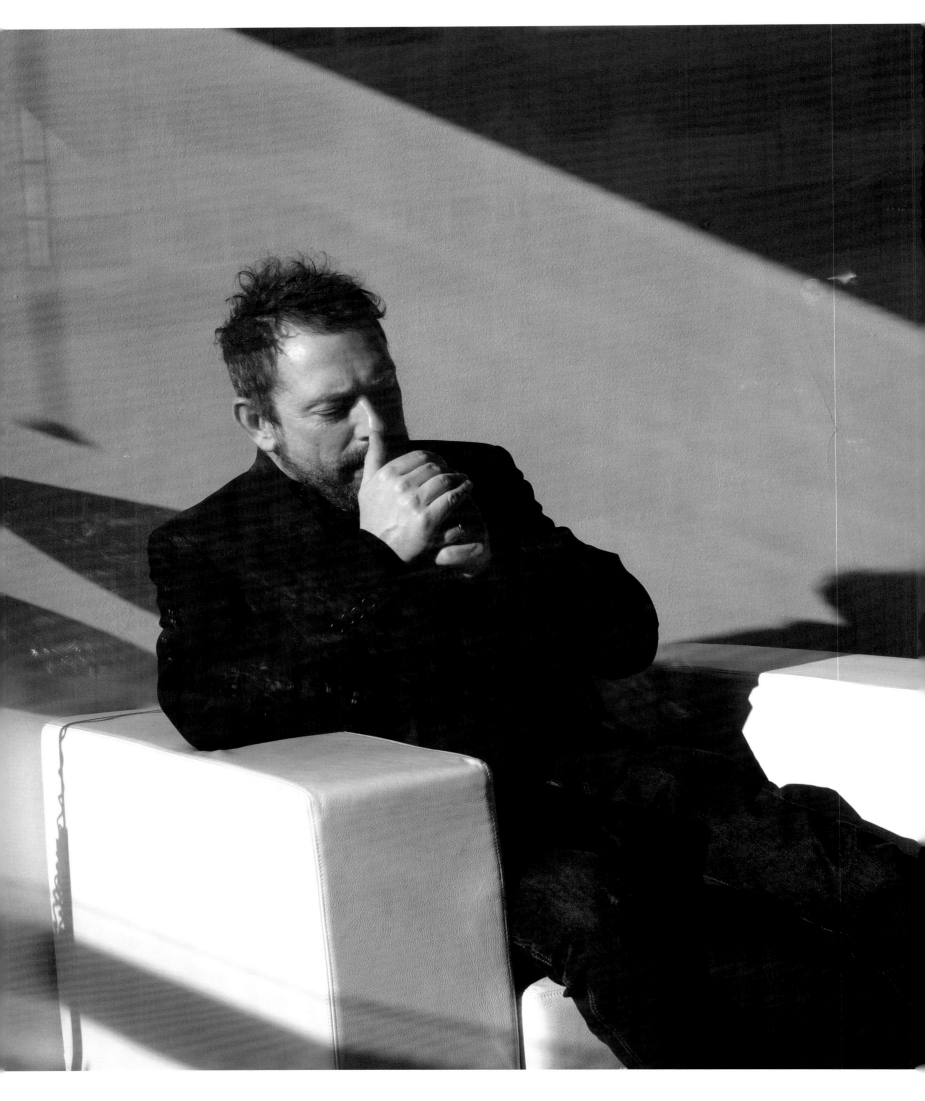

educated people, has become endless. When I was young, my grandfather, who worked with his hands all his life like most people did, always said to me, 'What are you going to do with all your free time?' Because he thought the future would be free, that people would have all this leisure. What happened, strangely enough, was that people ended up working more than normal. People who work in creative industries, or in management, or in finance, in any professional job – there is no end to work. So I think artists have to also not work; they have to show that there can be a life that doesn't involve labour.

I can take things off the table, and I don't have to think about them any more. I am not an artist today; I am someone else. And that for me is quite productive. It is easy to get caught up in the cycle of work, and there is a dignity to work. But I think artists have to show that the way they do things has to be an alternative way of life. At some time in the middle of the twentieth century in America and Europe, to a certain extent the way of doing that was to say, 'I am just a worker. I get up in the morning and I throw paint around, or I get blocks of wood and I stick them on top of each other.' That was good at the time. But now we have to negotiate another way of life.

What is your advice to a young man or woman wanting to go into art?
First they have to make the decision. They really have to decide it, because you can't go back in a way. A lot of people only half make the decision and then wonder why it's not working. Everything is still open to question; every relationship, every situation, every condition of showing art is always still negotiable. And as a young artist, everyone is looking to you for a new model, even if we don't believe anything new is possible. But it is easy for a young artist to forget that. They think they have to find a way to fit into the system when in fact they have to find an elegant way to change the system without becoming a clown or an idiot or a maniac.

You can question things by not speaking; it doesn't mean you have to say something. This includes ideas of what I call refusal. There is a reason why oppressive regimes try to stop art. It is not because artists won't behave or are political; it is because they sometimes are violent or they refuse. Art has become the immovable block or an immovable symbol of something. How could an artist living in the twentieth century who made quite elegant abstract art be a challenge to the state? What could possibly be worrying about that? Nothing. But there is something disturbing about it, and that is the fact that this person symbolises something that won't go away. You have to be there at the gate asking the question and pointing the finger. Sometimes it means that you refuse to take part. And part of my studio thing is about refusal.

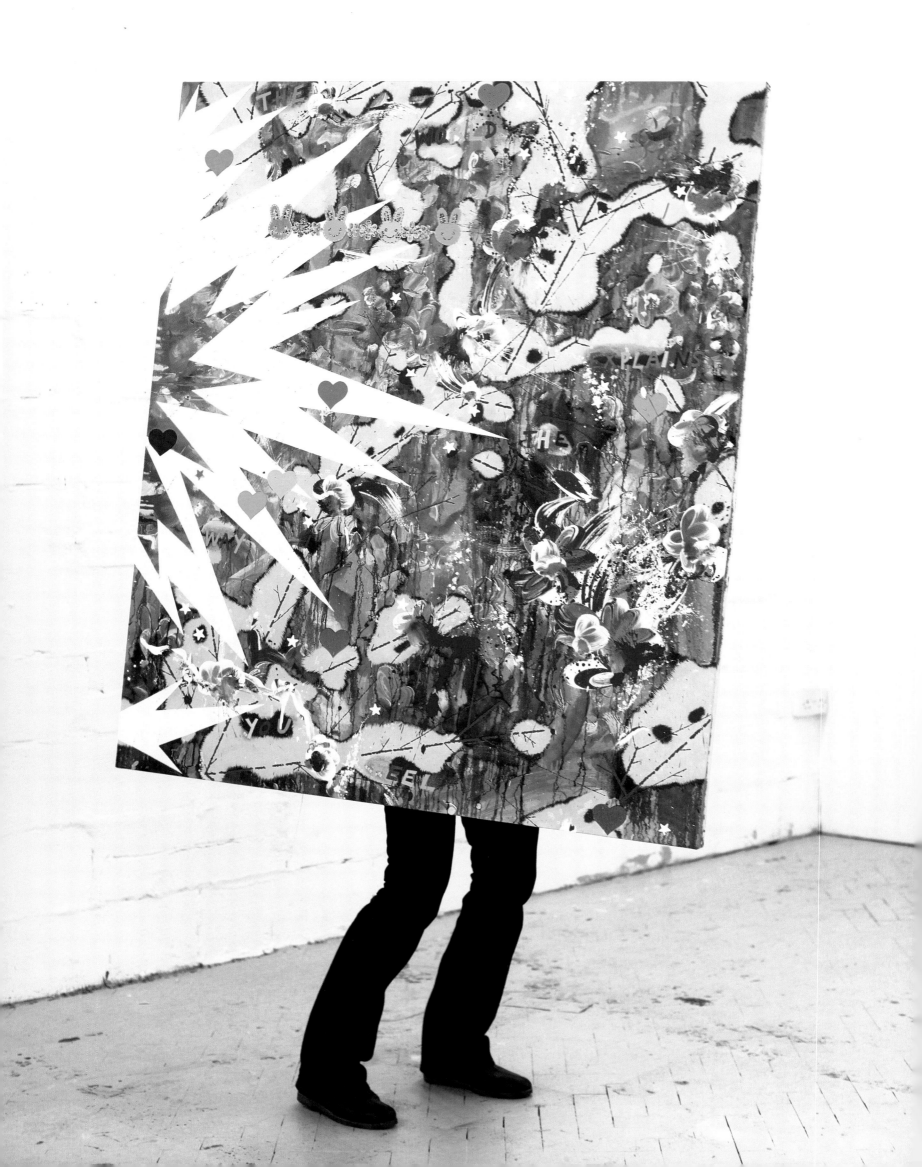

Fiona Rae

How do you relate to space? Do you see yourself as lost in the bigger picture, as an artist reflecting the universe, or as someone reflecting your own inner space? I'm trying to get at how you see yourself within your studio.

The studio is like a cave where I can be myself. It's a very private space where I can go off into my imagination. Although there's a point at which I become aware of an audience for an artwork, when I'm making it in my studio there's no audience.

So you have no audience in your head when you're painting?

The audience only comes into my head when I step back from the painting. When I'm working, it's very important that I can go off into my own world – that I can take risks, be daring, be silly, be serious, without worrying about what someone else might think. The moment I take a break is the moment when maybe an audience appears over my shoulder.

Do you panic at all?

I do panic – how can you tell?! It's a roller-coaster ride between feeling very confident, excited and happy, and then feeling anxious. In my paintings, I've found a space in which all those parts of me have a place.

Locked away?

No, acted out. In the paintings.

A refuge …

Yes. Although I can feel lonely, I usually like being alone and spend most of my time on my own. My husband Dan Perfect works upstairs. Often we'll have lunch together, and of course I'll see him in the evening. But I find it important to have that space and time where I can be by myself.

Is there rivalry between you?

Sometimes there's a bit of rivalry, but it tends to be a healthy rivalry having to do with whether or not we're excited by the paintings we're making. Sometimes I'll go into Dan's studio when he's making new work and I might feel a bit rivalrous because I'll think, That looks really good; I'd better raise my game. We talk all the time about painting and what we're doing and how to make it and what it means, anything from colour to ideas. I find it very useful, because I need another artist to talk to about what I'm doing.

Does this dialogue extend to arguments?

About how to make painting? Sometimes, yes. I welcome Dan being forthright about what he sees when he comes into my studio, and sometimes he might have something critical to say, and that's okay. It's like having an extra pair of eyes that I totally trust.

How does negative criticism sit with an artist?

It can be very destructive, but then I remember that I want to make work that's as good as it can be. So if there's something useful in the criticism, I'll try to take note of it. Otherwise I try not to mind and just carry on. The alternative is to give up just because somebody doesn't like what you do!

Whom are you pleasing with your paintings?

I'm primarily pleasing myself, then Dan, and then the rest of the world, hopefully! If you're not happy within yourself with the work that you make, I can't see the point in doing it.

As you've gone along in your career, there've been times when you've had doubts, I suspect.

Every night … I think that is part of who I am. When I left art school, I didn't really know what kind of painter I wanted to be or what kind of marks I wanted to make. I found a way to include a multiplicity of painting languages in order to play out my anxieties as an artist. So doubt is important for me, but not to the point where it is paralysing.

So fear plays a role in creative art?

If I create something that I haven't made before and maybe haven't seen someone else do, that can be quite frightening because I don't know how to assess it. Is it interesting or embarrassing? I have had to learn to get along with the fear and the doubt.

When you left college and started experimenting, when did you 'get it'? Did the 'I got it' moment come from within you, or was it a result of your success?

Success and people being encouraging are incredibly important because they help you make more work. But in a way I'm much more interested in how I feel about what I'm doing.

What do you remember of the time around 1988? How did you come across Damien Hirst?

Damien was at Goldsmiths two years below me, so I knew him from college. He came round to my studio after I left and said, 'I'm putting together a group show,' which was great because when you leave college it's an abyss; you don't know if anything's ever going to happen.

Did you think this was going to be a big break for your group?

I was just in the moment, actually. It was just a bunch of students putting on a show. I was lucky that Adrian Searle, the critic, invited me to be in a group show at the Serpentine Gallery. Then Stuart Morgan, another critic, invited me to be in the Venice Biennale. It was one step at a time. I wasn't projecting forward into some magnificent future.

You had no idea where you would be today?

I was always ambitious to make good art because I thought there was a point to that.

What is the quality that helps a particular artist to make it, do you think?

It's probably a mix of things. I was at Goldsmiths at a very exciting time. We had fantastic artists teaching there; we had a lot of freedom; there was a group of lively students. But I can't tell you why that turned into art-world success.

Do you remember any of the teachers who made a critical difference to your thinking?

Michael Craig-Martin, Jon Thompson and Richard Wentworth were the three key figures running the course. Helen Chadwick gave me some very helpful tutorials.

What has inspired your use of colour?

My use of colour has a lot do with my early years in Hong Kong and Indonesia. I don't think I have an English sense of colour, which seems to me to be muted: browns, greys and greens. Whereas I like the colours of cartoons and neon lights and cityscapes and tropical flowers.

Do you live with your own work?

I never used to, but Dan asked if he could have one of my works on paper at home, and I do like looking at it.

Fiona Rae prepares for an exhibition in Berlin, art to the fore.

Do you have memories of painting as a child?
No. I remember my father taking me to see Disney films in Hong Kong, so that American cartoon stuff was imprinted early on, and of course I saw the calligraphy, dragons and decorative arts of Chinese culture in Hong Kong. I tend to find bits of imagery from all over the place and make them my own. For me culture occurs in all kinds of places – up and down, high and low, left and right, East and West – and I love being able to take what's useful and inspiring. It's not really possible any more to stay in one place. Even if you don't travel, globalised culture and the Internet make so much accessible from elsewhere. My surroundings aren't just the East End of London, where I happen to work.

Do you travel to Asia?
No. But I go back in my dreams like a replicant!

How much dreaming is reflected in your work?
The paintings are dream spaces, fantasy places I would like to see.

Do your pieces surprise you?
Yes. I improvise, so I don't really know what's going to happen, although – as with jazz improvisation – there is a structure, even if it's just a predetermined set of colours. But I don't know how it's going to end up.

How does the process work?
Sometimes I start with a flat colour and leave it for a while to see if I have another idea. Sometimes I take a digital image of a painting I've already made and change all the colours in Photoshop in order to get a road map for another painting, although it usually has to be abandoned at some point. I find that a very exciting way to work. I've got some handrails if I need them, but at the same time I'm free to go in any direction.

How long does the process take?
Anything from a few weeks or months to six months. One painting took five years …

And how do you know when you're done?
I take a while to know when I'm done. I just leave the painting out in my studio, and look at it out of the corner of my eye. When it doesn't seem to need anything else, it's done. It's as if the waters have closed up after all the activity. I like challenging myself about the various stages when a painting might be done. Does it always have to come up to the same intensity, or are there variations? Sometimes it's like having a different voice for each painting.

You've said that you try to challenge your own taste …
Yes. I've got an iconoclastic approach to paint and imagery. I see no reason why something serious and passionate can't cope with something quite Pop or cute or even a bit silly. It's an examination of what different things might mean if you combine them in different ways.

Back to when a painting is finished … Are there times when somebody else tells you this?
Yes. Dan is very good at telling me when something's finished.

Only him?
I know that he completely understands what I'm trying to do, so it's useful to talk to him. It's like being a scientist working on a mad experiment that can never be finished, and because he's up to speed on all the things I've been doing, he's the person I would trust to say, 'This experiment might be done.' Whereas someone else coming into the laboratory wouldn't necessarily know what I'm trying to achieve.

Do you get involved in art fairs at all?
No. I find them a bit overwhelming. I would rather be in my studio or go to see an exhibition in a gallery. On the other hand, I really like the idea that I've worked hard on something, that I've tried my best to make it interesting, and if someone likes it enough to pay money for it and have it in their house or wherever … that's great.

Do you find relaxation in doing this, or is it stressful?
Being creative is a very privileged job. I find it stressful at times, but equally, if I don't get to come to the studio, I find that stressful too. It's as if being in the studio, even with its challenges and difficulties, helps me to centre my rather wobbly self. I don't have any relaxing hobbies like gardening or embroidery, because there's nothing left over for that. That's what I do here: I get to be creative and inventive as a professional job.

How many hours do you spend in the studio?
I don't like getting up very early so I tend to get to the studio around 10.00. I try not to stay beyond 7.30 at night because I tend to get tired without noticing and then I can get really destructive. So I've learnt over the years to watch whether I'm still fresh, and if I'm not fresh I go home. I usually work six days a week. Although I have a great studio in many ways, it's a somewhat bleak environment – I can't see out the windows; sometimes the heating breaks down; there's the occasional mouse …

What is the longest period of time you've ever taken off from painting?
A few weeks? In 2005, I did a Master Artist residency at the Atlantic Center for the Arts in Florida with about twelve emerging artists who applied to be there with me. They were making work in the studio there, and I wandered around talking to them. And in 2003, Dan and I travelled round the West Coast of America for five weeks.

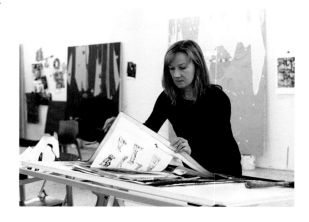

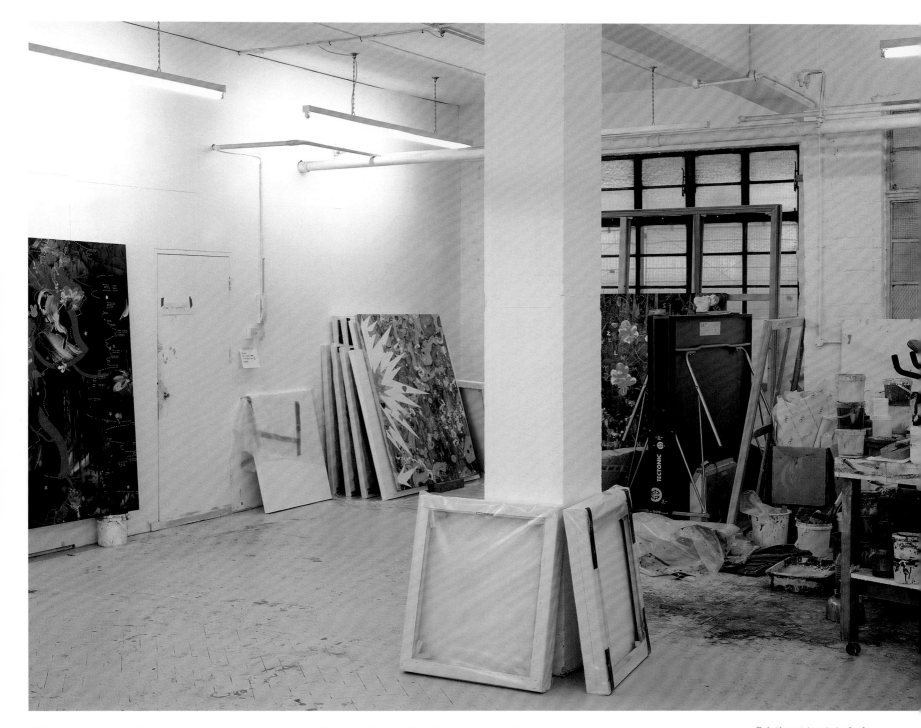

Where does art lead?

Does it have to lead anywhere? It can be an end in itself, it's an imaginative space that you're invited to share for a moment or two. Painting has a special place; it's about being confronted by a physical object in space that shows you a series of events that have taken place over time. It's slow food rather than fast food. All the other media and ways of making art are just as important in their different ways, but painting's the art form that I find the most intriguing. I think the reason people are still making paintings is because you can't replicate them on a video monitor or cinema screen. It really does have to be a physical object experienced in real time; it's utterly in the moment and yet paradoxically magical and poetic.

You mentioned that if you get tired, you start getting self-destructive. What does that translate into?

If I'm tired and working on a painting, I make a mark and then I think it's not good enough. I start taking it off, and then a bit more of the painting comes off. And before I know where I am, I've got the tub of white spirit out and the paper towels, and I'm wiping the whole thing off. That's happened more times than I care to admit.

So is there creative destruction?

Oh yes. There is a lot of undoing and redoing. Sometimes in taking something off you see an opportunity to do something else. The trick is not to take everything off.

How would you like to be thought of?

All I can do is make paintings and hope that people find them interesting or enjoyable. My control ends once they leave the studio.

Paintings (above) stacked against the walls, some showing their faces while others are hidden from the viewer. All artists tend to hide work, even from themselves. 'Doubt is important for me, but not to the point where it is paralysing.'

Jonathan Wateridge

How would you describe your studio?

It is an entirely constructed and fictionalised environment. Nothing that I make or depict (other than the performers themselves) exists or has been set up outside of the space in which I work. This notion of fabrication and the fictional runs through all of my paintings. A luxury I have in my current studio is that it's large enough that I can create full-scale sets in which to stage the *mise-en-scène*. The process is somewhat akin to a 'home-made' film studio where, as I'm working on one painting, the set for an upcoming picture might be built in tandem. Ultimately, though, I'm happiest when I've got a completely clear studio and I've just got paintings to make in solitude and quiet. Everything I go through is a form of conceptual penance to get to that stage.

For years weren't you fighting against doing what you thought had become obsolete?

Yes, to the extent that from the age of twenty I didn't paint for over twelve years. I think most students going to art school want to see themselves as being progressive. I certainly wanted to make cutting-edge, 'avant-garde' work and felt that working in a realist, painterly idiom certainly wasn't that. It was a long and arduous haul before I found the confidence to realise that the obsolete aspects of painting that had made me abandon it had become the very elements that were most exciting to exploit.

Were you trying to emulate anyone?

I don't think you ever try and actively 'emulate' anyone. Your inexperience or ineptitude means you end up making things that seem highly derivative, but that's a process most young artists go through. The primary way you learn about art (unless you're very lucky and have amazing tutors) is by absorbing and engaging with the work of other artists. You even flatter yourself that you're having some kind of a dialogue with them, but of course it's only one way!

As a student, I was into a great many different artists from Beuys to Nauman to various film makers. Within the last ten years, Jeff Wall has probably been the biggest conceptual influence on me. There's a clear visual influence of his work on mine, but, to be honest, it was his writing that originally affected me far more than his images. He has been extremely erudite in his delineation of the terms under which it becomes possible to make a 'contained' image that carries within it the fault lines of its own internal rupture.

Some of your works are mischievous in a way or, as you once described them, 'darkly comic'...

There's definitely a playful element to some of what I do. When I first started making paintings again, I think that slightly tongue-in-cheek element was something I pushed more in order to offset the 'dodgy' genre of painting that I was exploring. Any sense of play now lies in revealing the staging of the scenes, and that can often end up being relatively subtle.

Is this something you do for yourself or for your viewers?

For both, but then again you're also your own idealised viewer.

I try and think through the ramifications of what I do and how it might be read, but there are certain decisions you make that are instinctive, when you slowly realise in retrospect, 'Oh, that's what I was doing.' Many of the core themes I deal with now grew out of the practical necessity of finding the best way to control the making of an image. If I build something that I can have in front of me, I will have maximum control over the way that I can construct the image, in terms of composition, lighting, etc.

Are you a control freak?

Yes, in the sense that I want complete control over my working environment. But I'm also quite happy to then let things screw up because that's where interesting things happen. I like the fact that I've now reached a point where I understand the visual material I'm working with and where I want to direct it. That has slowly allowed me to build the confidence to set up these scenarios, build these sets and then bring people in and just allow them to behave. That tension between control and accident is something I enjoy.

Does anyone help you with your painting?

No. I like the fact that you know every inch of the canvas and understand why you've placed every mark. It's good discipline. I get help in other areas: building the sets and those kinds of things.

Painting, you've said, has a lot of baggage. What's an example?

Painting comes with a huge amount of historical baggage, but essentially it's just another language or idiom within art, and I prefer to see it in those terms.

Artists have a fondness for collectibles, (above), items of a personal or aesthetic nature often hoarded to no effect. This cubbyhole above the studio entrance is filled with odd items including replica rifles.

Jonathan Wateridge (opposite) seen through the window of his Tottenham Hale, London, studio on a cold morning in February 2011.

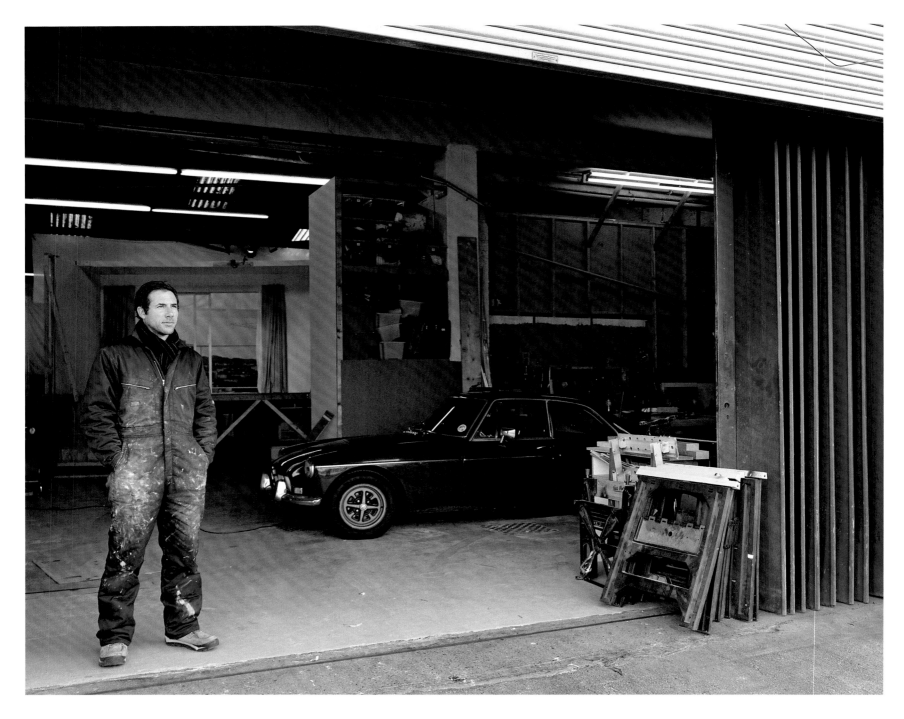

The long-standing mistrust of painterly realism in contemporary circles fortunately seems to be subsiding a bit. I'd argue that painters such as Manet and Courbet have more relevance to the contemporary than the more recent, though rapidly dating, absolutist tendencies of modernism. The way art echoes through history isn't necessarily linear. I find extraordinary parallels between Richter, for example, and aspects of Degas's relationship to paint and photography Sickert's late work seems incredibly contemporary next to other artists of the time who notionally would have been far more 'avant-garde'. Indeed the notion of the avant-garde itself is one that lacks contemporary legitimacy; its ideologies having ossified into the kind of orthodoxy it sought to overthrow in the first place. Ultimately, it's reliant on a romantic binary opposition that no longer exists. I believe we're operating in a far more interesting and fluid context than that.

Ironically, one of the reasons painting's baggage works well today is that painting is one of the least effective ways of reflecting the now. It's slow; it's very old; it takes a long time to do. We have instant mediums, so to try to use painting in a journalistic way is crazy. It tends to be almost like a glacier picking up stuff. It becomes about memory; it refers back to other things. I like it because of that, because it places itself outside of time in a way. We don't ask painting to be a marker for the real in the way that photography still tends to be. On the whole, we still trust a photograph to be a reflection of what's going on outside our window, whereas painting isn't. Precisely because we no longer expect it to serve a representative function, a realist painting has the potential to surprise us and provoke a sense of the uncanny.

Do you like to just get out and start painting sometimes?

Not in that plein-air Impressionist way. That idea, however enjoyable it might be, is an anachronism from my point of view. That's why I set everything up in the studio. I might paint from life in the studio, but it all has to get set up there. The fundamental reason for doing that is to play up the fact that this is a completely subjective construct. There is no truth to what I do.

Are you a fantasist?

No. I would more take the line that I don't exist. I never thought of who I am as being of any interest in connection with the way I make work. I'm constantly filtering images in the same way we all are. If you're going to get into the business of making images, you have to understand that those images are part of that much greater conversation. I'm just trying to set mine up in a way that says, 'I know I'm a lie.' Everything is a construct ultimately: our identities, our political systems, our social systems. There's no such thing as an innocent image.

Wateridge, (opposite), who works from life, builds scale models and full-scale sets in his studio to paint. 'Nothing that I make or depict (other than the performers themselves) exists or has been set up outside of the space in which I work. This notion of fabrication and the fictional runs through all of my paintings.'

Finished works (left) hang in Wateridge's studio while (above) remnants of his sets languish until used another day, their identity formed and re-formed, lost to waste. 'Everything is a construct ultimately: our identities, our political systems, our social systems. There's no such thing as an innocent image.'

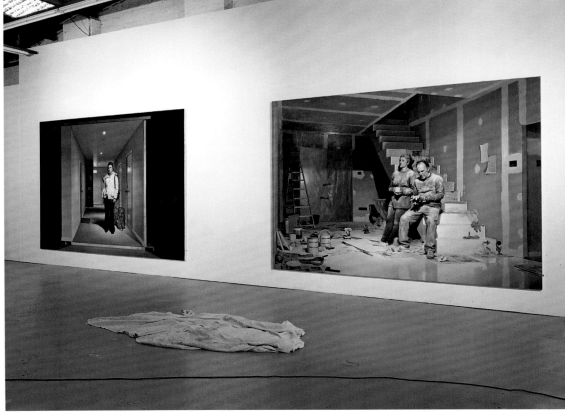

Gavin Turk

What would you ask if you had to interview yourself?

I would like to explain myself, but obviously I don't know myself. Being an artist allows me to play around with thinking about who I am, to experiment with the idea of who I might be. It allows me to think about myself.

I get asked frequently when the moment is that you realise you're going be an artist. I've never really had an answer to that question. I don't think there was ever a specific moment when I thought I was going to be an artist. I've almost become an artist through not doing anything else. By the negation of other things. When I was studying art at college, there was a point at which I could look out into the future and think of what I wanted to undertake as a career. I don't think I was very ambitious at that point. That reserve is probably still there in my work. I believe art should be taken to the greatest extension of its capabilities. In a way an artwork is made successful by being viewed, by being used and by being taken up by its audience.

Is there a use for art?

It's useful in that it provides a moment in time that you can use to think. It's expansive and a sort of mark-up, a conversation to continue the conversation.

You've mentioned a metaphor: the 'candles of life'. Is it possible that humans are inspired by the candles of life, and that art presupposes different visions of them?

If you go back to a caveman scenario, you have someone in a cave drawing – they may not be the main hunter. In a way they're the biographer, they're a recorder; they lay down information so the next generation can come and see the dreams or can see what might happen out in the field. It is useful for people to engage in art not from a position of making

it, simply from the position of being in an audience. I suppose if it doesn't go in front of an audience, it's not art. The caveman is experimenting with this ability to record something. I'm not sure whether this is a biological thing.

What was the caveman's purpose? What was he trying to do? Did he imagine that someone would come along twenty years, twenty thousand years down the line?

Maybe not. I guess it was a kind of singing, a kind of singing to itself, like poetry – like a dream. About having a dream.

Do artists need to be self-obsessed to produce good art?

I don't think so.

How much art represents the inner core of the artist?

It's a difficult question. If I worked on a desert island, I certainly wouldn't make art the way I make it at the moment. I would catalogue things around me, investigate my surroundings. I wouldn't self-consciously be creating things for an audience. The audience would be myself, and that would result in a very different kind of project.

A different art?

I think it wouldn't be art. It would just be playing around. If someone else would come to the island later on and find all these things that I'd made, they might say, 'Oh, it's the art of the island.' So it might be attributed later by others as art, but I wouldn't be making what I think is art, which is what I generally do at the moment, and which has an audience and a kind of cultural jacket, a cultural framework. If what I'm making tends to try and talk in certain languages, projects certain meanings and understandings, it

can only do so through or from its cultural context. So I have to be aware and engaged. I'm quite open; I enjoy art which I wouldn't make myself, which I see as the opposite of what I make, but I can still get value, still get information, some sort of nourishment.

What do your paintings communicate? How do you define playfulness?

What I like to try and do is marry up different ideas in my mind – half-ideas or fully formed ideas but not quite enough – the idea itself, enough to bring it into the room, bring it to the table. What I like to try and do is connect them up so that what you get is a hybrid form of Conceptualism.

Do you think art right now is taking the mickey?

There's a lot of art which possibly sells everyone a bit short.

A few years ago, Jeff Koons had an exhibition of work from 2003 at the Serpentine Gallery. I was supposed to give a talk about it. I did as much research as I could, looking at what Jeff had been saying in his pre-production speeches and press releases. The work was being presented, or promoted, as very open, very available. It was synthetic in a synthetic world everyone could understand and engage with. It was about openness. I went to the exhibition and found it incredibly difficult to understand, very opaque. I ended up giving a talk which was almost like throwing the talk open to the audience, asking, 'Am I on my own here, with these feelings?' The audience had a similar kind of feeling. Having said all that, I continued to go back and ask myself, 'What is this work doing? Why is it here? Why is it frustrating me so much?' And, almost like that process of looking into my own art thoughts, I've been drawn into an intelligent, important relationship with the work. The work has really affected me, has really stretched my thought processes.

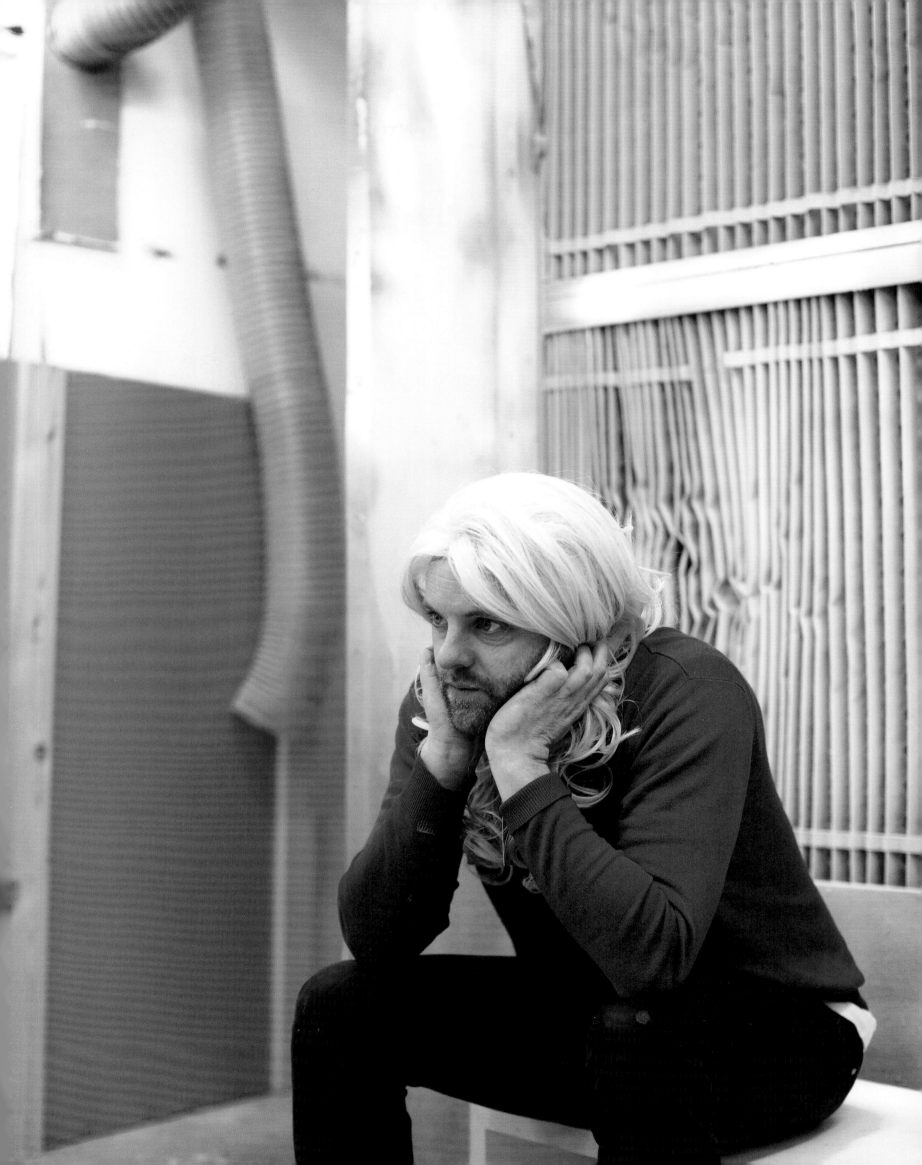

The question here is whether we are giving substance to whimsy just for the sake of being represented by a major gallery.

Artists don't change the world. The Surrealists set up their manifestos; they were ambitious to change the world. You can't, really – all art is political, but it is not actively political. It's political in a poetic sense. Perhaps if you look at Surrealism today, and you give it a context, you could say that they did change the world, they did change the way people perceive objects. They did actually do it, but it didn't happen in the way that they thought it would happen. One of the artists I can't get over is Marcel Duchamp, whose work just goes whenever you try to grab hold of it. Whenever you try to feel or understand what motivated him to create the work, it takes itself to another point. It's very, very elusive. One of the reasons his work is enduring is because of its poetic nature, its elusive quality.

So are you a romantic?

Kind of. I can be quite pragmatic as well. A sort of romantic pragmatist.

In which role would you like to be remembered?

Either one when I'm being the other. There's some sort of balance, isn't there?

What is your relationship with Warhol?

Every artist who is working today is seen through the filter of Warhol whether they are actively engaging with his work or not. There's this opinion that when you say that you're an artist there's an art button you can press on your computer. You press it and it has high contrast and many different colours like Warhol. That keeps coming up in my work. Celebrity is a necessary element. Artists have to deal with the notion of celebrity.

Do they have to play to an audience?

Yeah. And the audience is quite caught up, already understanding the system of recognition which involves celebrity painting. Generally artists aren't as well set up to be celebrities as others. For instance, if you're a film star, your celebrity status is continually being confirmed in the cinema.

Are artists camera-friendly or camera-shy?

Probably all of the above. They're probably ugly, camera-shy, not very friendly. They probably do take themselves too seriously as well on the whole.

Going back to the playful nature of your work, what's the story with the ice-cream van?

The ice-cream van is a children's educational project that I'm involved in. It's more like my partner Deborah's project. It's Deborah's artwork, but I suppose it's also a kind of collaborative artwork. It's a platform where education, family, children – where cultural activity happens. The ice-cream van is something we've made to take on the road with us. It's a beautiful 1950s van. It has a Rose Blake artwork hand-painted all over it.

So you're a travelling circus?

It's a kind of art circus, yeah. It expands and contracts. And in a way it performs. We've published a portfolio of artwork. We've done education work in schools. We've worked in the Barbican organising visual backdrops for performances. We go to lots of festivals around the country and do workshops. A lot of it is about making, doing and inspiring activity. Inspiring activity in people who wouldn't necessarily take part, who'd sit in the audience. We want to try to turn the tables on people and children, to make them learn through play, to see through ideas. As an artist, it comes as second nature to pick something up and run it through your hands and start to realise a way the thing in your hands has an application and how you might get inspiration, how you might incorporate that thing into your life. For lots of people who don't have that kind of training it can be much more distant.

Is all art anchored in the past?

Yeah. It's a dragging anchor, not a fixed anchor. Sometimes you've got a boat and you just throw a heavy weight over the side with a line and your boat still moves … but you feel anchored. You need the past to bring to bear on what you're looking at. It creates art history. It makes connections. History is important; it weighs on the artwork. You have a memory of a certain colour, you have a memory of certain mark-making, you have a memory of a certain composition. And you use that memory to start the process of understanding looking.

Gavin Turk (top) beneath a pastiche of his infamous heritage-style plaque, the original of which was presented by the artist for his MA show at the Royal College of Art, London, in 1991, resulting in his being denied a degree. Turk and his assistants take turns cooking lunch in the communal studio kitchen.

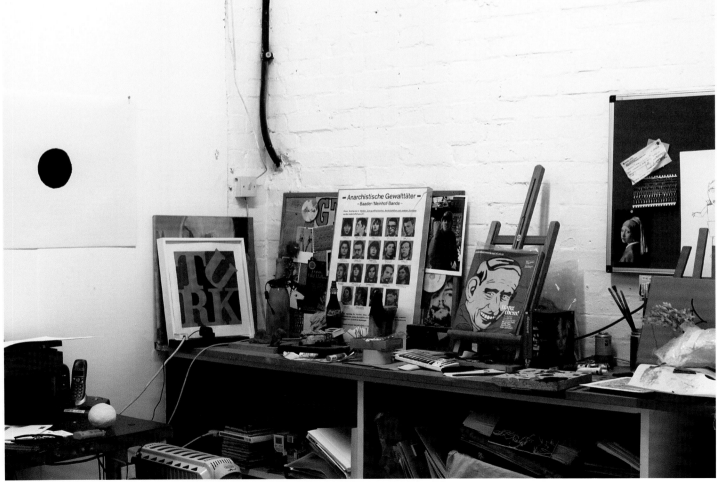

Turk often uses himself
(above) as a model for his art,
here seen as a cast in front
of a silkscreen from his Elvis
series: 'Being an artist allows
me to play around with
thinking about who I am,
to experiment with the idea
of who I might be.'

Studio junk (left), the refuse
of artistic practice, which
itself sometimes gets
transformed back into art.
'All art is political, but it is
not actively political. It's
political in a poetic sense.'

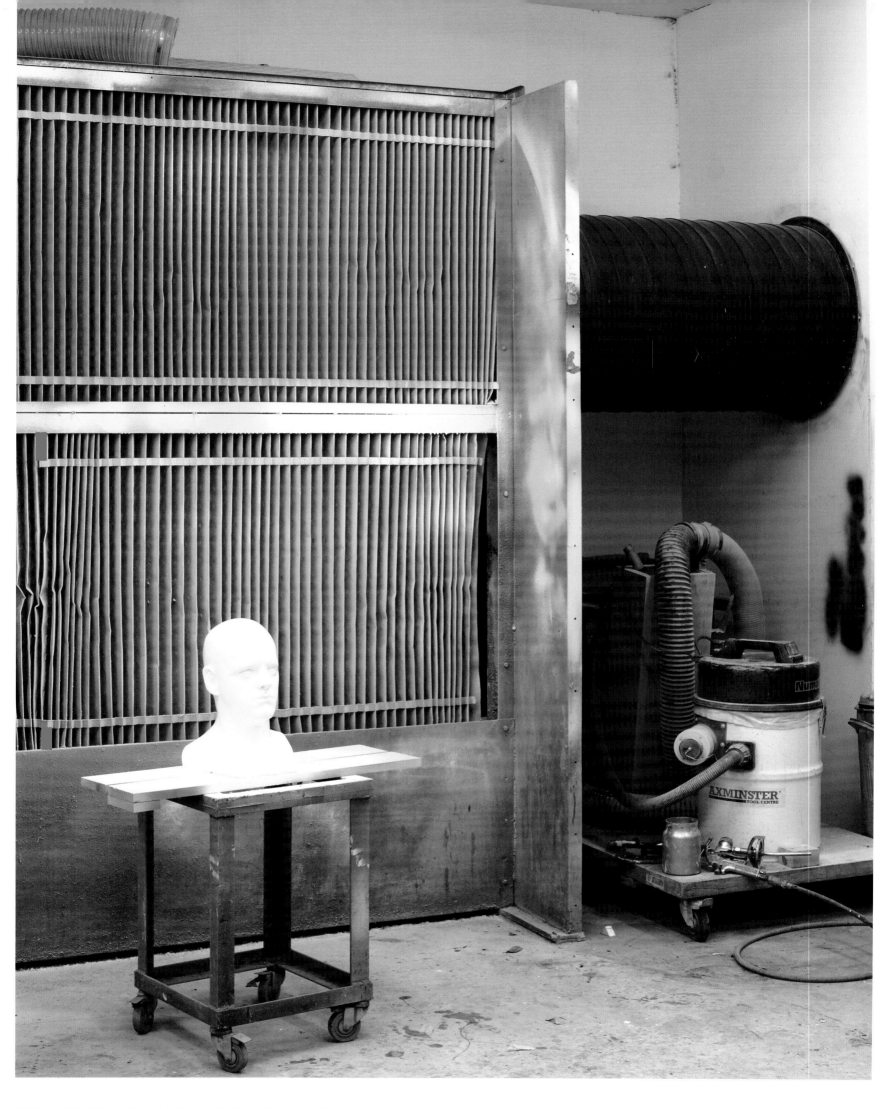

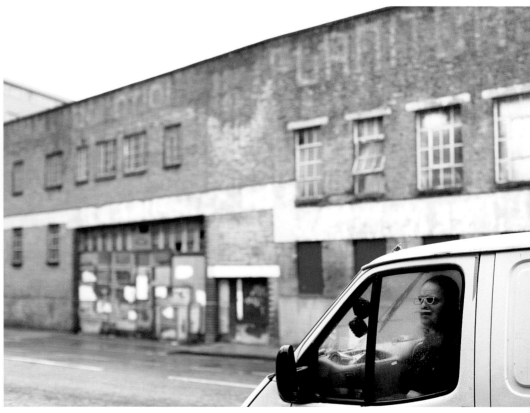

The artist's large studio in Hackney Wick, London, houses both new works and odd memorabilia (above left) of his practice, whether unfinished works in clay or an Italian scooter vying for attention with an Andy Warhol-inspired silkscreen. Turk on the loose (above) makes light of his working day.

Marc Quinn

Marc Quinn in artistic repose in his Clerkenwell, London, studio in February 2011: 'Perfection is an abstraction by which we rule our lives, and by which people destroy their lives.'

Why did you become an artist?

I guess everyone is creative.

You started out as a sculptor ...

As a painter more than anything. But it's your life; you can do what you want. Maybe next year I'll make films. It's a hostile way of getting things done, trying to stick things into a medium. I don't prioritise one medium over another.

You have a fascination with science, I believe ...

Being an artist is about trying to understand ourselves and our position in the world. Science is doing the same thing, but science is looking for artistry and art is asking questions.

And *your* art is intended to ask questions that shock ...

It's amazing how we create this idea of the normal to make ourselves go through life without asking too many questions. The fact that I'm looking at you, that the idea of *you* or *I* exists, that we can speak and think, is the most unbelievable, shocking thing in the world. Yet it's completely normalised. So I don't really understand what 'shocking' is. What I do think is interesting is making art that makes people feel good. It's about communication. Artwork is a factory of emotions and ideas and feelings.

How do you recharge your batteries?

The usual things ... you go on a trip somewhere; you do something different. I guess that's why I change my work all the time; doing one thing for ever would drive me insane. Art and life aren't one thing, and I think art should reflect life.

You mentioned insanity ... Many artists talk about the borderline melancholia that can inform their work, that can drive them. Is it a question of running away from that insanity in order to create art?

No. Art is about embracing the world, things that are beautiful, light and trivial, things that are heavy, dark and terrifying. My work should reflect all those aspects.

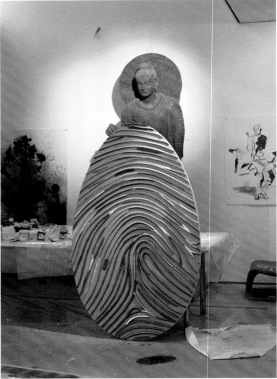

Quinn, himself an avid collector, has an orderly studio displaying some of his own works and the odd piece of South-east Asian art (above). *Mirage* (2009) (left), made of patinated bronze, was inspired by a photograph taken at Abu Ghraib prison. The sculpture stands in Quinn's studio next to his library.

What would you like to be remembered for when you go on to your reward?

Once you create works, they go off and have their own lives. When an object ends up somewhere in a thousand years' time, it may have its own reputation, have created its own reality. When you go to the British Museum and look at a work there, you have no idea – unless you're an academic – of the culture or intellectual reality that created that work. But you can still have an emotional response to it. Art is more complex than any one interpretation – it's beyond interpretation. The whole point is that you can't explain it. In some ways it's un-explainable.

Are you not concerned with what critics have to say about your work?

What critics say is a reflection of their realities. Obviously I like when people like my work and are amused by it.

Is art criticism a kind of gatekeeping, perhaps?

It's a form of containment, a form of control. Art is out of control, and people don't like things that are out of control. They try to control them.

Key themes in your work include genetic modification and hybridism, is that correct?

That's one thing.

But isn't all art hybridism in one form of another?

Yeah. Art is creating a new reality out of a collage of existing reality, I suppose. Everything is chance.

So fame and fortune in the world of art are down to chance?

Well, they are down to chance in that obviously there are people who are perhaps better at making art and others who make more compelling work, but you need to be lucky to make work that challenges the time you live in. You have to be in the right places to meet the right people. There are so many different things that go into any sort of success.

When you start on a new work, do you do any pre-planning? Do you leave things to stand for six months or a year and then return to them?

Things usually do mull for a while.

And do you pick up inspiration or ideas anywhere, at any time?

You never know where they are going to come from.

Do you record them immediately?

No. If you write something down or draw it, you kill it. You freeze it. You stop it from continuing or evolving. So I keep it all in my head.

Have you ever bought back or destroyed pieces?

Well, I've destroyed a few things.

You're a very cerebral artist. Your father was a physicist; you went to Cambridge, although you never finished a degree.

Yeah, I did: History of Art.

Have you ever made a pilgrimage to seek inspiration?

I was in India last week.

Did it affect you in any way?

I'm sure it did inspire me; I can't say how yet.

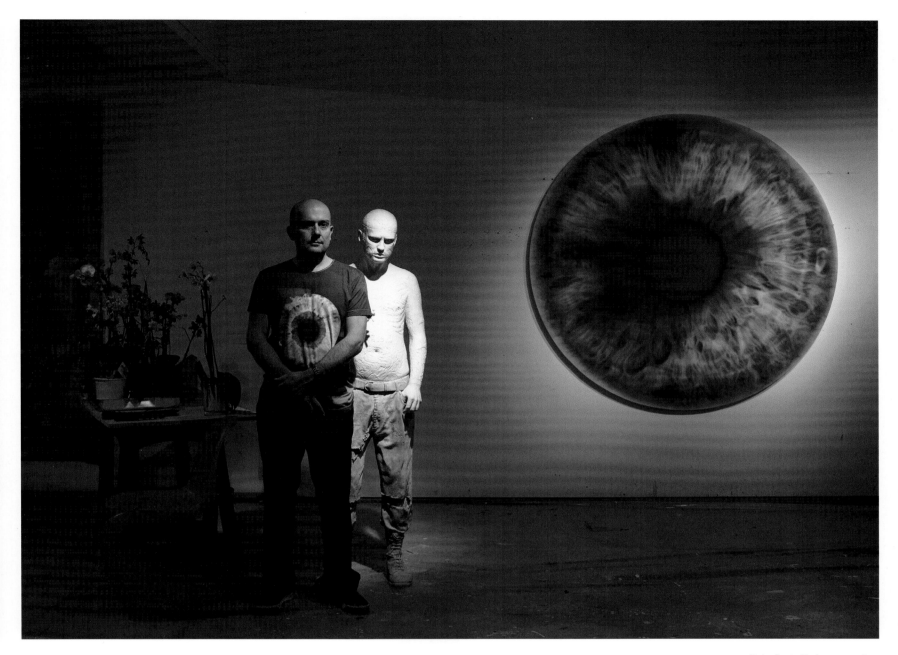

What is the role of the studio in your work, since a lot of it is made outside?
The studio is the place where it's my world.

Do you have assistants?
Not that many – three or four.

Who makes your big pieces?
I work with fabricators.

In terms of fabrication, how much are you on top of the situation?
A hundred and fifty per cent.

When you leave the studio, do you take your work home in your mind?
Yeah. You always carry it in your mind, but hopefully you can separate it or you will go insane. You have to turn your head off sometimes.

Would you describe yourself as a social animal?
I'm quite social.

Do you enjoy the celebrity circuit?
I like people.

But do you find it intrusive, excessive, oppressive to get that attention?
I don't notice it that much. Art has become more mainstream, and I think that's good.

But there's a price to pay inasmuch as you have to pander to the hype, isn't there?
I don't have to pander to anything at all. You do what you want. That's the whole point of being an artist.

You've said that part of the job of being an artist is to make people examine the world with fresh eyes. Doesn't that kind of re-examination sometimes cause a shock?
Yeah, it's possible. When you're looking at art, you should lose yourself. That is the whole point, that's why art is always in the present moment. Art is drugs for people who don't take drugs.

Quinn's studio is crammed with works from his *Garden* series and sculptures that depict celebrities such as Kate Moss. 'People don't read books of philosophy, but they want to understand the world, and art is more immediate.' (following spread) Quinn's sculptures modelled on Allanah Starr and Buck Angel, a man with a vagina with a woman with a penis having intercourse.

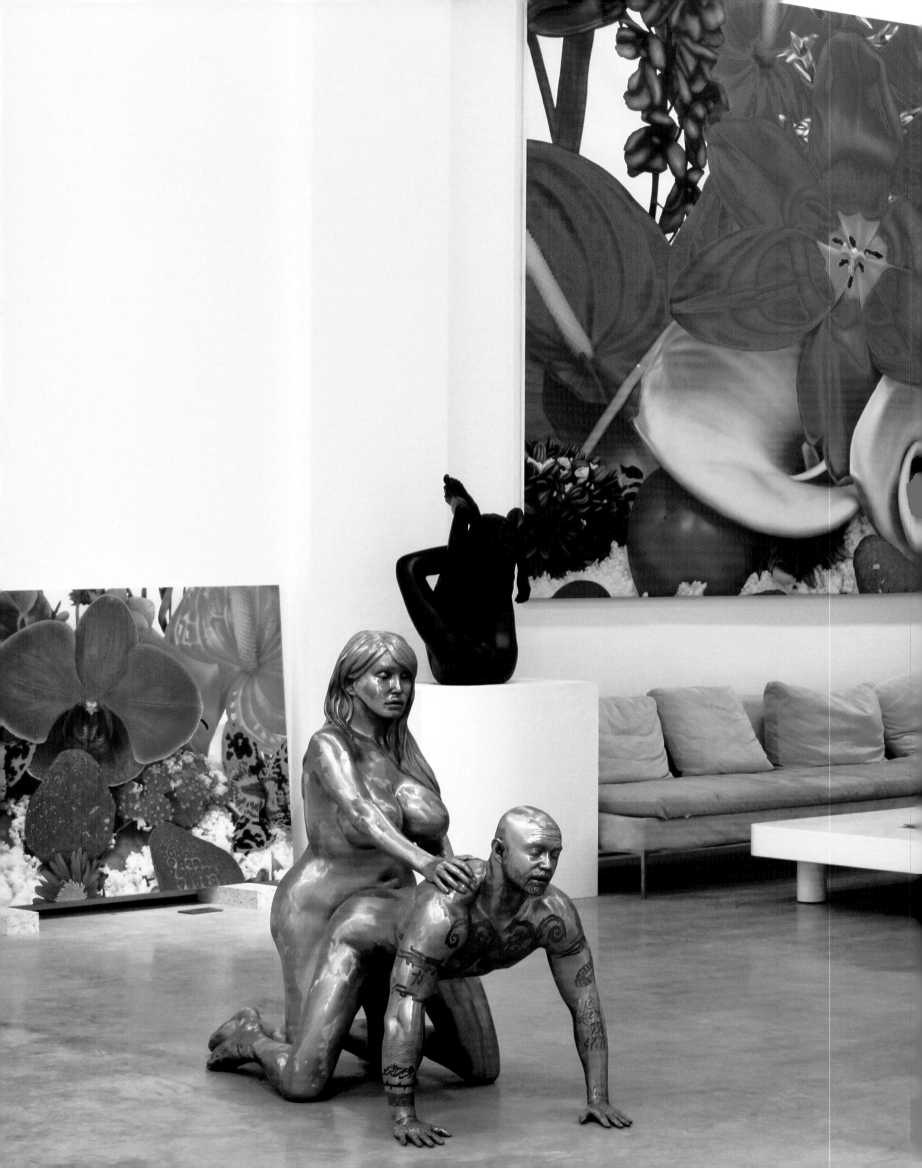

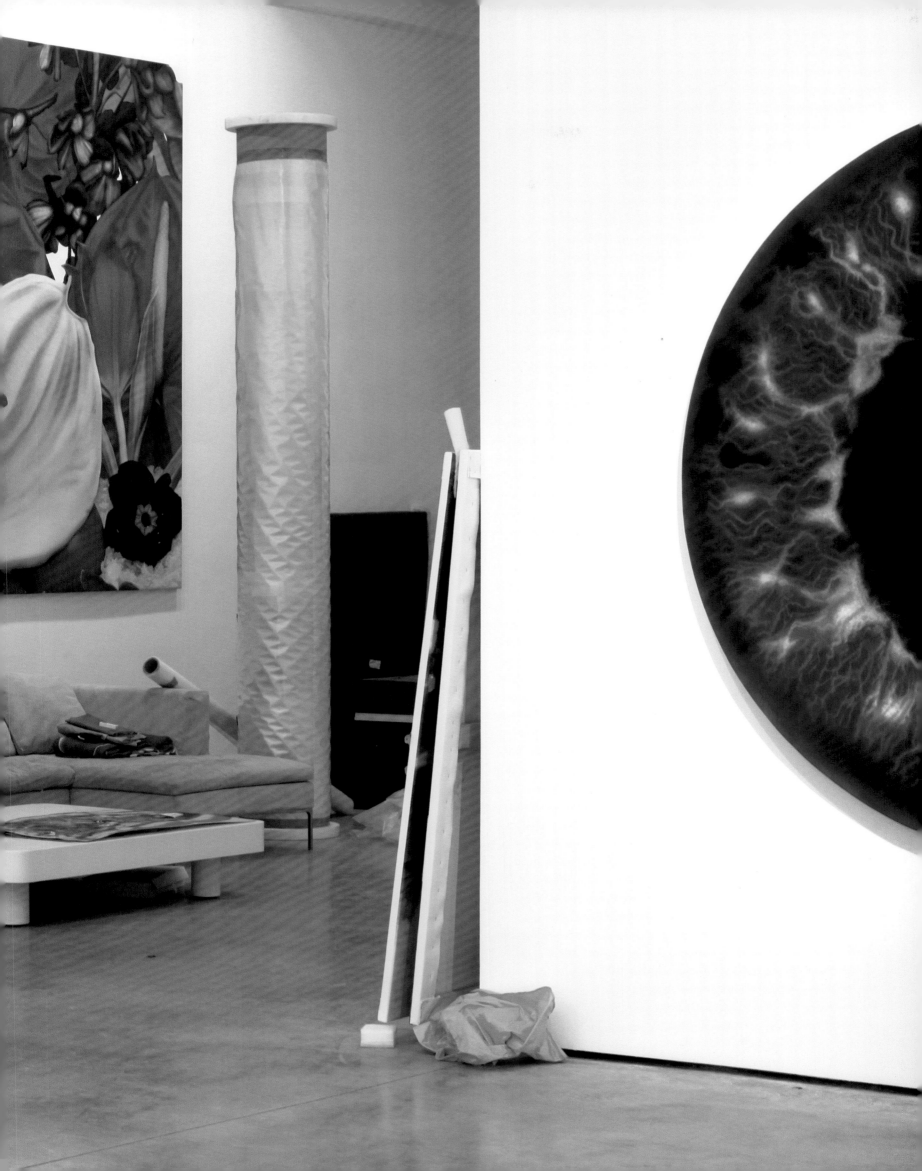

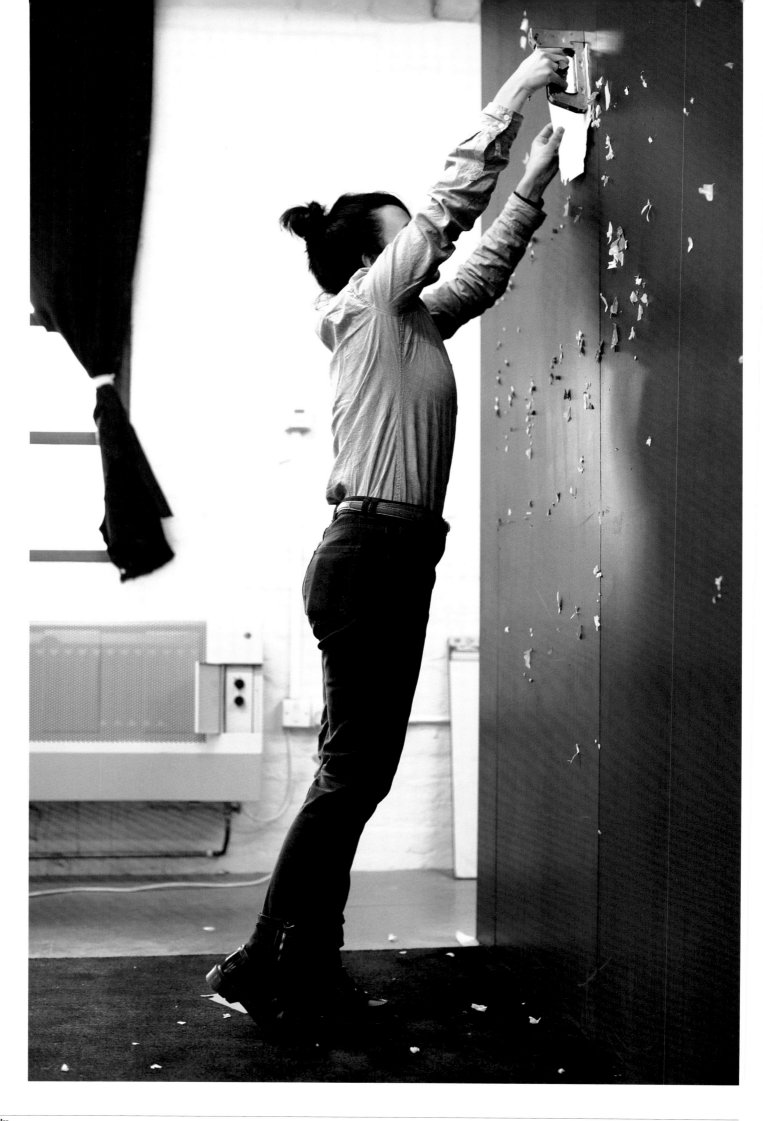

Anne Hardy

What does art have to do with locale?

If you mean my art specifically, a lot of what I make comes out of where I am based, in the sense that urban space is chaotic and layered. I'm interested in what makes a fictionalised version of what's around me or what I imagine to be around me.

You've never gone looking for different places?

I do look outside of what is immediately around me in the literature I read and in the places I travel to but have never used these as specific references. I think that what is close to you can often be the most complex and fascinating, as you can reach so far inside the layers of it over time.

Is art the sediment of life, almost like rubbish, or is it composed of ideas and inspiration?

For me, it's more like a filter for life, for the world. It's a way of understanding and looking at the world around me. Hopefully this translates for other people.

Your work is very mannered, almost engineered from your imagination …

Yes. It's obviously very specific to me, but then I always have in mind references that other people can understand. It's not about fantasy; it's about trying to tie the spaces I make back to the real world. But then I think that the reality around us is engineered anyway. Everything is entirely constructed.

How is that reflected in photography?

Photography shows you something apparently real, somewhere you can project your mind into. Just as with the built environment, where certain spaces are made to make us feel and react in particular ways. My work reflects on the nature of the world that I am part of, or the construction of that world, the layers within that world.

Do you have a specific viewer in mind or do you make work for yourself?

Mostly for myself. I can't think about somebody else when I am making work. I think of my own objectives for that particular piece. The process of making each work is quite slow. I make about three or four pieces a year. The thing that I make comes out of the process of making it. The work evolves from an organic process.

So it's almost like a painted canvas, where an artist picks up a brush?

Yes, or how a sculptor works with materials. It's a very sculptural process. It's closely linked to the materials that I use. Each work starts in a different way. Sometimes I start with certain objects, sometimes with certain materials, sometimes with a particular type of architectural space. Each work grows differently. For example, for *Lumber*, one of my first works, I started with stuff that had been thrown away by other people. I was interested in how materials and objects came to be in spaces. For instance, you have a Christmas tree in the house; it's special; you throw it out on to the street; it becomes rubbish. In a way the object doesn't have a status any more. I saw all these trees abandoned at the side of the road one day when I was driving home. They had been put out because the bin men were coming to collect them. I was interested in them because they looked out of place. That was the trigger for *Lumber*.

Does this, in a way, represent what happens in history, the fact that we go through spaces, objectify them, use them and then discard them?

I don't know if we always discard things. In a way I think we have a tendency to fill and construct things that fit the meaning of a particular time, and then that changes.

You've said that people manipulate objects to satisfy their lives …

I'm interested in how we all use and have an impact on spaces and leave our presences within them. Sometimes we arrange things in a particular way that feels significant and that also somehow carries a sense of personality, a sense of occupancy. When I put my spaces together, I think about the people who would occupy them, how they would use the space, what they would do there.

This is in an urban context … or can it happen in a village, in a rural environment?

It probably happens everywhere, but I am particularly interested in urban environments, in the way spaces and people are layered on top of each other very closely.

Are you trying to gain a specific reaction with your work, or do you leave it to the observer to make up their own mind?

I don't look for a specific reaction, but I hope that when you look at the pieces they remind you of the world you are part of, or of places that you imagine existed in the world around you. It's a bit like when a writer writes a novel, somebody like J. G. Ballard or Martin Amis. They write about London; it's not real, but you believe in the characters and believe in the created world even though you know they're not put together to be a documentary. A photograph in a conventional sense provides you with information; it records things as they are. I'm interested in disrupting that ability.

I'm inspired a lot by literature. Writing like Ballard's, say, creates a reflection of the world that is familiar to us – it's the everyday, mundane world in a way – but it reveals something about how strange our ordinary world is. The camera and the set are there together at a very early stage in my constructions. I don't build them and then come along with my camera; I make them in order to be photographed. I know where I'll photograph right from the beginning. I consider the set through the camera rather than by standing in the middle of it and thinking about how I might record it.

Could you say something about the absence of people in your photographs?

If there was a person in the spaces, the image would be about that person and how you imagine their psyche and their relationship with that space. I want the person who thinks about their relationship with the space to be you, the viewer, not you via somebody else's actions.

Is there a particular photographer who has influenced you?

Early on, I was influenced by American photographers like Lee Friedlander and William Eggleston, people who were looking at ordinary things and showing you something you've never seen before. Then when you walked down the street you almost expected that maybe you'd see some of the same things or look at things around you in a room in a different way. I still think that's really exciting.

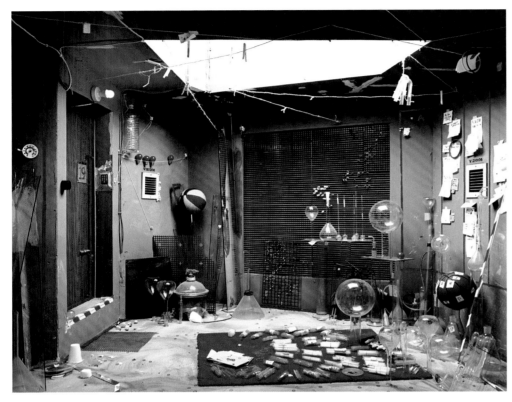

Anne Hardy builds entire installations, sometimes over periods of several months, for her photographs. Hardy makes three to four pieces a year. The scene pictured here (left) took two months to set up and was shot with a medium-format camera. 'It's not about fantasy,' she observes, 'it's about trying to tie the spaces I make back to the real world. But then I think that the reality around us is engineered anyway.'

(left)
Untitled VI, 2005
Diasec-mounted C-type print
© Anne Hardy
Courtesy Maureen Paley,
London

Hardy (below) building her set for an artist's residency at Camden Arts Centre, London, in May 2011.

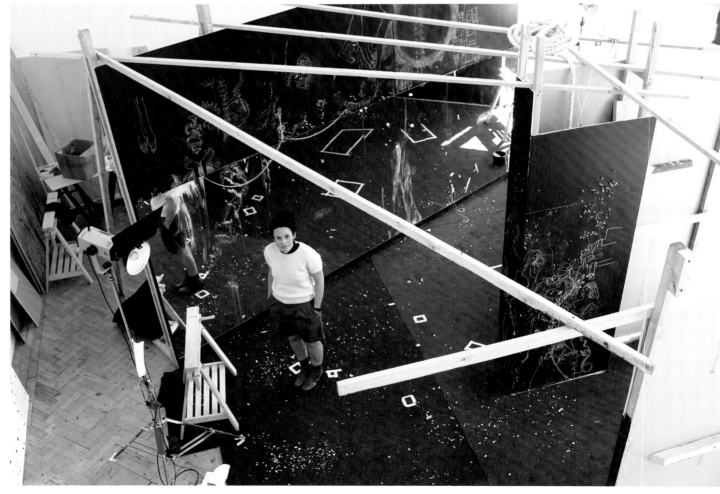

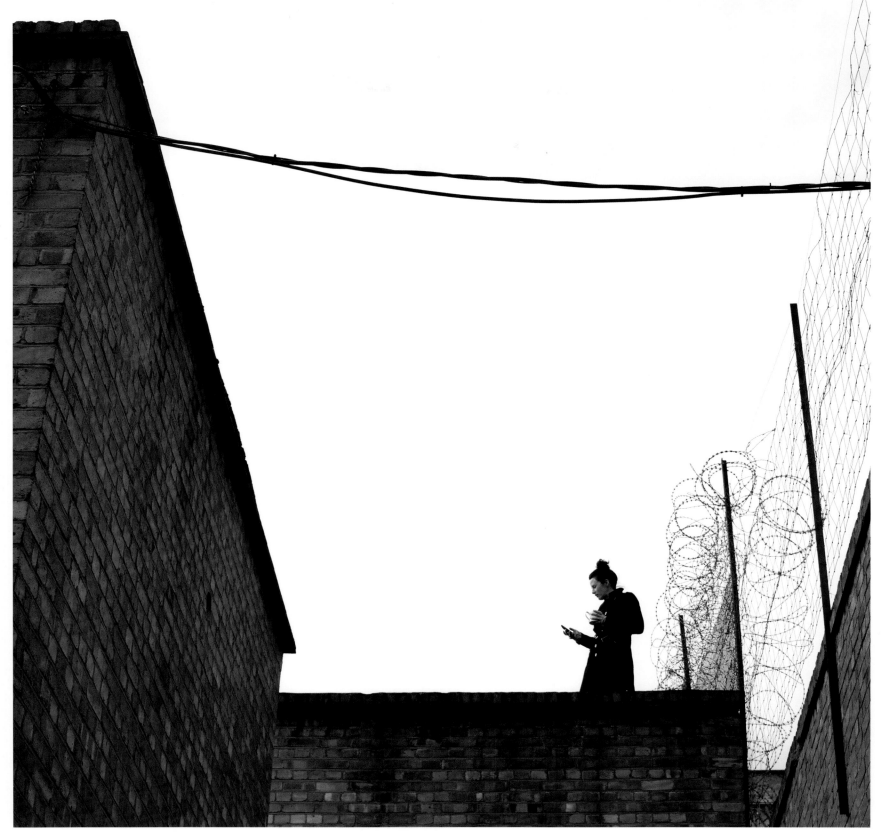

The artist on the roof
of her Bethnal Green,
London, studio.

Charles Avery

How does the art/family mix work?

It works pretty well, generally, when they're sleeping. I keep very regular hours in the studio. I take the girls to school, so I'm in the studio by 9.30 in the morning. I leave at 6.00, I get home, and I read them their bedtime story or make one up.

You're good at making things up?

Yeah.

So the analogy is that making something up is art?

I have all sorts of ideas in the studio, but when it comes to making up a simple children's story, I find that really difficult. Drawing comes the easiest. Thoughts and ideas come out of the process of drawing. I write a lot as well. The writing and the drawing can inform one another.

Does this interaction go back to your childhood?

My mother was an artist and my dad's an architect, so I think it's in me, definitely. The Isle of Mull, where I grew up, is a great place for stories. My mum painted a huge map on the wall of our sitting room there showing the Headless Horseman and various other mythological characters. We had these great

forests that surrounded our house. The forest was a great place for projections of all sorts. You had to make your own fun.

Does childhood experience determine an artist's entire body of work?

In my case very much so, but for lots of artists I think not. My *Island* project is very intellectual in the sense that I don't dream about it; it doesn't occupy my thoughts in that way. I'm always thinking about it when I'm awake, but I'm a great believer in intuition as well. I draw mainly from my imagination, which leaves room for intuition and improvisation. There's a colonialism or territorialism about ideas, and in a way my fictional island is a metaphor for that kind of ownership of ideas. One just comes across ideas; I don't feel that I'm their generator. It's like picking shells up off the shore …

You've essentially created a second life for yourself.

I have problems with the terms 'alternative reality' or 'second life'. What I have created is a fiction which is very much part of the real world, and the 'second life' is a huge part of *my* life – it's a vehicle for me to think and, I hope, will serve as a forum for people to

do their own thinking. I create something that *means* as opposed to being an artist who deals in aesthetics. I'm creating a structure of meaning, but the specific meanings are not prescribed. There's no moral story, no allegory, no narrative as such.

This idea of virtual exploration … is art virtual exploration?

You're not constrained by physical elements, yet that's the problem. Art has been largely overtaken by professionalism in the sense that artists make pieces a lot, and the making of pieces is something that happens for the market. You should be having lots of ideas, and about many different subjects, and sometimes I feel that artists maybe take that privilege for granted. When you start having shows, you get a lot of pressure, but not from the market – the market doesn't have a consciousness, the market is not making the artist do anything. There is pressure to create a formula, and make piece after piece after piece.

I became aware of that pressure quite early on, and part of the reason for taking on the *Island* project in the first place was to avoid that, because by creating the island I created an umbrella for all the things *I* wanted to do, all the ideas *I* wanted to follow. So I let my galleries down early. Nowadays they don't have so many expectations. This place allows me the freedom to pursue lots of different ideas and to use art-making as a way of thinking rather than just a continuation of making a piece and then making another piece and making another piece. I always wanted to do something holistically that would be greater than the sum of its parts.

You use the market rather than allowing the market to use you.

As an artist you can't deny the market. Even the artist who says, 'I will never make another piece of work in my life and that is my art' is still implicated in the market; they're involved in the marketplace of ideas. My way of dealing with that has been to understand my relationship with, for example, the collector. When a collector buys my work, they understand that they're enabling me to continue with this intellectual venture. It's a form of patronage in the proper sense, and therefore I have high expectations of the people who collect my work.

You talk about the physical integrity of your work as if it's a mental construct. Does it come from this island mentality? Are you on a Homeric journey?

I'm not heroic, but it's certainly an epic undertaking.

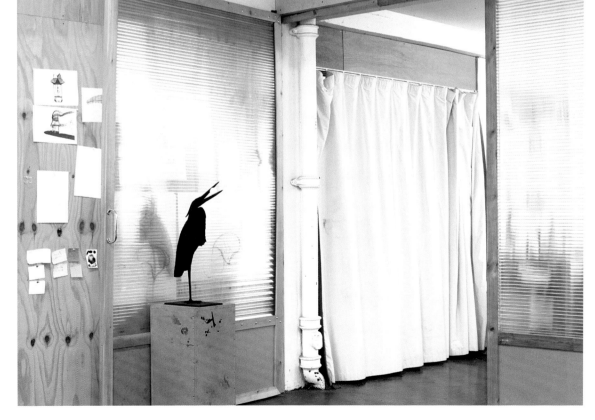

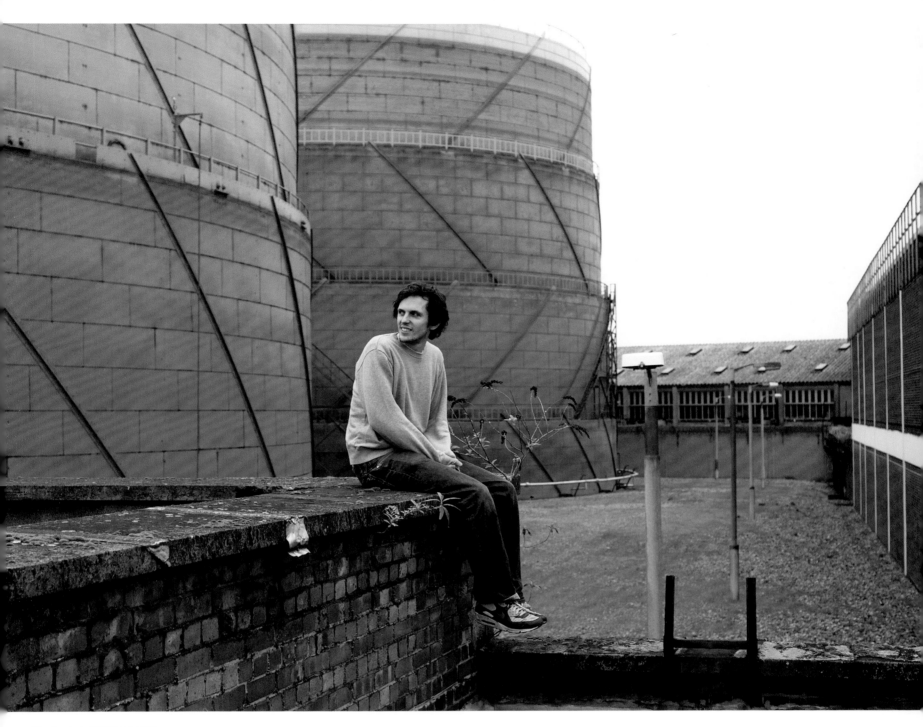

Charles Avery photographed in February 2011 outside his studio in London's Hackney district, where most artists tend to locate for economic reasons. The entrance to the studio (opposite) is guarded by one of the artist's fictitious creatures from *The Islanders*, his epic project which began in 2004.

Donald Urquhart, another self-taught Scot, says that when he talks to students for the first time he tells them to break out of their constraints.

I agree. But you can't tell people things like that; people need to make their own mistakes. I'm sure there are a lot of people who benefit from art school, but I'd say that interesting artists are likely to come from other backgrounds, whether from a philosophy background or from farming, so that they have something to talk about. Lots of art students have come straight from school and gone straight into art colleges and are part of the self-fulfilling art narrative. The machine carries on as though there weren't any alternative. I tend to disagree with that.

I think if you're brave enough not to go to art school you're more likely to be an independent thinker. It's about risk-taking. You take huge risks as an artist, and if you're at art school worrying about whether you're going to get a first, you're already worrying about your future, so you're not going to make it as an artist. I'm no fan of art education.

So you are a risk-taker …

Yes. I always assume the righteousness of my cause, and if I get something wrong or make a mistake, I'll brush it aside. I've always had a sort of confidence that everything would be fine even though all the evidence might be to the contrary.

It has been said that your research is remarkable for its inventive capacity and intellectual rigour. What does that mean?

I don't know if *intellectual* is the right word. Every idea gets examined and re-examined, tested for faults and improved.

Does money spoil artists?

Yes, it does. In recent years there's been an inclination for artists to think of art as a career option; they think about making a product. That is where the market is vitiating, because this is a unique opportunity as a forum for thinking. I reiterate the privilege of solitude, which is very rare in today's world: the right to be able to shut yourself off with few general responsibilities.

Also I'm against the idea of the masterpiece. When I do drawings, I just stop at a certain point, but there's always the sense of continuation, the sense that it could have been different. I think that effort is implicit in them, and that trying very hard is very important for me, trying but failing, constantly striving and constantly trying to improve. So I always leave all the old lines in a drawing, all the ghosts of where the people were … I leave all the draughting lines in. It's getting away from the idea that this work is perfect and if this work was any other way then it would be wrong. I tend in my solo shows to bring that element of continuation, that element of this being a work in progress, into the exhibition. Artists need to be allowed to fail, publicly, without worrying about their careers.

In this market-driven environment, there is no solitude, is there?

That's up to the artist. The market is not evil, the market is just the system; it's what's come about. Artists can't blame the market for their vicissitudes. The artist is the only person who can draw a line on the ground and say, 'I'm not going down that route. I'm going to use this privilege that I have to actually try and achieve something that transcends the market.'

You've said yourself that there are certain influences from where you've lived – Scotland, Edinburgh, Rome, Hackney. Which has been the most important one?

None of them is more important than the other; they all go to make up me. Hackney's becoming more important now that I'm spending more time there. I'm in the process of establishing a studio on Mull as well, so I can achieve some real solitude.

Do you find sanctuary in solitude or in your studio?

Solitude doesn't have to be literal.

Regarding your multiple skills as a draughtsman, as someone who works comfortably in ink, woodcut, sculpture, bronze, what is your principal aspiration?

By nature I'm a draughtsman. When I draw I don't think about how to draw; it just comes very naturally. I can write as well, in small bursts, but it's much more of an undertaking. I have to find a way of writing that doesn't betray my weaknesses as a writer. As soon as you think about how you're going to do it, you're in trouble. You need to get straight in there, like jumping into a cold pool, and not be thinking about it. I'm looking for an answer, I'm not thinking about being a great artist. I'm thinking about dying happy.

Over a ten-year period, Avery has produced drawings, sculptures and installations which inhabit the studio (opposite) and describe the topology and cosmology of a fictitious island and its inhabitants. 'I'm looking for an answer,' he says. 'I'm not thinking about being a great artist. I'm thinking about dying happy.'

Avery (above) overlooking his work *BAS7* in the Hayward Gallery's *British Art Show 7: In the Days of the Comet*. 'Artists need to be allowed to fail, publicly, without worrying about their careers.'

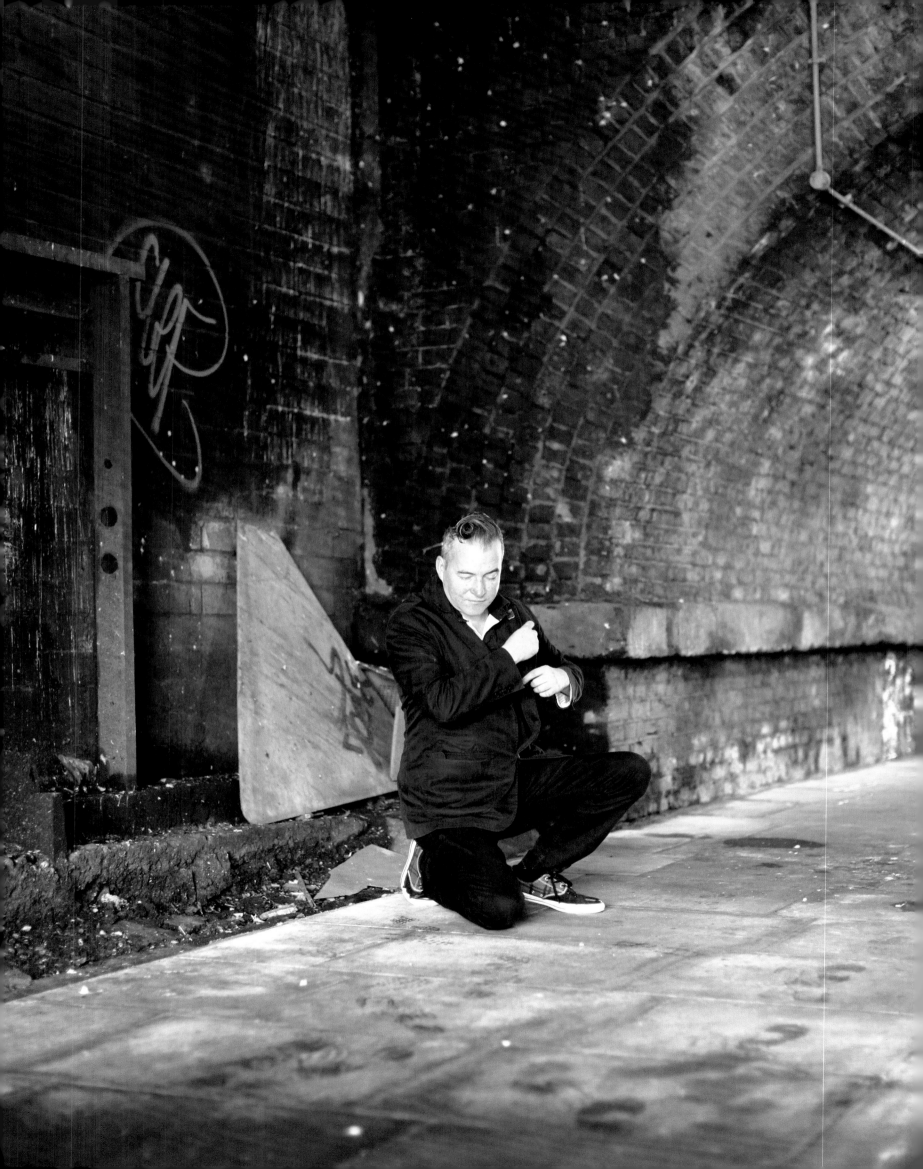

Donald Urquhart

When you feel the urge to express yourself, how does it manifest itself?

I've always liked drawing. My mother used to draw pictures, I used to copy them, and I never stopped drawing. That was what I did to relax.

What does your art express?

It doesn't always express the same thing. Sometimes I've got a point to make and I want to nail that point down. It could just be a piece of text, or it could be a picture of someone with a particular expression on their face.

My art comes from whatever crazy things leap into my mind. I'll think, I want to express that visually, so I make a note, either a text message on my phone or something on a scrap of paper. Some ideas just appear; for some you have to look inside your mind to find the idea. If I am drawing, it's usually a picture based on melancholy. Or I get annoyed by someone, and I'll draw a nasty caricature. I might write horrible things to get rid of hate – it's cathartic. At other times I might want to do something which is pleasurable to look at. There is sometimes sarcasm, sometimes it's sincere, but there is always humour. Humour is a sensitivity; it's knowing how far to take something.

Have you had a troubled life?

Yeah. There's always death, and I suffer from depression. My artwork a lot of the time is very exact and tidy. I think that's because I want to make something controlled in my world, which sometimes I feel is out of control. My artwork is a kind of self-therapy, a way of looking at what's inside my head and trying to make something positive out of it. Also it's about leaving something behind. A lot of artists suffer from depression. That's what makes them want to create; it's like digging themselves out of a hole.

Is there any fun in the process?

I don't know how to answer that, because sometimes I hate joy. Sometimes I want to draw a picture and it's just a drag. I use ink on paper with a brush, but I could make the same drawing easily with a felt-tip pen. I use a tiny sable brush, dip it in an ink pot, and then I have to be very careful and draw slowly to get a sharp line. Why do I make it difficult? I like the concentration; I think it's good to get that focused.

So painting and drawing stop you from thinking?

I really get into it. It's got to be really intense. Going to that intense place is good.

How long does it take to finish a big piece?

It could take a couple of weeks. Smaller pieces, anything from an afternoon to three or four days. I've got a saturation point – about six hours is the maximum. I usually lose it after that, start to swear and get angry. I go away and then come back. If I'm drawing in my house, I've got to get out of the house; I can't just go into another room.

What influences you?

Everyone's got different eyes when they approach a piece of work. I might go and look at a Rothko and think, That reminds me of the colour of my dad's second car. Someone else might look at it and see something inside their soul.

Some film directors and musicians influence me. I like the accuracy of Bridget Riley, but then I also like really wobbly stuff. Sometimes my stuff's very cartoon-like, like a Warner Bros cartoon or Walt Disney. People compare me to Aubrey Beardsley because my work is black and white. Most of it is about composition, about placing things within an A3 rectangle.

At street level, people think my art is humorous. I'm from a nightclub background, so people associate me with club culture, not so much in a fashion sense as in a decadent sense. The work is sophisticated, but some things are so simple that children like it.

Are you an artist by accident or by intention?

I didn't intend to show in galleries. When I was running a nightclub, I got a sketchbook, drew pictures, photocopied them, put them up. This went on for a couple of years. Then someone from a gallery said, 'I'd like to show some of your flyers and drawings.' I hadn't asked for that to happen. I went along with my sketchbooks and he said, 'Hey, can we frame some of these? We're taking them to an art fair.' They ended up in the Museum of Modern Art in New York. Then he said that he wanted to frame up sixty-five of them and give me an art show. So I did that. When I was drawing those pictures, I didn't think, These

would look great in a white gallery with a grey floor inside a black frame. They were purely for people to look at at the club and maybe laugh.

I hung out with Leigh Bowery, with Derek Jarman, with John Maybury, with different fashion designers in the '80s; they were all informed and cultured people. I got to find out about people like Luis Buñuel. That informed me as a person, and by using those influences I've created sophisticated artworks. I didn't need to go to university to become cultured or educated. I've got no interest in the news; I've never watched television; I don't really read newspapers. I'd rather sit down with a book of short stories or poetry. I'd rather talk to someone. Maybe my work is an expression of modern life in that I am not all that interested in modern life. I don't pursue this as a career. It's all about saying yes.

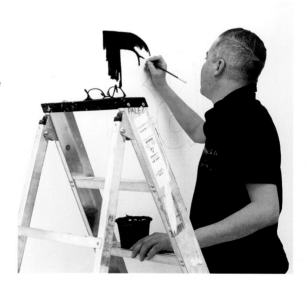

Donald Urquhart (opposite) under an archway in Shoreditch, London, February 2011. Urquhart's working studio is in Scotland.

(above)
A Joan Crawford Alphabet, 2007
Acrylic on canvas
© Donald Urquhart
Courtesy Maureen Paley,
London

Mona Hatoum

As a physical place but also as a concept, what role does the studio play for you?

I don't see the studio as the centre of my activities as an artist. I like to work in many different locations and often turn an invitation for an exhibition abroad into a kind of residency. Instead of shipping a lot of work created in my studio, I prefer to go to the place and make work in the location itself. For instance, I was asked to do a solo show at the Beirut Art Center. I was inspired by the space itself but also by the situation in Beirut, which is where I was born. I spent a week going around looking for things in flea markets and searched for possible fabricators and then went back a few months later and spent a month putting the work together. I tend to do at least one residency of this kind each year. I feel more creative when I am on the move and working in different contexts.

Yet in conversation you make repeated reference to the studio, so clearly it is of some importance to you and your work.

I do have a studio, but I don't spend much time there. I may set up something for an assistant to work on and check in on them once or twice a week, if I am around. On a daily basis, I like to work at home so I always have a private working situation, whether in London or in Berlin. I like to spend most of my time on my own; I don't like to have to deal with people every day, at least not in the morning. I find it very difficult to turn up routinely to the studio on a daily basis, whereas when I'm on one of those residencies, it's a concentrated effort for a short period, working towards a deadline and an exhibition. That makes me work more intuitively. I actually like the temporary aspect of residencies. It always feels like I have to make the most of them because they're not going to last very long.

For instance, in Beirut, coming across buildings still bearing the scars of years of civil war, I was inspired to make a simple grid structure out of stacked rectangular steel tubes. I wanted to have it burnt and cut through with holes to make it look like it had been shelled repeatedly. When I had this idea, I went back to my studio and with my assistant created a life-size model in cardboard to help me decide about the size and proportions. Then I went back to Beirut and worked with a metalworker to realise the piece.

How does the work in your studio relate to your frequent collaborations with highly skilled fabricators or other professionals?

What happens in the studio is mostly either maquettes or trying things out. Whatever is produced there is usually handmade and does not require machinery. Whenever something requires specialised skills, I like to work with professional fabricators. I have been working for the last few years with fabricators called mixedmedia in Berlin; they can make just about anything. They are very good at sourcing and researching the materials I need to use and they help me solve problems, especially when I am using a material in an unorthodox way.

Your work originated with performance, which means that you were largely working on your own. Now it frequently involves other people. How do these two facets of your practice relate to one another?

When I was at the Slade School of Art, I started doing performance and video work. After leaving college, it seemed like a good way of working because I didn't have the means to hire a space for work. My performance work was always improvised and I needed to be resourceful. I worked in this way for a long time, without a space to try things out. I still don't have many assistants; I don't like to be responsible for a community of young people who have to depend on me to organise and manage every day. I'm obsessed with wanting to be free to travel and spend extensive periods working abroad.

Do you make drawings?

Absolutely. I am always carrying notebooks around with me. This is where I make drawings for projects or note down ideas and thoughts. My notebooks are almost like a mobile studio.

While much of your work requires the input of others, are there still instances when you experience the pleasure of making things in a more direct way?

I like to be occupied making things myself all the time, whether it's hair weavings, *frottages* or paper cut-outs. At the moment I am making little knitted and crocheted pieces out of spaghetti and pasta. This is why I get inspired being in places like Mexico City or Venezuela or Cairo; all of these places still function in a pre-industrial way. They come up with simple and inventive solutions for making things by hand.

Even when a work is fabricated by professionals, I am very engaged with the process and keep checking in at every stage to make alterations if needed. In the case of the *Bunker* structures, I was in the metal workshop regularly marking the points where holes, cuts and burns had to be made.

I am very un-methodical and do not have a single way of working. What I like most about being an artist is not knowing where in the world the next exhibition will take me and what kind of work I will be producing for it. I have kept an experimental attitude and like to leave myself open to anything that catches my attention. Each new work is an adventure. I like to surprise myself all the time. This way I don't get bored repeating myself. and hopefully I don't bore other people.

Many of your sculptures recall the formal language of Minimalism. However, while Minimalism is generally associated with a particular industrial aesthetic that purposefully plays down the notion of the human, of the artist's touch, you have repeatedly mentioned your attraction to pre-industrial ways of making. How do these two modes of production inform your work?

I'm fascinated by the Minimalist and industrial aesthetic, geometric constructions, the cube, the grid, repeated modules and fabricated structures that make reference to architecture. In parallel with that, I have always been engaged in making delicate little things that use the craft of weaving, for instance. These are things I either make myself or in collaboration with craftspeople where I am working. Sometimes the industrial and the handmade come together in the same work, as in *Bunker*. This introduces a fragility to the rigour and regimentation of the work's environment.

To go back to your question about performance, I suppose having a proper space can change the way you work. From 1989, for a period of three years, I was Senior Fellow in Fine Arts at the art school in Cardiff, and for the first time I had the use of a big studio. The job entailed teaching one day a week; the rest of the time I was in my studio, a nice big space, and that's when I started making large installations. There were many other reasons for moving away from performance, but the change in my circumstances certainly helped me revert to my natural interest in working with materials and making things.

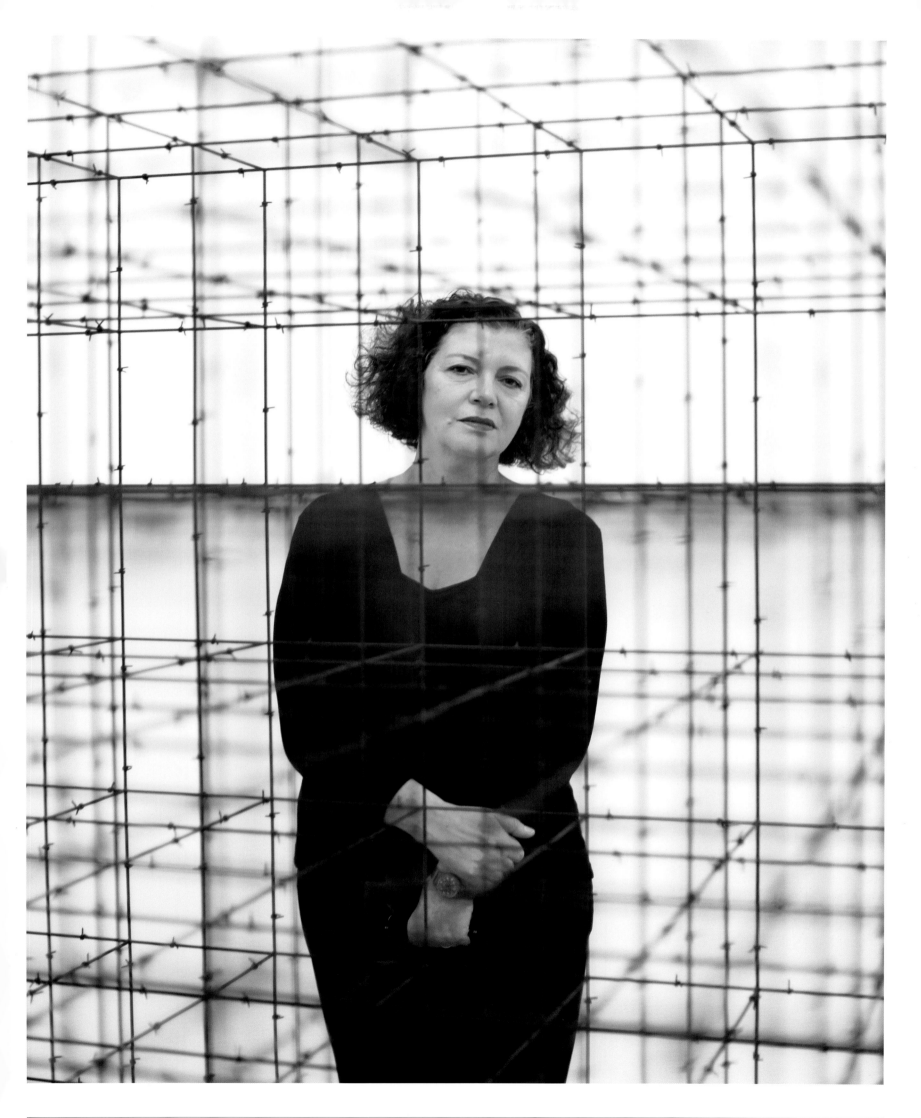

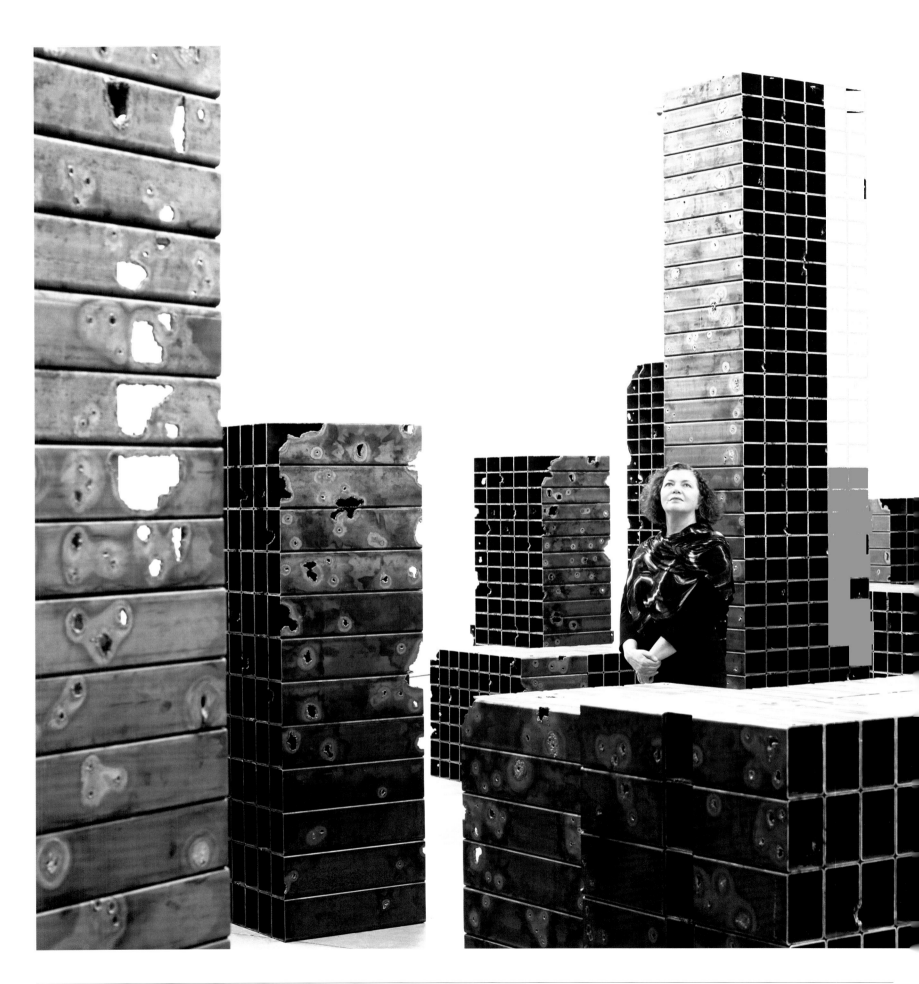

Was it the studio that made possible what was going on in your head already?

I suppose so. It was having the time to concentrate on my work and the space to make it. I had always been interested in working with materials and exploring the phenomenology of forms and space. Having a studio made it possible to get into that again.

Do your studio spaces need to have particular qualities?

Not really, just a lot of light. My studio in Berlin is a shopfront so the whole façade is a large window. I like working in Berlin because it is so much quieter. Sometimes I feel like I exist in a bubble there because I don't speak the language. I have many friends who, like me, spend half their time in Berlin and the other half somewhere else. It's a big city, with all that a big city can offer, but it has the pace of a village and it's nowhere near as crowded as London. Here you feel like you have to struggle against the crowds every-where. As soon as my plane lands in Berlin, I start relaxing. I feel like I have more head-space and more time on my hands. I work well during the day and feel entitled to go out at night and have fun, whereas here it's always work, work, work because you never have enough time. London is always very exciting for short periods – a week, two weeks – to see and do everything you want to do and then extricate yourself from it all and have a quiet time. In Berlin I feel that I have a choice to join in with whatever is happening, or, if I need to concentrate on my work, I can spend days not seeing anyone.

Mona Hatoum (previous page and left) photographed in February 2011 at her London exhibition *Bunker* at White Cube's Mason's Yard in London.

Hatoum (above) at her home in Spitalfields, London. Ordinary household items like cheese graters have featured in her work; an example is *Grater Divide* (2002). 'My favourite way of working on a daily basis is to have a studio as an extension of my kitchen table,' she says. 'I don't have a studio with a lot of machinery and assistants because every work I make may require different skills.'

Gary Hume

Gary Hume (opposite) amongst
the ordinary household
gloss paints he uses in his
work. Hume's largest bronze
sculpture to date (above) over
five metres high punctures
the Suffolk countryside
skyline at Snape Maltings.

**Is art a way of life for you, or is it a core thing?
If you didn't do art, would you feel less than …**
Zero, yes. It would feel like a complete psychological
nightmare. It can be hugely pleasurable, but it's
always anxious, because it's always me. It's not
romantic, it's not a well you can drop your bucket into
and pull it up full. You've got to fight not to lie, and
that takes courage.

Where do you get your inspiration?
The spark of inspiration can come from anything. It's
a pathological need to make things. It's a blessing
and a fault. I have to make things; I have to make
pictures. I will take anything that allows me to make
anything with overwhelming glee; I don't care what
it is or where it comes from. If it allows me to make a
picture from it or of it, I am as happy as a lamb.

**And if you're interrupted in this process of
making?**
It's an absolute nightmare. Life is a series of interrup-
tions. It's one of the things you work with; you can't
be entirely isolated. If a picture isn't working, you're
thinking about why it isn't working, about what you
can do to make that picture work. When you've made
a picture that works, it's like your kids have grown
up and they've done okay. But with the kid who's
troublesome, you think about it all the time. You don't
think, I've been a great parent; you think, what have
I done wrong?

For how long do you think about it?
Until it's right. That could be two seconds or two
years, or it never gets right and I strip the whole
painting and it gets thrown away.

**Is this element of doubt a process of self-
correction aspiring to perfection?**
I'm just doing the best I can. I'm not doubting all the
time, I'm desiring all the time, seeking something
that is beautiful … a beautiful thing.

Do you care how others feel about your work?
I care 100 per cent and am utterly hurt and mystified
if people don't like it. But I have to force myself not to
think about it because I've got no choice. It's not like if
I do this and you don't like it, I could do something else
– I don't have a choice. I worry that if I take people
on board who don't like my work, I'll disintegrate. I
mustn't disintegrate – that would be the end of my art.
 When you are in a studio, even though things
aren't working, you feel that your eyes are alive, and
you start to trust what you see. That world becomes
a real world. When you come in with your eyes skip-
ping over things, your eyes can be distracting for my
eyes. When you leave, I'm going to have to sweep
your eyes out because this isn't an exhibition. This
is my place.

Is the studio your sanctuary?
I don't feel safe here, but it's absolutely my place.

Then is your studio almost a castle?
No. It's where I try to be free. It's the place to
be liberated.

**Has each of your studios moulded you in
different ways?**
Not really. Each studio has come at a different point
in my life, so each one has had a very different vibe.
When I had a studio in my twenties, it was friends,
drink, drugs, parties. Now I'm in my late forties, it's
me and occasionally a glass of red wine at the end of
the day – and watching the light go and looking at
some pictures. It's about different periods, not really
about the studio. I have a studio in America as well.
You think, Oh my God, all the work will change, but
in fact you go there with yourself.

**Yours is one of the most jam-packed studios
we've seen in terms of artwork. Have you
always liked to work simultaneously on
different paintings?**
Yeah. Some paintings can take a long time to make
My concentration is all over the place.

**How does that work? Does it give you a god-like
feeling?**
Absolutely not. I go from one painting to the next. I'm
not supported by my last painting, I'm distressed by
the current painting, so there's no sitting back on my
laurels and saying, 'How marvellous!' I like people
saying nice things, but I don't believe them.

**So if somebody pays actual money for your
work, you don't believe they're doing it?**
I believe they're doing it, and I'm pleased it's me
and not someone else, but it doesn't make me feel
like I could posture and say, 'Welcome to my studio.'
That's impossible.

**You've been quoted as saying that you think
that shocking art is just there to shock …**
Most shocking art is not shocking. It's just stuff
that's less shocking than the real stuff in the world.
What I was saying was that there was a vogue for it.
When I saw subject matter that could be regarded
as shocking and I could have made a painting of

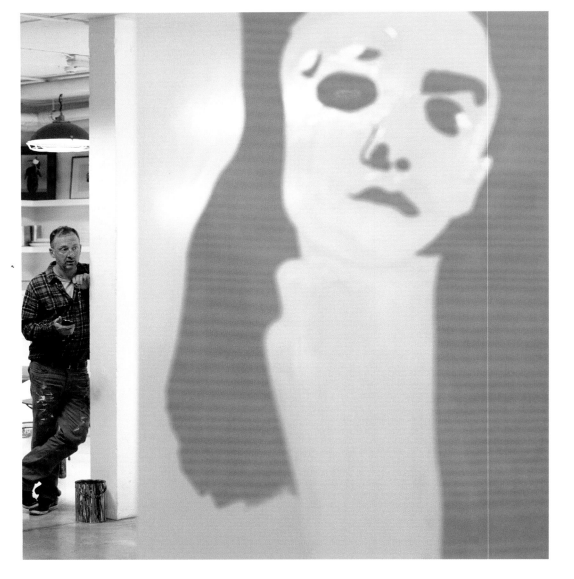

Artist and artworks at play
and on display in Hume's
large purpose-built studio.
Hume often likes to sit on a
chair and watch his artwork
in the solitude of the studio.

that shocking thing, I chose not to. I didn't want to
do it because that's the easy way to make my work
serious, and I didn't want my work to be serious like
that. I wanted my work to hurt you like your lover
leaving you hurts you.

Not to please me?
I also want to please you, like your lover wanting
to fuck you. I don't want to hurt you like the story I
heard on the radio this morning about a woman in
the Congo having her lips and nose and ears chopped
off by a boy ... that just makes me want to vomit. I
don't want to hurt you like that. I want to hurt you
because you're broken-hearted.

Are you a romantic?
Yeah.

And are you searching for the Sublime?
Absolutely. If the Sublime is the moment of rest, then
painting a picture that puts you at rest is extremely
gorgeous.

**What does it mean to say that art is not about
concrete affirmation?**
I don't really know when I'm making art. I don't have
a theoretical framework in which to work. I have an
instinctive flailing about. As I'm moving about in this
instinctive desire, I make stuff.

Is it an instinctive desire or a storm of ideas?
It's not a storm because a storm would make you
think that it's just fantastic, with gushing wind and
rain coming from all directions. It's more like digging
through fresh air.

**Did your art education contribute to your being
where you are now?**
Well, it was very theoretical, or it very much enjoyed
the theoretical. I have intellect, I like to think, so
things that make one think I find interesting. I'm not
as good at that as I am at following my instincts.

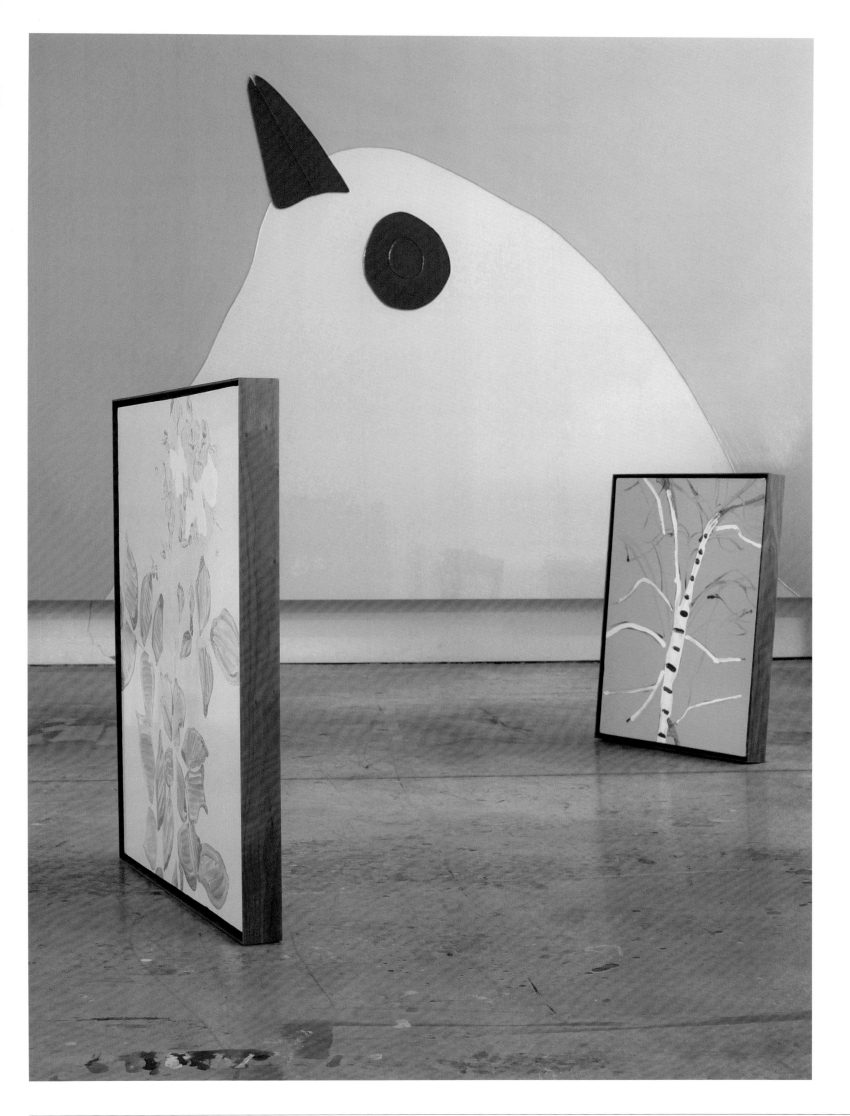

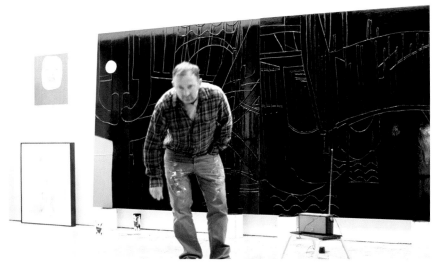

Hume in his studio in Clerkenwell, London, in March 2011. Unlike some artists, Hume has all of his work on display across his cavernous purpose-built studio. 'I'm not doubting all the time, I'm desiring all the time, seeking something that is beautiful.'

You've talked about enjoying and critiquing other people's art. Are there particular artists who interest you?

I've just been to Vienna; I went and had a look at the Klimts. Which is embarrassing, because of course Klimt is the artist you look at on your first day of drawing. It gave me great pleasure; it also gave me great anxiety. Klimt is interesting. It looks like 70 per cent of Vienna's income comes from Klimt. That's incredible, but it's separate from the art. It's also interesting to see what was going on at the same time as Klimt was making work and someone else was making something so different.

Your art is so joyful in a simplistic way, almost a reflection of a satisfied soul ...

I'm happy for you. But you can't separate your emotional state and your intellectual state. That's why when you look at something in a sentimental way, you're bored; you don't have the truth of an emotion that embraces an intellectual self as well. Intellect without emotion – you've just got cold theory. You'll end up with eugenics or something. So they've got to work together.

Is there no sentimentality in your art?

I do my best, but I can't promise that it's not there.

Where are you heading in your work?

I'm doing paintings on top of drawings, and I'm doing quick paintings on cardboard. I'm fighting to have the next twenty-five years of my life be as interesting as the last twenty-five years of my life. Trying to make some room. Some of it might be rubbish, but I've got to stick my elbows out.

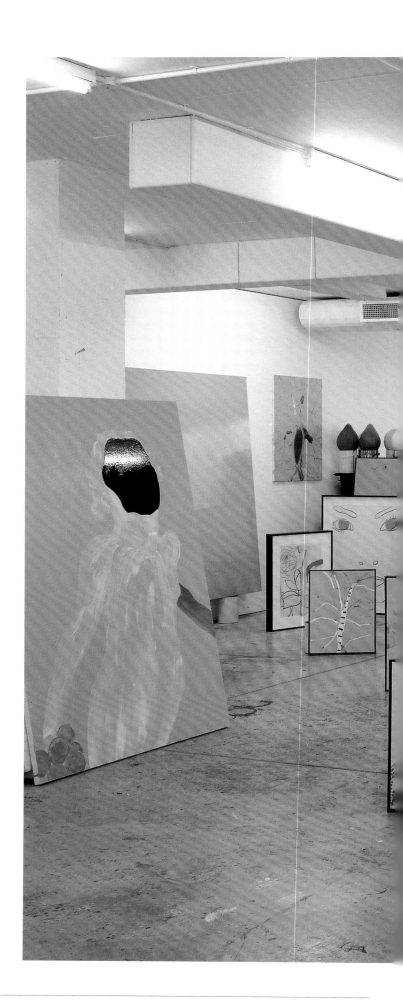

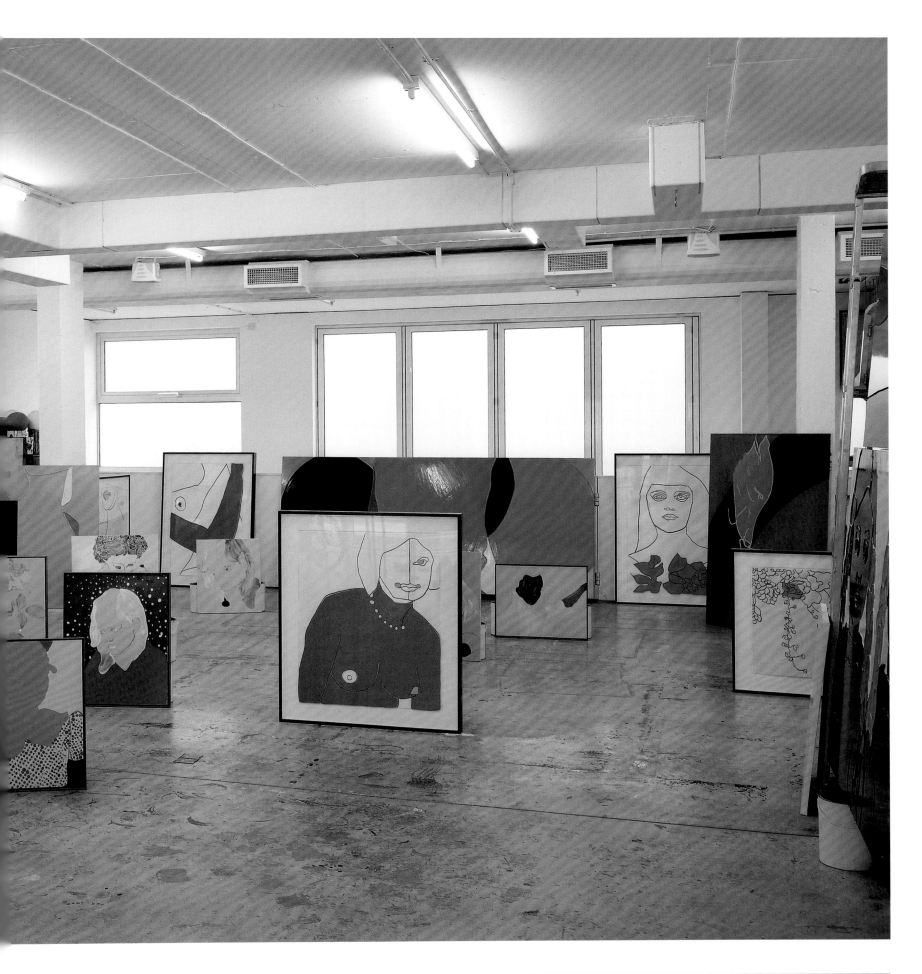

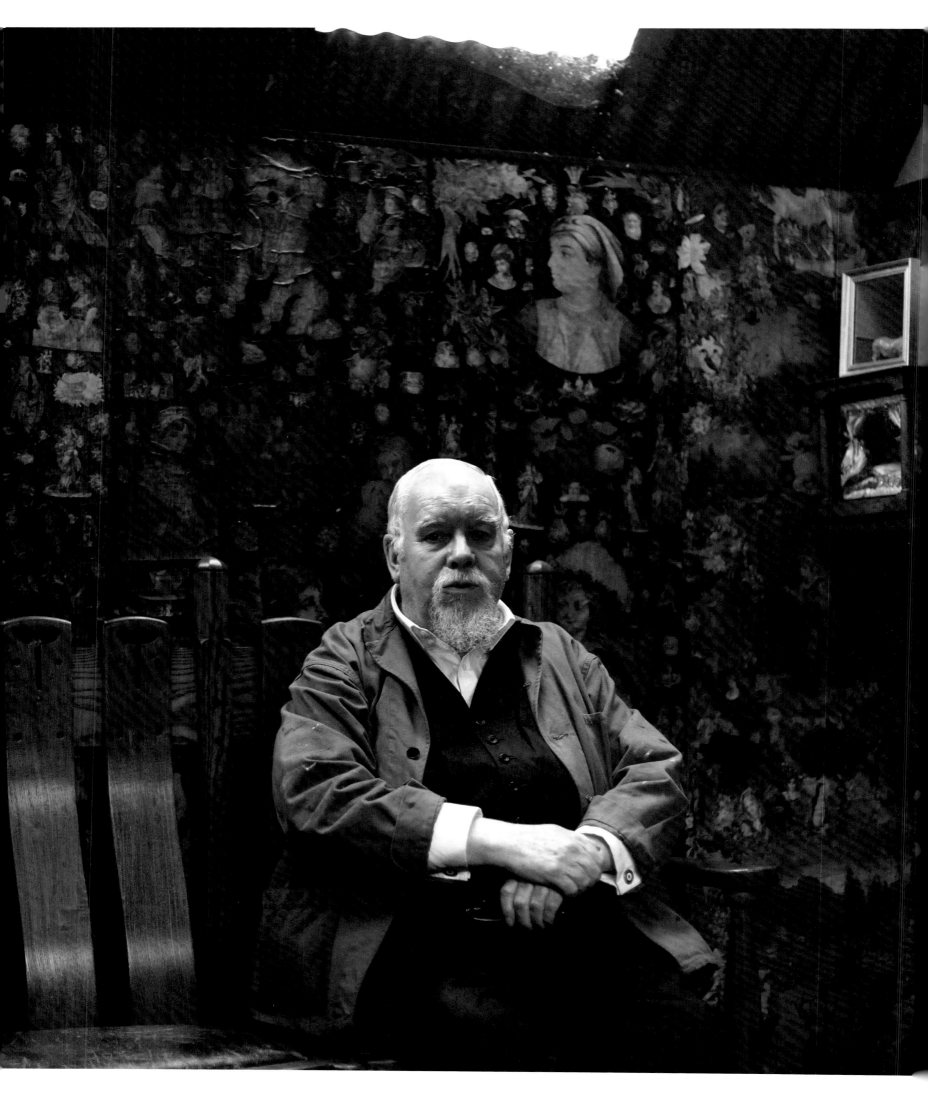

Sir Peter Blake

Why do artists choose London, or England, as a base these days?
There's been a good tradition since the end of the war, going through people like Bacon and Lucian Freud and Ben Nicholson to Pop art and the Young British Artists. I suppose a lot of young artists were encouraged to take up art.

In the post-war stages you describe, which was your favourite period?
Pop art, because I was part of it. We played a game at one point, plotting parallels between Pop art and the YBAs. You've got Robert Fraser as the main dealer and Jay Jopling now. With the bands, you had the Beatles and the Stones and the Who, and with the YBAs you had Pulp, Blur and Oasis.

You've mentioned Damien Hirst as being a genius. Is he a marketing genius or an artistic genius?
Both, I think – like Picasso. What Damien does that people don't understand is that he's interested in money per se, not in making money but in the phenomenon of wealth and what it can do to people. Things like the diamond-encrusted skull are about the grotesqueness of wealth. So he's not interested to be very rich himself but in the phenomena of wealth and power.

Isn't any artist fundamentally interested in issues of wealth and power?
I'm not.

In your own days, in the 1960s, were you just having fun?
No. I'd been evacuated during the war, and I went to art school in 1946 at the age of fourteen. It was a generation that before the war wouldn't have gone to art school, but with grants from the Labour government and encouragement, a lot of people went to art school that wouldn't have been able to before. So you've got a generation that brought a different class to art. In painting you've got someone like myself and David Hockney, who were from working-class families, and in photography you've got David Bailey and that generation, and with actors you've got people like Michael Caine and Terence Stamp. A different social class was prescribing culture. I'd been to football matches as a kid, I'd been to professional wrestling, to the speedway … I was pretty uneducated. I brought some of that to painting. I suppose someone like Sickert was from the working class and painted working-class phenomena, but you didn't get a whole group of people.

Were you the precursor of the YBAs?
People for a long time didn't give any credit to British Pop art. They assumed that Pop was an American phenomenon, whereas a lot of things actually happened here first. Now it's getting the credit. For example, I painted a series incorporating comic books before Lichtenstein did, and I made a wooden box before Warhol did.

Could artists do without business?
I couldn't. I'm a professional. I could make the art, but I couldn't live if I didn't earn money from the art I make. I didn't have family money.

Were the YBAs an artistic phenomenon or a marketing phenomenon?
Both. That's why Damien's so interesting. He changed the rules of art and business. I think when it goes wrong it's like football: there's a scale of values, and certain pictures are worth a certain amount. When you get Warhol's pictures going for as much as they are going for at auction, I think something's wrong. Something's gone wrong with the natural phenomenon of a scale of values. Some people are overpriced – perhaps Jeff Koons. There's more money involved than there should be.

Which money drives taste or directs the next wave of art?
Money in auction rooms, that phenomenon of processing and collecting, the big thing that went terribly wrong in the '80s, when the Japanese were bidding against each other for people like Van Gogh; you got extraordinary, inflated prices because pride was involved. In some cases I believe they didn't then buy them; it was just a thing that happened in the saleroom, in order not to lose face. It's happening now, I imagine, with Chinese buyers buying Chinese art. There're a lot of young Chinese artists who aren't particularly good but who have become incredibly famous and rich and perhaps shouldn't be.

You're clearly a collector yourself. How did that start?
It was really specific. An exhibition at the Museum of Everything in a way was the culmination of my collecting, although I'm now working on another exhibition which continues the idea of collecting but has more of my own work in it. But it started … it was deprivation, I guess. I was seven when the war started. As I was evacuated, I missed that bit of childhood; I didn't have any toys or anything. I tried to demonstrate at the Museum of Everything that by the age of fourteen I'd bought three objects:

a painting of the *Queen Mary*, a papier-mâché tray and a set of Shakespeare which gave me an instant library. It went from there.

How much do you think a collector believes in what he buys?

It depends. I asked Leslie Waddington not to sell my work to Charles Saatchi because I didn't feel he was a collector. I felt he was a dealer, and he was dealing in a kind of subversive way. He bought out Julian Schnabel's first show. So suddenly they all went up in value. Saatchi sat on them for a while and then sold them off for more money. Then there are collectors who are after trophies. And then you get collectors like me who just see something they love and try to acquire it.

Are you looking for anything in particular?

I'd like to have a picture by Alfred Wallis. I'd like to have a little watercolour by Gwen John.

And the value these objects have is nostalgic, sentimental, intrinsic. Which comes first?

Aesthetic values. And sometimes something – a Hockney drawing from the early '60s – becomes more valuable than it was, but at the time we just exchanged drawings.

Are you in touch with Hockney?

He's a good friend. I'm very fond of him.

Which other artist has an important place in your heart from the period you've been speaking about?

Lucian Freud's early work I admire enormously. Kitaj I was very close to and feel very sad that he needed to commit suicide. I was quite friendly with Howard Hodgkin but our paths separated. I would say that Damien was a friend, and Tracey Emin, but our paths separated as well.

In the realm of contemporary British art, who would you hold up as an iconic influence?

At the moment, Damien, if I had to choose a single person.

And of your contemporaries?

Lucian Freud. I don't think I've been influenced by Hockney or Kitaj. I've had very few influences, really. In America it would have been that group just after the war. They painted a kind of Surrealism that was very figurative. For instance, Ben Shahn did a painting called *Pretty Girl Milking a Cow*; I think it was simply a man sitting on a bank, and you thought, Why is it called that? You realised that he was playing a mouth organ; he was playing the tune 'Pretty Girl Milking a Cow'. It's not melting watches, it's not overt Surrealism, but you get storytelling that becomes surrealistic. That was a big influence. Then Stanley Spencer, the English artist, and the young Lucian Freud.

What story does your art tell, with hindsight?

If the question is: 'What's the purpose of your art?', I would say to make magic, to make something that can only be made through painting, but in a way that's become obsolete because you can pretty much make anything now on a computer.

Which makes painting redundant?

No, it makes one element of painting redundant.

How many elements are there in a good painting?

It's like anything. If you make a piece of furniture, it started as a tree, and to get to a piece of furniture you're cutting it and sticking it together, making something with it. Painting is the same. You're starting with this piece of white canvas, with pigment, with these silly sticks with hairs on the end, and with these things you can make something happen. It becomes decoration. It's like cavemen decorating their caves: it's something to hang on a wall and enhance your life. For me it's not political or anything like that. In the long run, I tell stories, I make magic.

If you could take one work of yours with you to the other side, what would it be?

That would change all the time. I have to twist the question to: 'Which are the key paintings?' The key

painting would be *Self-portrait with Badges*. It won a prize in the John Moores Art Competition, and it was 1961, which was a key year. The following year Ken Russell made a film called *Pop Goes the Easel*; the *Sunday Times* had its first colour supplement, and I was featured.

What makes you tick when you wake up in the morning?

When I woke up today, it was just about seeing how bad my knees were … When I came in here on Thursday to make a piece for charity, I could hardly walk. What kicks in is that I love doing it. This picture I have on the easel is one I've been commissioned to do by the Knight Bachelors, which is the grade of knight I am. They have a chapel in St Paul's Cathedral, and I've been commissioned to make this painting to go in the chapel. It's the first painting to be commissioned by St Paul's since *The Light of the World* by Holman Hunt. That's really exciting.

What do you think of as the ultimate recognition?

They vary. I had a vague list of ambitions, some of which I've achieved, some of which I won't. When I was younger, I thought I might have been chosen for the Venice Biennale; that would have been an achievement. Now I realise I won't be, but it's not important.

If you could have it all over again, would you do it differently?

I shot myself in the foot quite severely twice, so I'm not sure whether I'd do that again. The first time was when I was in a show in New York in 1961, at Sidney Janis Gallery. Although Pop art was happening, it wasn't a Pop show; it was a British–American realist show. I got vicious reviews from the critics, and when I came back to London I vowed I would never, ever show in New York, so for fifty years I turned down shows there. Then a gallery called Paul Morris asked whether I'd have a little show. I thought about it. I thought, It's a long time ago; why are you still angry? Probably most of those critics are dead anyway. But it was a very strange, modest little show. I made a group of little paintings of lady wrestlers, and I made a group of eight works called *Appropriating Jack Pearson*, and a single portrait of my wife and my baby daughter. So it was like three different people showing.

Does art make any difference?

Only in the sense that it enhances life. If you live in a house with nice, comfortable furniture and some good pictures, it adds to the quality of living. If no-one had ever thought of doing it, you'd probably get by without it.

Do you have any regrets?

Not now.

Sir Peter Blake (previous spread) photographed in his Hammersmith, London, studio in February 2011. The studio, a former Georgian stable, served as a builder's yard and garage for horse-drawn buses during the First World War. Blake's collection of objects placed higgledy-piggledy across this rambling space is famous as a 'museum of everything'. In creating it, he was mostly inspired by childhood deprivation: 'I was seven when the [Second World] war started. As I was evacuated, I missed that bit of childhood; I didn't have any toys or anything.'

The old Remington typewriter (opposite) will be used when Blake eventually gets around to writing his memoirs.

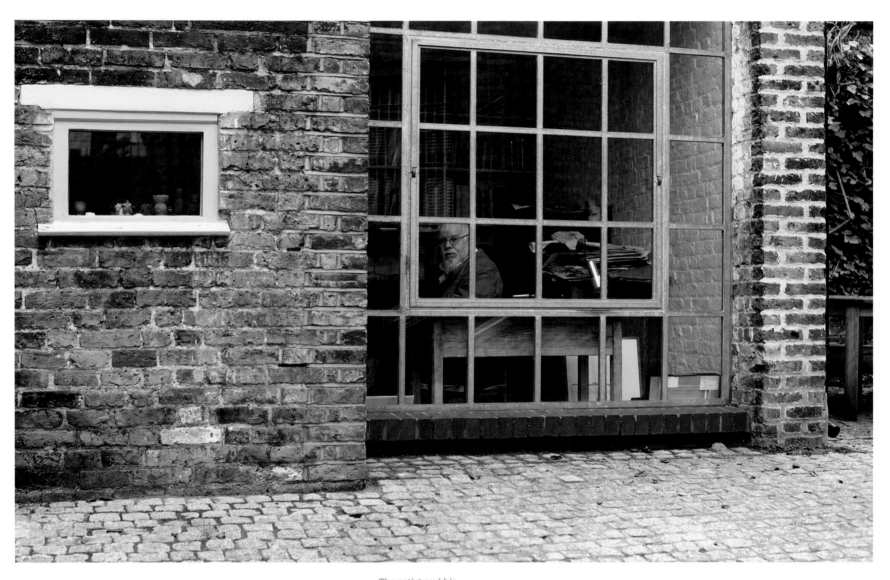

The artist and his
commission. Blake spied
through the window of
his studio finishing a new
painting commission for the
Knight's Bachelors Chapel in
St Paul's Cathedral. Different
rooms (left) are dedicated to
different periods, memories
and themes.

Sean Scully

It's been said that looking at work by Mark Rothko made you an overnight convert to abstract painting. Is that true?

What actually happened was that I started off as a figure painter, which I liked very much. I gradually moved towards abstraction; I had a love affair with German Expressionism, which leads directly to Abstract Expressionism. It's a continuation of a move towards the Sublime or the metaphysical. It wasn't that I was converted by Rothko; I'd already moved in that direction. Somebody gave me the catalogue from the Whitechapel Rothko show because they saw that I had a preference for it. Otherwise there would've been no reason to give me the catalogue. That's the truth. It's been slightly dramatised over the years for journalistic effect.

This dramatisation that surrounds contemporary art – has it always been so, do you think?

Journalists need dramatisation, and the artist can't say everything, so they have to say something with drama to make it readable. There's been a lot written on me; my life has been an interesting story, which of course is important, particularly with abstraction, because people need something to hang it all on. They want to pump it up, exaggerate it.

Do you think art is a process of cumulative imitation?

No. I think painting is poetry, music. It's a language. And when that language is forgotten or unsupported, it will die as language does. Spoken, visual, musical – all language needs to be current. It needs to have cultural importance. That is the reason I went to New York: I wanted to go to the place where the art that I was most interested in was treated as important.

That said, all artists imitate when they're young. You gradually, hopefully, find something that is somewhat original. It's paraphrasing with the possibility of originality.

When was the moment when you passed imitation?

I don't think it was a moment. In fact I made some work in '74 when I was in London that I now think is very original, but I didn't realise it then. Some of the paintings I did in '74 look like paintings being made now; they look a bit like computer paintings. But at the time I didn't realise what I had. My moment of, let's say, notoriety came in 1981, when I made a painting called *Backs and fronts* that was shown in New York. It showed a high degree of originality in relation to Minimalism. I imitated Minimalism when I was in New York, and then I was able to do the next thing: critique Minimalism, find something wrong with it. All artists are in a sense corrective of the generation before.

You've talked about emotionality and romance in your art. How do you incorporate them, marry them up with abstraction?

I'm trying to do something that is rarefied or austere, but at the same time I want to popularise it. I don't want to vulgarise it; I want to make it realise its potential for communication, not just reverence. That is of course the contradiction. A lot of good art is based on contradiction. My closest ally in this would be Arvo Pärt. His work is influenced by Minimalism but informed by deep, mystical romanticism. I tend to muddle up the repetition and formality of Minimalism, the toughness of it, with Romantic painting while also making reference to Quattrocento colour, making reference to landscape, giving my works titles such as *Outback* (thinking about Australia) and *Desert Night* (thinking about the desert around Nevada). Giving my paintings a kind of grounding in culture or place against this idea of serialised thinking and repeating structures. And then there's the colour, which makes reference to night, to landscape, to figures, to nature – all in a kind of confrontation with computer language.

Someone compared my work, very intelligently I must say, to Lego. The paintings do look banal. They are completely connected to the contemporary world in that sense. The way things are turned around and reconfigured to make a new product, for example, a new physics, a new structure. But they're painted in a way that people painted in history. I'm bringing history forward into a contemporary matrix, which is very much what Pärt does. I have respect for Minimalism, but I find it slightly fascistic.

Is there spirituality in your work?

I'm looking for a new kind of religious feeling without the tragedy of dogma and all the grief it's brought us. All the wars, all the rules, all the regulations. I'm looking for a self-affirming, self-involving, open-ended structure that people can use without being told what to do.

Religion has, to a very large degree, in our society, been replaced by art. It's where we can all come together. That's why museums now have such cultural power. They are cathedrals. You can put a museum up in any shitty old town and afterwards that town will be something. You used to be able to do that with churches, but you can't any more.

Museums are where people go to enter this arena of human experimentation. Art is deeply important, more important than politics, because culture is more important than what's stuck on top. What's stuck on top will fall off eventually; what's underneath decides what happens on top. You see it happening all over the world. People stay in power, but the culture underneath them eventually will remove them.

Art is part of that argument. Art is the evolution of human society. People now understand that in a way they didn't when I was young. Human beings need spirituality … it's a fundamental hunger. We're not meant to live in a communist matrix where everything is fair and efficient. We like the inefficient and we like the unfair. We like the romance of things.

'I think painting is poetry, music. It's a language. And when that language is forgotten or unsupported, it will die as language does.' Sean Scully in his studio in Mooseurach, a village near Munich, photographed in February 2011.

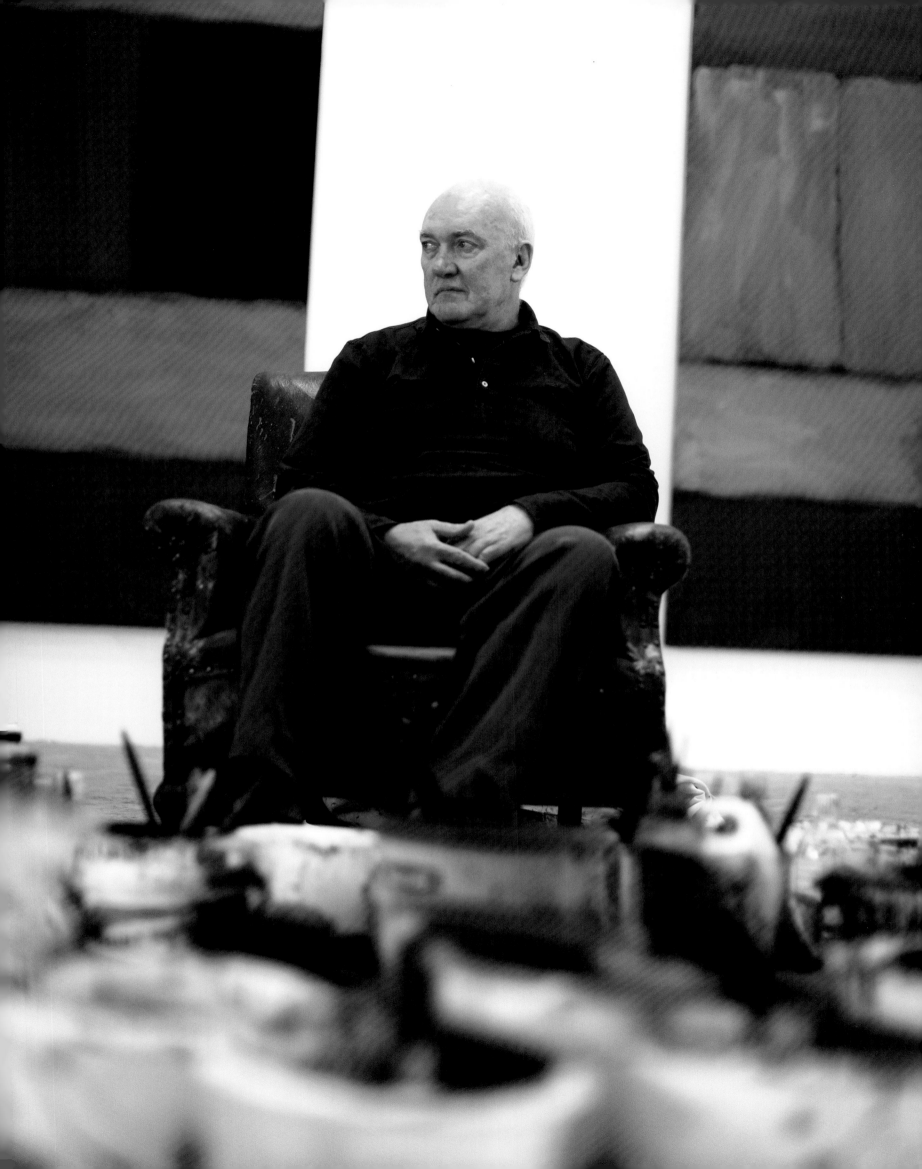

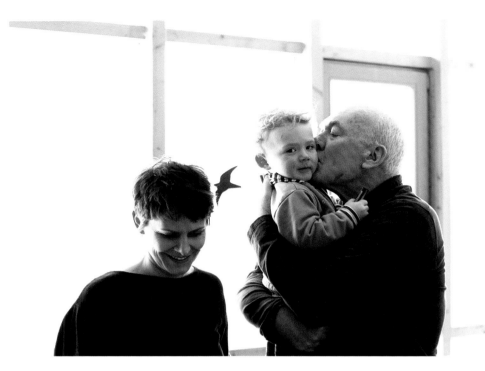

Going back to religiosity and art: does art-speak make sense? Is it like Latin, just for the priests, the critics, who need convoluted speech?

Priests and monks stand in a well of intellectualism. Most people can't understand what the hell they're talking about most of the time. They are talking in Latin, but we somehow respect it. We respect its mysticism. You might not be able to understand, but you can feel it Art writing is interesting because it's close to philosophy. Do people have to read art criticism? Well, no, but if you go to the opera and you don't know anything about music, you might as well be waiting for a bus.

What I'm trying to do is iconoclastic. I'm trying to mix up spiritual roots and structures. I did karate for a while, which includes the practice of Zen Buddhist meditation. Mexico of course is very Catholic, but Catholic in a way that's mixed up with the Indians. It ends up with this pagan Catholicism that's fascinating to me. So earthbound. Islam is interesting because they never show the face of God. It's the most recent religion and it's the most abstract visually. This fascinates me.

Making it all seamless is another matter. There's always a difficulty in joining up these arguments, and that's part of the fascination, of course. I think it was Mallarmé who said, 'That which is to be loved, must be mysterious.' In my work there's definitely mystery, not just in the painting but in the thinking, in this confrontation between the structure and the emotion that I myself am unable to resolve.

Your art is powerful. The voice that you project is powerful.

Yeah, but painters are extremely sensitive. The colours are dark – they're influenced by darkness, by shadow – they're weak on occasion, pale. There are no simple colours in my work, so in that sense they're completely un-fascistic. The Fascists, who understood geometry and its power to organise people, as well as the importance of the visual, used colours such as black, white and red. In my work there are no whites, no reds. Colours are always subverted by the colours underneath, so when you're looking at something you're never quite sure what you're looking at. The edges are intimately painted. The relationship between the concrete and the massive and the intimate hasn't been done before in painting.

Are you trying to say that life isn't black and white? But people need a little direction to survive …

Well, they won't get it from my work. For that they can go to Minimalism.

Do you care what they will think of you a hundred years down the line?

I'm sure that my work will be shown, and I'm sure it will hold people's attention like it does now. There's not much revisionism in art history. Most artists who are famous now were famous then. Art history doesn't get turned upside down.

So you don't think painters are too powerful?

No, I don't think they're powerful enough. I think war is too powerful. The arms industry is too powerful. I was thinking about this yesterday. The rush towards certainty, which can lead to situations like Iraq, is to my mind very weak. It doesn't denote strength, it denotes weakness. Insecurity. A lack of intellectual patience or profundity. Fascism plays with that, doesn't it? It recruits people. Radicalisation recruits people and offers them certainty. What I have is uncertainty

When you paint, are there emotions coursing through your veins?

Yeah, a lot. That's how the paintings get hammered out. When I make a painting, I have no clue how it is going to end up. I'm responding to something and then the painting moves in a certain way. It also depends on how I am that day. I'm always looking for a place, an arrival, without closing down the possibility of renewal. It's an endless search for some kind of harmony, some sense of beauty, some sense of truth, but not something authoritarian.

So it doesn't matter whether anyone likes your art or not?

If people like it or it means something to them, that's great. If it doesn't then it doesn't. I offer what I offer. Otherwise it wouldn't have any definition. It has to be identifiable.

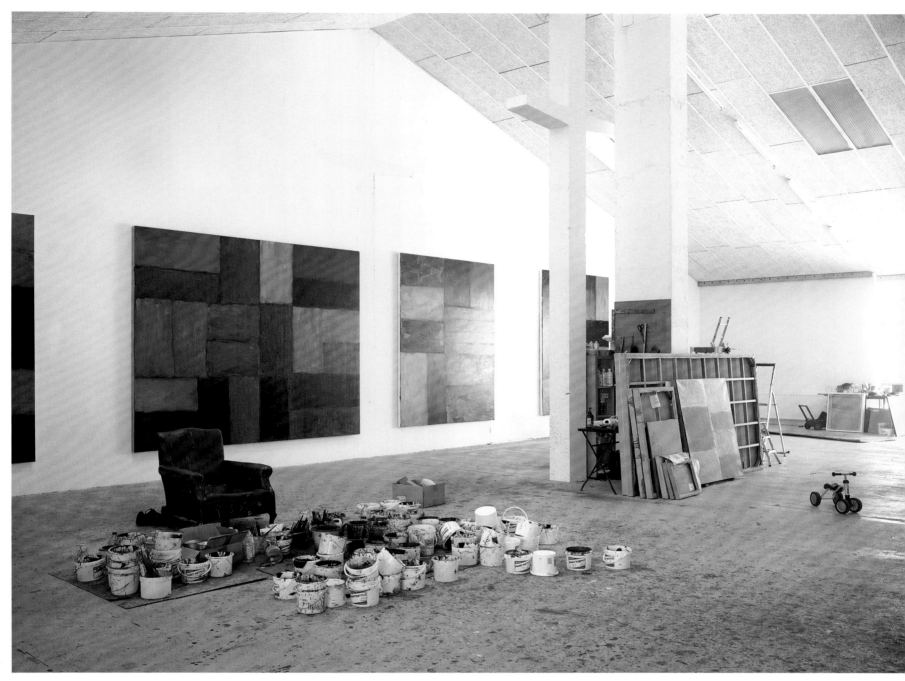

The artist (opposite) with his wife, Swiss artist Liliane Tomasko, and son Oisin. Scully's studio is a converted building in a picturesque Bavarian village where he lives and works when he's not painting in his Barcelona or New York studios. One of the large painting rooms (above) where finished and half-finished paintings hang on the walls, paint tins intermingling with a toddler's three-wheeler.

You've said, 'I've spent my life making the melancholic into something irresistible.'
Yeah. You're trying to convert pain into something else … into light. And that is a very interesting human capacity.

It's what the Christian tradition is predicated upon, perhaps …
I wouldn't tie it to the Christian religion. All religions, all spiritualities, are connected by the same desire. It's just branded differently.

You use the word branded. Damien Hirst is a brand, isn't he?
I'm a brand just as much as he's a brand. I put my stamp on culture. That's how culture works.

Could one claim that some contemporary art is a bit of a con?
No. I think all artists make the art that they have to make, and some art will stand the test of time and some will not. For example, Edwin Landseer painted one of the most expensive paintings of the nineteenth century, a time when people were obsessed with animals: *Monarch of the Glen*. People paid massive amounts for paintings like that in the nineteenth

century, and now we look at them and say, 'They're not that interesting to us.' Because the stag doesn't signify the same thing it did to the people of the nineteenth century. We don't think of it as a monarch, we think of it as a put-upon creature that we have to protect. We have different problems, so that symbol doesn't work for us. So for us the painting by Landseer is an honourable one, but it's not what it was. Things change, and people who are on everyone's lips today will not be so in the future. That's the way it goes.

How long does it take you to produce one of your big canvases?
Some of my best paintings I've made in four hours. Because when I paint I go nuts. Then when I finish I can hardly stand. But then with others I go back into them, so they can take six months. A smaller painting took me two years. But if I can get it in one go, like that big dark red painting … that was painted in four hours.

What made you choose to work in Munich?
I never actually choose anywhere. I am like a dog; I'm very passive. I had a show here, then a friend introduced me to a gallery, and the Academy asked me to teach. I said no a few times and then I said yes. Then I got a space here. That's how I do everything. My

friends direct me. In Barcelona this gallery wrote and asked if I would like to work with them. I said, 'Okay.' I was making prints one day and I was in this big, dark room and I said to the guy, 'This is a great room; I wouldn't mind having a room like this.' The next day when I arrive, he says, 'That room there, on the other side, is free. You can rent that.' So I rented it, and then I had an apartment and a studio in Barcelona. I don't really decide about anything. The only thing I'm not passive about is art. Then I'm really not passive. But now I want to be in Munich because of my son.

He's your first child?
No, he's my second child. My first child died. When I had a press conference in Ludwigshafen at the Wihelm-Hack-Museum for an exhibition of my '80s paintings, somebody asked me about the colour in my work. The darkness. Someone said, 'Your paintings all seem as if they have some soul in them.' And then: 'Is it because you lost your son?' And … everything stopped. Including me. I became speechless. Consumed by sadness. And then everybody was uncomfortable and there was a long, long silence. It's as if this woman touched me and I began to bleed. That was the end of the press conference.

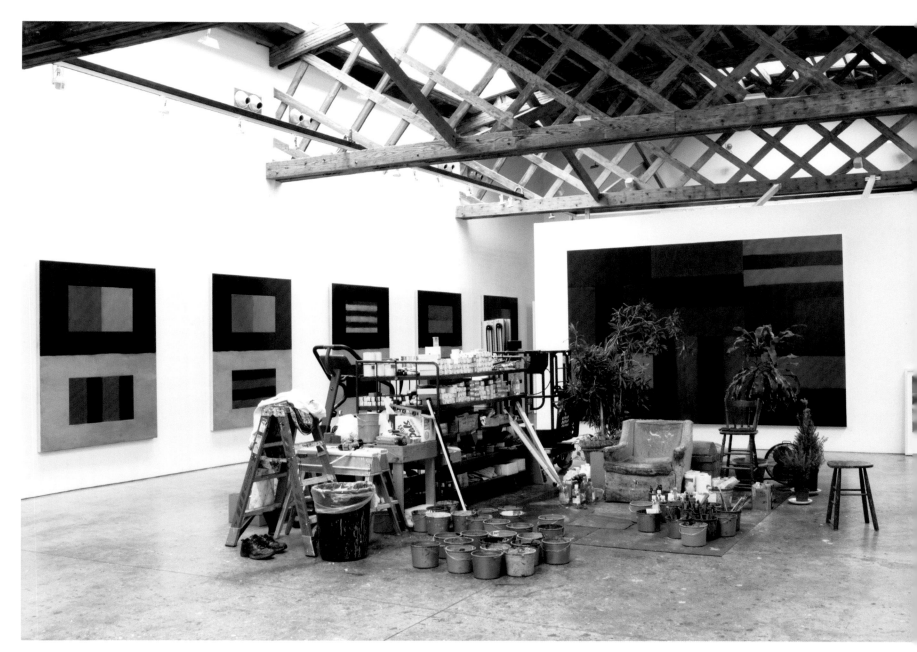

The artist (opposite) pictured in May 2011 in front of his studio in Chelsea, New York. In the studio's main work area (above) a worn armchair is a comforting reminder of the studio he has left behind in Munich. Although his studios resemble each other spatially, Scully believes that good art is based on contradictions. 'Art,' he says, 'is deeply important, more important than politics, because culture is more important than what's stuck on top.'

Is photography self-reflection?

All art is about the ideas that go into the making, not just what the work seemingly deals with. So there is always an element of self-reflection, however deliberate or non-deliberate.

Do you care whether your work is thought of as art or not?

No, because everything I do takes place within a cultural context. When that cultural context is not there, what I do *maybe* has no meaning. That is something I cannot change, the fact that for some people, some animals or some stones, my work has no meaning. I of course am interested in the development of culture at large, how society deals with questions of what art is acceptable. The way the Smithsonian Institution pulled work by David Wojnarowicz out of an exhibition, censored an artist because some Catholic extremists protested against it – that I do care about. But I do not care whether people think my things are art or not.

Is the studio reflective of the mind of the artist?

Answering a question like this with 'yes' or 'no' would be terribly simplistic and would also sound self-assured. Which maybe is the gesture you're expecting, my saying, 'Yes, my studio is my empire, and it is a mirror of my self, and it is my creation.' That is something that I find so totally uninteresting, and so clichéd. It is not for me to say what is my mind and what isn't. For me to be the judge of how tuned the equivalences are between inner and outer would seem very immodest.

Artists are never modest!

That is another traditional assumption. 'Never modest' is completely wrong. All good artists – I'm generalising – have to have a certain sense of modesty somewhere inside them. Or let me say that all artists who touch me personally, or who move me, or whom I like, have a sense of humility. Everything else is boring. I find nothing more boring than people who are too self-assured. Because they are not open to the secret and unexpected ingredients of life.

You've mentioned that you work within a specific cultural context. Would you care to elaborate?

I start with the fact that outside of us, outside of this room, there is no art. There is no art in nature. Art only exists in a dialogue between humans, and has been built through a tradition of 20,000 years. Without others there is no art. That means the hundreds of other artists whom one has to understand as contemporaries who lived in another age. And now, of course. At this moment, there are different art conceptions, and I can't necessarily connect with all of them. I am aware that I am in a Western, modern tradition.

Is there any relevance to art in people's everyday lives?

Yes. I was in Madrid yesterday, seeing all these visitors in the museums and in the city, and thinking that many of them obviously do not go to museums regularly. When you go somewhere, what is left is culture. You look at artefacts; what is left of culture is artefacts. So the value of art is obviously enormous. And it is really, in the end, the only thing that's left

The reason why art is so relevant is that it's a field where aimless research can be done. Because almost every corner of society is economised, is economical, has economic purpose and has to be result-oriented. Art is one place where no result is envisaged. Graphic design, advertising, professional design and a lot of architecture are all about designing things, usually with a purpose. That purpose has to be plan-able, and the result has to be plan-able. So by its very nature it cannot be aimless. It cannot be free. Art comes of, usually, a one-man activity that can happen in a very small way without any studio and assistants. Or it can be happening in a fifty-assistant studio, but that's the choice of the artist. People have realised that not everything has to be about money, and there is a certain freedom that art has preserved. I like the fact that art is useless!

Are there mornings when you don't want to get up?

I'm fortunate in that I don't suffer from life. I have a positive outlook: I'm excited to see the weather, to smell the air – excited by my senses. I embrace life, and that's what makes me tick.

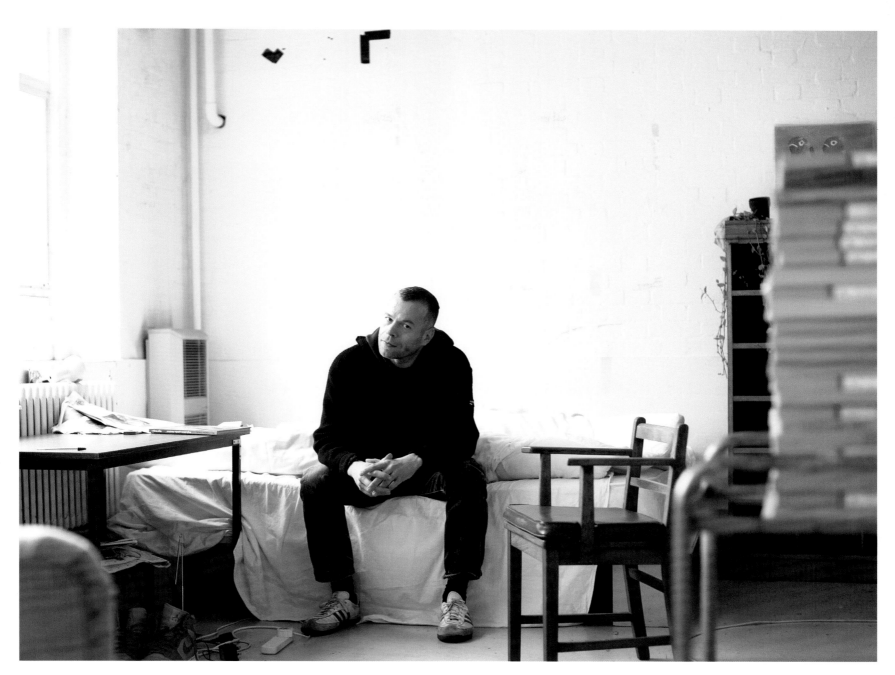

Wolfgang Tillmans (above) photographed in his Bethnal Green, London, studio, in February 2011. Tillmans (opposite) has a passion for DJing and techno music. 'People have realised that not everything has to be about money, and there is a certain freedom that art has preserved.'

Are you a sentimentalist?

That is a misunderstanding. My work is not about the specifics of my life. It's about using my experiences in order to make pictures. Which hopefully speak about something broader, or more general, than 'this is my friend' or 'this is who I partied with' or 'this is my breakfast'. That was never my interest. I use the world that is accessible to me to make pictures that function in the way that I think art functions when it's most successful, in that it uses a specific case to say something more universal. When we see a Bronzino portrait today, we are not completely tied up in thinking about this particular person, and who he might have been, and what is going on in his pose. Why the portrait speaks to us is because it says something larger about what it is like to be alive, what it is like to be human. Because my work was – and still is – very much grounded in the now, people have possibly misunderstood it as 'light', you know? As autobiographical. But I think a lot of good art is never afraid of being in the now. So many people – so many artists – are afraid of that and try to plan the future and make the work look serious, so that it endures. I think Caravaggio was dealing with his time and representing his time in his way. Maybe giving the saints in his paintings dirty feet was his way of making a contemporary comment.

The autobiographical isn't a problem as such. You know: 'I was in that place', 'I stood in that room', 'I met that person'. By default, the collection of it is some sort of autobiography.

And is that a sentimental record?

No. The sentimental bit maybe comes with age. Because photography, more than other art forms, makes us aware of time. When you see Manet's still life of asparagus, it is not clear that it is more than a hundred years old. It could be five years old. But if you see a picture of a twenty-one-year-old woman, you know that in the eyes of someone forty-five years old there is possibly a moment of loss, of sentimentality. But that doesn't make the work sentimental in its intention. Maybe I'm a romantic. But not sentimental.

You mentioned the dirty feet of Caravaggio's saints. Are you trying to show dirty feet like he did? But relevant for today?

Yes. I mean, I try. But knowing that today they may not be dirty feet. What ingredient of the now is the equivalent of Caravaggio's dirty feet? That's what my work is about, what every day of my work is about: to try and sense that. The real complication of my work is how to get in the now without making it loud. Because the moment it's loud, it's not interesting, and it won't last. But it can't be shy either, or be afraid of being in the now. Focusing on pictures made without a camera, non-figurative work, was the right way to speak about now, for me, in the last ten years. Right now I am taking a lot of photographs with a camera again. So it's constantly changing. And the moment you think you've got the recipe, it's lost. That's why it will never get easier.

The reception of my work also changed the framework for my future work. So something that was done ten years ago cannot be done the same way now. There are many people moving the goalposts, and I am part of that. Openness is the most difficult thing to maintain.

Are you worried about what time will make of your art?

I'm hesitating because I don't want to give you the 'correct' 'no' answer! Of course I care a little bit. There is the potential that people might be interested in my work in fifty years' time, when I'm not around and able to install it and advise on how it's shown. That is not a vain thought. That is an okay thought to have. I'm thinking about making things possible. That's mainly in my control. What I can't be concerned with is if it will have relevance, what people will think about it. I am quite happy that my work exists so well in books. It's a little bit comforting that one of these books might survive somewhere.

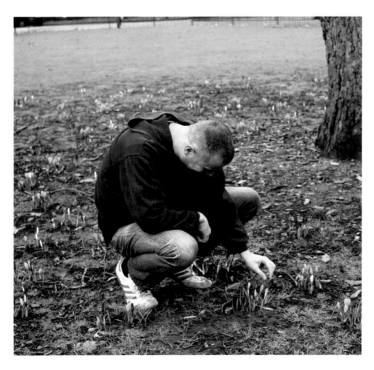

'I'm fortunate in that I don't suffer from life. I have a positive outlook: I'm excited to see the weather, to smell the air – excited by my senses.' Picking early spring crocuses opposite the building housing his studio, Tillmans muses, 'The real complication of my work is how to get in the now without making it loud. Because the moment it's loud, it's not interesting, and it won't last. But it can't be shy either, or be afraid of being in the now.' Tillmans (opposite) in front of a work from his series *Freischwimmer*, titled after the swimming badge earned by strong swimmers in Germany.

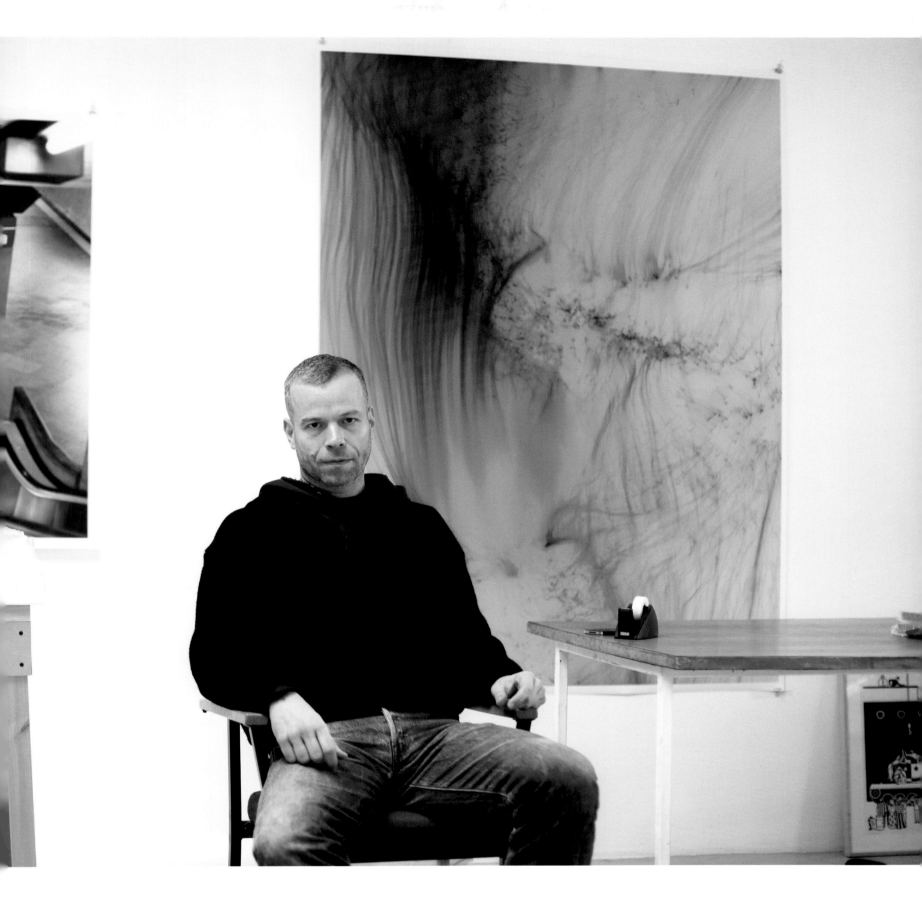

Michael Landy

Is working with your head as hard as working with your hands?

I'd say it's harder. My dad worked with his hands. He constructed tunnels; he was the pulse of the London Underground, the man at the face of some big drill digging into the earth. I made an exhibition about him called *Semi Detached*. The idea of that came out of his having an industrial accident in 1977 that left him disabled. I looked at all of the medical records from that time which included information on us as a family as well. I was seven or eight when it happened, so being able to see what effect it had on us was quite a profound thing.

There are a lot of similarities between my father and myself. We are both obstinate. After his accident, my father wanted to go back to tunnel mining, but of course it was impossible because of the injuries he had sustained. After I left art school, the Thatcher government wanted to retrain me in order to find work outside of being an artist, but there was no way I was going to be anything but an artist.

Would you describe your art as digging in the dirt?

Yeah. Digging things up. Having a look round. Digging for weeds. They exist in very small bits of earth and they are very opportunistic.

Can a contemporary artist sustain his imagination outside of the urban conundrum?

I am sure that they can. My weeds are urban weeds.

I was born and raised in London, so the urban and its aesthetic is my domain. Things that people disregard are of interest to me because I'm interested in what value people give to things, whether that is a weed or a crate or a person.

You are widely considered to be one of the best draughtsmen of your generation. There's nothing weedy about that.

What can I say? Drawing is where I begin. That is where I began as a child. When I was at Goldsmiths, people didn't draw because there was no draughtsmanship. The teachers just let you get on with it. No-one ever taught me anything, apart from my foundation year; teachers there did teach me perspective and life drawing.

I spend lots of time by myself. That is what I like about drawing. I can occupy my thoughts. I don't have to deal with the outside world. I don't have to have any dialogue with it.

Who has been your greatest teacher?

Michael Craig-Martin. As for the other lecturers at Goldsmiths, their practice was always at the forefront of their minds, so when we had a conversation, it was about their practice. Michael was always incredibly enthusiastic, which is un-British in a way. He's American and he just wasn't burdened as I felt a lot of people were. Michael took all of that weight off you and made you feel light, as if things were possible. In the '80s in Britain, the visual arts were still thought

of as not very interesting. The fact that no-one was interested was good in a way, because when you've got that indifference, there's your fight.

What determines the value of contemporary art?

The market decides, the manipulated market. I have nothing to do with the machinations of how the market gets manipulated. I probably cared when I was younger, but I don't care any more. Because that is completely out of my control, isn't it?

You did a recession show at Karsten Schubert. Was that before or after you jettisoned your belongings?

About nine years before. I destroyed all my worldly belongings in a former department store on Oxford Street in 2001. The idea behind *Break Down* came in 1996 when I had just sold my fictitious cleaning company *Scrapheap Services* to the Tate, so I had some money for the first time. I sat at the kitchen table thinking and the idea popped into my head that I should destroy all of my belongings. I prefer things when they go badly; that's when I'm at my best. I don't like it when things are going too well. So I thought, Well, how do I bugger this up for myself? Because it was the first time I had nice suits and a car. The only thing I didn't get rid of was my name.

When I destroyed my things, I talked about it being like being a child. As a child, you want to know what a house is made of. You are inquisitive about how something is constructed so you take it apart. I remember taking things apart … My mum said I was going to become a car mechanic.

I also used to be very quiet; I liked making myself disappear. Not physically … You just blend into the background at school and stuff. I wanted people to leave me alone. I didn't like school. Prison, isn't it? You put your head down, you conform to the rules, you do your time, and you get out.

Michael Landy (opposite) photographed in February 2011 in his Vyner Street studio with his dog named May. 'Whenever I have twenty minutes in the studio, I fall asleep with the dog. Then she starts licking my face.'

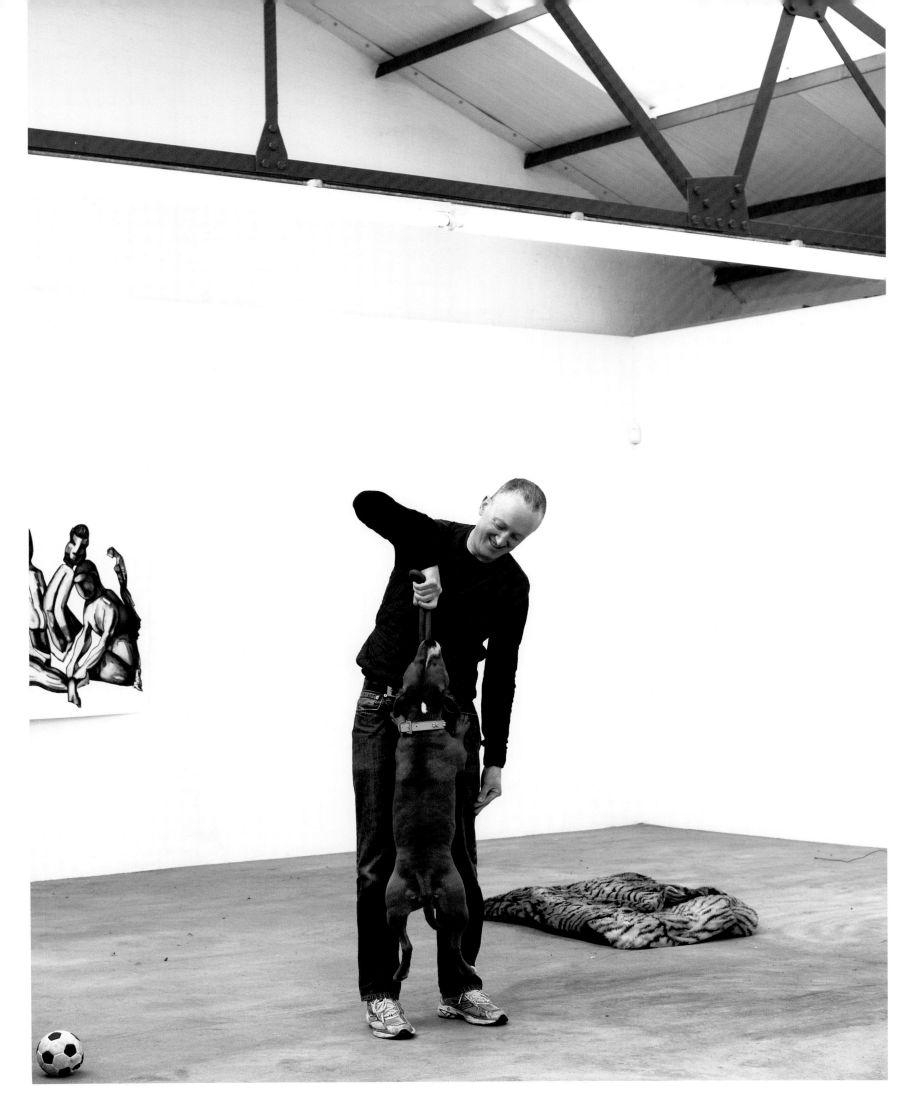

Your wife Gillian Wearing expressed it this way: 'Most people dream of momentarily ridding themselves of their identity, but to actually go ahead and do it … to open up the inventory of their life while simultaneously destroying it in public…'

Destroying all my belongings in *Break Down* was like witnessing my own death. But it also had a personal effect on the audience, who imagined their own belongings and how many things they possessed and what those objects would mean to them if they no longer had them.

How did you get into art?

There was a TV programme called *Take Hart* in the 1970s where children could submit their artwork. I made a little scraper board and sent it in to the BBC and they put it in the gallery. When they screened the programme, all my family watched it and complimented me on my drawing. As a child, if people tell you that you are good at something, you normally go with that. That's why I did it. I drew, and I kept drawing. I drew really lame things. Anything that was in front of me, I would draw it. Just to take up time, I guess. I could literally draw figures without even looking at the paper after a while. I'm quite an obsessive person.

I like expansive things, but I also like detail. So when I created my family house within Tate Britain in 2003, I literally recreated it. It wasn't any old house. It was all in the detail. The traces of my father's DIY efforts over many years, the parts left unpainted, everything was recreated exactly. The house was a portrait of the occupants – my mother and my father.

Your art has been characterised as having bare-faced ordinariness.

My work is quite ordinary. It doesn't have much glitter. I should apologise.

Would you describe yourself as a political activist?

Not at all.

Yet there is an activist tendency in your work …

Yeah. In 1995 a lot of my work came from anger, particularly *Scrapheap Services*. The idea was that the fictitious cleaning company I created would get rid of people who no longer played a useful role in life. I was thinking of the shrinking manufacturing industry being supplanted by the service sector; lots of people were being made redundant. The work was a reaction to unemployment and being put on the shelf because your skills were no longer needed.

What are you working on now?

At the moment I am doing a project for Art in the Underground called 'Acts of Kindness'. We are asking people to send in their stories of kindness on the Underground. So I have gone from Bad Cop, destroying stuff, to Good Cop. I like to go from one extreme to the other just to confuse people.

Where do you find moments of peace?

I should box, really, in a ring. Probably being hit by somebody would be good. But good boxers don't get hit.

Do you have a sanctuary?

No.

Is there ever any peace within Michael Landy?

There must be. Whenever I have twenty minutes in the studio, I fall asleep with the dog. Then she starts licking my face.

Landy's installations (left) in aesthetic discourse with ordinary household objects. 'I was born and raised in London, so the urban and its aesthetic is my domain. Things that people disregard are of interest to me because I'm interested in what value people give to things.' Landy shares his large studio with his partner, artist Gillian Wearing, shown here.

'I like to go from one extreme to the other just to confuse people.'

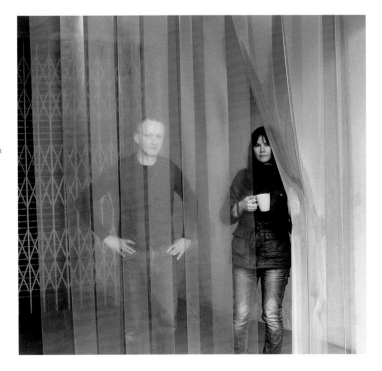

Gillian Wearing

We sometimes talk about art in terms of birth and rebirth. Is creating art as difficult as giving birth?
It can be frustrating, even boring sometimes. The hardest thing is before you make a work, when you have to think of the idea.

I don't get nervous about preparing. You get nervous when you are making because it is very intense, particularly as I tend to work with a crew. So you have to organise more than the idea; you have to organise all of the people around you.

You work in several media, all of which are very structured. Which one is the most spontaneous?
Any of them can be spontaneous. Some ideas need preparation. Other times you can set up something relatively quickly, but photography or video still means you have to think technically as well as artistically. So you always have to juggle practicality with creativity.

When you're making art, do you ever just close your eyes and let your hands take care of the rest?
No. It is very hard to be unselfconscious even if you are making abstract art. If you look at Jackson Pollock's paintings, there is a lot of thinking going on there. It is not just about letting go completely.

You became quite famous on an international scale within a decade and a half. Was that too fast, too far?
I thought it was sort of slow. It was just a steady way up. I left Goldsmiths in 1990; seven years later I won the Turner Prize. I thought I was kind of old at the time because I knew people who were twenty-three when they got nominated. All through art school I felt more mature than most of the others as I had worked for six years prior to being a student. I left school at sixteen.

What were you doing?
First I worked in an insurance broker's as an office clerk; then I left Birmingham to live in London when I was nineteen. I had several accounts clerk jobs until I ended up working in an animation company as a secretary. I became more interested in animation than in administration, so I decided to apply to art school, initially because I wanted to paint for animation and return to the studio I had worked at. But during my foundation year, a teacher said that I had a fine-arts sensibility so I should go in that direction. So I applied to Goldsmiths to do fine art. My whole journey happened by chance.

Gillian Wearing photographed (right) in her London studio in February 2011. 'My whole journey happened by chance.'

(left)
Olia
C-type print
© Gillian Wearing
Courtesy Maureen Paley
Gallery

You have been described as being shy about sharing your work with others …
I only feel comfortable talking about ideas with people with whom I've had continuity over time, like my partner Michael Landy, my gallerist Maureen Paley or my friend Helen van der Meij. You feel vulnerable when you are making a new piece of work as the idea is still evolving. Only people who can understand that process can really have dialogue with you.

Despite your shyness, you explore media which require that you interact with people.
When I started, I was crippled by shyness. It is just one of those things that you have to do, regardless of your personality. My work is not about me; it is about what I am trying to find out about in the world.

What is behind the relationship between contemporary art and the megalopolis?
The world is more informed by the urban than by the pastoral. Most things are developed or invented for modern needs and technology. So there is always the romantic notion of the pastoral, even though farm life is very difficult. When I was at college, I had friends whose parents lived in the countryside. Occasionally they would take me on trips there, but I would never get out of the car and go for a walk or anything. I didn't really understand the point of it.

Do creative people carry a particular gene?
I wouldn't say a gene … It could be that you see the world slightly differently and are able to express that. Whether that is because of a fine-arts sensibility I wouldn't know. Obviously someone could see that in me. And maybe I am able to represent the world in a unique way.

When people make a film, they always think that you project an idea of what the audience wants. Coming from an artist's perspective, I can never project how my work is going to be perceived. But when I like something, it tends to work. It seems to translate and become popular as well.

Is the process of making a piece intended for you, for an audience or for a gallery?
When I was first making art, I didn't have a gallery. When I am being commissioned, sometimes I make things for venues. But your ideas are personal things. You need to make them. You don't know if your gallery wants to show them so you have to take risks.

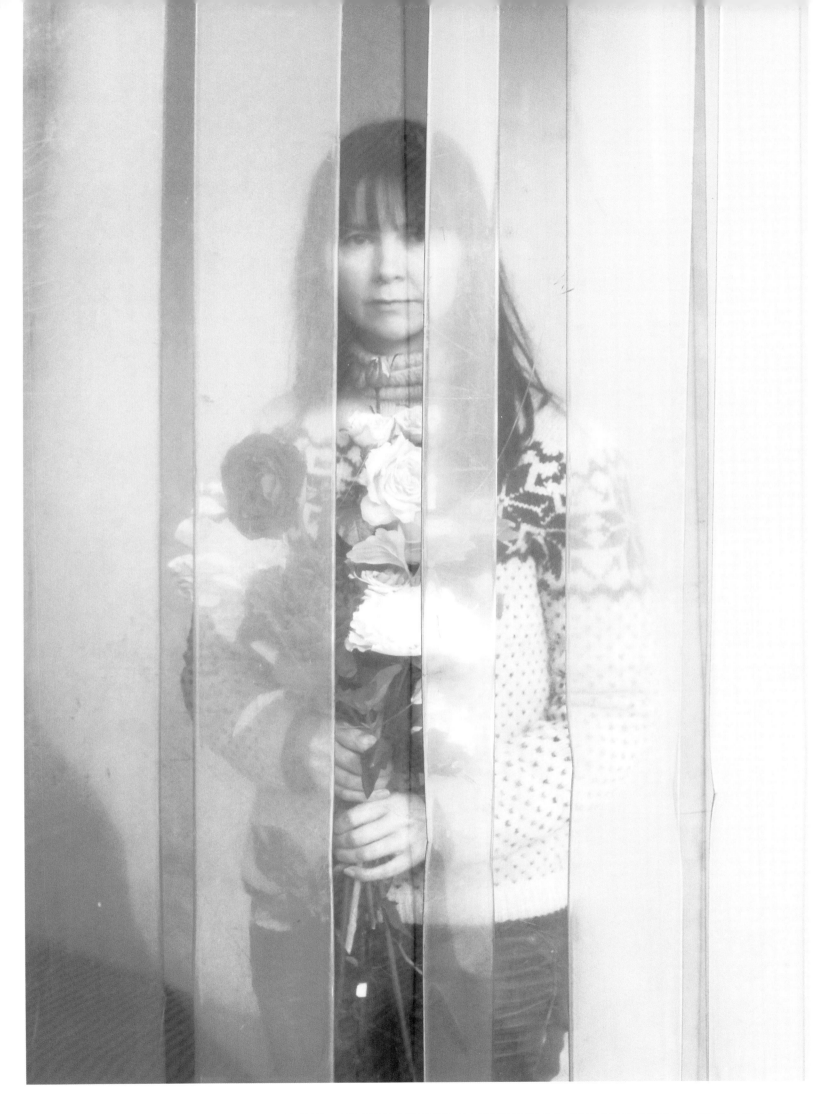

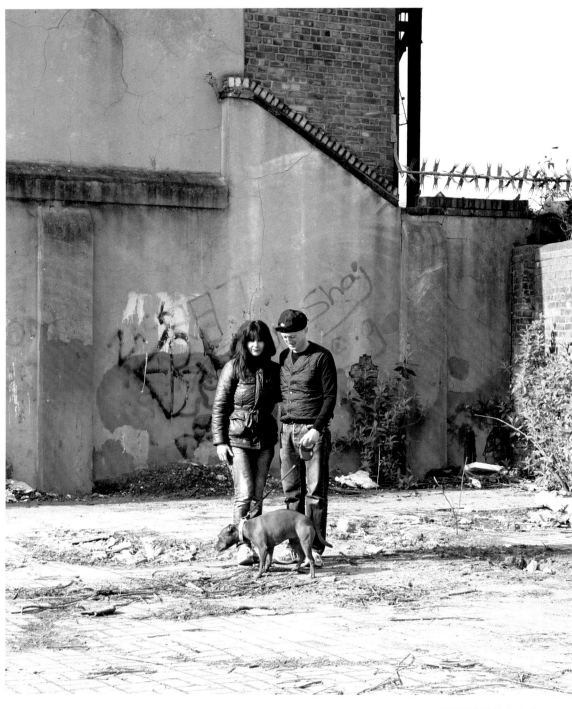

Wearing and her partner Michael Landy (left) walking their dog in Hackney, London, near their studio. 'You'll probably work harder in a studio,' Wearing says, 'and it's not harder to pay the mortgage, but it becomes a work environment as opposed to a home environment.' The artist (opposite) embarking on a new series of work based around the subject of flowers.

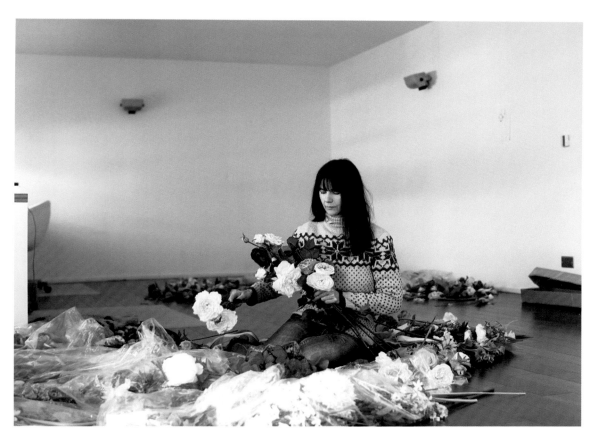

Do contemporary artists have to be anti-establishment?

I hated senior school; the one I went to felt like it limited possibilities and creativity. But that changed when I went to art school because I found something that I loved. After working in offices for six years, I knew what it was like to not have so much freedom and to work for a small amount of money. So I thought art was quite generous as an establishment.

Do you care where your art goes after it leaves your studio?

You have to have faith in what you make. It is not my job to be in the prediction business. I don't think about things in terms of a legacy. I didn't set out having goals. I set out to make work because it is interesting to me; hopefully then it translates. It is not like a business where you think, That computer has to serve its purpose for three or four years before it is obsolete. Artists make their work, and obviously they don't make it in line with the marketing department or the press department. It goes out as what it is.

Is an artist an artist even if they don't sell a single piece of art?

Yes. Selling work doesn't confirm an artist's identity. When I left Goldsmiths, I thought, If I have one exhibition, I will retire happy. I thought I would have to retire because I wouldn't be able to afford to be an artist for ever. Some people are able to teach and still make their art, but it's hard because you have to commit on a full-time basis to making work. To find a job and also make art is hard because you lose concentration. You have to be working five to seven days a week to make your artwork.

How much do you do in a week?

I work seven days a week, starting early in the mornings and putting in ten-hour days.

And then you just switch off?

Well, you constantly have things that you have to sort out. If something is pressing, you can take it with you.

The media that you work in … is there one you feel the most comfortable with?

No. Film is the hardest. A photograph, because it is one image, can easily become iconic. To make a moving image is a lot harder. The preparation is the most time-consuming, the research, the script, the casting for actors and crew, etc.

You've been quoted as saying, 'I really like the editing process. It is the closest thing you get to the old-fashioned way of making art.'

I don't edit any more, but yes, when I was editing I used to move things around. And when I painted in art school it was the same; you could always move things around, and you could change your whole pictorial phase or timeframe. Editing is great because when you have shot a lot of footage, you can actually make two different movies.

What about your influences? You've mentioned Warhol, Mapplethorpe, Arbus, Sander …

All of those people.

And where do you get your inspiration?

I don't know if I can answer that question. It might be something that you read in a newspaper or in a book. The thing doesn't have to be a literal starting point. It can be something that just catches you off guard. If it means something to you, then you will follow it.

So the artist is capable of capturing that individual moment, or relaying or reflecting it?

Yeah, because that is what we have chosen to do. A lot of people are creative, but they haven't chosen to express themselves creatively. Everyone has the creative capability if they want to pursue it.

You've said that you've always preferred a simple, smart work space. How do you see the role of the studio?

It doesn't play a major role for me. I tend to use my space like an office that is very neutral; I can just think there. I could keep references of what interests me on the wall, but I don't have anything like that. I keep all my interests in a kind of library in my head.

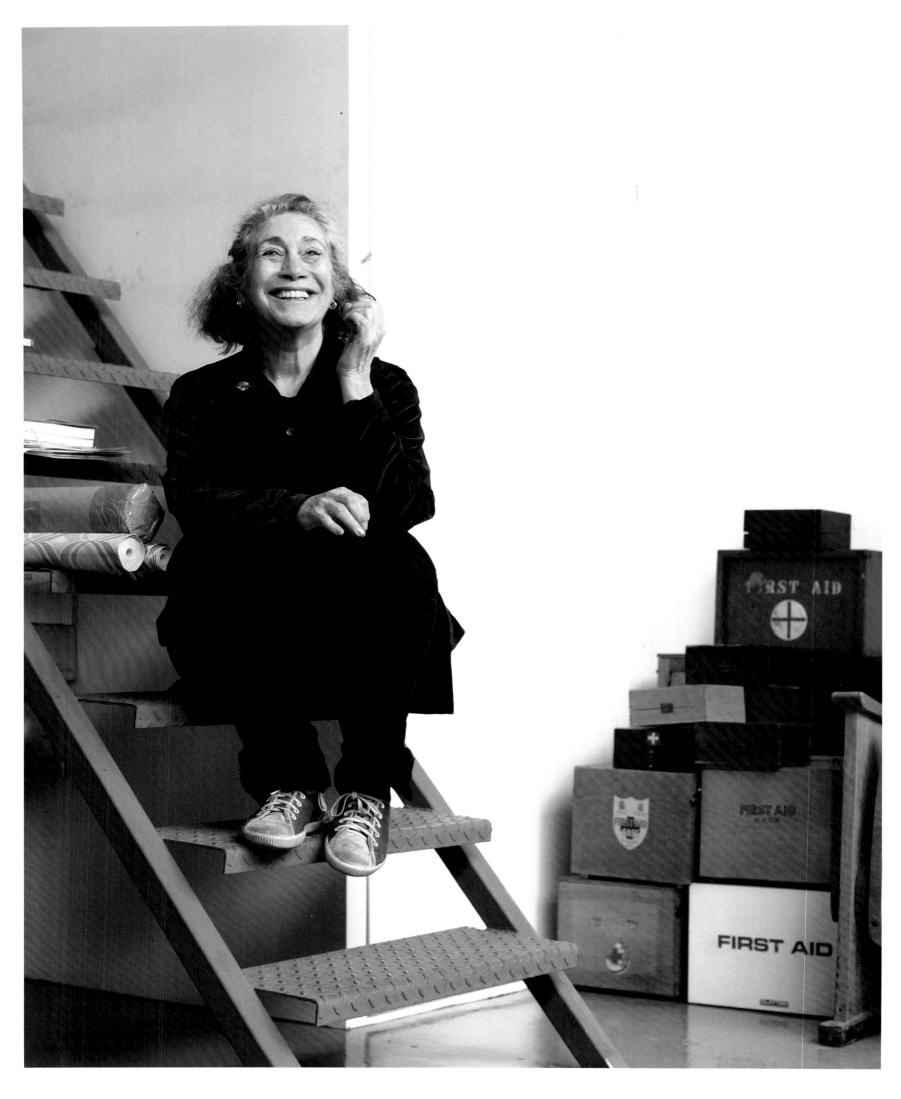

Susan Hiller

For how long have you had your studio?

I've been here off and on for nine years; I was based in Berlin for five years and was using a studio there for much of that time. Before that, I had studios in central and East London, but I found it disruptive getting moved on every six or seven years. The location I most enjoyed was on Shaftesbury Avenue in the centre of things. I also enjoyed another studio I had in Clerkenwell. But those buildings were converted to commercial use and the artists had to go.

When you came to this part of London, was it a new area for you?

I've lived in and around Notting Hill Gate for years, and this isn't very far away, but it's a dull residential neighbourhood and doesn't inspire. However, I like the stability of having a lease. The building belongs to Camden Council. I believe in the '60s they inserted three studio buildings into their new housing estates to provide facilities for artists to be part of the local community. I love my fabulous skylight and balcony, but – despite the modernist style and the traditional but unnecessary north light – the space isn't well planned. For instance, the windows don't open so there's a ventilation problem. And it's supposed to be a live/work space, but really it's too small. It's the smallest studio I've ever had and I'm always thinking about moving. But that's a distraction from work, so I never actually get around to finding another space.

How much time did you spend in Berlin?

About five years, off and on, first on a DAAD fellowship and then making the *J.Street Project*. One of the things everyone likes about Berlin is the presence of history. People are seduced by the presence, by the visibility, of history in Berlin, although the people who run Berlin are covering it up as quickly as possible, trying to make Berlin into a 'normal' city. Most artists who go there immerse themselves in this history and often make work about it. Because it's such a wonderful place for an artist for many reasons – cheapness, availability of studio space, etc. – lots of artists never leave town. I was fortunate because making the *J.Street Project* took me out of Berlin all over the country, to places tourists never see.

I read that the project happened by chance because you were walking around Berlin with a map, trying to find your way. All of a sudden you saw Judenstrasse where you didn't expect it to be, and your investigations started there. Would you say that most of your projects start this way?

Yes. I never know what the next thing is going to be. But at the same time, I'm very consistent in my focus. Everything I do starts with a ghost of some kind. Recently I've been looking at some aspects of modernism that influenced me but that are still unresolved and almost invisible, like ghosts. I've found 'ghosts' in the work of Yves Klein, Duchamp, Beuys and Gertrude Stein and have made pieces about them. The truth is that any artist has a very small number of themes or obsessions, so I think all of my work is pretty much the same. The subject matter differs, but the content that interests me is closely linked from one work to another.

I am always pleased to see a woman artist gaining in stature, because I think that's an area where all of the arts institutions are lagging behind.

It is interesting, that phenomenon, because there are a lot of younger women showing everywhere, which is good, but there is a big interest in older men internationally and not much interest in older women. That is sad because it shows that we haven't actually changed anything. We are also seeing a lot of all-male or mainly male group exhibitions. When I try to think of role models, it is difficult for me. People always ask what women artists influenced me, and I can't really think of any because they weren't there for me to be influenced by. Although that's changing, it's very, very slow.

How does one keep going, then?

Stubborn persistence. And realising how boring it would be to do something else.

What was it like arriving in London in the 1970s and deciding to become an artist?

I had decided before I got here to do what I wanted to do. I was very lucky coming to this country when I did, when everything was open and available, and different fields of work were influencing each other and merging. I knew musicians and poets, and I could quietly go about doing whatever it was I did with a certain amount of encouragement just from the general atmosphere. London was bursting with creative people in so many different areas. It was smaller, the art world – I didn't have very much to do with it. In general, art in this country was still very conservative.

There was no consistent development of a confident modernist art practice here until very recently. Advanced work in film, photography, performance, etc. was happening, but no-one in institutions paid attention to it. That meant that artists were very engaged with one another, and there was an important off-the-record kind of art scene. This country was the place where people came from all over Europe and the States to do exhibitions because there was a network of public galleries. Nobody ever thought about an art market; they thought about art. The art establishment seemed removed from what was actually happening among artists.

Don't you sometimes think it is better for creativity when commercial pressure is completely absent?

I think an atmosphere where there's space to work and living's not too expensive is ideal. England was quite cheap in those days; it was like Berlin is now. People were working part-time or living on benefits; the atmosphere was tolerant about such things. All the musicians were on the dole; they didn't make money from their music either, until later. So it was a very good time to be here, and that's how I got started. However, I would say that it's a good feeling to earn from your work. In our society, financial reward is the only 'real' reward. That may not be how it should be, but that's how it is.

Susan Hiller in exuberant mood in her Camden Town, London, studio in March 2011. The first aid boxes seen here are intended for a new series in homage to German artist Joseph Beuys.

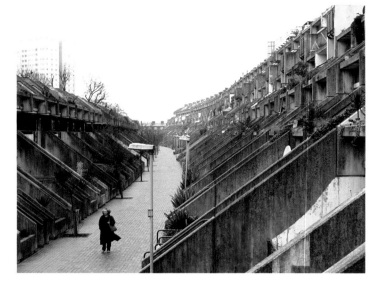

Hiller (right) walking through the famous Alexandra Road housing estate on her way to her studio. The estate was designed by architect Neave Brown in 1977 and is now a Grade II listed building. 'It's the smallest studio I've ever had and I'm always thinking about moving. But that's a distraction from work, so I never actually get around to finding another space.'

How did you experience the '80s?

I'd been working with young artists for a long time; I've taught at the Slade School, Goldsmiths and the Royal College, so I wasn't surprised that there was a lot of talent around. What did surprise me was how the government leapt on it as a way to advertise the country. It was fascinating to observe that this old, old, old country tried to present itself as new, new, new and young, young, young! The branding, in other words, that went on between Saatchi and the government promoted a group of artists who were very talented indeed but possibly no more so than a lot of other young artists. Art was suddenly hot.

The emergence of so much new talent wasn't actually a surprise, because this country has always had the best art schools in the world. What was new was the sudden public interest. These days there are young artists everywhere, and all governments are promoting them as new and progressive and so forth, and frankly I think it's rather boring. There are tons of them, but will they last? And is 'young' really a synonym for 'new'? In other words, do young artists produce fresh ideas and older artists produce stale ideas? I think not!

Hiller collects medicine vials (left), dug up randomly from London soil, and fills them with 'holy water' sourced from wells and springs across England. 'I can work anywhere, but a studio is like an empty space in my head reserved for a particular kind of thinking.'

Looking back at the intellectual fashions of the '80s, it seems to me that the most important element was feminism. This was inspiring and at the same time uncomfortable. I was told that I had ruined my career by being a feminist. It made people in institutions anxious if you mentioned anything of the kind. And I think the influence of the Turner Prize has not been entirely beneficial to the development of truly substantial and long-lasting British art. The prize focuses attention on certain artists and inevitably detracts from the achievements of others who have to be really self-confident not to feel overlooked. Maybe benign neglect is the best way to grow good art.

Have the explosion of the art market and new institutions such as Tate Modern made any difference for you and your practice?

It's a huge cultural shift, huge. All these things are part of the shift from a literary culture to a visual culture. People always say culture in this country is literary, but I think it is intensely visual. You only have to notice how clever British advertising is. TV adverts here are so much more intelligent and fun than they are any place else, and they require a sophisticated understanding of visual codes. There's a huge appetite for exhibitions, and artists have become iconic public figures. To say specifically how this has affected me: it has enlarged the audience of people interested in what I do, but it hasn't changed my life or how I approach it.

Where are your roots?

In a way I remain American because my deep roots are there, although I am considered to be a British artist since I never practised as an artist until I came to live here. You can never change the deep patternings that are part of your upbringing. But my connections to the States are more nostalgic than real at this point. I do like teaching and exhibiting in America. It *touches* me more personally to do something there, as you would expect. But I started to make work here, and this is where I have lived for most of my life.

I suppose one of the things I always enjoy in this country is that there is still a little bit of mystery to me about what people mean when they say something. Because you can never really understand all the nuances and all the implications of phrases in a foreign country. A lot of the work I did when I first came here was based on looking at things that struck me as being somewhat familiar but were actually rather different. *Rough Seas* was the first time I realised that there was something I could do that would be exciting *personally* and also could possibly be part of art.

Do you have collaborators or do you do all of your projects on your own?

I have done group pieces, though not recently. But I think my work has always been collaborative.

Is the studio your sanctuary?

I need to have a studio even though sometimes I am not here very much. I can work anywhere, but a studio is like an empty space in my head reserved for a particular kind of thinking. As long as I have a studio, I have that space ready and waiting.

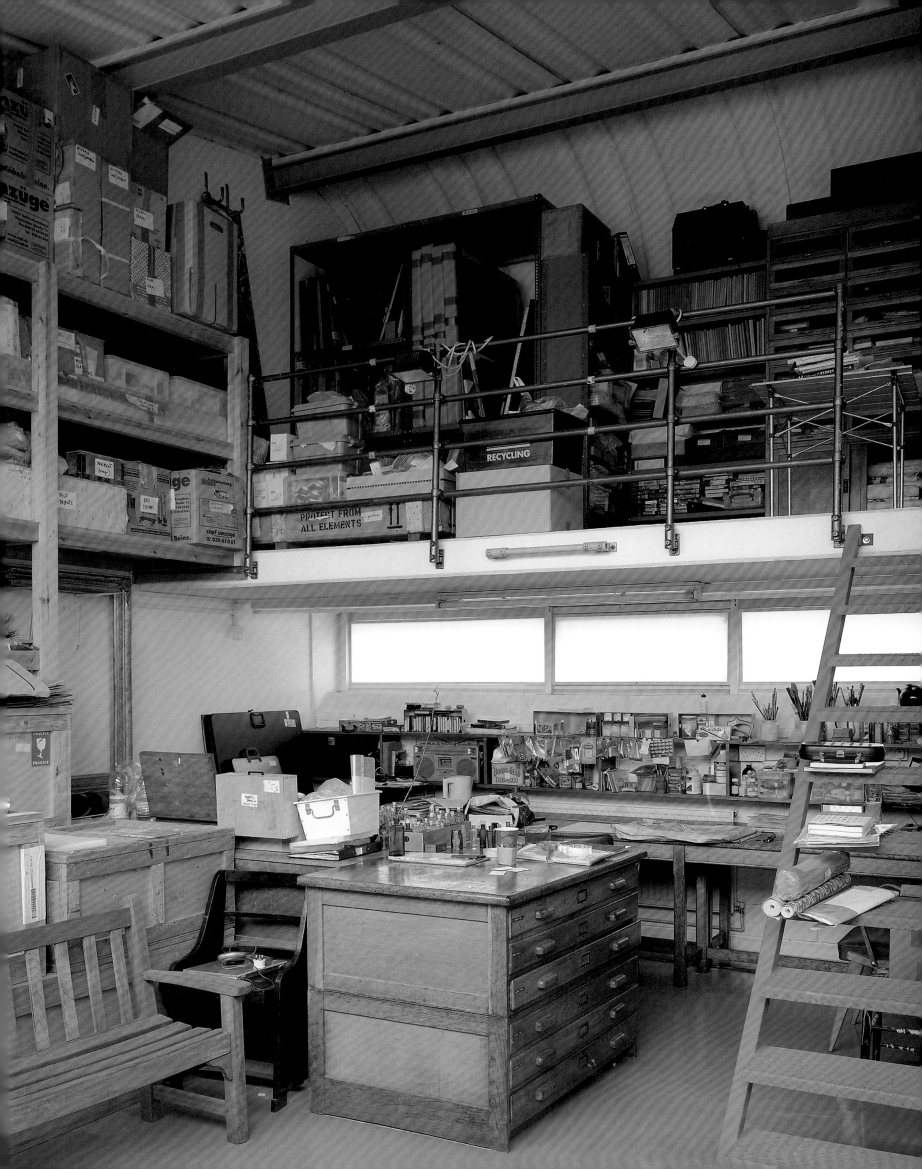

Jason Martin

Tell us about your studio in Lisbon.
I work in a large ex-sugar depository in the docks beneath the 25 de Abril suspension bridge. I am going through planning issues with the local council in Alentejo, 100 kilometres south of my rented studio. I have a farm with a cork forest, and I want to build a studio in that environment. My metal workshop is there alongside my house. All my panels are made there.

Do you mean the metal panels that you use in your paintings?
Yes. The panels are mostly aluminium. I work with stainless steel also. If I work with transparent oils, I get a reflection coming through the oil and a hyper-kinetic light interaction occurs.

Do you always work on the wall?
Not always. The oils are made on the wall, and my mixed-media and pigment works on the flat. Both approaches demand a choreography of sorts, repeatedly going over a surface and refining many movements. Some works come good very quickly, but I can work over the same piece for months.

How do you know when a painting is finished?
It's absolutely intuitive. I look for a balance between form, space, colour and movement.

Do you need to be alone in the studio?
Yes and no. I like to play music loud. My assistants generally have editing and prep work to be getting on with. I usually work independently in a private room.

Is it a kind of tortured, Abstract Expressionistic process?
No, it's more that I chase an enlightened space. There is a curiosity and a fascination with the improbable events I generate with my bespoke brushes. You have an oversized brush and move it around in any number of ways that are unrepeatable. There's always something happening that you can't recreate. I'm always exploiting paint with the intention of balancing chance and intention. I'm caught between deliberation and abandon.

It's a case of that's a winner and that's not. How a space becomes organised and precise may demand quite radical approaches. Eventually you move in a direction you feel is worthwhile and fertile.

For how long have you had your London studio?
I have had my London studio for ten years now. The building was a glass factory and, previous to that, a scull-making workshop. I fought the council for three years, finally winning my appeal to convert it into a studio and home.

So it's one big complex: the house, the studio, the office. With so many things going on at the same time, are you always working towards a show?
Absolutely.

Would you consider your paintings self-portraits since you put so much of your physical presence into them?
There is something autobiographical about my work. I give paintings personalised titles when I have the time to reflect; I try to discover what personality the painting has and to give titles that have emotional identity or meaning. The titles could be places I've been to, people I've met, even words that are not correct or slang, some memory or experience that has some sort of reference to the painting but not a literal one. People generally talk about my work descriptively: 'It's like a shell or a feather or hair.' The references are of forms found in nature. There is a naturalism that I encourage, an organic abstraction found within the genres of still life, landscape and the body.

Are the colours completely intuitive? Do you look at what is available in terms of pure colour and then start using it?
I'm trying to avoid more earthy tones at the minute because I think there's something transformative about using pure colour. There can be a mystery about both the medium and the colour. Would there be movement on the surface if I touched it? Is the surface paint or rubber or paste or concrete? Colour has transformative properties which transcend the material it inhabits so I try to explore these evident possibilities and think about colour structurally, not decoratively.

Do you feel any affinity with the work of Yves Klein?
Yes, and also Fontana and Pollock. I feel part of a small club as they all used their whole body in the making of their work.

But you don't really seem to be attacking your work …
No. I engage with painting as a stage and an event where serendipity thrives. However, I am also committed to resolving a pictorial space. I like the idea that painting is a vessel for your mental landscape, allowing freedom of reference and poetic association. You look through it as a window onto a world, as a space beyond. You also have this surface, a physical space; it's very sculptural. When I started out, I had an interest in bringing a cool approach to a rudimentary idea of Minimalism together with the live, emotive and more heated posture of Expressionism. My finite act or acts remain elemental.

Jason Martin uses pieces of metal or board to move paint across the surfaces of his works, often repeating movements until he achieves the desired level of translucency. 'I'm always exploiting paint with the aim of balancing chance and intention. I'm caught between deliberation and abandon.'

Martin (opposite) in his Teddington, London, studio. 'The building was formerly a glass factory. I fought the council for three years, finally winning my appeal to convert it into a studio and home.'

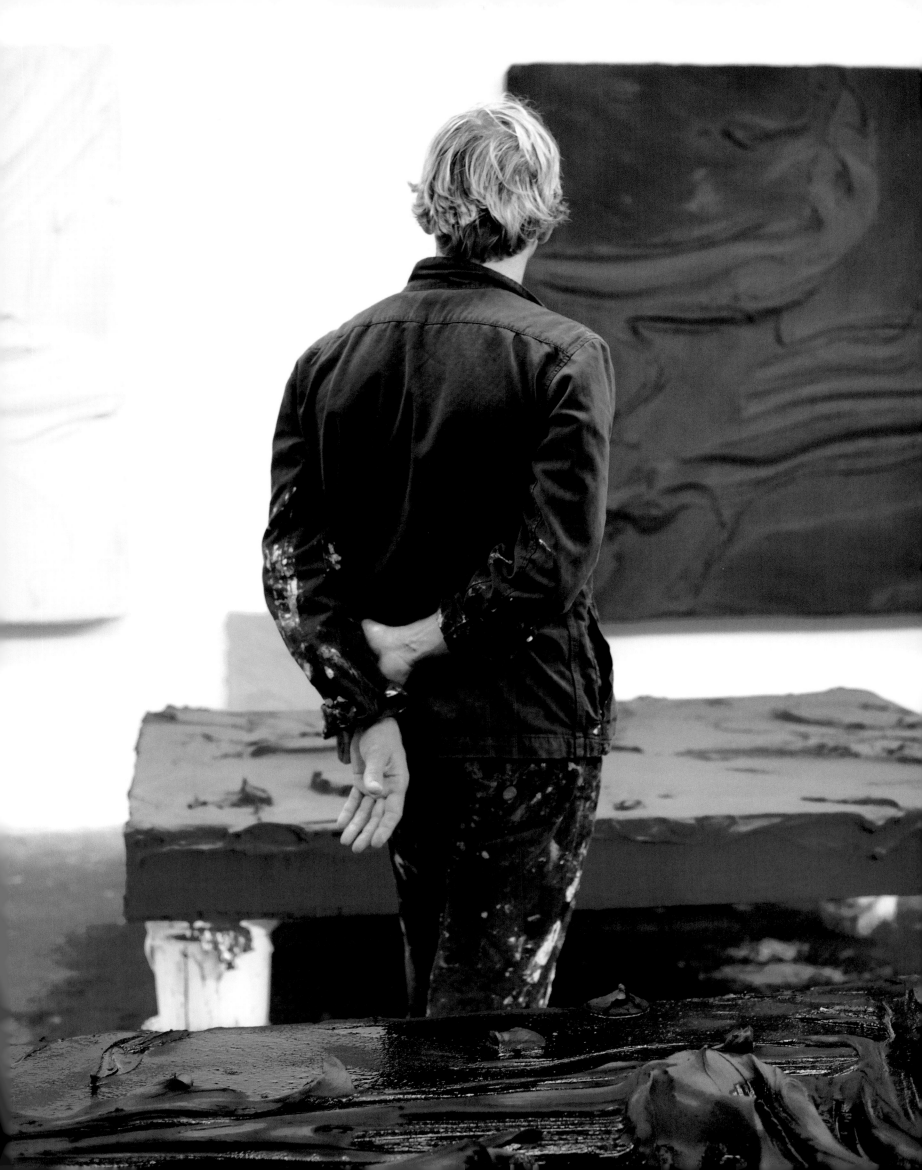

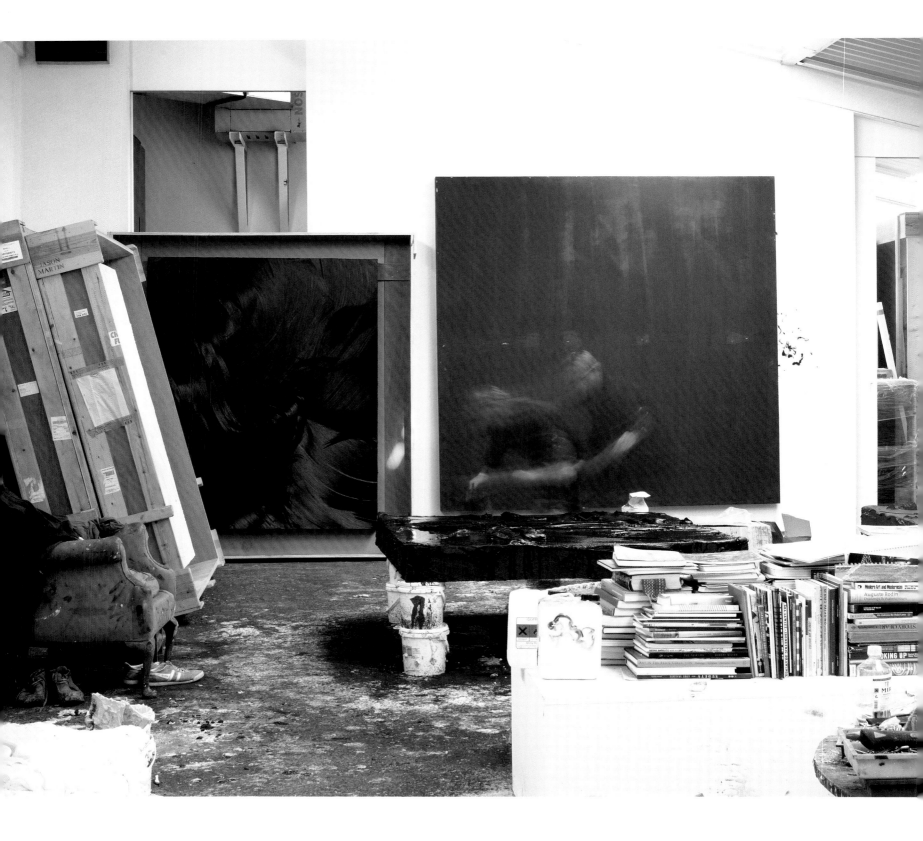

(above) **Martin's recent body of work uses pure pigment on panel. 'I think there's something transformative about using pure colour.' A tree trunk** (right) **fallen victim to lapis pigment and plaster. 'I'm a paint junkie,' Martin admits.**

What does having a studio mean to you?

I've always wanted to work in large industrial spaces. The prospect of engaging in studio practice in more ambitious spaces raises bigger challenges for the advancement of my work, not least in terms of understanding scale. With my London studio I found a space to work and reflect in and hopefully further my artistic endeavour. I am guilty of cocooning myself in this environment.

How many hours do you work each day?

I usually work a full day starting at 8.30 or 9.00 in the morning and working through until 7.00 in the evening.

Are there differences between the works you produce in England versus Lisbon?

I have a more grungy approach in my Lisbon studio, since for parts of the year the walls are crumbling due to high humidity.

Your first exposure was the 1997 *Sensation* exhibition. Did you feel part of the YBAs?

The YBAs came together for generational reasons. There are previous movements in art history where an ethos or an ideology brought artists together. I don't see the YBAs as having too much in common. During that time I wasn't included in many of the group shows, and although I was in *Sensation* I didn't feel part of that group. In fact, people really haven't known what to do with me here. I've had much more success overseas. The Latin cultures respond better to the physicality of my work. Brazil, Portugal, Spain and Italy engage more than the UK, where sentiment and mood are more nonchalant or even indifferent.

What would you like to be remembered for?

I'd like to be thought of as developing a new territory in painting, pushing the margins or the understanding of what painting can be, developing the language and the story of abstract painting, or the story so far. I'd like my work to bring enjoyment to future generations who may or may not have a cultural attitude.

Do you think of artists who deal with similar issues as kind of lonely?

High modernism is quite a solitary path. There are artists I really admire: Kelly, Marden, Ryman. There aren't many who have that grace and that power. There's truth and integrity in their work. I like to think that I'm part of that story. I like to think that my paintings, as much as they are contemporary works, also relate back to early communications in art, to cave art. I'm exploring classic, more quiet concerns which have seemed compelling to artists over the centuries. Fundamental issues in painting.

When you wake up in the morning, what drives you?

I want to make my contribution to painting. I've always felt that that's why I'm here. That's my purpose, that's my vocation. I've always felt a sense of urgency and I've always had a work ethic, so I've always been very driven to make work. I have the belief that I have something to offer in the story of painting. Also I'm very curious to work with paint. I'm a paint junkie. I am really in the business of trapping mystery in oil or acrylic. Maybe it's a combination of fear and entropy and knowing that eventually we're all going the same way. There's no life other than a creative life.

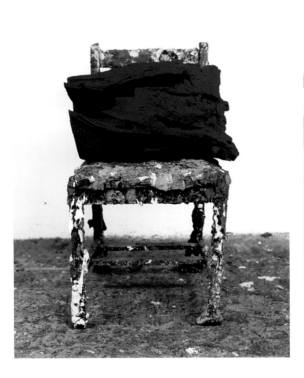

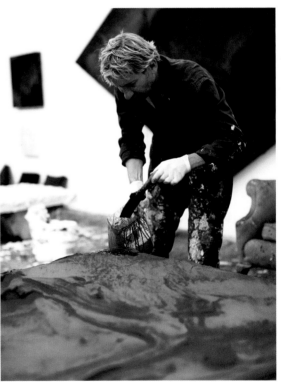

Anya Gallaccio

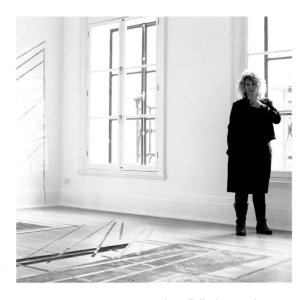

Your practice is essentially studio-based, isn't it?

No. I have always had a studio, but I have a complicated relationship with it. I find it very hard to produce work within the neutral space of the studio, and yet I spend much of my time there. I have a huge studio, which was part of the reason for coming to California, to try and occupy this space and tackle this problem and explore the possibilities of a parallel practice, a solitary practice. When I left Goldsmiths, a group of us shared several floors in a derelict warehouse building in Docklands for practically nothing. That was the last time I had anything that resembled a conventional studio practice.

Was it important to have a big space?

No. It was just what we were offered. It was great to be able to spread out and make a mess. I was surrounded by painters who had a strong studio ethic, so we all went in every day. I was working with a ton of lead. I tried to emulate their discipline, going in and working on gesture and repeating my actions. I am not a painter, although sometimes I like to delude myself. I have a fascination with and terror of painting ... I could work on technique in the studio, but it felt like an exercise. I was frustrated; it was an endless rehearsal. I prefer to respond to a place or to the pragmatic restrictions of a real situation.

Has your view of what sculpture is and how you respond to it changed over the years?

It has evolved. I am not sure that I had a definite view of what sculpture was. I was just making stuff, and it wasn't painting. I was initially working with found objects and mass, and I have expanded my palette of materials over time. I got more invested in a conventional sculptural language – gravity and weight and balance – which I didn't address initially; I was thinking more about material and space, about a fleeting, more performative investment. I felt an intuitive affinity with Arte Povera and Minimalism while being oblivious to its historical context, so I made up my own logic. Jon Thompson, who was teaching at Goldsmiths, introduced me to this work, some of which I saw installed at the two shows he curated for the Hayward Gallery.

The art world as a system constantly demands stuff – it is a market economy – and yet at the same time it is in denial or conflict about commodification. I wanted to make work that played with this structure, that teased it, to see how to make an object that is not an object and that is both have-able and not have-able.

There was a social project behind Arte Povera. Is that your kind of social project?

Not so explicitly. It was more personal. I am a product of both '60s idealism and '80s enterprising individualism. There wasn't an art world in London as we know it today, just a handful of established galleries. We made our luck and barged in on the scene. At college all of the conversation was focused on ideas. We did not discuss things in relation to a commercial market so it felt like making new rules. I was just making things, exploiting and seeking out opportunities. I didn't consider the possibility that anyone would want to buy the things I made. Then when my friends began selling their work, I was shocked at the anonymity of the exchange. I determined to produce things that, because they were temporal, could not be sold without my participation, so that collectors or curators would have to negotiate with me and I would have to remake and install the works. I wanted to continue the conversation and hoped somehow to be embedded in the works because you would have to engage with me.

Is it still like that?

Not in such a literal way. It seemed like a great idea at the time, and also in some naive way I thought this was a feminist statement. At the time – which is hard to believe now – there were few women visible in the art world. It felt important to insert myself into some kind of conversation, to be at that table. They were unsophisticated strategies on my part, because it took up so much time travelling and reworking things rather than moving forward. At a certain point I got bored with it. The conversation wasn't interesting.

Do you think about permanence, about the longevity of your work?

Nothing lasts for ever, but I am interested in the idea of investment, an investment of time or belief. There was a conceptual and pragmatic logic to working with organic materials, but they don't all disintegrate and literally disappear. The materials and the work have pretty consistently been determined by the invitations I've received and so are more varied than one might imagine. I have a perverse logic and am great at sabotaging myself. When I'm working with more conventional sculptural materials like bronze, which initially I couldn't afford, the logic and process of how I use them is as perverse as working with more obviously ephemeral materials. The bronzes, for example, are unique; they are not editions even though they are in series. Maybe this is a subtle distinction, but it is important to me. Most of the casting is done by direct burn-out, which means that the original object

is destroyed in the process, a transformation, one for one. It is a decadent investment of time and labour, a laborious process without a guaranteed result. Whatever comes out of the mould is what we use; it is a fatalistic process rather than one of control and perfection. You can repeat the process as with any of my works, but the outcome will be slightly different.

You made a constructivist composition out of sand and dirt from the deserts of Nevada, Utah and Arizona. That was quite a departure.

Do you think so? It is a formal gesture. The earlier works were incredibly formal in how they responded to a space. It was an important show for me as it was both a reaction to being in California and also a displacement. California is so far away physically from Europe. I was coming home as a tourist. I am fascinated and enthralled by the scale and the cliché of landscape and the American West. My work has often invested in some notion of landscape; I was curious to see whether by displacing myself, by moving to California, my sense of self would change, to see how British, how European, I am, to challenge my assumptions. I wanted somehow to respond to the scale of space here, to the landscape here, and acknowledge Land art and Smithson and Heizer, even while thinking that a lot of their work was macho and epic. I wanted to make something slight and vast, to respond to the gallery in London and also the landscapes that I had travelled through. *Where is where it's at* in a sense returns to the beginning. I was really just presenting the material, which is what I used to do.

So where does the studio come in?

It's a safe place. It is a place where nothing has to happen.

Ryan Gander

Are you looking for a particular theme?
I am interested in all content and all subject matter and all ways of making. The only signature trait is the fact that I use multiple references that collide in a particular way. Some works are based in narrative, some are based in design … it's difficult to explain because it always changes. I purposely change my role and my position. People do the same things every day and complain about it. The liberty for me being an artist is that I can be something new every day. I think I've got the best job in the world because of that.

You often advise artists just starting out to remain amateurs …
Not often, but I have done, because it's easier to be creative if you are not worrying about the external pressures of being a professional and working within the art world, the history of art and the art market.

But, given all the hoopla around the art market, it has an obvious attraction for young people.
It has an attraction for people who are fickle and interested in fame and fortune, but it has no attraction for people who are interested in working with ideas and making artworks. A lot of young artists are interested in the lifestyle of being an artist, but they are not very interested in making art. Most really good artists don't even refer to themselves as artists.

Can you say a bit about your working method?
I start by collecting things, and then those things get sorted into notebooks, and then the notebook pages get cut out and swapped around so the references get mixed. Then the pages fall together, associations are made, and I have a pretty good idea of what the investigation will entail. When an investigation is complete, the fallout that you are left with is an artwork. But these aren't directions for making an artwork; for me the artwork is usually the by-product of an idea.

How long does this process usually take?
It could be for ever … from collecting material to performing the investigation.

Is your London studio a container for your thoughts?
No. I have a studio in Suffolk, where I live, which is more like that. I spend three or four days a week here and three or four days a week there, depending on what else I have on. But when I'm in Suffolk, half the time I'm not working, because my family is there. That studio has lots of records in it, books, a computer, lots of tables, and lots of photos and notes. Some of the ideas are really embarrassing, but it's nice to have them around me. This London studio is a semi-public space. There are always people coming

and going, and I have a night school here once a month. We have a clear-out, seventy people come in, and then people do lectures, like a salon.

What is your intention with that?
Well, I've taught at all the colleges in London, and I don't think they are that good. If you condense the idea of an art school down to its most basic principle, it is just a warm room; tutors aren't necessarily important because you learn from your peers more than you do from tutors. The only things you really need are space and time. Most students can't afford space, so I thought, If I've got a studio, it's selfish not to somehow share it.

So you are extending the use of the studio …
Yes. But we have to be very kind of light on our feet, because the ideas I have are kind of light on their feet. So there's no point in having a studio full of welding machines or wood machines. This studio has to be adaptable, multi-functional.

Is there an anarchist inside you waiting to jump out?
No! Yesterday we were talking about the number of young artists who come and ask us what a consignment note is, or does a gallery pay 50 per cent of production. They don't know how to protect themselves,

Ryan Gander in his Haggerston, London, studio, late March 2011. 'The liberty for me being an artist is that I can be something new every day. I think I've got the best job in the world because of that.'

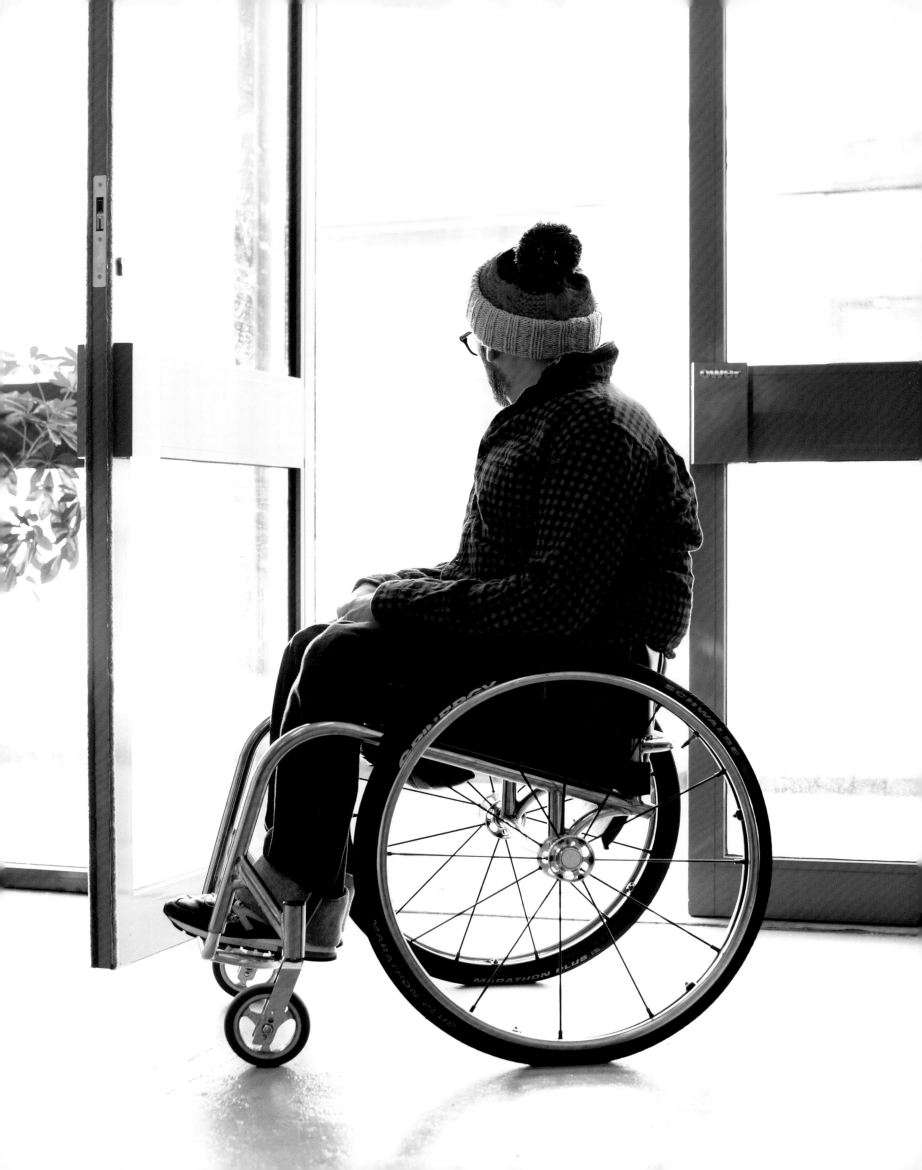

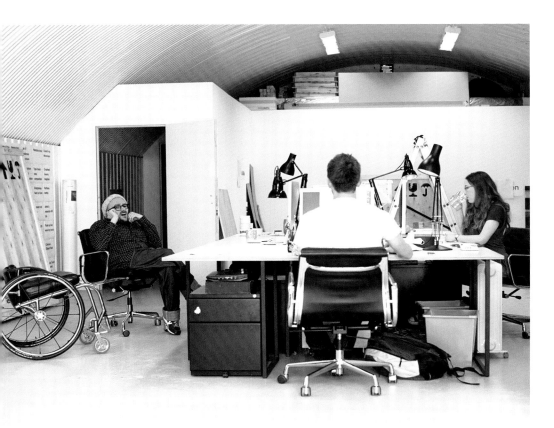

and they sometimes feel vulnerable. They are taught how to network, but networking is possibly the worst thing for an artist's work, morale and career. So the art schools have the idea of professional practice all wrong. Most artists who teach these professional-practice courses aren't successful practising artists; otherwise they would be too busy to be teaching. The sort of competition that I encounter in London art schools isn't really healthy when you don't have your own practice yet, when you haven't developed your own language or your own way of making work. These young artists just mimic what they see around them as being successful work, whereas if you sent them off to live in a hut in the Alps where there wasn't any art and told them to make some, they'd probably develop a very interesting, idiosyncratic language of their own.

How much time do you devote to your work each day?
The logistics of doing shows and books and things are like having a full-time job.

How many projects do you have on at the same time?
It depends. Presently there are about fifty. This year there are nine or ten solo shows in Japan.

You went to art school in the Netherlands. Was it your decision to leave England or just something that happened?
I applied to some colleges in London but didn't get an interview at any of them. All my friends from the town where I was born who were studying art went to Goldsmiths, to Chelsea or to different places, and

I didn't have anywhere to go. A guy came round my foundation course and said that they were starting a new course in Manchester and asked if I would go on it because they didn't have enough people. So I went to do that. There was an artist called Ben Cain on the same course whose girlfriend was living in the Netherlands. He went round all the postgraduate academies, and when he came back he said, 'This one's the best.' I applied because he applied. It seemed like a good idea because he'd done the research.

I'd wanted to be an artist when I was seventeen or eighteen. But I thought I probably wouldn't because if you were born in the North of England, where there were no art galleries, and you didn't know anything about art, and the only art you knew about was through word of mouth or mediated through books in the library or magazines that you got sent through the post, you had this idea that art was the way it appeared in *Artforum* and *Frieze* and that was it. It was '92 or '93. Artists were in the newspaper every single day; every third headline was something to do with Goldsmiths. I really thought that if you didn't go to Goldsmiths you could never be an artist. With friends, we used to go to things like the British Art Show in Manchester, and we'd buy the catalogue and look in the back to see how many of the artists lived in London. It would be a hundred per cent.

When the YBAs came on the scene, were they role models?
Maybe some of the younger ones. I think British art is a bit embarrassing when you look back at the history of art internationally, when you think of Arte Povera or De Stijl, all these moments, and you hold it up against Britart. Britart blatantly fails in comparison.

Conceptually, given the quality of work and the absence of issues being investigated, it's astonishing that Britart ever got past the door of a gallery. Most of it is terrible egomaniacal ranting. If you look at most good British artists, they don't live in Britain. They've all moved out, out of the shadow of Britart and the hangover it's left us with.

Whether you like it or not, the YBAs supported entrepreneurship. Could you at least say that something positive came out of it?
I'm not sure you can say that. If you look through the history books and there is this big shadow over the '90s because of a load of embarrassing, simpleton, advertisement-type art, I don't think it is such an achievement, is it? When the recession hit, there was panic; everyone was talking about everything being on the verge of collapse, that it was the end of art. Yet the most important moments in the history of art have been achieved with no money at all, by intelligent people with energy and integrity who just wanted to see something happen. That's a counter-argument to how much Britart has done for Britain. Maybe it hasn't done anything for Britain. Maybe we'd have a really good art scene now, and young artists who weren't desperate to be the next Damien, and who were more interested in making good art shows … I don't know, I'm just speculating.

So you don't believe that cultural branding helps the social perception of art?
Some pieces from that era are interesting – the early ones – but I don't believe that all the artists from that period could have been making work about the art of self-promotion. The myth needs exploding. Students

'This London studio is a semi-public space,' explains Gander. 'There are always people coming and going, and I have a night school here once a month. We have a clear-out, seventy people come in, and then people do lectures, like a salon ... Most students can't afford space, so I thought, If I've got a studio, it's selfish not to somehow share it.'

(top right) Gander's Japanese exhibition catalogues. He has ten shows in Japan in 2012.

need to know that Charles Saatchi is not going to walk into their degree show and pick three artists and turn them into people who go and have dinner with Bono from U2. There are of course better, more conscientious collectors who believe in supporting artists' practice, but they wouldn't be interested in turning you into anything. They are people who believe in what you are; they're not puppeteers.

What does the word *sanctuary* evoke for you?
Somewhere that protects you from external stimuli, which is a weird place for an artist.

It sounds like your studio in Suffolk ...
There is a trend with artists now ... I hear them saying, 'I don't need a studio; the world is my studio.' Or artists who live in Nairobi, Berlin and Wellington, and have a studio here, here and here. Or artists who work from a laptop; they only need the *Yellow Pages* and a mobile phone, and that's their studio. For me, it depends on what I am making. If there's a load of physical work that needs making and overseeing, we need a studio to do it. You can do it remotely – get everything made in China – but you lose a bit of something if you don't see it, keep an eye on it. But then, with the children's book that I wrote, I did it on holiday in France in a week. I didn't need a studio to do that! Some of the best work is made over the dinner table. So it depends on what you make, doesn't it?

Hannah Starkey

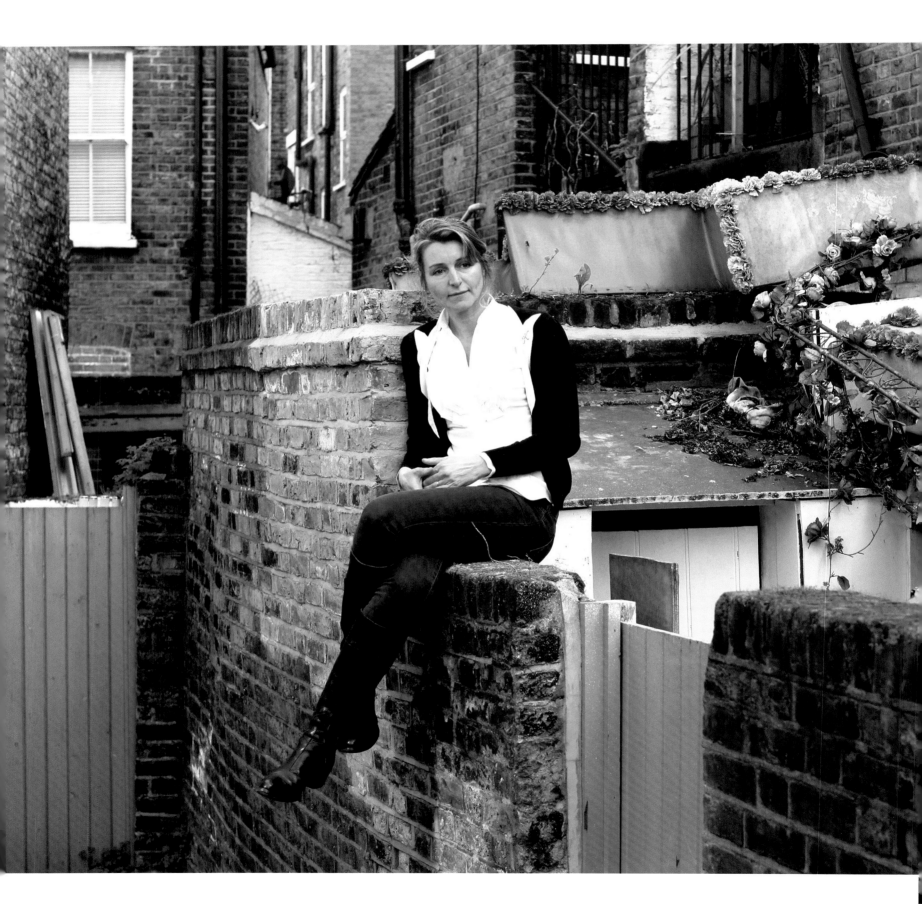

Describe the place of a studio in a photographer's life.

I generally work on location, but I do have a studio in Bethnal Green to which I can escape when I need space to think. It has my books and various bits and pieces for inspiration. I also use the studio to store my boxes of photographs and alternative prints, of which I have hundreds. For a lot of photographers, printing with an enlarger is an obsessive process; you get tunnel vision trying to find the perfect print. Those boxes represent hours of trying to get the best out of the negatives – the best print. The funny thing is, after a period of time you go back to them and it's often hard to see the very subtle differences, and even which print is the best. It's very subjective and depends on your mood and various other things at the time. So I don't throw those prints away.

How does the process work when you're on location?

There's no particular way of working. I see myself as a photographer who has limitless access to my environment, to my life in the city. I articulate myself and my experience through the photographs I make; they're often specific to women's everyday lives. Since I left the Royal College of Art, my work has been autobiographical in part, drawing on my long-held interest of documentary and photojournalism. Having also worked in fashion and commercial photography, I've been able to take all these different languages and feed them into my work. The striking difference with being an artist is that I have complete freedom as a photographer. Being an artist-photographer is the ultimate freedom.

As long as you're able to meet market needs ...

You don't have to meet market needs.

So what are your needs?

I am practising complete autonomy. No-one tells me what to do, what to photograph. I have no brief to fulfil. When you want that for your work, you make sacrifices. I have a different relationship with photography. I don't see it as a career; it's something I've done for a long time. I don't ask anything of it, and I don't ask anyone to help me or fund my work. It comes by itself; I just guide it and try to make it work. I think that's more interesting. Life is worth working out. Photography allows me to engage, learn and be inspired through observation. I'm lucky that people find my observations noteworthy and my photographs collectable.

Hannah Starkey (opposite) photographed beside the remnants of a Hindu wedding ceremony, dumped in a backyard near her Bethnal Green, London, studio. 'I see myself as a photographer who has limitless access to my environment, to my life in the city.'

Where did this urge to photograph originate?

When I was at school, a photography GCSE was introduced. I took it up and got an A+. Then I studied it at A level, and at degree level. Then finally I did an MA at the Royal College. So it seemed a very natural progression.

It triggered an interest in how women are depicted in our visual culture, particularly in magazines and advertising. I know how seductive and powerful these images are and how destructive they can be. So I wanted to create an alternative. To give back some control to the female subject rather than creating one-dimensional or stereotypical depictions of women. I'd like to change the hierarchy within that type of image-making and then change the value system. Subliminal messages in photographs of women can be changed, and positive role models should be encouraged.

That's a rather big ambition.

Yeah, I know. All the reasons in the world to try and do it.

Is this a mission or an artistic expression?

It's both. It's born out of direct experience. I went from being a young woman to being a mother of two daughters. I have direct access to something that is incredibly influential for generations of girls, but unless you're in that space at that particular time you cannot see it. Self-esteem has to be more than this obsession with being perfect. What I find really interesting is that no-one seems to want this. Instead, it's being controlled by the advertisers, the people who are selling products and creating advertising campaigns. When I work with professional retouchers, I always make a point of asking them what advertising photographers ask them to do. The answer is invariably, 'Make the models thinner.' Thinner, thinner, thinner. It's very damaging.

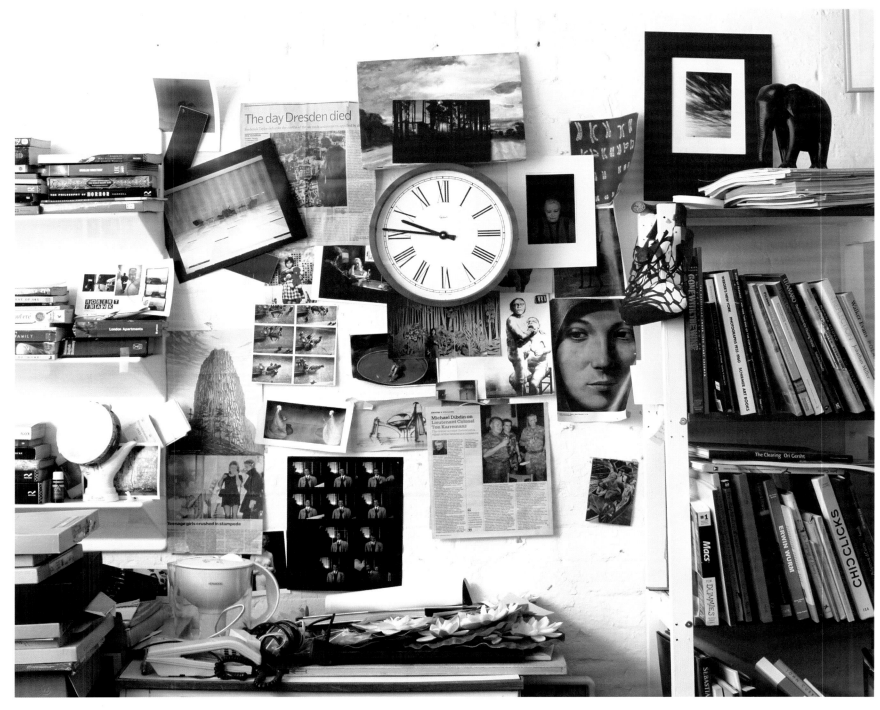

'I articulate myself and my experience through the photographs I make; they're often specific to women's everyday lives.'

What evidence have you seen that your work or work like yours has made a difference in perceptions?

I haven't really got there yet. I'm trying to figure out my own language without any restrictions.

You mentioned earlier that you had to be represented by a gallery, that you had to abide by certain promotional criteria, which doesn't please you.

I'm lucky to be represented by great people, and the advantage of having them around me is that they look after me and my interests. I can just get on with making work. My gallery also understands who I am and what is important to me. I'm not very good at posturing and positioning to build a reputation. Growing up in Northern Ireland I learnt that what really matters in life is not what you can get but who you are. I have my own criteria for what I want to achieve in my work. What I strive for is autonomy. Photography is quite a natural, instinctive, virtuous way to move through life, and my galleries can make that happen for me.

How much does film influence your work?

I've been watching films all my life. I think it's something most of us are very educated in, even if it's just through experience rather than study. However, in my work I'm interested in celebrating the idea of the single image. A photograph isn't a frame from a moving image, or even part of a sequence. It's one image that exists on its own and tells its own story. Within that image it has to contain the analysis that begins and ends outside the frame, and it's imbued with all our understanding of photography. I like the lightness of a photograph. It's not necessarily laboured. One second the shutter is open and it's beyond my control, then it closes and whatever's there is there. The framework of control as well as the nature of the medium can allow elements of serendipity which you then can build into the language of a photograph.

The pursuit of the 'beautiful' photograph, the image that manages to say everything so eloquently

and so poetically in a language that everyone can understand, is an amazing thing to strive for. Certainly film does influence me, but it's such a subliminal influence that I couldn't pinpoint one particular film any more.

How do you define being an artist as against being a photographer?

Being an artist is something that you are, as opposed to something you make a career out of. It doesn't seem that difficult unless you put restrictions on yourself. I didn't want to be an artist just because I could wear

the right clothes, hang out with the right people and so forth; that is more of an affliction than a life choice. I am interested in people and I like making connections with them. Art photography allows me to do that in a way commercial photography doesn't. There are of course similarities. I'm still armed with a camera and I still capture images that I hope people will enjoy looking at. But, being an artist, I'm able to walk the streets under the radar and without an entourage of people in tow. So in a way I am disguised.

You penetrate the harem of the night ...

That's one way of looking at it. I have an inquisitive mind, and the packaging that you're in is what allows you to move among people and maybe not be noticed. Not be stopped. Not be questioned. It's one of the perks of being female.

Starkey (above) **uses the studio to store boxes of hundreds of photographs and alternative prints. 'Those boxes represent hours of trying to get the best out of the negatives – the best print. The funny thing is, after a period of time you go back to them and it's often hard to see the very subtle differences, and even which print is the best. It's very subjective and depends on your mood and various other things at the time. So I don't throw those prints away.'**

Howard Hodgkin

What is the role of your studio?
It's where I go and hide.

Intellectually or personally?
Both.

Has your studio always been important to you?
Yes. I will never be able to do any work without it.

Did you have a studio to begin with?
I always had a room that I used as a studio. My first studio outside of the home was when I started earning my living as a teacher at the Bath Academy of Art.

Did you like teaching?
I liked it too much in the end. It's a great trap for artists because most days – this is very long ago – you couldn't really earn your living as an artist at all, unless, oddly enough, you were a sculptor. I don't just mean Henry Moore and Tony Caro; people wanted sculpture. They wanted paintings much less.

Do you care about money?
Oh yes, because I am a dedicated shopper and a collector, and you need money to be a collector.

Do you collect anything in particular?
Indian paintings, ever since I was at school. Indian paintings are very special to me as an artist in that they are very formal and yet they are very representational as well.

Do you mean miniature paintings?
Yes, but the word is misleading; some of them are very big.

You've talked about every painting being a memory ... So paintings are memorials of a sort?
Yes.

When you start a painting, do you have a conscious memory that is reflected in the piece, or does it just evolve?
Of course I have a conscious memory.

What art movement would you say you most identify with?
I don't believe in art movements.

Howard Hodgkin in March 2011 in the garden outside his Bloomsbury, London studio, where he admits to hiding 'to keep space for myself. I don't think of it as a luxury; I think it is a necessity'.

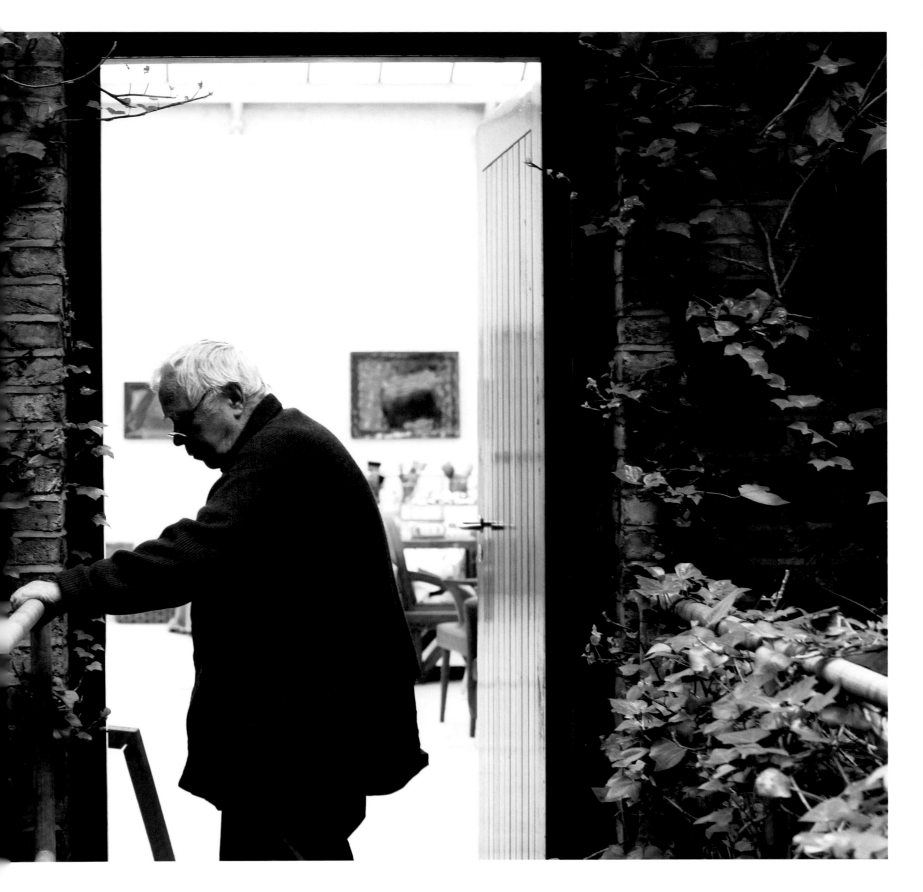

That is a profound statement. It goes against the grain when everybody makes their money today talking about how movements affect other movements and one artist affects another. Is that all bunk?

Probably. But it is the best they can do. Long ago I said it would be interesting to see what happened to painting now that there was no-one to tell you what to do. In the past, the patron would say, 'I want this' or 'I want that'; nobody would dare say that to an artist now.

Is that a good thing or a bad thing?

It remains to be seen.

Do you believe that artists get too much adulation or too much money today?

I am all for *all* of that.

I suppose you could have chosen to do anything – why painting?

I can't do anything else, that's why.

Harking back to the '50s, how different was that time from the art scene today?

Totally different, because of money. There was no money in the art world in England when I was young. I remember being asked by an interviewer in New York what I thought of the art scene in London. I said, 'There isn't one.'

Has this engine of money corrupted the art scene?

It has not corrupted any artists that I know of. I think they are all very happy to have it.

You come to the studio every day ...

I hide in it, if possible. From the telephone.

Why do you hide, if I may ask?

To keep space for myself. I don't think of it as a luxury; I think it is a necessity.

How does it make you feel that artworks which you cherish end up in someone's home?

I am delighted as soon as a picture is sold. First of all, it is nice that someone likes it enough to buy it, and nice to receive the money. But I can't wait for them to leave, you know. They are like children you want to go off and look after themselves.

Have you ever kept a painting back for yourself?

Never, except the first painting I ever did. Sickert said that he couldn't live with his own work because it was a reminder of past miseries and past disappointments ...

Have you ever doubted yourself?

I doubt myself every morning, every minute.

And that is part of your artistic process?

Absolutely.

You ran away from school, from Eton and Bryanston ...

I thought that if I stayed where I was, I would never be an artist. The only person who understood it the first time I ran away from school was a policeman who stopped me in the street and said, 'Where are you going, young man?' I said, 'I'm running away from school.' He said, 'Why are you doing that?' I said, 'To be an artist.'

Why do you remember that incident so precisely?

Because he was the only person who took me seriously. He thought it was a perfectly practical reason for running away from school, and he was right.

The schools were all in their way very good. I was completely wrong, particularly at Eton, because I thought the sort of people who were there were not at all interesting. But I grew very close to the art teacher Wilfrid Blunt, who was a charming and wonderfully silly man. My next great teacher was Charles Handley-Read, who wrote the first book, so he claimed, about Wyndham Lewis as a painter.

Poussin is referred to quite a bit in reference to your work. Why is that?

He is the greatest Classical artist that ever was. His work contains, as far as I am concerned, almost all human emotions.

What would you most like to be remembered for?

I never think of that. I don't care what people remember me for.

Hodgkin holds the first painting he ever created, in 1949 – the only painting he will ever keep for himself. 'Sickert said that he couldn't live with his own work because it was a reminder of past miseries and past disappointments …'

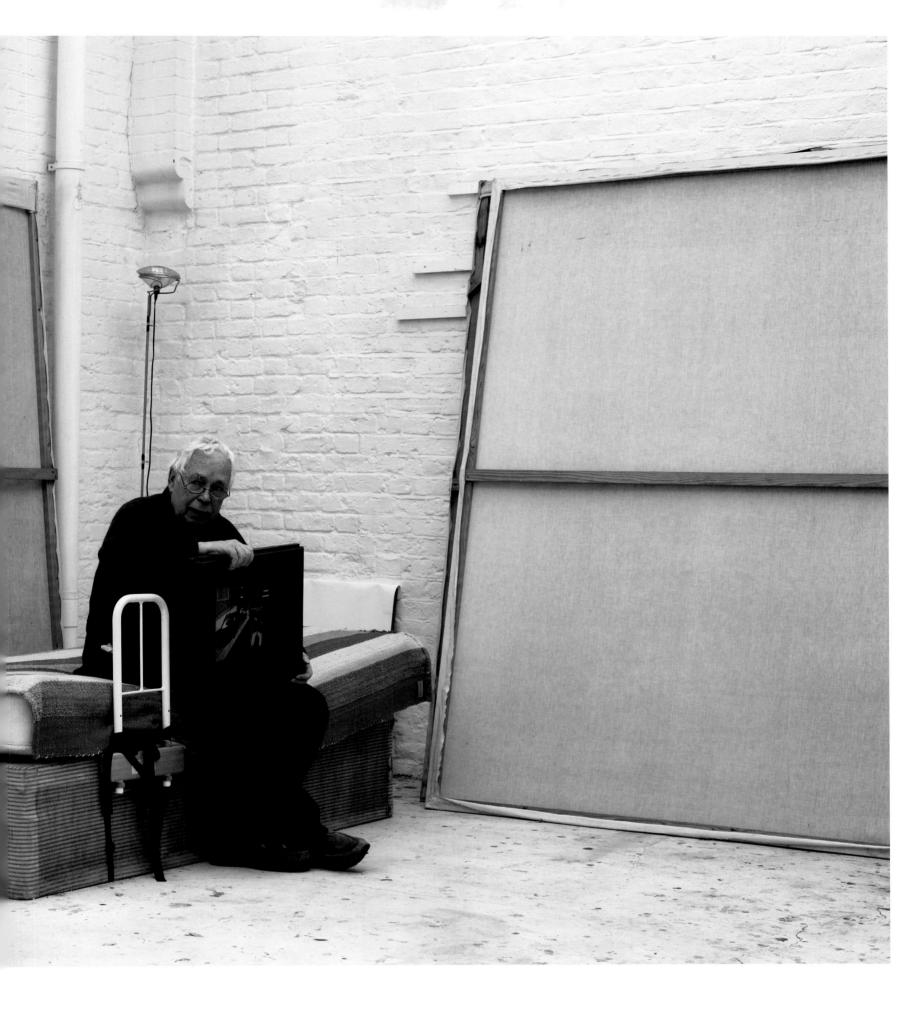

Maaike Schoorel

You were born in Holland; you work in London. Is London the centre of contemporary European art?
It is one centre. There's brilliant art everywhere, but for me it was a good step to move to London.

What was the thing that drew you to London?
When I was a student at the Rietveld Academy in Amsterdam, there was a lot of discussion about London because of Britart. Things were starting to happen there that drew some foreigners.

Are you an artist who likes having celebrity status, or do you think an artist needs anonymity to be able to develop their work?
I don't know. It's something I think about sometimes. I think it depends on what you're trying to say. Of course eventually it is only about how the work is done, but being an artist is not only this isolated thing where you make a work in the studio and that's that. It's a way of living. For me it's important to have discussions with people outside of my studio, which is part of the discourse of art and the discourse within my work. I discuss a lot with curators and other artists in order to create what I do. The idea of creating something is interdependent; it's not something you do in your own little space.

What role does ephemeral and negative space have in your work?
Obviously a big role, because in the first instance it looks like there's nothing there. It's as if you're looking at a blank space or a dark room that you've come into, and then slowly you can feel your way through something. It emphasises the experience of looking. The negative space in my paintings, one could say, is the space that's not painted onto literally, although the canvas itself is always prepared in a specific way with either off-white or nearly black gesso, gently tinted with shades of yellow, pink, green or blue. I play a lot with the idea that initially you think you aren't looking at anything, just dust on a canvas. My work is involved with perception.

Is this somehow linked to your own memories?
Some of the photographs I work from as source material capture specific personal memories in generic images.

People like to have these discussions about memory in relation to the work because only certain parts are more visible. For me it's more about a different way of looking, about trying to ask how we can approach things in a new way. It changes the hierarchy of looking. For instance, when you listen to music, tones come to you at different speeds. That's how I see the paintings: their different colours and

textures move towards you. In my paintings, the detail of a pattern of a bed sheet might catch your eye sooner than the person lying on it.

Is there mystery in your art, or a subtext? Or do you leave it to the viewer to figure out?
I leave it to the viewer to some extent, because my work hovers between abstraction and figuration. Whether you see the actual image I work from is not that important. The fact that you see an image forming and collapsing again is a process that I find very important.

How long does it take you to finish a work?
It depends. I make very few paintings in a year. Some paintings I work on for many months and then I leave them for a while. Sometimes they get taken out of the studio because it's not so good for me to have them there for too long.

Are you ever happy with your paintings?
I am, but it's a struggle. I am too much of a perfectionist. And of course nothing is ever really perfect. Failure is part of the process of the painting, and the charm. Probably if they were perfect, I wouldn't be happy either, so it's a process of searching for things. Even when I paint, I don't know exactly what's going to happen. I keep changing and then rubbing out. You're always going to be left with traces of that.

So the end product is not the original intention?
No. You have to feel rather than try to understand it all.

Do you have any fear that what you're doing isn't good enough?
If I'm honest, I think that most artists feel that fear. You always have to project this idea that you're great. I do think my work is good eventually; otherwise I wouldn't put it out in the world. But I think the constant questioning is a natural process, and you have to try and work with it to see whether the questioning comes from your ego or is genuine questioning of the mind.

Is there a difference between the ego and the artist's mind?
This is more about the spiritual quest in general. That's why the question of being mindful is becoming more prominent in our hectic society at the moment. In the Western world our mind is often thought of as formed by our thoughts and emotions. As an artist, to be able to create, I try to connect with a natural state of mind and not get distracted by thought patterns or all the other noise that surrounds us.

'I play a lot with the idea that initially you think you aren't looking at anything, just dust on a canvas. My work is involved with perception.' Maaike Schoorel creates very few paintings each year and only works on one at a time. 'Failure is part of the process of the painting, and the charm,' she says.

It has been said that you maintain the most characteristic traditions of classic Dutch art, including the informality of the domestic interior and the intimate portrait.
I make a lot of references to archetypal painting, not just Dutch painting.

Do you remember your first studio?
It was in London. It was a very dark building, but I loved working there. There were a lot of interesting artists working in that building, but there were leaks and the toilets stank.

It's interesting that you pointed out that it was a very dark building. Is light not important to you?
It's hugely important, but at the time I would've taken anything. I didn't have much choice. Then I moved to another space in Hackney Wick. They have beautiful studios there. But I sometimes work until very late, and I didn't feel safe there at night.

What does this new space signify for you?
It makes a huge difference if you've a nice place to work in. The studio I have now has a very special atmosphere. Sometimes even if you don't physically

Schoorel in front of the
Hayward Gallery, London,
where her work was featured
in *British Art Show 7:
In the Days of the Comet*.
'For me it's important to have
discussions with people
outside of my studio, which
is part of the discourse of
art and the discourse within
my work. I discuss a lot with
curators and other artists in
order to create what I do. The
idea of creating something
is interdependent; it's not
something you do in your
own little space.'

make work, it's very important that you feel comfortable because you build up energy. It's like when you go into a classroom where people have just had an exam and all of them have just left … you can feel it. When you have difficult moments where you question everything, you come into the studio and say to yourself, 'Okay.'

Say you've had a rough night. You go into your studio the next morning. What is it in that atmosphere that captivates your mind? Is it something that you grow into? Or that grows around you?

It grows around you. Literal objects help. I always have flowers, and I have a couch. But it's also the atmosphere that you build up. The flowers are really Dutch. That's something that I grew up with. And I have a couch because it's comfortable!

Do you take naps?

Lately not so many. Most artists have naps because afterwards you work a hundred times better.

What objects in the studio particularly fuel your psyche?

I don't want to have that many things around me. I like to have my paintings around me, but they all have to be turned to the wall except the one I'm working on. And then I have certain items that people gave me that have come into the studio – I leave them in a corner – and some of my really old sculptures. If I had the paintings all facing out, I'd be really distracted. When visitors come, I turn them face out. But the minute people leave, I turn them around again because otherwise I can't focus.

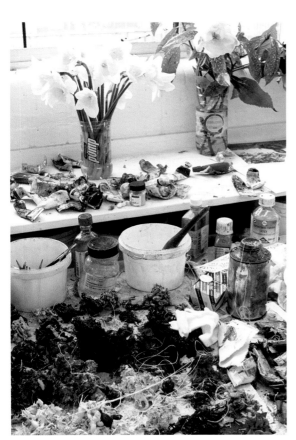

Do you resent intrusion into the studio?

Of course it's nice, but I have to prepare. I don't like to have too much of it. It's good to have a discussion, but not always. At certain moments it's also good not to have that discussion. Once I had someone who was important to me come to the studio. He said, 'This painting doesn't look so good' and I had to turn it to the wall for so long! I had so many struggles with it because of what he said.

So insecurity is very much a part of the creative process …

Doubt and insecurity can be part of the creative process. But in my case it can sometimes be too much of a hindrance. It's something I'm working on to improve.

Is there intentional sensuality in your work? Does an artist have to be sensual to portray a sensual moment?

Most artists may naturally be sensitive. Anybody can be trained to make things, but one aspect that can

create art is empathy. If you think about Vermeer painting portraits or domestic settings, many people did that at that time. Why do we look at his paintings rather than at the other people who were doing a similar thing? It's because of the empathy he felt towards the subjects he was painting. The light source is felt within the painting. That comes through in the way the lines are drawn and colour is formed. If he paints a pair of lips, the line goes through the lips rather than just being an outline; colour and shape are formed by their interrelationship with light. You sense this awareness in the way it is painted.

Do you enjoy success?

Of course! Who doesn't? It's good to have your work out there and to have people being interested. It's a joy. What I would like is that my paintings are seen by people and that there is a discussion about the work. Otherwise there's no point.

Schoorel (above) at the London Fields Pub in Hackney, a regular haunt for a number of creatives.

Although Schoorel's paintings appear monochrome, her studio (left) is filled with mounds of colour which she uses in layers of paint and for grounds. Describing her studio decor, she says, 'Literal objects help. I always have flowers, and I have a couch … The flowers are really Dutch. That's something that I grew up with.'

Hiraki Sawa

You're Japanese; you've said that you're still an outsider. How does it feel being in the centre of London?

The reason I moved to England was to study art. That was fifteen years ago. I finished my Master's degree in 2003. I could have gone back to Japan, but I already had a gallery, and I had another gallery in Tokyo, and both of them said I should try to be an artist in London. For me it was challenging, to be honest. At that time I didn't know anything about being an artist. I couldn't believe that they were selling my work and paying me and supporting me. I didn't know how it worked. So I said, 'Okay, I'll stay.'

Do you think your decision to become an artist in London has affected your art?

Definitely. If I had gone to a Japanese art college, I might not be making video art; I'd be doing something else. Since I came here, I had to try and find a way to express myself. For example, I couldn't really communicate with my friends. When we had a tutorial or presentation, I couldn't talk like the other students. So I had to find a way to express myself without words. That really pushed me.

What does your art say without sound? What language does it speak?

It's my thought in my head that is the language. Even now I can't explain what I'm thinking with words, but with the artwork I can show this thought or these ideas outside of my body. I wouldn't say that it's a universal language but that I can share with somebody who has got different languages or without language. Sometimes viewers think in a different way, and that's fine.

I read that you've been inspired by children because of how they use their imaginations. Can you comment on that?

In 2004 I did a workshop commissioned by the Hayward Gallery with eight children, focusing on flying objects or things. One of the kids made a bus with wings on the sides. I asked why she wanted to have this flying bus and she said it was because the traffic in London was terrible and she wanted to get home as early as possible so she could have more time with her friends! I realised that children's imaginations are often mixed up with reality.

In 2002, I was kind of stuck in my work. My first video, *Dwelling*, was about flying inside my flat. Before that, I was making sculpture, objects, installations, kinetic works, moving and changing forms, but not videos; I had no computer. Then I had a chance to use a computer to make some animation, and I thought it was a great medium. I was really interested in making those moving images. After two years, I became stuck. It was almost like an accident to find this medium, and I didn't know what to do with it. Then this opportunity to work at the Hayward came along and helped me out.

So working with children got you past a creative block?

Yeah.

Dwelling created a lot of commotion in New York and London. What was it about the video that was so enticing?

I just wanted to have an aeroplane flying in my flat.

Why did people see it as so profound?

I don't know. In 2002, people were so concerned about terrorism. Every time I showed *Dwelling*, people came up to me at the private view and asked, 'Is it something to do with terrorism?' I said, 'No. This is more about what I think. The reason I use aeroplanes is because my granny used to take me to airports to see the planes and I just loved it.' I used to go to Heathrow to watch the planes every Sunday. That's why I did it. It had nothing to do with terrorism, more to do with memory and imagination.

Then people started forgetting about terrorism. But people still say that's what children do – when they go to sleep, they imagine something flying around the room. Maybe that's why some critics say that my work has to do with nostalgia. But it's not about nostalgia. It's about memory.

What is the significance of the studio in your work?

I didn't used to have a studio. I worked at home. Since I moved into a studio, I've been able to try things out more. I can make props. It's widened my creativity.

Is the studio a place of comfort or purely a place of work?

It's like my living room. Otherwise I can't work, I can't think. I just go home to sleep.

Why do you have a studio in Hackney?

I was at Angel first. Then I moved to Essex Road because the rent had gone up. Then the rent went up again so I was pushed towards Hackney. Almost every year I was pushed further out from the centre of London because of cost.

It's been said about your fascination with deconstructed motion that your antecedents in film are Alfred Hitchcock, Busby Berkeley and John Ford.

No! I'd be embarrassed! I'm not that great. I just did it for myself. For me, video is about making an object, making a sculpture. I don't think I'm making film or video. I just like making. I'm still into handwork.

Your obsession with time is interesting. Are you trying to control time through your artwork?

I'm interested in several things; time is one of them. I'm also interested in borders.

What is it about the multi-screen process that appeals to you?

There are things I can do with multi-screen, making atmosphere, time and space with different screens. I think single channel can do it but not as strongly.

What are you working on now?

I'm thinking of making something about sleep. I'm not sure if I can do it. I've got this project with a friend who is an amnesiac. I'm not making a work about his life; I just started thinking about memory as a result of his experience. He went to sleep on the sofa for thirty minutes and woke up without his memory.

Hiraki Sawa (left) in front of a projection of his work *O*: 'If I had gone to a Japanese art college, I might not be making video art ...'

Sawa (opposite) on Ridley Road Market, Hackney, where his studio is based. Born in Ishikawa, Japan, Sawa arrived in London as an art student and has lived there for fifteen years.

Katy Moran

What was the first formal studio you ever had?
It was in Peckham, South London. It was small, with a window, in a big block. I got it through a friend when I finished college. I painted at home as well, because I use acrylic paint; it's not toxic like oils and turpentine. So I painted in my bedroom until I got my studio. I just need a place where I can shut the door and get on with it, shut everyone and everything out so I can concentrate.

What does the word *sanctuary* mean to you in that context?
I never really notice my surroundings at the studio. I never would make an attempt to make it nice. A lot of artists go to their studio and spend time making it just right, the right atmosphere in which to make work. I just needed a space on the floor, really, just a room, and I didn't care what it looked like, or what facilities I had, as long as it had a kettle and I could make a drink. Now I am getting older, I need to make it a bit more comfortable, a bit more of an attractive prospect to make me want to spend time there. The studio I am in at the minute has an outside sink, and in the winter I always wash my brushes under the outside tap, so I am getting a sink installed to make that more homely. A studio can be a bit of a mess as well, and now I feel like I need to get a sense of order; I need things to have a place. So I am changing the way I think about the studio, actually.

When you want to be alone but not to paint, where do you go?
I go to the gym, I go swimming. I get ideas about what to do with my work, see it as thinking time. It is a bit meditative. I'm swimming up and down, just doing lengths, and then I start thinking about my work and what I might do next; things just come to me. There is no distraction. If I am at home and doing things with people, daily-life stuff – really boring everyday tasks – gets in the way.

Tell me how the last idea you got by swimming or walking about got transformed into a painting.
I had made a painting, and there were interesting parts of it, but it wasn't working as a whole. I was doing my lengths, and I thought, I could take the painting off the canvas and cut it up, cut it in half, and then start playing around with those two half bits of canvas … That just came to me when I was swimming. I don't know if I would have thought of it if I'd been in the studio looking at the work.

What's the best inspiration that has come to you recently?
There was one evening when I was at home watching TV and I put these paintings on the ledge in front of me. I often have paintings that are in a half-finished state on this ledge, so while I am relaxing or watching TV I am looking at them and working out what to do with them. I got this inspiration for what to do with this painting so I took it into the studio and started working, and within five or ten minutes it was finished.

How long had it been sitting on the ledge?
Probably a couple of months, but the actual painting was a few years old. It was like a series of attempts to make a painting. It doesn't work so then you start again, layer upon layer upon layer. So it had been going on for quite a long time, and then I resolved it in ten minutes. You just think, Well, if I did that painting in ten minutes, where is the logic in slaving away over something for eight hours a day? Is it just that you wait for that little window of inspiration and then it happens in ten minutes? How do you set that up again? There is no rationality to it, I suppose. But it is great; I welcome it.

How many times has that happened to you – a ten-minute painting?
Very rarely. But it's not a ten-minute painting; it's the icing on the cake, that moment when it all comes together. Often I am working and nothing is happening; I am just putting things down. Then it's that moment where something happens and it is resolved and comes together, that moment you are always chasing. You can't plan it or necessarily create the atmosphere in which it is going to come about.

Is painting a struggle for you?
Yeah, it's exhausting. It's also infinitely fascinating because there is no set formula. You can create an environment where things will happen; you can follow certain processes that you always follow. But I am always waiting for this thing to come in that upsets the process, or sabotages it, or introduces something new and gives me that moment of excitement that I didn't expect. It's about being greedy for chance, I suppose, chance and accident that work in my favour.

Is a finished painting an accident?
Yeah. I have maybe five different strategies that I employ to start a painting or to carry on or whatever. That is all controlled, but there is this small

area of chance and accident that you want to come in and suggest something that you couldn't plan for. The things I could intentionally create or plan are not going to be as exciting as things that come about by accident; they seem more interesting, more authentic, because they come from somewhere else.

Sometimes you've taken a picture on your phone and then done something to that image … does that still happen?
Not much at all. But I often use collage. And I have shapes to work over and work with, because otherwise there is no reason to make a particular shape or use a particular colour. The other day I found myself picking out pages in a book; wherever I opened the book, I would take something from that page and put it down as an image. It was totally random, just to get something down on canvas. To get me to that point where something interesting was happening. It doesn't really matter how I do it.

You talked about four or five techniques that you use. Are they trade secrets?
Not really. Erasure is one of them. I put paint down and then I take it away. That way, I am losing control. New marks are created that I didn't make with my hand and didn't plan for, and that may suggest something different. Or turning a canvas upside down, or on its side, or taking a canvas off the stretcher, piecing it together with other things. I am not so bothered about colour. I use colour, but it doesn't really matter.

Your paintings have always been small. Is there a reason for that?
The sense of illusion that I am interested in happens best at that scale. I've noticed that when I go to exhibitions, I am often drawn to smaller works. It's something about distance, about the relationship you have with the painting, where you stand and what you see. I don't like feeling that I have to fill a certain size, that that size is controlling me or determining what I do. But sometimes I work with a larger board or canvas, and then within that I crop and find paintings within the larger painting. That seems quite authentic, less contrived sometimes.

Does design figure in your art?
I look at a lot of interior-design magazines. The scale of my paintings definitely relates to the domestic, and I am interested in that.

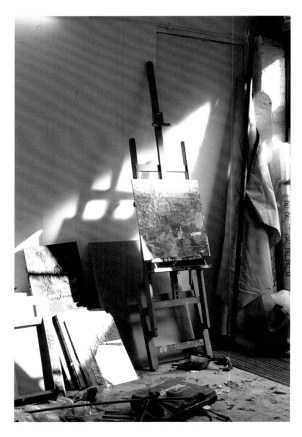

What do you mean by 'domestic'?

Domestic scale. I think of things in the house as well as on a white wall in a gallery. Now I have got my own house I can be quite obsessive about it. I start seeing everything like a painting. I want everything to harmonise.

What are the influences that bear on your art the most strongly?

Outsider art, Francis Bacon and Surrealism. I like lots of different artists for a lot of different reasons, and my tastes change.

Do you care about success?

I want to have a long career and a credible career, and I want always to make interesting work. I want to be honest with myself. That is my definition of success, and of course if people appreciate it along the way then I will be very happy.

Is money important?

Money is important to a certain extent because I have a family and a house and I want to enjoy a reasonable lifestyle, but I don't want that to be at the expense of the work. That is something I always need to be careful of.

Do you have an audience for which you paint?

I paint for myself. I don't want to think about an audience because it's not a natural thing. If people say they like a certain painting, I can't replicate it because it would look contrived. But there are a few people to whom I always show work: my friends, my gallery. My gallerist Stuart Shave has been a very important influence on my career, and I value his opinion on new work very highly. I don't tend to show my friends until I have got to know the work and feel that, whatever they say, it's finished.

Does family come into play in terms of criticism?

Sometimes my husband is around, and he has an opinion, so I listen. But he's a football reporter!

If you were to define your painting, how would you do it?

The paintings are very personal, I suppose, but they are always figurative to me. That is when they work for me. I often feel quite disillusioned when I am painting. I feel like it is a bit worthless, pointless, especially if I spend the whole day painting and then am left with this mess on the canvas. I just think, That was a complete waste of my time! But it never is a waste because it always goes on to inform something eventually. That painting that didn't work, in a

Katy Moran sometimes works on paintings over several years. 'That painting that didn't work, in a few months or a few years, can come back into play with something else; it's the grounding for another idea, another painting.' She gravitates towards smaller works, explaining, 'I don't like feeling that I have to fill a certain size, that that size is controlling me or determining what I do.'

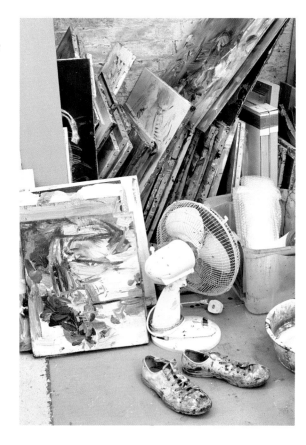

few months or a few years, can come back into play with something else; it's the grounding for another idea, another painting. You are just trying these things to get closer to something that actually means something to you, and it is a struggle. It feels like this elusive thing that you are chasing, but you can't even work out what it is until you see it.

Are you affected by your moods when you paint?
Yeah. I get very depressed and it just seems worthless. I am always trying to work out what works best for me. There's no rhyme or reason to it. It sounds pretentious, but it's like an athlete who has pent-up energy and has got to run a race and get it out of their system. It is like that with artists; you can never quite relax until you have got that next painting done. And even when you have done that, you feel like you'll never make the next one, so you are on edge until you've done it.

Moran leaving her Kensal Green, London, studio.

Des Hughes

Is London the centre of the art world?

Even if it is the centre of the art world, it does not necessarily mean that all artists need to be there. I think it's important for an artist to have a standpoint, a viewpoint from a particular place, not necessarily from London looking at the rest of the world.

I was always desperate to get to London, even when I was a child. I graduated from Bath College of Art, and it was a very gradual process working out how I could get there. Now I find it quite odd that there can be hundreds and hundreds of artists living in the same artificial place.

You're living this country idyll and you produce extraordinary urban art. Is that a contradiction?

Often it's to do with people. A lot of things I'm drawn to are anecdotal. The sculptures come about because of combinations of objects or practical decisions that people make about objects and about how they use them, also the way in which objects acquire certain values. You can find that anywhere. As for the effigies, we're surrounded by them here; in most small churches they're just there, abandoned. It's a different type of history or a different type of time than I used to find in London. Every square inch of space here isn't monitored. As a result, things just sit there gathering dust.

Are you a sort of social scarecrow?

There's a certain aesthetic about a scarecrow, about the way scarecrows are put together. They've a casual resemblance to a person. In the past I modelled effigies on my own proportions. I've got a collection of photographs of effigies, based on their poses. They're posed in symbolic ways; the use of animals is very significant. What I find most interesting about them are the practical decisions that were made, especially when effigies were carved from stone. A lot of the decisions about proportions and pose had to do with the practicality of the material. You only want to do as much work on stone as you need to do to suggest that it's fabric or chain mail. There's a lot of shorthand that goes into the surfaces. The proportions are likely to do

with the material and the fact that they're supposed to be quite resistant; there's a certain robustness about the shapes. That's why they often look like bollards; there aren't many bits that protrude. I walk to one of these churches; I find a medieval effigy; there's nobody around; I can go and just stand with it. There are craftsmen's criteria for how these things are made.

In a manner of speaking, you're immortalising outcasts or casting non-existence.

I think so. Also the fact that they're clothed, wrapped up … I build a kind of armature and it gets dressed or clothed. It's a system that stops me having to make certain decisions.

Do you make your own things, modelling, casting and so forth, or do you have assistants?

I have assistants for some jobs, although very often the only way I can explain myself is through the making. Not that they can't do it properly; I just think there are decisions to be made. The process of casting is considered to be a kind of truth. You get an object and cast it and you end up with a version of it in another material, with another truthful version of it. Having taught these kinds of processes for years, I think it's possible to keep some of the object's vitality. The good thing about rusted objects, depending on where they go and who does what to them, is that the rust will carry on rusting.

What does your studio mean to you?

I have different spaces for different parts of the process. The outside space is basically a workshop. You go there with a procedure in mind, do it as quickly as possible and get out. I've always had an odd relationship with studios. I've had various studios and they just seemed to stagnate. Once they're too full of my stuff, I don't feel very comfortable being there. The process that I've worked out now is much more fluid and practical. I tend to use the office when I do watercolours. Where the work actually takes place I'm not sure, really.

Des Hughes admiring an effigy at his local church in Kington, Herefordshire. 'I walk to one of these churches; I find a medieval effigy; there's nobody around; I can go and just stand with it. There are craftsmen's criteria for how these things are made.'

Hughes keeps geese and ducks at his Herefordshire home, which he shares with his wife Clare Woods, also an artist. Of living in the country, he says, 'It's a different type of history or a different type of time than I used to find in London. Every square inch of space here isn't monitored.'

Do you control every stage of your sculpture production?

Yeah, apart from the bronzes, which I started making in the last two years or so. It's a liberating technique because you can hand the work over to an expert. But when it comes back, there's still a certain intimate connection with the work. The polishing is very, very time-consuming and puts you in an intimate position with the work.

Is there room for the studio in the overall scheme of art today?

I'll always have a studio, even if sometimes it's empty. The processes that I use are quite archaic. In the past, effigies were commissioned to commemorate great people; that's what my effigies aspire to do. For some reason, the fact that they're clothed, that they're wrapped up against cold weather, that they end up slouching or looking slightly contorted, gives them an element of realism. There's a sort of composure but also a certain vitality.

When did effigies and their iconography first take your breath away?

I was always taught that certain objects are considered to be sacred.

Is your work somehow a process of mummification?

Kind of. There is a certain weight and permanence.

You think about your work as existing in an ideal space. It doesn't have to sit on anything or fit onto a surface. It just exists. It's possible to walk around things in your mind, to pick them up and flip them. The closest I ever got to that was making small sculptures; I could have things in the palm of my hand. I would bring them home and just sit them somewhere; then I could put them somewhere else. The house is full of things. When they're first made, they're perfect. But unfortunately these things have got to exist and go off somewhere else. There was something about effigies … during the Reformation they were damaged or stripped. It's about me acknowledging the fact that maybe these things will have a future and a past. They don't exist in an ideal space any more.

Do artists tend to take themselves too seriously these days?

I don't think so. Even artists who deal with humour or failure require seriousness. It's difficult, I think impossible, to function as an artist and not have a certain amount of drive and focus. Even if chaos is your subject matter, you have to be clear about how you produce it.

Do you concern yourself with commerce?

I produce things that are very impractical and that also require a lot of responsibility to own and look after. Sometimes the outcome is more practical for someone, depending on their level of engagement with the work.

Without money it's impossible to be an artist. I'm not saying that you need to build an industry around your work, but you need to be able to produce it. You need as much money as it takes to produce your work.

Your wife Clare is also an artist. Does she criticise or influence you, and vice versa?

Yeah. In a way you always make your work for one person.

Is Clare that person?

I think so.

An old horse barn (above) where Hughes stores many of his works.

'I've always had an odd relationship with studios. I've had various studios and they just seemed to stagnate. Once they're too full of my stuff, I don't feel very comfortable being there.'

Rachel Kneebone

How would you describe your daily routine?

Because of the way I work, it's not really like work; it's simply what I do. I get up, I come to the studio, and then I go home. For most people when they go to work, it's much more separate. This is more of a daily conversation that I have with clay. What I produce is a side-effect of a thinking process.

Do you ever get post-natal depression, as if your art is a kind of biological thing?

No, because there's always the next thing. Which isn't to diminish what I make. I don't want to make something better; it's more that there's never nothing to do. There's never a definitive work. It's not like I make something and feel any completion beyond knowing when a work is finished.

So you're walking in the street and suddenly you see something that inspires a reaction, or a thought comes into your mind and you build on it?

Yes. My work is my response to being alive, to big things, to tiny details … to the way I see someone standing.

What are the basic building blocks?

Well, I have my language, and that's always evolving. When I started working in porcelain my works were simpler. When I look back at pieces I made before, that was almost like when I was working on my words. And when I got more familiar with my words, then I could say something of greater complexity.

So you're developing a language?

I never know where I'm going. When I make a work, I generally know my starting point. The actual making and the problem-solving – my thought process is linked with the making process – are how it develops. A drawing never becomes the sculpture because something happens in the physical act of making the work.

Are you constantly exploring the same museums or galleries or books? What are your research tools?

I've just begun looking at still life because I felt very still and stuck. I went to the Wallace Collection to look at still lifes, and I was reading about Freud and repetition. It's like feeding, all these things, these different references. Around Christmas, I went to Selfridges, and there was a shop assistant who was clearly very bored – he was just static – and I thought, 'There's still life.' So there are loads of references. I couldn't say, 'My work is a response to that,' because it's a fusion of things.

So the thinking comes before the seeing?

Yes, because if I don't know what I'm asking of the piece, what I'm questioning, I can't make anything. There has to be a drive. I can't make just for the sake of making something, which can be annoying.

Are you concerned with movement and flow?

Always, because life is movement. Although the works themselves are made of porcelain and they're rigid, something seems to be moving within them. Some of that is my process with firing and shrinkage. The clay does literally move when it shrinks by 20 per cent.

This sense of inspiration from the netherworld, from Hades, from metamorphosis … what draws you to that? Are you trying to make the viewer see a darker side of life?

I can't make anyone do anything. And I would never want my work to be that didactic. But I do address, or question, or look at, things that I guess someone might say suggests a darker side. When I made *Lamentations*, I was looking at grief, at ideas of loss and death. So yes, I would hope that people looking at those works would feel that. But I can't make a definitive statement of, say, sadness because next week I might know a different sadness. Everything is always in a state of flux.

I see my work as a process. I know that my works exist, that a moment is arrested, but that's still not it. My problem is talking about it; that is why I make art. Because there are things there is no language for. Communicating: that is probably why I work.

Why did you adopt a seventeenth-century style of ceramic-making?

I've worked with clay since I was eleven. Obviously it was a choice to use clay, but it wasn't a calculated decision. Why does the painter use paint? It's my material; it's what feels natural to me.

The whiteness of my work is in order to try and

Rachel Kneebone off Broadway Market in Hackney, London, in March 2011.

keep it fairly ambiguous. Colour locates meaning in a way that white doesn't, and I love the super-glossy glazed surface of my work, the wetness. It comes in and out of focus when you look at it.

Obviously there is an element of artifice in what I do. It isn't real, but it is real to me. I work in the in-between. The cracks are where I see myself working, in the gap between life and death. That's the space I'm interested in.

People often comment on the sexual content of your work. You've said that it's there but not the primary focus.

My work is sexual, but it's not about fucking; I think that's the misconception. My work has a strong feminine and masculine element to it, but the use of sex is more like erotic fusion. You can access that presence-by-absence through orgasm.

What does your studio represent to you?

It's an anchor. But it's not always peaceful. It's not always good being here. Some of my biggest fights have been in here, with my work and with frustration and boredom.

Have you ever smashed a work in anger?

Not in anger, but I do break things, because you can't keep everything. If it doesn't work, it doesn't work. I only break it if it needs to be broken. I have that authority.

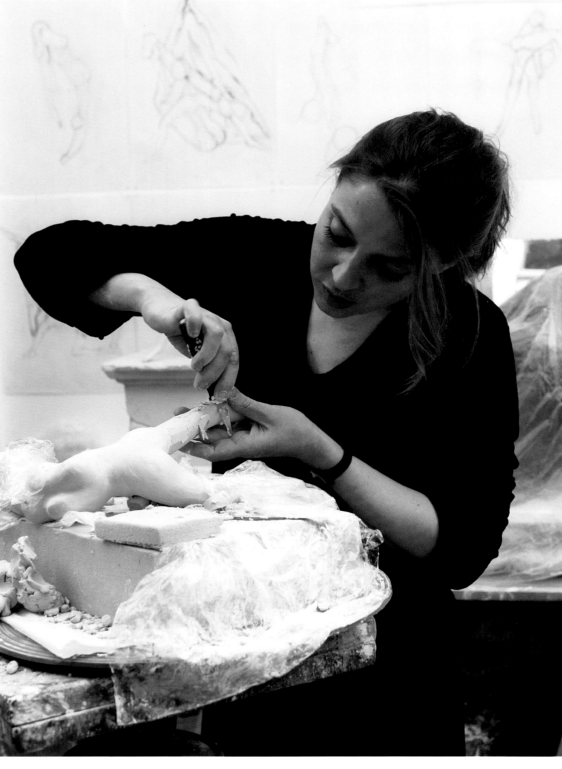

'Although the works themselves are made of porcelain and they're rigid, something seems to be moving within them. The clay does literally move when it shrinks by 20 per cent.'

Of her studio (left) Kneebone says, 'Some of my biggest fights have been in here, with my work and with frustration and boredom.'

Tony Bevan

Has the idea of art changed much in your lifetime?

No. The popularity of contemporary art has changed, though. There are more people going to contemporary art museums at the moment.

What are your first memories of art within a social context? Did you have to work hard to get noticed?

You had to be very single-minded to carry on working, to eke out a living doing another job and then paint whenever you could get the time. It was very difficult to begin with. I used to do construction jobs. You worked for a period of time and then you could make a space of time when you could get your own work done. I'd work as long as I needed to, to buy time really. The first year I managed to live from my painting was probably 1983; I've lived from my work for the last twenty-odd years.

Do you ever miss those times when you had to labour for your art?

Well, I still labour for my art. I don't miss construction work. A lot of artists now are in the same position, having to work to get money to rent a studio and do their artwork whenever they can.

So nothing has changed except success?

Yeah. Rents in London are constantly increasing, and it's more difficult for artists to find spaces to work in. A lot of warehouses have been converted into residential units; people like the idea of loft living.

How do you parcel your time in the studio?

It depends. I try to get into the studio as often as possible. On Sundays I'll have other things I need to catch up on so it's not like a nine-to-five job.

When do you know that you're done with a painting?

At times I set myself a certain goal to reach with a particular group of work I am occupied with. Some days are very long.

And if you push it, what happens?

I suppose you're incredibly tired then, and you lose your train of thought. It can be an advantage and at other times a disadvantage.

Is there a method to the way you work?

Oh yeah. There is a lot of error when you are working. Things flow and metamorphose. A lot of unconscious streaming is taking place.

And the role of the studio in that streaming of consciousness is what?

It's an essential space. It has to be a space that I know and that I'm comfortable in. I find it difficult to work in new spaces. Sometimes I am invited to a different city to work in a studio, and I find it incredibly difficult because I don't know the space. It takes a long time to settle into a studio.

It's not always chaotic in my studio; sometimes I do have a clear-out. The clear-out usually begins when I can't find things I'm looking for.

Do you ever clear out artwork?

There are paintings I'm not sure about, so I will put them away and then look at them in six months or a year and make a decision. I've destroyed quite a lot of work. It's about whether it can be put out into the world on its own, whether it's strong enough and good enough. If it's not strong work, I feel it would make a painting very vulnerable, and it's best not to do that. Paintings have to exist on their own merits.

Do you take criticism to help determine your own opinion?

Yes, from my partner Glenys Johnson. I trust her aesthetic eyes. She is also a painter. With her having a studio next door, I ask her opinion quite often. Sometimes she sees things that I don't and vice versa. I think I have things to offer too.

Do you get into arguments about paintings or ideas?

Not arguments, but we sometimes disagree about particular pictures.

You are such a calm human being on the outside, very modest, and yet when I look at your paintings they somehow expose existential anguish which I don't see in your behaviour. Am I reading them correctly?

There *is* a kind of rawness and directness. A lot of the portraits are not to do with outside appearance, but I don't find them full of anguish or anything. There might be elements of that, but there are other things too. They work on different levels. It's about exposure and coming to terms. I'm always thinking that I'm making particular spaces for the imagination to inhabit in those paintings.

So the canvas becomes an existential space upon which you then brand an emotion?

No, it's a space the imagination can enter; it's like a threshold. That's the thing that really interests me about painting: that pictorial space.

Were you an introspective child?

As a child I was always incredibly shy. I used to do lots of drawings as a way of occupying myself and exercise my imagination as a form of communication. My grandmother was a painter and my grandfather brought lots of sculpture back from Africa, so the house was full of paintings and sculpture. I was very much aware of art materials too, seeing my grandmother's art box, all the tubes of paint; they were fascinating.

I find in a lot of encounters with artists something creative in their backgrounds: a parent or a distant relative being an artist of some kind, or artworks around the house. Is that important, do you think?

If you grow up with paintings and sculptures around the house, it's incredibly influential. I don't think you realise how important they are. I remember when we lent one particular work to a museum, we didn't realise that my daughter felt anything emotional about the painting. One day it wasn't there and she was incredibly upset.

Tony Bevan at work in his Deptford, London, studio in March 2011: 'I tend to work on the floor, sometimes on the wall and then on the floor. It's constant movement between the vertical and the horizontal. Part of the reason I work on the floor is that I need the physical contact. You get the consistency of gravity on the floor and you can move the paint around.'

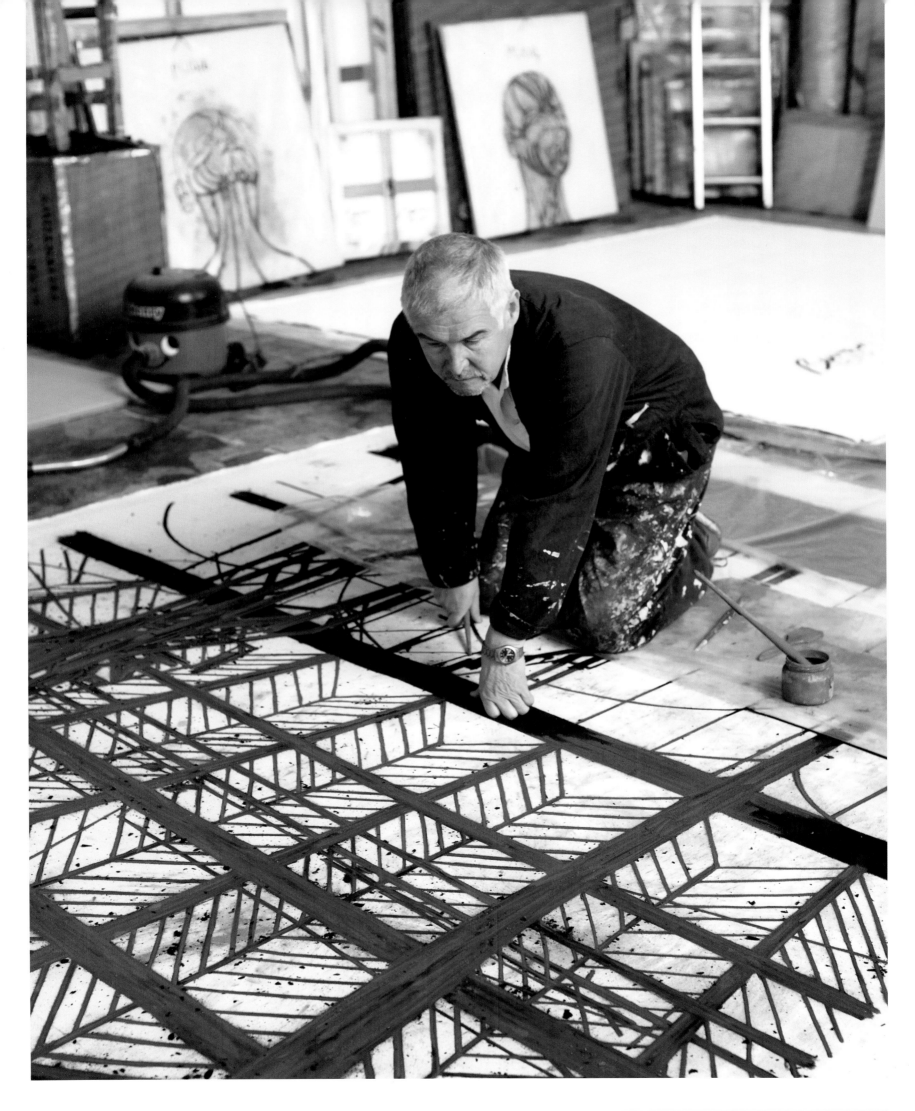

Bevan (above) climbs the plinth at the Slade School of Fine Art, London, revisiting his old art school for the first time in over thirty years.

What about influences on your work?

Forty years ago, when I was a student, I came across photographs of Franz Xaver Messerschmidt's sculptures in a book, and what struck me was that I'd never seen anything like them before. They seemed very contemporary although he lived in the eighteenth century. They have stayed with me, and elements of them have fed into my work.

You've been both to Goldsmiths and to the Slade School of Art. How important do you think art schools are?

I think they are immensely important. The access to art history too. Some art schools currently don't do any art history. I think that's a shame. It's all become very much about now.

But art is all about breaking with tradition, isn't it, at least to some degree?

Yeah, but a lot of the issues that artists are dealing with now have been dealt with in the past. Break-throughs happened in the past as well.

Are you okay with the hyper-marketing surrounding contemporary art?

It's something I don't understand. A lot of contemporary art has become a trading commodity. People follow it like stalkers, almost. National newspapers monitor artists going 'up' or 'down' – it's like sugar or pork bellies or whatever. That's a new situation. You even get managed art funds that people invest in. It bothers me that people aren't actually looking at the art, just buying it for its value.

Can you explain how you approach painting?

I tend to work on the floor, sometimes on the wall and then on the floor. It's constant movement between the vertical and the horizontal. Part of the reason I work on the floor is that I need the physical contact. You get the consistency of gravity on the floor and you can move the paint around. I'm very interested in materials and weight.

Returning to the question of influences, you've talked about Holbein, Goya, Manet and Bacon, but you also made a trip to China. What significance did that have?

Three or four years ago, I was invited to go to China for three weeks, just to travel and to look. It was an amazing experience travelling on my own. Flying from Europe to China, it's an amazing change culturally, as is the difference in China itself between what's going on the cities and what's going on in the countryside. The immense speed of change in the cities is phenom-enal. And, across the East, the ancient landscapes ...

What was the first trip you did that had a profound effect on you, that would have ignited artistic emotions?

A trip to Mexico, probably in the early '80s; seeing that culture and realising how advanced it was. I didn't know much about Mexican culture or civilisa-tion before I went.

What impact did that have on your artistic output?

That's difficult to answer because these things percolate through. Certain things get locked into your mind. I remember the first time I went to Madrid, going to the Prado, and also, here in London, the first time I went to the National Gallery or the Tate.

How old were you when you first visited a museum?

I think I was about seven or eight. It was Cartwright Hall in Bradford, which has a fine collection of nineteenth-century paintings. And I remember an exhibition of German Expressionist prints at that time; I have the catalogue somewhere.

You say that you still get excited by painting. It's not necessarily a medium that is popular today. Explain what it is about painting that you love.

I think it's the materials. Paint is a material that's got endless possibilities. Each piece of charcoal's different. It's not manufactured in the sense that a pencil is; it has its own particular behaviour. Paints and pigments all have their own behaviour and potential.

Is there an element of accident in painting?

For sure. There's the element of being out of control.

Which part of the process do you enjoy the most?

The process of art can take you to great highs and low troughs. It's that oscillation and, when a painting is going well, the immense satisfaction that you are producing something that surprises you. Other times, when it's going quite badly and you just can't get it right, you have to destroy it and start again, which happens often. The peaks and the troughs seem to happen all the time. It's probably advantageous to have doubts about what you are doing.

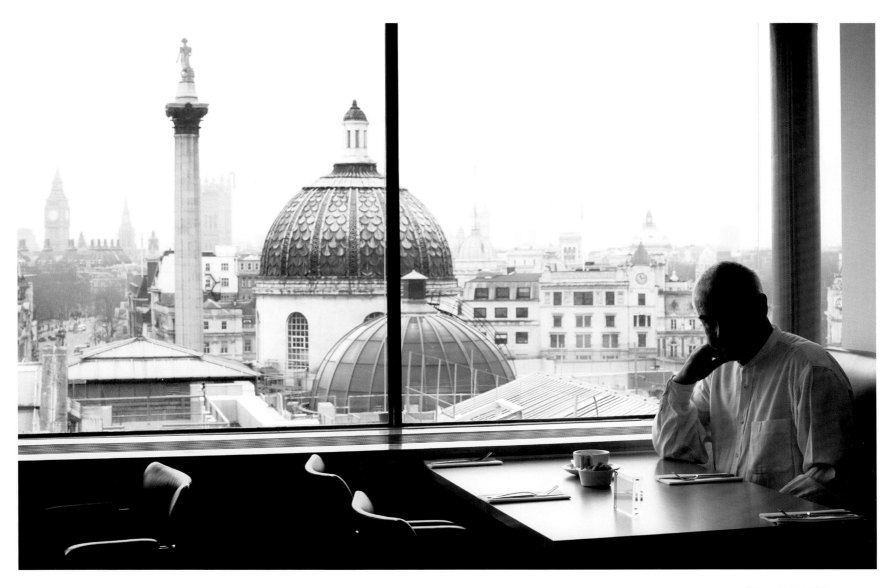

Bevan (above) takes
a moment out in the
restaurant, while planning
the opening of his exhibition
Tony Bevan Self-Portraits at
the National Portrait Gallery.

Bevan (following spread)
surrounds himself with his
work and cuttings. 'There
is a lot of error when you
are working. Things flow
and metamorphose. A lot of
unconscious streaming is
taking place.'

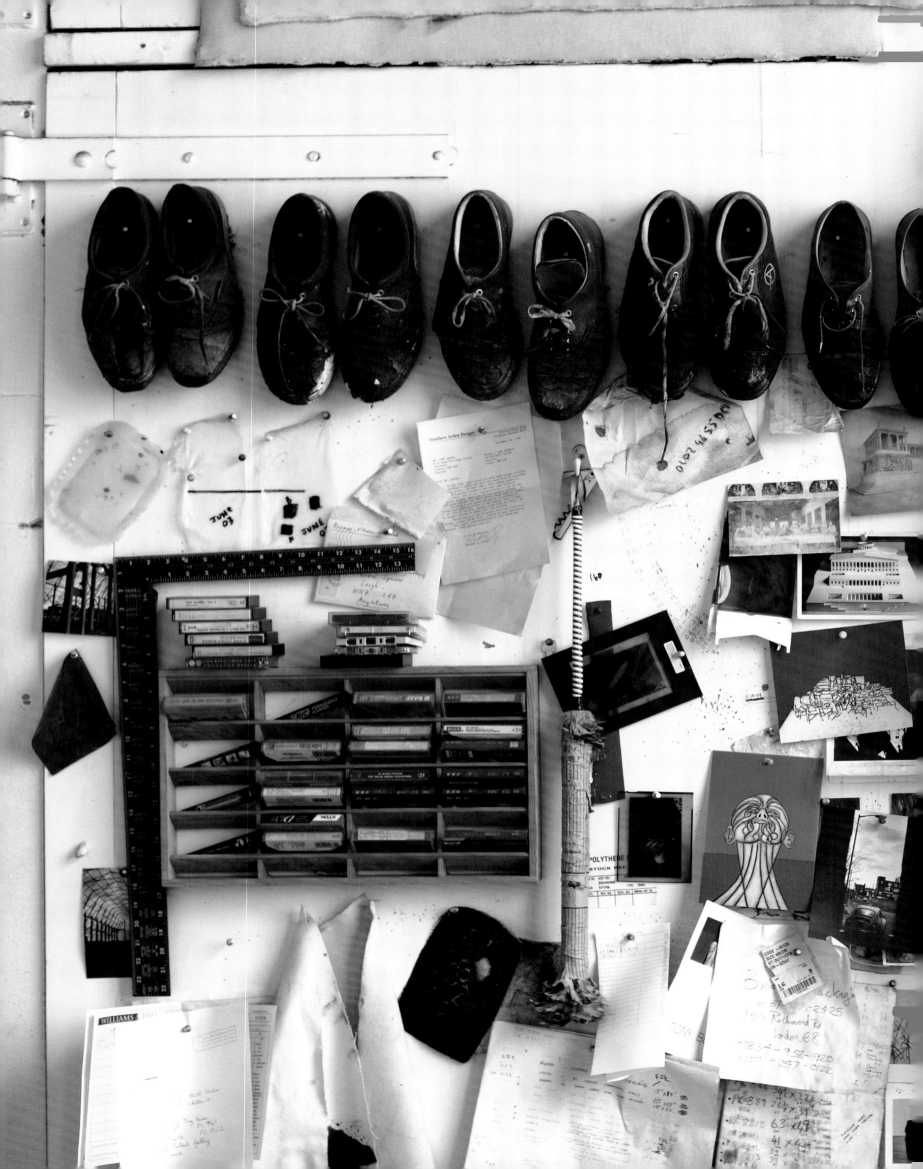

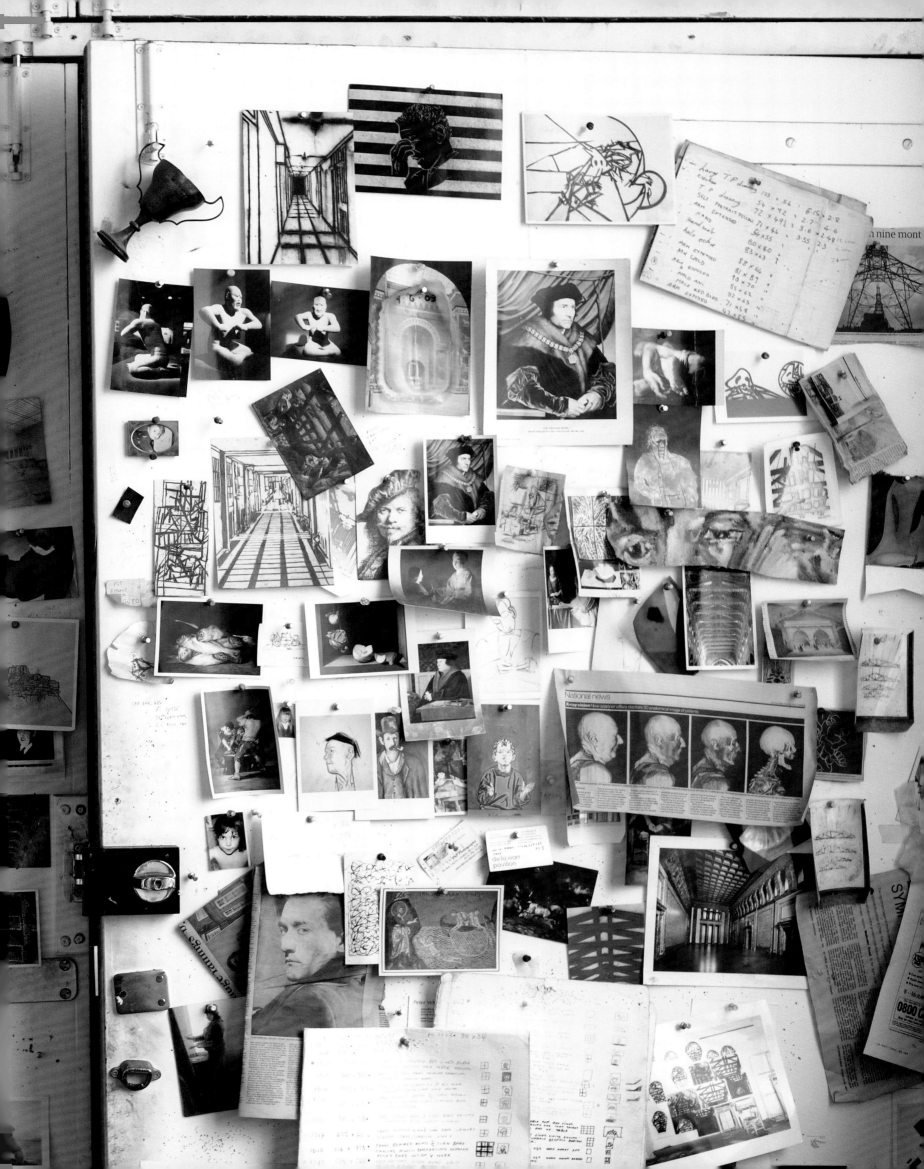

Chantal Joffe

Is your studio more than just a work space?
It's somewhere that I always find incredibly peaceful
to come to. I sometimes come in for half an hour and
look at books or just think. It's an oasis, I suppose.
I have models come in, and sometimes that's quite
useful, but I'm really glad when they go. I find it quite
hard to have other people in this space. It taints it. All
the work feels locked at when you start; everything
in it feels exposed. It feels ruined. I know it's a filthy,
messy space, but it's *my* filthy, messy space. It's the
one place in the world where nobody else can do
anything. My home is quite messy, but it's not *mine*.

There's nothing worse than people going, 'Do you
fancy a cup of coffee?' all the time! Then anything
you've had in your head is immediately dispersed.
You absolutely have to have your own private, door-
lockable studio.

**Suppose you're engrossed in your work and
somebody breaks down the door. What does
that do to the work?**
It's shattered. Immediately you see it from somebody
else's point of view. Then the work is not mine any
more. It's not private. It's lost.

**You've said that you work at speed. What does
that mean in terms of actual time spent?**
I paint very, very fast. How fast depends on what
I'm making and how I'm making it, but I can make a
very big painting in a couple of hours if everything is
somehow right and in place. I love the speed when

your thoughts and your physical self are in complete
accord and you're mixing paint and thinking and
almost dancing with the paint.

I can't think about painting unless I am painting.
It is a bit like I imagine it is if you're addicted to
heroin. You can paint in a pedestrian way a lot of the
time and then you get real highs. The reason you go
on looking for the high is that it's so great; there's
such a oneness, whether you're being individual with
the paint or with the thought. It's funny, because you
can get maybe a week of it, literally as if you've been
transformed; you feel that it will be like that for ever.
But then of course it's not for ever. You stop dead. I
suppose that's why I don't want to be interrupted.

So you go on painting in a pedestrian way and wait
for it to get good again, but you don't know when that'll
happen. The only way to get back to that point is to
paint and paint and paint even if you have to do it in a
totally leaden way. A painter I read about once wrote
about finding a door in a wall that you fall through. You
can't believe it's such an amazing place, and then you
wander out the door again. The door is shut; you can't
find the door again. That's a brilliant analogy.

In an odd way, I am not too interested in art …
I'm more interested in the making of it.

The best painter in the world is the person who
is the most able to *register*. Van Gogh was able to
orchestrate the experience with the painting and the
material, and distil that into the best echo of all. You
feel him calling back to you across time. When he
was painting, it was, I think, an extraordinary joy. He

knew how good he was. You see it in the letters; he's
so at one with it, so in the moment.

It's quite hard to be unhappy painting because
if you are painting you are in the act; you are in the
continual present. You're not thinking into the future
or the past. You're in the now.

I like showing in one way, but it's quite painful
because you only ever fall short of what you wanted
to achieve. But for the moment in which you made the
work, you felt an extraordinary kind of transport, so
they are like a remembrance of what could have been
if you'd just tried harder or been able to get further.

**How does it feel when your paintings end up
somewhere else?**
I'm really happy. I wouldn't want them here.

It's funny, though … if they are from far enough
back in time, you feel affection. I'll get them out and
think, Actually, you are bearable now. But the ones
less than five years old I find pretty hard to bear.

**What is it about the female figure, the female
psyche, that interests you?**
I find women more interesting to look at. It's pure
pleasure! I'll see someone with amazing red hair in
Old Street and I'll think, That hair! The fact that it
exists is incredible. What I love is disjuncture, some-
body with great hair but a giant arse, or someone
really thin but with a funny nose. I love incongruous
beauty, I suppose.

Chantal Joffe's desk (left)
caked in oil paint, a medium
she describes as being
very dirty.

Because of the scale of her
paintings (opposite) Joffe
works from mini-scaffolding
set up in her studio near
Angel, London.

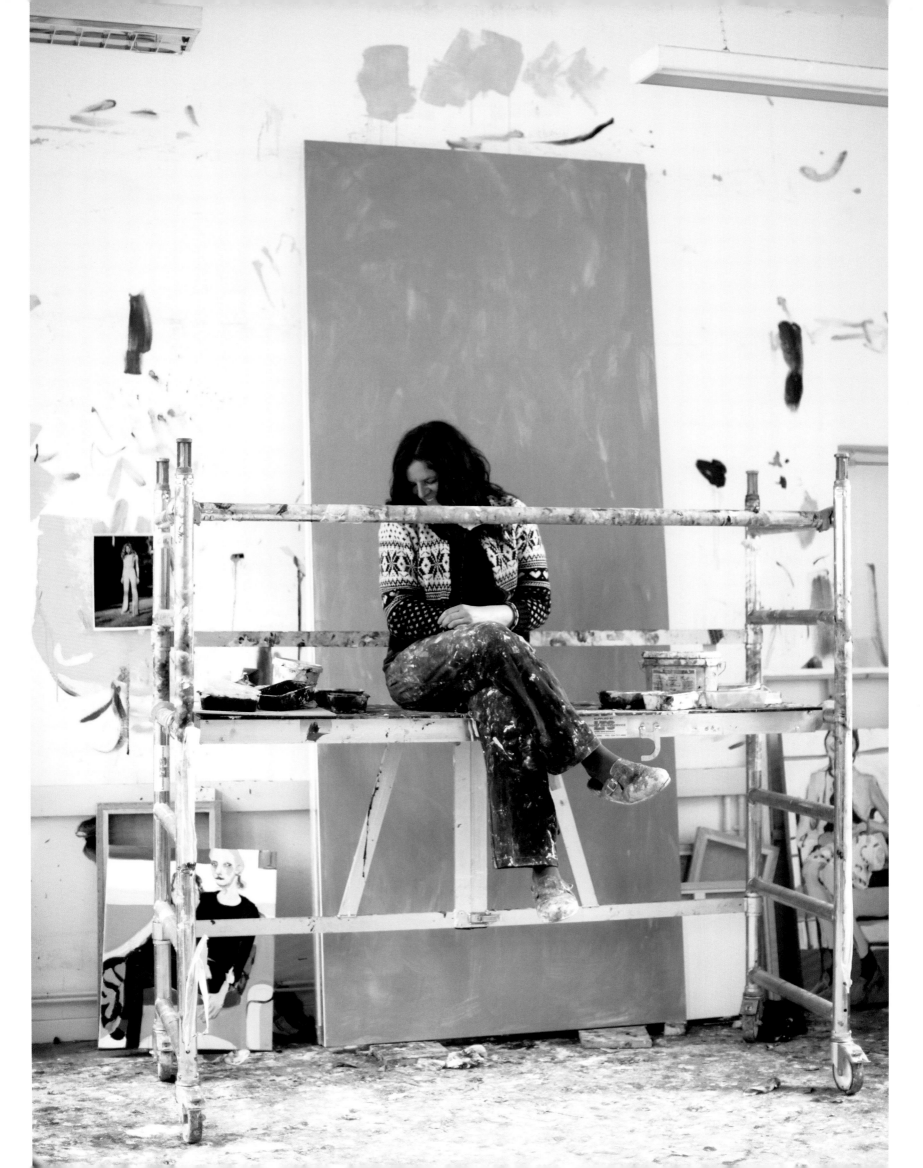

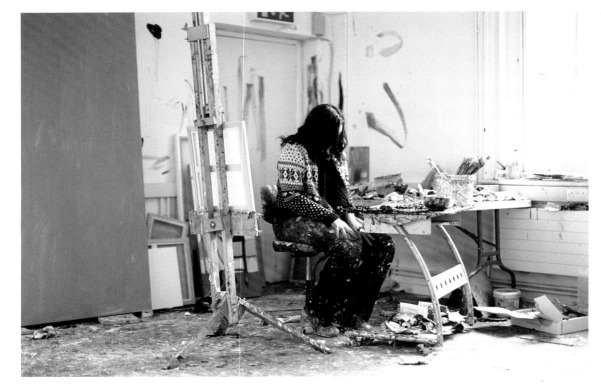

Is that something from your childhood?
Probably. It's a funny thing, looking, because the more I look at somebody, the more I love what they look like. I become enchanted, literally; it's like the man who mistook his wife for a hat or something.

I've noticed that, regardless of the type of women you paint, their eyes seem quite similar. Why is that?
They always have to look out of the painting. I find it odd when people look away. It's a basic human desire, isn't it, to look into somebody's eyes?

In the few portraits you've made of men, what was it about those sitters that you found interesting ?
They were, at the moment I was painting them, somebody I was interested in. With my partner, it was quite a contrivance to paint him. I wanted to see what it would feel like and how I would react. He was a great model. I didn't have to worry about what he would feel about how I would make him look, which was important. But the painting lacked an element of fantasy, if I'm honest.

What about your use of pornographic imagery? You've been quoted as saying, 'At the time, I thought I was bringing those women back to life.'
Yeah. I thought I was giving them back their dignity. Now it seems a bit presumptuous to say that, but I was about twenty-three when I was making those paintings. I started down that road because I wanted to make paintings of nudes; I wanted to make paintings that reflected the real world of sex. The first paintings I made were at college: big paintings where I collaged my own face onto those women, replacing myself with them. After that, I made tiny pornographic paintings, thinking of fourteenth-century religious paintings and how in the end, for me, they weren't really about religion. When I look at them at the National Gallery, I'm interested in the realness more than I am interested in the spirituality or the narratives. In porn mags, there are little picture stories; you read across them, which is not so different from the way you read across an altarpiece. I also thought the whole point about pornography – which is also true in literature and in painting – is that you have to slow the effect of viewing. So if I made these tiny paintings where your mind took a moment to rest on what was happening, they would still be paintings of sex rather than pornography. Then I didn't really need to make them any more, because they had done what I wanted them to do. Also, I couldn't look at porn any more. I felt like it was damaging to keep looking at that stuff.

What do you want to be remembered for?
If I'm honest, I don't think I will be remembered. There are so few people who are any good at painting that almost nobody will be remembered. You'd be lucky if anybody looked at your pictures in a hundred years. I like painting because it's the hardest art. There are thousands of people like moths flapping against the flame because it's hard to keep doing it.

You've been quoted as saying how messy painting is, how it gets in your hair and your eyes; your whole body is involved in it. Do you almost have a sensual relationship with the materials that you use?
At its best, it's like being a cook. You can't divide it up. Materials, object, support – they all have to be just right. You can work at it for fourteen years and it still won't be enough. With most things, if you work hard enough, you get good at them. With painting, you go on and then fall back. But that's its greatest pleasure.

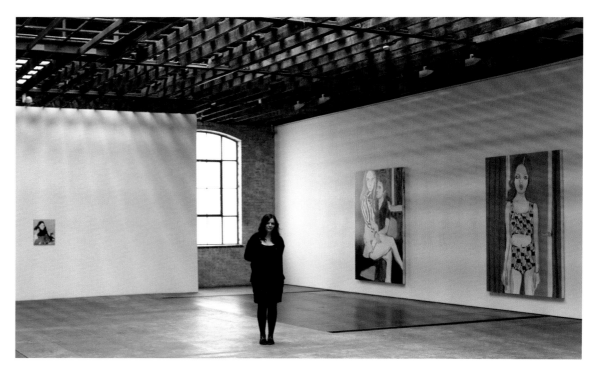

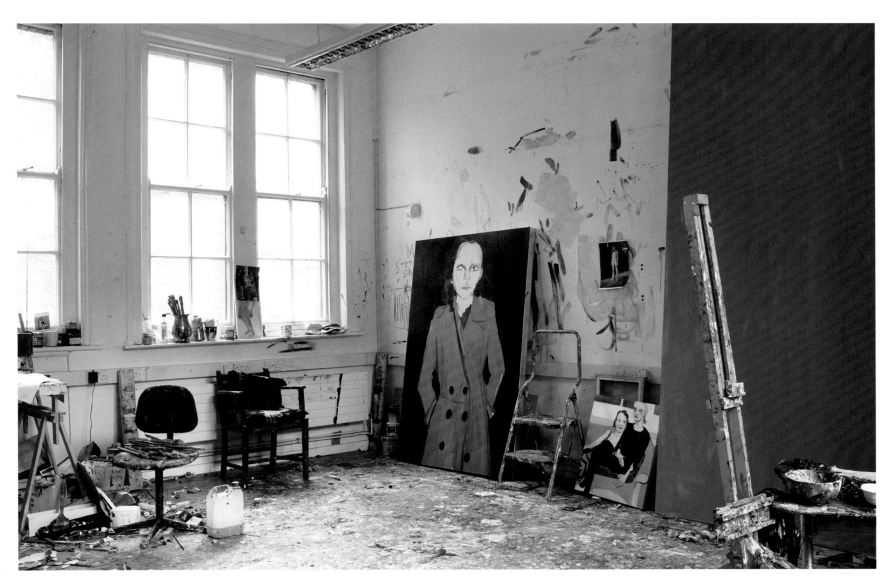

Joffe almost always depicts women in her paintings. 'I find women more interesting to look at,' she explains. 'It's pure pleasure!'

Joffe (opposite) at her solo exhibition at Victoria Miro in March 2011: 'I like painting because it's the hardest art. There are thousands of people like moths flapping against the flame because it's hard to keep doing it.'

Antony Gormley

Does art bring enlightenment in any form?

I like the idea that art can be an instrument of reflexivity. In other words, an art object has no intrinsic value, but if we can use it, value can arise out of our relationship with it. It can be used as some kind of fulcrum for thought and feeling, for our sense of *being*. For me, sculpture is a form of testing our incarnation and mortality because it deals with time. Sculpture has always, I think, been an attempt to leave some trace of human existence on the face of an indifferent universe. Most sculpture starts from a confrontation with geological time – the hard, mineral condition of stone – and attempts to mark it in some way.

Is art a reflex, then?

Art is something that human beings make in order to understand our condition better or maybe to just accept our condition. This is an age of spiritual darkness because we are more materially bound and more capable of material manipulation than ever before. There's a contrast between today's way of judging art in terms of monetary value and its use-value as a catalyst for charting our passage through space and time.

And what is the relevance of your art?

I don't think there is going to be a time when my work is more or less relevant. It is just what it is. When it's bought it's marvellous because it allows me to continue with my experiments – but it also means that someone will take it into the future.

You signal value in your art, yet you cast yourself as emblematic of something else. What might that be?

I call it my body, but it isn't really my body; the material condition of my life starts with a body just as it does for you. I want passionately to acknowledge the subjective condition of that universal. It is foolish to ignore the fact that your body is the only bit of the material world that you happen to be inside. Every work that I make starts again with an open question of what art might be. Maybe that is the problem I have with a lot of art that is made today: it assumes its status as art. Everything that has any real meaning for me starts without that assumption and asks, 'How do I bear witness to being alive?' The way I respond to that imperative is ever-changing. Every work is a proposition: once made, it invites you to make it again, but better. What do I mean by that? I suppose I mean 'truer'. The problem is, once you start putting these things into words, the potency goes away. As a sculptor I believe in the power of things to speak in ways that words cannot.

How is the urban context relevant to your work?

We are now, most of us, bound by the city. We live in these boxes and very few of us think about, let alone look at, the horizon. Our nature as animals has totally changed. I can't say that I am trying to give an accurate impression of what the human animal has become, but that has something to do with it. I am trying to transpose the feelings I have of being in a body and being embedded in architecture into form. In the process I think these forms become literal stumbling blocks for others. The by-product of my thinking and feeling produces these things which then displace our shared space in the world. They are an invitation to stop.

I believe you adhere to the idea that art should not just be for the privileged …

We have suffered for art being a specialisation. We live in a very interesting time in which artists are less interested in the syntax of their visual language and more interested in talking about life. The world is responding by wishing to participate. So we have an extraordinary explosion of interest in the spaces, mental and physical, that art offers, in a way that has never happened before. Art is coming out of its ghetto. I don't think it is a new religion; I do think that art can in a sense be an open space in which individual freedoms can be tested and indeed expressed in a way that both religion and politics have failed to do. Nobody believes in politics any more; we all know that we are run by money, not ideology. Art is, as it were, the last testing ground for

the human spirit that hasn't become market-driven. We have to accept that the market is the dominant form of distribution now, but through it a lot of other things get disseminated.

What does your studio represent to you?

It is an industrial unit for creative work, it is an asylum, and it is the home of a community of creative people who have chosen for a variety of reasons to join me and make this work. So it goes out under my name, but it is collaboratively produced. I looked for the right building for a long time. There weren't any – I have to be able to put down five tonnes anywhere, to be able to build a work inside and outside. Building this studio was the best thing I ever did, making an instrument and then seeing what kind of music we could play with it. I think we haven't even begun yet. The possibilities are endless.

Has the space affected your work and your thinking?

Oh yes. I was in Peckham before, in a space that was roughly one of these units but on the ground. David Chipperfield and I built this based on that. I was insistent about keeping the memory of domestic architecture but multiplied by seven and made twice as high.

Your Peckham days were probably hard …

The first work I sold was from my show at the Whitechapel in 1981, but I didn't make any money until 1993. The first twenty years were not so lucrative but were very good fun. I used to think I was the sole author, the sole intelligence that could determine whether something was working or not working. Now I think that the work makes us. It makes very clear demands and if we are careful enough, if we listen properly and act responsively, it allows us to make it.

So one of your pieces can originate with any one of those twenty people?

Not really. I am there at the beginning and I am there at the end, and I try to be there in the middle. All of the assistants here are given a choice about what they want to work on, and the rule is very simple: If you can think of a way of doing something differently, then you should do it. If you can hear what a work is telling you to do to make it better, stronger or clearer, then you should do it. That is the way things evolve. Once a piece or a line of work is finished, everybody in the studio comes together and looks and talks. This is not a Taylorist idea of productivity: every single piece that comes out of this studio is unique, even if it is in an edition of five, and the responsibility for it is

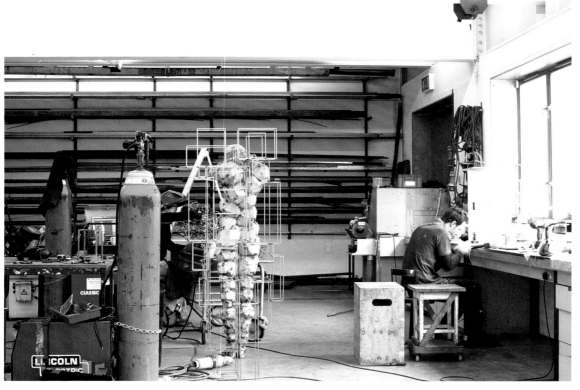

You seem very engrossed in philosophy; you are an intellectual. How much is being a showman part of being a contemporary artist?

People are always going to tell you that what you do is rubbish and you have to be resilient enough not to get depressed! Somebody tried to suggest that I was a showman and I really resented that, because I am not interested in the idea of a spectacle. I would like to think of my sculptures more as phenomena that work with intimacy and distance, that can be big but that can touch you from a distance of 2 kilometres.

Going back to Buddhism, did you ever come across the Bamiyan Buddhas that were blown up by the Taliban in Afghanistan in 2001?

Of course. If the works were supposed to be images of Sunyata, the void Buddha body, then the Taliban did a great final stroke. It is an interesting thing, the Silk Road. The Dunhuang caves are another example of the relationship between merchants and the sense of having to pay back something from the profits that you have made out of other people's gullibility; this is powerfully evoked by the popularity of the Pure Light School. That is a lot easier than sitting on your bum for two hours a day trying to still your mind.

Will Antony Gormley's name live on for ever?

Well, we don't know what will happen. I don't know if you have ever been to Crosby Beach, but the pieces there are changing every day; they are either a little bit more barnacled or a little bit more rusty. You could say that this is the antithesis of the single sacred object placed either in the church or the museum and conserved for ever. It is something that a man once made, exposed to the elements, and it is changing. That is where its power lies. The journey that each of these objects makes through time is more important, in a way, than whether my attachment to them is remembered.

Antony Gormley (previous page) in his purpose-built, 930-square-metre studio designed by David Chipperfield north of Kings Cross in London. 'I looked for the right building for a long time,' Gormley explains. 'There weren't any ... Building this studio was the best thing I ever did, making an instrument and then seeing what kind of music we could play with it.'

Gormley employs many assistants (above) in the production of his work and engages them in discussion once a piece or series of works is finished. 'The criterion for judging a work is not whether it perfectly reproduces something that we already know but whether it has become something that we don't know at all.'

Gormley (right) surrounded by maquettes, reviews some feasibility studies for new commissions. He subscribes to the philosophy that art is not merely for the privileged and has installed a number of well-loved public artworks. 'I do think that art can in a sense be an open space in which individual freedoms can be tested and indeed expressed in a way that both religion and politics have failed to do.'

down to me and every single person who works here. The criterion for judging a work is not whether it perfectly reproduces something that we already know but whether it has become something that we don't know at all.

Isn't that the crux of art?

You have constantly to embrace the mutation or the thing that slipped out of your control. At the same time, it is all very paradoxical, because you have to work continuously, preparing for the unknown to arrive, and then when it arrives, you have to know what to do with it, because you might throw the wrong thing out. Alertness is necessary on all fronts, from me and from everybody here.

You've been quoted as saying that you spent a lot of time as a child 'very confused as to whether I had the Devil in me or whether I was in a state of grace'. Who is the better artist, God or the Devil?

The Devil is always much more interesting! I feel very grateful to my parents for having confused me so totally as a child. In Buddhist terms, desire and hatred are the major forces in human behaviour, and there is no escaping it: we have to build our own provisional structures that somehow withstand those forces.

You were at school at Ampleforth. Did you enjoy it?

I loved it. The monks in the junior school said, 'There is a wall at the end of the corridor; why don't you do a mural on it?' That was me aged twelve, that was the first thing I made in a shared space, and it was amazing to be encouraged and given the opportunity to make such a permanent statement.

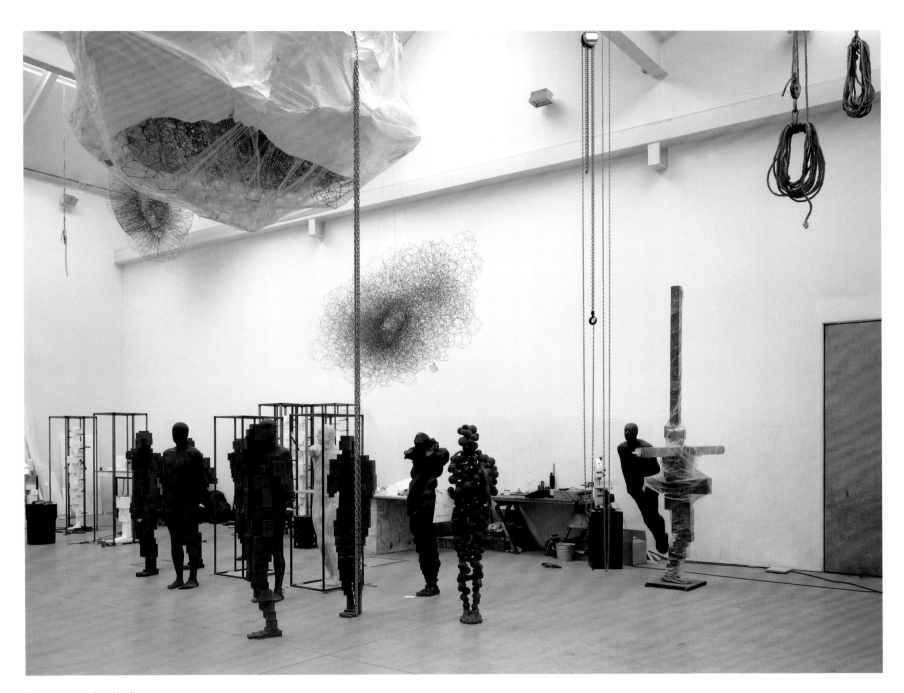

Pulleys suspend works from
the ceiling. Sculptures stand
in Gormley's studio, which
he calls 'an industrial unit
for creative work' and 'an
asylum'.

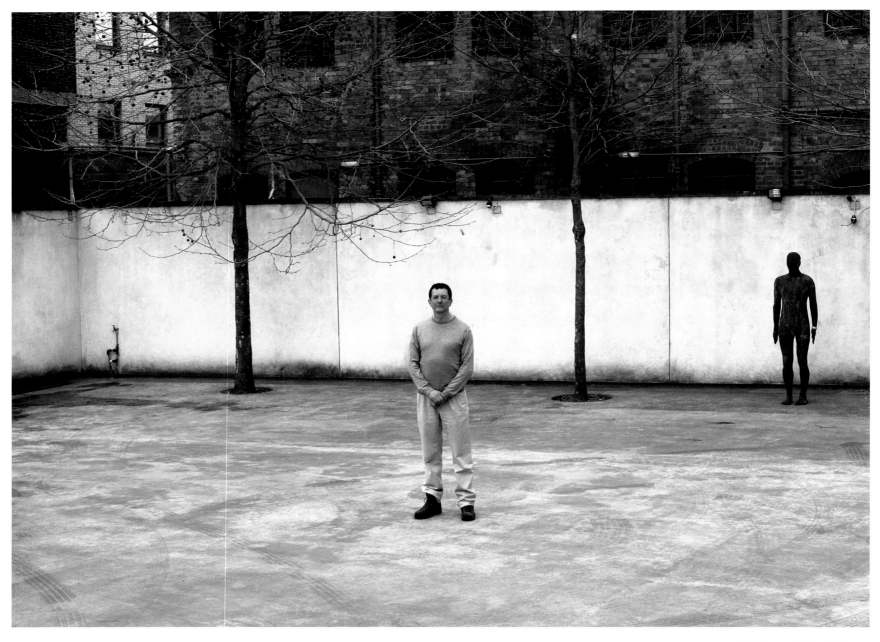

'The journey that each of these objects makes through time is more important, in a way, than whether my attachment to them is remembered.'

An assistant (opposite) rolls small figures across the studio's courtyard, which contains 140 tons of steel in the floor to support pieces up to 10 metres in height.

Hollowed corpses (following spread); Gormley's body casts lie waiting in storage.

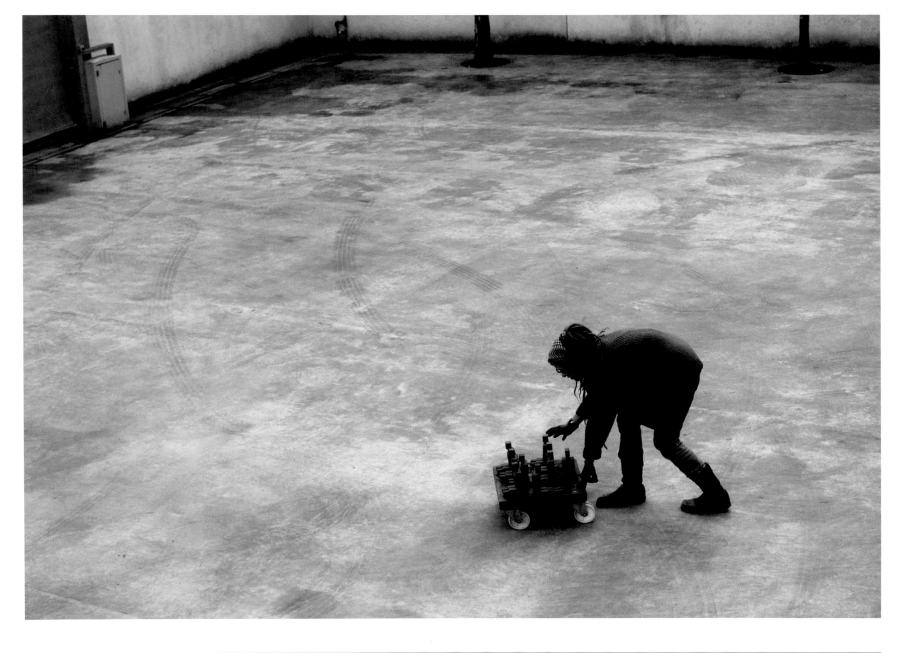

Ron Arad

You were born in Tel Aviv; you moved to London at the age of twenty-two. Which was the more formative experience?

Probably being a teenager, when I started thinking that I knew everything. At sixteen, when you know you are almost independent, you start inventing who you are. That's formative life.

How much of an art scene was there in Israel at that time?

It was very intense and active. My mother was a painter, so it was like galleries and openings every Saturday. I was a spoiled brat. That was part of what I thought was normal life.

How does that sort of parenting affect an artist's potential?

We don't know about a lot of good second-generation artists. This was one advantage of coming to England. When I came here, I was completely on my own. I didn't know a soul. It was like a blank canvas to just make marks on, without a plan or anything.

Your personality has been described as bold, experimental and inventive. What does this mean in practice?

I'm doing what I am supposed to be doing. Maybe if I grew up today, a different sort of work would inspire me and I'd become a lawyer, an accountant or a dentist. I have to invent things to camouflage my shortcomings.

As for education, my young daughter holds a pencil in a very special way, and she has amazing control; she draws well and she writes very well. Every teacher who teaches her wants to discuss this. But she does fine. Education is sometimes an impediment.

You have been said to be constantly questioning and always an outsider …

Questioning is like: 'How can we do it?' Curiosity is: 'What if?' What if we zoom in on something and make figures, make two pieces, one negative, one positive? 'What if?' might be interesting; you explore it.

Yeah, I think I am an outsider, not very happy with conventions, even ones I have to create myself. I'm not saying that that's the way everyone should be; I'm not turning it into a creative manifesto or anything. It's part of my make-up. I love architecture; I can't stand the architecture profession; I can't stand the way they go about things. I'm the rebel.

But you are now a consummate insider. You are at the top of your profession internationally.

Yeah, but I can't help it. I didn't do anything to make it like that or to be big, I mean to be accepted. I didn't plan ever to have an academic career, but I accepted a professorship at the Royal College. I'm very lucky; nothing is part of a five-year plan.

I'm not self-taught; I studied architecture. In school I managed to be an outsider as well. I decided in my first year that I'd never use a ruler or compass. Then I had a lot of pressure to use them, so I bought a set and boiled them. The ruler was wavy and the triangle was out of kilter. I did lots of projects with crooked tools, which I thought was a nice and interesting thing to do. I got lots of brownie points for it. Again an example of how you survive as an outsider, how you picture your weaknesses or whatever.

Are you an artist or a designer?

I'm a ping-pong player! And I am a fantastic designer and a great artist and a wonderful architect. At least my parents think so.

When I was young, I would show scale drawings to my mother and she would say, 'Oh, he's going to be an artist!' or 'Oh, you're going to be an architect!' She thought that maybe a common-sense profession would be better than being a piss artist. The reason I studied architecture at the Architectural Association was that it seemed more of an art school to me than the Slade or other schools. No-one was building anything, and paper architecture was more important than built architecture, so the place looked like more fun.

I made the crossover from art and design, not the other way round. When I did my first piece of furniture, it had more to do with Picasso and Duchamp's ready-mades. Later I was happy to pirate. So I was sucked and dragged into design work. As to architecture, it took us a long time to get jobs. The first clients we had were ourselves in our studios. It took a while for people to make the connection and say, 'Let's ask them to do whatever.'

What role has the studio played in your art?

It's everything. What you do is you sketch and you talk; you have people to whom you can talk and you get ideas off the ground with them, not only technically but intellectually. I need the company. I never work alone. I'm not a person who turns up with a masterpiece. I need people.

Ron Arad, whose ping-pong table even has a twist to it! The Israeli-born artist-designer has made a career of being different. 'I think I am an outsider, not very happy with conventions, even ones I have to create myself.'

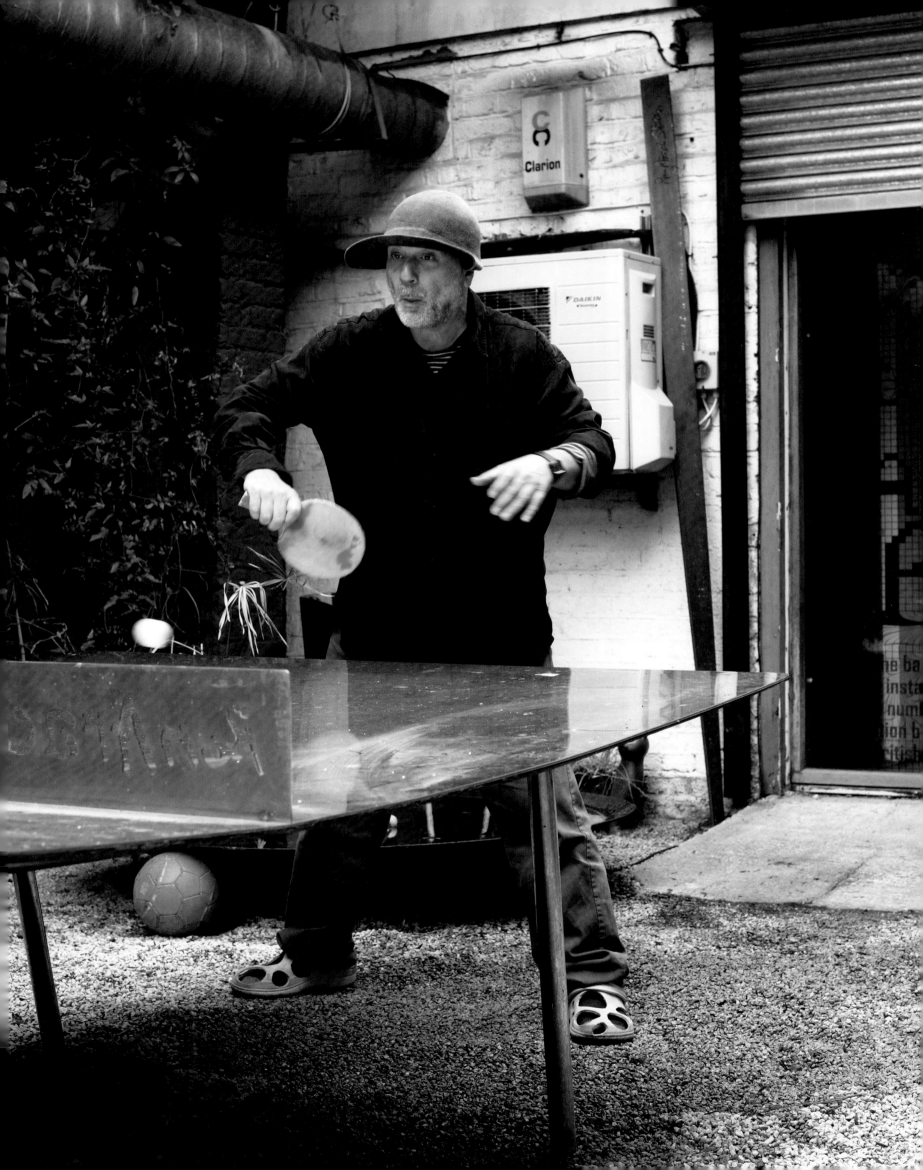

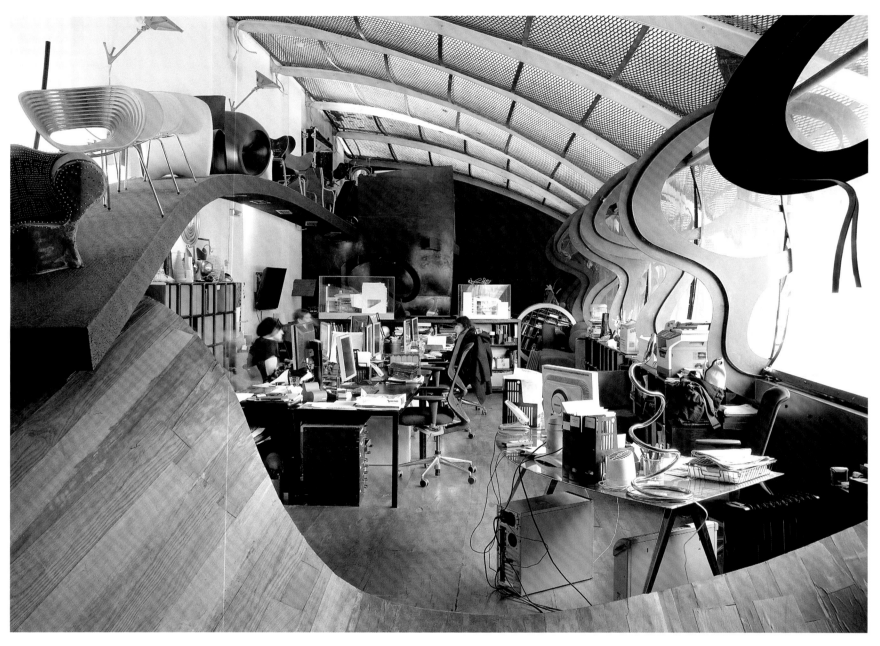

Arad's team in the quirky studio (above) he designed in Chalk Farm, London. 'I need the company. I never work alone. I'm not a person who turns up with a masterpiece. I need people.' Arad studied architecture in school but even then ran against convention: 'I decided in my first year that I'd never use a ruler or compass. Then I had a lot of pressure to use them, so I bought a set and boiled them. The ruler was wavy and the triangle was out of kilter. I did lots of projects with crooked tools.'

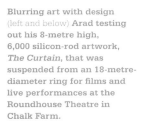

Do you ever paint or draw for your own comfort?

I draw a lot. I don't draw what exists, I draw as blue-prints for something, so when I draw, I make. I draw a lot and I make things (to the best of my ability) to look like something that does exist, but it's all things that don't exist yet. It's not conceptual; it's working drawings, if you want. I used to use crayons and paper; now I draw with a light pen.

Like we said before, I've been lucky. I'm very lucky to have this studio, really lucky to have this space, very lucky to have the people here. It's evolving rapidly, though maybe not rapidly enough, because if you came here twenty years ago we would've been welding, and there would've been fumes and you'd have heard hammering. Downstairs was a workshop, and up here was the showroom. I've fond memories of those days. Now I have Roberto here from Italy. He makes amazing things. He came here for a meeting, looked down at the people welding and could not understand what they were doing. He said, 'Why, why?' as though we were so primitive! We were cowboys! When Roberto started making things for us, they were too perfect. He continued with some pieces that we had started, and some discerning collectors only wanted the ones made in London, not the better ones made in Italy. So we decided to move the workshop to Italy.

Is the studio becoming extinct, then?

No. We do different things in the studio. We play ping-pong, we have computers.

We used to have half of this space; there was a company that traded in CDs and went out of business. We have the whole courtyard now. We have a little workshop upstairs, and slowly we are making more things here. The studio is not extinct; the activity changes. We use computers in the same way that they were using welding and hammers, and I can go to Italy.

Are you trying to expand the horizons of art?

No. I'm trying to do what we are good at and want to do. I'm not trying to liberate anything.

Would you say that art has to be an impractical proposition, with nothing utilitarian about it?

Some things are definitely created as industrial-design pieces. It is to do with the cost of production, with technology, economy and distribution. Given the way the world is organised, if you find a particular chair in an art gallery, you might sit down on it. It is a mass-produced, industrial piece; I don't think it's less important, more important, less beautiful, more beautiful. There is a sort of continuity and there is a lot of cross-feeding. It's been acknowledged that you accumulate experience through designing a mass-produced chair, so why can't people accept that it has its physical presence, it has its visual presence, and it also has another layer if someone is sitting on it?

So you've never had equivocal feelings about your work being art as opposed to design?

It depends on what it is. If I design cutlery, it has a deeper balance that I also use in my sculptural pieces. It can be very arty. It's a piece of design. It's sold in a box and is as commercial as I can make it, and the more they sell the better. It's nothing other than what it is.

What does your studio mean to you?

The most important thing is the light. I need light to make paintings, to look at colour. Also I suppose the studio's somewhere to concentrate away from everything else. The only things I have here are the tools to make my paintings, whether they are brushes or palettes or paint or whatever. It is a very focused place. Studios always feel really private. You try things out there.

How much time do you spend in your studio?

A solid eight hours, almost always just during the day.

Does the space where you work influence your work?

All I ask from a space is to have light and to bring me a certain focus. Beyond that it is all about the paintings themselves. So I wouldn't say that the studio affects me too much in terms of atmosphere. But those two things have to be right.

Let's talk about your paintings. Do you see your work as referring to your childhood?

No. All of the images in my paintings are things that I have experienced myself, but they are not about exploring personal experience in terms of telling a story. It's more about finding the essence of a subject. That subject needs to mean something to other people.

You've talked about your work as evoking a particular atmosphere infused with darker psychological undercurrents …

Colour, form and subject are not distinguishable in my work; they're all part of the image. It is about building up an atmosphere, a mood. I am exploring and constructing different feelings and atmospheres. Each painting is quite distinct, and that is partly what I find fascinating. I am interested in painting what something *feels* like rather than what something *looks* like. That's partly why I don't work from photographs.

You spent most of your formative years in California and then moved back to Cambridge, 180 degrees away in terms of colour, of lifestyle, of light.

I grew up in California; my family moved to Cambridge when I was nine. There is something about those formative years … I can't help but remember the light, the colour combinations, the plants, the Mexican folk art. In contrast, Cambridge gave me a more controlled palette.

In a recent exhibition of your work, one could clearly see the difference in palette between the very colourful bursts on the one hand and the much more subdued, almost neutral tonality in others. Does that reflect your personality in any way?

Not really. It's more about the subjects I am interested in exploring. That is what leads me. It is important to me that I don't know what a painting will look like at the end. There has to be risk-taking involved; it is an important aspect of the working process for me. The painting needs to have its own life in terms of me being curious as to what it will look like. The palette range is as much the subject as the image. That is why I am also interested in using lots of different materials. A blue in spray paint will be a different kind of blue from a blue in oil paint. They have different connotations; they create different surfaces; they leave different marks.

Where do you find your inspiration?

Everywhere! That is what makes it an exciting and engaging process for me. Part of the challenge is to create a framework, choosing what my inspiration might be for a particular painting.

You've said that memory is a self-editing exercise and that you find sources or starting points or catalysts in memory. Is this accurate?

This goes back to what I was saying about photographs. For example, that painting I did of an aeroplane meal … It was very important to work from a memory of an aeroplane meal rather than to look at an actual tray. I didn't want to have the knife and the fork and the yoghurt and the butter. It was more about a machine/body relationship. The painting is not just about an image of a tray but about a memory of being slightly trapped by a tray and the sensation of the surrounding space. That is what I mean about using memory. It is not personal storytelling.

Phoebe Unwin (opposite) contemplates her next move in her Hoxton, London studio. 'I always work in one size of sketchbook. My sketchbook is somewhere I can be very gentle with my ideas. When those ideas are translated into paintings, of course I need to be really rigorous with them.' Paintings and art materials (left) lie strewn across her workspace.

'All of the images in my paintings are things that I have experienced myself, but they are not about exploring personal experience in terms of telling a story. It's more about finding the essence of a subject.'

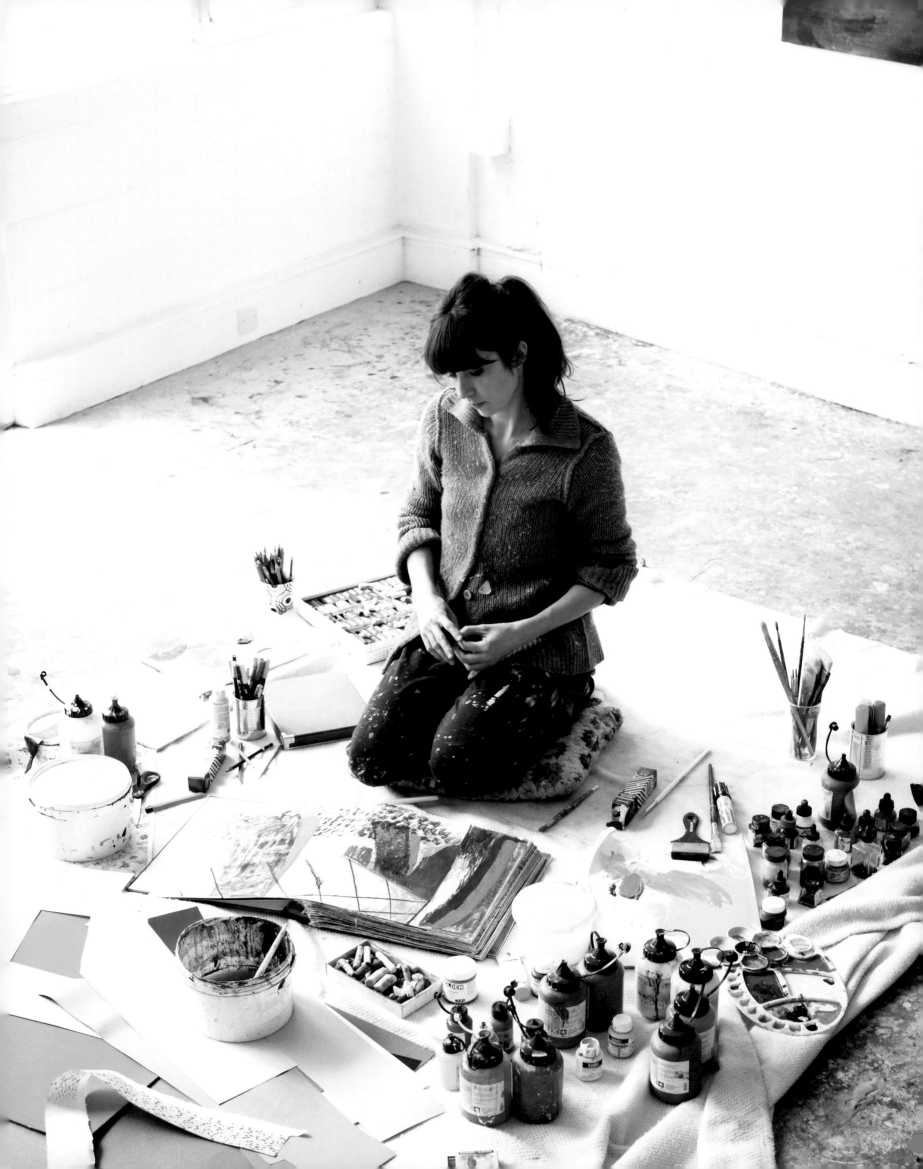

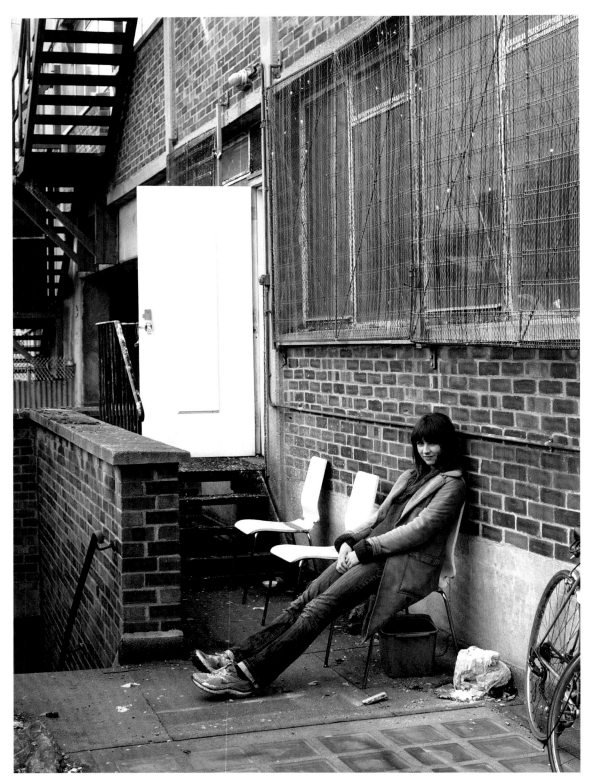

Some of your works contain figurative elements and others don't.

All of my paintings are figurative to some degree. It is important that there is always an element of figuration because they are about explaining or exploring something. If they were completely abstract it wouldn't quite give me the tension and those relationships to play and work with.

You work at both small scale and large scale. Why is that?

The scale of a painting is as much a part of the communication of a subject as the image. I want my paintings to feel physical. They aren't a window onto somewhere else.

Why did you choose painting? Have you ever been interested in other media?

In some ways it is about personal chemistry. You have a connection with something that fascinates you, that you feel energised by and obsessive about. For me that is colour and form and all the possibilities I can see in painting. I have always been focused on working in two dimensions. When I was a student, I did a floor-to-ceiling installation of my bedroom; all the furniture was screen-printed to scale. Even then, I was interested in what I would call ergonomic composition and the everyday as a subject. I also made some paintings on steel and they had magnetic shapes; the idea was to move around the composition. So I have made work in other media, but it is always about the idea of painting and about being playful and experimental, in some ways irreverent.

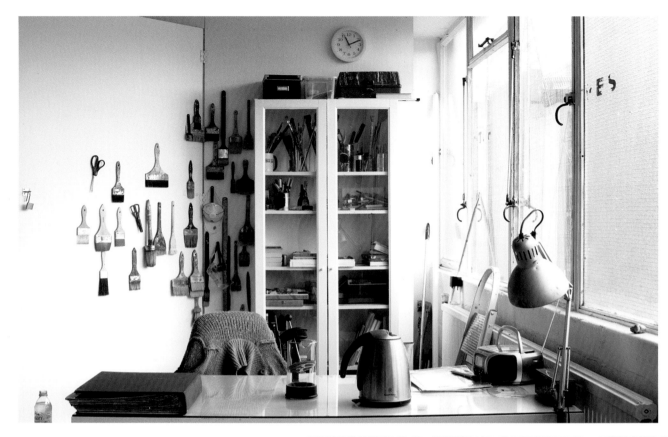

Unwin (opposite) takes time
out on the terrace outside
her studio in April 2011. 'The
only things I have here,'
she says of her small studio,
'are the tools to make my
paintings, whether they are
brushes or palettes or paint
or whatever. It is a very
focused place. You have a
connection with something
that fascinates you, that
you feel energised by and
obsessive about. For me that
is colour and form and all
the possibilities I can see
in painting.'

What was the trigger point in your career when you thought, Okay, I've arrived?

I don't think you ever feel that. I think that you just feel focused on the work and on making another painting. I feel very fortunate to have had the opportunity to exhibit in the places where I have, and I find it interesting to see my work in different contexts. But then before I know it I am back in the studio and focused on the work.

Which other artists have influenced your work?

It would be a range of artists for different reasons. The painters I am interested in include Picasso, René Daniëls, Van Gogh and Hockney, but I find it important to look at sculpture too; for example, Brancusi, Caro and Franz West come to mind. Also fiction, for instance John Updike, with his detailed descriptions and his focus on seemingly mundane moments. Then Nabokov, with his powerful and finely tuned use of the physical world to reveal the psychological one.

Do you always start with sketches?

There aren't so many rules in my work, but sometimes you need a few rules to not feel inhibited by total freedom. In order to have a rule, I always work in one size of sketchbook. My sketchbook is somewhere I can be very gentle with my ideas. When those ideas are translated into paintings, of course I need to be really rigorous with them. But to have somewhere gentle for these ideas to live is very important; it is somewhere where there is no judgement, in a way. There are ideas in my sketchbooks which may become a painting in two years' time or maybe next week. Some paintings I make from beginning to end in one go, but sometimes I work with a small group of paintings and then respond to those after having a break from looking at them. Thinking time and making time are different things. I have to keep aware of what I feel my paintings need.

Roger Hiorns (incognito)
at the Alexandra Road
housing estate, designed by
Neave Brown for Camden
Council in the 1970s. 'This
is the architecture I was
surrounded by when I
was growing up in central
Birmingham, which is
concrete. I derive a certain
security and comfort from
this architecture.'

Roger Hiorns

Is art a form of escape?

It's not therapy; it has more to do with how you relate to the world, how you deal with the stimuli you're surrounded by. You want to translate that through yourself into activities that your artwork eventually can be. I wouldn't say that my work involves escapism. Actually, the more I make work, the more problems I'm involved in, and that complication is quite nice, quite interesting. It's good to complicate your life to create a fantasy or fiction of your life. Leaving home is a first step, I guess. Eventually, you have to step outside of your comfortable background and move into the uncertainty of your future.

You say that an artwork sometimes causes more problems than you were trying to look at in the first instance. Do you have an example?

There are problems when you surround yourself with certain objects or procedures, ritualistic practices, things like that.

I have a piece at the Hayward Gallery at the moment that is based on re-ritualising the space of art. The disturbance of the work offers disturbances to people's lives. It's not that dissimilar from a definition of the political in that you're offering some kind of stoppage; your actions as an individual are changing the flow of daily life. Making an artwork is creating a problem that people have to negotiate. So artworks that are in the public realm rather than in a mediated museum space tend to be more problematic, more interesting, more challenging to the viewer. When you go to a museum, you expect an experience of some kind. But if you see work outside of a museum, it tends to be more difficult. That is what led me to have my studio in the middle of a housing estate, a particularly brutal one. Your behaviour is affected by the idea that you're among a high-density group of people. I obviously have to keep my behaviour low-key here because I will get in trouble if I don't. But in my art I can be as free as I want to be.

Is art a form of spectacle?

I'm not looking for spectacle in my work. I'm trying to find a way to pour my ideas into the mind of the viewer. It's not engineering, it's not deliberate, but there is a way to shape objectivity through making artworks.

Is there an element of ambiguity in the transference?

That's tricky. I wouldn't suggest that the language of psychoanalysis is a tool with which artworks can be interpreted. I'm perhaps looking towards a further language that doesn't have the set motivation of understanding the unconscious. The language of psychoanalysis is perhaps a bit compromised so I don't want to go directly into that way of interpreting the work. Seeing as Hampstead is just down the road, we're on the front line of psychoanalysis; we have Freud's house in the Tavistock Centre, and we have countless practices here. That may have been the reason why I chose to live around here. The area's populated by people who are being analysed. It's interesting to know that that's on your doorstep.

You chose to live here, not over in the posh part ...

That has to do with the fact that I don't have any money and also with the fact that this is the architecture I was surrounded by when I was growing up in central Birmingham, which is concrete. I derive a certain security and comfort from this architecture.

Can an artist be separated from their work?

They eventually get separated from their work through the stages of making. There is a challenge to understand why they feel motivated to do a certain activity. I try to keep my activities as wide open as possible. I don't have a set agenda or aesthetic. I have an equivalency with every work that I make – one is just as important or unimportant as the other. That's one of the procedures I set up so I don't foreground myself. The work becomes part of the separation, the (for want of a better expression) sacredness of the art collection or the art establishment where even the artist can't touch their own artwork because an institution owns it or takes charge of it.

It's possible to achieve things not by withdrawing but by overproduction disguised by future choices ... My son could take over ... Who knows?

Hiorns pumped 75,000 litres of copper sulphate solution (right) into an abandoned council flat in Elephant and Castle for his work *Seizure*. 'If you see work outside of a museum, it tends to be more difficult. That is what led me to have my studio in the middle of a housing estate, a particularly brutal one.' The resulting work won him a nomination for the Turner Prize in 2009.

Seizure, 2008
An Artangel/
Jerwood Commission
Harper Road, London
Courtesy Corvi-Mora,
London

Hiorns in his studio, an empty shop (above) at the end of the housing estate where he also lives. But help is not far away. 'Seeing as Hampstead is just down the road, we're on the front line of psychoanalysis; we have Freud's house in the Tavistock Centre, and we have countless practices here. That may have been the reason why I chose to live around here. The area's populated by people who are being analysed. It's interesting to know that that's on your doorstep.'

Are you concerned with longevity, especially given the materials that you use?

The materials I use encourage self-destruction in some of the works that I make. I remember talking to the Tate about a particular piece they own that has crystallisation on it. We spent a long, long time negotiating how it's supposed to be protected, and the terms were that they own it, and that they will keep it 'alive' as long as possible. My idea was: Let's see how it goes. Leave it to its own devices and let it disintegrate at its own pace. I turned the institution into an intensive-care unit. Also, most museums have sophisticated archival and restoration departments. You can see artworks that are in critical condition. One that was quite interesting was a Naum Gabo sculpture made of Perspex – it just collapsed. It was fine, then suddenly it decided to go. Materials dictate the period of time they can survive for.

If the institution becomes a hospital, then is the studio your lab?

I don't have a studio practice. The studio is to get dirty things done, perhaps. I don't want to have a studio to do one thing well so that works can accrue. I need to know what it is before I make it, and I don't spend more time than I need to in order to understand what I'm going to do next. You see an empty studio because a group of works has been made there and then they are gone. I don't recycle and I don't put series out there.

So you practise in the studio of the mind?

Yeah. Most of it happens in my head. Most of it has to happen in places other than the studio because it's a confined area. If you want to engage in the implications of the world and you're trying to really, fully understand how you're supposed to relate to the world, you're supposed to position yourself outside of it rather than contain yourself within a place where you're supposed to be making artwork. Also, the motivation to make work in a studio has to do with thinking about production, about just producing. They're meant to be places of contemplation, but there are other places where you can do that more efficiently. You need to separate yourself from the idea that you are constantly producing or running a small business. It's nice to pretend that you're not.

Is studio practice redundant, then?

It's about the notion that we don't have to feel that we're tied to the idea that we have to produce to have legitimacy in the world. Our identities aren't necessarily tied to what we do or produce. It's actually more about what we can imagine, about the fact that we have the ability to imagine things. Maybe contemporary art is about what the contemporary mind looks like. I spend a lot of time not making things. I make a lot of work in my mind that could potentially work in the world, but I find myself inverting it and thinking up ways of not producing what I potentially can produce. That exercise is quite useful. And it's a contemporary issue. The definition of 'contemporary' is 'to be rethought' – it's a trap.

Is the role of the artist in effect to outline or define contemporary life?

Sometimes not, actually. Sometimes artists can be reactionary. At the moment we want to rely on a certain type of artwork that played out in the 1960s. Certain assembly artists are relying on forms that haven't changed. So in a way we're stuck in a revision of what has gone before, glossing it as a contemporary moment. That comes down to why *contemporary* – the word itself – is a trap. *Contemporary* seems to accommodate everything since the word modern disappeared. That means that we don't have a good grasp of the temporal somehow. We don't seem to have a grasp of today, because everything implied by the word *contemporary* seems to suggest that we don't need to grow aesthetically. We're just feeding off what *contemporary* is. It's a closed system. The next stage in making artworks is to open up that closed system and not make things that we don't necessarily have to make. This goes back to the reason why I don't make certain things: because I don't think the world particularly needs those objects. But again, by extension, I make mistakes in my work. I don't know whether or not my works are self-critical in terms of whether they need to be in the world. It's a problem I'm trying to work out, a life problem.

What is your fascination with nuclear-disaster films?

It seems a reasonably good reflection of how I think people in this country relate to other people. There seems to be a sense of community, but when problems happen the community seems to become its opposite. It was the invisibility of an inherent threat and how, as a kid, you have to train yourself in metaphorical terms. The idea that a real material, not a supernatural deity, can invisibly affect you or become part of your own body is interesting. That transformation is interesting, the fact that it could create a growth inside you which would not be welcome ... When I was building *Seizure*, there was an overtaking of the interior and of the social body. We wanted to build a factory to do something awful to a building, but it turned out to be beautiful. I quite like the idea that beauty could be a by-product because it could never be a definite article.

'The idea that a real material, not a supernatural deity, can invisibly affect you or become part of your own body is interesting. That transformation is interesting, the fact that it could create a growth inside you which would not be welcome.'

Concrete with legs (following spread)**: art, artist and architecture combine in this surreal image, somehow adding another dimension to Hiorn's oeuvre.

Peter Joseph

We interviewed a young Conceptual artist yesterday who lives in a sort of council-house-avant-garde-turned-on-its-head flat. So we have the cityscape on the one hand and someone like you out in the landscape …

I am a bit odd because I don't think much of the last thirty years or more's worth of contemporary work, but I am fascinated by older work. Always have been. I go to the Ashmolean Museum, for instance, because of one particular artist: Pissarro. They have a large collection of his work. I wouldn't say that I am a landscape painter disguised as an abstract painter, but I am charged, if you like, with landscape. All of my work is to do with colour – when associations of colours become a possibility, I finish them off as studies. I eventually think I can possibly make a painting in large. Obviously it's very personal, very disciplined.

It seems like a puzzle or an equation. Do you know instantly what form it will take?

No. It's subjective. It's there and it's gone, or then sometimes it emerges.

Why do you live in the remote English countryside?

Because the position we found is remote enough from all the urban madnesses that I don't want to be mixed up with any more. Not only the obvious ones – the capitalist nightmares of shopping – but competition among artists I don't like. It was healthy competition when I was younger; I am talking about the exciting years, the '50s up to the mid-'70s. Then it began to change, almost imperceptibly, into art and consumerism and what you could sell.

For a painter concerned with doing something because it was contemporary and had meaning to him, you would have been looking to America, to the Abstract Expressionists, people like Barnett Newman and Rothko. That was a wonderful time for someone like myself. It was very difficult unless you went to America, which I didn't, so my first recognition of it was in London. It was revelatory, it was a shock, it took me some time to take it in: the scale, the panache – and I don't mean panache in the vulgar sense, I mean the strength they had introduced into painting. And something much more important – I don't like to use the term because it sounds a bit quaint: the *metaphysical* need implicit in what they were doing. Their early work was done without any help at all from the art establishment, never mind the rest of the establishment. So they never expected to sell those works. They made huge pictures, much bigger than the things I make. Those pictures were made as a statement about life, and it was ignored, of course. The establishment continued to buy Post-Impressionist work and odd, quaint American work which was of no importance at all. When the Abstract Expressionists did emerge, they were pushed by the CIA, of all people, to hold exhibitions across Europe as part of a promotion of American imperialism.

For someone like myself, this all became a huge voyage of possibility that cut across national boundaries. It was like energy released, like the sort of thing happening in the Middle East now, the Arab Spring, a real burst of energy, a new thing, not something that was fettered. Of course, this coincided with the Vietnam War. People who were enlightened and who were in the arts were almost inevitably against the Vietnam War, so art had a great importance because it separated the conventional, the hidebound, the stupid, the imperialists, the money-makers, the politicians, from the adventurers, the young people. They weren't just idiots taking drugs to be different; they were trying to find a way out of a culture that was dead.

And now?

Now the art scene, as far as I am concerned, is just plain disgusting. It's not even run by critics or magazines or so-called art historians who appear on television. It's run by the great auction houses. They know nothing about the work; they get young people from art schools and try to promote them. Even a strong, independent and renowned gallery like I have is in the shadow of these people because what they are attached to is enormous. They have poisoned the art world.

I don't mean that I am against new art, although I find most of it wet. What I am against is the taking over of the scene by the money-makers, the imperialists, if you like.

Does that devalue the art that is being produced?

Of course it does. I can't speak for other artists, but I do feel that I have seen art ruined from what was a glorious time in the '60s.

When I was inspired by Rothko and Newman and the New York School in the late '50s, I also learned from them about existentialism, this mode of thought independent of politics and philosophy which of course started in Europe. I found a new way for myself as an individual. In the late '60s and '70s, I got disillusioned with the scene. I made more public, huge work, constructivist work to be put in galleries, not to be sold. Then I decided to break away from the art scene, from everything. That is why I wanted to find the circumstances to come and live here. The defining year would have been 1970–71, but I hadn't the money or the ability to move then. I had to wait until the late 1980s. I had to stay in London, and I suffered because I tried to be separate. The work was deliberately quiet. I didn't think about it like that; it came automatically.

How do you define your work?

My work is different from that of others in that it is concerned with tonality. I am very fond of classical music, particularly early nineteenth-century musicians like Schubert and Schumann, who wrote song cycles about the loneliness of the individual often involved in a love affair. Song after song would come out in its modulations, its distinctions and its changes, a fascinating equivalent of painting.

Peter Joseph outside his country home and studio in Stroud, Gloucestershire, in April 2011. 'The position we found is remote enough from all the urban madnesses that I don't want to be mixed up with any more. Not only the obvious ones – the capitalist nightmares of shopping – but competition among artists I don't like.'

Are you at all concerned about the emotions and feelings that you project onto the viewer?

It's not my concern in that I wouldn't want to do as a lot of Conceptual artists do: put an idea out there, saying, 'This is a public offering and I hope you all agree' or 'I hope you might be interested.' Art to me is totally personal. I go through this endless performance in the first case looking and then discarding. My belief system makes me think that, if I can find rightness, it can be ethical as well as subjective. I can find something that ties me together with the human race. It's not a demand, it's an offering, a simple offering. My work is based, if you like, on my system of belief, which is against logic or scientific positivism. I can only think of the subjective, of the person. There is a connection between us all, what we crudely call humanity.

What value can art transfer to humanity?

Well, if you don't know, you don't know what art is. If you see a work, you know. Something strikes you, like a light suddenly on the landscape, or a person; it's the light they might generate themselves on a rare occasion. It's a delight, it's a moment, it's an epiphany of possibility.

Are you touching the verge of spirituality with your art?

I don't have to use that word. I can just sit here and quietly and gradually be aware of the light moving over those trees and find that a wonderful moment rather than having it stated for me by a piece of music or a philosopher. True communication is what I try to find by manipulating colour and light and forms in my painting, and trying to make these things apparent to myself.

I started off in advertising, of all things. I started off in the muck because I come from a very poor background. They couldn't afford to send me to art school, so I went into advertising because I was talented. I soon became successful. I longed to paint, but there was a paradox there, and a curious dilemma, in that my idea of painting then was the great Italian artists (still is, as a matter of fact). So I tried to paint like that, and it was hopeless.

I enrolled in the Royal Academy because I could draw and paint quite well. TV was only just beginning in those days. I realised only much, much later that the most dynamic work I was doing was in advertising, not in the pathetic paintings I made of the nude in particular, trying to make pseudo-Renaissance painting. The dynamic came – and I only realised it unconsciously – from my excitement in making simple forms of letters and bodies of type balance each other in a short space in the newspaper. I was not interested in the content or what they were selling; I just had to find a dynamic around those shapes. I realised only later, once I had left advertising and suddenly was free of all that, that it was my first realisation of what abstract art was. I understood that I was far nearer something I was to appreciate only later, which was the abstract art of the twentieth century, people like Malevich, Mondrian and others. They have nothing to do with advertising, but their particular use of something as simple as a few forms in an imaginary space has a symbolic and actual power to work on the mind.

What is your relationship with the art world today?

There is nothing that interests me. I feed off the artists that I love, Pissarro in particular. Pissarro is obviously not as great an artist as, say, Cézanne, but his personality, which goes into the work, and the modelling of relationships and light and dark and tones, are so delicate. In the last seven or eight years, I have become interested in Caro, whom I never bothered to look at before. He is a beautiful artist. The intimacy and the delicacy of tone, of light, I find exquisite. Another one is Boudin, one of the Impressionists but hardly known. I love his light and his touch, the way he makes clouds, the masts of ships. I relate it to my own ways of making marks on canvas.

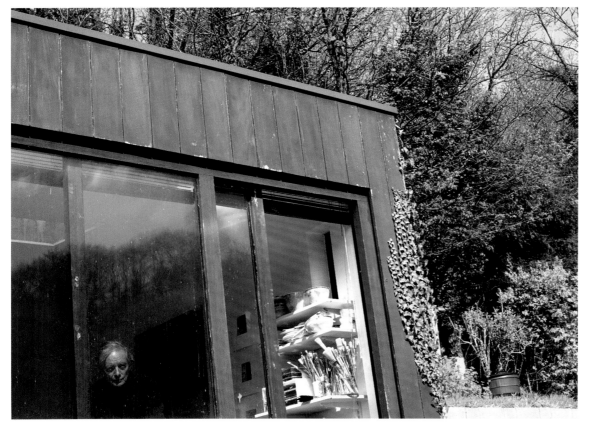

Why is it that art has a left-wing tinge to it and artists are always trying to break social norms to create different paradigms?

I have never thought about it quite as directly as that. I keep myself to myself, but I am aware that at least some artists are doing something that I did myself, along with a few others, in the '60s, which is to attempt to make public art rather than just gallery art, which means sales to rich people. But I didn't think in terms of making statements about wars and capitalism and that kind of thing. That to me is going too far. To me, art, real art, is human and essential; it transcends politics, which is ephemeral.

Is art elitist, then?

That's daft, art elitist! How can it be when most artists haven't got enough to eat?

Joseph's studio practice is modest, as modest as the artist, who has chosen to take himself outside of the mainstream for fear of being corrupted by the materiality of the art world. 'To me, art, real art, is human and essential; it transcends politics, which is ephemeral.'

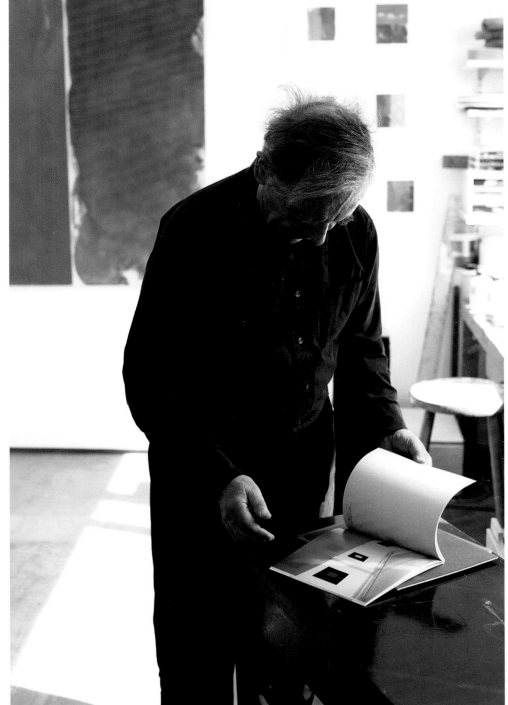

Joseph and his wife, writer and poet Denise Ward (following spread) on the roof of their purpose-built home and studio (designed by Lisson Gallery architect David Roberts), which was only approved by the local planning council after gaining support from the Arts Council, Sir Nicholas Serota and Pompidou Centre architect Richard Rogers.

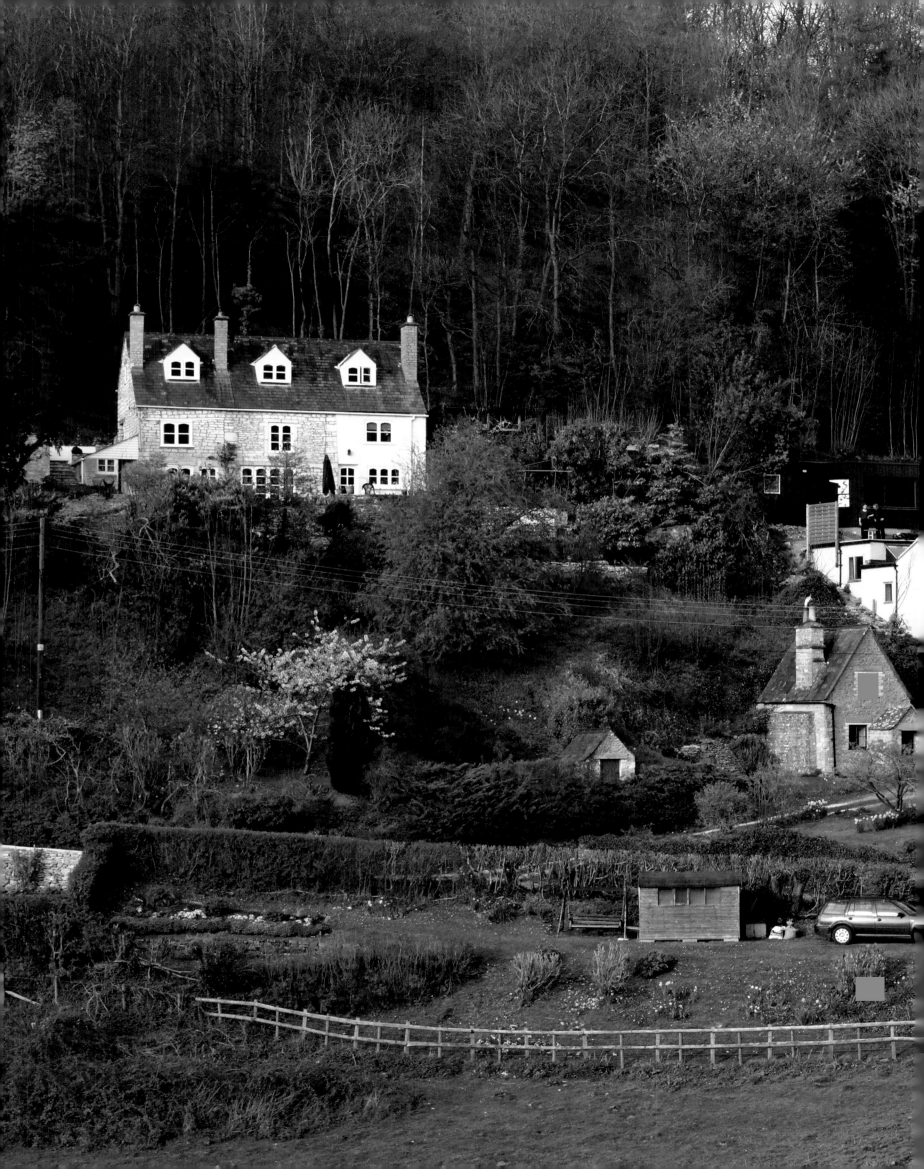

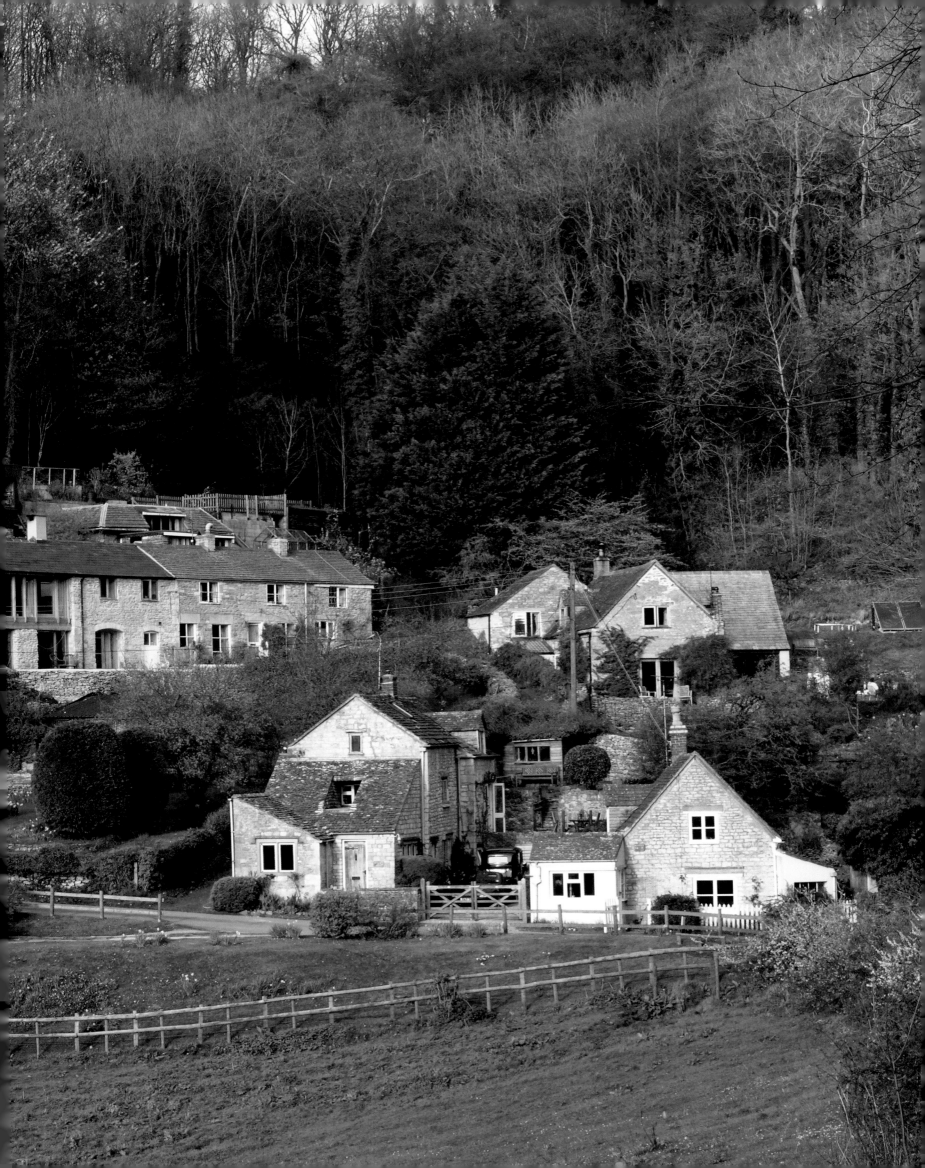

Conrad Shawcross

You seem to have a very active studio, and you actually live in the studio environment. Has that always been the case?

I started working in my bedroom when I was about eight years old, so I suppose it's always been the same. When I was starting out, it was purely financial and pragmatic. Because my work is very labour-intensive and also very material-intensive, it was always a massive issue. So it made sense to me to live and work in the same place.

Marina Warner, your mother, and William Shawcross, your father, are both great writers. How did it feel to grow up in that environment?

It was a lovely upbringing. Although they are both writers, they couldn't be more different. It was a very rich sort of environment because my mum was married to an artist, John Dewe Mathews, and my father is married to Olga Polizzi, so we had very contrasting times when I was with my mum or my dad. They've both always been unconditionally supportive, always afforded me the time to explore my ideas.

If you'd grown up in a different environment, do you think you would have become the same artist?

I don't think so. It's not just nature; nurture has a huge part to play. The belief of one's parents and their support are crucial.

You make fantastic machinery. What playthings did you have as a kid?

The one thing that's surprising about the way I've turned out is that neither of my parents had any tools. They didn't even have a toolbox in the house! I remember seeing a toolbox and looking inside it in awe, at the spanner and the screwdriver and the hammer, and thinking, Oh my God, this is the most incredible kit! It actually, in hindsight, was a pretty sparse set of cheap tools, but I became obsessed with them.

When I learnt to drive, particularly, I became obsessed with how the car's engine worked, and I was really uncomfortable with not knowing how I was meant to get from A to B, not knowing how this thing was carrying us forward. I had a sort of mission to become familiar and fluent with how an engine worked. Luckily, I had a 1978 Leyland Sherpa camper van. It wasn't the best example of British engineering, but it taught me a huge amount. When I was a poor student, I couldn't afford to take it to a mechanic, so every time a gasket or something went wrong I had to fix it myself.

So you had the toolbox, you had mechanical problems with the old van. You've been obsessed or intrigued by motion, by kinetics. From A to B: how does one get there? Is that a philosophical problem or a mechanical one?

It's definitely philosophical; I hope it isn't seen as just a mechanical enthusiasm. The work is very much driven by conceptual reasoning, by a lot of philosophy and epistemology and metaphysics. There is a fascination with machines, but I don't describe myself as a kinetic artist.

Who is the philosopher who has affected you the most?

I did maths and physics at A level, but I didn't do any beyond that. I wasn't particularly good at it. I was much more interested in the ideas and philosophical problems that the sciences throw up, and the impossibilities we face when we're confronted by certain models, whether theoretical or real. And how we deal with them in terms of the limits of our own perceptions. I was very influenced by my time at the Ruskin School in Oxford, which is part of the university. It was amazing to be surrounded by all the other subjects. Rather than being at an art school that concentrated on art history and on contextualising yourself within an art-historical context, I was at a school that looked outwards. The idea was very much to try and conceptualise yourself within the history of ideas. That was why I went to the Slade for an MA rather than to an autonomous art college.

Rationality is a theme that seems to crop up in many of your interviews. Would a simple observer of your work see rational constructs or an irrational attempt to extend the bounds of art?

With my early works, when they were more hand-made and just by myself, I was trying to couch them in the aesthetic of the rational, the aesthetic of the machine and the utilitarian. So those early wooden pieces look like antiquated machines from some other era. The evolution of the aesthetic has been a sort of dogmatic pursuit of beautiful design in terms of function.

But once the function is analysed, once you're confronted by the authority of this machine or this mechanism, you have all that power and authority pushed on you. You, as the viewer, then have to take it seriously because of the rational way it's been produced and the sheer attention to detail. You're forced down more metaphysical or philosophical paths to try and justify the work's raison d'être. But the machine is slowed down to a ridiculous extent. For example, it might make rope at the rate of only half a metre a day, so the justification has been taken out of the machine because it works much more slowly than a human doing the same thing. This makes it useless as a machine. There's a sort of tragic-ness to it.

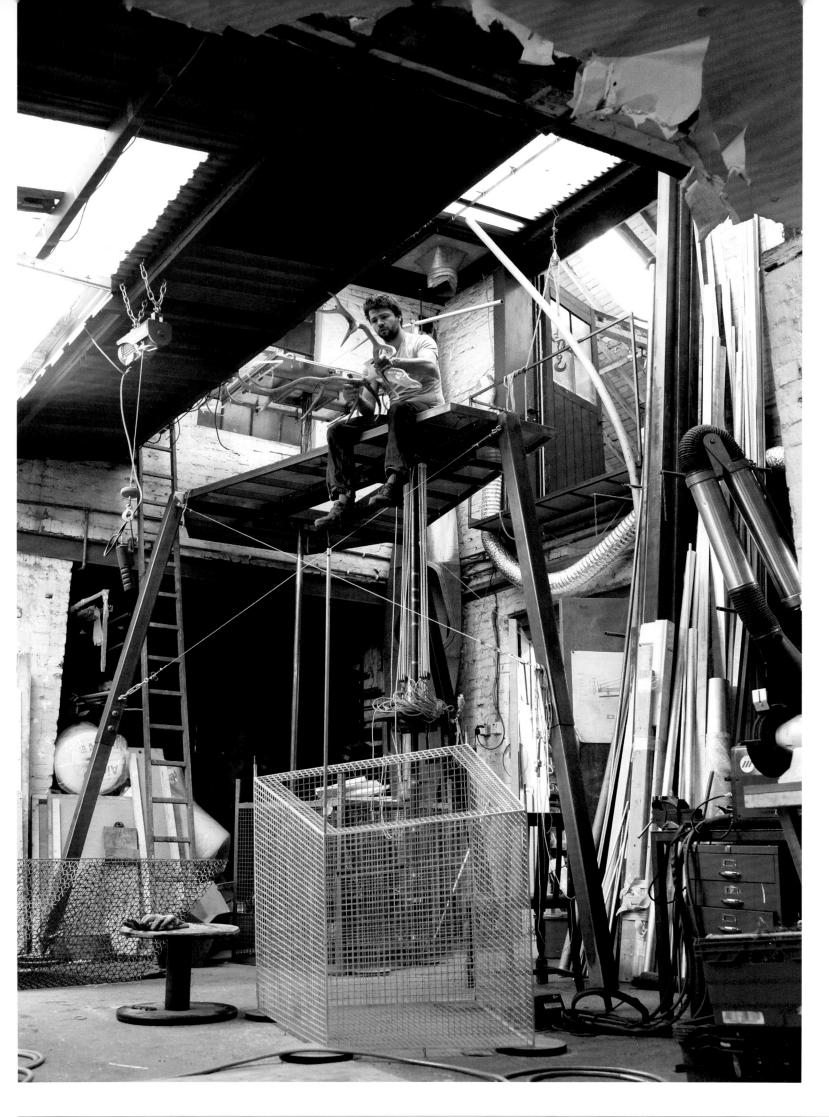

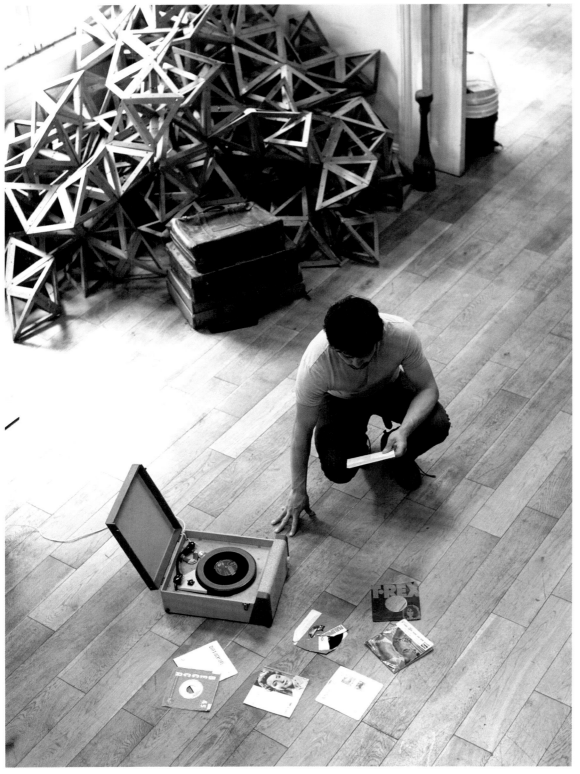

If there is no utilitarian value, where is the aesthetic component?

The machines are not useless as vehicles for ideas and for conversations around them and the ambiguity in them. They are, hopefully, successful as artworks. To go back to the example I mentioned earlier: my original interest in making a rope machine had to do with my preoccupation with the idea of time and the metaphors we use to describe it. Quite naively, when I was twenty-two or -three and made my first rope machine, I saw it as a model of time because it was producing this linear structure out of all these rotating spools, almost like planets. Time can be conceived either as a line or as a cycle, as kind of a circle. I liked the idea of rope as a perfect actua-lised metaphor for time because it is both linear and circular in its structure. So it was a structural metaphor that was being realised by taking some-thing real, something physical, and using it to explain something abstract. I was turning that metaphor back on itself, back into a physical object again, rather than just using it as a way of trying to describe something complex.

The irony was, having made the rope machine, I realised that it was not a model of time at all. It was a sort of failed model of time. In that sense it was much more interesting as an artwork. If I had made a model of time, I'd probably have been given the Nobel Prize! It would have been a very different situation. What's interesting is that as an artwork it would have been kind of boring. It was in its failure that it became successful because it highlighted our problems with perception, the limits of our perception. It's those failed models that I'm interested in.

What is contemporary art?

The thing that defines it is the questions that it raises. It doesn't answer questions, it creates ques-tions. The less it answers them, the better. It creates problems and it creates conversations around objects. It creates ambiguity, it creates debate. Contemporary artists are constantly looking at new ways of seeing something from around the corner. Art has to evolve and mutate, I think, in order for it to be contemporary.

I got asked a lot of questions recently about J.M.W. Turner. What Turner tried to do was return to the same subject at the same time of day. At each place, he painted it again and again at that same moment. And he painted it differently and made it hyper-real and pushed the colours and changed the colours, and just kept on pushing what he could see. Just like Monet would return to the same lily pad, or Carl Andre would return to the same hundred bricks and make them into every possible arrangement he could make. It's trying to create objectivity by creating sequences, to represent the same information in different ways. That's exactly what science tries to do when it envisions information, but there are so many different ways that you can interpret data.

Is there a particular artist who has influenced you?

Duchamp is a big hero of mine. *3 Standard Stoppages* is one of the first pieces where he attempted to create an artwork that doesn't look like an artwork. For me it's a very revolutionary sort of piece.

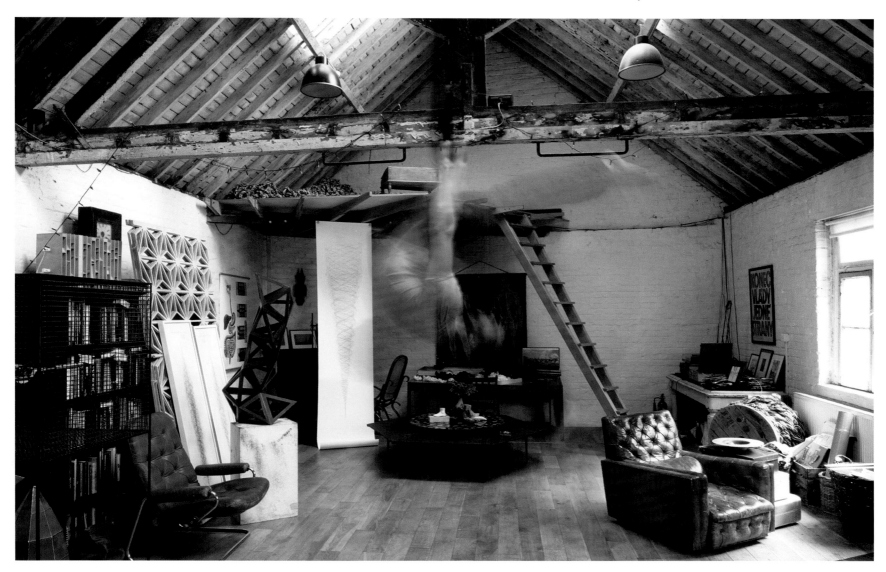

I remember visiting your studio in New York when you had a residency there. It was a tiny space, very concentrated. Knowing the incredible size of your installations, I'm interested in your working methods. Does work always start in a little space, on paper?

No. In my twenties, when I was doing almost everything myself, I was becoming very rushed, and I had quite a bad quality of life. I believed that I had to do absolutely everything, from every piece of carpentry, from the conception of the design and drawings, to the sketches, to the cutting of every piece of wood, to the welding of every component – everything. It would be, sort of, mine. In my thirties I made this vow to change my way of working. It would be very much about creative partnership. So I have a very close relationship with a structural engineer; I work with a mechanical engineer; the guys in the studio have become experts in certain areas, which is on one level quite humbling.

I'm trying to get back onto the floor more, because I've become a bit stuck in the production role. But having a team is actually superior. I get up every morning and I'm on my own in a cerebral space, just there with a piece of clay or a pencil; I'm immersed in my own dreams. But it's not as simple as that.

A trapeze (above) hangs in Shawcross's living room, which is part of his studio. 'I'm trying to build a full-sized rig, a portable rig, to start a circus that I can tour with.' Shawcross relaxes by practising on the trapeze several times during his working day. Old vinyl records and a record player (opposite) occupy the artist's attention, while new parts of an installation piece are stacked in the corner of his living quarters.

Conrad Shawcross

Maybe you find solace in your works in paper?

Absolutely. I need to create more of a cerebral space to retreat into.

I'm fascinated by your passion for trapezes. When did it start, and why?

I've been doing it for about ten years. I'm trying to build a full-sized rig, a portable rig, to start a circus that I can tour with. I've worked with this wonderful structural engineer, but this is the one point where he's continuing to let me down. He's very, very nervous about engineering the parts for the trapeze, because it's about people flying through space and a lot of perverse forces going on, so it's quite difficult to work it all out. But I'm determined to carry on doing it.

But why the trapeze?

I'm probably a bit of a show-off. I always used to climb up things when I was a kid, and hang off things. I was always a bit of a monkey. So I really liked the idea of it. I started taking courses. I had this romantic idea that I would meet a beautiful, petite girl, and we'd become this romantic duo. The irony is, when you do those classes, you only get caught by big, burly men! So it hasn't really worked out the way I wanted it to!

'There is a fascination with machines,' the artist says, 'but I don't describe myself as a kinetic artist.'

At work (left) and play (above): Shawcross, a keen canoeist, sits atop a bridge along the Hackney Cut canal in London in April 2011.

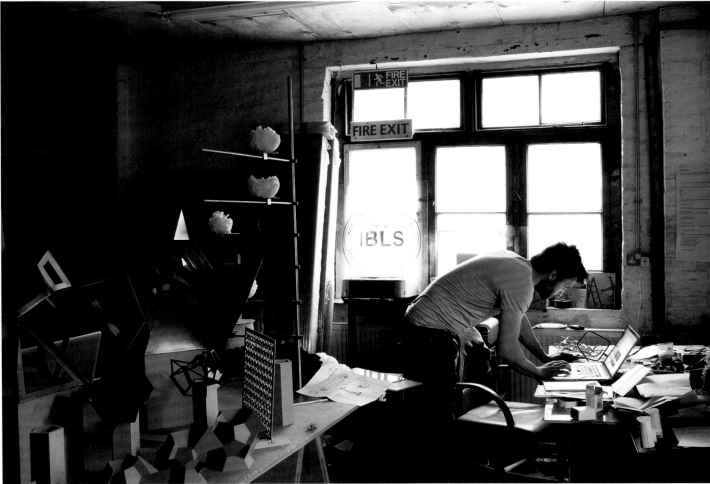

Richard Deacon

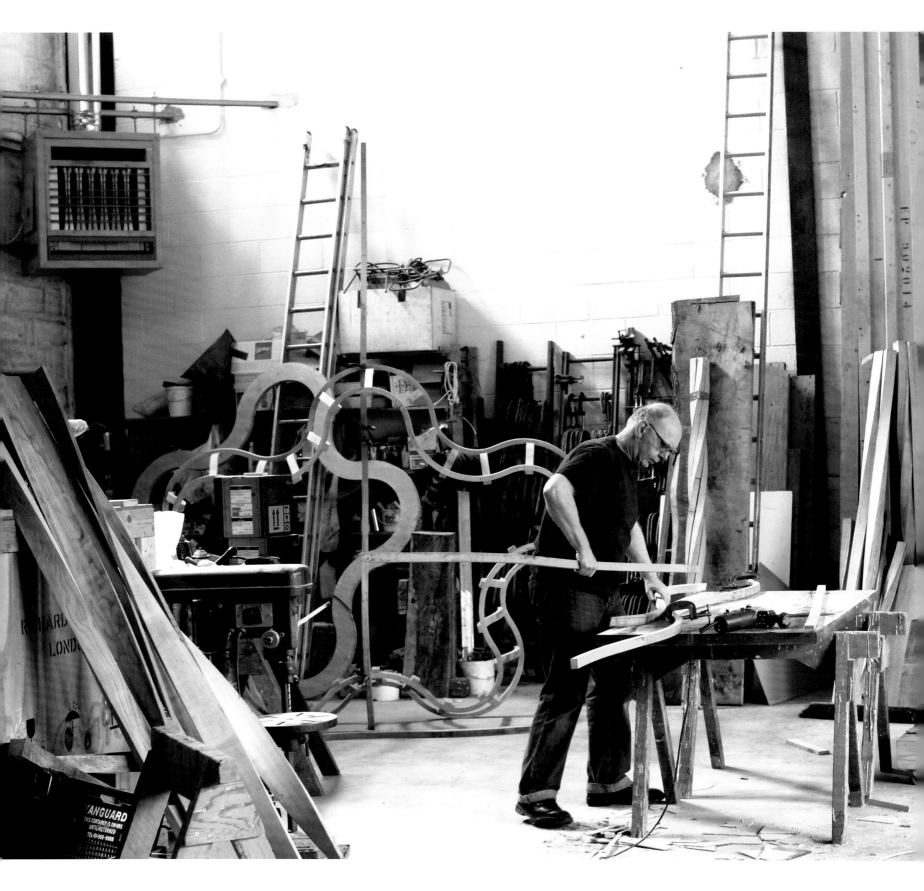

There is a great deal of tension in the materials you use, in the way they are assembled, in your process. But you have often said that there is tension between what you see and what you don't see, between what is there and not there. Would you care to comment on that?

A lot of the work I make involves putting an outside around something in some way or other, by either wrapping it or putting a frame around it. In the first instance, the sculptural motivation had to do with wanting to make things that didn't grow from the inside, because growing from the inside implied an explanation for the outside. If you start in the middle and work out, there is a rational connection between the bits. I wanted the inside to have a kind of potency, to be a nub or container of meaning.

I started making sculpture when I was thirteen or so, and by the time I went to art school I thought I knew what making sculpture was all about. Then when I got to art school it got a bit confused and I lost that certainty. All I knew was that it was material of some sort made by someone, somewhere. For a while I focused on that material quality. I began working on producing a material of some sort, a kind of manu-facturing process; this led to a lot of performance activities associated with production. Later, I returned to actually making objects. I wanted the material to remain important but not as the whole explanation. I thought the idea of meaning was interesting, but I didn't know what the meaning was.

The means of making that I began to use basically involved capturing a space of some sort by rolling up or folding. Sometimes that space was the studio floor space, because a lot of the time I worked on the studio floor and then kind of rolled it up. A lot of the early works are sized according to the studio floor. So the studio existed as a special place, a kind of focus, and those sculptures point to the studio.

The studio is a place that enables some sort of activity to happen free of instrumentality and of reason. The sense of tension or relationship between this empty space – the material space in which things are made – and the material entity that is the sculpture became a creative area for me.

When speaking about your structures, you often refer to skin ...

I use the word *skin* quite deliberately, because it's the outside and the carrier of appearances. You also refer to the skin of an aeroplane or the skin of a boat. If you think about your own skin, that's the place where you meet the world, and it is also how you look. If you think of taking off your skin, then you kind of disappear. Skin is a semi-permeable membrane – transpiration, perspiration and respiration pass through it. The relationship between you and the world is filtered by the skin. For me, sculpture exists in that relationship between you the perceiver and the inside, which is actually empty in the majority of cases. The inside remains empty but is also somehow a carrier of meaning.

You talk about metaphor as a way in which objects can be put into relationships without having any necessary resemblance between them. What reaction do you seek from your viewers?

There's a lot of ambiguity in my work. There are a lot of different potential readings of most of what I do. In a metaphor you see something as if it were something else. In the relationship you just described between the viewer and the sculpture, there is never just one message; there's a multiplicity of messages. The content has to do a little bit with that multiplicity of messages and with ambiguity. The sculptures I make are never didactic, and in fact meaning is a kind of slippery thing anyway. The context can change the meaning the object has.

You mentioned that you were thirteen when you started making sculpture. What was your first piece?

The first piece of sculpture that I remember making was a pig's head, a carving. I was very lucky to go to a school where the teacher worked after hours and ran an art club where you could work with materials rather than paint. I'm not mechanical, in the sense that I didn't build things to work, but I liked putting things together. One day I turned up to the art club and there was a big pile of wood, pieces that you could carve. There was one piece that looked like a pig's head, so I started carving it to make it more like a pig's head, because that's what I thought you did. I thought you saw something that looked like some-thing and then you made it look more like it. That was the first idea I had about making art: adapting appearances to make things resemble something more closely. I went on to make things from nothing, as it were, to make things completely from out of my head, but the first thing I made was a modification of something that existed.

I worked very happily at school and was convinced that I wanted to be a sculptor. When you are a teenager, it all comes flooding out; you know exactly what you want to do. When I went to art school, it became more difficult because then you have to start thinking a bit harder and explaining. When we hit the '70s, I had to go back to the beginning several

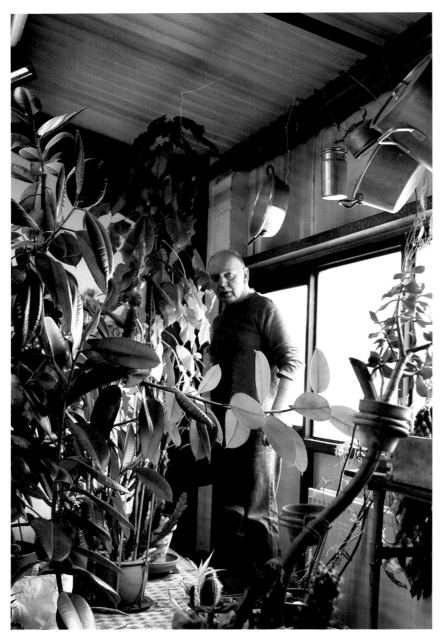

Do you think there's too much hype in the art scene today?

I can't generalise like that. It's very difficult to make work for the market, and, if you do, you're trying to out-guess the market, which I don't think you can do. You can only make the things that you want to make. If you try and make things you think someone else wants, it doesn't ever really work.

There are problems caused by the market now. Art activity has shifted from the arts pages to the financial pages and the news pages. That seems to be a good thing, in that more people are aware of the activities that artists do and more artists are making money, but the measure of success shouldn't only be financial.

You make small domestic pieces, and you make pieces for gallery exhibitions, but you also make big public artworks. Which do you prefer making?

I don't have a preference. Making big public works has some problems attached to it, because you have to say what you are going to do before you do it. On the other hand, making very small works is difficult because it's hard to be spontaneous. Size changes the viewer's relationship to the object. In exhibitions I often change the size because it changes the way you relate to what you see. There is a certain dynamic involved when several things are together that allows you to put a small thing with a big thing in the same room. In terms of 'What shall I make today?' kinds of questions, the size of things I do in the studio is purely determined by what happens to be interesting and by ongoing processes. If I am working on a commission, in some sense its size is more or less determined by context.

I make some things here. The wooden things are made in West Norwood with Matthew Perry, the bigger steel works with a steel fabricator in Milton Keynes, and the ceramic works in Cologne. A number of my contemporaries have large studios with a lot of people working in the one place. That doesn't really work for me; I'd much rather go to other people and keep this place semi-private or kind of to myself. It makes me feel guilty to have a lot of people working. For some artists, it energises them; for me it doesn't. It paralyses me, simple as that.

So the studio is vitally important to you?

The studio has always been an important place even if I am not here.

And it's a place for reflection and creation?

Yeah. It's also a place where you cannot do anything at all. It is not necessary to be always working. I think a certain amount of boredom is sometimes quite productive when you're an artist. Your brain is slightly free of obligations, but you have enough time

times, but I never abandoned the idea that I wanted to make sculpture. It was a surprise for it to become an economic activity. The market as we understand it now didn't really exist; it was artists' co-ops and artists supporting each other. As a young artist you never really thought that the sales were going to be significant, so you had to find other means of earning a living. In the '80s it all changed. People began to take the work seriously, and it became possible for me to think about myself as a professional artist, not just a hobbyist.

I had quite a difficult period from the mid-'90s to 2000, when there really wasn't much going on for me professionally, but I made some very good work in that period. Also it was a time of crisis in my personal life. I took on a job in 2000 in order to liberate myself from the necessity of selling in order to pay for a studio. It's difficult to work when you worry; it's difficult to make things that you need to sell. The financial anxiety obviously related to an underpinning of emotional anxiety.

The last ten years have been very productive and very successful, if you count success as showing or visibility. For me they have also been successful in the quality of the work I have made.

to play, as it were. It can be playing with materials, it can be playing with things. It's not necessarily just a thinking process, it's also a physical process attached to materials. Creativity comes out of idleness. One of the things I think an artist does is pursue those funny thoughts that bubble up.

Is art in some way replacing religion in progressive societies?
Perhaps. I wrote a little essay about this, imagining why people go to museums. It's a kind of sacrilegious thought, but it's hard to account for the success of museums without taking in a notion of the hunger for meaning and the idea that the museum has retained the capacity to project a possibility for meaning which is diminished in relation to religious culture. Religion certainly hasn't gone away, and in fact it might be returning, but there is some crossover.

Do you think that art needs intermediaries?
It needs a place where it can be experienced, whether that is a museum or a gallery, a room or a cave. I don't think it needs a priesthood because the primary experience of art is by the individual in front of something. Meaning is generated out of that.

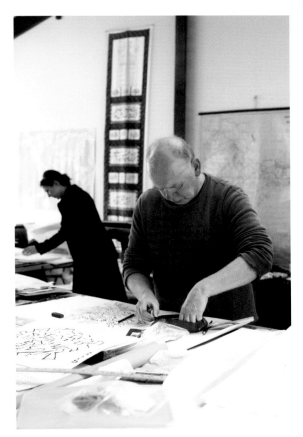

Deacon is an eclectic collector, including figurines and even fossils among his holdings. 'Creativity comes out of idleness. One of the things I think an artist does is pursue those funny thoughts that bubble up.'

Darren Almond

Your parents both worked; your father was a miner …

My grandfather was a miner. I come from a mining tradition. My biography has been my tool for navigation. You need a starting point. We all have our history. We have a local history and then there's a broad history, and those histories connect through geography; they connect across a field of time. My memory is as old as maybe my grandfather's memory. I have a notion of his life.

Why do you think that is?

In order to have some kind of engagement in a subject or a place or an object, there has to be some sort of emotional connection. That in turn leads to investigations. I'm a Cold War child, so I grew up with this idea of the Cold War operating above my head. I started by making films. I made a large clock and put it on a boat and sailed it to New York – that became an instrument of navigation. I had this clock constantly in flow around the globe, which would suggest that I'm interested in a global landscape. Within that there's the global self, which has responded quite slowly to things happening to me and within my family.

The global self travelling for art, even to Kazakhstan?

The reason I went to Kazakhstan is because the elements that were in place in the coal mines in Kazakhstan were similar to the coal mines in the North-west of England at the turn of the century, when my grandfather was working down the pits. I wanted to experience that. It was like a personal journey. You open yourself up through these scenarios … I like that. I don't program, I don't direct, I just respond to the pit I've dropped myself into. The piece that resulted from that trip, called *Schacta*, is a two-screen film with audio. The audio is important because it is a recording of a female shaman singing as part of a burial ritual. The men worked down the pit, and the women operated the pit from above; this seventeen-year-old girl would control the elevator because you wouldn't put men's lives in the hands of a man; the person with the most care and attention was a seventeen-year-old girl. There was this interesting primal structure within these societies. I thought *Schacta* would be the third in my trilogy of films about trains; I had made two films previously that relied upon the train for their structure. *Schwebebahn* and *Geisterbahn* had occupied the opposite ends of a polemic but both somehow were fictitious. I was searching for a middle point, a landscape that had a present and political resonance. Railways are always an invasion, be it through landscape, into a nation, through mechanisation, through modernity …

Anyway, the film that I needed to complete the trilogy was called *In the Between*. It's about the railway that China has just constructed to Lhasa to enable China to facilitate a military position against India. This was the perfect railway to finish my trilogy because the film starts in the year 700 inside Samye Monastery. The title *In the Between* comes from an accurate translation of the Tibetan Book of the Dead written by Robert Thurman. 'In the Between' implies we are in a constantly changing landscape.

Do you have a political bent?

I have a humanitarian bent. I'm only a witness to my times …

Does your work refrain from moral commentary?

Possibly, but it makes observations. In the gulag, you have men struggling for survival in temperatures as low as minus 70, mining nickel in order to make stainless steel. There's a lot of sulphur in the ore, so you need to burn this sulphur, which goes into the atmosphere, which has caused the largest devastation of forests across Siberia. One man's harvest is another man's waste. That's my network. It led me from Siberia to Indonesia to work with the miners who harvest sulphur in the most toxic of environments for the sugar industry.

Earlier in life my grandfather would sit me in front of the fire and tell me how the coal had got there, about his personal experiences of mining. That makes quite an impression when you're young … even in the '70s we were still getting coal from the side of the street.

At what age did you figure out that you were going to make artistic statements?

When I was thirteen, I started doing art. I was very bright on the mathematical front, and everyone thought I'd be going off to Oxford, but it didn't fascinate me. Art seemed to bring everything to the table. The mathematics is there; I still look for equilibrium when I'm making work …

How did your parents react?

My mother kind of understood. My grandfather would *really* have understood, but he died when I was quite young. He was quite creative.

Darren Almond, nursing a broken arm after a skiing accident, is pictured under the Westway flyover near his studio at the end of April, 2011. 'Vulnerability opens you up; it allows you to be more instinctual.' Intellectual instincts and cerebral inquiry are hallmarks of the artist's work.

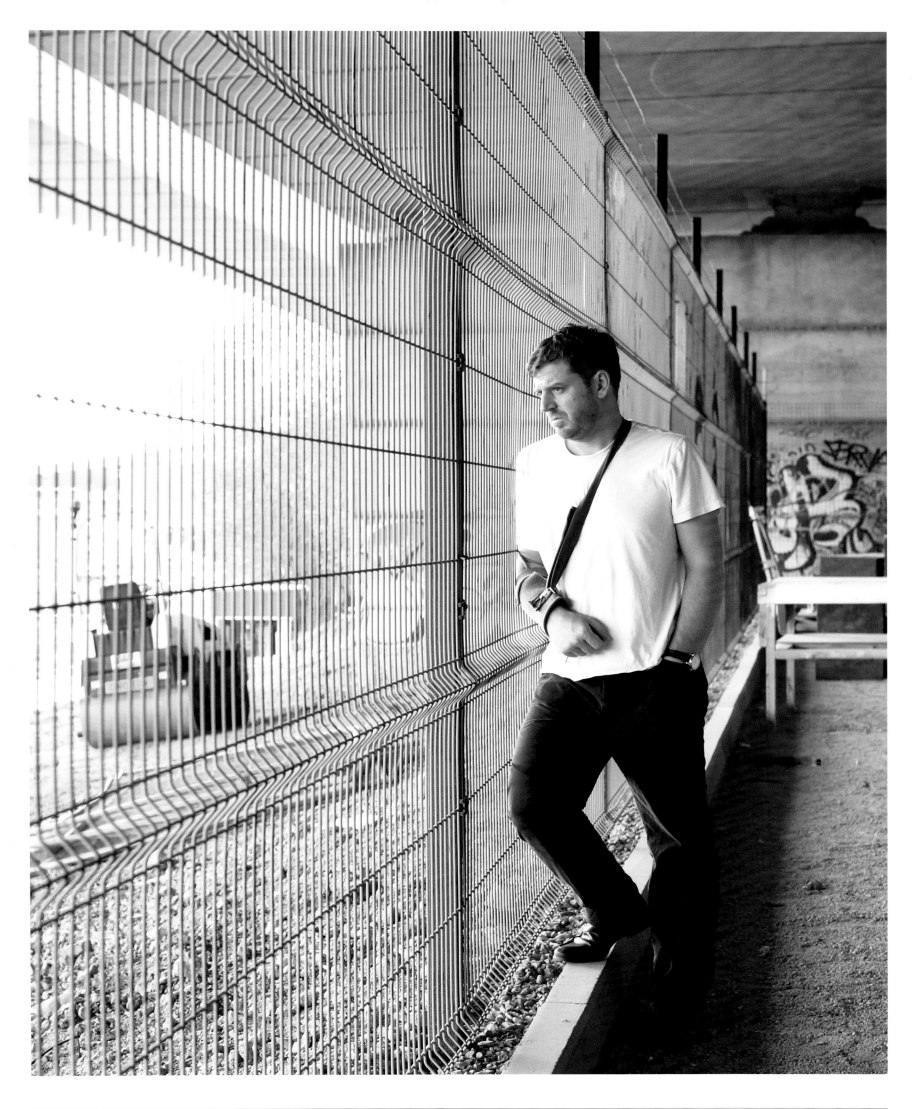

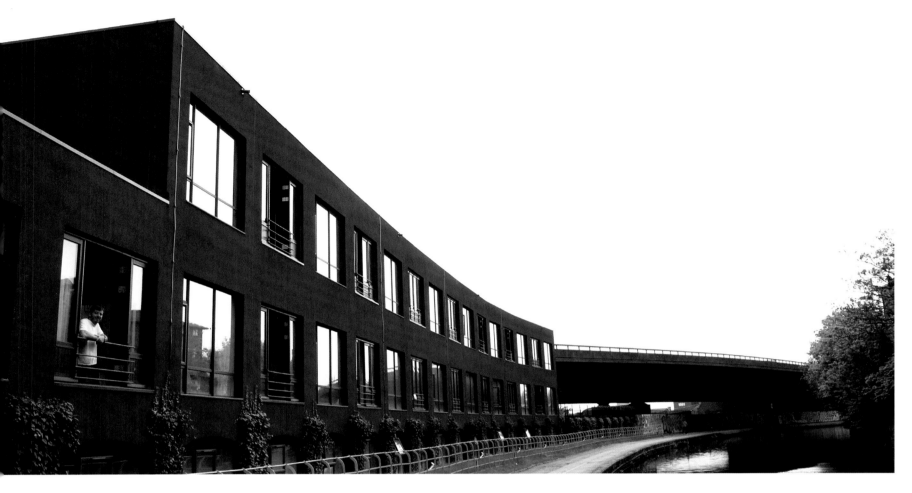

'We don't have a word for how insignificant we are. Maybe we need to accept that a little bit.'

Which photographers inspired you when you were young?

I used to collect postcards when my grandfather took me to antique markets. He'd give me 50 pence. You would get war memorabilia and crockery, silverware and old dolls, and there'd always be an old camera stand as well. I would go through this stack of postcards and choose some, and I would pin them to the door of my wardrobe. I only realised the first time I visited Yosemite that I'd had a postcard of Yosemite Falls lodged in there since I was about five years old.

You've said that you expect your viewers to find their own interpretations for your work …

Yeah. It's about leaving the work open so that you can enter. That is the balance I was mentioning; there is a pure side to mathematics, and then there is the applied side. The pure side is more abstract, but you have to keep a balance. I try to generate the kind of balance within my work that allows somebody else in.

Are you exploring inaccessible locations as a spiritual quest or as an artistic journey?

It's a combination of the two. Art itself has been a kind of spiritual guide, and my practice has been to follow the full moon. That started twelve years ago as an instinctive response to something beautiful and spiritual and incredibly romantic. It has become an important part of my calendar. It took me to Japan, to the marathon monks of Mt Hiei. I finished a piece last year called *Sometimes Still*, a six-screen video instal-lation that follows the paths of these monks, who run the equivalent of the circumference of the world over a seven-year period. They have an incredible relationship with the natural world because they run this route through the mountains above Kyoto. Over the period of a year, I spent time with them but only during the night. The monk times his run to arrive at dawn at the Emperor's Tree, a vantage point which overlooks the city of Kyoto. Every morning they offer a blessing to the city as it awakes. This has been done since the 1400s and is a beautiful moment.

Also I had always wanted to see the Iguazu Falls on the border between Brazil and Argentina. Every day 2,500 people look at the falls, but if you go out at night under the full moon you find yourself alone, you are able to have these solitary moments of reflection which one might call spiritual.

Would you say that Darren Almond is on a marathon looking for Wigan Pier?

It's only because George Orwell took the road to Wigan Pier that I knew that I could leave via the same road. If it wasn't for him going to Wigan and writing that book, I would have never left. I would have never thought this journey was possible.

Do you think that the written word is more powerful than the photographic images you create, or vice versa?

The visual transcends language and seeing comes before words. The power depends upon the author.

Where do you find inspiration?
I have followed trains since childhood and have used them continually as a point of inspiration.

Could the moon in some way reflect our insignificance in the scheme of things?
We don't have a word for how insignificant we are. Maybe we need to accept that a little bit.

And your art, without passing comment, goes in that direction …
It may offer a window onto that. It maybe gives you a moment.

Does your studio represent a creative space or is it a working space?
The studio has become the natural recurring platform for my departure and return. It's a fixed point within my emotional landscape, where I'm able to digest my experiences gained through my travels and formulate new work.

You've talked about needing a sense of vulnerability to see things. Could you elaborate on that idea?
Vulnerability allows you to be more open, more instinctual. Travelling beyond your comfort zone can lead to vulnerability, in these moments your instinctual senses are heightened and can lead to observations you may otherwise of passed by.

If you'd been around 30,000 years ago, how would you have left your mark?
Frozen.

A keen trainspotter in his youth, Almond has since made numerous works which explore railway themes. The series of works (above) based on signs employs the typeface used exclusively for rail and road signage in Britain. 'You can be in the middle of the Arctic ice – and you'll come back and make a piece about your grandmother. But you have to go to the Arctic to think about that.'

David Harrison

What are the most important influences on artists and on creative expression in general?

I don't like to stay idle, so everything has a sort of movement. Empty space frightens me, so I fill it up with shape, colour and form, with things that I think are important.

Is the space-filling meant to address an emptiness, or is it the need to take creative action every minute of the day?

It might reflect the world, because we're killing everything and the planet's dying and death means nothing, so I like the idea of nurturing. Filling a space is a form of nurturing. Your mind is always curious about how things work and how you can create order out of chaos.

Can you describe your studio?

My space is a sort of lived-in studio, an extension of my mind.

How much time do you spend there?

All day.

If you get an idea during the night, do you get up?

Yeah. That's quite scary, isn't it? I might move something before I go to bed and then think, Why did I move that? That's totally wrong. I don't like things to look too controlled; I like things to look a bit haphazard, a bit like they've happened naturally.

You're often quoted as saying that we act as if nature is our enemy. What can we do to counteract that behaviour?

Nature's been cut completely out of the picture. I don't understand why we have to kill all the wildflowers that grow around the streets which help insects survive which then feed the birds. It's the circle of life. Everything now is designed for flash buildings. The idea of designing a building is gone because there are no great architects. People don't design buildings any more; they work them out on computers. They don't go and look at the space where a building is going to be built and see what's already been living there.

Do you consider yourself a political artist?

I never think of myself as political, but what I am saying is political. It wasn't until I got involved with groups like the RSPB and started reading about how the only way to save nature is to rally against certain political choices that I became 'political'.

What qualifies an artist to make political statements?

Everyone's qualified to make a political statement. I don't think people listen to artists very much, do they? People are more interested in celebrity status now.

You were expelled from school, I believe. Would you consider yourself a troublemaker?

Around here, people think that I'm a bit of a nuisance because I'm always arguing for the sake of the fox or the tree. For instance, there was a fox living in the garden and I started to feed him. Straight away everybody got upset, and there were emails and residents' associations saying, 'You need to stop feeding the fox because they do this and they do that.' It was all this ignorance about the fox. So I sent an email around saying, 'Look, I'm really sorry. I think you should read up on things before you start expressing your views. The fox is a solitary animal, so I'm not encouraging other foxes.'

It's been said that you dress unusually. Has this been intentional?

In the 1970s, when I was growing up in London's East End, there were still leftover Victorian attitudes about, and I used to like to antagonise people by being obviously homosexual and dressing in a way that would maybe upset them … but I was just having fun, really.

You've said that you knew you were gay from quite an early age. Was that difficult?

It was difficult within the family. Once it was established, it wasn't difficult at all. You were ridiculed, but you also had a world that was yours. It was a secret society, it was a fun society, and it was a theatrical society. A group of people accepted you and you accepted them and that was nice. I don't want people to like me because it's the law. I don't care if people think I'm a dirty old poof as long as they don't get physically aggressive towards me.

Your stint with the Sex Pistols was quite interesting …

That came out of the whole thing in the '70s of dressing and looking a particular way. I was interested in '50s rock 'n' roll, and I used to scour the shops and buy old stock but as a downtrodden rock 'n' roll porn sort of fairground-type thing. That's when Malcolm McLaren noticed me and said that he'd love me to be in his band and that he'd like the band to look like me. He was going to call them the Sex Pistols. I wouldn't take all the credit because Vivienne Westwood was creating that sort of look anyway and I was buying things from her shop, too.

How important is art's role in changing social mores?

I think art reflects society; I don't think it makes society. A lot of artists were always at the forefront of what was happening on the underground scene, but there isn't an underground scene any more; it's been completely blanded out. There's no room for the brave to step forward. Liberation tends to lead to special treatment rather than equality. I've never been involved in any gay rights movement as I've never felt the need to belong to any group to justify my existence. I did far more for gay liberation by walking down Mile End High Street with Hoover, my bright pink pet poodle, and my matching pink quiff in the early 1980s.

David Harrison feeding pigeons in his garden. 'The planet's dying and death means nothing, so I like the idea of nurturing. Filling a space is a form of nurturing.'

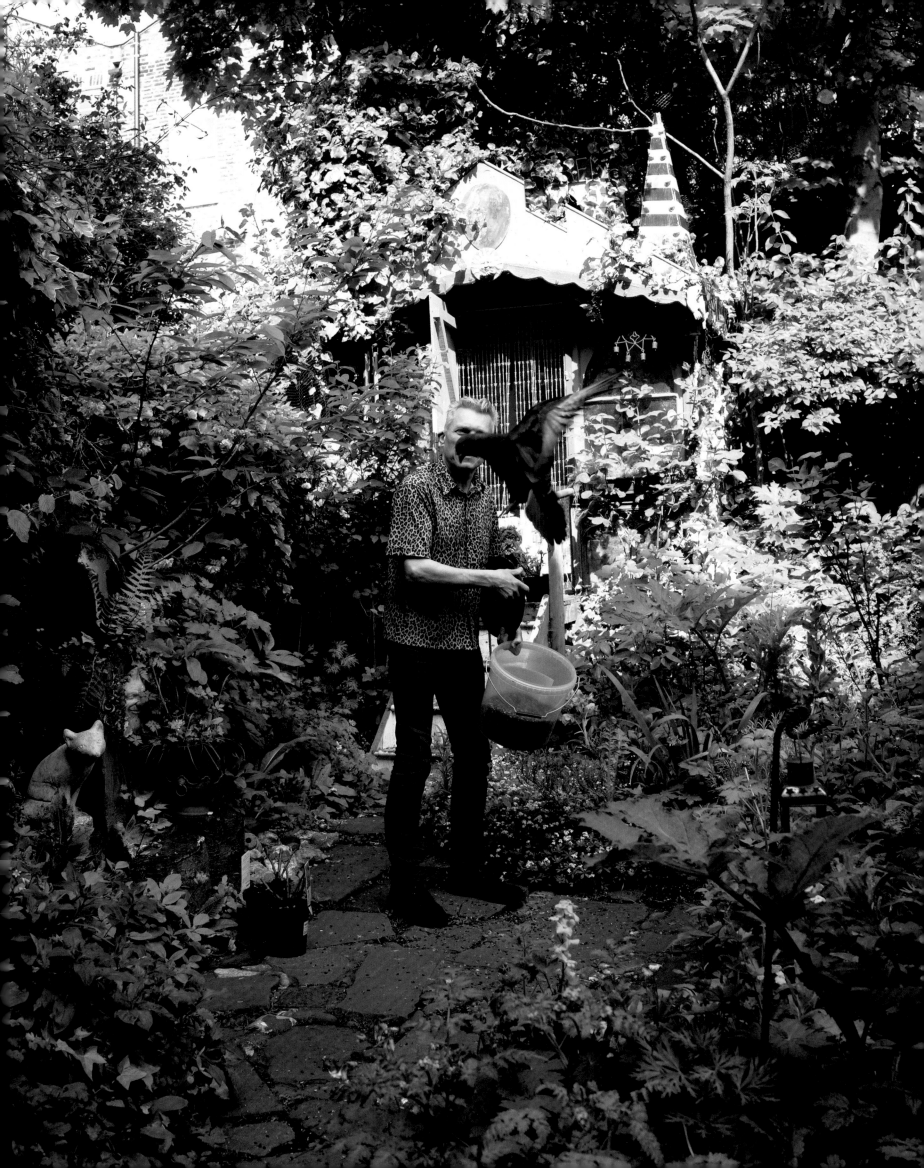

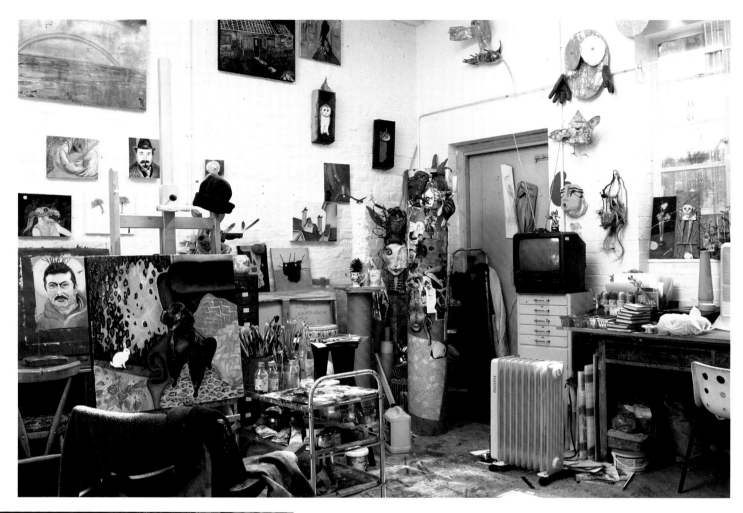

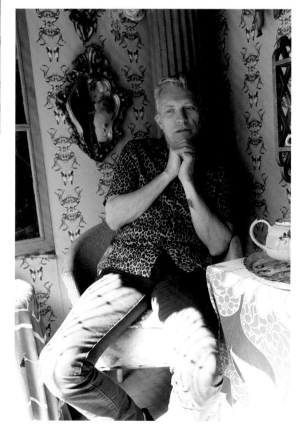

Harrison's studio (above and opposite) filled with his sculptures (shaped of prosaic materials) and his oil paintings. 'It was actually Peter Doig who encouraged me to use oils as he said I was trying to paint with acrylics as you would with oils.'

Harrison's home (left): 'My space is a sort of lived-in studio, an extension of my mind ... Empty space frightens me, so I fill it up with shape, colour and form, with things that I think are important.' Harrison even paints his pet poodle. The rather large rabbit (opposite) is named *The Red Haremaphrodite*.

You've been doing some work on historical scents. Can you comment on that?

Perfume plays such an important role in life. The sense of smell is important to the senses of sight and touch because it immediately takes you back to a particular place and time. It's memory-based. We're so inundated with chemicals that take away smells that we're missing something major in our lives. I wanted to capture some of the magic, glamour and mysticism from these historical perfumes.

What do you do as a hobby?

I'm forever foraging, that's what I do. I never sit still for very long. I'm not a relaxing person. I worry that I've wasted time if I've just sat. Birdwatching is one of my big relaxations.

Is it correct to say that you switched your medium to oils in the '90s?

Oil paint always daunted me when I was younger because it seemed to be such an involved process. I was always interested in ready-made things, and acrylics lent themselves to that much better because they dried plastic and you could play with them and make them into a solid thing. I took that plastic world as far as I wanted it to go, and then I needed to express it differently and that was by painting. It was actually Peter Doig who encouraged me to use oils as he said I was trying to paint with acrylics as you would with oils.

Your parents took you to galleries when you were a child, didn't they?

Yeah. My mum used to take me out for the day. I thought that all families did that. We often went to the National Gallery. We never went to the Tate. My parents weren't interested in modern art.

What was the defining artistic moment for you as a youngster?

I remember growing up with a picture on the mantel-piece in my bedroom. I didn't know the name of the artist for years. It was Memling's *Adoration of the Magi*, and it was thousands of angels coming into this broken-down old palace-y place that looked more like a Gothic cathedral than a stable, with the Virgin and Child and animals and things moving in every corner. There were cracked paving stones with things growing through them; there were little creatures running around. I used to look at that painting for ever. I've always liked things you can look at for ages.

Your friendship with Peter Doig has been an influence in your life. What else has influenced you over the years?

Above all, nature, I love many Russian authors such as Bulgakov and Gogol, English classics like Dickens, Lewis Carroll, Mervyn Peake and John Cowper Powys. Music plays an important part in my life. The person who's influenced me since I was a child was Prokofiev. One thing I remember about Prokofiev is that when I was five and first started school, I was terrified of leaving my mum. Being stuck in school, I thought, This is it now, for the rest of my life. The teacher was playing *Peter and the Wolf* and suddenly I was absorbed in this magic. That was the first piece of music I was aware of, really. And the idea that someone could write something so beautiful yet not hold back intellectually. Even with its dark side, it can reach children and calm them.

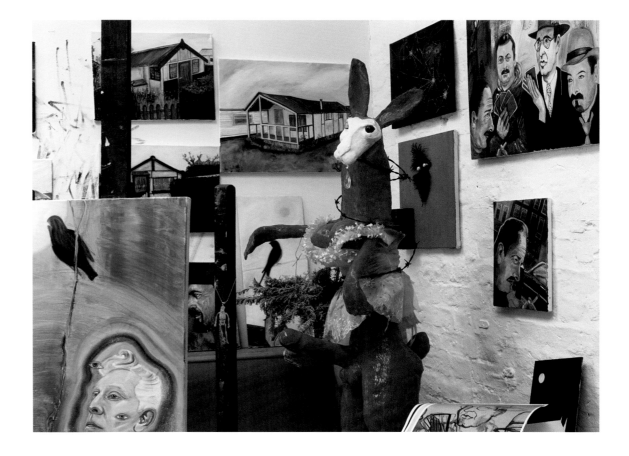

Hew Locke

Politics, history and voodoo all seem to play important roles in your art.

Politics, yes; voodoo, question mark. I say this because the voodoo thing came about years ago, when someone asked me, 'What festival are you making this for?' I realised that people had a misconception about what I was doing. They saw it as folk art. So I started making this deliberately exotic kind of thing. It's almost an invented world.

And history?

If I wasn't an artist, I was going to be an historian or an archaeologist. I've always been obsessed with history, with how we get to a certain point with a particular situation. Take, for example, Afghanistan. How come we're back there again? It doesn't necessarily solve the situation to know that this happened because of that, but it gives me some sort of perspective. Having grown up in Guyana, I'm very aware of history. Two-thirds of the country is claimed by Venezuela, where it's illegal to display maps of Guyana. That's to do with a dispute that goes way, way back – to 1600-something – over which European power first claimed land over the river. A simple thing like that and you end up in trouble in the twenty-first century.

Referring again to history, we see a lot of the Queen in your work …

That is personal history. It's to do with the fact that her face was on all my school exercise books. We all got into trouble for giving her a beard and moustache and stuff like that. She was on my school exercise books years after the country became independent. That was strange even though I was at a school run by Anglican nuns from Kent. Also I was a stamp collector, and the Queen's face seemed to be on half the stamps I was collecting.

There's definitely an archetype thing going on there. It's become something more personal, something to hang stuff on; it's become an image I hang ideas on, in the same way that somebody may sit down and think, Right, I think the Queen is absolutely wonderful, and they hang ideas of royalty and monarchy on her image. Somebody else may think, She's horrendous and she should go, and they hang that on her. I come in between the two. I use her as an image on which to display things and hang ideas.

Like a political voodoo doll?

When I first started doing these images, I referred to them as 'royal voodoo', reflecting the audience's stereotyping back onto them. Obviously it's not real Vodou. Over time it's become stranger, maybe a bit more sci-fi.

What role does history play in art?

For some people it doesn't play that much of a role at all. I think it's there whether you like it or not. In art-historical terms, I find it very, very interesting looking at people's work and seeing this thread going way back.

You talk a lot about fusion in your work. What is multiculturalism, in your opinion?

Multiculturalism is simply the world I live in. We're all here, we're all living together, and I don't think twice about it.

Do you carry cultural baggage with you?

Where you are is what you are, and I live in London. But also, I'll be working on a piece, and when it's really working, even though it's got all the connotations, issues of global history, even something referring to, say, India, I'll look at it and say, 'This is like Guyana.' A lot of my work is about dripping and hanging. That comes from growing up in a tropical country where everything is seeping and hanging and evolving. You don't escape who you are …

Surely an artist is recognised by their speciality, not by a wide range of media and styles?

Some artists have a speciality. I find it more interesting to do a number of different things. One of the places I derive inspiration from is Brixton and the changes I've seen over the years I've been living there. The hub of Brixton is the market. I walk around Brixton and ideas flow through me and around me. I come to the studio and then I start to function on that sort of high from being in the market. I've been living in Brixton for about sixteen years and I'm not bored yet, which is quite a feat.

The studio is my home. I walk in here, and, like most artists, as soon as I open the door, it's like, Ah, here are my friends. It's all the work that's here. It's all here within certain parameters … It's a long commute to Hackney, but I'm very fond of it here. On the journey, I mull things over, read the newspaper. By the time I arrive, I'm in a different head-space.

Isn't it your practice to move to the studio for a short period to do a project and then move on?

Yes. I do that from time to time. It's a difficult process because it takes a while to colonise a space, for it to become the box, to become home. Once that happens, I'm okay. The studio that I'm in now, in Hackney, I can't quite believe that it's a studio I took on temporarily. It feels like it is my place.

Hew Locke collects objects from local markets for use in his work. 'It's about managing that obsession within the work, managing it so that's it's not collection for the sake of collection.'

Locke lives in Brixton, South London, but commutes to his Hackney studio to work. 'I walk around Brixton and ideas flow through me and around me. I come to the studio and then I start to function on that sort of high from being in the market.' He explains that 'it's a long commute … By the time I arrive, I'm in a different head-space.'

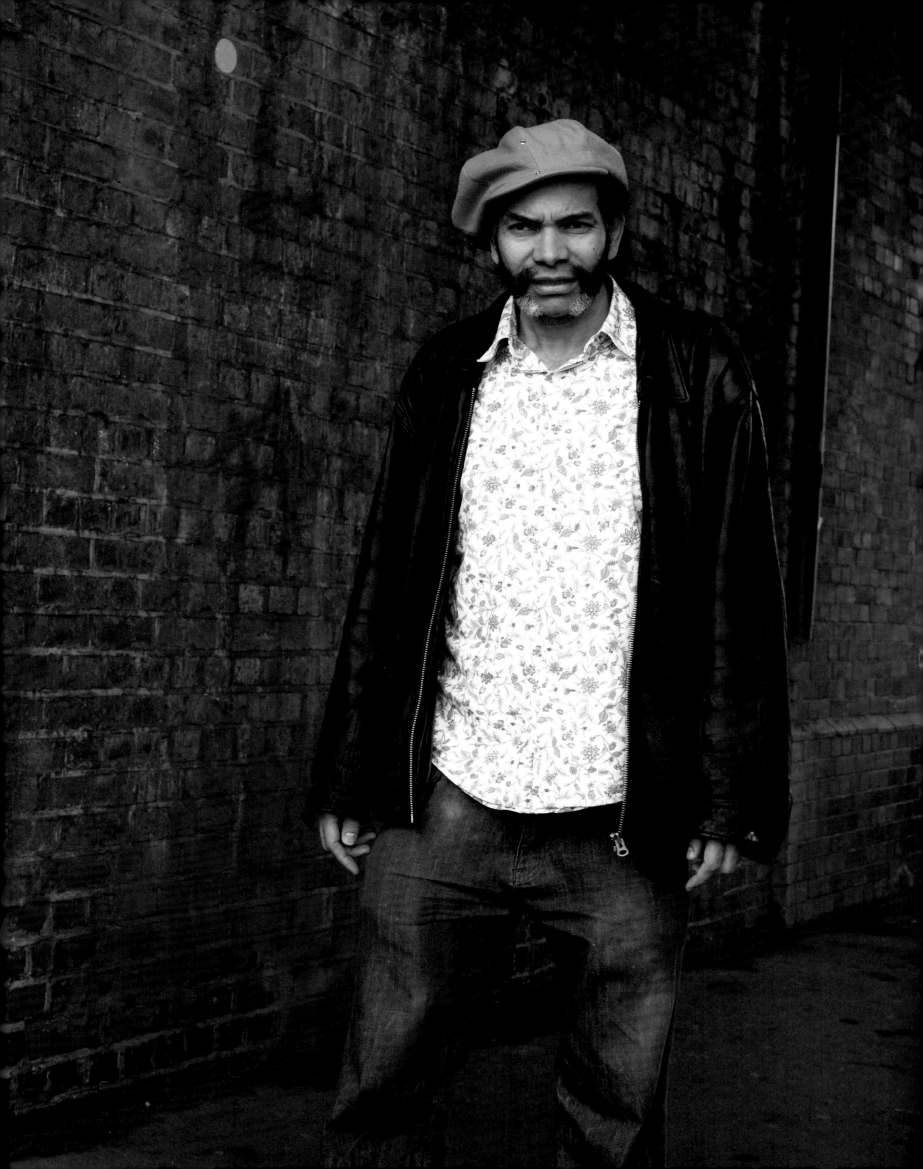

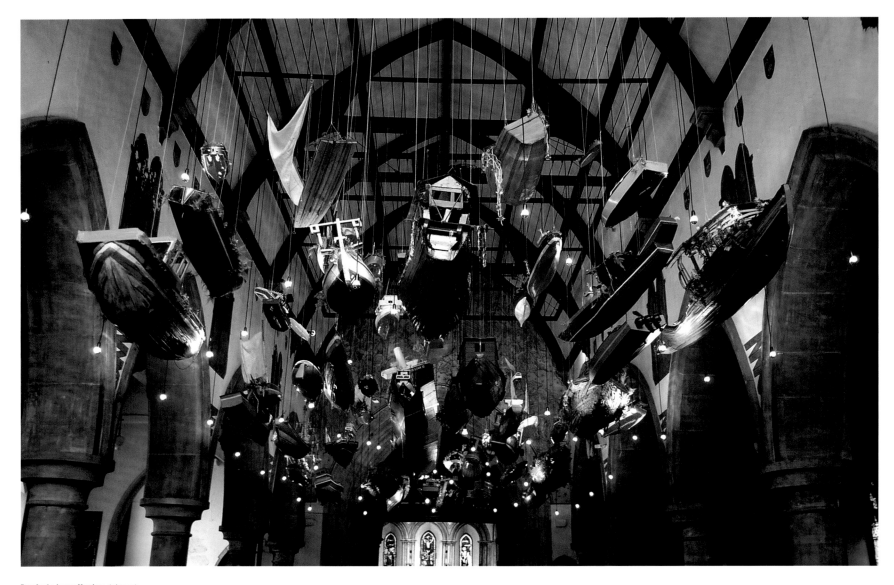

Locke's installation (above) of a hundred model ships collected from around the world and made in his studio, *For Those in Peril on the Sea*, hung in the nave of St Mary and St Eanswythe Church (the oldest building in Folkestone) for the Folkestone Triennial.

Locke (opposite) works with an assistant on his Folkestone project. The artist was born in Guyana and moved to England at the age of ten. 'A lot of my work is about dripping and hanging,' he says. 'That comes from growing up in a tropical country ... You don't escape who you are.'

You've also described yourself as a collector, as the collector of wonderful, bizarre beads and colours and fabrics, strings, ribbons. Then the collector becomes the artist. Is this collector's obsession an aspect of your work?

It's about managing that obsession within the work, managing it so that's it's not collection for the sake of collection. It is fine-tuned to produce a specific result.

Did you start this intricate putting together of things as a child?

No. It came much, much later. As a child, my work was tight and restrictive. It didn't have remotely the same flair as it does now.

Both my parents were artists in an artistic circle. I grew up surrounded by work which seemed to go three ways. My mother was a sort of post-Impressionist painter. My father was more of a modernist but working with imagery derived from African sculpture. Everybody else was either a Cubist – as in post-Picasso Cubist – or a follower of Rothko. In among all that was a bunch of intuitive artists, folk artists. It was out of this mix that I came up after leaving Guyana. I couldn't have become the artist I became if I'd stayed in Guyana.

When you go to the market in Brixton, you lose yourself. Can you stop yourself?

I can. I've had to force myself to get better. I buy things for specific reasons. Say I buy a plastic flower: 'That's an unusual shade of green; I can use that.' Or I buy bits of bamboo for a project. I think, This is the right thing; I know how I can use this. Once I pick the thing up, I'm already working; I've already started including it. Occasionally it will take time; occasionally I buy something and think, What am I going to do with this fluorescent spider? But I know that it will happen at some point.

Would you describe your art as organic?

Absolutely. It starts out in a very formal way, but it develops in an organic way. So I don't know what the conclusion of each piece will be. It arrives at a point of being finished and not finished at the same time. It arrives at a point where I can't add anything else. I'll try to add something, and to other people it looks like it can take more stuff, but actually it can't. You reach a perfect equilibrium, shall we say.

Your work has political content, but to an outsider it's also very aesthetic. Do aesthetics play an important role in your art?

Definitely. You need an absolute balance between the two because otherwise it doesn't work. It's an obsession, how something works the way I see it and how an audience will view it. How far away do they need to be to see it? How close do they need to be to see it, to receive a work of art? What do I need to add to this piece to make it tweak their brain in such a way that they will ask, 'What's going on here?' I'm not playing a game with my audience but trying to create a connection.

Speaking of games, are you at the top of yours?

Cézanne on his deathbed said, 'I failed to make it real,' meaning, 'I've just started to figure this thing out.' I feel a bit like that in the sense that I've arrived at a certain point where I know how to do a certain thing. I have a certain way of working and I'm comfortable with it. I'm comfortable with Hew Locke the artist. But then it's always like, Can this thing get better? That's what keeps driving you: the excitement and the possibilities.

I don't want to be an artist who's seventy-five and thinking, What I'm doing now is rubbish. You want always to be hitting that high. That's the fun and also the pressure.

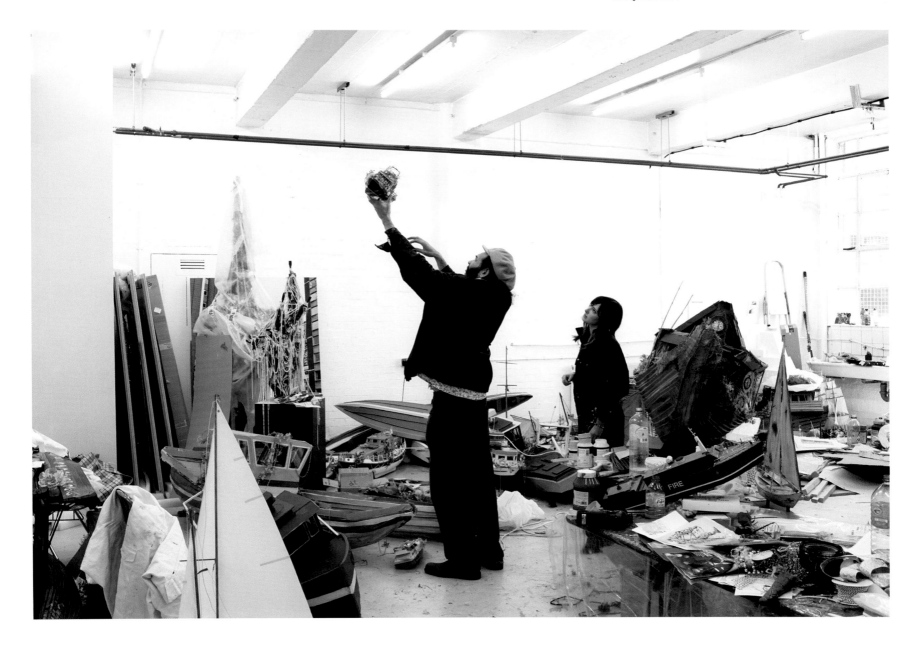

John Stezaker

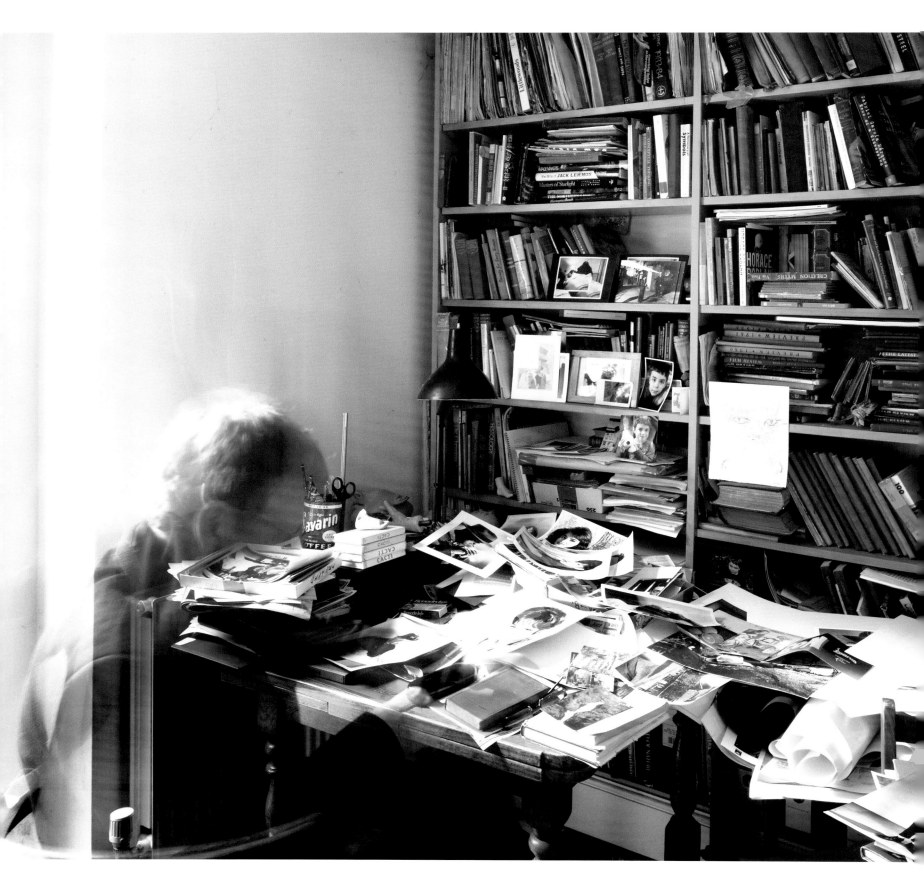

John Stezaker lives above his Camden Town, London, studio, which he has kept for the last fourteen years. He prefers to work at night.

Do you cut books up?

I'm afraid I do. I'm a real vandal, but I keep it very secret from the second-hand bookshops. Any picture book, I just buy it.

Have you been in this studio for a while?

For about fourteen years. I live upstairs.

What about the old packs of photographs that you buy?

I started collecting film stills in the mid-'70s. In any second-hand bookshop or junk shop, you could find a cardboard box of film stills. Then gradually they found their way into specialist cinema shops. London was important because it supplied the main access to British film stills, which are my favourites.

So you've turned into a collector?

I am now. My collection has grown considerably in recent times. In fact, I think I might need to employ a curator to get everything in some sort of order.

Upstairs I tend to categorise things and cut things up, monitor them, look after them, conserve them in a way. Down here I am cutting them to pieces and destroying them. I am a strange combination of conservationist and vandal, really.

I've read that you like to do most of your work at night.

That's right. It started because of teaching. I was a teacher for thirty years, pretty well full-time, and the only chance I got to work was at night. For many years I would sleep very little, work through the night, and then go and teach.

It's been five years since I last taught, and I still work at night. In the daytime there is always something happening, but at night I come down and that is when things really start. I used to think that the really creative hour was just before dawn, when somehow your conscious control is lowered, but at the same time you are awake to the world as alive or possessed. Images come alive; they seem ensouled.

Was there a catalyst for your obsession with photographic images?

It was a rather strange one, really. When I was about eleven, I went to a boy's house. He was a bit older than me. We played for a bit, and then he opened an album of images which he had been collecting; it consisted entirely of women's breasts. I remember his mother rushing over and, as soon as she saw the book he was showing me, taking it out of his hands. I never saw the boy again, but the idea of this arrangement of images and objects of pleasure around the page stuck in my mind. I suppose it was round about then that I started collecting images.

The first images I collected were postcards. I didn't quite connect what I was doing with art until there was a colour supplement about Picasso with a picture of him on top of a scrap heap in the 1960s. I thought, Ah, there is a connection between my two interests – finding things and art – because I loved drawing and painting, and I loved collecting things. So I started to make collages.

When did you first sell a collage?

Probably about 1977, so I would have been not quite thirty. But that wasn't really a collage; it was a series of found images and texts. I was dramatically unsuccessful initially; I had various galleries who all gave up in despair. In the end I found it easier to support myself through teaching. I found the art world an increasingly depressing sort of place.

Is this something that interests you, the opposing forces of life?

Collage is a way of holding two opposing forces together, and in a way it reflects my working life, divided as it is between the intuitive practices of my art work and the more conscious practice of teaching. I wasn't teaching in art school as an artist, but as a theorist. One of the courses I gave was on William Blake, who is of course the ultimate dialectician. The dialectics between text and image that got me interested in Blake led me to German mystics like Hegel. The key thinker for me is Walter Benjamin. And Rilke was a big influence.

Your masks are amazing, and you use a lot of landscape. Where does that come from, the relationship between the figurative and landscape?

The first landscapes I did with film stills were actually American stills. What I did was to put English landscapes into them. I don't really know quite why. I thought of it as reflecting a provincial reception of Hollywood cinema. The masks came about a few years later. When all this material started to hit the junk shops in the mid- to late '70s, pictures of film stars were thought of as much more valuable than film stills. That's how I started picking them up. As I began to engage more with the image, I was re-engaging with the tradition of Surrealism. The masks were my entry into what I thought of as Surrealist territory.

Is making art generally lonely?

The word *lonely* suggests something to do with isolation, but I always feel, once I start working, that whatever I call 'myself' has vanished and I am sort of immersed. In solitude I feel more connected, actually, to the world of images.

Is your work with photography reflective of nostalgia?

I don't think it is nostalgia because it feels more like disquiet than something reassuring.

I remember, when I was collecting images that were not from my period for the first time, knowing that nostalgia would come up as an accusation. But in the end, that was part of the freedom I was enjoying of not having to account to anybody. I thought, That is another reason not to show any work! The reason I collect old imagery is because it is already disconnected from the world of communication; it has already achieved a degree of autonomy as an image. So half of the work has been done. Time is doing the work for me.

In a way, the photographic image is tied to death. It is always about a moment that has passed. You could say that imagery is always trying to get over its own deathliness and become contemporary. It is no longer tied to particular personalities. They have been forgotten. This is the point at which an image is no longer legible, is no longer standing for something, is just itself.

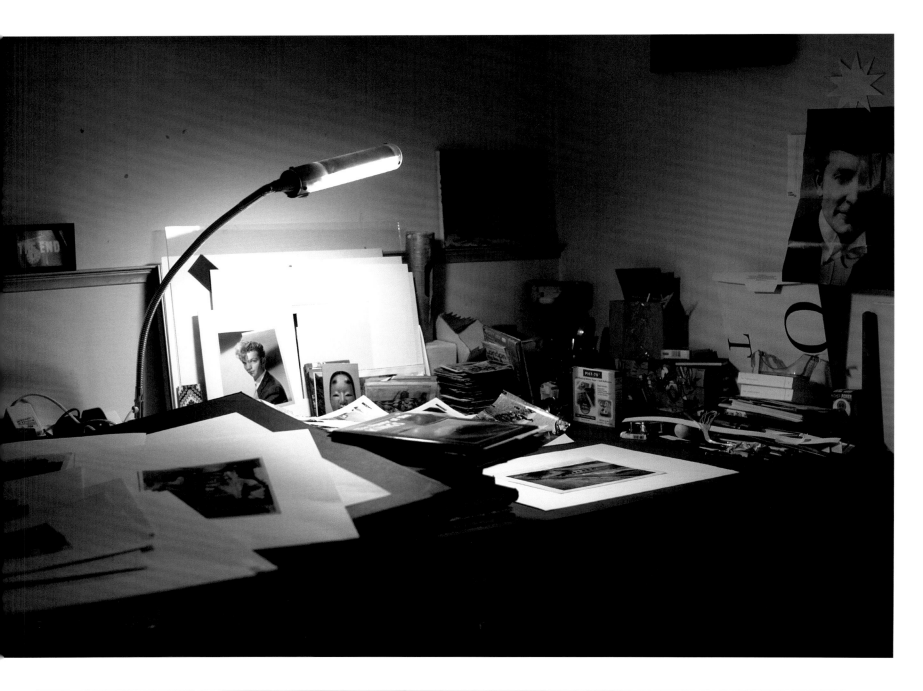

You've been described as 'quietly influential'. Does it pay to be quiet in the art world today?

Everyone is interested in money, obviously, and I certainly don't want to be involved in the art-world circus. It is demeaning, I think.

You were part of the first generation of British Conceptual artists exhibiting in the '60s and '70s. What does it mean to be a Conceptual artist?

I did exhibit with the original group of Conceptual artists, but I was already aware of Conceptualism as an aesthetic cul-de-sac. I was struggling to find my own way out of this cul-de-sac by appropriating imagery. Appropriation was the one aspect of Conceptualism that interested me. The rest – the self-referentiality, the anchoring of everything to language, the reduction to the word – was something I felt was diminishing for art. Somehow it had to be the image out there in the world. Of course, that immediately got confused with Pop, so, having been a Conceptualist, I was now a Neo-Pop artist! But there are a lot of artists of that generation who suffered that association, until people began to realise that to be engaged with the cultural image wasn't an extension of Pop art.

I don't think anybody ever really reaches maturity in an artistic sense. We are always evolving. I found myself living in the world of images, as an exile from the real world. My art inhabits the imaginable, whether I support that through teaching or doing it in my spare time or earn a living from it. You see a lot of artists who, after a couple of years of doing well in the art world, find themselves imprisoned by what is commercially acceptable.

Given that you are a night owl, is your studio a sanctuary?

I find it very difficult to leave the studio. In fact, I worry about it when I go away. I think, What if somebody breaks in and destroys all my work? I really, genuinely have these fears.

How much does fear play a role in the creative process?

Someone described the Sublime as beauty tinged with terror, so if you're talking about engagement with the Sublime, then fear is involved, I suppose.

You've been quoted as saying that 'finding, as Picasso pointed out, is not just the outcome of searching'. Is that your definition of your art?

I believe that you have to search in order to find, but I think that the two things are quite separate. Often the process of going about the search is the thing that blocks you from seeing what you should be seeing. Searching can prevent finding.

What I do involves a series of diversions and digressions. I head out towards one thing, I have an idea, I combine this with that, I get the components, and something doesn't happen. Or maybe on the way to getting the components, I see something else; I think, Oh, that's actually better. Eventually, through a series of distractions, I have actually forgotten what it was that I was originally doing. That to me is the point where the work starts; it is coming from the outside world rather than coming from me. It's when I lose control over the process that the image appears or comes alive.

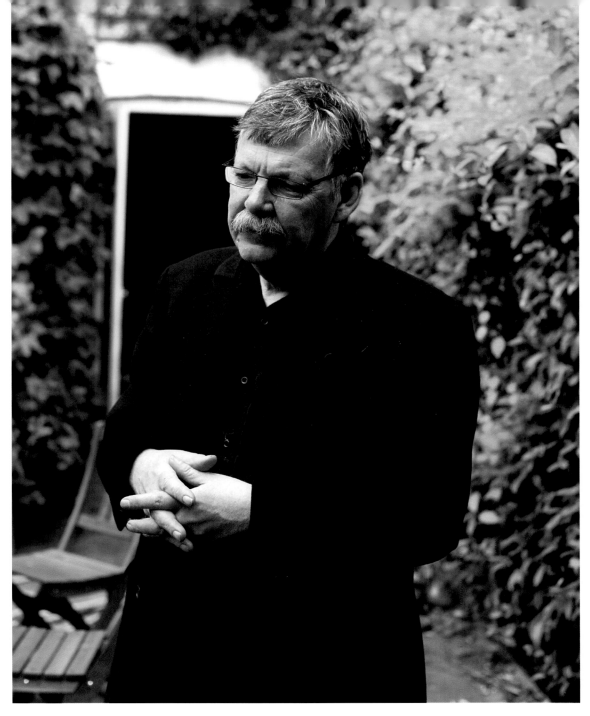

(opposite) **'I tend to categorise things and cut things up, monitor them, look after them, conserve them in a way. Down here I am cutting them to pieces and destroying them. I am a strange combination of conservationist and vandal, really.'**

(right) **'In a way, the photographic image is tied to death. It is always about a moment that has passed.'**

(following spread) **Stezaker purchased this collection of film stills *en masse* when the failing business he had patronised for years revealed plans to divide it up and liquidate stock. The bought archives contain over 10,000 images, most of which Stezaker has not yet had a chance to go through.**

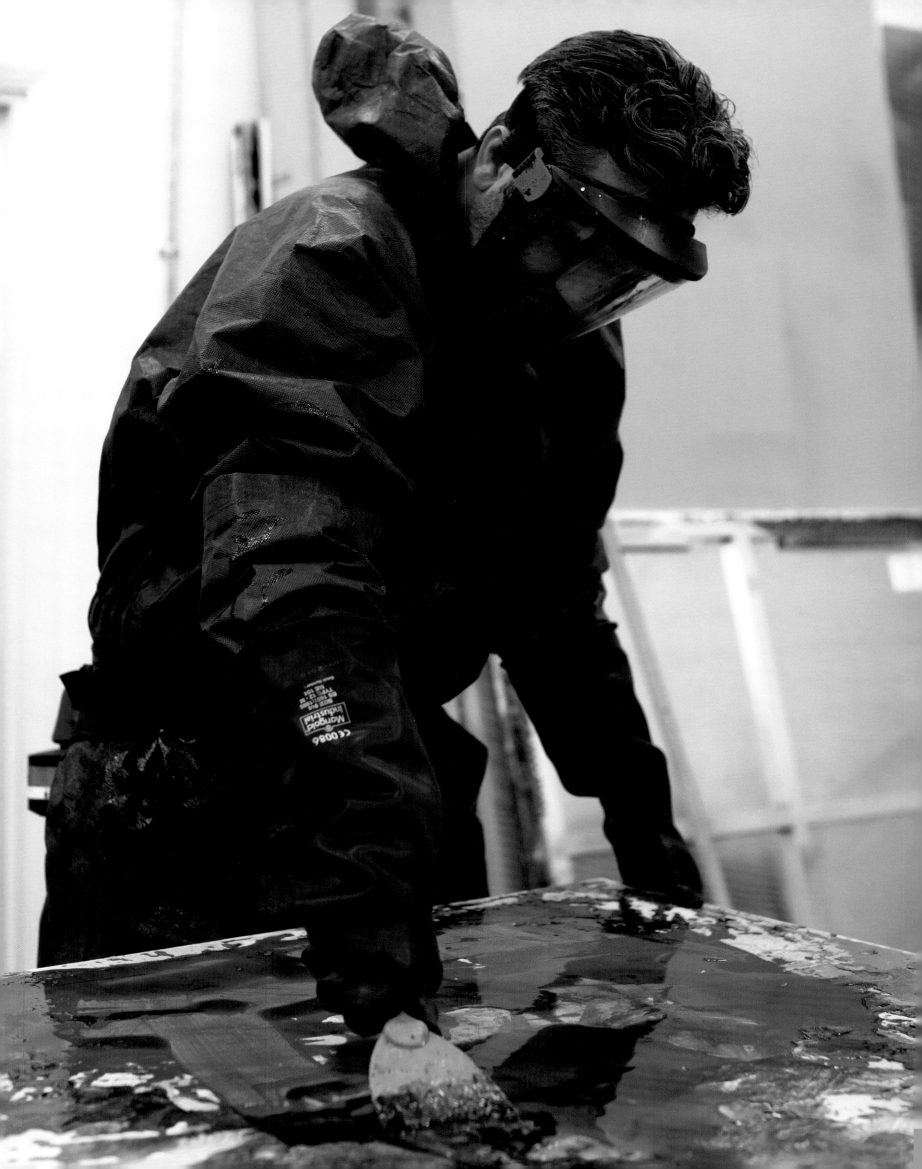

Keith Tyson

Do you like being interviewed?

No, but I am comfortable with being interviewed. I am comfortable with myself, though I wasn't for many years. I come from a working-class background. You're not supposed to go and be an artist; you are not supposed to have ideas above your station. So I struggled at first.

But you believed in yourself?

Yes. What I do is aligned with the truth as I see it. In my childhood I was told all sorts of stories about the way one should behave. I would go out into nature – I lived on a farm – and walk around. I aligned myself with that instead. Art to me is a natural progression of aligning yourself with what's going on around you.

Are all artists defined by emotional trauma?

If you are creative, you are sensitive to the world, and as a child you do not yet have the tools to manage that. I don't buy into the genius/madman dichotomy. Trauma is just the trigger. If I had been born in a Buddhist country, they would have said, 'Oh, he is enlightened!' But because I was from a working-class family in the North of England, they said I was crazy and retarded and beat me up.

I would count people like Isaac Newton as a genius. Michelangelo was a genius. The thing about Da Vinci that I admire, or maybe am nostalgic for, is that he could be a scientist and an artist and a philosopher and a mathematician and a musician and a social butterfly simultaneously, and that was seen as a legitimate thing to do. That seemed like a rounded occupation for a gifted human being. The compartmentalisation of knowledge since the Enlightenment doesn't feel like a rich way of existing.

What is happening with contemporary art today?

Contemporary art is slow in catching up with the rest of society. We have changed from an industrial model to an information model, yet the art world still has this idea of physical commodities, connoisseurship, and buying and selling in galleries. The contemporary art world still talks about masterpieces and having a good eye. This is like having an investment banker going to make a deal and carrying a wheelbarrow full of gold upstairs instead of doing an electronic transaction.

And the role of science?

Science is a language to discuss one particular model for understanding the world. It is not complete, but it is a very useful, extremely beautiful, elegant language. My interest isn't in science, it is in nature. We can approach nature scientifically; we can approach it like a Romantic poet. I see no contradiction there because both are embodied in human beings. I can also reduce nebulous things to pragmatic systems. I think this comes from being a member of the generation that had to make computers and programme them ourselves. It altered the way we thought about thinking. My pragmatism and logic come from a fascination for working with mathematics and programming.

Often it is charismatic scientists who inspire me the most: Richard Feynman, Einstein, people who had colour and expansiveness to their personalities. I don't have a lot of patience with the art world any more. There was a point during the boom when I was making £50,000 notes. The way that I was treated was horrific. I was probably the most unhappy I had ever been in my life. Since the crash, I have got healthy. I feel that I am doing something with a purpose, and I don't care who shows it to whom because my vision is 200 years off from now.

Time is the ether in which an artwork germinates and becomes great, and it is arrogance to say we can predict that and mark up the prices of young artists. It is not that I am not doing exhibitions or anything. It is not the idea of selling my work or showing it in museums that I am against. But when the reason that I am making the work becomes forgotten … I am a bright guy; if I wanted to, I could work in the derivatives market. It would be fun, I'd do very well at it, but it is not what I want to do. There is a tribe of human beings and it is my job to explore these ideas, to feel things and express them. I see it as a privilege to do that job.

Do you think ahead when you are doing a piece of work, or does your work just evolve?

That is like asking a jazz player how he plays. You have a structure and you are working towards it, but you have to allow serendipity and the world to interact with it.

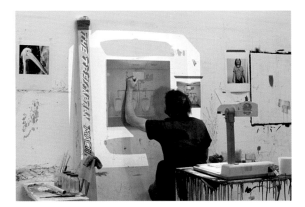

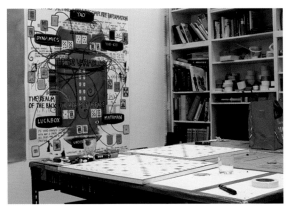

One of Tyson's assistants (top) draws over a projection in the studio. 'Creativity,' Tyson says, 'doesn't happen in a linear way. You have forty ideas simultaneously, and then there is a huge drought.'

Keith Tyson (opposite) applying a secret chemical technique to his work.

'Contemporary art is slow in catching up with the rest of society,' Tyson observes. 'We have changed from an industrial model to an information model, yet the art world still has this idea of physical commodities, connoisseurship, and buying and selling in galleries.'

Tyson employs up to fifteen people in his studio in Shoreham-by-Sea, near Brighton (opposite). 'I come from a working-class background. You're not supposed to go and be an artist; you are not supposed to have ideas above your station.'

A walk beside the seaside April 2011 (following spread). Tyson partially hidden as life apes art, the gigantic metal skeleton of an Arcelor Mittal warehouse complex looming in the background. Who said mechanical engineers are not artists?

Would you say that your work is technology-based?

No. I am more interested in the idea that the world is now seen in most disciplines as being made out of information. Physics thinks of the world as information, economics thinks of the world as information, biology thinks of your body as information. I don't see that art is any different. I am part of a process manifesting work out of a soup of information.

I once had the idea to buy a building in London, in the City, and make it available for one year to anyone to do anything they wanted to do. I was talking to some lawyers about it and they were saying, 'But you've got to have insurance! How will you govern who uses it? What happens if someone uses it for illegal things?' It was all about potential litigation because I was going to create this terrifying thing: a space with no rules. It became impossible to do the project because the potential litigation around it was so immense. When you create a little vacuum, lots of things appear. For me, art is a bit like that.

Is your studio more of a workplace or a thinking place?

They are the same thing. Making art is a dialogue.

How many people work with you?

Up to fifteen.

And yet you can call your studio a gestational space?

Yes. Working with assistants was challenging initially, but I began to see each individual as being a sort of generator. I am interested in serendipity, interdependence and how systems collide, so I will learn about each assistant, what their strengths and weaknesses are. Often I will use them to make something that they are not comfortable with, because I want them to make a mistake. It's a bit like how a film director might work or how an architect might use a structural engineer.

You keep a diary of ideas, as you call it, on the walls of your studio …

Yes, because creativity doesn't happen in a linear way. You have forty ideas simultaneously, and then there is a huge drought. So you want to keep them all on coat hangers, as it were. Or you just want to record the moment. I am not a control freak; it is more of a Taoist approach. I believe there is a system, that I am a conduit through which art can come out. I am a discoverer as much as an inventor.

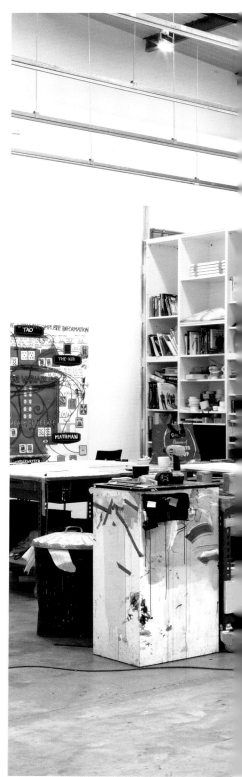

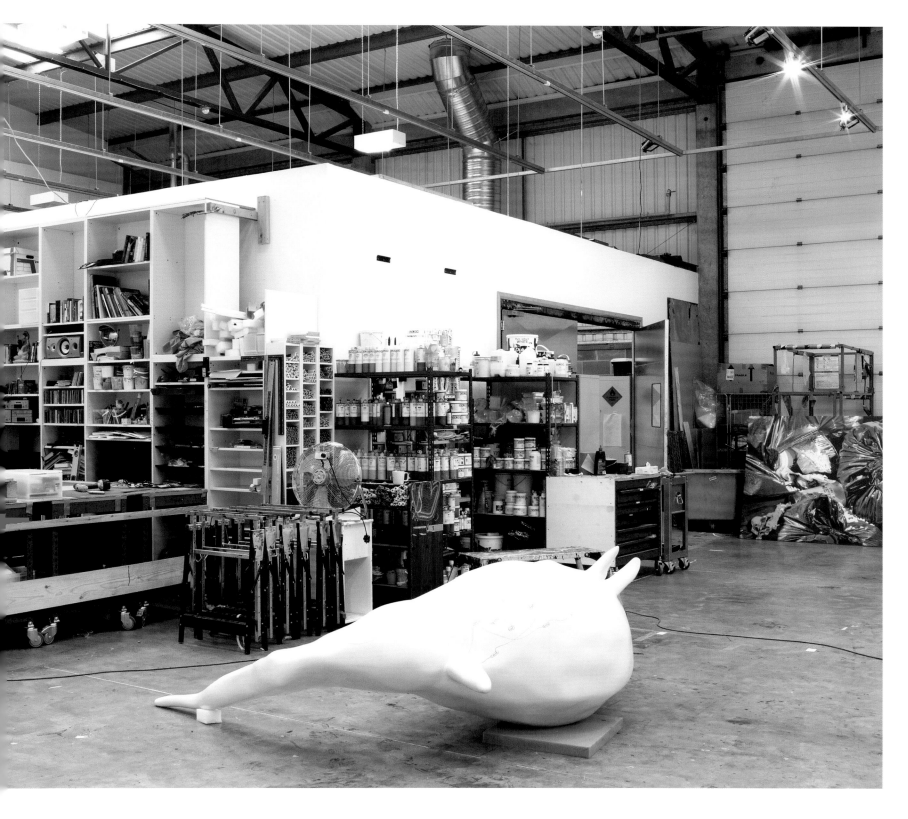

Paul Graham

Do artists require character to express themselves?

What's interesting is that as you work, it forms you as a human being, including your character. Everyone's job changes them as a person. Everybody needs character, but the more important question is: Does what you do change who you are? I think eventually it does; it must do. Everything is self-reflecting in some way. The clothes you choose are not random, the haircut you have … they reflect decisions you have made. I am out there making photographs of the world and making decisions about what is interesting, what I find stimulating and revealing, and that inevitably says something about who I am.

When you choose a subject, do you form its character through your choice of setting and mood, or is it reflected afterwards in the work?

Maybe the subject chooses me. The type of photography I do is the dance of the world. I go out and perhaps I do have my own ideas, and then the world slaps me around the face and says, 'No! That's no good! *This* is much more interesting!'

I am a photographer who goes out into the world and makes pictures of life as it happens. I don't stage things. I walk on the streets, I go into the landscape, I make photographs, and while I do have the beginnings of ideas, they are shaped by the world speaking back to me as much as anything. Who exactly is in charge of the idea and where it comes from is a good question.

Were you questioning or observing before your days in photography?

Hopefully both. You are looking at the world and questioning how you can articulate the things you see when you take photographs. It's a beautiful balance between the two.

The world is endless in terms of how many pictures you can take. I can take a picture here of your boots, and your hair, of the view outside of the window … I am reflecting on all those things, but at the end of the day I am choosing. You build that up and you edit this endless way of life. You cut that into this beautiful little sequence of carefully controlled portions of time, and once you have edited the world into this series of small photographs, you take these small photographs and edit them into a new world. You have reduced the world down to pictures, and then you have magnified the pictures up into a new, fresh, believable world.

So in a manner of speaking it's personal refraction.

You could say that. Are photographers human prisms? That's very interesting …

When did you first pick up a camera?

In the boy scouts! The scoutmaster gave it to me. He showed me how to use a camera. Problem is, you can technically learn how to use a camera, but no-one tells you, 'Hey, you can say something with this! It can mean something!' So there are two parts to your question. The first one is: When did you first pick up a camera and learn how it worked? The second one is: When did you discover what a camera can do? That was the eye-popping moment. I remember going to the university library and finding books on Walker Evans and Robert Frank and Lee Friedlander and Diane Arbus, and this whole world opened up. They weren't in a photography section – this would have been around 1979, maybe 1974 – they were in a section called 'American Studies'. In this giant university library this was a small reference section about American society, but of course the photographs were greater than that. If at university you didn't study art in terms of art history, you went to art school to become an artist. University was more academic or scientific, so the only way that a creative photography book, an artist's photography book, would be in a university library would be as a social or historical study of America.

When was the first time you made a living out of photography?

Out of photography? Next year!

How did you survive the early years?

The strange thing is that in England the biggest patron of the arts then was the Department of Unemployment. You signed on for unemployment benefits and that would pay your rent. If you had somewhere to live, and they gave you enough money to eat basic food, you could subsist. I was using the welfare system. Inadvertently you had all this time on your hands. You could make your music, make your rock band, design your books, paint your canvases, whatever.

Did you hustle for commissions?

The odd one or two. There weren't so many then. There wasn't money to be made if you said, 'I've got this great idea, a series of photographs I want to make.' There was nothing. You had to go off and do it yourself, use the unemployment money or paint houses or whatever you did, drive vans. The one thing that was very good and very farsighted was that the Arts Council had this grant to help to publish photography books. So I could apply with my first book, and, once I had made the work, apply for a publication grant to publish it. It was the first book that connected new colour photography with the strong tradition of British social-documentary photography – Bill Brandt, Tony Ray-Jones, people like that. The book is still around; thirty years later you are holding it in your hand, and that's great. That was the very first thing I did, supported by the Arts Council.

What made you decide on New York?

I stayed in England for a long time; I only left in 2002. You reach a plateau and you want to carry on growing. Some people have to step out and go to another country, another culture, and grow and develop there. Most of the hints and reference points I have given you have been American-based photography, so obviously those are key focus points for me.

Also, when I left England, photography was not being embraced. There was a very dominant YBA scene, which was fantastic but which meant that there was less room for someone working outside of that area of practice. Secondly, the major institutions – the Tate, the Serpentine – had no interest. The most you could have hoped for was a show at the Photographers' Gallery. Once you'd done that, you had to wait ten years to maybe get another show at the Photographers' Gallery! I'm sorry, but that is not growing as an artist. It was this artificial, callous level that you were allowed to achieve and no more. I had to go elsewhere. The Museum of Modern Art in New York and the Whitney and the Guggenheim and the Metropolitan had been showing photographs and collecting for years.

It has been said that you do not shy away from making pictures that ask awkward questions about how we see and interpret the world through photography. Does photography represent both a question and an answer?

You can broaden that question from 'Does photography' to 'Does art'. The art that interests me asks thought-provoking questions which resonate with people. I don't think art is about providing answers. Just to have an interesting question posed that we don't know how to ask, about what we all feel about

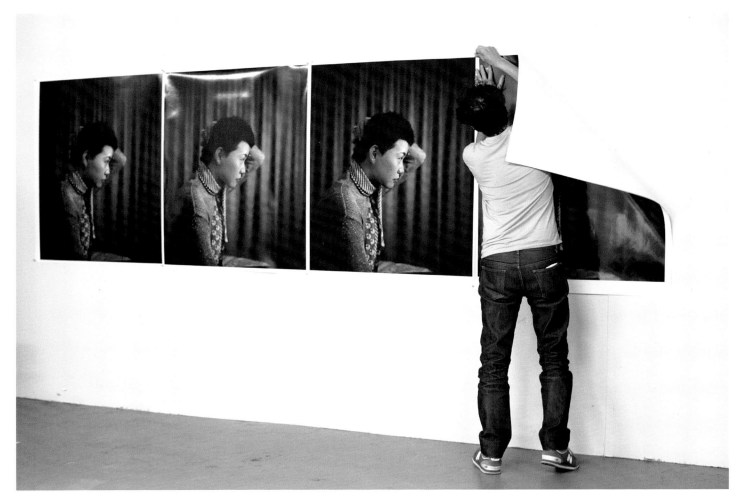

Paul Graham (above) testing the quality, density and depth of various papers in his West Village, New York, studio.

(previous page) Graham at his exhibition *Paul Graham: Films* at Anthony Reynolds Gallery, London.

life, about emotions, about the world – just to have that phrased well is often an answer of sorts. It's enough that someone has posed the question and put it in a form that makes you think, Yes! That's what I was thinking! Why is it like this? Why do I feel this way?

I struggle taking pictures, feel lost, feel washed up. Then at a certain point, if I am lucky, I come across something that is really stimulating. Then I go, 'Wait a minute, that's different.' In some ways I feel like I am the first member of the audience, the first lucky person let through the door for a special preview of potentially interesting photography. Then you take more pictures and you find two that work, and you keep going and you keep going, and after a couple of years maybe you have twenty or thirty of them, and they build into some totality that is interesting.

Whether we like it or not, there is a lot of front-loading on the significance of a moment in history or the name of a photographer who captures it. This sets up a frame of reference for the viewer. Do you care about that at all?
That isn't the type of photography that I do. Press photographers like Robert Capa or Cartier-Bresson have to have that basic integrity, and we have to work on trust. But we are naive to believe that people don't slightly adjust their position or say, 'I missed that; could you stand up again and point that gun again in that direction?' Photographers are going to do that. It isn't a question of telling heinous lies. But it's not my type of photography.

Has living in New York affected your thinking, your process?
What has been great for me is being in a community of like-minded souls who take photography seriously as an art form. There is a higher dialogue there about photography.

What does your studio in New York mean to you?
I am not really a studio-based person; I go out into the world and take pictures. The glib answer is that the world is my studio, but then I come back and work at home on the computer. It isn't a question of darkrooms or contact sheets any more. I've always had a printing studio because I print all of my own pictures. It has been important to me to be physically involved with making them. I use the studio to reflect on the work, to see what it looks like as a physical photograph. I can see it on my screen without going anywhere, but I do make a print to look at it. Essentially the studio is a production base. It is a place to put works on the walls, try different sizes, different combinations.

There is no such thing as an accidental artist, is there?
I don't know about that. What did Ed Ruscha say? Something smart about how for the first forty years of his life he was only an artist so that he could get laid. We all start out doing something that we think is cool. I'm sure the Beatles started making music because they thought it would get them girls. Then they continued to make money, and we ended up with their wonderful music for all eternity. It is the same for many artists.

'Everything is self-reflecting in some way. The clothes you choose are not random, the haircut you have ... they reflect decisions you have made.'

'Essentially the studio is a production base,' asserts Graham. 'It is a place to put works on the walls, try different sizes, different combinations.'

Graham (above) on Brick
Lane, London, and in
Chelsea, New York (opposite),
photographed in May 2011.
'I am a photographer who
goes out into the world
and makes pictures of
life as it happens. I don't
stage things.'

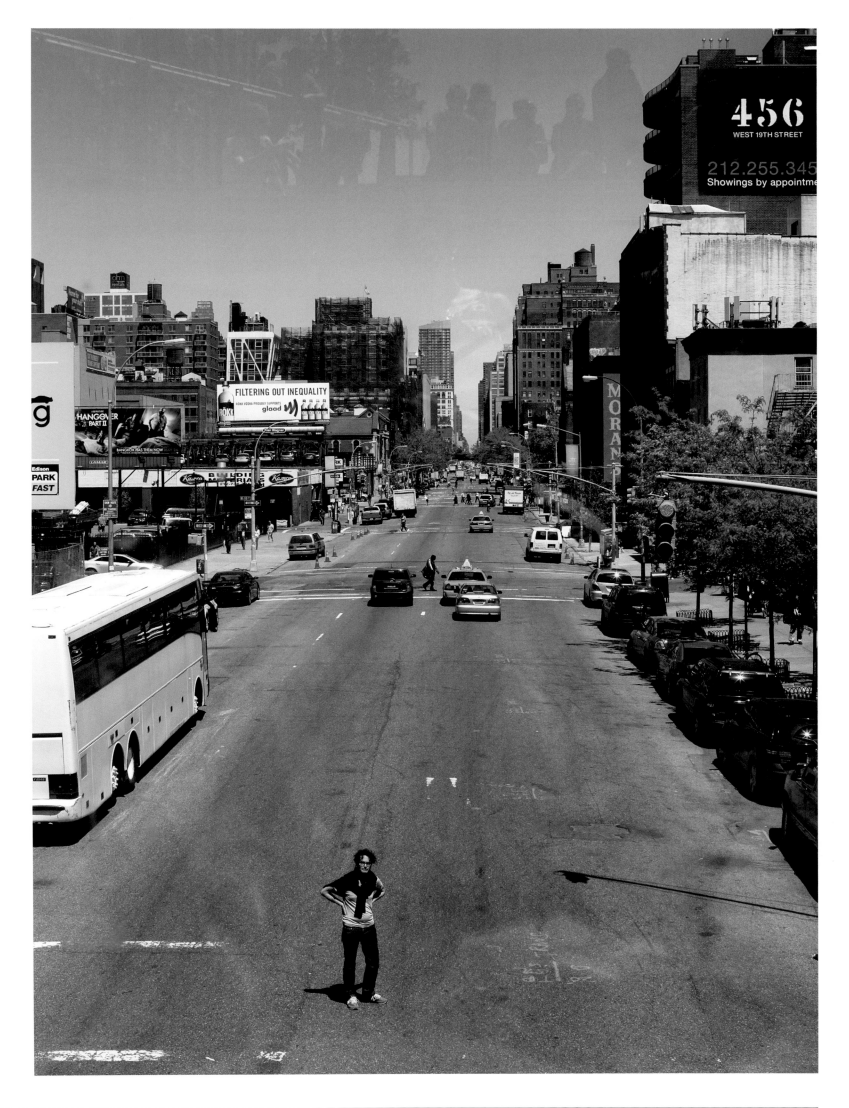

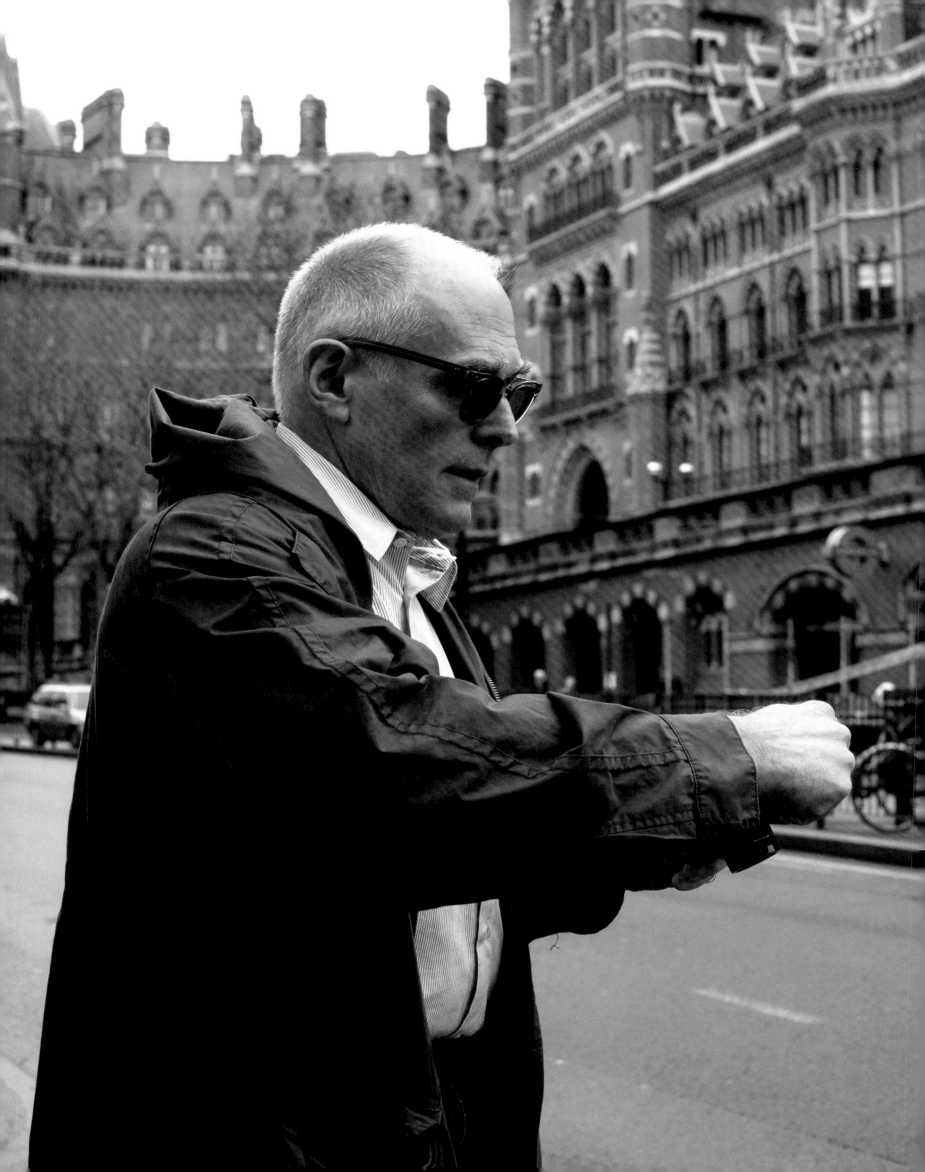

Richard Wentworth

You mentioned that Bryan Robertson and John Russell's book *Private View* inspired you to become an artist …

When did *Private View* first come out? Was it 1965? I'd be interested to know which month it was, because I can remember it meaning so much to my art teacher. It was exactly twenty years after the war. Maybe that was the first time there was some kind of expression of colour in Britain.

Funnily enough, about two years ago I spent a hundred pounds and bought a copy. I now realise how male the book was. The quickest memory I could describe would be of men who made things, and that they made things in what seemed like an independent way. I thought that was kind of marvellous. If you turned the pages, you could say that at least two-thirds of the work was informed by Europe, and maybe one-third or even as little as a quarter was informed by America.

What amount was informed by Britain?

The British are, I think, a crossroad-ish culture. That came from us being merchants. It came from the Indian accident, the cotton story, the industrialisation story, from those two words we have which I don't know that anyone else has: *cosy* and *comfy*, which you cannot translate. The thing that is very strong about English art is its domesticity. Our light is a major issue but also how things are furnished. Chintz and closeness, something about proximity, even the width of our houses. I am not being rude about anyone's art; I am talking about the air people breathe.

You've called your art 'reconstitution' or 'regurgitation' …

It's probably more towards being sick, I think! I remember the first colour supplement arriving at my nice school. I think it probably had Hockney and Bridget Riley in it. That is how I learned: through those people. I remember Bridget having a lot of white things – whiteness – which the English have a funny thing about, because they don't really like white, they like whitishness. This is something that Howard Hodgkin talks about very well … he says that the British don't have any guts when it comes to colour. That is why they scumble walls. The English space is a small space. It's not really a self-enabling

culture, and I only can say this now because I realise that it's what I grew up in. It is also what I wanted to get away from.

I don't really believe that there was a class system. I think there was a caste system, and the caste system was incredibly complex across the working class. There is an incredible argument between materials and trades. We don't use the word *artisan* in England, and this is all to do with having an industrial revolution. And there are all kinds of funny old money.

Does life choreograph art, or is it the other way round?

It's a Mobius strip. I think artists are prescient; they often go where the bigger consciousness hasn't yet begun.

You take everyday objects – the routine, the banal, the ready-made – and then you create something new out of them.

I think the objects take me, for a start; I don't think I take them. Because we are humans, all objects have meanings. I think that my confusion about, and pleasure in, how the world is assembled and what it means and how physical it is, are very old. I am not knowledgeable about archaeology or anthropology, but how we own things, how we share things, is different in different cultures. We are all doing this all the time, and of course it's a spatial conversation. It took me a long time to realise how endlessly engaging I find it. So it is not a plan and it is not 'a project'. It's my condition. As you get older, it becomes more and more interesting because you can see what fed into it, and the fact that we are all emotional wrecks, so we are not happy for very long. In fact, we are never happy. We are negotiating just being in the world.

Does art in any way encapsulate a happy moment?

I would turn the question upside down. A gallery is an unusual arena of potential contemplation. The very fact that you encounter the things that are nominated as art is already pretty clear, because there is a set of protocols that arranges things. The worst protocol is a big label on the wall; the simplest one is a well-hung picture. I think people recognise

the caring-ness of the act. In any museum, really, you can learn something about display. But while you are doing that, you give attention, and that act of giving attention often goes into a reverse process where you feel that the artwork is giving *you* attention because somebody made it. You know that there is human purposefulness embedded in this space, thing, object, painting, drawing, and that space is really privileged. That is like happiness, that space of giving attention. It is not about academic study; it is just about recognising that there are things in the world that have put themselves up for that level of attention.

You started working as an assistant to Henry Moore when you were twenty years old. Was there happiness in the fact of worshipping at the altar of a god?

There is no way in which Henry was very god-ish, and it wasn't very altar-ish! I never had a sense of him as an old man, and there was a way in which he was available. There were lots of questions I would ask him, and I am surprised at how generous he was in his replies. Really we did very simple tasks. We had to make a small thing bigger, and I am good with my hands; I found it interesting.

That activity of working for an artist … there are some jobs, they've got to be done, the day has x hours in it, and this has to be completed. What you absorb from it is the same as any … you know, you should be able to absorb something from washing up. It is an incredibly old activity and it's full of meaning; it is in Dutch paintings, it puts the shine back on things. Plates and dishes are arenas for how we behave towards each other.

What does art have to do with branding?

I am a brand-resister, but certainly Damien Hirst knows all about that; he is very alert to the diffusion range. I would be very happy if, when I go to my grave, maybe I am remembered as a different kind of diffuser, but it is important to me that what I care about is diffused. I am always amused when someone says, 'Oh, that is very Wentworthian.' It's funny because that means it has escaped its bounds, but not necessarily through its imagery, more by means of a comprehension of liaison and fallibility and the fact that the world is malfunctioning all the time and we spend our time trying to make it better.

Going back to Moore, how do you outgrow an overwhelming figure like that?

By not subordinating yourself in the first place. My motive for going there was not adulation. There was a little bit of convenience; there was an awareness that other artists had done it. When you are young, you pull down various processes, procedures and images from other figures. There is emulation, but the act of emulation, if it is to be successful, needs to be resisted. Henry Moore was not Picasso; I probably knew that. I understood something about his self-mythology. He was very able, he was a modest man, but he was very alert to power.

Are you suggesting that there is an excommunication of art from the human condition today?

Something much more elaborate has happened than what we call globalisation. The flattening out of social classes has embedded in it a sort of diffusion range of gestures that I don't like to make. I am happy that creative people work in that space, and I know that those people definitely move the culture along. But that proliferation and the accessibility and availability more or less worldwide are the same lake in which contemporary art swims. Where you might have said, 'I am going to make a multiple' forty years ago, now it's almost the standard condition of all visual art because anything on the Internet is automatically multiple. Nobody seems to have really understood how to use the Internet for art itself. So this is a period of immense noise, but it's completely illegible.

What is art, then?

I don't know. Probably at the centre of that is a loss of privacy. We have all got the same goals, and we are distracted, and there is something to do with being atomised …

Is contemporary art transitory?

Contemporary art as we are speaking about it is extremely transitory, yes. I hope I will get under the wire, but that is not because I want celebrity. It's because if the things I attend to are worth anything, they are only going to be measured by subsequent cultural experience. That's why we go to look at things that have survived.

You taught at Goldsmiths and then at Oxford. In the mid-'80s, was there a defining moment in your relationship with the YBAs?

No. That is all part of that mythology-making. A human is in a perpetual state of education. Part of my own process has been to repair some of the emotional damage from my childhood by being involved with young people. It is not a vanity project. You look after children and then, surprisingly, they respond a little, if not a lot. So the hidden answer to your question is a crude answer, which is that I think 1986 was a very bizarre moment: the death of Henry Moore, the death of Beuys, the death of Warhol (I think; certainly in that period), Chernobyl. London was no longer going to be run by men from Sussex in chalk-stripe suits. Pret A Manger was invented that year. There was a confluence of unrelated things which I now see as being a kind of hinge. That is what changed the economy of London.

The year 1986 was a bit of a starburst. It is very important that all those people who left Goldsmiths didn't have any money. And being young and not having any money is fine; you can wash up the next day or call your mother the day after that. But it was a quite raw kind of confidence. There were no educational standards; people just cared about what they did. If you talk to the un-famous or un-celebrated students, they say it was all incredibly decent. They say that things were shared, that people gave you time. The most important thing when you are young is that somebody gives you time! Damien in a way is a kind of cliché: 'I'm going up to London; the streets are paved with gold!' He is like a character in Dickens. But if you talk to people with whom he worked then, they all talk about how he would energise things and share things and make things happen.

Is there a childlike quality to the YBAs?

If I am disappointed in them, I would say that they are very childish! I would say that they are committedly not growing up. I know they were resented in Europe for being like a bad crowd of football supporters. None of them speak any other languages. They all slept with each other, which is fine, but what I mean is that I don't think anyone particularly enjoyed their complexity. I mean, you don't go to art school to become an artist.

You've said that London is your studio and that you rummage around looking for dead ends and scraps of human detritus. What is the role of the studio in your art?

The studio is a nest site. It is very private. It's very like a skull. It's that unfortunate American term: a 'head-space'. Because I know how to make things, I am very nervous of the side of my activity that is the production, and I think that I make better work when I hinder my ability to produce things. The most dangerous thing about the studio is that it can become a place to make wares, and I don't think I want my work to be 'wares'. I love selling my work, and I think a lot of people are quite confused by the fact that it doesn't look enough like a 'ware'. But that is also an ambition I have; I don't want it to be a bad joke.

When I look at what I have done, I think I am proudest of things that look as if they met each other and had been together for ever. Some of them look really right, you know? It is kind of impossible to imagine them not being the way they are. The least laboured works are the real Wentworths. I'll probably be remembered for the gaps between things, not for the things themselves. So maybe that's like a gestalt test: 'Do you see the paving, or do you see the gaps between the paving?' I think I am the kind of person that sees the gaps.

Wentworth (right) **and his son Joe, a designer and mechanical engineer, at the artist's studio in Smithfield, London.**

Wentworth (following spread) **photographing the new Central Saint Martins building. Kings Cross is a rapidly developing area of the capital city.**

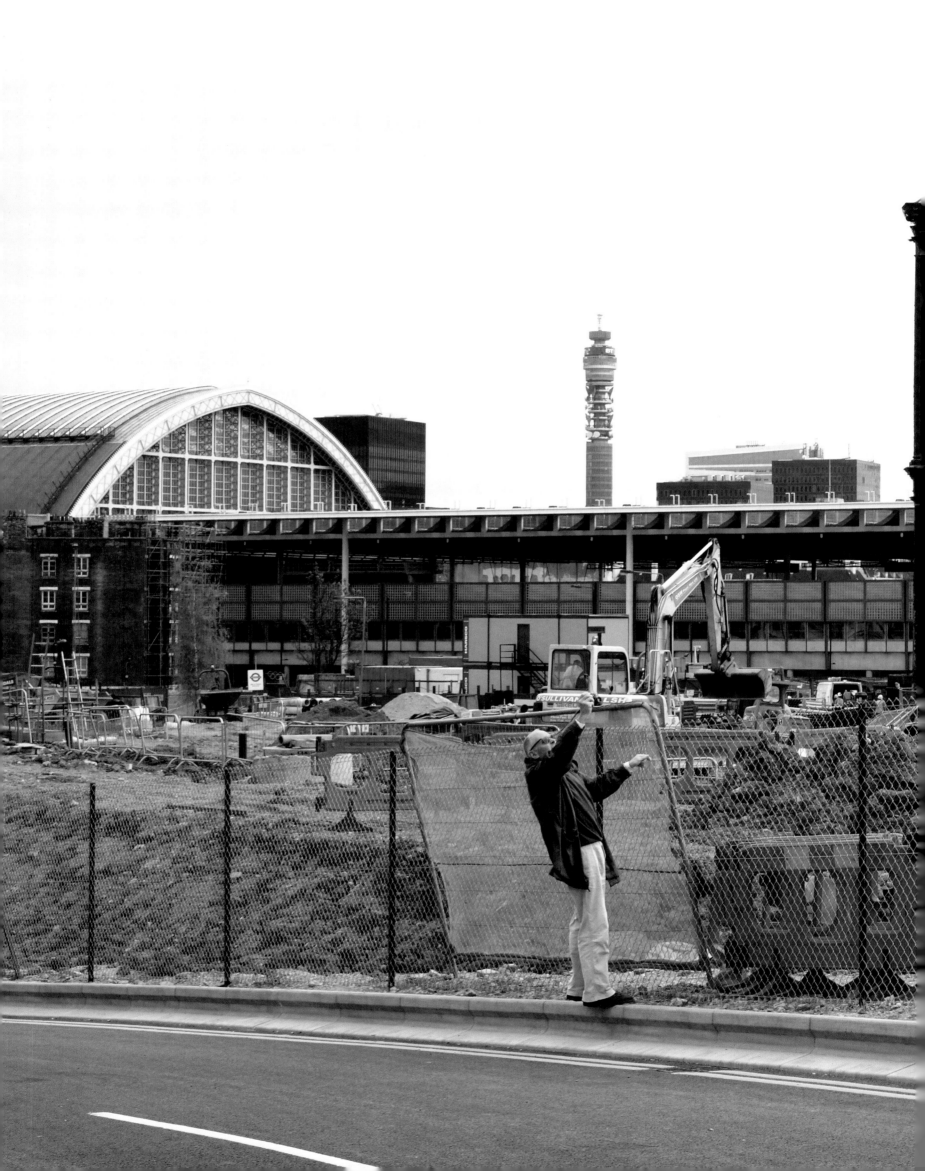

Dexter Dalwood

Your studio is very tidy. Is this how it has always been?

I don't think it is, actually. It's a new, grown-up version of me. I make a colossal mess – paint on the floor and everything – but I clear it up. I don't really like the myth of the studio having to be like Francis Bacon's; that's an outdated model.

You've spoken about your painting changing and not having relevance until you had the intellectual background for it. Is that what you mean by growing up?

With paint it takes a long time to do what you really want to do. It's not just the painting but also what you permit yourself to do. Moving out of your comfort zone is important. You always have to paint against your own taste, in a way. Often you do something that is slightly uncomfortable. I think that's interesting.

Is that an intellectual exercise or is it intuitive?

It's an intuitive visual thing to try to make yourself do something that sometimes surprises you with its ugliness. It's like pitching things above your own taste. I don't like painting – I love it. I love looking at it and I love thinking about it, and I love Old Master paintings and post-war painting. But you have to push against all of that.

Where does your process start?

It comes out of the daily practice of working. If you've been doing it for a long time, there's no reverse gear. Each work has its own life. Obviously when you are working towards a show it's different because it takes on its own momentum. Historically artists never thought about that. Chardin never painted for a show; he painted paintings. A lot of pre-nineteenth-century artists painted for the Salons and for private collectors. The whole thing of doing a body of work is different, how one painting relates to another painting and how, when you go into a room, you are surrounded by them.

I tend to do a show every eighteen months to two years, so I do a body of work and then I do an exhibition. I know lots of artists who seem to be producing half their work a year in advance for the art fairs. I don't work like that and I don't do roll-out either, which is like getting other people to paint them. It's just me who does it, and in that sense I'm old-school analogue.

In terms of patronage, you had the pope in the Renaissance and you have Charles Saatchi today. Is there much difference between the two?

It's very discursive now. The model of the tortured artist who died alone in a garret is not really the story, is it?

What about this myth of the tortured or starving artist? Are artists necessarily subject to genetic melancholia?

Van Gogh is the obvious mythical artist, the tortured genius who didn't sell a single work in his lifetime and now is the most successful, biggest-selling artist ever. It is an amazing story. But it's a story about family. Theo didn't only think that Vincent was the most important artist of the nineteenth century; he thought he was the most important artist ever. Now, I don't know many people who have a brother or a family member who believes that about them. Somewhere somebody has to believe in you, or you have to believe in yourself and make the rest of the world believe in you. When the Kirk Douglas film came out in the mid-1950s around the time of Abstract Expressionism, it was the ideal moment to say that's how it was to be an artist. It fuelled thousands of people's ideas of what artists should do and the romance of it all.

Who was the Theo in your life?

A lot of it came from my own bloody determination. My stepfather, an amateur sculptor, was very supportive. I left school – I signed a contract with CBS when I was seventeen. I was in a band, but it all collapsed within a year. I did five evening classes a week and worked in a bronze foundry. It was absolutely nuts because I was sold on the idea that I wanted to be in art. There's a conversion when you finally decide that this is it, this is what you want to do. I don't think it happens until much later in life, but it's obvious when children know they want to be artists.

You've talked about art history being separated from history itself …

I'm interested in how art history is not a science. You forget that Picasso was painting during the Vietnam War; you think of Paris in the '50s and '60s. As a titan of art he separates himself out from the reality he endured. I'm interested in how you can tie that back in again, in how you start thinking, Oh, was Hendrix already dead when Picasso was still painting?

Ideologies shift – I'm interested in that. I'm interested in the '60s, and how the Summer of Love happened, and how the '70s were such a strange decade, and then the '80s, a decade that has not been properly appraised yet in terms of the arts.

But is it not obvious that social irritants or artists' subversiveness gets more attention on the contemporary scene?

The hoo-ha around paintings normally evaporates. Think of Manet and *Le Déjeuner sur l'herbe*. When that painting was shown, people not only laughed

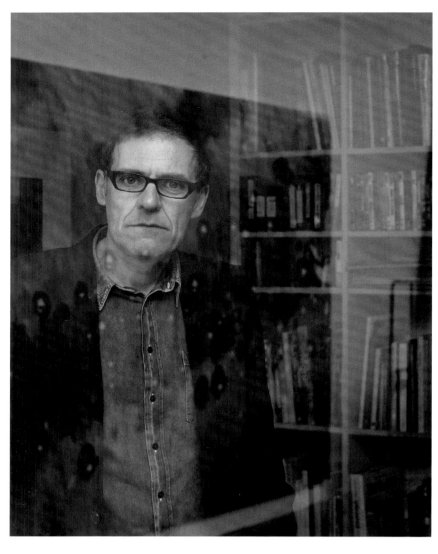

Dexter Dalwood (previous
spread) in his studio near
Angel, London, in early
May 2011. The space was
designed by Marcus Lee.

Dalwood reflected with his
2011 work *Two Girls in a
Poppy Field* (above): 'I make a
colossal mess – paint on the
floor and everything – but
I clear it up. I don't really
like the myth of the studio
having to be like Francis
Bacon's; that's an outdated
model.'

at it, they spat at it and were in hysterics. How could
somebody make such a technically bad painting?
People walked into the Salon and pointed their
umbrellas at it and wanted to destroy it – and now
it's one of the great works of modernism. The fuss
around that painting has disappeared.

**Taking that to the next stage, is it true that a
great artist is ahead of their time?**
Not always. A lot of the time people are on the
money, but in the end, any writer, any artist, any
musician wants to be acknowledged within their own
lifetime. That's what it's all about. I don't believe
in an afterlife. I don't have any interest in what will
happen to my work when I'm dead. I want to show
paintings, to be a part of painting while I'm alive.
That's the only advantage to being successful: you're
part of the debate rather than being the lonely boy
shouting in the field.

**You've been quoted as saying, 'The viewer must
use their imagination to complete my images –
so I create images that trigger memories.' Are
you producing a simple phrase and then leaving
the rest of the narrative to be developed? Or
are you going all the way? Is there an answer to
your question within the canvas?**
I have to twist that around. I'm not interested in
self-expression on canvas. I'm interested in how the
viewer comes upon a painting and makes sense of
it through what I've painted. That sense is through
the image and through its relationship to its title,
and then the ramifications of how that operates – the
pebble in the lake, which sends out ripples that hope-
fully stay with you.

How do you determine that?
I don't. I'm the zero. I'm the one who tries to pull
myself out into the cold air of objectivity. I don't know
if it's going to work or not.

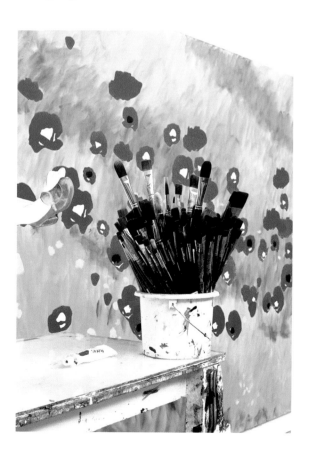

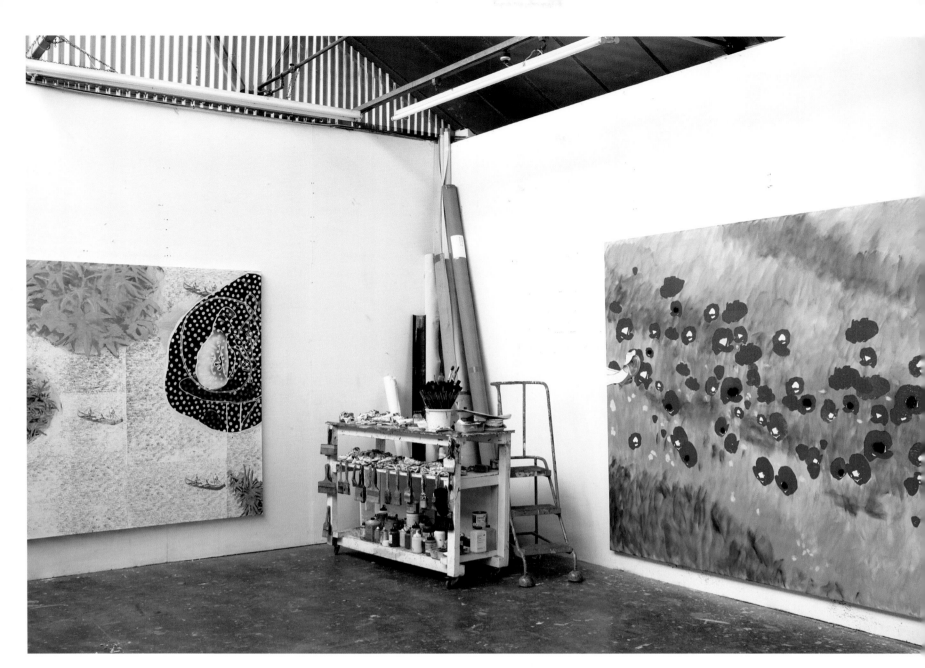

So the viewer is the painter …

Yeah. You're the audience, the viewer and the critic.

Talking of critics, are they a necessary evil?

What would be the alternative? You don't let the people choose – that would be a disaster. You can't have a common denominator. If in this country we showed what the common denominator would like to see, we would have very boring art.

So is the artist's role to educate and herd the public?

The role of the artist is to up people's game big-time, and always to presume that they're intelligent. The way that visual art is covered in the national press in this country is an utter disgrace. The great thing about sports journalists, particularly football journalists, is that they like football. The majority of people who write about art in the newspapers don't love it. They have various axes that they want to grind, they fall into it by writing about something else – they don't look, they don't look. What we lack is intelligence in looking, the intellectual encouragement of looking, which is not a quantifiable thing. You can't teach it to people; the intelligence of looking is an intellectual pursuit. That is *greatly* undervalued in education in this country, from primary school to university. What are valid in this country are words, above anything else. If you see a panel of critics on television talking about a novel, they can dissect it and talk about the history of the novel; they can talk about why it's interesting to write like this now. When it comes to talking about visual art, most of them say, 'I like this because …' 'I think this is really great.' 'It's really powerful.' There's no information available! *Why* is it powerful? *Why* is it important in the history of art? *Why* are we looking at it? You know, I think that's just unbearable.

Isaac Julien

You've described yourself as being post-studio, as working in a virtual studio. What does that mean?
I guess it means that a lot of time is spent using computers. I joke that I'm a post-studio artist because a lot of the work I make involves shooting film or photography and working with lots of people. My practice is working in the field, which means essentially outside of the studio. The only time I think about a studio is when I'm installing, which is when I'm thinking about what the work will look like, but that's more in terms of a gallery than a studio. All of those things I would demarcate as post-studio production. What is really important is the virtual/digital part of it, working with computers, which is ironic as I'm computer-illiterate.

You deal with a lot of technical people. Are you a technical person yourself?
No. I'm someone who thinks about images and how to make them. I work more as a director, as a conceptual artist. When I am working with photographers and camera technicians, it involves many conversations, recceing locations and working everything out in the actual space. This visual research then gets documented, and that is how I make photographs or films. The process is like visual ethnography, like surveying the field or the terrain where you are going to make the image and then bringing the rest of the accoutrements to the real setting. It involves stylists, lighting, costume designers, make-up artists – so many things. A lot of resources go into making the images. I see myself as someone who is not enamoured of technology, but my work cannot be made without it.

You often refer to your art almost in a painterly manner, in effect going against technology …
When I was showing *Ten Thousand Waves* at the Bass Museum in Miami recently, the Director of MoMA, Glenn Lowry, commented, 'Isaac, you're really a colourist, like a painter.' And I thought, Yes, I'm very interested in that painterly approach to making images or thinking about pictorial representation. My approach is connected to the fact that it is new technology. It is more developed through practice, conversation and being excited by innovation. Innovation is the key to contemporary art. I respect all of the fine-art mediums, but for me what's exciting is the connection between mediums in fine art and new technology, how those things can be sutured together.

You have been quoted as saying that viewers are greedy and like to see different aspects, so therefore you use a multi-screen approach.
What is interesting is making work for a gallery context versus the more classical setting of the cinema. One of the reasons I moved into the art context was because I was able to think about the audience in a different way. The technology that was developed through video art and video projection enabled one, with the aid of computerisation, to think about making work in a more sculptural sense. You can see this perfectly in *Ten Thousand Waves*, for example. With classic cinema these days, we go to be entertained. In an art context, we know we're not going to be entertained in that sense; we are going to experience something a bit different.

At some point in my work, there will be a sensory, immersive relationship to looking at images that hasn't been developed to its full potential in single-screen linear-film format. It's artists who will lead that development. We are all immersed in these new technologies already, on our iPhones, on the Internet, on Facebook, on the Web simultaneously. So the question really is about artistic subjectivity and how a visual language and visual multitasking inform our practice; these technologies seep into artists' work, almost through a process of osmosis.

You're neither a normative film maker nor a storyteller; you are challenging the boundaries of the moving picture.
I'm very interested in cognitive dissidence. Sometimes it is good to make work in a single-screen format; I can think of many works I like which were made in that way. Different contents create different responses. But in my practice, I am interested in the modularity of images as I find that more exciting and innovative.

I am yet to shoot a whole film in high definition, though I probably will for my next project. Then everything will be on file, and that will be very interesting in terms of the concept, because analogue photography and film will become obsolete. So we are in this nebulous space now, which is very interesting.

Talking of space, methodology and equipment, do you take photographs yourself?
I work with one or two photographic technical assistants, but I direct all aspects of the image-making, both conceptually and practically.

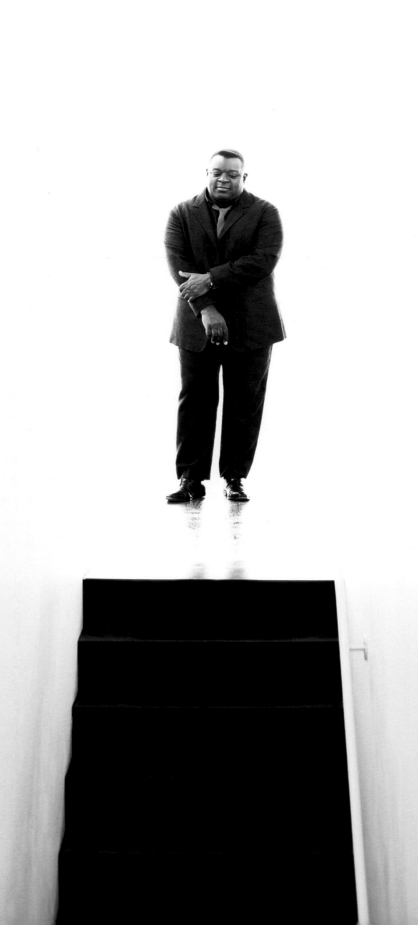

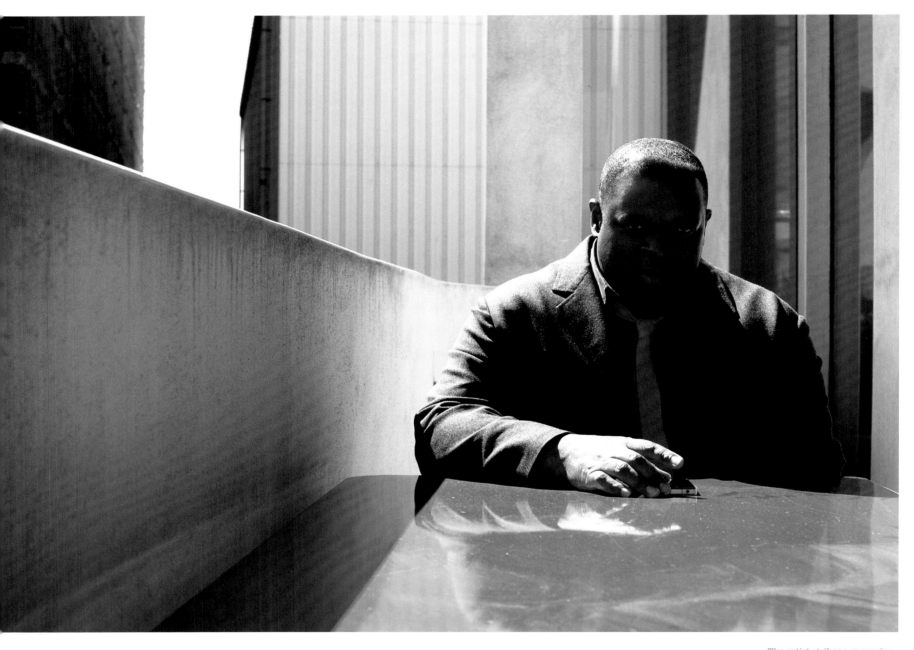

The artist strikes a menacing pose (above), quite the opposite of his mild-mannered character. Julien's large photographic works are printed and mounted at the Grieger photography lab in Düsseldorf (opposite): 'A lot of resources go into making the images. I see myself as someone who is not enamoured of technology, but my work cannot be made without it.'

As far as the themes of movement, migration and identity are concerned, what is it that drives you? Is race a particular concern?

In my early works it was. If I think about a work like *Territories*, it was really about changing the rules for representation around race and identity. I was interested in contesting a hegemonic representational strategy, which was being articulated by the dominant media. We were making works to challenge that strategy in the Sankofa Film and Video Collective of the late 1980s.

Some of my films were about trying to rearticulate self-image. This was central to discussions around post-coloniality. It was an important debate in Britain, certainly in London in the mid-'80s and early '90s. This culminated in a conference and exhibition at the ICA in 1995 entitled *Mirage: Enigmas of Race, Difference and Desire*. We were concerned with problematising the concept of identity by making artworks and films which questioned black representation. This high point in critical theory with a post-colonial awareness was inspired by conversation between America and Britain. Prominent theorists included Homi Bhabha, bell hooks, Richard Dyer, Stuart Hall and artists such as Steve McQueen and Glenn Ligon. It was a rich and dynamic moment.

The work that I am making now is post-those questions. Works like *Western Union: Small Boats* are dealing with globalisation, and people who are familiar with my work will recognise the themes. I am interested in trying to rearticulate those themes for a new audience and to express them differently because I think part of this discourse became mannerist.

I like the idea of someone like me making a work in China because it is an unexpected move. We are in a moment of the unexpected.

You are of Caribbean origin and moved with your family to London, where you grew up in a tough environment.

Where I grew up was not that comfortable; I was schooled in Shoreditch, which was a National Front area. However, the East End was interesting for me, and probably the reason why I make art today was that there were artists living opposite the estate where I grew up in Bow. My curiosity about what they were doing made me become an artist.

So does art seed art?

No. It has more to do with the fact that you have the inspiration or are able to experience things differently from the way in which you would ordinarily experience them. Having that access to be able to do things slightly differently was really important.

Now that you have scaled the heights of success, how does it feel?

I mean, I'm a Londoner, so I look at myself and think, Well, that's okay, but I can do a lot better.

Fiona Banner

Fiona Banner in her sunlit
Shoreditch, London, studio
in early May 2011.

Is it true that your fascination with aircraft has its source in the walks you took as a child in the Welsh countryside with your father?

I don't know if it springs from there, but seeing and being moved by military hardware – specifically fighter planes – are my first memories. On those walks, we were almost waiting for the planes to appear and crack through the sound barrier in that pastoral calm. The way they broke through it became this incredibly exciting thing. We would be completely awestruck by the aeroplanes and found them – if we were being honest with ourselves – incredibly beautiful. Of course the calmness of nature was meant to be incredibly beautiful. I remember the way they always silenced us. Not only because of the sound but also because afterwards it would knock the language out of us.

Years later, I started to reflect on my enthusiasm for these objects. It's something that I share with many other people. In this country there are vast numbers of air shows every summer. I think we have a strange, celebratory relationship with aircraft. When I started to reflect on how I was seduced by those aeroplanes, I started to reflect on my own aesthetic judgement and on the fact that those planes are designed to function. Their function is to kill.

Are stopping language and breaking barriers metaphors for the work that you make today?

Those planes take you to a place beyond language, I think. Perhaps they signify a meeting between, if not a clash between, my intellectual self and my emotional selves. So what I feel emotionally and what I think when I reflect on them are two entirely different things. I'm interested in that contradiction. I often play with the idea of them being beautiful.

We're all stuffed full of language, which is our main negotiating tool when we try to define where art comes from and, more often than not, to locate it within a specific experience, as if it's a linear journey. I don't think that's the case. It's more of a web. It's hard sometimes to know what experiences feed into art. The depth of history and how you might develop a relationship with something are as transient and ephemeral as thoughts or ideas. My work normally is deep and shallow at the same time, and there's a sort of darkness and utter simplicity. I don't mean to imply that I think that my art attempts to simplify, because it doesn't. It reflects on the unresolvable, complicated things that we can't articulate in other ways.

In Britain, society is incredibly brittle about art. People often reject it completely because they think it requires some kind of professional education, which in my view it often doesn't. That fetishistic, trophy-object aspect of art can be confounding and problematic. It's an aspect that I also choose to play with. I'm mindful about how we discuss beauty, about how we are seduced, about how we move around these highly fetishised objects.

And this fascination with words has led you to a fascination with books? Or did that originate in your childhood?

No, it didn't. I publish quite a lot of books now. I didn't grow up in a house with many books. It was only in my late teens that I got into reading. I got *very* into reading in my twenties. I also used to write a lot about my problems with art, about how to make art, and my sketchbook would always be full of writing, not imagery. One thing I like about producing books is that they're the opposite of the unique object in many ways.

Does an artist need to be clever, or is there a gene that makes art happen?

An artist has to be intuitive. An artist probably has to be intellectual. I think it's probably better if an artist isn't 'clever'. The kind of art I really dislike is the sort where you look at it and know exactly what the artist was thinking. There's a sense that all the boxes have been ticked. You can understand that work of art; you know where it is coming from; you probably know where it's going. Often, actually, my favourite works are things I didn't like when I first saw them. I was irritated because I couldn't understand them. Work that's confounding, that exists slightly outside of your normal modus operandi: that's where I think art starts happening.

You have been quoted as saying that you are 'radically un-feminist' and don't hold too much with 'isms'. A lot of contemporary artists use what is outrageous almost as a leitmotif to try and attract attention to their art and to themselves. To avoid doing that as an artist is therefore rather difficult, I would have thought.

Well, being an artist is difficult! Art has this very particular place in our society, so it is entirely appropriate that it should be difficult to make. After all, there's a difference between a design object and art.

Feminism was a historical movement, and we're very grateful for it. But I think it's too simple to describe myself as a feminist. Our relationship to our sexuality and our relationship to men are too complex, too contradictory. It's a privilege to be a woman. I was born into a society where I could follow my desire as a woman. None of those things are lost on me, but I think it's much more complex than what the term *feminist* implies. It's clear that I'm interested in female power, but I'm also interested in the conundrums around that, and the contradictions.

My work annoys a lot of people. What can I say? I don't make art to shock or annoy, but sometimes I do use strategies to gain attention. For instance, using fluorescent paint is a strategy to gain attention, however facile or obvious that might be.

Your work has been described as concerning itself with systems. What does that mean?

I am interested in systems of information. So for instance I am interested in biography and the cult of biography. I suppose that the work I did with ISBN numbers, which is about how we move information around, was very reductive. But I'm interested in those things in quite a playful way.

What else sparks your interest?

Things that draw me in but also things that push me away, things that I'm drawn to but also disturbed by, things that I'm seduced but also repelled by. Somehow the draw/repel elements are intimately linked.

Do you use your studio for purposes of investigation?

'Investigation' might involve reading, sleeping, listening, thinking, drawing. Drawing, I would say, is the waking equivalent of thinking and sleeping at the same time! I use my space at home for investigation. I do lots of other things there, but when I come here, that's what this space is for. I suppose the implication is that I spend a lot of time here not making work.

I got to a point in my studio where I couldn't proceed with language. I couldn't find an application for it; the application wasn't there. And verbal language had very much become my language in the studio. What I ended up doing was making work that looked at language without context, that looked at being stuck. That was an investigation of 'losing it' – of losing the thread, I mean. But I was also trying to think a little about what happens when you end up in that abstract space without words or when you can't describe what you're doing. It's about the opposite of language and communication, in a way.

Banner's studio exposes her fascination with words (above) and her childhood obsession with aircraft (left). She created a catalogue of fighter planes in use by the British Air Force, her fascination born in childhood holidays spent walking with her father through the Welsh valleys where fighter jets screamed low above their heads. In 2010 Banner installed an imposing British Aerospace Sea Harrier in the Duveen Galleries at Tate Britain.

Her studio library displays the artist's large collection of books. Banner runs the publishing imprint Vanity Press and has even tattooed her ISBN number on her lower back. 'An artist has to be intuitive,' she muses. 'An artist probably has to be intellectual. I think it's probably better if an artist isn't "clever".'

In 2002 Banner described a porn film for her Turner Prize exhibition, which, together with the other nominees, prompted the then Culture Minister Kim Howells to label the show 'conceptual bullshit'.

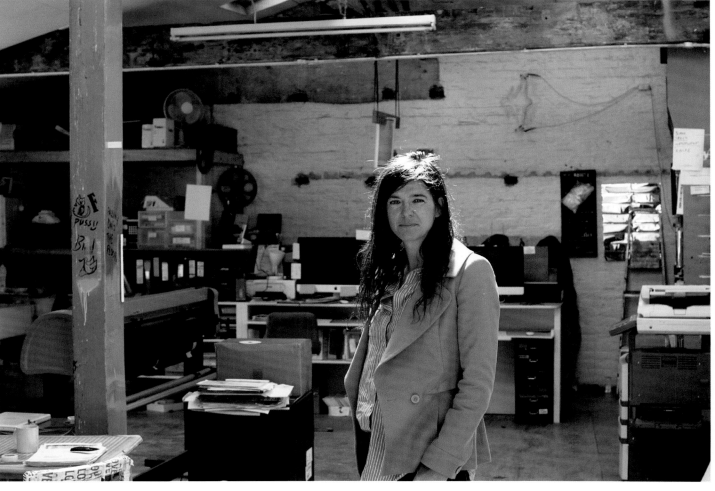

Gordon Cheung

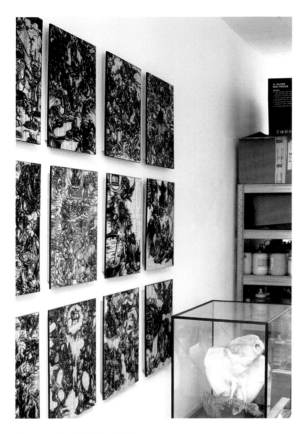

You're Chinese by origin and British-born – not necessarily an easy upbringing. You've mentioned facing racism when you were growing up.

In school I was the only ethnic person, and inevitably there were fights just because I looked different. They were formative years in terms of my identity and also one of the reasons why I am drawn to the idea of 'in-between' spaces where borders and boundaries blur. When I got accepted into college and art school, it was a breath of air that I absolutely appreciated.

Were there similar tough times in the process of becoming an artist?

Everything was easier, as I was generally doing something I wanted to do and was where I wanted to be. When I was at Central Saint Martins with hundreds of art students and started visiting galleries, I realised that there weren't that many Chinese artists represented. I thought I might need to do more, so I started to organise exhibitions to get an idea of what it might involve. All of that put me in a good position, I suppose, as I have never taken anything for granted. I just work as hard as I can so that I am free to make art.

Speaking of Chinese contemporary art, did anyone ever try to pigeonhole you?

When I did a residency at the Chinese Arts Centre in Manchester in 2004, it was the first time I came across British-born Chinese artists who had this thing about not being pigeonholed. I couldn't really understand why they cared that much about it. Equally, in my recent solo show in Shanghai, a Chinese writer insisted that my work wasn't Chinese, to which I replied that I am both British and Chinese, so my art is as well. The dominant reason why I make art isn't about persuading people that my work is Chinese or British, which is why I am bemused when it comes up.

If you were to pinpoint a moment in your career where you were propelled forward, was it that residency?

It was also about having just returned from a residency in Pakistan, where I was able to 'let go' of ideas from art school. The residency at the Chinese Arts Centre was where the curators of the British Art Show 6 selected my work.

Were your parents supportive?

They had high expectations and were very supportive of me getting a good education, but I underachieved academically for many years, except in art. Ironically it was when they gave up that I started achieving. I think it was that pressure of wanting to please my parents that made me falter under exam conditions. Understandably, they were always concerned about how I was going to make a living and gave me banking-job applications years after I graduated from the Royal College of Art. The prospect of doing anything else intensified how much I wanted and needed to make art, so I bought all the art magazines and applied for everything on offer. That's when I started to win awards and create opportunities to show my work.

What is the purpose of art?

It's the free and creative expression of humanity.

You've mentioned John Milton, J. G. Ballard and Philip K. Dick as influences ...

I made a body of work based on John Martin's etchings of Milton's *Paradise Lost*, which are depictions of a world where everything is controlled by a divinity. Ballard's urban, surreal, science-fictional depictions of our existence in a world in which society is quite fragile ... take away one block, and it all collapses and we regress to being primeval entities. Philip K. Dick for his multiplying realities, his drug-fuelled, paranoid descriptions of worlds in which all-powerful meta-structures control individuals.

Digital technology preoccupies you, doesn't it?

Absolutely. We exist in an increasingly technologised era, in which our perceptions of reality are in a state of constant flux. When I was at Saint Martins there was this modernist ethos in the Painting department about surface, touch and texture. When I looked around, though, there was all this other stuff going on! There was a digital and communications revolution; mobile-phone technology was just becoming readily available, the Internet as well, and there was a utopian euphoria about what technology was going to enable us to do. So I sidestepped the traditional discourse of painting, and, though I was still dealing with modernist language, I used collage rather than paint. I made collages of maps, star charts and the stock listings from the *Financial Times* to look like paint by manipulating them on colour photocopiers and computers. There was this whole question of whether it was or was not painting.

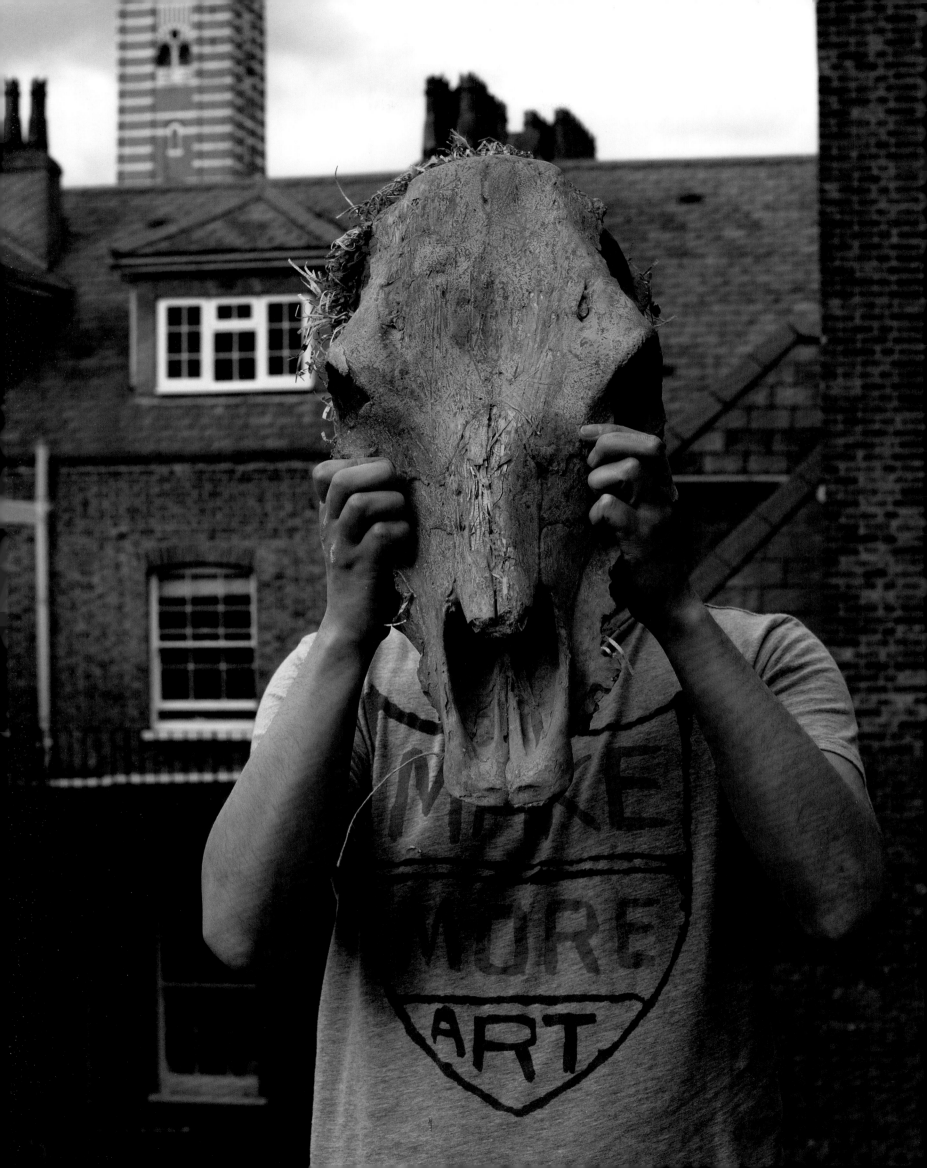

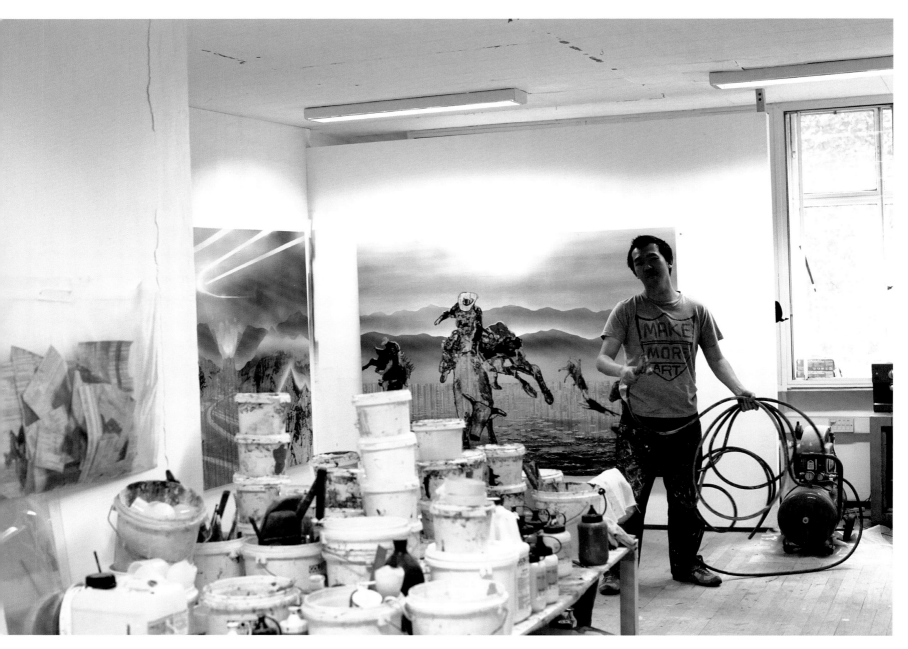

Cheung lets off steam, lassoing a spray gun in his studio (above) while working. He paints over dense collages made out of stock-market listings and the *Financial Times*. 'I call the idea of all the information that flows through us and carves out these global economic landscapes the "techno-sublime".' Cheung is also inspired by digital frontiers, consumerism and science fiction. Another work hangs in his studio (opposite), finished and ready for collection.

Do you think that politics should play a role in art?

Yeah. Politics affects all of us.

People have said that your stock-market works almost predicted the financial crash …

I began using the stock listings in 1994 in my work during the digital and communications revolution, throughout the tech-stock bubble, the Millennium Bug, natural disasters in 2001 alongside the 9/11 attacks, and the collapse of Enron and WorldCom, all leading up to the War on Terror and the global credit crisis. Of course I didn't predict any of those events; I wanted to find something that could be a metaphor for the information space surrounding us. There was all this talk about globalisation, Internet superhighways, global villages, data spheres and so on, and I felt that the stock listing was a dense metaphor for this new landscape. The stock market is the dominant economic model that to a great extent dictates our realities. So for me it was like painting with information; it was as if I was exchanging pigment for the stuff of information. I used numbers almost like an overloaded brush. In a way I am like a plein-air artist painting the virtual landscape that is bearing witness to the unfolding events of nature.

Where does nature fit into your work?

I use symbols of nature and the visual rhetoric of the Romantic Sublime. Traditionally the Sublime is nature overwhelming us, resulting in a transcendent experience that brings us closer to a divinity of sorts. In my work it is information that overwhelms us. I use symbols of nature from traditional Western landscape painting as a way to convey this new type of landscape. I call the idea of all the information that flows through us and carves out these global economic landscapes the 'techno-sublime'.

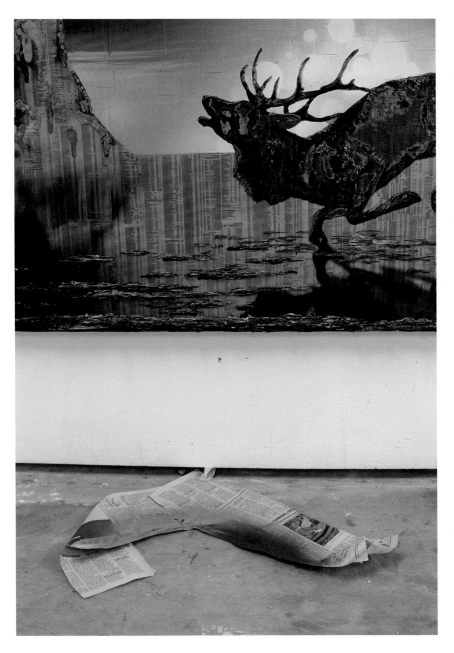

How do you divide your work between what could be called sculptural painting – using various paint media – and your wood panels burnt with lasers?

It all starts with the ideas that flow from one work to the next, which usually decide the medium that will be used. I started the laser works three years ago when I saw some laser-cut works online. At the time I was looking at Albrecht Dürer's *Apocalypse* series, and it clicked that by using the laser-cutting machine it was the *act* of destruction that would create *images* of destruction. It was about looking at the classical idea of the end of the world and causing it to converge with the modern idea of ending, which the media at the time were calling the end of capitalism.

What does your studio represent for you?

It is the place that I love to be and where I will spend most of my life.

Cornelia Parker

Are you interested in people? Your work is mostly centred on objects …

Objects can be surrogates for people. The process of making my work is often oral. It requires social interaction. Then, through the exchange of words, what's left is the object. Whether I am working with the British army, Customs and Excise or the Government Art Collection, I like the exchange that goes on with an outsider interacting with an institution. There is a friction created by different worlds colliding or overlapping. Something gets made out of that situation.

How did you interact with people to create your new installation?

The bronze mermaid I've been working on was installed yesterday for the Folkestone Triennial. Every house in Folkestone was leafleted asking for a model who would be willing to have their body cast taken in the nude, adopting the pose of the Little Mermaid in Copenhagen. I had fifty people send back their pictures wearing swimsuits and posing on the kitchen floor, or on the sofa, or in the backyard. From all these images of women of different ages and sizes and shapes, I chose six and asked if they could send me new photographs of themselves in the same pose without clothes. Two dropped out because they suddenly realised what it might mean to be immortalised in bronze in the flesh, warts and all. Four were still up for it. I decided not to meet them but to select from photographs only. I finally chose the person I did because the way she held herself in the photographs told me that she was confident in her body; her strong personality was expressed through her physicality. I didn't know what my true criteria were until I saw the photographs. I usually have an initial concept but never know what it is that I am looking for or trying to achieve until I get the hairs at the back of my neck standing up. Only then do I know what is intuitively right.

Does this intuition grow over time?

I think so. I always allow my subconscious to lead the way, because I presume it knows so much more than my conscious mind.

How do you know the difference between the conscious mind and the subconscious?

Consciousness is the idea – you might have a persistent idea, but you don't know why. Often with my work I am trying to forget what I have done before. I am always reinventing the wheel; that's why my crafts are diverse. But in the end, the same themes emerge, obsessively, naturally, quite subconsciously.

Are you trying to reinvent the wheel through creative destruction?

It's the theme throughout life, isn't it? We are all made up of little bits of molecules of dead things, dead stars, whatever. That's how life evolves. All my work does is mimic that process. It feels right to kill something off to create a space for something new to emerge. It is like trying to make a void, a new space, in the densest of matter.

It seems like the process itself interests you more than the end product.

The end product is just a residue of my involvement with the materials, a chemical reaction between me and the world.

You've been described as a 'Conceptual artist, a provocateur, a theorist with a sense of humour'. Which title do you prefer?

'Artist', because you can be all the others under that umbrella. I don't want to be hemmed in by labels because the beauty of being an artist is that you can express yourself in any way you want. It's making sense of the world, which can be a very hard, nonsensical place. The act of making art is a kind of digestion of things, inhaling, absorbing and then exhaling or even excreting. The work is a residue of that process.

You formalise a lot of your artwork through suspension. What does that signify?

I like things to be in limbo, in flux, because that's what the world feels like to me. All the time we are living, evolving and dying, we have an ambiguous relationship with the earth's surface. The things that inform me formally are trees or grass, things that are moving, in flux or made up of many different parts, porous rather than solid things. Saying that, I have just made a bronze sculpture, which might feel like an anomaly. What I like about the mermaid is that my model, Georgina Baker, was cast, recorded, on a particular day in her thirty-eighth year. She will age, and her children will grow up and have their own children, and perhaps, if it's still there as a sculpture, they will play around the curious bronze cast of their grandmother captured in her youth. I loved fixing that day; it is now a kind of time capsule. I like photography because it has a similar function.

Do you aim for commercial success or does it not concern you at all?

My art has evolved incrementally over a long period of time without the pressures of commerce. I would

Drawn to objects with a past, Cornelia Parker (shown in her Shoreditch, London, studio in May 2011) collects heirlooms and silver (anything from spoons and saucers to wedding rings and bullets), which she crushes with a steamroller.

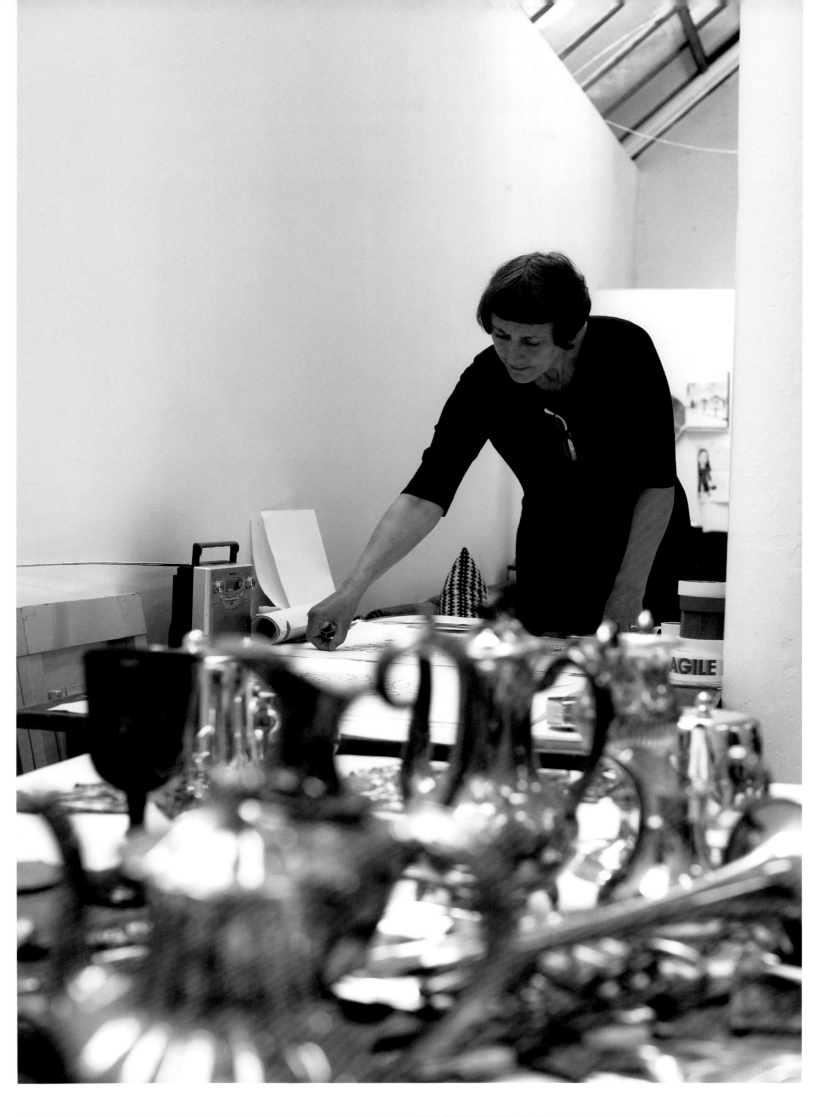

'Being an artist is a political act,' the artist says. (above) New work, beautiful sterling silverware ready for the knacker's yard, crushed by a 250-ton press in preparation for Parker's Frieze Art Fair presentation. Parker's camouflage tents, made out of black safety netting and cut-up black clothing and held down by bags of lead shot, represent traps or snares, or shelters without walls.

The artist's private workspace (right), images of new designs mixing with artwork by her daughter, Lily.

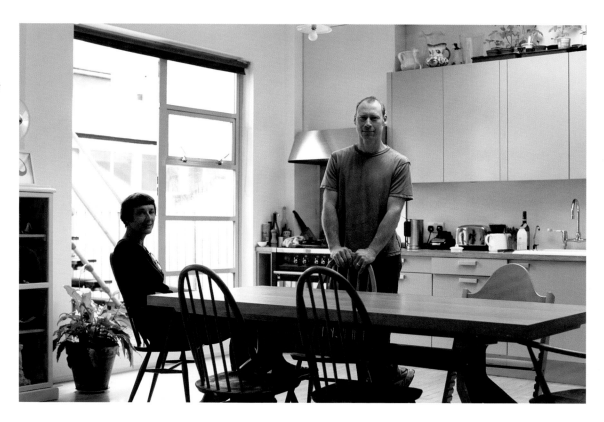

never have made a lot of the early works if I'd been worried about them being sold. They were un-sell-able, but they were the stepping stones. I had to make those works to be where I am at now.

Until I was nominated for the Turner Prize, I had hardly sold anything. I had been teaching in art schools to make money, and I refused all representation because the right gallery hadn't come along. I was in a major car accident in 1994 where I shattered my pelvis and ended up in hospital for weeks. That was a bit of a growing-up point. I thought, Oh dear, if I'd died in that car accident hardly anything of my work would have survived. I gradually changed my opinion, allowing my work to be owned by other people. Now I live off my work rather than teaching to support myself, and that's liberating because it means you give responsibility to someone else; they are now the custodians of your work. You allow the idea to go out into the world and have its own life and possibilities.

You've described yourself as part of a 'lost generation that never quite had a moment of their own' …
I am a little bit older than the YBAs. My generation was working in all kinds of ephemeral ways, because before the YBAs there wasn't much of an art market in this country. Very few artists lived off their work alone. When I was at art school, you thought that art was more a philosophical tool or a political stance. It wasn't something you did to make money. It was like becoming a poet; it affected the way you looked at the world. Artists doggedly carried on because the work was essential to their emotional survival; another larger percentage dropped out. Then the YBAs came along with Charles Saatchi, and with London becoming more of an international hub, finally connected to the world art markets. It meant that many more artists finally could make a living out of their work.

You never felt any resentment towards the YBAs?
You should never, as an artist, be worried about the success of other artists because it's just more grist for the mill. It enriches everyone.

Arte Povera and Piero Manzoni have been mentioned as influences on your work …
Marcel Duchamp, Yves Klein and the Arte Povera movement were important to me because they used any kind of material and found objects. A lot of their work was temporary, ephemeral; they were interested in ideas rather than technique. When discovering their work as a sculpture student, I felt liberated and imagined I could possibly be an artist myself.

Is your art political?
Being an artist is a political act, and increasingly so. I don't want my work to be too overtly political but to have a plurality of meaning, to be ambiguous in its reading. Having worked with a lot of organisa-tions that I find quite scary, like the British army or the Daughters of the Republic of Texas, has made me question my prejudices. I am always trying to have a dialogue, trying to put my prejudice on hold and see what comes out of the situation.

Consumerism, globalisation, the role of the mass media: which of these elements most inform your work?
They are all part of the same thing, part of the political landscape. In my early works I was using the little souvenirs you get of famous buildings, casting them in lead and hanging them upside down as plumb lines. There is a refrain of things we can picture in our heads, but they are inverted.

And your studio? It is obviously a live/work situation. Is there a clear separation between the two?
No. I do a lot of things on the kitchen table. Big-scale work like the mermaid gets made on site. I collect materials or take them away to be processed. I don't usually invite people into the studio; it's very much a private domain, a quiet place where you can draw threads together and try things out, make mistakes. If I try things out for too long, I overdo them. So I like the 'gun to the head' bit of working in situ to a dead-line. That's when your subconscious can really do its stuff. You don't have time to prevaricate.

So is the studio a sanctuary or a challenge?
Probably both. I don't like the idea of 9.00 to 5.00. For me the studio seems like going to the office. I much prefer working on the kitchen table, pretending it's not work.

Then where is your sanctuary?
In my head or on the roof. The most creative thoughts I have happen when I am in transit or in conversa-tion. The studio is not where inspiration happens for me. I know it is for a lot of people – you can try things out, and you make breakthroughs on a technical level. But a lot of the real creative thing goes on inside the head and in situations where you have to think fast. The studio is slow. It is a formalising place. It is where the stuff resides that I've gathered from all over. It's a bit like a cave for a hunter-gatherer.

Parker installing *The Folkestone Mermaid* at the end of the Stade (overlooking Sunny Sands beach) in Folkestone for the Triennial. The sitter was Georgina Baker, a mother of two born and bred in the town. 'Objects can be surrogates for people,' Parker says. 'The process of making my work is often oral. It requires social interaction. Then, through the exchange of words, what's left is the object.'

The boulder on which the mermaid sits was craned into place and the bronze cast positioned on it to look out to sea.

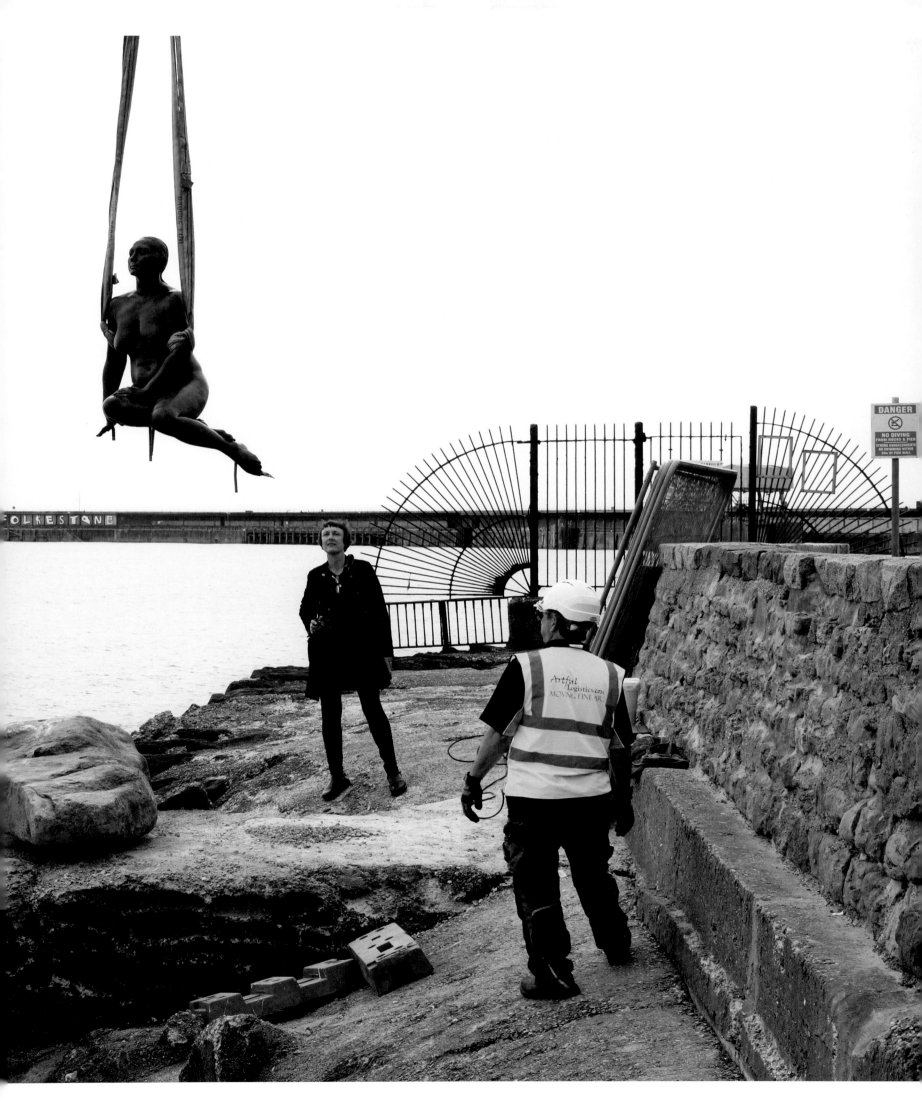

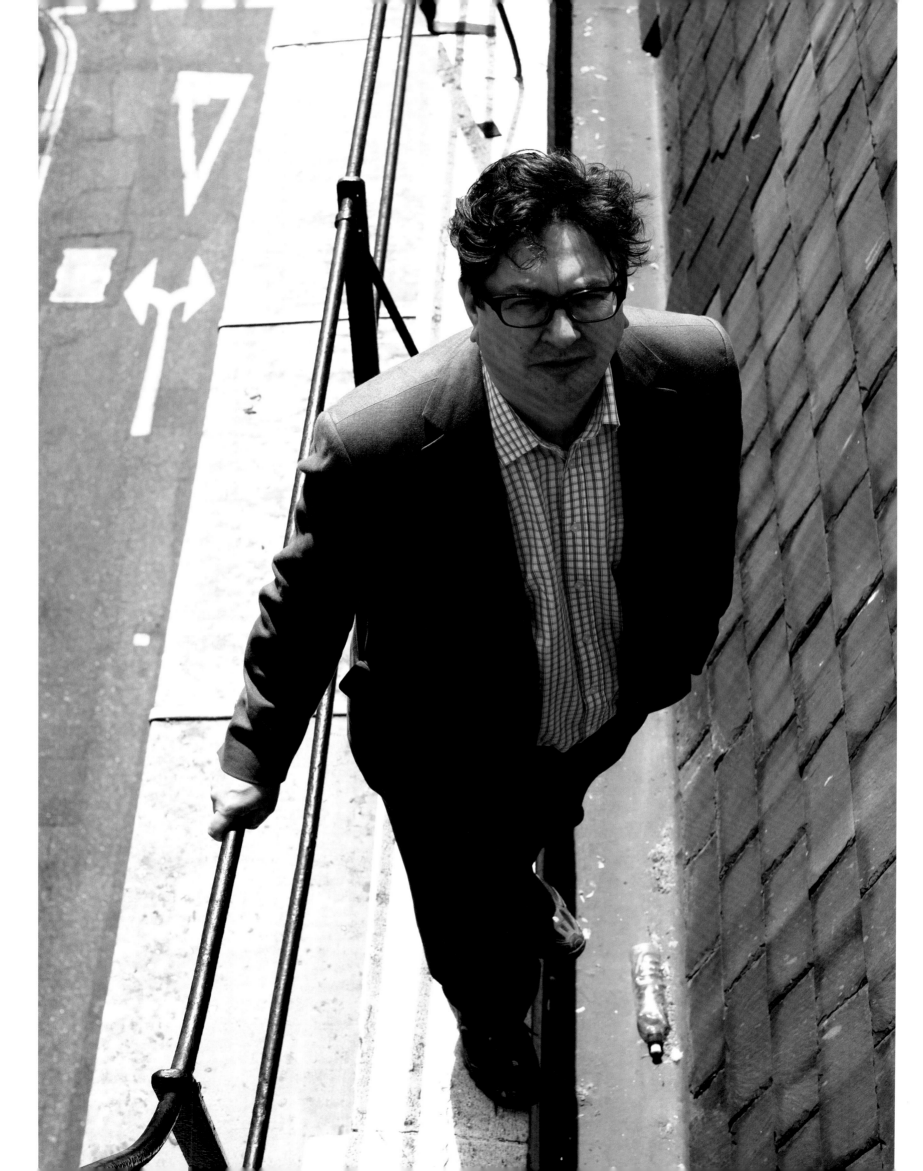

Mark Wallinger

What are you working on at the moment?

I'm messing about, really.

Is messing about something that you use your studios for?

Yeah. I had two rooms in my previous studio. One was more of an office and thinking space, and the other was more a doing space. I'm trying to keep that arrangement here. Over the years I've had more approaches for competitions and commissions, dance projects and all the rest of it. Sometimes, in between emailing, it's hard to keep a studio practice going.

It must be comforting to have an experimental space to work in. What made you move here?

We've just moved to Frith Street so it's rather handy. I've become a bit of a Soho man. Didn't figure that would ever happen. It's good to have an uprooting like that.

Does the size of your studio matter?

This is a nice size. Everything huge I make is outsourced anyway. This is a perfect wall in that it faces north, so it never gets direct sunlight.

Can you talk about your obsession with horses? You used to own a racehorse that you once used as an artwork. What happened to it?

She won a race and was placed a few times. Then she became a brood mare and had quite a few foals.

Another aspect of horseracing evokes the historic British obsessions with race, gender and class. Do you think these obsessions are still there, or have we moved on?

We haven't moved on in terms of class, have we? We've got an Old Etonian Prime Minister and an Old Etonian Mayor of London. So I think we've regressed. It's too boring to get involved with, I think. The ineptness with which successive governments have dealt with everything from education to housing as a way of stopping social mobility has just made the country more divisive.

You won the Turner Prize in 2007 for your work with the peace campaigner Brian Haw. You really pinpointed what is going on in the country.

I wrote a piece about the Turner Prize in 1998 for *Art Monthly*, so I know how the game goes. But, having put myself up for the award, I couldn't suddenly get precious about it. I was very happy to win. The Tate were amazing in terms of issues having to do with freedom of speech; the top people there didn't even see the work until it was being installed. They had complete confidence. The wonderful thing about

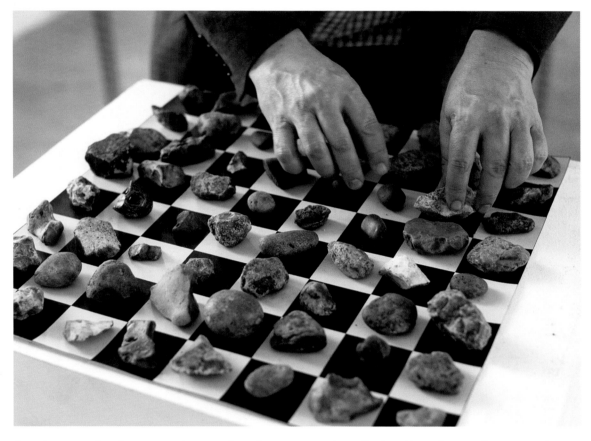

that piece was that the museum became the only place in which something that had been confiscated and denied access by the public suddenly became public again, and in a manner in which people could contemplate what Brian had to say. He was a remarkable man. It seemed to me that he was the last protester in Britain. It was kind of weird. There was a huge march against the war, and because that didn't result in policy change, it seemed like the country threw up its hands. And the new restrictions on protest around Parliament angered me.

Did winning the prize change anything for you?

It probably did a bit, but at the time I was the oldest winner, so people already knew what I was about.

How did *The Russian Linesman*, your show at the Hayward Gallery, come about?

I was approached by the South Bank. They were hosting a marvellous series of artist-curated shows. I was honoured to be asked and to be in the same company as Susan Hiller, Michael Craig-Martin and Richard Wentworth. They all did great shows; that put me on my mettle. I went back through my work and thought, Well, I seem to be preoccupied with thresholds and the liminal. So that was the

stepping-off point. Along the way there were a lot of nice bits of happenstance. For instance, I saw Monika Sosnowska's *Corridor* piece and I thought, Yeah, that's perfect. I really need an immersive work that does something bodily and physically, you know, to fit in with the other works, which are a bit more discreet. So all that was fun.

To judge from your CV, you seem to have done everything. Where do you go from here?

I'm doing a couple of dance collaborations; that's a new thing. And I'm working with Wayne McGregor and Mark-Anthony Turnage at Sadler's Wells. To be a choreographer like Wayne, to have the confidence in your own creative abilities ... you're making people do these things with their bodies every day! It's not like coming into a studio and just ... crumpling paper!

Was *Ecce Homo* on the Fourth Plinth in Trafalgar Square your first public sculpture?

Yes, it was. To be honest, when I was first approached, it was with the idea that there were going to be three proposals and the most popular one would become permanent. So *Ecce Homo* was intended to be a permanent work. But then the goalposts moved a bit.

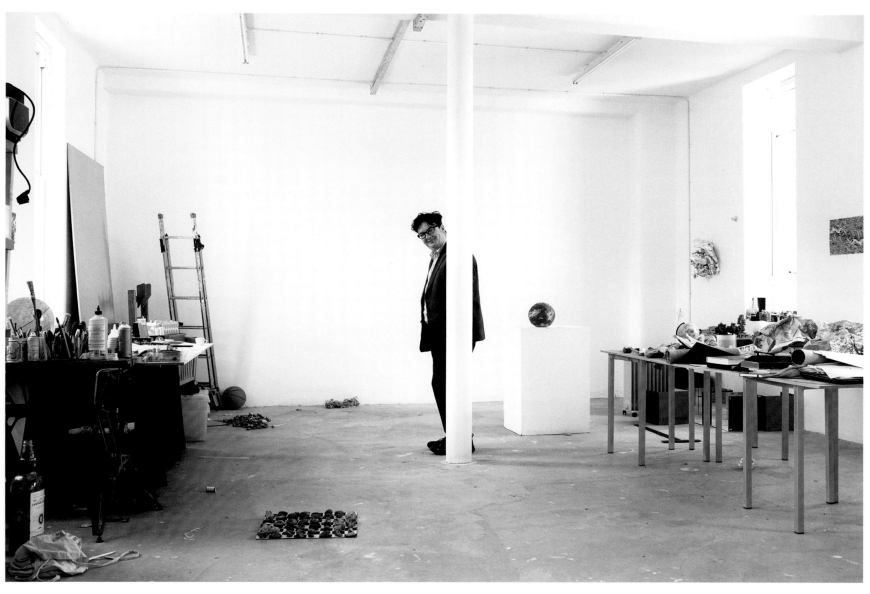

Where is it now?

It's in storage. In my head it belongs in the square. There are three other casts: one in Jerusalem, one in a collection in Italy and one in Vienna.

What about these crumpled-up maps of the world that you're playing around with now?

I quite like the idea of something that from afar might appear to have something to do with the authority of the globe or the Earth. And then you get closer …

How important is the actual making?

When I outsource things, it's generally because I want them to be an industrial object or finely honed. It's still the same idea of the artist's workshop that, in a sense, goes back to the Renaissance. But certain things I like doing, yeah. I like doing things with my hands, and the odd painting. Sometimes there are things that I just like as media, like the screwed-up mats and silver foil I have been toying with for a while now. They've not quite got anywhere …

That's interesting, because a lot of your work is so cerebral …

I always like to get there through the medium if possible. So the works always are rooted in reality.

Do you still go to Berlin? You had a studio there, didn't you?

Yeah. Quite an odd little place, really, a *Hof* at the back of a residential block. There were these turn-of-the-century purpose-built studios.

Did you learn any German?

Not much. It's a nice bubble. You can go on the S-Bahn and not get irritated by people's conversations or accosted by anything.

Mark Wallinger (previous spread) **employs a variety of media when creating his works, which are often described as both humorous and profound. The artist, shown here in his Soho, London, studio in late May 2011, is interested in what he calls the 'the politics of representation and the representation of politics'. The artist's working table** (opposite) **strewn with crumpled ideas: maps and globes, a model of a village, copies of the latest book published about him and a ruler to measure political scales, no doubt. One wonders what will come out of this soup made from the artists's imaginings?**

Pablo Bronstein

Your personality has been described as 'innately contrarian'. How would you respond to that?
I like things that happen to be unfashionable, so in that sense maybe that's right, although it's never a conscious thing.

Doesn't most contemporary art attempt to be contrary, to be shocking, in order to grab attention?
Yes. My focus is very narrow, but even within that narrow confine, you can be shocking.

You are fascinated by architecture that is often missed …
Yes. It can be missed, but it also can be desperate to be noticed. I'm a fan of the Charing Cross Station enlargement by Terry Farrell, and I love the MI5 building. They are very, very, very unfashionable buildings, but everybody knows them. One thing I like about architecture is its attempt at aspiration, its desperation. I'm not excited by good-quality, decent, sophisticated buildings. I like buildings that want to be seen as better than they are, not trying to be good design, trying to be loud design. I'm not a fan of integrity.

What new building in London attracts you?
I'm interested in the work of Caruso St John. Also I've seen the new design for Tate Britain, which I'm very excited by. I like the ornamentation, the gratuitousness of the project. Tate Modern is good at getting us to believe in its integrity and its power and its importance.

But that is post facto. When they were building the Tate Modern, people laughed at the idea.
The importance of a building like the Tate Modern is that it has a lot of accumulated knowledge. When I go to the Tate Modern, I feel at home there. I know I'm being catered to. I feel like my class, my financial status, have been taken into account. I'm being pandered to. Certain decorative tricks are employed: the high doorways, the wooden floors, the off-white walls, the remnants of industrial landscape. Lots of those things are post-'80s middle class.

Well, the art world is driven by a small group of well-heeled individuals who support this system they've started. The masses don't have an interest. It's the middle and upper classes.
One of the things that has started to happen to me in the last couple of years is that I am having to deal with the general public. I had to do this on two occasions: one was for the Metropolitan Museum of Art in New York, and the other was for the ICA in London. Both are high-volume spaces; there were going to be thousands of people walking through those shows every week. So there were certain things you could do and certain things you couldn't do. I enjoyed that aspect, but I have to say that it's a braver, more horrendous conversation to have than the small, exclusive commercial gallery where you are talking to your three friends and your five collectors. I'm excited by it, but it's a dangerous, double-edged sword.

Before architecture took your fancy, it wasn't reflected within the contemporary art world. You brought it to public notice through dance and performance. Would it have worked as art by itself?
I think so. The thing that was difficult at first was to contextualise the old-fashioned-looking drawings. There was a fear that those drawings could be misread as extremely conservative. Building up a context around them was crucial for their perception as contemporary art. The performances were a part of that.

My feeling is that if it looks too much like art then it probably isn't art. My work might seem reactionary on the surface, but in terms of how it infiltrates and relates to things, it can be complicated.

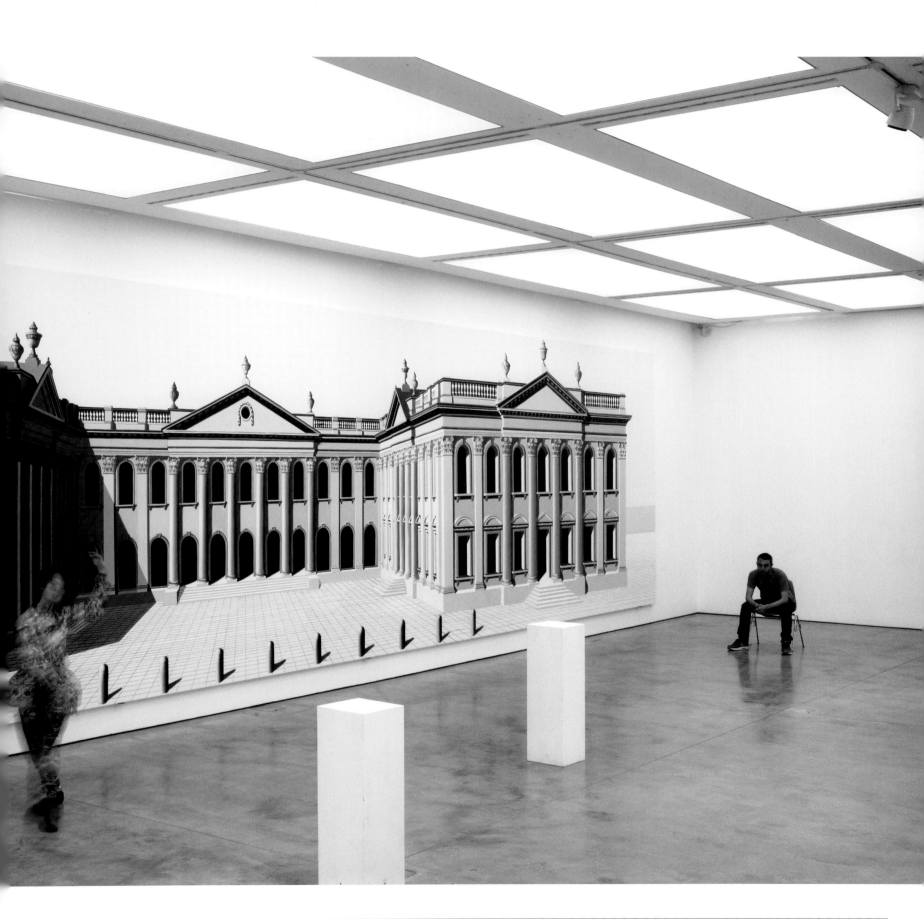

Pablo Bronstein (previous page) with performer Irene Cena in his 2011 work *Tragic Stage* at his *Sketches for Regency Living* show (ICA, London) in June 2011. The exhibition referenced the Regency period as a moment when developers began to lead the way in the field of mass construction.

Bronstein (above) descends the stairs at the ICA, which holds the sixty-six drawings comprising his *Designs for the Ornamentation of Middle Class Houses* (2011): 'One thing I like about architecture is its attempt at aspiration, its desperation. I'm not excited by good-quality, decent, sophisticated buildings. I like buildings that want to be seen as better than they are ...'

The artist (right) unpacking *Pair of Consoles* in the ICA exhibition.

So you are saying that your art is attempting not to be like art?

It is art, it behaves like art, but it doesn't often look like contemporary art.

In the architecture world, people are interested in my work. There's been a lot of press about me and I've collaborated a lot with architects who've sought me out. But the dance world couldn't give a fuck.

My work is very current. I mean, I think that my way of working is a contemporary way of working. I started working directly with Nicky Verber, my gallerist, so I never had this problem of trying to find a dealer. I never had to toe the line, and therefore I did what I wanted to do, thank God. Other artists like Spartacus Chetwynd came out at the same time in the same way. We all made pretty weird work.

What you do really has no need for a studio, does it?

No.

So you've effectively never had one.

I've always worked from home. I *loathe* studios. I think they are scams. You pay huge amounts of money to rent them and you get a horrible little concrete room with no windows. Yes, I'd love to have a huge room to wander round in, but what I actually need are tables to do my drawings on. Everything else is extra.

When did you become interested in architecture?

My parents have kept drawings of mine from when I was four or five that are similar in essence to the drawings I'm doing now: obsessive architectural drawings, castles where I would do all of the bricks, one by one by one. More than anything, I'm interested in how architecture looks on paper or in how paper can make it come alive.

I'm an immigrant; I was born in Argentina. I lived in a modern flat in Buenos Aires; then I found myself in a very old house in London. My grandmother's house in Buenos Aires was spectacular and classical and grandiose; the house we moved to in London was small and in a horrible neighbourhood. Perhaps that sense of loss ... I'm not sure ... or a sense of wanting to escape, or an aspiration to bigger things ...

What would you like to be remembered for?

How about as one of the world's greatest collectors of eighteenth-century silver? To be remembered for something totally disconnected from art would be great.

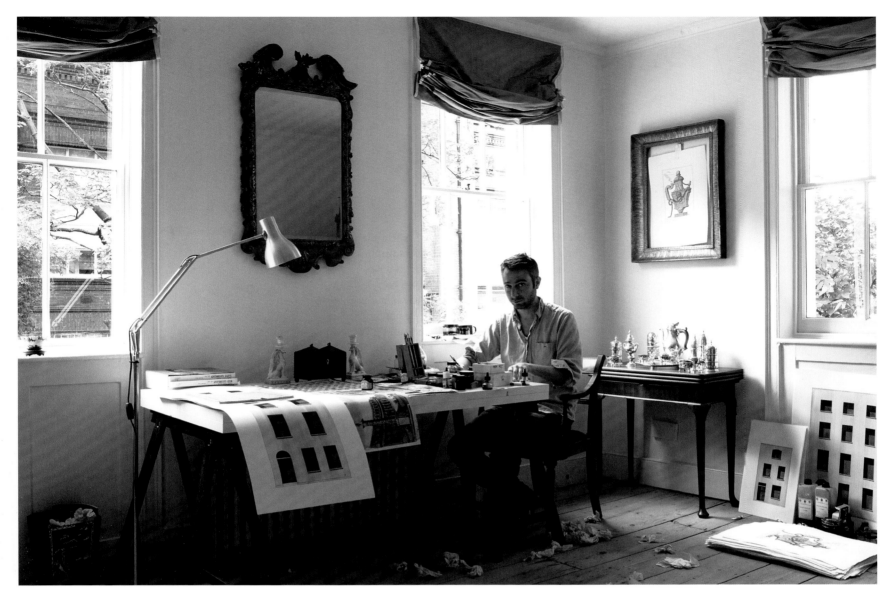

Bronstein sketches at his
Bethnal Green, London,
home in May 2011.

Grayson Perry

Does the studio change fundamentally as a consequence of becoming public? Do you feel differently about it because it's been photographed and filmed?

So many people come to my studio and take photographs, I forget how many. About fifty TV crews have been to my studio. Whenever they come, I say, 'Well, I've spent *hours* making this look like a studio for you!' When I was at college, we all had our little chipboard cubicles that we worked in. Someone came up and went, 'Oooh, you've got a meaty space!' And I thought, Yeah, I do like to have a busy space. I like the feeling that it's got a density of creativity going on.

'Meaty' has male connotations. Is it in any way relevant to consider your space in terms of masculinity or femininity?

Nah! It's a bloke's shed. But the shed, in some ways, is a kind of cockpit. And a cockpit is like a male womb. So there is a nurturing aspect to it. It's a place from which you can journey out into the world. Even when I had my studio designed in the country (I've got two studios), there was a feeling that it was a *super-glam* shed. It's where you get on with stuff and make a mess and collapse in an armchair and listen to *The Archers*.

Do you 'act out' in the studio? Is it a place where you can experiment with being somebody else?

Nooo! It's me! It's where I'm most un-acted-out, where I'm most 'authentic', to use a horrific word. It's where I have to strip myself down and ask myself what I want to do. That's your job as an artist. The first thing you have to ask is, 'Who am I?' The second question is, 'Well, if I'm that person, what do I want to do?' The trickiest bit is always that initial commitment. It's lovely when it's like a fuzzy golden thing. The minute you say, 'Right, now I've got to put the first mark on the piece of paper,' it starts to have an idea about what it's going to have to look like. That's an exercise in controlled disappointment. The minute you start to draw a shape on a piece of paper, it's like you're discarding all the other options.

I have a lot of anxiety about making stuff. The bigger the project, the more anxiety there is. Because you think, Am I committing all of this time and all of these resources to something that's going to be a bit shit? There's always a point where I feel like I've turned the corner. I think, Hey, it's going all right! That's when I really enjoy it. I quite often do my best work as well because I'm relaxed.

Do you have a strict routine in your studio?

Yeah. It's quite a long way from my house so when I get on my motorbike that's a transitional moment. I arrive in the studio and then I'm in studio mode. I'm a 10.00-to-5.00 person. In the country I might put in a few more hours.

What's the difference between the studio in the country and the studio in town?

I tend to do the sculptures in the country and the pots in town. In the country, it's a lot bigger in terms of ceiling height, so I can do my more ambitious things there. It's quite nice also for doing drawings in, because it's hellishly quiet.

Grayson Perry (left) lives in London with his wife, the author and psychotherapist Philippa Perry. They have one daughter, Flo.

Claire (right), Perry's alter ego, near his home in Islington, London, before a visit to Saint Martins College of Fashion. The artist, who is openly transvestite, frequently cross-dresses in public, famously having accepting the Turner Prize in 2003 as Claire.

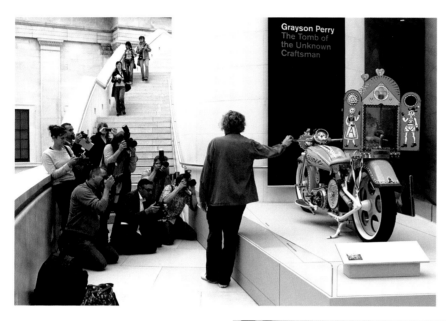

Perry (above) photographed next to his colourful motorbike by the press on the eve of his opening *The Tomb of the Unknown Craftsman*, the exhibition he organised at the British Museum, London, in 2011. The bike holds a carrier for Alan Measles, his teddy bear, surrogate father and god of his imaginary world. (In his blog, Alan Measles states, 'If I am a God of anything, I am a God of doubt.')

Is there a discernible difference in the work you produce in a rural context as against an urban context?

I wouldn't want to have just the country studio. It would be too nice looking out of the window and seeing trees and sheep and sky and all that! It's really uninspiring! If I ever feel like I need to give myself a kick up the arse, I go for a walk round the North Circular or something. Somewhere really ugly. I find that much more interesting, and ordinary. From my studio in the country I can walk straight out to the South Downs, and there's the sea, and it's all classically beautiful. That for me is always a burden.

If you're producing a work and it starts to look 'beautiful', do you always want to subvert that?

Oh yeah. *Beauty* is a strong word. I sometimes think I can hardly use it about my own work. *Pretty* I might use, because I'm English, so therefore I've got to be hypocritically modest. One of my ambitions for my old age is to make unequivocally pretty things.

I'm interested in the fact that the art world ties itself up in knots. An innocent outsider will think that we're in the making-beautiful-things business. Anybody who's had a brush with contemporary art knows full well that it's not that. I know the idea of 'beauty' is fluid. But surely we're in the business of making something that is visually appealing.

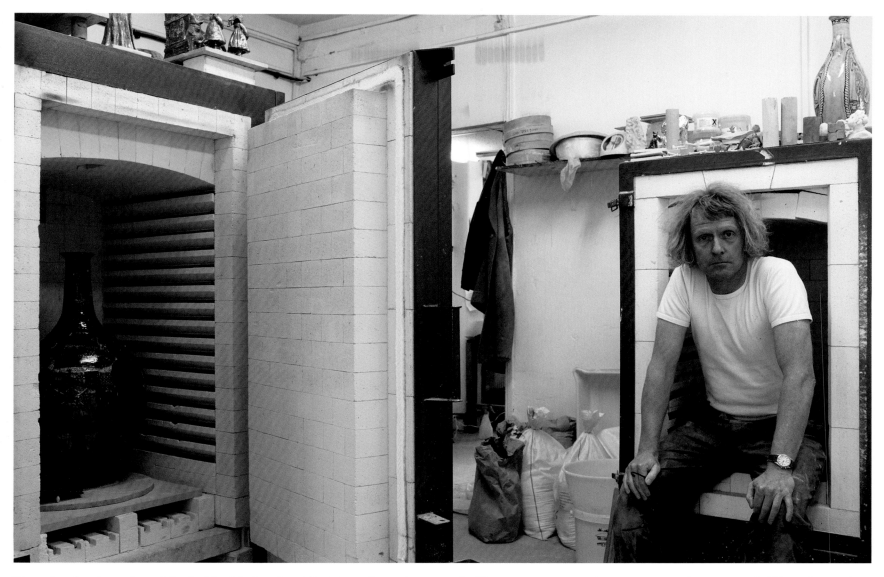

Have the visual arts been hijacked by ideology?
Yeah. A lot of art is category error. It can be politically strong, or it can be funny, or it can be shocking; that doesn't make it good art. A lot of artists think if they lean a plank against the wall of a gallery, that's somehow making a statement. Yeah, they're making a statement. A really boring and uninteresting one.

So is there a formalist deep inside you?
Totally. The problem is that people have relied on this easy process of saying 'It's art' to sidestep the idea that you might need some skill. I want to see something that I couldn't do myself.

Is your practice playing with the idea that people can make bad pottery?
Yeah! I don't hold myself up as an exemplary craftsman. I've become good at it and I'm not going to fake badness. In a way, the authenticity of my art is that it reflects my skill level. That's one of the reasons that I have trouble sometimes with the idea of using a fabrication studio, though I have used people to help me with certain things because they've spent a lifetime becoming good at it.

Would you like to have the facility to make the most immaculate pots ever conceived, or is that not the point?
It's not. I'd love to be good at woodwork and metalwork. I'd love to be able to weld. I'd like to be able to sew. But I've only got one lifetime. I'm more interested in being an artist than in learning all of those crafts.

Is there always an idea that you're trying to realise, or is the process led by the medium you're using?
I always make things that look like the thing I'm referencing. So if I'm making a tapestry, it looks like a tapestry. I make pots that look like conventional pots. I make prints that look like classic prints – superficially. I'm not interested in pushing formal boundaries; I'm interested in 'borrowing the clothes' of those things in order to surround the ideas I'm dealing with.

Do you carry a notebook and write down ideas in it?
I have things I'm obsessed by. Big pots can take a couple of weeks to build, so I've got a couple of weeks to think, What's this pot going to be about? I'll be looking at books, I'll be researching things or whatever, starting to take photographs that I might use in the transfers.

Has success made your studio life easier, or does it come with a burden of expectations?
That is the big problem. I think of it as if I've got an amphitheatre in my head. You start to have an idea and it's like the orchestra is tuning up. Then the people start coming in and going, 'I wonder what he's going to do this time?' That feeling of an audience in your head can be incredibly inhibiting. Also if you're dealing with an exhibition in an important place like the British Museum, it's going to have a huge audience and publicity. You're also dealing with a big budget. So you're thinking, Whooooah! This could be a bad idea and I've just spent x thousand pounds on it!

What about Claire and the studio? (It should be noted that during this interview you are Claire ...)
Claire never goes to the studio. Making pottery is a dirty business. You don't go to the studio in a nice dress. You want to be totally relaxed. I dress up as Claire when other people are dressed up, when I go out to an opening or a party, or I might dress up for lunch.

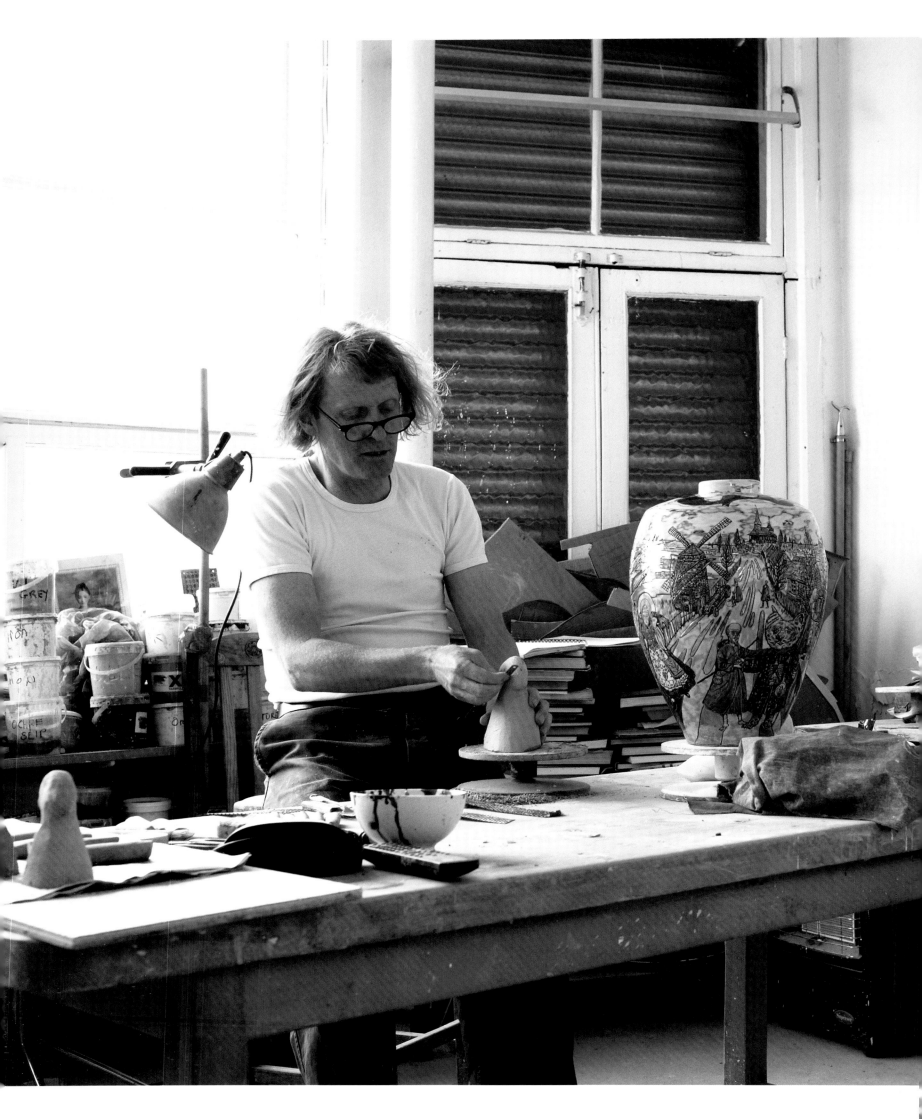

What impact does Claire have on your creative self?

In some ways, being a trannie means that I've exempted myself from the tyranny of 'cool'. One of the most uncreative forces is this social, aesthetic pressure that 'coolness' brings to things, this idea that there is a right way to do something. That can be dangerous, you know, taking the zeitgeist too seriously.

Has the art world changed significantly since you started out?

Hugely! I left college in '82, when art was modest and low-budget. Conceptual artists particularly were very low-budget. What happened is that a generation of artists took up a lot of the ideas the Conceptualists had framed. But they ran them through an ad agency with a bigger budget – literally in some cases. So you had this bigger, shinier, sexier, more shocking version of Conceptual art that was very appealing to the public. That was the big shift. The danger started to happen when it gave too much weight to people who had loads of money, who weren't part of the art tribe. There was an incremental turn of the art world's gaze: Maybe they've got a point? Maybe that is important art? I'm thinking, No, it's just big, expensive, shiny art that those people like.

So do artists perhaps set the agenda less than they have in the past?

Yes. Another force that's been operating heavily over my career has been the rise of the curator and the themed show. I get asked to be in shows, and I don't like the feeling I sometimes get that I'm just another illustration of someone's thesis. I'm thinking, I don't want to support your vanity project, Mr Curator Man. So I say no.

Do you have a sense of what you might want to have achieved in, say, ten years' time?

If you start worrying about posterity, I don't know if that's a good thing to do. An attack of hubris is a dangerous thing for an artist.

Both showman and master craftsman, Perry works in his Walthamstow studio surrounded by finished and half-finished sculptures and vases. Perry's urns are rendered with an incomprehensible craftsmanship, with textured designs worked into the clay.

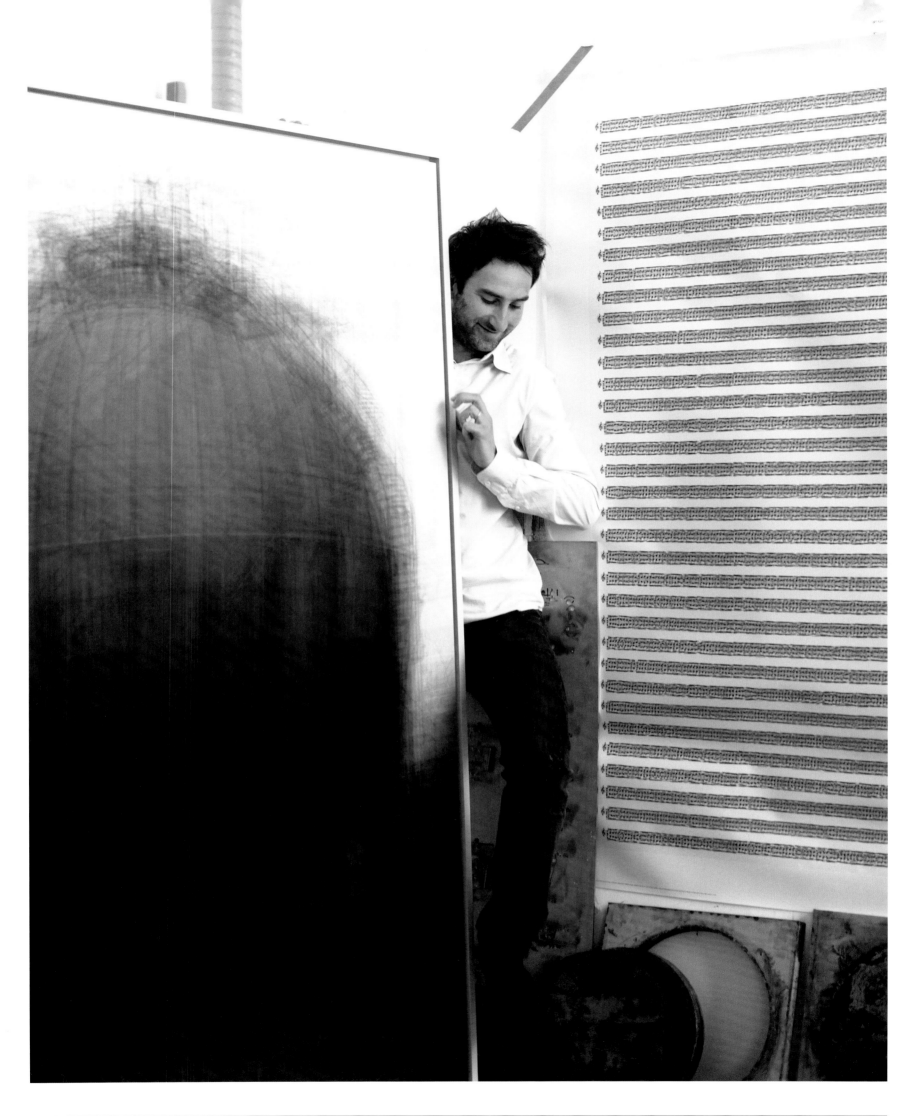

Idris Khan

Your work is almost entirely about spirituality and religion, yet you have forsaken Islam, the religion of your birth. How do you reconcile these two things?

With any religion, you're given a set of rules. There are rituals; there's daily practice. My reason for making art out of religion is to reconfigure the rules. I'm trying to understand religion not by practising it but by making art.

It's important for a viewer to see my works of art as beautiful objects. For me the *idea* is important; for the viewer it might not be. They just see a very seductive object with a religious theme. Minimal art has a spiritual feeling. It's clean; it's precise. The precision is so strong that you almost feel a tension with the piece.

You've chosen – in terms of the present day – the most explosive of religions as the focus of your practice, and your interpretation is almost schismatic. Is the artist's role that of a prophet?

In a way. Why not? I always think that I am learning about the religion I was brought up in through making my work. As a child I rejected it, as did my brothers and sister. So in a way I'm finding it more interesting now. Good and bad Islam is everywhere. As an artist you're pointing at something, and this is what I've chosen to point at right now.

In some of your works you interpret the Qur'an. Would you expect the Wahhabi or Salafi sects to listen to you? Would they not call you an apostate?

I don't think so. When I used the Qur'an to make my work, I went to Pakistan and showed it to different mullahs and to my family. They saw it as Islamic art. I'm not defacing anything. It's not sacrilegious. I made an image that held all the power of the book in a beautiful way. I was using it as source material. My name gives me a licence to make work about where I come from.

You grew up in Walsall. How did that affect you?

It's a strange suburban town with slight racial tension although I wasn't fully aware of it at the time. It has a large Muslim community of which I was a part. I had two older brothers and one younger sister, and we all went to the mosque together. We were the only white-looking kids there. I remember the first mosque I went to – I must have been seven or eight. I saw that mosque develop into what it is today: a huge place; in 1986, it was just a room in a house. My dad used to say, 'Repeat after me, repeat after me.' I followed him, doing the movements of the prayer, though I had no idea what the prayer meant. He never really taught us that. We could repeat it, we were taught to say the words, but I never knew what I was saying. The movement was what I liked: the repetition and the rhythm. Maybe there's something subconscious there and that's why I make the work that I do.

Is this how you see religion, as an absorption of one's neighbourhood?

I think I do. Absorbing patterns and rhythms, and the overlay of chanting and prayer. An artist's role is to absorb everything around them, to try and make sense of whatever world they choose to look at.

The first piece I made using repetition and overlaying images involved looking at my own old travel photographs. It was the first time I looked at my past and at the insignificance of the individual photograph and the importance of accumulation and compression of time. I then started to think about my work as a daily practice, the idea of returning to something every day, overlaying and overlaying until the original object starts to shift into my vision of art.

Which is what happens in culture, like peat in a bog that is compressed to form poisonous gases or something useful like oil …

Yeah. What comes out of that compression of time is something very beautiful. Time is nature.

Where do you find your inspiration?

Books, music and the history of art. Even though I studied photography, I've always loved painters much more. Rothko, Pollock, Frank Stella, Cy Twombly, and sculptors like Carl Andre and Richard Serra are massive influences on my practice.

Recently my work has become more minimal. The painter Agnes Martin is a huge influence. She used her art as a religious and spiritual experience; she shut herself away from the world. I can't do that because I love everything around me and I need to get out and see the world. But there is one thing she said that has always stayed with me, and that is that 'music is the highest form of abstraction'. I took that notion and said, 'If I make a minimal image using musical notation, then surely I will have produced the most abstract work.'

You grew up around music …

Yes. My mother played piano. She was Welsh. She converted to Islam when my parents married. You were asking about what it was like growing up at a time of racial integration or tension. In the late '60s my parents lived through the race riots in Bristol. They dated in secret for two years.

Idris Khan (opposite) lifts one of his photographic prints, an appropriation of a photograph of gas tanks by Bernd and Hilla Becher, in his Islington, London, studio in April 2011. Revealing influences from both his pianist mother and his Muslim father, Khan digitally alters and appropriates images, religious and philosophical texts and scores. Interestingly, he says that 'there was no art at home, no art tradition in my family at all'.

There was no art at home, no art tradition in my family at all. The first museum I went to was probably the Saatchi Gallery. I was seventeen or eighteen. The *Sensation* show was my first experience with contemporary art. I actually wanted to be a runner. I'd run 80 miles a week. I was never going to be the best because there were always two others ahead of me. Annoying. After that dream ended, I asked myself, 'What am I going to do?' I wasn't that good at drawing, but art was a strong subject for me. I went on to do a foundation year, and photography took over. I suddenly found a language that provided a way to translate my ideas into an object.

Although you use a camera in your work, it has almost become superfluous …

Actually, the camera doesn't exist at all! I just scan. I go through a rhythm of scanning pages and pages and pages of music or literature. The works are becoming more constructed with strong minimal compositions. Right now the camera is completely redundant for me. I think it went when I was studying photography at the Royal College!

When I was at Derby University, I loved to make large black-and-white prints. I loved the physical act of making a large photograph in a smelly darkroom. I didn't love taking a photograph of the outside world, and essentially I didn't like the surface of a photograph. I wanted to find a way of compressing the gap between the lens and the object. The only way I could do that was with the scanner. There's no gap; it is reading the surface of an object. Photographs are about your eye, about what you're looking at in the world. I wanted it to be about my hand and the illusion of my hand.

What is the role of the studio in your work?

It's very much an ideas space. I love coming here in the morning at 10.00, leaving at 6.30 or 7.00. I'm very strict. For me the studio is about researching and reading. It becomes a space of contemplation. I don't print here; that all happens outside. I can do tests; I have research images on the wall; I scan and create all my images here. But I don't actually, physically, *make* them here. I print in London and Düsseldorf,

and I make sculptures down on the south coast in a steel foundry. It's really industrial down there, not prissy, and the people are very good at their trade. I love working within that environment.

What about film? Is that still important to you?

Yes, very much so. I love big productions. It's such a great medium to experiment with. You get so many talented people working together.

Have you ever been on the hajj?

I haven't. I'd like to go not as a pilgrim but as an observer. My piece *Seven Times*, which is made up of 144 steel boxes resembling the Kaaba, is a piece of art about what it feels like to see something in the flesh that you've been praying to your whole life. About longing to be next to this black box which has such power for billions of people.

You've said that your work 'transforms appropriation into mediation about authorship and time'. What does that mean?

There's tension when you appropriate a piece of work because images can be so iconic. My struggle with direct appropriation is that it's not about change, it's about ownership. My work is about asking when it becomes about your own hand. When does it stop looking like the original and take on a different form? At that point it takes the aura of its original into a meditative state so that the viewer can almost see a length of time unravelling in front of them.

Couldn't you be open to claims of plagiarism?

In technical terms I guess so. I've got away with it so far! I believe I have artistic licence to make the work that I do. It never looks like the original, and it embodies what the artist was trying to do but in a different way. I made a piece of work called *Nicholas Nixon's Brown Sisters* where Nicholas Nixon photographed his wife and her three sisters in the same place over thirty years. Nixon got in touch and said, 'I've seen a piece of work you did, and I don't think you should have done that.' I replied, 'I'm an artist trying to understand your work through re-photographing it.' And I asked, 'Haven't I added something

to it?' He came around to the idea, so we swapped pieces, and that was a nice thing.

Legal definitions aside, when does your artistic impression of the switch from original to originality happen?

In the making. I start off with an idea and I know it is not going to be the same as the original work that I am appropriating. I change the feel and mood of the original. It becomes mine because it's my process; what I add and what I take away from the original become important. The point at which the image in front of me stops looking like a photograph and becomes an abstract pattern or an expressionistic drawing is when I know it's mine.

Do you believe that there is ownership in art?

Definitely. You own your work. It's *your* hand.

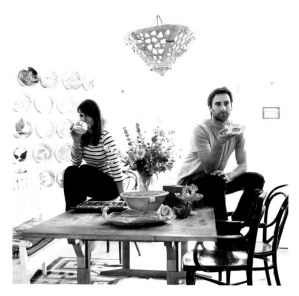

The artist leaving his gallery,
Victoria Miro, in London's
Wharf Road.

Keith Coventry

Keith Coventry in his Shoreditch, London, home, which doubles as a viewing studio. Coventry, a painter, sculptor and curator, works in series. A bronzed crack pipe from his *Crack City* series sits atop an engraved antique table. 'My work is about reflecting, looking back. I am not interested in breaking through boundaries. It is more about ideas and trying to re-empower them ...'

How important is it for you to have space in which to work?

Quite important. I've got four small spaces.

Why is that?

I have a lot of different styles of working or series I'm working on. I like to work on all of them at the same time and I can't do that in one studio. It's a practical thing, to clear the mind. I like the compartmentalisation of going to one space in the morning, working on one body of work, leaving, having some lunch, going on to the next one, working on that series of paintings, leaving, then maybe early in the evening going on to the third, so that I am constantly keeping myself interested. There is a small journey between each space. It's all within a mile and walk-able.

Is this walking an act of transition?

It is. When you come to the next thing, it is like starting afresh. The only frustrating thing about it is when you leave something that you need at the other space. So I've started doubling or trebling up on things.

Is some contemporary art about compartmentalisation, about the deconstruction of life on the street?

In order to contain your energy or interest when making art, it is important to take a slice of something and explore it. If you work without boundaries you can dissipate energy.

But isn't contemporary art about icon-busting, breaking rules, breaking through boundaries?

My work is about reflecting, looking back. I am not interested in breaking through boundaries. It is more about ideas and trying to re-empower them by fusing an art historical reference with a social issue or something that makes a connection. The reference comes alive as if it is still relevant.

Artists are meant to be slightly ahead of other people in the visual field, to be slightly prophetic. What happens in art is picked up in other areas, so in a way it can shape the image of society.

Do you believe that most contemporary art is suitable for mass consumption?

Only after it's been through a mill of designers and advertising.

You are often described as being a maverick. Is this a characteristic of most artists?

It probably is. I wasn't part of the YBA gang yet I was exhibiting at the same time.

Did you choose to be an outsider?

No. I am just much older than everybody.

Does that make you wiser?

No. It just makes me older. It just means that I didn't go to college with them.

You've been quoted as saying that the important thing for an artist is to be responsible for 'all aspects of making an object' from beginning to end.

Yeah. That's because the things that I like within modernism are the details, and it's the details that I want in my own work, the way the edges meet, for instance. If you put that out to somebody else to do, they wouldn't have the same feeling. I don't want the work to look perfect. I want it to have a cracked quality, to look home-made with a few rough edges. I try to build time into my pieces, to suggest how a work might look in, say, twenty years when it's been out in the rain for a while. I like to get that appearance when it's brand new.

How would you differentiate your oeuvre from those of the other big names in British art today?

A lot of artwork now is about aspects of how someone's mind works. So you get some surrealistic things. I am not interested in exploring my psyche. I am interested in making objects that comment, I hope in an intelligent and efficient way, on something that is happening in society.

Why do you prefer to work in series?

I like the idea of making bodies of work. The idea is bigger than any single piece, so it is possible to do more pictures before the idea is completely consumed. It's about putting it through its variations and its shapes and colours. If I did one painting for an idea I had come up with, the cost of that painting would be the forgoing of all the other possibilities of composition or size ... It could be the tenth painting down the line that is the really beautiful one. You have to make a number of paintings in order to discard some.

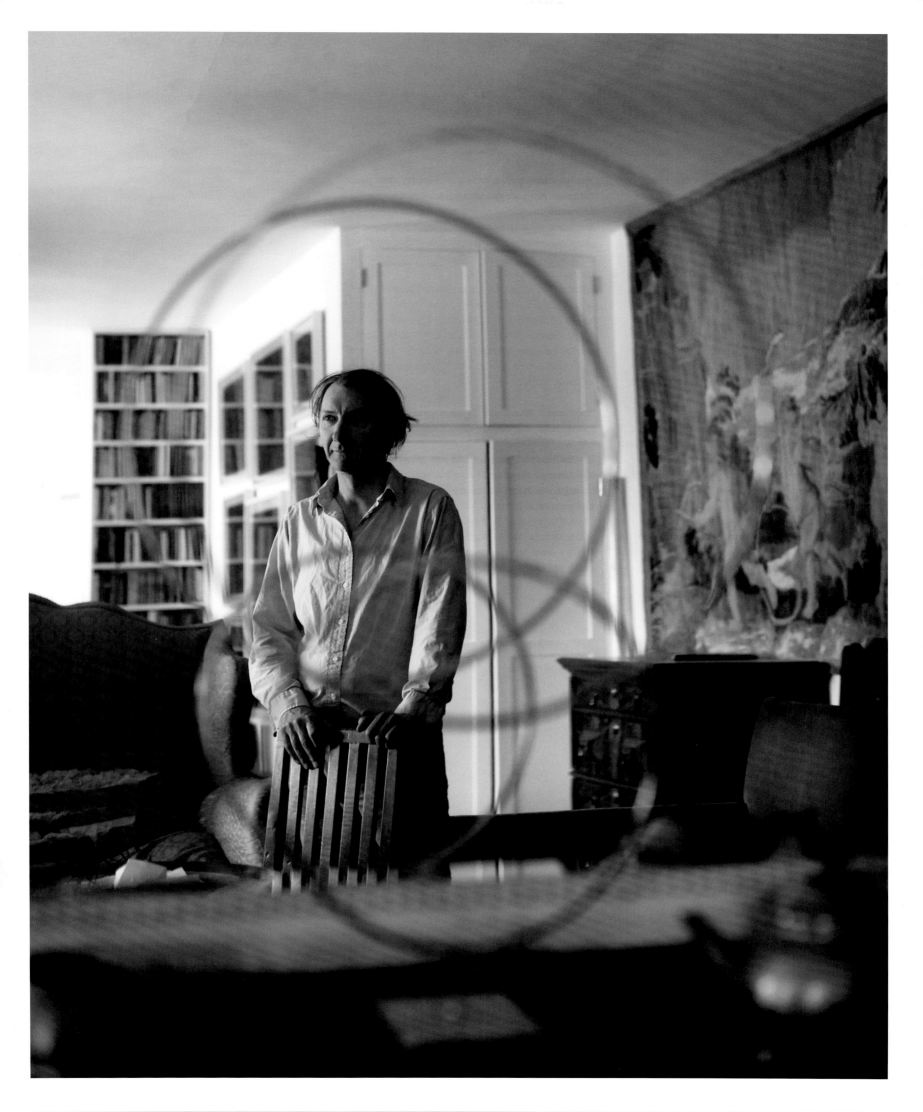

How do you know which ones are the ones?

Because they seem to work. Some ideas only seem to work when they are of a particular scale. Too big an area of colour becomes dull, but if you reduce it a bit the area might come back to life.

Do you ask for other people's opinions while you are working?

Normally, before I even pick up the paintbrush I've decided what I am doing. I build the idea in my head of how I am going to go about it, so when I am actually making a painting, *that* is what I am doing: making the painting. It's not like I wade forward thinking of how it can be developed, because I can try that with the next painting.

Going back to the question of your studios, you've been quoted as saying that you 'just rely upon yourself; materials are simple; there is no shooting schedule, weather, etc.' Does this suggest that your studios provide you with a type of sanctuary?

I don't have to rely on anyone else to produce art; I've got everything I need. I just come in and do the work. It'd be awful to have to wait a week for someone else to clear their schedules just so that I could come in and make something. I like everything to be there each day so I can get on and work. Painting is perfect for that.

You've also been quoted as saying that your 'themes are caught straight from the tabloids, or based on social observations' …

Some are tabloid things. For example, I've made paintings contrasting the exploits of football hooligans with the exploits of Greek or Roman heroes, trying to see if there was any moral difference. It's the context of things you read about, whether in the *Sun* or in the *Iliad*. For instance, after the battle between the Horatii and the Curiatii, the only survivor was one of the Horatii. When he found out that his sister was tearful because she had been betrothed to one of the Curiatii, he slew her as well. That's straight out of the tabloids, isn't it?

'Psychotic Murderer Is Hero-worshipped' …

David painted a picture of it, I think.

So the human psyche has not progressed since the time of the *Iliad*? Are we still the same even though we have so many intellectual or material gadgets at our disposal?

I heard today that half-price coach travel for pensioners is being cut because the government doesn't want to subsidise it any more. That doesn't seem like progress to me.

And the role of art is to highlight these disparities?

If it is done in a way that isn't didactic, then yes. It is not about forcing issues. You have to find a visual means to talk about them in an eloquent, concise way.

You don't strike me as being a particularly controversial figure, though.

I have no desire to be controversial. I have always been happy with the idea of being a long-life, low-watt light bulb. I've never been bothered about having a great, blinding moment of deliverance. I just want to have a long career and produce art along the way.

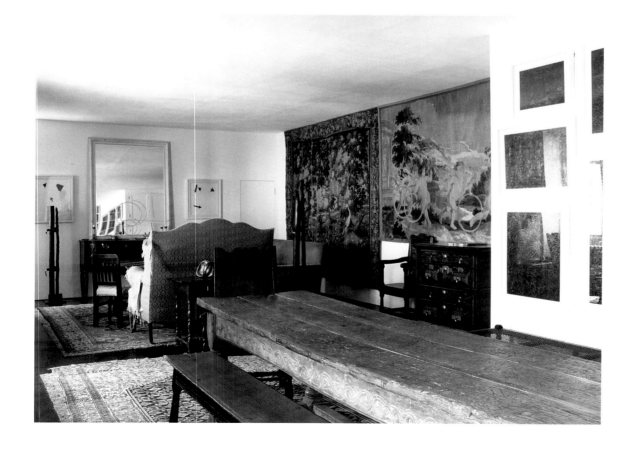

Coventry, who has a deep interest in history, collects tapestries and furniture for his home. Of his artistic aspirations, he says, 'I have no desire to be controversial. I have always been happy with the idea of being a long-life, low-watt light bulb … I just want to have a long career and produce art along the way.' The artist cycling to his other studio in Hoxton Square (opposite top) and at work.

Nicole Wermers

Why do you live and work in London?

I moved here in 1999. I did an MA at Central Saint Martins, but that wasn't why I moved here. It was because I was always an anglophile, and at that time there was a high energy level here in terms of architecture and business. Empty shops in the high streets were starting points for a lot of my work.

You chose London, not Hamburg or Berlin …

I don't like Berlin. It's a German thing not to like Berlin. For me, it is loaded with German history that I'd rather not be reminded of. Whenever I am there, I am interested for a few days and then I find it depressing. I don't like the art hype and the amount of people there; it turns it into an artsy-fartsy cultural Disneyland.

But London is such a cliché now.

I am getting too close to the whole thing where I am living. When I moved here, this wasn't what is it now. This area is being massively gentrified as we speak. I am going to Rome next year for a residency, so …

Is gentrification a killer of art and creativity?

It is always the same pattern. Artists move into a derelict, poor area and that is the kick-start for gentrification, because artists tend to want to live in urban areas with great diversity. Usually that means cities where space is limited and valuable. And then because artists are there, cafés, boutiques and artisans move in, and after a while it's Starbucks.

Can you say something about your fascination with architecture, your exploration of 'the temptations of beauty and artificiality'?

I am interested in visible and invisible structures of public space and urban space, and how they manifest themselves in materials or objects and then determine our actions and movements within a city. And the way the design and purpose of space communicate desire, power and emotion. I am interested in how those things work historically but even more in the realm of the everyday. I work mainly with sculpture, but I also do collages from fashion and architecture magazines in which I tend to work not with the featured product or model but with the background. I am more interested in the means and the structures and how all these things work.

Are the ideas that comes out of an artist's work imposed by the market?

I don't think that hype influences my work, but I am very aware of the status that art has. I wasn't aware of it when I started out, but you get the point early on in art school that it is a commodity. It is a luxury and it is used for a purpose. Aspects of my work deal with that sort of desire and how it is communicated; I suppose it touches on that 'art as a commodity' notion. I am quite materialistic in my work in that I produce objects, products. I am not a conceptual artist, but I wouldn't say that a discussion of hype comes into my work. I find it important to deal with contemporary life. That is my inspiration, and by doing it I am commenting on contemporary culture.

Do you know what the comment is going to be before you make the product?

No. It is a more organic process. A lot of my work plays with functionality and its obstruction.

How much of an artist's work is representative of other artists' work?

I am suspicious of artists who argue that their work comes entirely from within. We are so saturated with what we see, with what we have experienced, with the history of art and the visual culture that we live in, that it is completely impossible not to be influenced by all of that and to draw on it. It's important to do that, in fact.

How much of your work centres around your studio?

The collages are all done in the studio. I have a large archive of magazine pages that I work from, divided into categories according to materials and visual indicators. I do large-scale metal sculptures and they can't be fabricated here, so I work with a guy who has a workshop in Oxfordshire. I have access to another workshop in Bow which I sometimes use for larger-scale stuff.

Do you entertain fantasies about working outside of London at all?

I am happy to be going to Rome for a year, to the mother ship of urbanism. I would like to spend time in New York and Los Angeles at some point. As to fantasies, I don't know what London is going to be like in the next couple of years. I think it is going to change dramatically. Maybe it's not going to be a place I want to live in any more. There is always the option of going back to Germany, but I don't think that far ahead.

Some people claim that artists take themselves too seriously. Do you agree?

A lot of them do. Do I? I would hope that I don't, but I think that I do. We all have massive egos and are very fragile at the same time, which is a recipe for taking ourselves too seriously.

Nicole Wermers (opposite) in her Shoreditch, London, studio, in late May 2011: 'I am interested in visible and invisible structures of public space and urban space, and how they manifest themselves in materials or objects and then determine our actions and movements within a city.' Nicole, who is originally from Hamburg, has lived and worked in London since 1999.

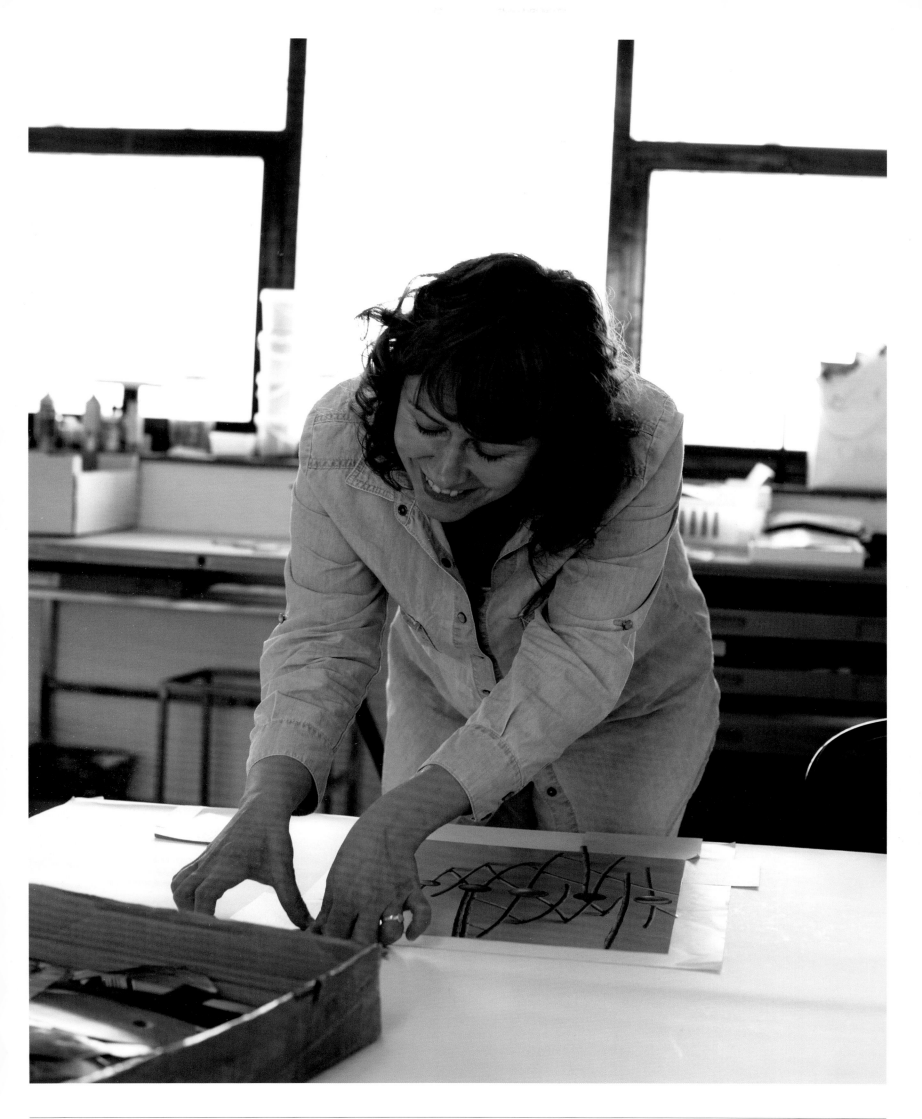

Tony Cragg

Do you ever make pieces that you simply cannot part with?

Oh yes. There are things you love and things you hate, but at the same time the work marks more or less the passage of my life. I don't think it's so much to do with nostalgia as with how much one's involved in it, and also the fact that people often ask where the ideas came from.

You've said that you park things or hide them away …

No, I don't really do that. What I meant is this: if you make new things and you try to do something that is from yourself and your experience, there will always be a lot of you in the work. There's also the risk of failure. Actually, without the risk of failure you can't make interesting art. There are degrees of failure. Sometimes it's evident that something just doesn't work, and sometimes things need a bit of reflection. Part of my activity is just to *try*, and the things I am not happy with I just rework. When things leave the studio, I feel that they're the right work.

Can you explain the role of your studio?

When I left art school in London in the '70s, I made work on my own and collected the materials for it. One of the first things I realised I needed was space. You have to be able to store things; you have to be able to make a noise; you have to make dust; you have to sit there and think. In the early '80s, when I started to do exhibitions, I was working in a performative way, developing work in installations. At the time, people said, 'You don't need to make the work yourself; somebody can make it for you. You do a drawing or a maquette, you send it off, and some brilliant Italian workman will make the work for you.' I tried to do that with the result that the work came back and I had no psychological attachment to it. I realised also that I had not learned anything. There was nothing – it was just a product. So I knew that I had to make things myself. I had a couple of assistants who taught me how to use materials. Then the space really started to vibrate!

In Wuppertal I've had four studios. This space works really well. I have a team of people who are very good at different aspects of handwork. Most of it starts with drawings. From drawings, we move on to making models and smaller sculptures and wooden things. What I try to use the studio for is what I call 'thinking with material'. To do that, you need an arena. You need a page to write on. You need a space to work in. That is what a studio is.

Where do you put yourself in the firmament of British sculptors?

I don't think about it. There was a tradition in the twentieth century of making sculpture in Britain. Maybe it had to do with Anglo-Saxon empiricist philosophy. It suited the British mentality to be engineers. Helen Chadwick's interesting, Barbara Hepworth is interesting, even Kenneth Armitage, Jacob Epstein and many others. The generation of Anthony Caro is fantastic, Phillip King too, and people like (a bit later on) Barry Flanagan and Richard Long. I never think about my own position. How can I? My position is where I am, standing in the studio.

Since the early '80s you've abandoned installation art and retired to your studio with the aim of making things. What brought about that switch?

Partly exhaustion. Running through the world for four or five years – I did thirteen exhibitions a year or something – was quite a lot of work. Also I started to realise that there was a repertoire that I used to make work and which I could develop. The profit, in terms of what I was learning, became less and less. I didn't want to become like a performing artist and go on for ever.

You've said that you don't see any significance in being British as opposed to anything else. Yet it is British art which carries the flag, or extends the brand. The Chinese look at British sculpture; so do the Japanese and the South Americans.

It would be sad if it were so. Sculpture's not about flags.

Where did your interest in sculpture originate?

I wasn't interested in sculpture to begin with. My father was an electrical engineer and designed parts of aircraft. We travelled to many places, so I went to lots of different schools. I was interested in science; my idea was to study biochemistry. I actually worked as a lowly laboratory assistant, dealing with a lot of smelly experiments. I thought that I was missing something. Then I started to draw, just for myself.

At some point somebody suggested that I go to art school. I got into an art school in the West of England and started to paint. It was a very classical course. They said, 'Next week you're going to make a sculpture.' And I went, 'Ugh! Make a sculpture? No way!' On the Monday we started to make a sculpture. I got the material out and started to work with it, and after a few hours I was really absorbed. Because everything you do with material gives you a new thought, a new emotion, sometimes new ideas. I was quite amazed.

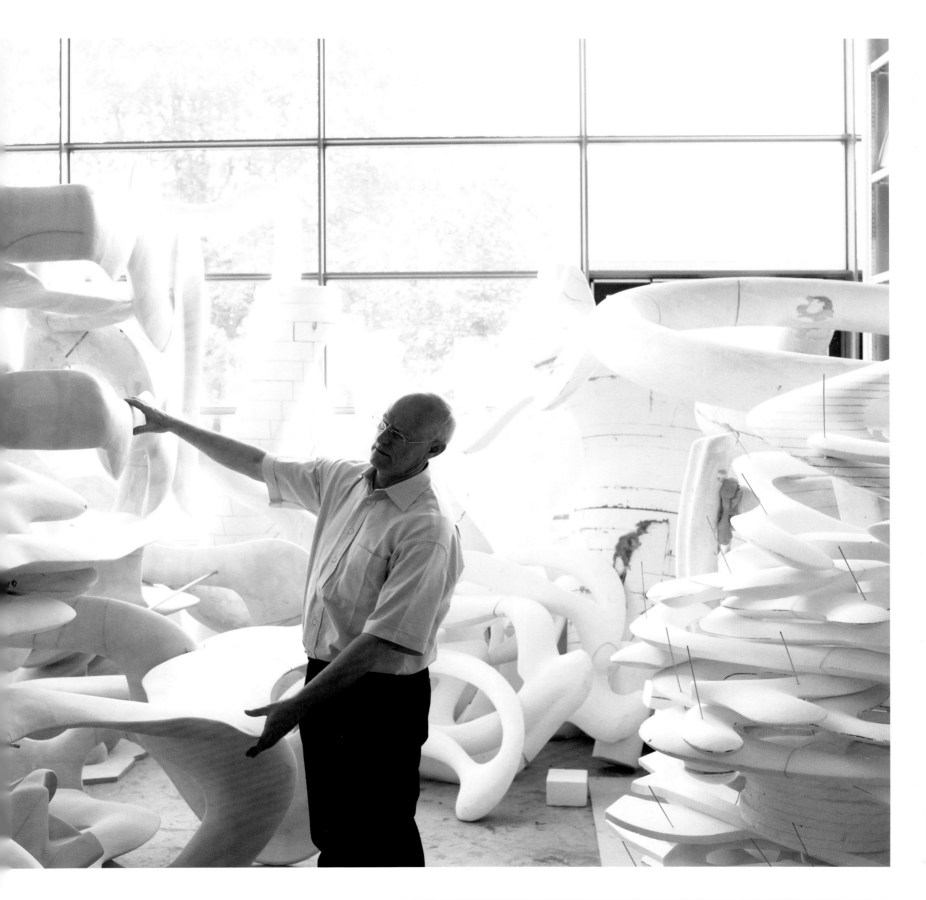

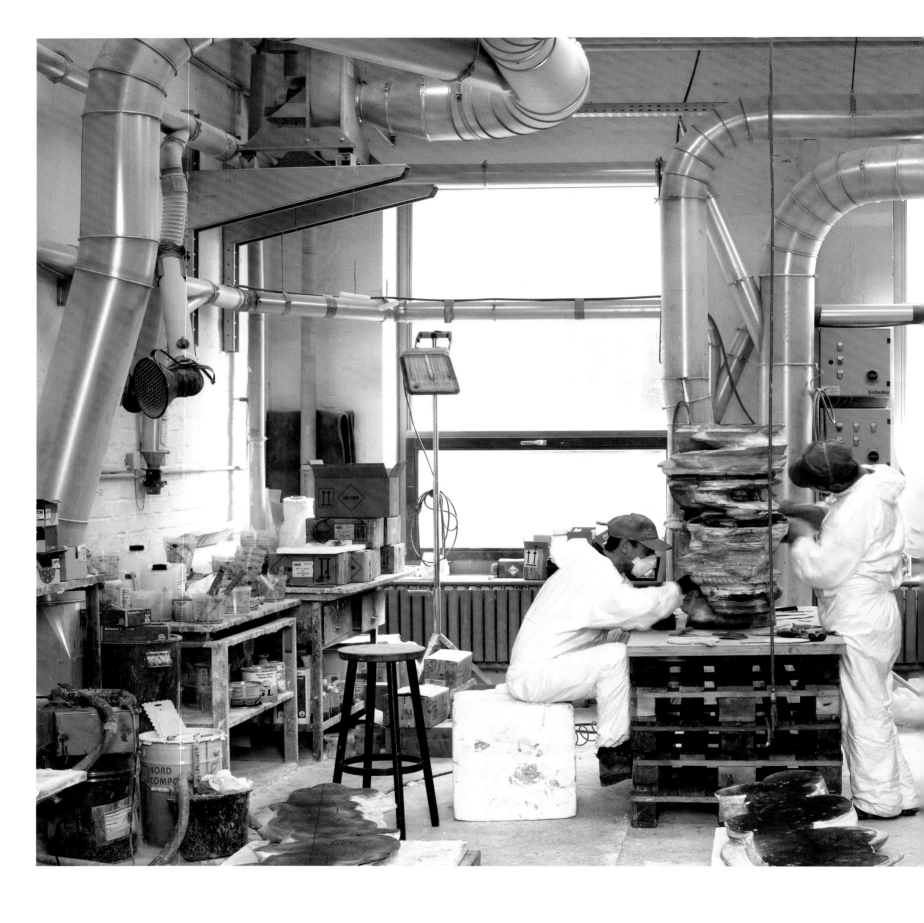

That summer I worked in a foundry, in a very physical job. I went to a different art school, in Wimbledon, and wanted to paint. But that was another false start. So I went down to the Sculpture department, and they said, 'No, no, no, no! That's not sculpture, what you're doing!' They sent me back to the Painting department. So I made a lot of work using my own body and changing materials and being an agent with the materials. Only much later, maybe by '73–4, did I think, Okay, this is getting more serious. Then I went to the Royal College of Art to study sculpture.

There's a sense of dynamism in your work. Do you think of it as invisible movement?

I never see these things as being static. Our vision relies on the light reflected off the surface of things. Form belies what's underneath that skin. So even if we're looking at the floor, we know that there's this fantastic structure of the cellulose in the wood and then something underneath. That is a preoccupation of sculpture. Even in classical sculpture, if they make an arm full of muscles in marble, they copy the bone and even the veins and, perversely, the hair. All they are doing is producing symbols on the surface of the material to show vitality, some kind of living force in the material. Because sculpture stopped being something that copied nature at the end of the nineteenth century. That's not the intention any more. Back then, all art, all sculpture, was figurative. Things changed very slowly, first of all with people like Medardo Rosso, who was trying to force your mind through the surface. Or Rodin, who modelled figures, not just their energy, with swellings and with form, but then he threw them on the ground to give them some trauma, to indicate that there's psychology behind material. All of this was about using materials as energetic states. 'Non-energetic' means dust, means lying passively on the ground, sinking into the ground, into grey, into gravity, becoming dead. Sculpture stands up in a room, has 'static' in its name. Do you know what it is to take 300 kilograms, or even 900 kilograms, of marble and stick it in the air like that? It's so fantastically a sign of life. So sculpture, away from its figurative interest, has turned into a basic study of the material world. It gives the material world value. It gives it meaning.

Tony Cragg (previous page) in his studio in Wuppertal, Germany, where he has lived and worked since 1977.

Cragg produces between three and five versions in different materials of nearly a dozen new works every year. He employs twenty full-time workers in his studio, where the lingua franca is German. Tea break and communal lunch (right), when Cragg gets to talk art and craft with his workmates.

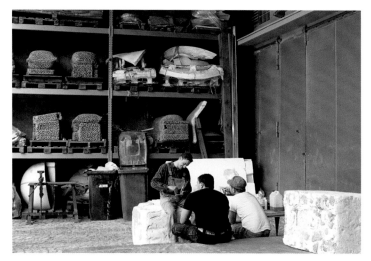

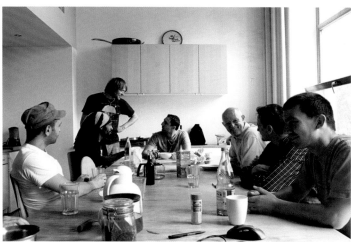

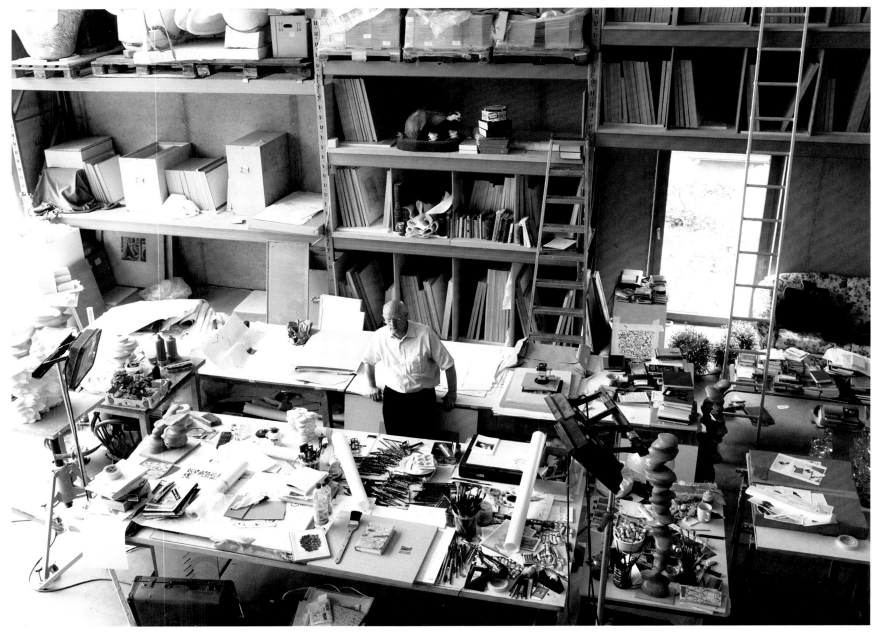

Cragg (above), shown here in his private studio, works primarily from pencil drawings.

Here Today, Gone Tomorrow in the Waldfrieden sculpture park (opposite) near the artist's studio. There are twenty of his works in the park, thirty acres of land which Cragg bought and converted for public display of art. The world's largest stand-alone, single plate-glass building at its centre acts as an exhibition centre for fellow artists from around the world and as a film set, most recently for a feature-length dance film in 3-D made in memory of Wim Wenders called *Pina*.

Artist and god, Tony Cragg (following spread) shown in scale compared to his huge studio. From the 1920s, the space served as a garage for repairing tanks and military vehicles. Cragg employed local architect Rudolf Hoppe to renovate the structure eight years ago.

What about your choice of materials?

I don't think there are so many new materials. Again, you have to go back a hundred years. There were only ten, twenty materials for making sculpture. After Duchamp gave us the industrial object, we realised that for every material there is a range of expression that you can achieve.

Are you in any way concerned about your reputation?

Maybe I'm too simplistic about this, but I feel that my only strategy is to make artwork. To be in the studio. At the end of a drawing I'm in a different space than I was before the drawing. At the end of a sculpture I'm in a different place than I was before I started the sculpture. That's the only strategy I have. As soon as you see anything that concerns itself with other things, it is already a failure.

How important is public art to you?

It's a difficult subject because ideally, what I do is made in the studio. There are two dangers with art today. One is that it becomes something that is just used for entertainment and, if you like, tourism. The other is that it becomes territorial. So you start to see people working in museums with the idea of 'filling them up' or 'making an impression'. In the end, that's not at all interesting to me. The work in the studio is the work I want to make. The minute it approaches the door, it is already potentially in a state of decay. The reason for that is that the moment it goes through the door, it is down to people to look after it. Once it leaves the studio, that is the only thing that can happen. If you start to think about the public, you're probably more or less lost.

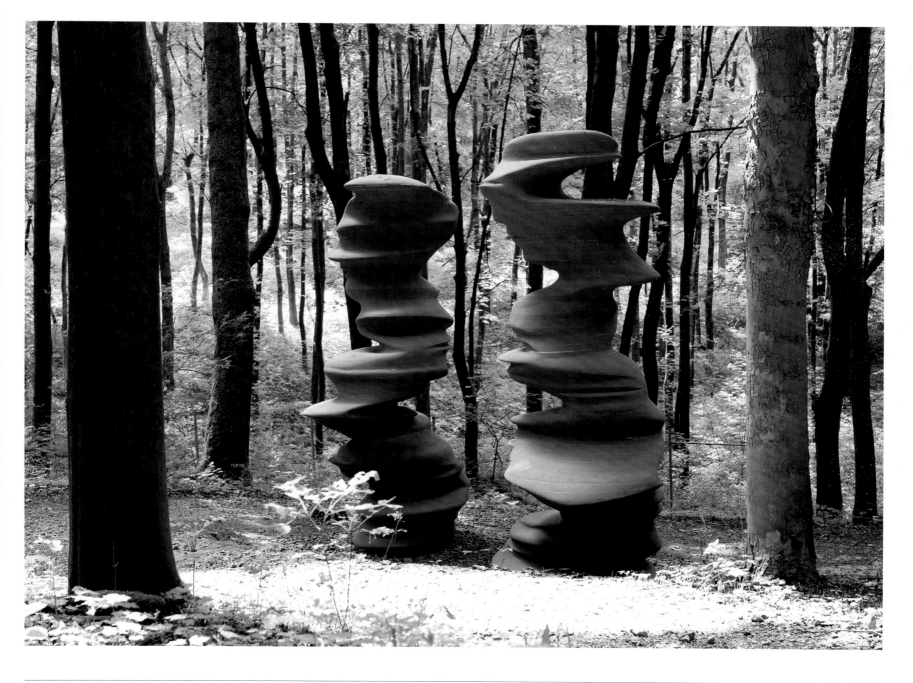

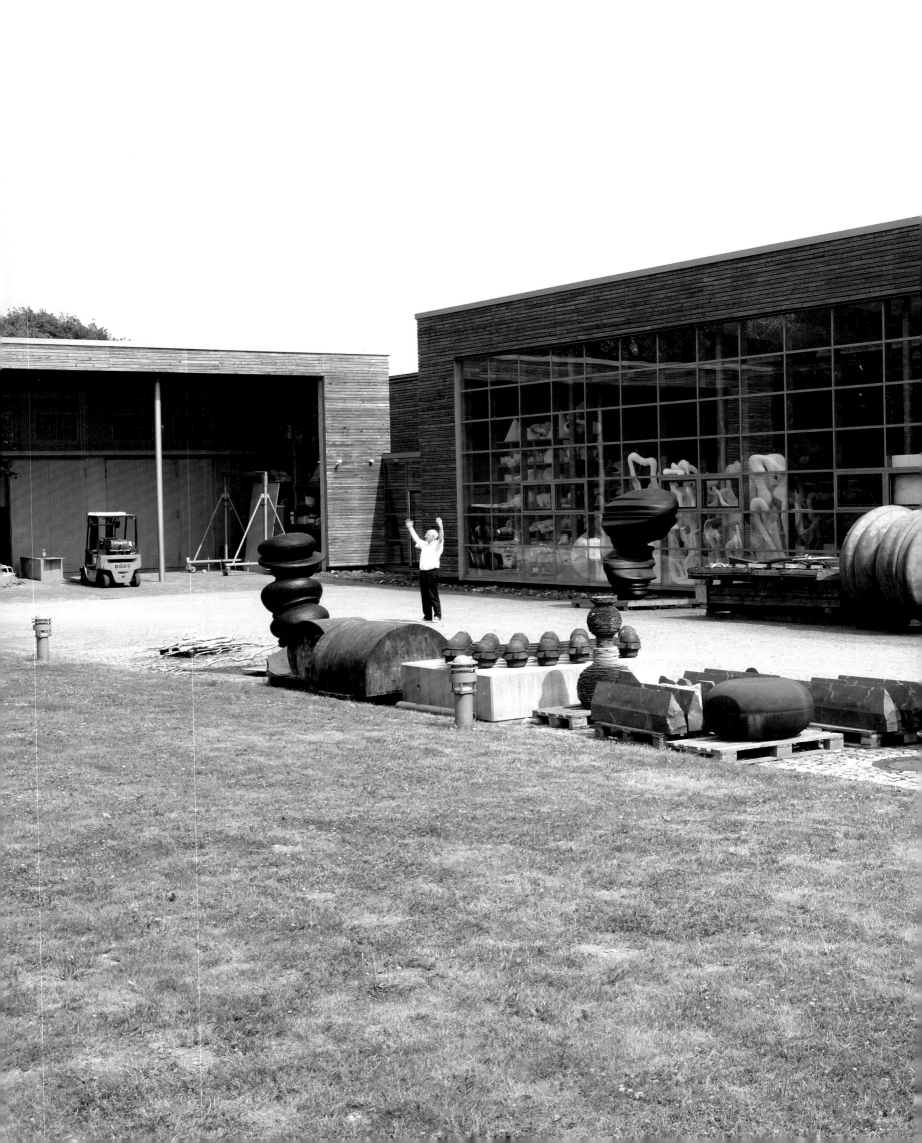

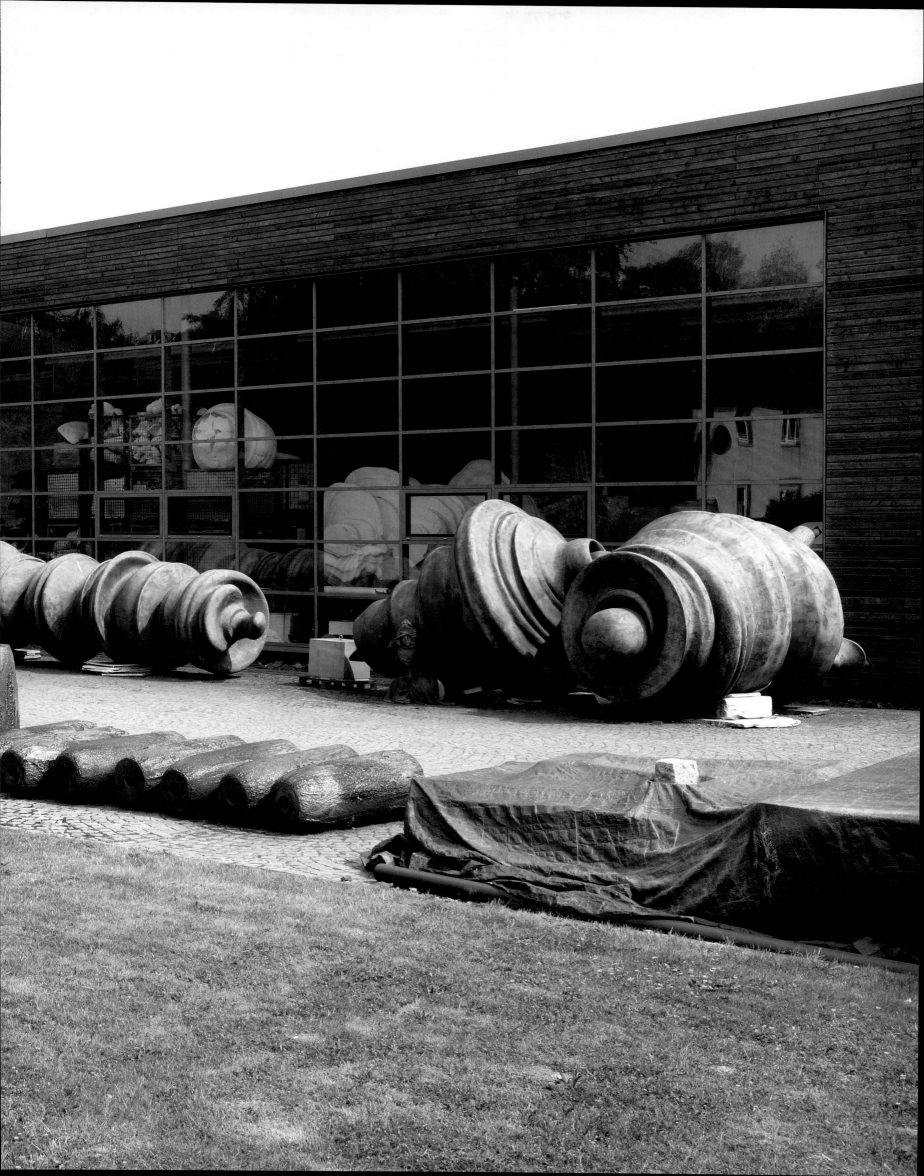

Angela Bulloch in her Berlin studio in May 2011, another British artist who has chosen the city as her preferred habitat for art.

Angela Bulloch

Why did you choose to live and work in Berlin?
I had a big public commission and a lot of other work because one of my main galleries moved here. I wanted to make some new work and there were people I could do it with. Also I'd had to move out of my studio in London because of developers.

Does the location of a studio affect an artist's work, or is it a continuation of, or a development out of, it?
There's no one answer to that question. Having a very large studio gives you a different kind of freedom, and time also. In London or Paris or New York you can't get that.

Do you remember your first studio?
It was a room at the top of my parents' house, when I was a teenager. I did a lot of painting and drawing as a teenager; I didn't make too much sculpture there.

Was the transformation from painting to sculpture a seminal moment?
I was always making things, but I didn't think of it as 'sculpture'. Yes, there was an important shift at one point. I felt like I'd got too good at painting and I was no longer interested in the illusion of it. I was more interested in concrete matters: objects, things that change, that flirt with time, also things involving music. I found a way to join up all of these things I'd been interested in, not in an illusionary way, in an actual way.

You've been quoted as saying that you 'come from the forest and … always wanted to live in the city' …
I was born in a place called Rainy River, in the middle of nowhere in Canada. I turned my bedroom cupboard into an apartment, and I watched TV shows about people in New York. I wanted to live in the sky, in a kind of high-rise. Even as a young person I wanted to live in the city. You learn a lot from the forest about how to survive. I mean literally: how to dodge bears and stuff like that.

Generally speaking, the bigger names in art usually live and work in big cities. What is it about cities?
That's where all the other people are, and where all the museums are. That's where culture 'sits'. That's where history is, too. It's also where you can work with people who can do things better than you can. It's the community of others.

What are your sources of inspiration?
Other art and life in general. Quantity counts, but it is the quality of what you observe, and your reflections, that really count. Looking at art is like breathing. It's like reading, it's like writing. When you look at art, it's an experience that feeds your knowledge. It's history.

Are you trying to evoke particular responses from your viewers?
No. I might act on my *own* feeling towards something, on how *I've* reacted to something, but I never try to imagine or tell somebody how they should feel or behave. That's not what art's about, really.

At the moment I have a solo show at the Berlinische Galerie. They gave me a prize and I made an exhibition. I worked a little with the museum collection, and with a project of mine that has been ongoing since '92. I really built a new aesthetic. I worked with the architecture; I worked with the shifting of contexts; I dealt with historical things such as a manifesto for the Novembergruppe, which is very important in terms of Berlin's history and artists being political. I had my construction and then I built different things using three different types of graphic design and concepts, and using the museum as a construct, too. I made ten giant wall paintings as well as condensed versions of each of them made in a totally different way, as prints. It was like using formats, forms and different ways of seeing the same thing.

You work with imagery from the films of Kubrick and Antonioni, among others. Is your intention to put your own mark on their work?
For a start, I work with specific quotations. But I translate this durational material into digital form, and I play this digital form in a completely different way. It doesn't look like the original at all because I've invented a structure from which to see it. Technically, I mean. That's one of the reasons I came to Berlin. I wanted to work with somebody to construct an RGB system. I made this three-colour, additive colour system into a cube, a large sculptural object; these cubes can be joined up to make a screen. I call them 'Pixel Boxes'. So yes, it's a direct quotation, but in *such* another form! *My* version has the capacity to change the scene – only once every second, so it has a totally different kind of rhythm from film, which changes at a much faster rate of twenty-four frames per second.

And you leave it to the viewer to interpret these works?
No, I shape them, extraordinarily.

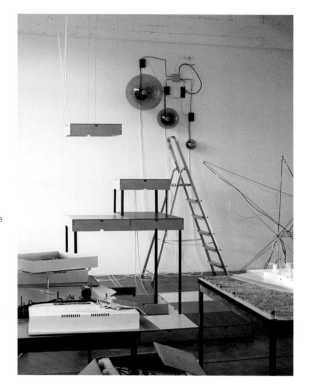

You direct the viewer's imagination?
Yes. But often they already know the script because my works are quotations from films by someone else.

So they're almost alien translations?
They are algorithmic translations.

Would you say that your audience is the general public?
I don't know. I know who I make my work for, but then there's everybody else as well. I don't know how to tell somebody what to do or look at. My work is for people to have their own freedom. I make it for a select group of imaginary or actual people with whom I discuss it. In my mind I have a conversation with certain friends, other artists, people who discuss work and care about it. There are a dozen or so of them.

Is art a popular activity or an elite one?
That's a kind of trick question. I make my work, and I think about *that*. Of course it's open for everybody to see it. In order to communicate, you have to have a feeling for the receptor. Since I'm just one person, I need to think in terms of something I can grasp myself. When the target audience gets too large, it's beyond what I can contain for myself. It's not useful to me any more to try and imagine what everybody thinks.

Interior of Bulloch's Berlin studio (above), where she uses technology to create dynamic and interactive installations. The artist (opposite) at her exhibition *Information, Manifesto, Rules and Other Leaks …* at the Berlinische Galerie. 'I might act on my own feeling towards something, on how I've reacted to something,' she avers, 'but I never try to imagine or tell somebody how they should feel or behave. That's not what art's about, really.' The *Group Rules* series, begun in 1992, consists of a continuously growing collection of rules, regulations and norms.

Do you feel elated when there is a big response to one of your works, or do you move on after you've finished it?

I'm very happy with some of the responses I have, which are extraordinary, something you can never imagine.

You've said that you're interested in systems that structure social behaviour. Is your art social archaeology, or does it exemplify the moods, sounds and colours of the city?

It's less picturesque than that, more literal. I do think about people and how they behave within the context of museums. It's a relevant question to set within the work, so that others can experience it and have a feeling of being a part of the work because they're implicated. It's like bringing in a fifth dimension.

Is there a subliminal social message in there somewhere?

No. You're imagining that I behave like a politician or something, and I don't. I'm an artist.

A lot of artists have political messages in their work.

Yes, and I am one of them, but I do it differently. I have behaved politically very often. But with the construction of the work, this is a key point: there are many people who behave just as viewers. They look at a painting and then look at the next one. And the relationship between the viewer and the art is a prescribed one. This area, this exchange, between seeing something and understanding it – or it affecting you, or you affecting it – is an area that I'm interested in.

Does it follow that contemporary artists have an extraordinary amount of power when it comes to social media? Does your work perform in that arena?

I hope so! As a general point, art has an effect on the society within which it's working. That's true of all time periods.

Speaking of power, and of influence, is there a particular person whose work has influenced you?

As a teenager I was very inspired by Bridget Riley; I went to hear her talk about her work. And there are many colleagues, people I studied with, with whom I am still in contact. I don't really want to name names.

I know that you don't like the term 'YBAs', but are there artists from that period whom you respect?

Yes, certainly. I visited Sarah Lucas in her studio just last week. She has relevance for me. I don't like the term 'YBA' because it's so out of date. It was a phenomenon funded by the British Council.

Do you see yourself going back to London?

I go back regularly.

But without equivocation you are a British artist?

Without equivocation I am a British artist who is also Canadian.

Where does art stop and technology begin?

Well, for me art is the part that I'm interested in. I usually ask someone else to help me with the more technological bits.

You're not a scientist yourself, of course.

No, I'm simply a curious person, and it's that which leads me into things I don't imagine I will get into when I'm starting out.

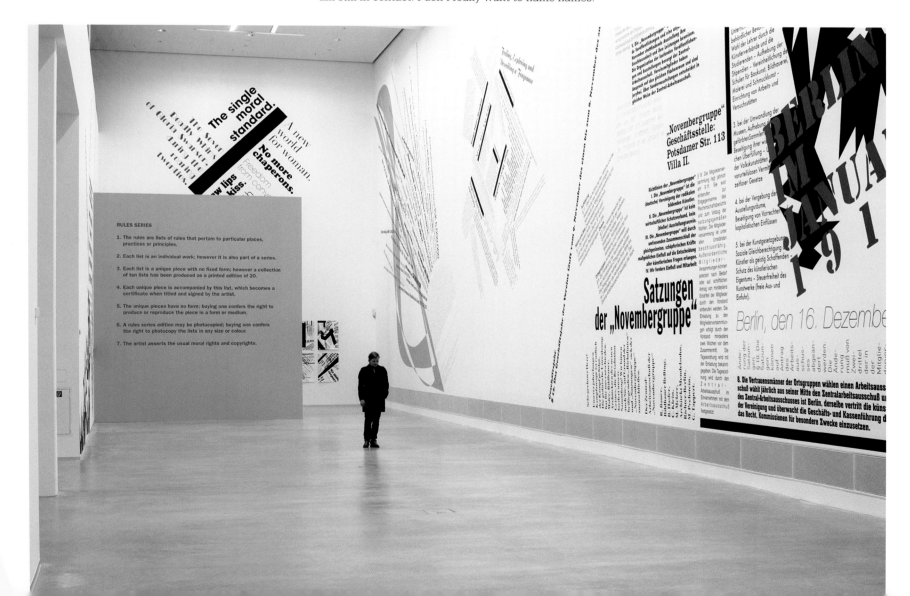

Edward Lipski

You've described yourself as an evolving artist or evolving person …

An evolving person. My art is secondary to everything. I'm not arriving or going to a place. It's a process, but it's not about arriving or a destination, because I don't know where that destination is so I can't define it. I'm driven by what I don't know. To have an objective would mean that I knew the solution or the outcome; that's why I don't provide my objective.

Is the instruction you are looking for human, i.e. sociological or psychological, or art-specific?

I can't separate the two. Art is an expression of human-ness. I try to have a view of art which isn't about one particular line of histories. I look across cultural references to the things that define human-ness in its highest form.

What is your principal influence?

It's about direct experience more than mediated experience. A lot of my imagery comes from the lowest levels of culture, from street graffiti to the most ancient wall drawings.

I take the notion of affiliation on board. If I use an African sculpture, it is because it's been colonised as an object. If I use a Chinese sculpture, it's because it's been appropriated and used in the West; it is something already outside of its own context. My parents were from disparate cultures: Paraguay on one side and Polish/Ukrainian on the other side. I was born in England. So I am always very aware of this invention of local context. That's why I mix cultural references. I use things that have already been over-defined and over-used; I start from that point. For example, African sculpture belongs within the mythology of the West from the 1920s; think of Man Ray's exhibition of African sculpture alongside Western art. With Oriental sculpture, it's the same kind of appropriation, the idea that people have Buddhas in their houses. They've moved over from one culture to another, so much so that you've forgotten what has occurred.

Would you call this 'decorative psychology'?

In a way it's a critique of the inability of imagery to remain attached to its starting point.

I find it interesting to start working with something when it somehow becomes slightly deadened; I think it's good to bring it back to life again. I want to re-animate that original experience. With the Chinese sculptures, the original use would have been for spiritual guidance, and I use them with total disregard and disrespect in a way. I'm re-describing a process that occurs when things are extracted from their original contexts. They become new things, new presences. That's what I find interesting, the idea that if you shift something very subtly, the whole narrative gets confused or changed. In a way, I am making up my own narrative in order to try to define myself continuously. Within these objects there would have existed an intention, and that intention is lost as far as I can see. Therefore I am interested in how to animate an intention that might have been lost by going in through a kind of sideways motion.

For instance, I'm interested in a type of graffiti called *pixação* in Brazil. Modernist concrete buildings are drawn upon high above eye level like a kind of pagan iconography. That enhances the architecture; it gives it a presence that is very powerful – it's renaming the building in a way that excites me. It's reclaiming it and re-owning it as well, because the kids who do it don't have *anything*; they don't have any material investment in the city, so their way of having a relationship with it is to rename it in their own language. They will never own anything, but they can live in an environment that they are part of.

Are you an archaeologist in search of an artistic narrative?

The narrative isn't going to solve anything for me. The narrative is just an entry point.

We have never not been primitives. Primitivism is imminent within us all the time. I'm interested in that aspect. Our rituals are disguised. They are the icing we use on cakes on particular occasions. The idea of celebration in general is a very primitive one.

I look for the idea that something might appear to be superficial but actually have depth like a disguise. I search in that zone for potential openings into depth. It excites me when things can shift from having the appearance of being very light to actually having gravity. I don't want only to work in the zones where you have expectations of what you are going to get.

What does your studio mean to you?

There is an aspect of the practical workshop at the back where things get cast. It's an externalisation of what's going on in my consciousness. Certainly I feel protective of it; I feel there is a distance from the kind of world that I see outside. There is safety because I'm less conscious, so more can happen. I'm not even aware. When I'm in the studio, I'm just *doing*. There is no experimenting going on. It's just doing what is needed.

Is that a painful process?

No. It's very frustrating because there are so many detours and disappointments along the way. The journey it takes to make a piece isn't necessarily one that's set up from the beginning or that ends the way I want it to. When it's going well, I'm not conscious it's going well, but when something good happens I feel brilliant. But that only lasts a moment and then you end up with the next problem. It's like being a boxer who trains for months and has one fight and is knocked out. That's why the pleasure aspect is not always clear to me.

Have you ever had a studio outside of London?

No. I'd like to, somewhere in Brazil, maybe, near a jungle. I'd like to be near very powerful nature. It's something that I need as a guide right now, activity that's not about building, not about architecture, not about culture. It's very much about fruit. There is something about genetic repetition that I find interesting. Not the seed, just the image of nature repeating itself. Something that is influencing me right now is working with the complexity within that simplicity.

I always think the thing I'm doing right then is the most exciting, the most interesting. I always have the feeling that the next thing will be even closer to where I should be. But then each time I get to that place, it falls down for something that is more, as far as I'm concerned, important. Maybe I'll never arrive. Maybe I'll die in the process.

Would you describe yourself as heretical?

To have any authenticity you have to be heretical.

Edward Lipski in his studio in Stepney Green, London, in May 2011. The artist is of Paraguayan and Polish/Ukrainian parentage. 'That's why I mix cultural references,' he says of his work.

Edward Lipski

Lipski uses found objects
and reworks their surfaces,
thus distorting their forms.
'My art is secondary to
everything. I'm not arriving
or going to a place. To have
an objective would mean
that I knew the solution or
the outcome.'

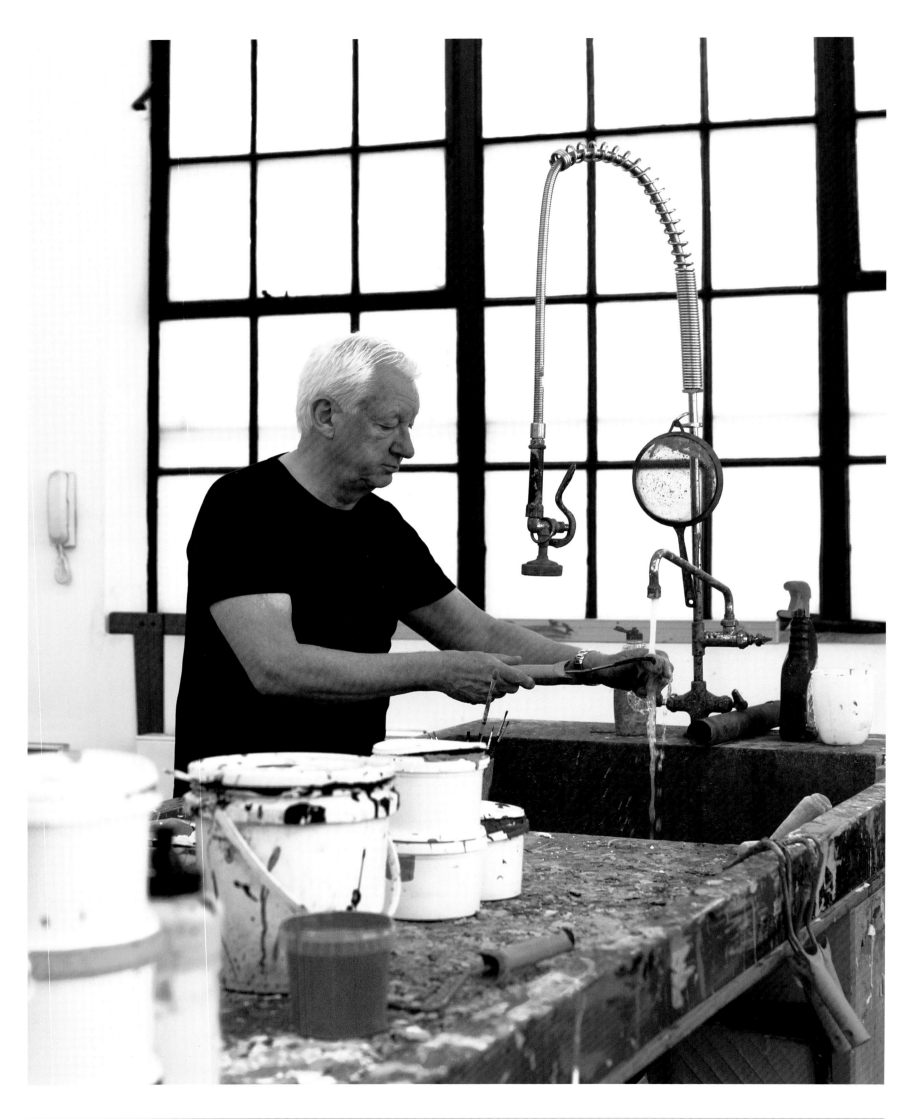

Michael Craig-Martin

How private are you as an artist?

I'm private as an artist, not private as a person. I would like my work to be known by as many people as possible, but I am not interested in celebrity. The only things that truly interest me are to do with art. When I was young I was very shy – teaching taught me to get over it. I gradually realised that I had the ability to articulate an artist's point of view better than many people. It's a risky thing to do sometimes, so I try to judge carefully when to speak. The artist is usually the silent partner in the system of the art world, often manipulated in the scheme of things. Artists almost always have a different point of view about everything to do with art than anyone else in the art world. And a much more interesting one. In the '60s and '70s the artist was in a stronger position. Now the power is very much with curators and collectors, and the things like art fairs that appeal to collectors dominate the contemporary world.

You disdain celebrity yet you are recognised as the father of the YBAs …

I think it is still possible to be well known in the art world without being in any way a celebrity. Britain has become a surprising place for the public recognition of artists; if you go to America, the only contemporary American artist anybody has ever heard of is Andy Warhol. When he died, that was the end of it. Nobody outside of the art world has heard of Jeff Koons or Richard Serra. You couldn't have a newspaper in America with their names as a headline; here it has become possible, as a small number of artists have entered the popular imagination. You can have quiz shows on television and the answer to a quiz question is 'Tracey Emin'. The general public is expected to know that the answer is 'Tracey Emin'! For someone of my generation this is a very strange phenomenon.

This kind of celebrity in England probably has to do with the unique character of the British press. Nobody else has this kind of popular press that feeds on celebrity to such a nonsensical extent.

In your opinion, is that a corrosive influence?

No more than anything else.

Michael Craig-Martin
at work in his Islington,
London, studio, in May 2011:
'I'm private as an artist, not
private as a person. I would
like my work to be known
by as many people as
possible, but I am not
interested in celebrity.'

Is your studio your sanctuary?

Yes. I absolutely love this studio. I come here six, seven days a week. I live most of my life here. I work, go out to eat and go home to bed. That's all I do at home: sleep!

I usually get here in the morning between 9.30 and 10.00. I may stay until 7.30 or 8.00. I have one principal assistant who has been with me for many years, and manages most of the things I do. He is a very good artist himself – I couldn't work with someone whose work I didn't respect. We've worked together for such a long time that he can double-think me. I could die and – as long as he didn't tell anybody – I could go on having shows of new work for years! I don't understand how some artists have ten assistants. I wouldn't know what to do with ten people! I'd be worried all the time, trying to find jobs for them to do. I work as hard as I can because I like it. The only thing that limits what gets done here is me.

This studio is essentially for making paintings; that's what we do here. I do most of my preliminary work for everything on a computer in the studio office. If it's sculpture, it's generally done elsewhere. I work with print studios, and I have someone who does all the software for my computer works. So there are people who are doing various things for me, but they are rarely 'in-house'. A lot of the people I work with, I've worked with for a long time. So we know each other well.

Does an artist have to be neurotic to gain extended insight?

I don't think I'm particularly neurotic, but I can be very obsessive and controlling. The hardest thing about being an artist that no-one ever tells you is the challenge of trying to maintain creative development over a lifetime. I've always felt that dealers are much more neurotic as a group than artists, more egomaniacal, more narcissistic, more self-absorbed, more ridiculously eccentric.

Artists seem to me to be sensible people, essentially well-grounded. If you need a shelf put up, most artists can do it. That's something I like about art. On the one hand, it's very abstract and high-minded, and on the other hand it's simple and practical and down to earth. It's not all in the head, it's in the hand. It deals with the limitations of the world, not in the perfection of things. That's very attractive to me as a picture of reality.

You were born in Ireland, you grew up in the States, and you moved to the UK in '66. Where do you feel that you belong?

To an extent it depends on where I am and who I'm with. As I came to Britain directly from art school and my whole career has been here, I think of myself as a British artist. However as my childhood and my whole education were in the US, I am aware that my cultural roots remain basically American. That I still have an American accent after more than forty-five years here always shocks me. I am surprised that, despite the fact that I never lived in Ireland, I have a very strong sense from family and history of being Irish. I like the vague comprehensiveness of the term *British*, but perhaps it might be most accurate to describe me as a Londoner.

When I came to Britain, I didn't come with the idea that I would stay. But I immediately felt at ease here, and I was treated extraordinarily generously. I'd just come from art school and yet I was immediately treated with respect as an artist by other artists here. I'd never had a gallery, I'd never had a show, I'd never done anything. Yet I was offered a job teaching in an art school. It wouldn't happen today.

It was very difficult for me in Britain for the first ten or fifteen years, because in coming here I had lost my context and it took time to establish a new one. On the other hand, having to teach provided me with grass-roots experience of being an artist in Britain. It's where I paid my dues. It was a real meeting ground of people and ideas – British art schools were excellent for about twenty or thirty years.

You also had an amazing experience at Yale, having been there at the same time as Richard Serra, Chuck Close, Brice Marden and all these amazing characters.

I was very lucky. It's at least as important to have good fellow students as it is to have good teachers.

Most of the British artists I met when I came here had disliked their education, which they thought had failed them. When they became teachers themselves, they tried to create the education they wished they had had, and they largely succeeded. My own experience had been very positive, which made me useful in certain respects because I had a model of what good art education might be. It was a golden age for art education in Britain because there was very little money in the contemporary art world, and only a handful made enough from their work. So many very good artists taught to survive. Today most artists don't teach, partly because they don't need to but also because the openness and academic freedom they knew as students are gone.

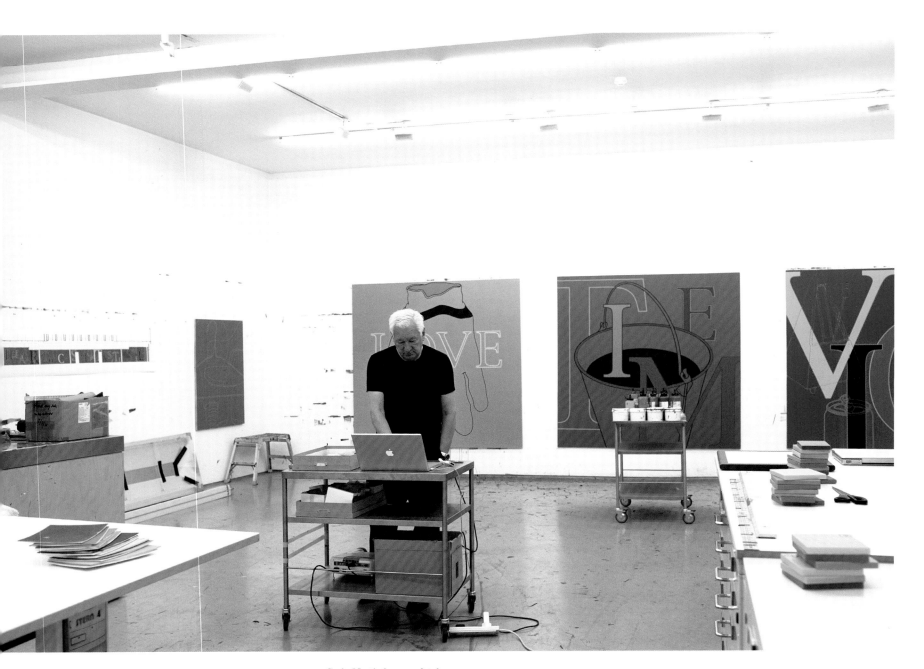

Craig-Martin keeps a database
of objects he has drawn and
uses the same twenty or so
colours in all of his paintings.
Craig-Martin is considered
one of the leading influences
on British contemporary art,
noted for his fostering of the
Young British Artists, many
of whom he taught in the
1980s at Goldsmiths, including
Damien Hirst.

(following spread) *Umbrella
(Blue)* and *Umbrella (Orange)*
at the New Art Centre,
Wiltshire, in spring 2011.

Where did the database of 200 or so everyday objects that you use as your 'vocabulary' come from?

In the late '70s I wanted to work with images of ordinary things. I thought I could find them as ready-mades, but to my surprise I found they didn't really exist. So I had to draw them myself. I did one image at a time, each on a sheet of A4 paper, and then traced them in tape on acetate. These became my templates. I certainly never expected still to be using them and still adding to my 'vocabulary' all these years later.

In a radio interview, you said that you're essentially interested in the question of what defines art …

I've always thought that the most interesting thing about art is art itself. My work is an attempt to find what is most simple, most basic in art. Children often recognise this. But I try to keep in mind something Einstein said. 'Everything should be as simple as it is, but not simpler.'

Are you more interested in making public or non-public art?

Most of my work could not be described as public. But I have always liked the idea of being able to make public works, architectural-scale things. I try to take the opportunity to make art in places not made for art, places that people use or go to for some other reason, but where the art can touch them in an unselfconscious way.

Going back to the question of what defines art, you've said, 'Making art is about making particulars. And that particular something might be the generator of a generalisation.' What does that mean?

I'm not sure what I meant. A theory is a *general* principle that can be applied to a lot of particular things. You can't have a theory about one thing. But to make 'art', you have to make a specific something. Artworks are not generalisations; each one is particular. Works of art should be thought of as 'prime objects', things whose function is to generate speculations, ideas, feelings, experiences. In that sense they are generators.

The reason why some artworks stay in the imagination of a culture through history is that they retain their ability to induce speculative play. They remain seductive but elusive.

If they were to take this studio away from you, what would you do?

Several things, all of them bad! There's a wonderful story about Picasso. Someone asked him, 'What if they put you in prison and you couldn't paint?' He said, 'I'd draw.' They said, 'What if you didn't have any paper?' He said, 'I'd draw on the walls.' They said, 'And if they took away your pencil?' He said, 'I'd draw on the walls with spit!'

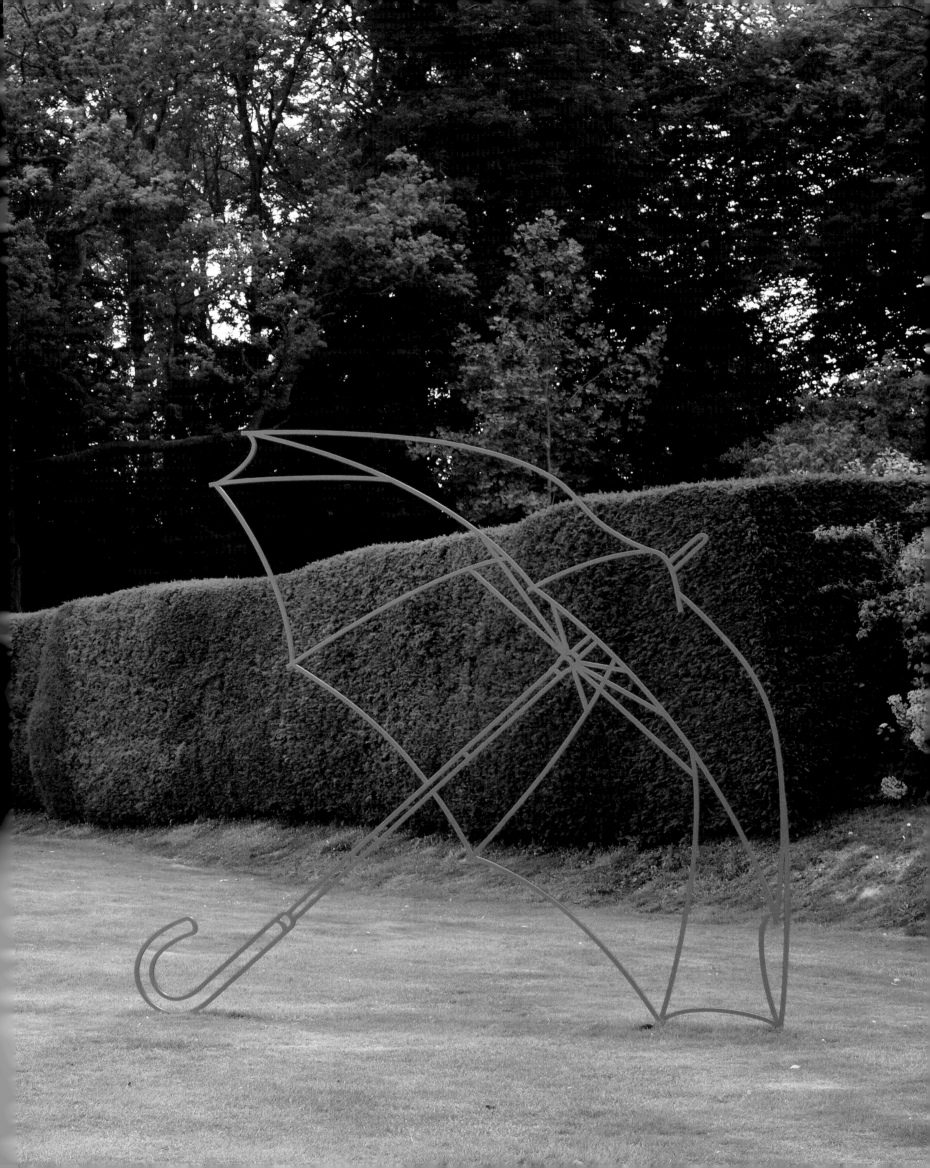

What role does the studio play in your work?

The studio is something productive for me, but not only in relation to the creation of art objects. It is divided into two parts. The top part is where I do my production meetings and my drawings and paintings. But I also have a project space, which I see as an essential part of my practice – it has a more perfor-mative element to it that involves a wider constitu-ency and public than just having a studio where you work. I have a proposal box outside. Young artists put proposals there and I select three projects a year. The studio is also a space where seminars happen and performances and film screenings. So I don't have the kind of old-fashioned studio where the artist works. This is a space for the exploration of ideas. It there-fore has a broader remit than just my needs.

Does location matter?

The location of the studio is essential. It is in the East End of London, where a lot of artists work. So artists passing by can drop in and look at the show and look at my project space, and I can get feedback from them.

There was a time when my studio was primarily in my house and mostly in my head. That wasn't out of choice; it was because I didn't have the resources to set up a studio. It's essential that the studio is separate from where I sleep, from my home. I get a fresher outlook when I come into the studio, and that is partly down to the broader context with which the studio engages.

When you reference a fresher outlook, is this about finding inspiration or rethinking certain ways of working?

It's more about seeing things again – or reconsid-ering ideas in different ways, perhaps even ones you once thought good or useful. It's rather like writing a text before going to bed and thinking it's absolutely wonderful. Then you read it in the morning and you can't believe what you've written – and that you thought what you had written was actually good. You need to maintain a distance to get perspective – my studio functions in this way to a certain degree.

Do you think of your studio as a sanctuary?

The notion of 'sanctuary' sounds a bit romantic and melancholic, and there's a kind of isolation about it. My studio is the opposite of that. There are four of us working in the studio on a full-time basis, and then other people coming and going. So my studio is very much a mini-community. A sanctuary seems a bit elitist and separatist – that wouldn't be my idea of a studio.

What are the most challenging aspects of the creative process?

I encountered a lot of challenges at the beginning of my career. For me, challenges are part of the creative process. I love problem-solving. My practice is always going in new directions. When I did my first public sculpture – *Nelson's Ship in a Bottle* – in Trafalgar Square there were serious challenges to producing a bottle that size, so experts had to be brought in to solve the problem. It took nearly a year to solve, but it was an interesting exercise. I learned ways of doing something new. I like challenges in that they enable me to resolve difficulties and to think in different ways. I also like discovery. I'm pushing my work into different media now. For example, I'm going to be doing more public sculpture. What's required in relation to putting together a production team, doing visibility studies, budgets – that's quite a challenging aspect, as is getting new commissions and managing them.

Yinka Shonibare lives and works in the East End of London, where he converted a warehouse into an artists' space: 'My studio is very much a mini-community. A sanctuary seems a bit elitist and separatist ... that wouldn't be my idea of a studio.'

So is the studio a space in which to play out the challenges you face, for example when making public sculpture commissions?

In the studio we produce virtual scenarios on the computer so we can get a sense of scale before we make the proposals. Just to give you an idea of how that aspect of the studio works: I have a produc-tion assistant who is in charge of co-ordinating the production of work and also making some things as well; she trained as a prop maker. Then there's my personal assistant, who deals with the administrative side; she also organises the project space downstairs. Then I have my studio manager. The role of the studio manager is to be the ambassador, if you like, for the studio. For all external constituencies or meetings, she is the person they approach first. She also deals with the four galleries I work with. Of course, I have overall directorial control of the studio, but I also do some drawings, collages and paintings here, so it functions on a number of levels.

So in a way, a lot of the work, despite its visuality, is pure research?

Absolutely. There is a lot of research because I tend to work in series.

Finally, how does art address the challenges that we face in the contemporary world: the uneven effects of globalisation, for example, and how it has created a new underclass?

The best thing about art is its superiority to the mundane. I don't think that the job of the artist is simply to mirror the world or, indeed, its problems. Art has to be better than the world – it has to go one better than what already exists. So the artist is constantly pushing at the boundaries of what can be seen, said and heard at a given moment in time. We are the producers of dreams, of fantasies. They are dark fantasies sometimes, but they can also inspire or 'twist' how we look at things, and why. That is the only claim I would make for art.

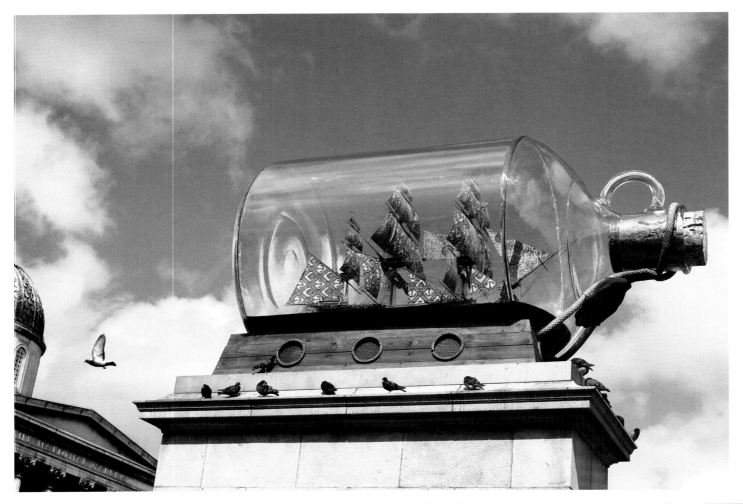

Shonibare's first public sculpture, *Ship in a Bottle*, on the Fourth Plinth of Trafalgar Square, used brightly coloured fabrics from Brixton Market. Shonibare was the first black British artist to be commissioned for the Fourth Plinth.

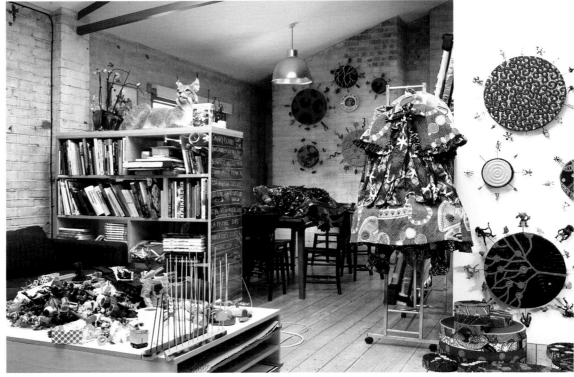

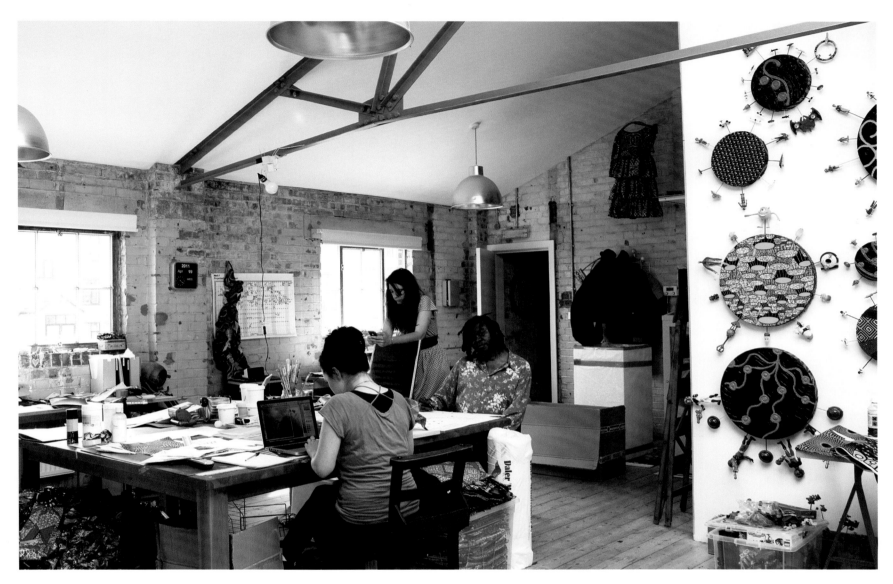

Shonibare (above) at work with his assistants, the origins of his work reflected on the studio walls. Of his engagement with the wider artistic community, he says, 'I have a proposal box outside. Young artists put proposals there and I select three projects a year.'

Tim Noble and Sue Webster

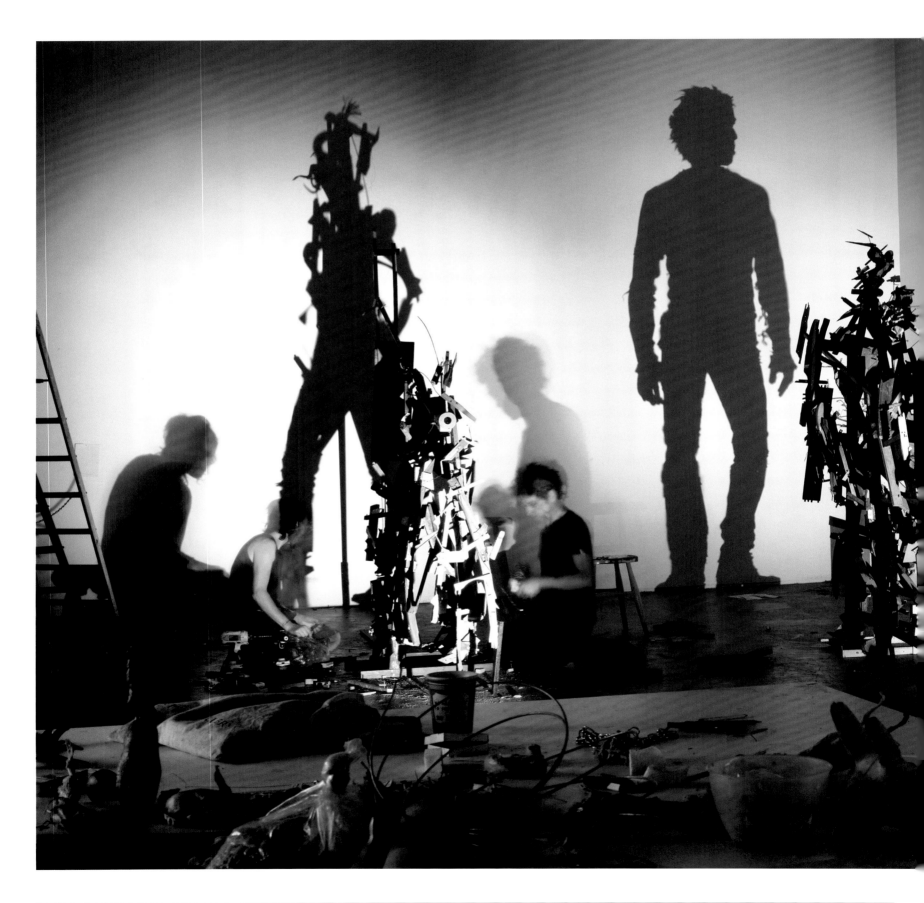

What is time?

T: It's something we're obsessed by. I haven't got a watch ... I'm sort of timeless, like Las Vegas – they haven't got any clocks on the walls inside the casinos, which are also windowless, so the gamers are never aware of what time it is, day or night. This is similar to our studio set-up. Our windows are blackened so we can work in complete darkness. It's like being trapped inside a casino.

SW: I need to live within a structure. Tim doesn't live by time at all. So we're complete opposites.

Is structure an obsession? Does art have boundaries?

S: I need boundaries. They guide me through the day.

T: You're constantly confronted by physical and mental boundaries. You can skip them, or go through them, or navigate them. You trip over them and become the carcass, or become the hunter, or you become what I am.

Everyone's got desires. If you want to deal with people, you've got to understand their desires. People put up barriers to protect themselves. We live in constant fear. If you talk to a young child, you get labelled a paedophile. If you don't have money or you live on the street, you're lawless. If you're obsessed by sex, you're a barbarian.

S: Wasn't it Freud who suggested that man created the work ethic in order to preoccupy the mind, to distract himself from his primal, animal instinct – which is thinking about sex all day?

How important is sex in your art?

S: I don't make art about sex. The art is circumstantial – it's wherever you happen to be, or whatever materials are around.

Which of the emotions inspire you?

T: The emotion between us two is sort of volatile; it makes something called passion. It's an extreme form of energy; it can be emotionally upsetting. As well, it can create a rickety bridge across the huge abyss.

So you're a tightrope act?

T: Nah, just a little rickety bridge ... This bridge is real passion; it's self-belief. Otherwise, we become static. There is a fear of wasting this moment between when you're born and when you die. You have got this muscle in your head that you can choose to stimulate to make you do things which can change the world. There's a fear that if you don't exercise it, you could sit in front of a TV and probably be happy and not be an Einstein. There are too many people, too many space-fillers; who are the ones that actually matter?

Do artists matter?

T: Absolutely. If you have music in your ears, which is art, you have a form of meditation. In a way, it's also an assault. It wakes people up by creating synapses and original ideas. It's that bridge again, talking about creating an electrical impulse that wasn't there before.

How is artistic energy utilised between you?

T: I'm very daydreamy, floaty, spiritual. Sue has very sharp structure. We stick the two things together.

S: Tim tends to wander off and create something and then I come along and give it meaning.

T: And then I'll try to mess up your idea of what that meaning is.

What is that meaning?

S: Whatever gives the work a conceptual edge, I suppose. Maybe there's a bunch of elements I can see floating around and I need to pull them in.

T: We're all molecules, aren't we? I see a lot of people I'm attracted to; I realise they want to do what I'm doing, or what Sue is doing, but they can't. But they have an extraordinary capacity to do something that I can't do. There are also people who just are sludge, who can slow you down, get in the way.

S: There are too many people in the world, and I don't have to connect with them. I'm the complete opposite of Tim; I don't like going out in case something happens. I don't want to bring outside influences into my structure to disrupt it. It's a problem, I think, because if you become quite successful, and if you venture outside these walls, you become public property. I guess I'm quite an introspective person.

But you are almost art celebrities, are you not?

S: I hate the word *celebrity*. People are labelled celebrities for doing nothing. I feel I have contributed to the world and I deserve a better title.

And the pollution you speak of from the outside ...

S: As you become more successful, those on the periphery want in and conjure up interesting 'side' projects for themselves which involve your 'product'. Then it becomes a job, doesn't it? I don't know why we live in Shoreditch any more; we should be living in some other country, or in a desert. We try to live in a bubble. This house is like a castle; it's designed in such a way that it's dark – it absorbs itself into darkness, so you don't even know it's here. You can't even find our front door.

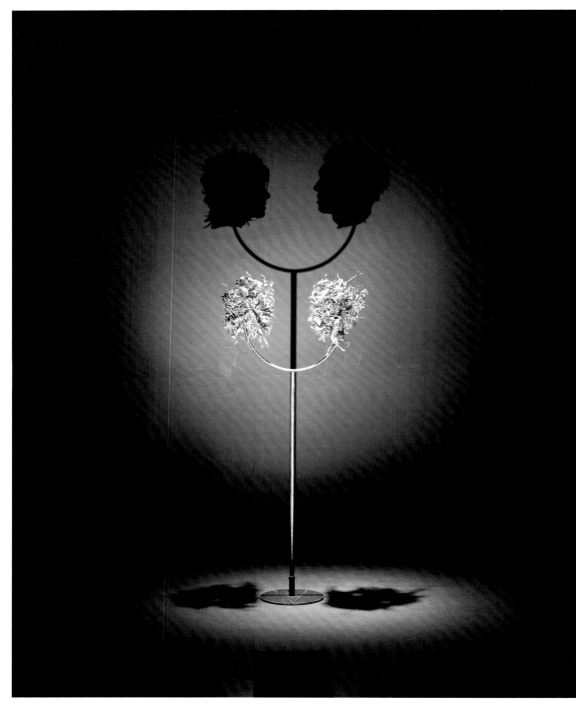

Have you spent time in Las Vegas, and is that an influence?

T: Originally we fell in love with the imagery of Vegas
on television. Especially in black and white, it had
a power and a pulsation that were mesmeric. Of
course, we had to go and check the place out. We
spent two weeks just walking up and down the Strip
... a ridiculous amount of time. There was some pink
neon coming down to the pavement ... it was so raw
and so spatially spectacular. And the noise! It was
almost like evolution. But it's all about people, isn't
it? A form of mass seduction.

Art has become sensational, hasn't it?

S: It's what the newspapers are interested in. There
wasn't a future in going to art school; now it's the
dream of every parent to push their child towards the
arts. Art's in the newspapers; it's become a proper
job; you can make loads of money, become a celebrity
... The industry around art has found a way to cash in
on it. You do it for a bit; you never signed up to be an
artist – you were just born that way. So money was
never a thing that you chased. Then a whole industry
built itself around you. That's when it all gets a bit
confusing. You have to walk away; you have to think,
Oh my God, did I just make decorations to hang in a
shop? You've got to go back to the point that inter-
ested you in the first place.

T: It got to a point where every conversation we were
having was about money. I forgot what art was, so
something had to change. Luckily things have changed
a little, haven't they? It was quite exciting for a bit. Now
people are focusing on other ways to make things.

What are the themes that concern you today?

T: We're offered colossal spaces to show in, and we're
actually creating quite intimate spaces and saying,
'Let's go over here instead.'

S: What concerns us is to see what everyone else is
doing and make the opposite move.

Is there any particular area that's taking over your life?

TN: We're known for doing shadow works and light sculptures, so one of the things is to pursue that, if it's still worth pursuing. We've made some detailed pieces with insects, and now we're looking forward to seeing what happens. You get bored – your fingers need something to do – those fiddly things that are not part of your proper routine start festering and become fertile ground. That's the basis of our studio work.

S: We collected, over a period of three years, rats and mice which we left to rot. Flies would get attracted to the smell of rotting meat and lay eggs on the rotting animals. Then maggots would come and eat the flesh. We made sculptures showing decomposition and then thought of a way of casting them so we could make multiples. It took us years of experimentation to progress to the next piece.

What is the origin of this genre?

S: One of the first times we made a work with taxidermy was called *British Wildlife*. Tim's father died ten years ago, and we went to his house to clean it out. He was an art lecturer in Cheltenham and had managed to persuade the local museum to lend him their collection of taxidermy to give to the students to draw. We realised that the specimens had never made it to the art college; he just took them out of the boxes and had them around the house. He had a golden eagle on top of the television, a vulture on the back of his armchair. We wrote to the museum and the museum didn't really want them back, because they were pre-Victorian, which meant they had arsenic in them. So we took the ones that were British and made *British Wildlife*.

On a personal level, these things don't affect your sleep, or your temper, or your mood? They're gloriously fascinating but also dark, brooding, almost frightening. Is that what you're into: drawing the fear out of people?

S: Don't look at life through rose-petalled glasses; we live among the garbage in the street.

T: Damien Hirst doesn't have a monopoly on death. There are glorious images inside your head … Death is quite playful, isn't it?

What are you trying to say through your self-portraits made out of trash and decaying animals?

S: You could be working for twenty years; one idea leads to another and you don't understand why. Then you come to do a lecture or a monograph and you're faced with images of your own work; only then do you discover a connection with it all. It's the stuff nobody is interested in, the stuff people leave in the streets, the stuff people throw away. They think there's no beauty in it. We, for some reason, see more beauty in that than in other stuff.

As children, were you drawn to shadows? Were you private kids?

T: I seemed to come awake at night. My brother had a tree house and I wanted to be underground … As a boy in the countryside, you're going to come across life-and-death scenarios. That's what I love about the great English seasonal change: you go through this miserable grey-on-grey weather, and then spring comes, and everything is breathing and attracted to flowers and colour, and babies are being born … and things are eating babies.

Do you remember the first dead thing you saw as a child?

T: I think it was my dog's stillborn puppies. She buried them behind the sofa, and in every pillow I lifted up there was straw and a dead puppy.

S: I remember the first dead person I saw: it was my grandfather … I don't know where it comes from – you're drawn to stuff. I always drew. I wasn't encouraged like parents push their kids into art school today; I just ended up here.

Does art make you happy?

S: No. I've always said that it is a burden you can't escape. You look over your shoulder and it's following you. It chose you; you didn't choose it. There's fulfilment, isn't there? I wouldn't call it happiness. You're fulfilled, then you have to move on to the next thing. You're always chasing or being chased.

Does it matter how people react to your work?

T: Of course. But I'm not a slave to a good reaction. In fact, often we've done exhibitions and been annihilated critically. I've always found that interesting.

Do you care how history thinks about you?

T: If you walked around a museum in a hundred years' time, wouldn't it be great if someone was looking at one of our pieces?

Noble and Webster use dead animals, such as rats and mice, in their sculptures. Webster (left) adding the finishing touches to a new work, while (above right) Noble sets a rat trap in their studio. Talk about found objects!

Simon Periton

Would you call yourself a political artist?

There is a political dimension to some of the work, but I wouldn't consider myself an agitprop artist. Some of my work reflects politics accidentally; it wouldn't reflect well on me if it didn't. If I am interested in making work which is as honest as I can make it, it has to reflect who I am as a person. I am interested in ideas of freedom and confinement and restraint, but that came out of quite a few years of messing around. A lot of the early work had to do with anarchy. It had political content, but it was also about absurdity and an apathetic political stance in Britain at that time. This was the end of Thatcherite rule. I was old enough to remember what it had been like before Thatcher. Those issues became interesting for me because I was teaching at various colleges and became aware that there were students who were completely apolitical. Even if they didn't necessarily believe in everything Thatcher was interested in, it struck me as odd that they weren't more agitated and involved in things.

Your work during the last decade had to do with the invasion of Iraq and terrorism …

I don't think it was about Iraq. The first anarchist pieces were about the failure of systems, if you like. There was personal history to do with being a teenager. I was interested in whether it was possible to make work that generated that kind of feeling. Actually, I thought there wasn't, which is why the anarchy side became about decorative patterning. At some point I also became interested in whether it was possible through purely decorative style and image-making to make more challenging pieces. I was using terrorist images from the late '70s partly because I remembered those events from my youth. There was a kind of absurdity in using them in the '90s. 9/11 changed the way we perceived all of that imagery. I made a piece for a show in 1998 of a Taliban guy shooting; he was actually looking up his rifle to see if it was clean. If you explain the imagery of that piece now, it means something completely different, but in 1998 it didn't have the same connotation. Equally, I made a piece that showed two Hezbollah guys reading a press release after hijacking a plane; they were wearing pillow slips on their heads with slashes for eyes. I found this image absurd. They were making violent demands and the only way they could effect any kind of anonymity was to get two pillow slips from the plane and put them on their heads! It looked like a cartoon image of what terrorism and any kind of alternative viewpoint might be.

If I think of what the work is about, there has to be something about the surface that I am penetrating but also about the screen that I am revealing or not revealing. Which is it? I don't know. It ties back in with decorative art forms, though, especially Islamic screens, which are designed to obscure viewpoints.

When did you start dabbling in art?

I don't know that I necessarily wanted to be an artist, but I knew that I wanted to make pictures. For years, I was embarrassed about telling people what I did. After I left college, I thought it was okay to say that I was an artist. I wasn't met with total laughter. Now I do it all the time.

I was a mature student by the time I went to college. I had been interested in photography and making Super 8 films. When I couldn't afford to do it any more, I thought maybe it would be a good idea to go to college, where I could get access to equipment. Some friends said, 'You should go to Saint Martins!' I remember walking in off the street one day with a shoebox of Super 8 films. I spoke to some tutor and said, 'I want to know if I can apply for a course.' They said, 'Have you made any films?' and asked if they could see them. I sat and watched them with the tutor for the best part of forty-five minutes, something which would never ever happen these days! They said, 'Yes, you should apply.'

I'd been out of school for about six years, so I went back and did A-level Art and then ended up in Foundation in Saint Martins. Suddenly I had access to printmaking, etching and sculpture, which completely changed the way I approached the film course once I went on it. About halfway through my three years, I got frustrated about being able to get anything done. Some other students said, 'Leave and join the Painting department.' I said, 'No-one is making painting! Why would I go to the Painting department?' So I went over to Photography, and they were like, 'Yeah, brilliant, at last somebody wants to work across all these boundaries!' In actual fact it was not like that at all. So I transferred – somewhat controversially at the time – and spent the last half of my degree in Painting. I've never made a painting, and my degree show was sculpture.

Anyway, at one point one of the senior lecturers, a head of department, bunked off, so suddenly they had all these hours available for tutors. They came to us as a group of students and said, 'Who do you want to come in to teach?' Half a dozen of us were vaguely interested in what was going on in contemporary art. We piped up and said, 'We've heard there's something going on at Goldsmiths. They've got some groovy tutors … can we nick some from there?' So we got Matthew Collings coming in, Fiona Rae, Stuart Morgan … Stuart curated a show in a gallery in Cork Street the week after my degree show, and I was in it. That was quite a good break.

Simon Periton uses sheets of paper up to 8 metres high in his stencilled paperworks. He is shown here at the end of May 2011 in the studio where he has worked for four years.

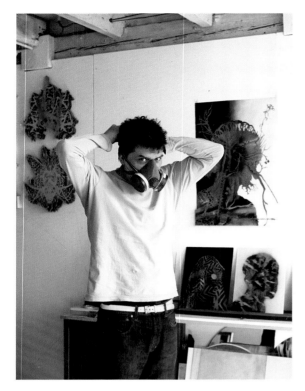

Ready for art, Periton (above) dons a gas mask to spray paint. Periton (below) outside the Camden Arts Centre, London, where he exhibited in 1999 and where he currently serves on the Board of Trustees. 'We've just been through ten or fifteen years of quite an extreme situation in the art world in England.'

You described yourself in 2009 as 'taking my scalpel for a walk down a path strewn with the detritus of contemporary life'. Does that follow from what you've just been saying?

Yeah. It's a bit of social dysfunction, a bit of high-art decoration. I made art using imagery I was interested in. It might have been an absurd, arresting image that I'd seen in a newspaper or magazine; it might have been something punk. I grew up with people not considering the popular cultural references that I was interested in as anything other than rubbish. When I was fourteen or fifteen, the idea that the Prime Minister might be into the Jam was absolutely hilarious.

What is the attraction of social phenomena for you?

I'm not necessarily interested in delinquency as such. There's a level of anarchic freedom about being a child at play that might be delinquency, I suppose. I am interested in how far those things get pushed, and where.

When you come in to the sanctuary of your studio, do you conform or do you exorcise?

I would like to say that I exorcise, but I probably conform more often than not.

You've been in your present studio for four years, haven't you?

I think it's four years. The attic I had in Brixton was an accident because I was on the list and eventually got a cheapish studio. Then the building was lost and we all traipsed somewhere else. In the end I couldn't afford to do anything else so I went with what was nearest to me.

How does it work when artists move in to a place and it becomes hip?

That's the first level of gentrification, isn't it? I can give you one example. In the early '90s, when everyone was doing their own thing in warehouses here and there, what tended to happen was that you were looking for space to put on an exhibition. You went to the local estate agents who had commercial properties and you said, 'Can we borrow your empty shop for six weeks?' The property developers were quite savvy. They realised that these kids were going to be putting on these art shows and that the people who were going to be coming to look at their stuff and perhaps buy it were potential clients for the agents' properties. That's how it happens, in a nutshell.

We've just been through ten or fifteen years of quite an extreme situation in the art world in England.

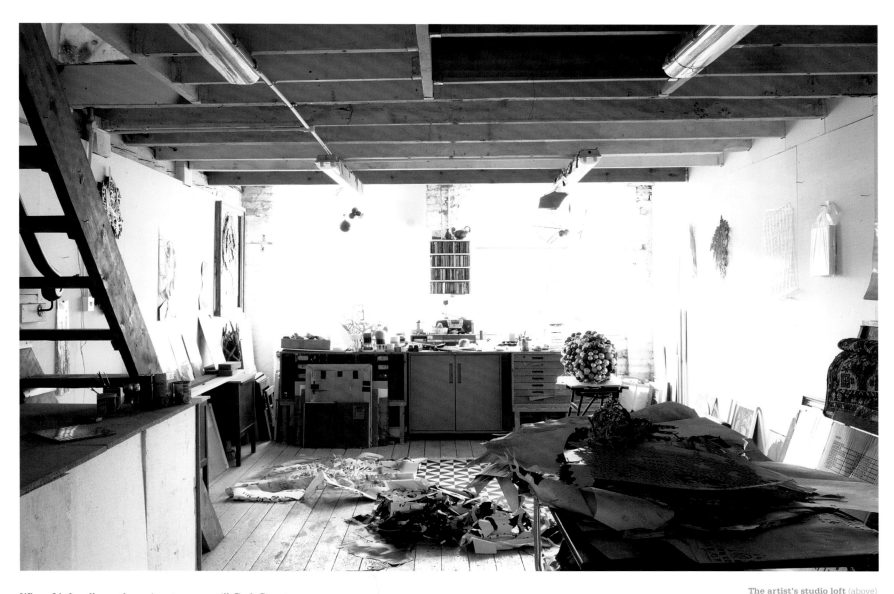

When I left college, the epicentre was still Cork Street. It was blue-chip, old-fashioned and traditional. I never expected to have a gallery; I just thought I was going to do art anyway. In those days, galleries would pay your studio rent, but no-one ever really expected to get picked up by those kinds of galleries. I don't think we ever thought we'd make any money at all. What happened then was the whole YBA thing. It challenged that status quo because suddenly all these guys were organising their own shows, bypassing the galleries and going straight to two or three collectors. That flipped everything round. The galleries were left sleeping. Then of course they started getting younger and funkier members of staff in to bridge the gap.

What's it like now?
Now you have a situation where the gallery structure has returned to how it was before. Some artists work independently, but a lot of us don't any more.

Do you regret the passing of those days?
I do in a way. There was a nice freedom about them.

Bob and Roberta Smith

You have said that you want people to laugh at your seriousness ...

I'm all for art being serious, but I'm not for art being what I would call po-faced. Art is about pleasure and enjoyment and also about politics and serious things – I think they can be combined. I don't think art should always be humorous; that would be a mistake. I don't want art to be up its own ass ... Artists can sometimes take themselves far too seriously.

Is some of contemporary art in Britain 'up its own ass'?

I think that's true. Don't get me wrong: art is saying this universal thing that is extraordinary and that unites people. Art is for everybody, and anybody can make art and enjoy that and get involved and try and change things. Artists sometimes think that their power resides in saying that art is this special thing – and it is, but it's a universal thing. That's where the 'up its own ass-ness' comes from. What makes art great is the democracy of it, not the lionisation and specialisation.

But a lot of artists on the British scene today are dictators of taste.

Dictators of their own world, aren't they! I want to participate in the world, I don't want to construct my own world in that way. I'm not interested in showing in private spaces to the right people – I want to show to everybody in public spaces. I'm not interested in saying, 'What I do is incredibly special, and you must come worship it.'

Do you think contemporary art is about expressing emotions or about building up a storm of controversy?

Most artists are quite humane people. You are right to think that all the trappings around the art world are to be avoided; sometimes it can be fun, but it's not about art. There are extraordinary artists whose work is not marketable, for instance Gustav Metzger. There are a lot of Conceptual artists; their art is not especially marketable, but they are more interesting artists in a way.

Why is that?

Because they are trying to say interesting universal things. The quality of the conversation and the openness: that's what it's about. The art world itself is a bit of a sideshow.

You've said that you could be inspired by art you don't necessarily like that much ...

Yeah. Some art you see and you immediately don't get, and maybe you understand it on a different level later on – and that's inspiring. For example, there's nothing terribly aesthetic about the work of Susan Hiller, but the whole project of Susan Hiller is very inspiring.

Do you agree that the artists who taught the YBAs are artistically more powerful than the YBAs themselves?

I think that's true. All those people made puzzling, troubled work that inspired Tracey Emin and Sarah Lucas, whom I do like. But in a way the magic of the YBAs was that they realised they could turn it into cash in a way that those artists didn't think was important or interesting – or they didn't want to. I do think that is interesting. I admire that generation of artists. I suppose they were the ones who taught me ...

All that stuff about trying to engage the public in a conversation about art ... it's complicated and you have to spend time with it to understand it. The problem sometimes with the YBAs is the shock aspect – it is all in the moment, so you see it, you get it, you understand it – when actually art can operate on lots of different levels. More interesting art, I think, operates on a more subtle level where it comes up behind you rather than hits you in the face. That's what Susan Hiller does, you know ... it's almost meditative, almost thoughtful, philosophical. And that's something we don't generally do in England – have philosophy in our lives. But actually, it's quite important to engage in these complicated things.

Is today's art too time-sensitive, too much of the moment?

I think two things about that which are slightly contradictory. One is that art is a universal thing. You can see what humanity was like in the art of the past, and that's amazing. But also, it's important to say things about what is happening now, and which may date. I've made work about current political situations, and they've disappeared and might seem dated. I don't mind embracing that. It's important for art to engage in the now and reflect what's going on at the moment.

Bob and Roberta Smith, né Patrick Brill, at his studio in Cambridge Heath in early June 2011.

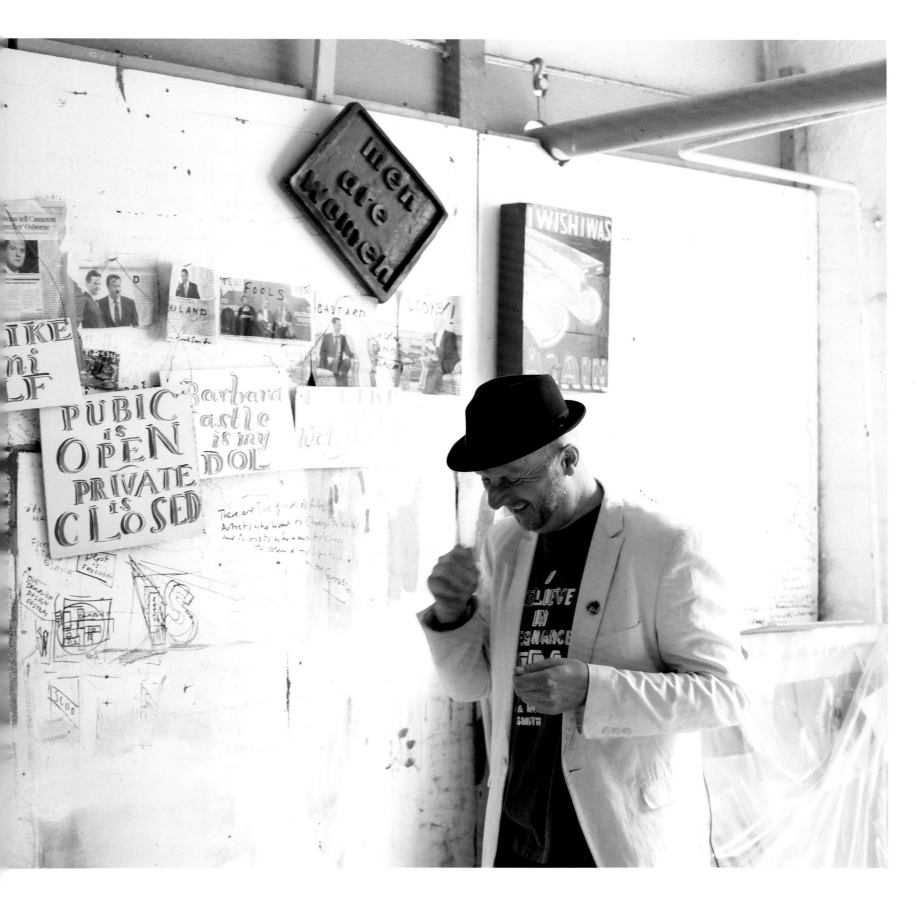

Does this time-sensitivity create a social or political context for art?

It does. I made a lot of angry work about the Labour Party during the Iraq War, and now I'm making a lot of angry work about what the Conservatives are doing to the arts. Those two things are contradictory, but I think it's important to engage in the politics of now.

You've said that all good art is political …

Yeah, that's true.

But do political artists make a difference?

I think we do. I'll tell you one thing that I think is important: creativity and making things are peaceful. Making things is peaceful. You're not going to see artists just destroying things, unless they are Gustav Metzger, of course, but the reason he does it is a critique of destruction. When you make something, you are saying, 'Look at this. I'm trying to construct something.' We human beings construct art, we construct societies, we construct hospitals, we construct roads, we make cars. You need a peaceful society for all these things to work. Although art may seem to be outside of society, that idea of making things, creating things, is part of the peaceful act.

I was in a film recently about Picasso going to Sheffield, where the British were trying to tell Harry Truman not to drop an atomic bomb on Korea. They had this peace conference in Sheffield and Picasso came to it. And he said, 'As an artist, I am for creativity. I am for life versus death. I am about art versus destruction.' That's a simple statement, but it's true. Art is about life and peace.

Does it also help let the steam out of political situations, or is it merely reflective of social tensions?

That's another issue. It's important to have a countercultural vein to your existence – that's why I'm not so mad about the YBA thing, because it is all about getting power out of mainstream culture. All the things I like about British culture are countercultural things – punk, hippies, the early '90s rave movement. It's not about being in the mainstream, and it's important that artists don't think their power resides in moving into the mainstream. They've got power. Everybody's got cultural power. So in a way it could be a safety valve, but it's more like being opposed to something. To say how society, or life generally, could be better, sometimes you have to stand outside of it. Maybe it's being a bit of a visionary …

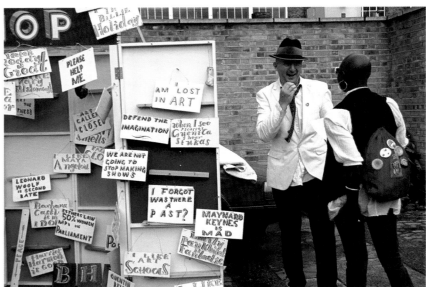

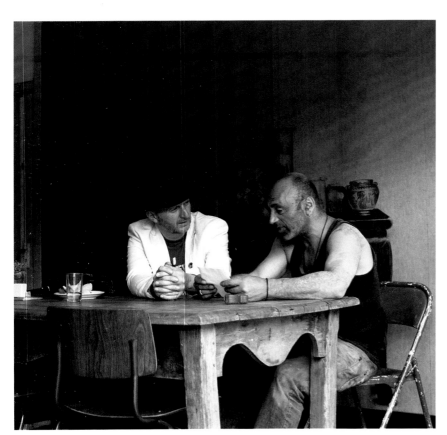

Bob and Roberta Smith (above) at the Art Car Boot Fair off Brick Lane, London, in June 2011. The artist (left) consulting with a neighbourhood friend, a mechanic who is an artist in his spare time, at a café near his studio in Bethnal Green. 'Art is for everybody, and anybody can make art and enjoy that and get involved and try and change things.'

So breaking the rules has a price?
Yes, there is a price – have you seen my studio!?

How does that work psychologically or financially?
It's not a psychological prize, because I enjoy life.
And I'm not completely broke – I'm broke but not
totally broke in a really bad way.

And you don't care about politics?
I'm passionate about politics, but I loathe political parties.

**Then doesn't everything come down to the
bottom line, which is financial?**
You do it because you're passionate about it. The fact
that I'm not wealthy doesn't make me frustrated.
Making art is a release for that in a way. It's impor-
tant to get your ideas out there.

**And it's a form of power, because you have
more power when you're not looking over your
shoulder for clients, for an audience, wondering
what your gallery may want you to do ...**
I don't do that. I don't try to make things for the art
market – although I am making little things for this
funny little street fair ... I try to make things I really
want to make. I don't do commissions.

**Going back to your studio, how has it changed
within the context of these ideas?**
The art world and the art market have their claws
into you and try to think about you in certain ways,
and sometimes things are useful to you, but the
studio is a place to be left alone. I like that. It's like a
field with a lot of weeds growing in it; it's gone fallow
with sunflowers and things. That's what I think about
it. It is a sanctuary. It's a kind place in which to turn
on the radio and think and make things.

A place of untended dreams or ideas?
That's a poetic way to put it, yeah. Of possibilities.

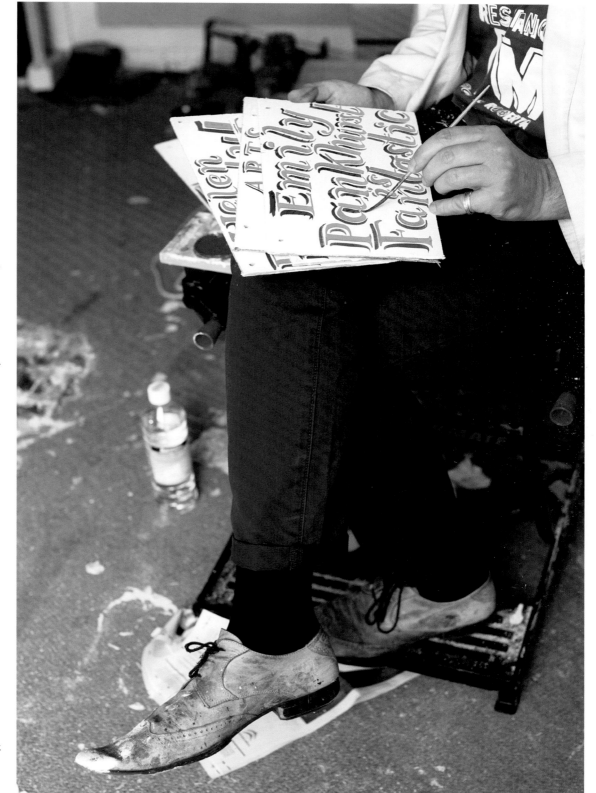

Bob and Roberta Smith paints
on gloss-primed floorboards
using a signwriter's paint
and brushes. "The quality
of the conversation and the
openness: that's what it's
about. The art world itself
is a bit of a sideshow."

Toby Ziegler

How long have you been in this studio?
Three years, I think.

Has it become very much your space?
Yeah. My last studio was probably half the size of this one. I moved here thinking it was an extravagance, and within months I was doing a show for a vast space with very high ceilings and couldn't possibly have done it in a smaller studio.

Let's talk a bit about your working method.
It varies. I work with five assistants, but they're only in three days a week. I work on the computer making three-dimensional models for my sculptures. A lot of these things start from photographs, sometimes low-resolution images of existing objects; the paintings often derive from photographs of historical paintings. I do a lot of 3-D modelling with one of my assistants. Then we start making actual models. A lot of those derive from sculptures that exist in eroded, damaged forms. Remodelling them is like trying to reinvent them. You're looking at something that's got very little information and trying to redraw it. On the one hand, it's an approximation of an existing form, but on the other hand it's sharpening something, redefining it, sometimes completely re-imagining it.

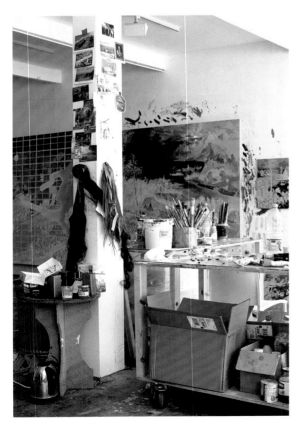

What are you working on at the moment?
I'm looking at Brueghel. It's to do with an idea of collective memory and landscape, with how an image can be a trigger. It might be an idea of an Arcadian past. Part of the interest is that I'm working from a corrupted JPEG file that I found on the Internet. I went and saw the painting in Vienna; it was a strange experience knowing this painting so well but having absolutely no sense of what the thing was as a *thing*.

You always seem to be juxtaposing computer-generated, precise, geometric repetition with something that is organic and derivative …
Not necessarily organic but historical. A lot of the sculptures derive from early primitive or Classical sculpture.

Do you actually make your sculptures together with your assistants? Is there craftsmanship involved?
Definitely. It's important that I get involved because you make mistakes and through the making serendipitous things happen. There's a strong part of the process which is sculpting but on a computer: sculpting in virtual space. Obviously I am responsible for that part. In the actual making, things go wrong, and sometimes they are fortuitous mistakes or parts of the process that are less controlled. Then things are allowed to happen.

So that chance element is important to your practice?
Yeah. It's to do with control and relinquishing control.

Are your works always installation-based?
Yeah. They exist as groups of works that talk to each other, and usually they're made with a specific space in mind.

The grid or net structure seems to be very important to you.
It prevents you from entering the pictorial space. You're aware of the fact that there is this depiction of space, but there's a grid or a layer of patterning on the surface that describes a different space and very much sits on the picture plane. It's also something where the hand is evident.

Does the net always come over towards the end?
Not always. At one point I was making models of landscapes or figures or forms and then wrapping patterning around them and using that as a drawing to start with. Sometimes I work with collages as

sketches for paintings. Again, that's using computers to create the patterns and depicted space and then ripping up bits of paper and disrupting that space. There are different sorts of sequences.

This seems to be one of your ongoing concerns: how nature comes into our lives and how landscapes are tamed …
It's more to do with concepts about being human and where those ideas are located. Collective memory doesn't exist in a painting, and it doesn't exist in an individual's mind. It exists for a crowd. A painting or a book or an object can be a trigger for it.

You did some huge models of Staffordshire porcelain dogs, didn't you?
Yeah. I worked on a few different versions. They interested me because they're kind of ubiquitous.

Was that a social commentary meant to associate a type of ornament with a particular class?
I made a show called *The Liberals*. There was a group of paintings based on Victorian pornography, and there was a giant set of Staffordshire pottery. I was interested in the narrative behind the pottery because the dogs first arrived here from China through colonialism. They gradually became anglicised and domesticated and turned into spaniels. The fact that those forms got repeated over and over again, and that sometimes the moulds would lose resolution and you would end up with something that was really just a lump, also interested me. It was barely a dog at all! But I was also intrigued by how these things exist in domestic places and get ignored. Little chotskies similar to the statues on Freud's desk. He obviously chose very specifically because those statues signify particular things. Maybe they represent a psychological or a sociological idea, but gradually they became things that just lived on his desk. And then they were just familiar. Apparently he used to walk up to them and pat them on the head.

There's something interesting, then, about what they became for the people who came into Freud's study, the fact that he almost used them as a screen. He'd sit at his desk and his patients would lie on the couch, and they couldn't see him directly, but they could look at all of these sculptures. I thought it was interesting that people would project onto these things and they would then be creating another layer of narrative, but also how the sculptures had been changed by the fact that they belonged to Sigmund Freud. A small fertility symbol in a museum is somehow very different from a fertility symbol on Freud's desk.

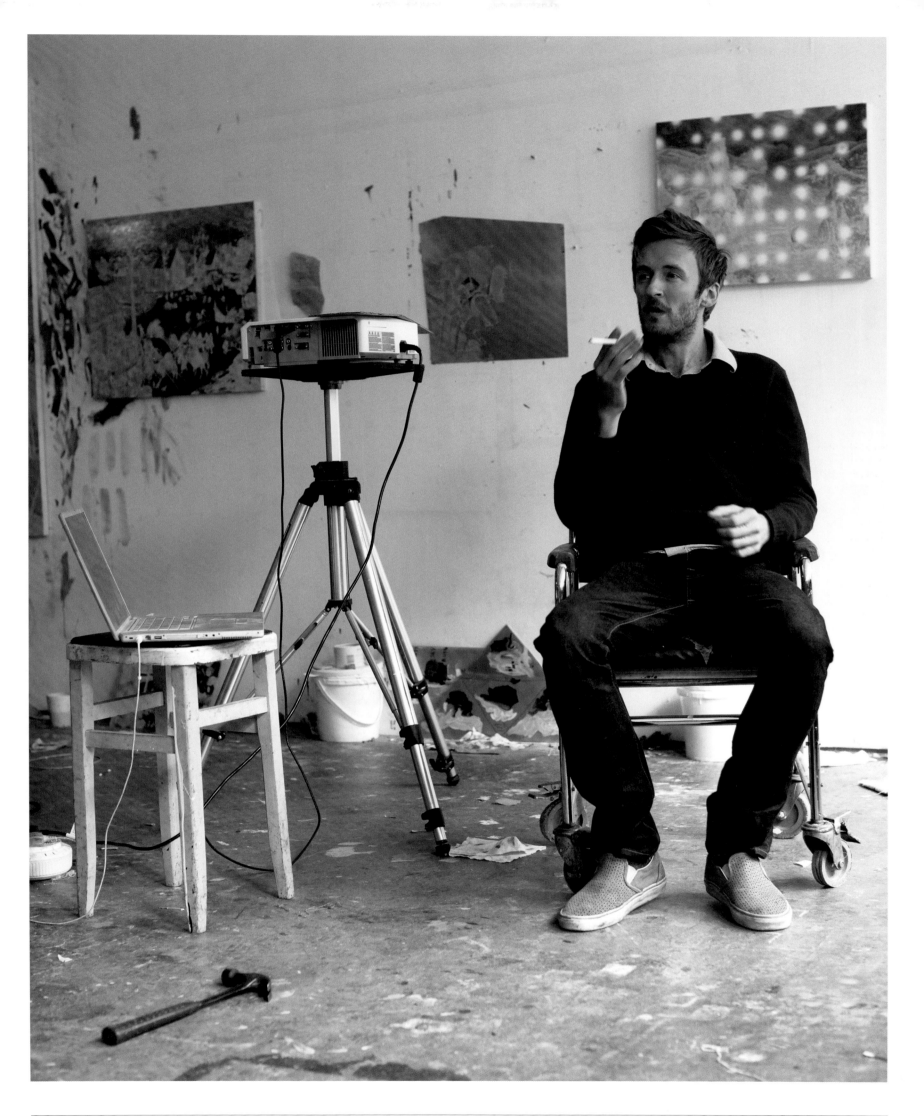

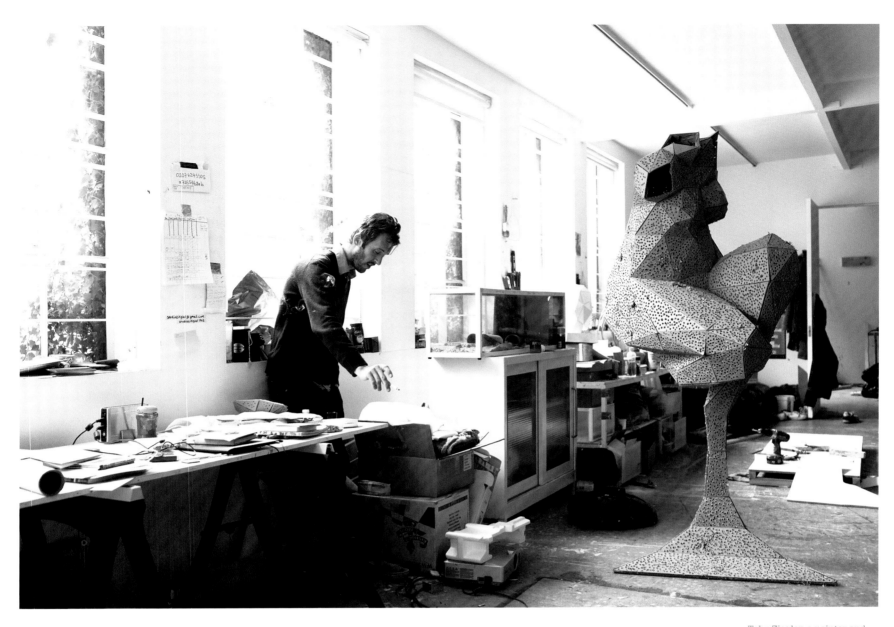

Toby Ziegler, a painter and
sculptor, works with up to
five part-time assistants in
his Kilburn, London, studio;
he is shown here in late May
2011. 'In the actual making,'
the artist says, 'things go
wrong, and sometimes they
are fortuitous mistakes or
parts of the process that are
less controlled. Then things
are allowed to happen.
It's to do with control and
relinquishing control.' Half-
finished sculptures (above and
opposite) populate the studio
alongside instruments of
creative capture.

Is making one of your big paintings a laborious process?

They are quite time-consuming. The work sometimes goes in bursts; sometimes it accelerates and things really change. Sometimes I keep regular hours, starting at 9.00 and finishing at 6.00. I like painting at night, and frequently what happens is that I come down here and have assistants with me. We work together and I try and ignore them as much as I can.

When there was a lot more geometry in the paintings, it was easier to delegate parts of the work, because some of them were mechanical. But it's getting harder to let go of the paintings. The sculptures involve a lot of legwork, a lot of cutting out of aluminium panels, a lot of drilling of holes and riveting, so there's a lot of process that I can hand over to someone else.

Do you work better under pressure?

It's something I do every day, regardless, and I know that it makes me a slightly more balanced person. I do tend to work on a group of sculptures and paintings, a body of work, usually with a particular space in mind.

Having a studio with big windows means that you can see where you are. Is this something that influences you?

I appreciate having that much space outside my windows; it's rare to get that sort of distance in the middle of London. But I don't think it's something that consciously affects the work.

Are you close to some of the artists who studied with you?

There are people I talk to about the work, and there are a few people I visit to see their work. I have a couple of friends in London who come and see what I'm doing. It's really important to have friends who can be rude.

Which artists do you particularly admire?

I keep going back to early Renaissance painting.

What about Paolo Uccello? I mention him because you seem to be interested in perspective and in how things are built up.

I do find myself drawn to that really clunky perspective when people hadn't quite got a handle on it.

They knew there was something to be done but also had a kind of freedom to put in multiple vanishing points, to have things shooting off all over the place and to distort scale. Also there was a planar depiction of space more like Japanese prints, or like when you used to get transfers and put them on the back of your Weetabix packet – those things that float one in front of the other.

Playing computer games has a resonance with the space that is depicted. But I've always looked at old paintings.

Is it important for you to be in London?

I was born in London, and I never escaped, and I don't think I will. It's got progressively harder to live here, but I still think it's the most exciting city that I've spent time in. The fact that it's difficult and abrasive is part of what makes it stimulating. I'd make very different work if I lived in the Highlands of Scotland.

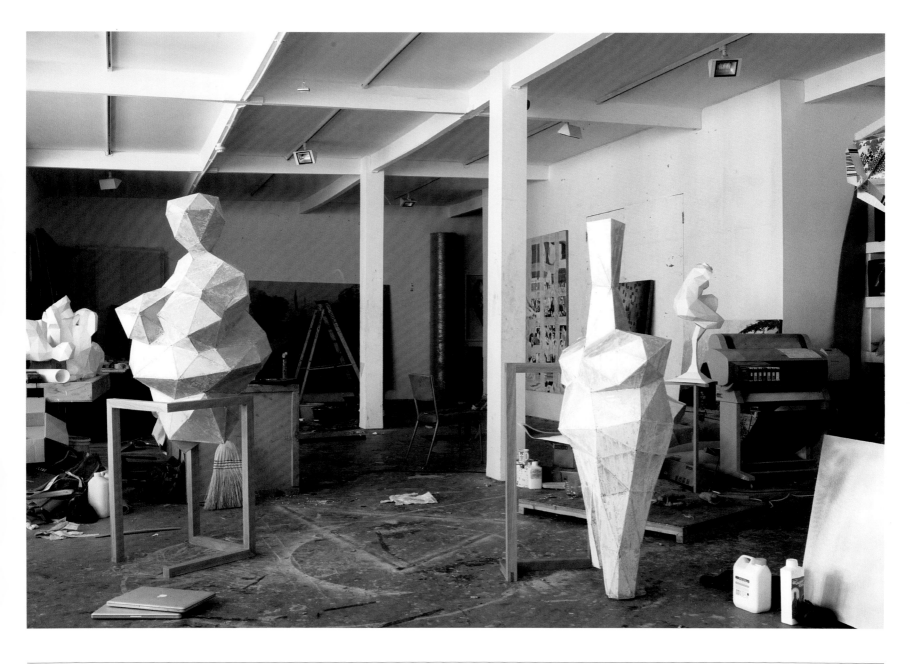

Nigel Cooke

Nigel Cooke (opposite) **sits
in front of his work** *Siren*
**(2011), in Greendale, his
Canterbury studio, in early
June 2011, and** (above)
**holds a mask of Stumpy,
an allegorical character
in his paintings based on
Donald Trump. 'Creating
things,' Cooke says, 'is about
bringing something into
the world that didn't exist –
that's the addiction for me.'**

What is it about painting that attracts you the most?

The possibility of creating a version of your own mind that you can then look at. It's a way of surprising yourself. Creating things is about bringing something into the world that didn't exist – that's the addiction for me. It's about the thrill you get when you interact with the material; it has a life of its own. There is a magical transformation there that I find addictive. But it is also about making paint into light or bodies in space or whatever – converting mud into an illusion. You can easily draw a comparison with the omnipotence of being an overseer of the world and doing what you want to it, but it's also about being weak in front of that, being small, not being in control, not being guarded, being a mess, not knowing. It is a kind of innocence that is ridiculous. You create a story of your own insignificance. Although it aggrandises you by being a monument, it is also a theatrical breaking down of authority.

So where life is an ordered construct, art is breaking down dogmas and superficial structures?

Yes, but art has its structures as well. It has the marketplace, it has exhibition culture, collecting culture, museum culture, all of which are institutions in which there are certain rules. The business of being alone with the object is separate. Executing an artwork for me involves putting an idea to death. The further you go, the more dubious that execution becomes, until twenty years later you realise that you aren't really doing anything other than what you always did anyway, that it doesn't get put to death, only changes shape again and again. It is about building a relationship with the object that is unlike any other relationship in your life. The better you get at it, the less you know. In a way, a painting is like a second mind, and a studio is like a second head. I often call the studio the 'exo-brain', a brain-outside-the-brain that makes what is going on within it.

The work you make is an equation between your temperament and your current interests. It is a sort of algorithm that comes out looking like 'x'. That's the artwork.

I was going to say that as you grow older in art you might have to regress to a more childlike or uninhibited imagination.

That's what studio culture is about, if you like. Studio culture is about making a bed and lying in it – you are creating a space the only consequence of which can be total freedom. It's this little world where anything can happen. The most interesting art is a clear negotiation between freedom and irresponsibility.

Isn't that a contradiction in terms?

That is what's good about it.

So the studio is a kind of submarine?

Yes, you pop up and you look around … that's what I do, anyway. I am still interested in where an image comes from, so that involves leaving the studio behind sometimes. What you do with it is slower and more private.

When and how did you come to art?

Even when I was very small, I always had attention for drawing and painting, so there was never any question about it. I can remember doing a drawing of a car when I was six years old or something and then gradually decaying it. Drawing the car and then blackening it up and rusting it and bringing in the entropy because it was fun, and it gave me two realities in one, gave me a kind of time-lapse element. It *is* fun to create something and then reverse it, make something look pristine and then wreck it. Put dents in the car, scratch it, put dirt on the wheels, flat tyres, rust. That's still what I do.

Do you think you have talent?

I don't think about it like that. I think about whether the thing is interesting to look at. Talent is a trap; it's vanity that can swallow you whole. You can become completely vain. You have to destroy the idea of results to immerse yourself in the process.

But the results are success and monetary awards and critical acclaim. Are these not part of the game?

Not in a studio, no.

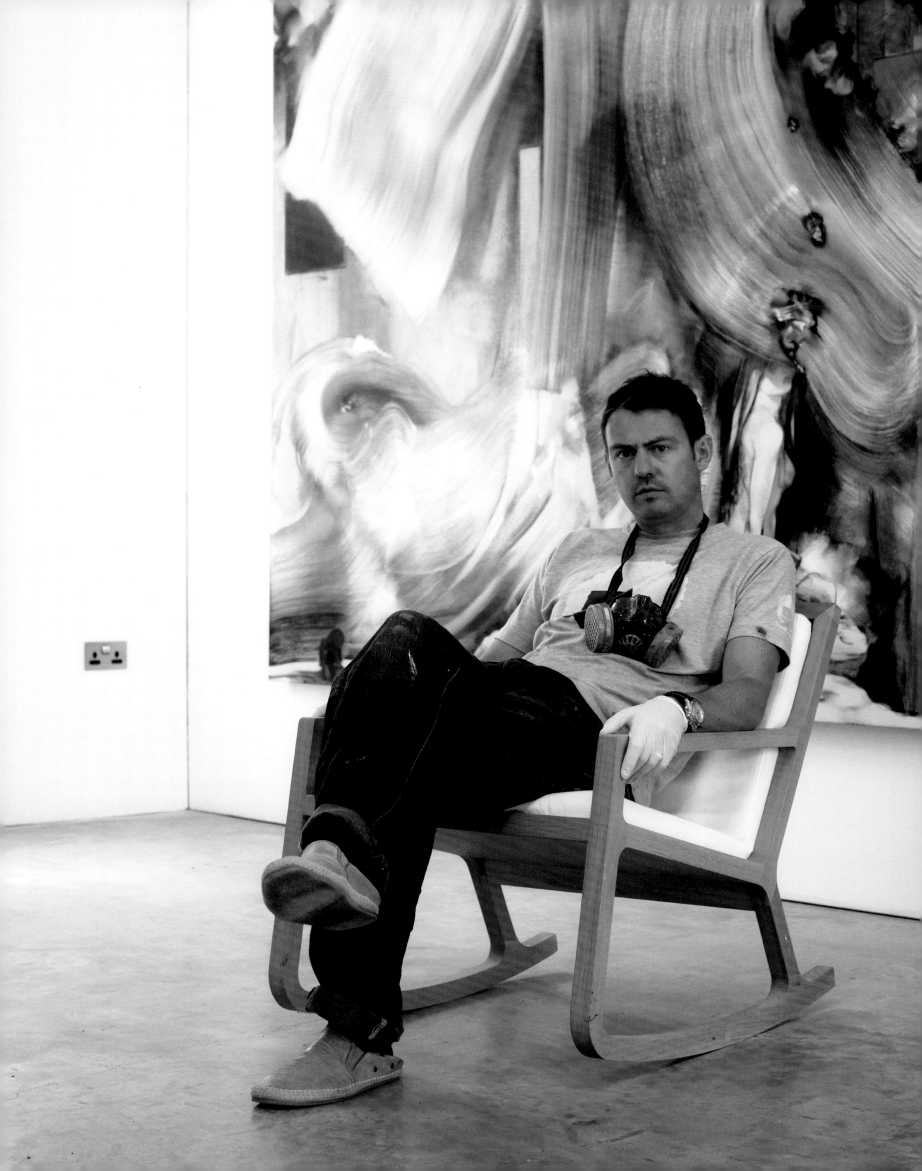

Isn't the ability to build a stupendous modern studio like yours predicated on exposure and success?

It is. That is why some artists would not do this. The danger is that it affects your work and you become someone who is paying for things with painting, which is a distraction and a pressure the work can live without, a pressure that limits your freedom.

Isn't it rather faddish of collectors to go for certain artists just because they are in vogue?

It could be, but everyone has to start somewhere. It's the journey that matters, not necessarily where you end up. A good collector is excited about that dialogue, I think. When I read a novel, half of me is engrossed in the story and half of me is wishing I had done it. Isn't that the most exciting thing about cultural forms? You are so happy it's there, what once wasn't there and now is. It's a thrill; it engrosses you and changes your thoughts, reroutes you and inhabits your mind. It is also intellectually rigorous and a way of challenging complacency and consumption as a form of comfort-eating. It is saying that you can consume it and be changed by it in a radical way. I often find that when I interact with cultural things – film, art, music, whatever – I become different. That to me is civilisation.

In a way, I am trying to make excessive paintings. Even if you hate them – and I often like to evoke repulsion as a way of involving people in them – it can be amazing how that can lead to a new relationship and become something that gets accepted.

Do you employ shock and awe?

Not necessarily. It's more like surprise. With me it's more about slapstick comedy, buffoonery, an alter ego who is in dire straits all the time. He is either falling off a boat or dancing badly in a nightclub, or he's had his head smashed off. There is a sort of human tragedy, a pathetic fallibility, to making art. That's what facing an artwork is about: knowing that it is all about failure.

Is painting literature by other means?

For me it is. I am a frustrated novelist in a painter's body. A painter's intelligence is very specific. It is not the same universal that allows a novelist to write about four different layers of reality or several different lives. Painters create in order to get themselves off the hook of the responsibility to be knowledgeable. They can be dumb, and that's the embarrassment of it too. The images that I borrow, the structures of stories, allow me to make a complex, layered painting. It is a structure, like a coat hanger or something, or a hat stand.

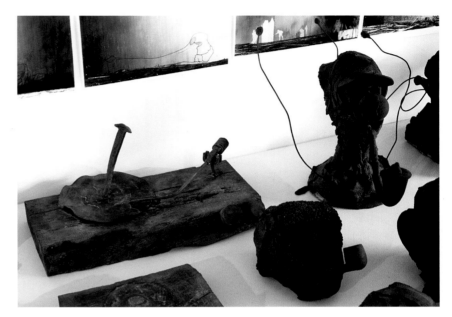

'In a way, a painting is like a second mind, and a studio is like a second head.' Cooke's purpose-built studio, designed by his wife, architect Joanne Cooke, is the first artist's studio in the UK to be built to the *Passivhaus* standard, resulting in ultra-low energy use and a reduced ecological footprint. Cooke's *Book of Crap* (left), which is used regularly in his work, rests with other items in his studio: 'Executing an artwork for me involves putting an idea to death.'

Clare Woods

This juxtaposition of extremes – the beauty of the English countryside, the quietude and this horror story that you bring into play – which is more important to you?

To me, the landscape is looking beyond the beauty or what is seen as scenic or pretty. I think about history in the landscape. I am interested in events, which are the layers of history. So I find landscape quite violent, quite extreme. I am drawn to that, and I photograph it.

The landscape has played such important roles in our identity, being British or especially being English. It's like our identity has been imagined through landscape. Through landscape painting, through literature that talks about landscape – that's how we see ourselves. Although most of us live in cities, we still see the country as a pastoral. It is a totally false identity. I lived in London for a long time and I never felt particularly safe or at home, so when I moved out of London I had other ideas that came from the landscape. That's informed the work over the last three years.

What informs this almost ritual fascination with the dark side?

It's just a theme. I am drawn to places, but that's not specific to my work. You don't need to know the narrative behind a place that informs a painting to read the painting in a certain way.

Is your art a reaching out to ghosts?

No. It's more about trying to understand what we are now based on our history. I don't feel comfortable in the countryside either. In London there is a real threat; here it feels more like a psychological anxiety.

What I am trying to say is that we have a long pastoral tradition, and I am trying to understand the context. I am interested in a lot of the painters from the past century – Paul Nash, John Piper – and the idea of returning to landscape in times of national problems. A lot of my work is non-figurative, but I like the idea of human presence in a historical way. There is always an element of trying to see something else.

What is the organic element within your painterly process?

There is a photographic process at the beginning when I am gathering hundreds and hundreds of images to be used for one painting. Then there is a collaging process to create the final image that I will work from. And then there is a drawing process where I draw and channel things onto the structure. Then there's the structuring with masking tape. The lines are cut and I start working flat; that's when I start painting. Every aspect of the painting can be broken down; each section is dealt with separately. It's about creating scenarios to tap into and that give direction in terms of colour. There is only so much I can do because the enamel has its own life. When I make a brush mark, the brush doesn't make a mark; it carries on moving. It takes on its own life after I've finished. So when I have finished, the lines can change or the paint can drip or the paint can pour into the space. Everything is very mechanical until the last part of the painting, and that is when things change, I suppose.

Who would you say are the most important influences on your work?

People like Peter Doig. But Graham Sutherland, Piper and Nash are the most important, and I look a lot at Goya. I am attracted to artworks for lots of different reasons.

When was the first time you came across mystery and the attraction of the unknown?

I've always been interested in history and in what's been happening in a place – ideas, cults, handed-down truths, changes and rituals. Rituals not in a mystical, magical sense, more along the lines of wassailing when they bless orchards and have fires around them, for example.

You had a studio in London for fifteen years, and then you decided to up sticks and live in the countryside. Given that your studio is located in a setting of breathtaking beauty, what role does it play?

The studio is purely a workshop. The studio is in the middle of an industrial site; it has a warehouse on one side and a woodworking shop on the other side. There is nothing in the studio except paint, a chisel, a chest and a stereo; I literally just come in here and paint. It is not about thinking time, reading time or drawing. Everything else is done in different places.

Do you get up early in the morning?

I get up really early, usually about 5.45, and work in the office. Then I get the children off to school and go to the studio. I tend to work in the studio until late afternoon, when I collect the children. Then I work in my office at home until around 11.00 in the evening.

Clare Woods, photographed near her home in Kington, Herefordshire, is an expert clay pigeon shot. 'I am a control freak, so I have to let something go to be able to shoot well. It has a relaxing effect on me.' Woods the artist (left) gathers hundreds of photographs for each painting before making a collage out of them.

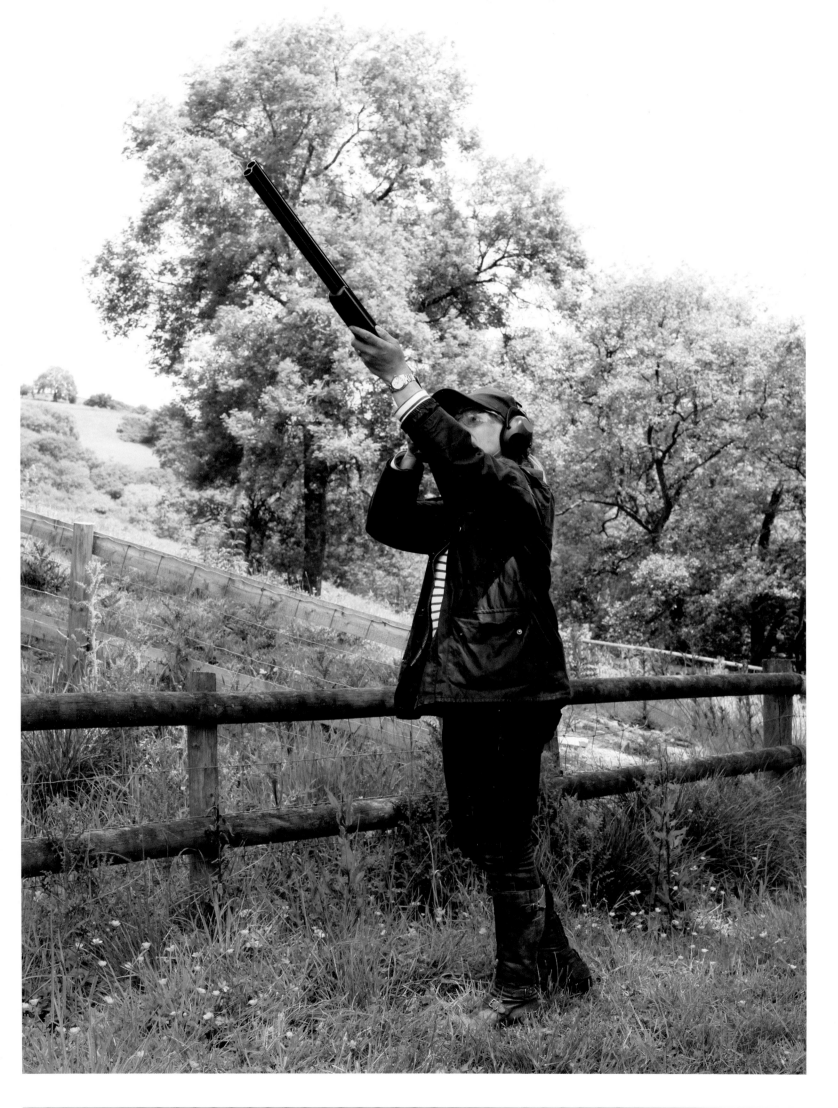

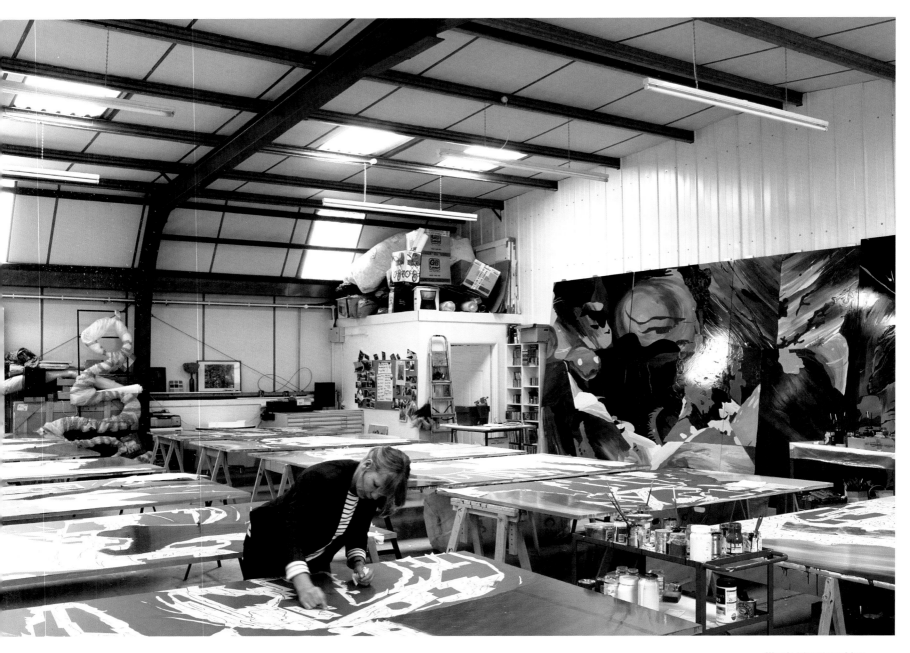

Woods (above) working
in her large studio on an
industrial estate near her
home, and (opposite) relaxing
outside her drawing studio,
a small conservatory that
sits at the bottom of the
garden. 'Although most of
us live in cities, we still see
the country as pastoral. It is
a totally false identity,' the
artist says. 'There is always
an element of anxiety or
fear, constantly, wherever.
It's always there, niggling.
If it wasn't, I wouldn't be
able to make my work.'

You've said that you take your camera for walks in the woods. How does that work?

Sometimes I go somewhere because I have read something interesting about the place. It may be that I am travelling along and then I see something and take a photograph. It used to be more that I would plan to take a photograph, but now a lot of the time it is just that I see something by the highway. I drive around a lot in the countryside.

Where did your passion for shooting come from?

I used to shoot as a child but hadn't shot for a long, long time. Weeks were going by – it was such a depressing time and it was so cold that I couldn't sit and work in the studio. I needed something that wasn't work or children. That's when I started shooting.

Do you find inspiration or distraction while shooting?

No, it is a type of brain switch-off. I feel like I've had a massive massage.

Weren't you picked for the Welsh shooting team?

I've been shooting for a while now, but I haven't been picked. I was offered to shoot, but I don't want to. But I am good, which is strange because I am not good at any other sports. So it's quite nice. It is pure. I am a control freak, so I have to let something go to be able to shoot well. It has a relaxing effect on me.

You say that you are a control freak … Is it necessary to be disciplined in your work, or is it an extension of your personality?

It's an extension of my personality. The way I make my work is unique to me because of that, but I need to be organised and ordered and to be able to do everything that has to be done in the day.

When you enter the studio, is it a mechanical process, putting out the paint and developing your canvases, or do you feel that you're engaging in an emotional seance, so to speak?

Because of the way the practice is broken down into elements, you can devote yourself to each aspect, which works really well for me. So when I am in the studio painting, I am thinking about colour and form and that's it. You do think about the work; your mind just goes off and you think about all the things you think about when you are doing art.

It's not that you suddenly get so frightened that you have to shut down and leave the studio?

No, no, no. I do get frightened when I get off the train at night but not in the studio.

Do you need to be freaking out to be able to translate that into the work in a closed environment?

I am freaked out all the time! There is always an element of anxiety or fear, constantly, wherever. It's always there, niggling. If it wasn't, I wouldn't be able to make my work.

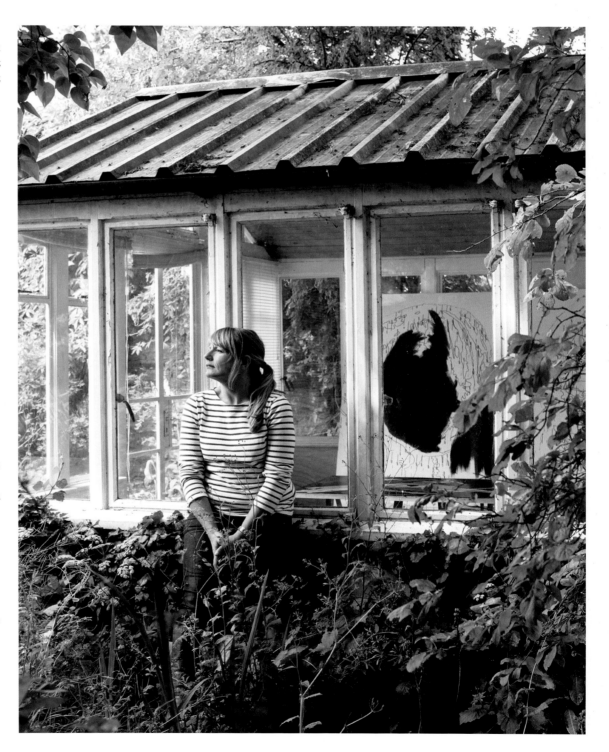

'When I was young, I believed
in poverty,' says Gustav
Metzger. 'I believed at
different times that the artist
is stripped, or strips himself,
of much of normality. Poverty
would be an element of that
radical self-examination.'
The hermit artist, a rare view
of Metzger photographed
outside his home, which
also acts as his studio,
in early June 2011.

Gustav Metzger

Is art a happy coincidence of life forces or a purposeful act?
Art, design, architecture – this whole area – is fundamental. It covers almost the entire realm of human activity. I cannot imagine civilisation without art. Without art, everything falls out of place.

Do you believe that children should study art history as well as studio art?
It would be a very, very good move.

Would it have an evolutionary impact on the understanding and interpretation of social functions? Would children become different people if they were familiar with art? And in what sense would that happen? Because in a way you yourself are a teacher. You create art and use methodology and ideas to change perception.
I've tried to change perceptions and in a small way have perhaps succeeded. The recent news from Germany that they are going to shut down all nuclear reactors in ten years' time, that is what I've been concerned with in particular, with challenging the way things are in the spheres of science and technology, and the interconnectedness of politics and power. This news is of tremendous importance for me personally.

Along with Bertrand Russell and the Reverend Michael Scott, you were part of the Committee of 100, which was behind the anti-bomb and anti-war movement in the early '60s. Do you have memories of how art engaged with pacifist or anti-nuclear ideas back then?
What you were getting were pockets of resistance, pockets of experimentation, in South America, Poland and so on. Minorities, often hidden minorities, would engage in a critique of nuclear states. Artists were barely concerned with these major issues, much to my regret.

You've mentioned being deeply affected by Picasso's *Guernica*. Who is an equivalent figure in contemporary art?
You cannot find someone to stand in the aura of Picasso.

Technology figures dramatically in your work. Do you believe that technology is a necessary evil or that it's being misapplied?
Exploitation in the interest of the so-called philosophy of growth dominates world systems. It's fundamentally a path of death. Growth, for me, equals death, equals the crippling of the genuine potential of human life. Certainly the last few years have shown the self-destructiveness of the capitalist system. If this goes on, if we strip capitalism of its glamour and appeal, we may come to a more fundamental understanding.

But surely the appeal of growth or greed is fundamental to capitalism? Humans would still be in their primitive state if there were no aspiration for growth, no envy. Today the whole world of art is underpinned by the capitalist trauma of greed.
I've been saying that for decades.

Could you have art without a certain amount of envy, greed and possessiveness?
We are feeble and full of errors, but we have the capacity to look past this with choices, and the choices that we make – for instance, the German government's phasing out of nuclear reactors – are so important. It's the capacity of the human being to order his or her life. My main preoccupation is human-caused mass extinction. I've come to the conclusion that there has to be a worldwide movement against extinction. We can make the choice to continue as we are, which will decimate nature to an unprecedented extent and possibly lead to the end of life when the majority of plants and insects cease to function. Everything we know may fall to pieces.

Do you still believe in the ideals of Communism as you did in your earlier life?
I've never been a Communist. I've been very interested in the Left's way of dealing with thought and politics. I was a member of the Committee of 100 for two years. I would hardly call that a political party; I'd call it a pressure group.

Would you describe yourself as a liberal humanist, as an archivist of human folly?
It's only fair to let others describe me.

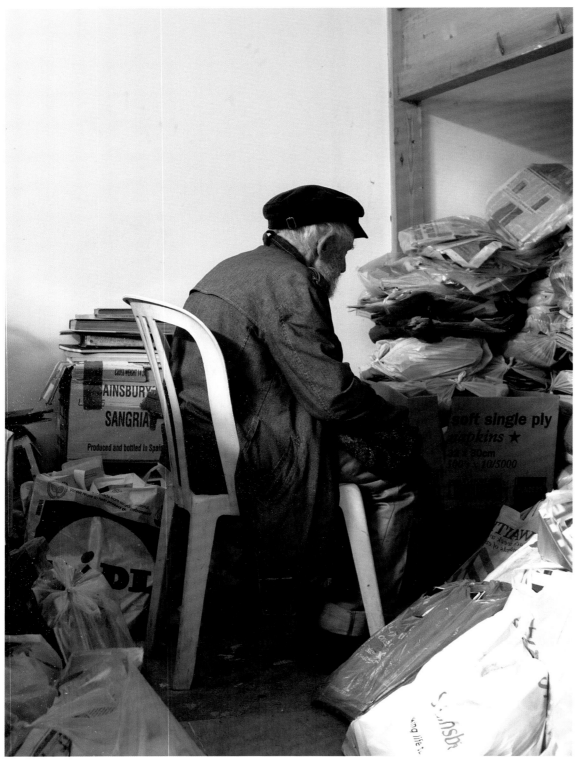

German-born, Metzger has lived in England since his escape from the Holocaust in 1939: 'I cannot imagine civilisation without art. Without art, everything falls out of place.' The artist in his Hackney home and studio surrounded by ready-made objects, bags of rubbish which he has used in exhibitions to demonstrate the finite existence of art and critique the wastage of consumerism. A cleaner at Tate Britain accidentally threw out a rubbish bag that was an integral part of one of his works in 2004. Metzger did not want to be photographed facing the camera.

And would you describe your work as an archive of human folly or as a reflection of capitalism's redundancy?

I frankly would rather not describe my work. All I can say is that it's been varied and has changed over time. I hope it goes on changing.

When were you first inspired to scribble on a piece of paper or look at a painting?

At the age of eighteen, during the war, in the summer of 1944, I made the decision that I should go into the practice of art. My interest in art had to do with my childhood experience of Nuremberg, where I lived until I was nearly thirteen. The town centre was simply all art. You had fountains, you had churches, you had museums, you had handicrafts all over, going back centuries.

Wasn't Nuremberg touched by the war?

The centre was almost completely destroyed. I've been back three times since the end of the war, and it was a shock to see not so much the destruction as the reconstruction, which was an attempt to mimic the past and which is rather horrid.

Is political destruction ever justified within the context of the extinction paradox you've talked about?

What a difficult question! You can't say that all destruction is wrong because then you would have to stop eating plants. Certainly destruction in every sense is fundamental to life. Scientists tell us that our bodies are continuously falling apart. As to the world wars, fundamentally they were mistakes, whatever short-term gain some nation, or some ideal, might have achieved.

I think strength should be controlled. We can't undo the past, but it's crucial that we learn that if we go on following this egocentric direction, we might soon extinguish everything.

May I ask you about the influence of David Bomberg and his teachings on your life?

When I go back over my life and think of the people I've met, one figure stands out and that is Bomberg. We had a close personal relationship, and I admire his drawings, his graphic art; I love his paintings. It's tragic that he died relatively young in extreme poverty and isolation.

Do you embrace poverty and isolation as a ritual act of integrity?

When I was young, I believed in poverty. I believed at different times that the artist is stripped, or strips himself, of much of normality. Poverty would be an element of that radical self-examination.

You don't have a phone, you don't use a computer; there's not even a doorbell at your house. Are those purposeful acts?

One part of the answer is that I don't like the technology of the telephone and its ability to home in on somebody and make instant demands. In a sense I am sheltered from that, which I see as positive. The rejection of the uniformity that decrees that we are expected to do certain things, like, for example, be part of the World Wide Web – I resent that. I also resent the capitalist system, which makes enormous profits out of people interacting through that kind of technology. I'm interested, when I look at newspapers or listen to the radio, to try and interact with the thoughts being expressed in the media. This is my daily activity above all – testing what is happening out there. For that I don't need a telephone. The moment I step out into the street, I find a *Metro* lying at the entrance to the Underground. My day is comparable to that of Baudelaire's *flâneur*.

But isn't that a dialogue of the deaf?

Yes, but that makes it more interesting. It's a question of stripping voices down. Is it the voice of a wise person? Is it the voice of so-called youth culture? This is my life: testing day by day what's going on out there. I don't want to present myself as some superior being; believe me, I have a very low opinion of myself. I keep going because it's fun and stimulating.

I believe it is necessary for me to be an artist or to go back to being an artist. At this late period of my life, art is at the centre of my existence, or at least I would like it to be again. When I was younger, I spent years dreaming about art, trying to make art, thinking of the future. It was a full-time job. I would like to go back to being the kind of artist who day by day faces the challenge of making art instead of simply talking about it or exhibiting.

Or making money out of it?

If money comes through my art, I will take it.

If you were to be remembered for a particular period in your artistic career, what would it be?

The best periods have been when I've been painting and drawing full-time.

And what will be your legacy?

There are plans to set up a Gustav Metzger Foundation, which might be connected with this studio. The intention of the foundation will be, first of all, to preserve the actual works and pass on an accumulation of ideas developed in the course of the past sixty years.

How important has having a studio been in your life?

I had my first studio in 1951, when I rented one for about a year. I passed it on to Leon Kossoff, who shared it with Frank Auerbach (Kossoff moved out; Auerbach is still there, in Camden). I just gave it up and they took it over and I'm glad they did.

Is there an element of sanctuary embodied within your studio, or is your sanctuary to be found elsewhere?

Being in this studio is a tremendous relief. It's extremely important to me to have this. In that sense, it is sanctuary. It's a retreat.

Richard Hudson

How would you define your work?

My looking at it defines it, and the shape, the form, the line … if you follow it, you'll find that it is a long process of smooth curves. You start at the beginning and go all the way to the end, and then you start again. There is never any break; the view is never fractured. It doesn't matter what angle you look at it from. There is always a nice angle that is smooth, a continuous line, which I think is important.

What is the inspiration for this linear continuity?

I've always been fascinated by the female form. I love the way it looks, especially when a woman is lying down – you get the curves, like a continuous landscape. My eye's always following it, wherever I am, whether I'm in the street or in a café or in a bar. I notice everything. That's where I get my lines from.

Are you inspired by classical sculpture?

Of course I was, at the start. But I wouldn't want to try to compete with those people by creating realistic sculpture. It's important to move on from that. I like to take the form and create sensuality in the individual who is looking at it. I want it to impart feeling or emotion to somebody, so that, through their eyes, even if they are closed, they can feel the form close to them.

Is this some sort of primeval sensuality?

Of course. We all have it in us. We all have inner thoughts that we keep to ourselves, because of our religion or mother and father or whatever. I like to try and bring those thoughts out in people so they feel completely uninhibited.

You spent a lot of time in Africa …

I spent a lot of time in East Africa, walking and living in the bush, with the Maasai and other tribes. I was looking at their shapes and forms. I remember one of the first inspirations I had was watching Maasai women washing in Lake Naivasha. It was the juxtaposition between them and the flamingos … the shape got more and more beautiful. When I became a sculptor, it transformed and started to appear in my head.

I had been travelling in Africa since the early '80s. I am a late starter as a sculptor. I'd been farming, acting, modelling, building, doing interior design – all sorts of things. In 1990 I decided that I needed to find out what I really wanted to do. I got offered quite a lot of money to do a development in London, and I went

off and sat on a beach in Lamu for a month, rang the guys back and said, 'Sorry.' I thought I would go walk-about instead. The 'walkabout' ended up lasting for five years. I met a girl in Mallorca who was a painter. While I was with her, I drew her, and she started saying, 'Why aren't you painting or drawing or doing something like that?' I said, 'I've always wanted to sculpt.' There was a fire in her studio, and I helped put the place back together. The old boy who owned the building said, 'Do you want to rent the rest of it?' So I rented the rest of the building as a studio and started working as a sculptor. It's grown from there.

What is the purpose of art?

Finding myself as a sculptor meant that everything started to fall into place. I'm always happy. I was before, but it has such contentment about it now. I love the business of art. It's a crazy world, the art world. I like the recognition. I love it when people come up and say, 'I really love your work.' You get goose pimples, you know? And it's very – I can't think of a word to describe it – when somebody who has worked hard to earn their money wants to buy something that you have done. I feel lucky that God or whoever it is gave me this gift to create, and that I am able to live and work from it.

Where does Spain come in?

I'd travelled extensively, in some pretty funny places, and then I met this painter in Mallorca and that's where it stopped. My work was quite conceptual at the beginning. I wanted to use my hands rather than using ready-made objects, which I did at the start. There are beautiful pieces out there, but I like the idea of creating a shape out of my head and getting angry with the piece sometimes because it is not coming together. When it does come, I feel physically exhausted. It does take it out of you.

Has it been difficult for you? Spain is not an obvious centre for contemporary art …

I always wanted to go to a foreign country where I knew no-one, to see what it was like to survive. Madrid fitted into that category. I was lucky to find my foundry right at the beginning. They have been very supportive, especially dealing with a perfectionist. The guys I have working with me are bloody hard workers, smelly, sweaty; there's dust and dirt, everything. But I love all that. I could never work in an office; it would be impossible! I was brought up on a farm, milking cows, driving tractors, things like that.

The materials you use are very varied. Why is that?

I like materials. I like metal; I like the solidity of it. I know that if I make a bronze, it will be around for ever, if there aren't any nuclear bombs or something like that.

Who are your main influences in the art world?

Girlfriends I've had. It sounds awkward, but obviously I've studied their bodies. When it comes to sculpture, I love the old sculptors like Michelangelo and Rodin. Then there are Jean Arp and the first pieces of Brancusi, and of course Giacometti. But that is completely different from what I do.

Some would say that you are more famous outside of Britain than inside …

I don't know. I got my first break with Sotheby's three years ago.

Do you feel resentful about not being in the public eye in Britain?

No! Life is a process; it's a fight. I teach my children this: be good, be well mannered, and keep going forward. Things will happen; they will come to you. Running it up is the worst thing you can do. Just be patient.

Your work has been characterised as having a 'constant, investigative tension' …

Trying to achieve perfection and working with the hardest material to do that is a constant battle. I'll be sitting on the train and scribbling, and invariably when something starts to go into three dimensions it takes on a different form. As I said, I feel physically fucking exhausted by it, so I can do a maximum of three or four hours and that's it. I have to get the hell out of the studio. I always find it crazy to work when I'm tired.

What role does your studio play?

It's the place where I physically make the pieces. The creativity just comes. I don't know where it comes from; it just comes. My studio is not a sanctuary; it's almost a battleground. My sanctuary is probably my bedroom, where I go to free my head.

When you started out on your travels in Africa and the Amazon, it wasn't packaged tourism, was it?

No. A lot of it was on my own, sometimes with a friend who sadly died of malaria. It was about finding myself. It's in my blood; Sir William Speke is an

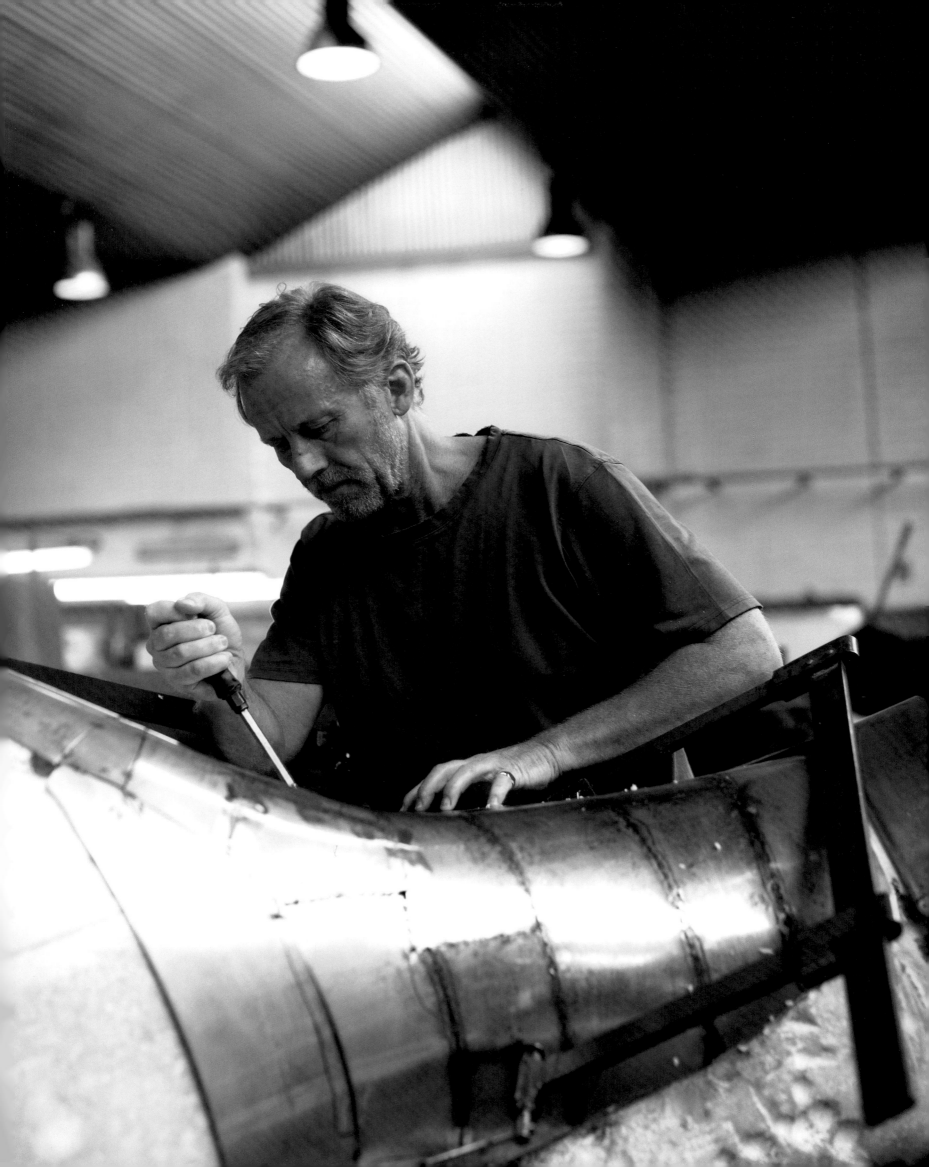

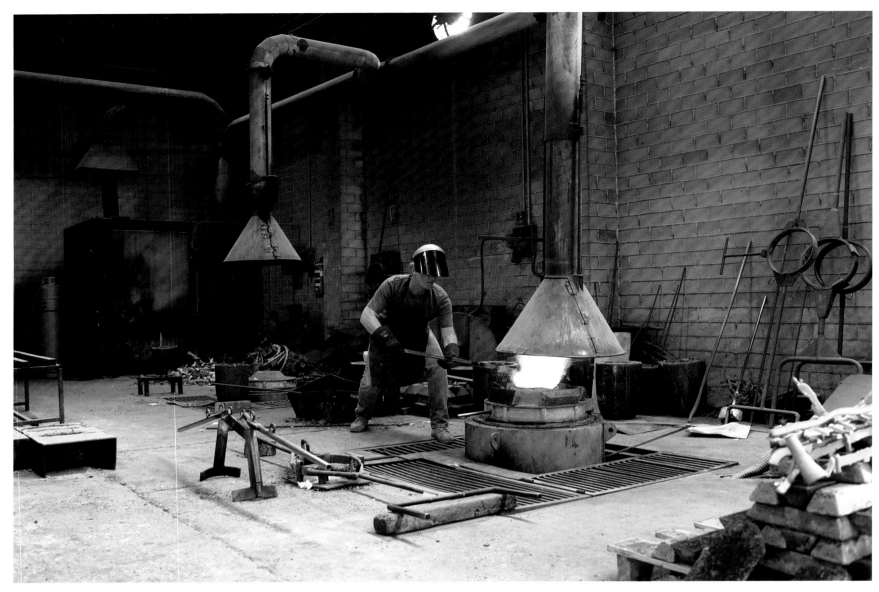

(previous page) **Richard
Hudson**, a sculptor who
came to art late in life,
photographed at the Magisa
foundry near his studio
outside Madrid, Spain, in
early June 2011: 'My studio
is not a sanctuary; it's
almost a battleground.
My sanctuary is probably
my bedroom, where I go
to free my head.' Hudson,
who works in bronze,
marble and plywood, casts
a bronze sculpture (above)
at the Magisa foundry. The
artist, who has travelled
extensively and lived in
Africa, cites his time among
the Maasai tribe and the
female form as principal
influences in his work: 'I've
always been fascinated by
the female form. I love the
way it looks, especially when
a woman is lying down –
you get the curves, like a
continuous landscape.'

Giving form to substance
(following spread) Hudson
weaves his magic on metal
with real flesh in the form
of a model.

ancestor of mine; Lawrence of Arabia is another. I was inspired by Sir Richard Burton. I wish to God I'd had somebody standing behind me saying, 'Richard' – when I was in school, because I loved art – 'this is what you should be working at.' But I didn't have that. I was at an English boarding school, which was a nightmare. The art lab was up in the attic, and it was just cuckoo. You had to qualify for something, and that was it.

You are self-taught. How long did it take you to learn to make art?
The practicality of tools, metal, welding and working with organic materials is a natural thing that I've been used to all my life. I had to mend things by using tenacity, and it evolved from that. Hammers, chisels – I was used to them. I worked in a foundry for a couple of months to see the process, see who was making mistakes, just keeping my eyes open. I'm very practical; that wasn't a problem.

How did you sustain yourself financially during that period?
Credit cards.

I am very lucky … Either the first or the second time I went to the foundry to pay my bill, I had had quite a few pieces made and was hoping that he would help me out a bit. He added everything up and said, 'This is what you owe me.' I said, 'No, I owe you more,' and I showed him. He said, 'You are definitely not Spanish!' Since that moment, he has been very good to me. When I first had some shows, he knew that I wasn't getting paid anything until afterwards. I remember saying to him, 'I know I owe you a lot of money. If you want, I can go to a friend or to my father or something.' He said, 'No, no. I am your bank. You stay with me and I'll stay with you.' It has gone along like that for fifteen years.

What was the first piece you sold that resonated both for your art and in your pocket?
It was the first piece I had at Chatsworth. That was the turning point because it meant that I had some capital to start making more pieces. Now it's going okay.

Given your background, do you feel that you are in a relationship with nature?
I do. I knew it when I was growing up. I would go out at night into the ditches and watch the foxes. I always felt close to animals. When you are farming, especially when you are with cattle, you feel close to death and life all the time. Trying to save life when you have a cow giving birth and it's not coming out properly and you have to stick your arms in there and pull it out, those sorts of things … The closer you are to nature, the more you understand three-dimensional shapes. What is a three-dimensional shape? It has an outside; it has an inside; there are holes involved. We come out of a woman; we come out of this hole and into this world. Us guys spend the rest of our lives trying to get back in there. The creation of life is fascinating. A lot of the world disrespects it, which I find mind-bogglingly stupid.

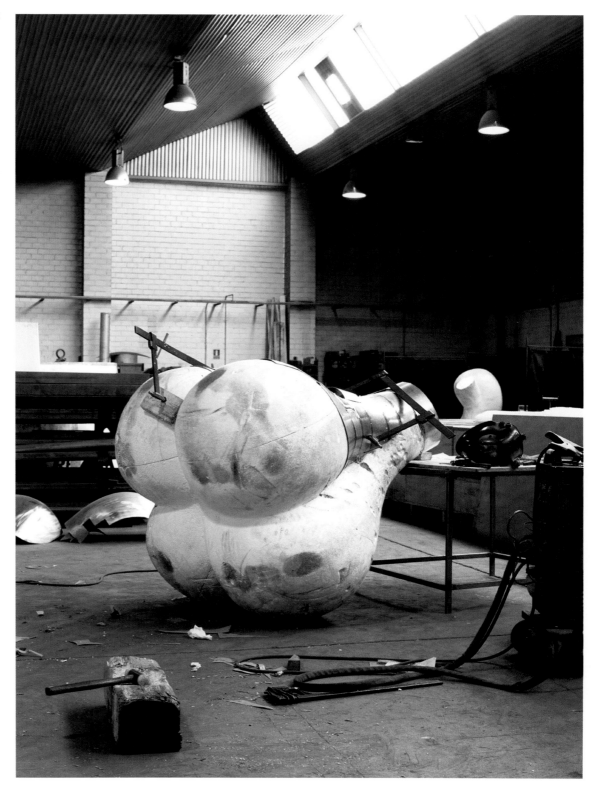

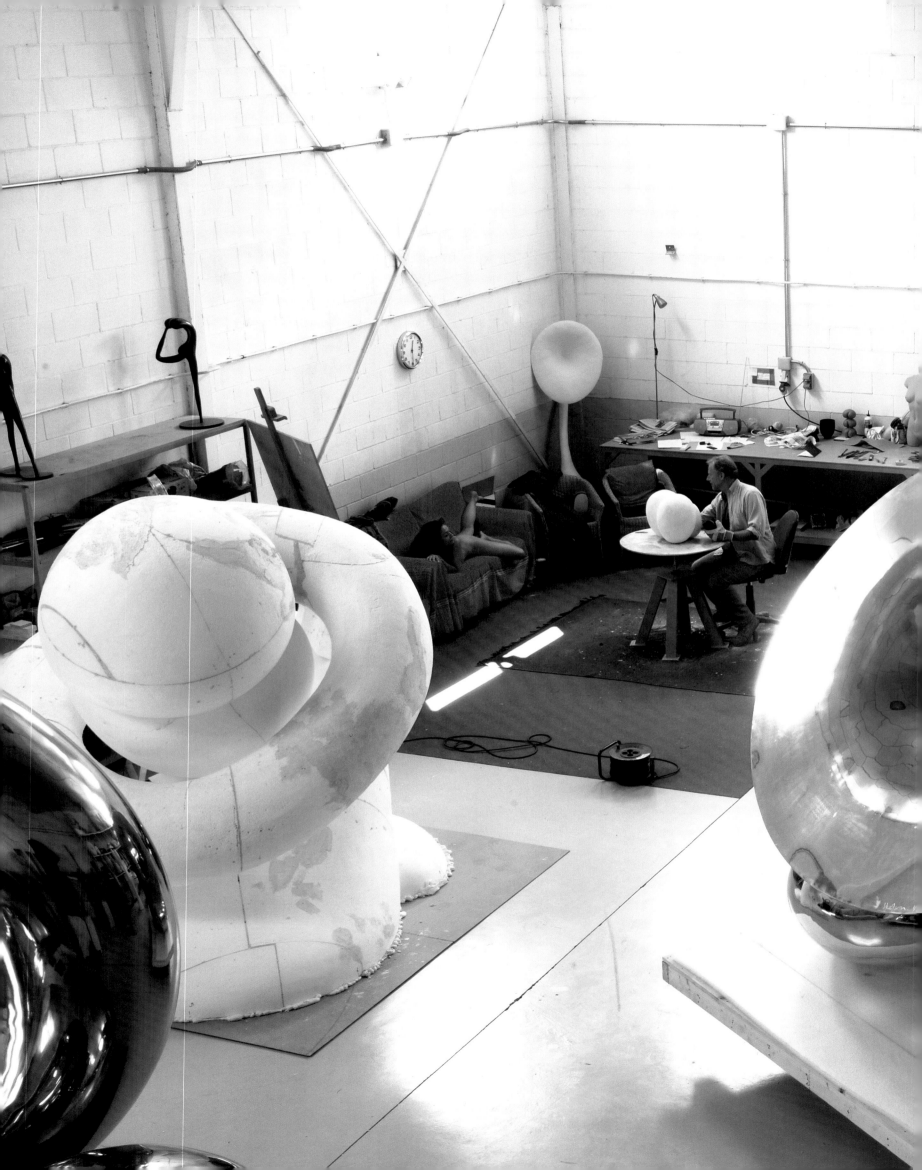

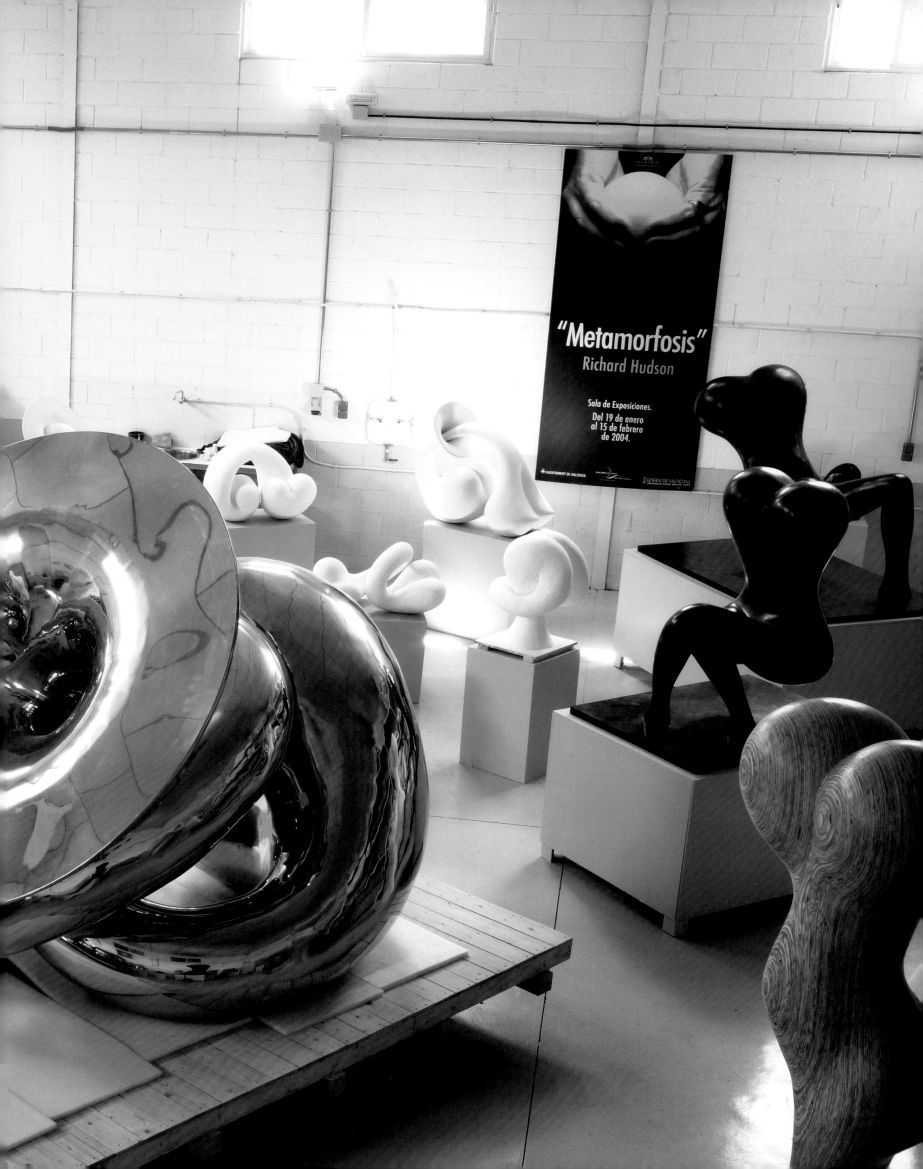

"Metamorfosis"

Richard Hudson

Sala de Exposiciones.
Del 19 de enero
al 15 de febrero
de 2004.

Goshka Macuga

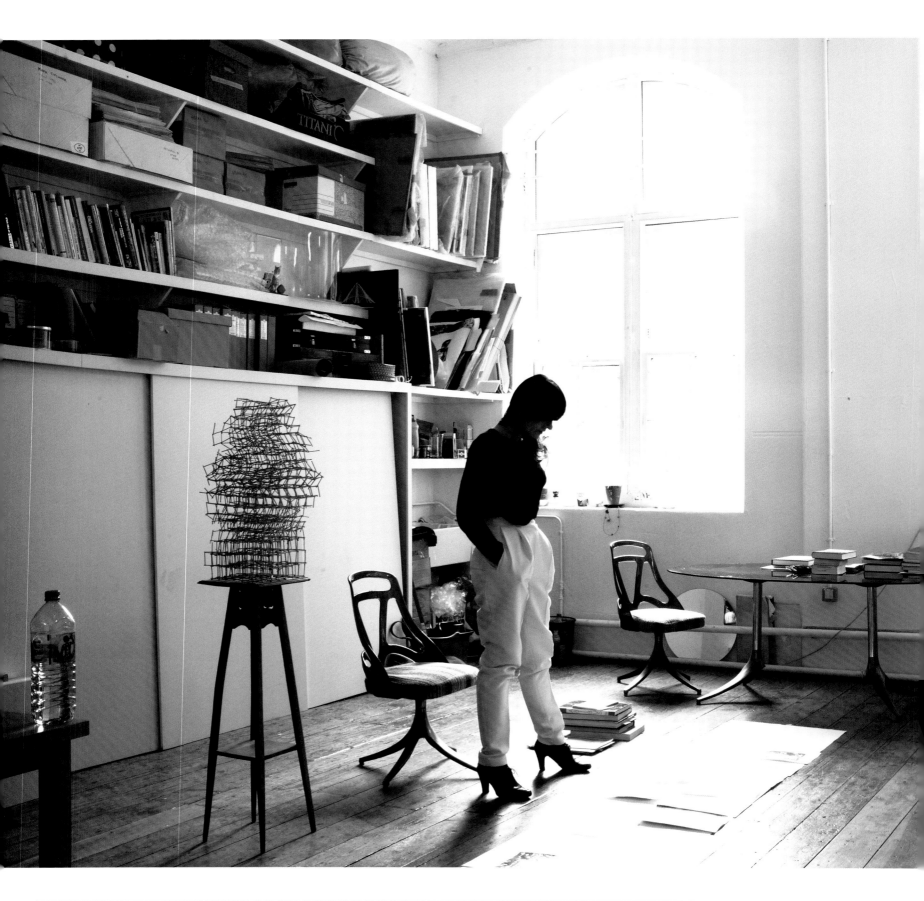

How do you define normality?

I live life through work. All of the steps that I take, most of the relationships that I have, are somehow related to work. The research or preparation period, which takes from six months to a year or more, is when the whole excitement about work happens. That's what I love, so of course I treasure all of those relationships. This is a kind of normality.

Do you sometimes have jarring experiences within yourself during this process?

That happens all the time. The thing about the art world is that there aren't set rules. The relationships that you have with your commercial gallerists, the relationships that you build with institutions, are not relationships defined by law. In a way it's about starting a romance. And if you agree to do this, you have an expectation that it will be a positive experience, so often you discover that you are slightly naive because things aren't as perfect as you would like them to be.

So artists are very high-maintenance?

Yes, but everything that has to do with the art world is high-maintenance. Artists are just one element of a larger complicated social group.

Is this social group almost a dramatic set piece?

Well, yesterday I was watching something on TV about our understanding of the universe. You can consider that this whole system is very much interconnected and that there are different sets of energy levels that result in different situations. If you look at Duchamp, for example, he talks about transubstantiation, which is a religious ritual where something is transformed and becomes something else just because of this relationship taking place. Without these different characters being involved, the artwork would never exist, or the meaning of the artwork would be different. What's so interesting about now is that it's more about technology and the way we communicate with each other, how far we can reach to communicate with people and how people have access to your space, your work, your progress within your work. There is this expectation of democracy.

What spermatozoa of ideas impregnate your mind in this process of creative chaos?

After finishing Goldsmiths and trying to set up a studio practice outside of an educational structure, the most important thing for me was to have an eclectic number of activities as an artist. This is about trying to be open to many possibilities.

Do you ever take your artist's hat off?

Of course! I have to compromise. But also I respect and am inspired by other artists.

How much self-respect is there as an artist?

You have to have a lot of respect for yourself and for others, but you also have a responsibility to take the work seriously. I am lucky because I have opportunities to show my work, so I have consistent invitations to make new pieces. You have to persist with being truthful to your intentions.

I was looking into the life of the German art historian Aby Warburg, who had schizophrenia. The thing about Warburg that struck me was that he wrote a lecture about snake rituals among the Hopi tribes in North America. Basically he was talking about this human need to understand or to deal with things that we don't understand by creating rituals. Perhaps making art, or doing any kind of creative work, is an attempt to create a ritual involving elements of the world or things about ourselves that we don't understand. With contemporary art, if we are talking about the twentieth century, there was a need to replace traditional rituals or beliefs. But the ritual didn't change. The belief just became more complex.

Can you compare art to religious practice, then?

Comparing art to religion is very interesting. If you think of the white-cube space, this place where you go and you are supposed to meditate on something, the feeling is similar to the feeling you would have going to a church or to a mosque. It is about a particular kind of environment, creating a space where you can have this contemplative or spiritual or intellectual experience.

Which comes first, the intellectual experience or the spiritual one?

The intellectual one comes first. But I am not a spiritual person, I am a practical person.

One of the main reasons I left Poland was the pressure after the breakdown of Communism when socialist doctrines were replaced with intolerant religious doctrines. I am doing an exhibition now in Poland to look at this transformation in my country, at the evolution in the moral context of art. Maybe what is so great about the art world is the fact that people are open-minded, and that questions posed about rigid beliefs can become interesting propositions. Outside of the art world perhaps it is harder to get away with. Things become very solid; there is no flexibility. There are places like Poland, for example, where it is much harder to have freedom as an artist than it is in Britain.

I'd like to return to the question of the church being replaced by art in contemporary civil society. In the grand scheme of things, art is infinitesimally small compared to the car industry or the technology industry, so how is it that art punches way above its weight?

Maybe there is an illusion that it involves a certain freedom. When the public began to think of artists as celebrities, that is when it started becoming popular. If you look at the Tate, it is the merchandising of an idea. It's a brand, and people buy into it. The Whitechapel is becoming a brand as well. So there is a kind of censorship, but overall the economy is very much attached to art, and it would be naive if one just believed that these are spaces that have been created for people to visit and have a spiritual experience. It's a much more complicated situation. And there's the whole curating thing as well. A curator becomes this kind of guru personality.

Does contemporary art concern itself with the future?

Art possibly finds this idea of living in the present very difficult. It is almost impossible to recreate the feeling of the present time. If that becomes something that feeds into your work and motivates you, of course you are going to create a certain nostalgia. Such works almost become reportage, and it is difficult to create a substitute for them. I wonder whether it is actually easy for artists to make work about the

Polish-born artist Goshka Macuga (previous spread) has lived in London since 1989. She was photographed in her Shoreditch, London, studio in June 2011. 'Art possibly finds this idea of living in the present very difficult. It is almost impossible to recreate the feeling of the present time,' Macuga says. Refusing to commit to any single medium, she blurs the boundaries between curator, collector and artist. She says of her studio, 'I have to be able to have access to lots of visual materials, and I have to be able to design and plan work that is usually made outside. So it is like an experimental place where I rarely finish a work, even if I make a simple collage.'

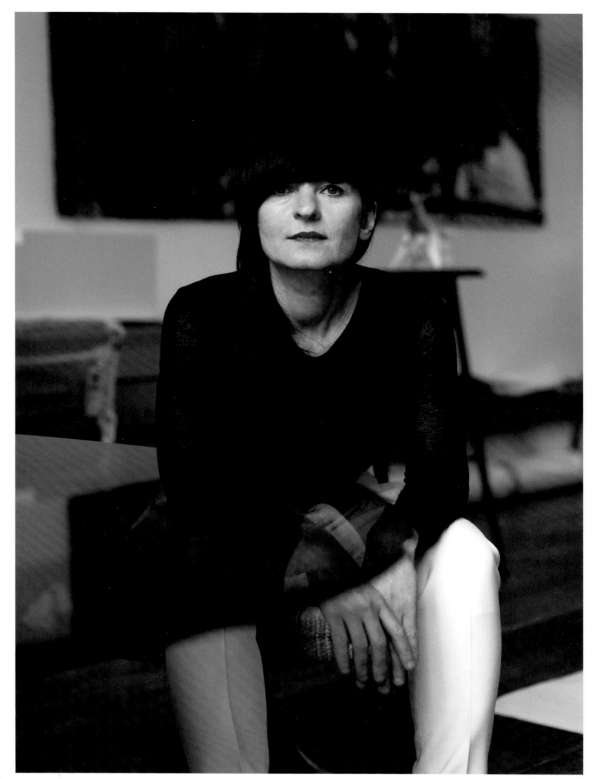

present, especially when it is about politics, about big social changes. Work that is more about aesthetics never gives me the same thrill as work that goes into something that is not so acceptable. It is hard to take a position about what is happening today because things happen very quickly, and the information that we get nowadays is already mediated in some way. It is not necessarily the truth.

What is the role of the studio in your life?

I have books here, I have my archives of previous projects, I have space. I have to be able to have access to lots of visual materials, and I have to be able to design and plan work that is usually made outside. So it is like an experimental place where I rarely finish a work, even if I make a simple collage. Somebody is printing my photograph, somebody is mounting the work, and then someone else is framing it. The idea is born here, but it is never really made here.

In an ideal world it would be interesting to be able to do everything yourself, but since I go from woodcarving into photography into tapestry-making into video, it is not possible, with my income, to have a laboratory on a large scale, to have people specialising in all of these different disciplines, to be able to do it all in-house.

What brought you to London?

When I finished art school in Poland, I applied to the Academy in Warsaw several times and wasn't accepted. So I thought, I have to do something rather than sitting with my mother and pouting and feeling lost. In Poland at that time it was possible to find a job and live with your parents as long as you wanted to, and a lot of people did just that. I decided that I had to become independent; I had to escape. I applied for a one-year foundation course in London, and from there I went to Saint Martins and then to Goldsmiths.

Has emigration from Poland to England defined your character and artistic product?

I only started working like this maybe two years after I did my Master's. I did video work and different things. I wasn't focused on anything that I wanted to commit myself to. I didn't have a full understanding of myself; therefore I wasn't able to define the place where I wanted to go. It was more of an intuitive journey. Through these different experiences, different things that happened accidentally or through my choice, I could see better what was actually happening. I became able to go back to the moment when I left Poland, to my education there, perhaps to how the political and social changes there informed my work, to how that gave me the freedom to work with history as a fluid material. That is my background, really.

Macuga hunting for inspiration in Epping Forest, a former royal forest in Essex. 'With contemporary art, if we are talking about the twentieth century, there was a need to replace traditional rituals or beliefs. But the ritual didn't change. The belief just became more complex.'

Jonathan Yeo

Are you an artist who celebrates famous people?

I didn't set out to be a celebrity artist; I am fascinated by faces. When I started out doing portraiture, everyone said, 'Get out of it! It's so out of fashion!' It was the most uncool thing you could have done in the early '90s – which I quite liked. If you're going down the road of doing portraits and making them universally interesting, you need to refer to faces that everyone knows. Although I don't spend my whole time doing that, the pictures that become known are the ones in which I represent people that other people know.

Human faces are the most interesting thing you can look at. We are animals, highly sensitive to subtle variations in movement. We read other people's faces much faster than we read anything else – at a glance. From that point of view, it's a great area to play with.

Were you shy as a child?

I don't think I was particularly shy, but I was interested in trying to figure out people's personalities through their faces and in drawing people. I'd draw my teachers from the back of class at school, partly because it made my friends laugh, but partly because it was more interesting to me than what my teachers were saying.

I became ill in my early twenties and had all kinds of family drama, which was very public at the time. From that point on, strangers would tell me their secrets and problems. Being able to deal, by the age of twenty-one, with the possibility of death makes you look at life in a different way. You live much more in the moment, and you *have* to make assumptions that things are going to be fine.

Am I correct in thinking that you're celebrating life in your paintings?

No. My illness made me keener to engage with as many different experiences and people as possible.

When did you have your first major break?

What tended to happen was that one thing would lead on to another. The first proper commission I got was when I was recovering from my illness. It was a man called Trevor Huddleston, who was heading up the anti-apartheid movement. Because he loved his picture and showed it to all his friends, that got a few commissions started. I had just enough work to live. I was living in London at the time, so I had a diverse group of creative friends such as Ozwald Boateng, who was making his name as a trendy suit-maker. Ozwald began swapping art for suits. Probably my most conspicuous break was getting to do paintings of Tony Blair and the other Party leaders for a Sunday

newspaper during the election campaign. As soon as your name's out there coupled with what you do, it's much easier.

You're mainly self-taught. Does that mean both artistically and otherwise?

I left school at seventeen, eighteen. I thought about going to art school because my friends did, but at the end of the '80s hardly any of the schools were teaching painting, let alone figurative painting.

Did not going to art school help or hinder you?

I regretted it for the first few years because I had to learn by looking at things, talking to other artists and reading. I made elementary mistakes. A lot of the paintings I did early on were terrible. Having said that, if you're not taught what to do, you've also missed out on being told what not to do, which is quite an interesting thing.

Take yourself back a couple of hundred years. Who would you have wanted to be as a portraitist?

A Renaissance painter. Maybe someone like Van Dyck. He's someone I'd like to have met because he was celebrated in his own time and in the court of the king but also had his own massive set-up. He lived grandly and had access to all the interesting people. I suppose that's the key. There's no point being brilliant at doing it and not getting anyone interesting to paint.

Do you mind feeding your sitter's vanity when you do a celebrity portrait?

The vanity thing is a distraction. You couldn't accuse someone who was being painted by Lucian Freud of being on a vanity trip! If you were having Mario Testino take your photo, you might get criticised for being vain because he's a flatterer. These days if you make people look better, you look ridiculous yourself, because what we look like can be corroborated by photographic evidence. In Van Dyck's time that wasn't possible. It's like Erin O'Connor: she's someone who photographs beautifully, yet she was keen for me to make her look as she looks. We're used to people photographing things with an agenda, lighting things a certain way, Photoshopping. You see Kate Winslet on the cover of *GQ* and you know she's been changed a lot. Photography doesn't have the primacy that it once had. I've strayed a bit from the point, but I suppose what I'm saying is that portraiture has a validity now that it hasn't had for a while – if you trust the artist!

How long does it take you to do a portrait?

It depends partly on whether I'm painting well or badly and partly on whether I can get people to sit for me when I want them to. It's interesting doing famous people who don't live around here, but it's a pain in the arse as well because you don't know if it's going to be two weeks or six months between sittings. So I tend to have several things on the go. I also take thousands of photos. You don't need someone sitting in front of you, but you do need to spend enough time with them to know that the expressions in your pictures are genuine. It's just as useful to have a four-hour lunch with someone as it is to have them sit in front of you while you paint them.

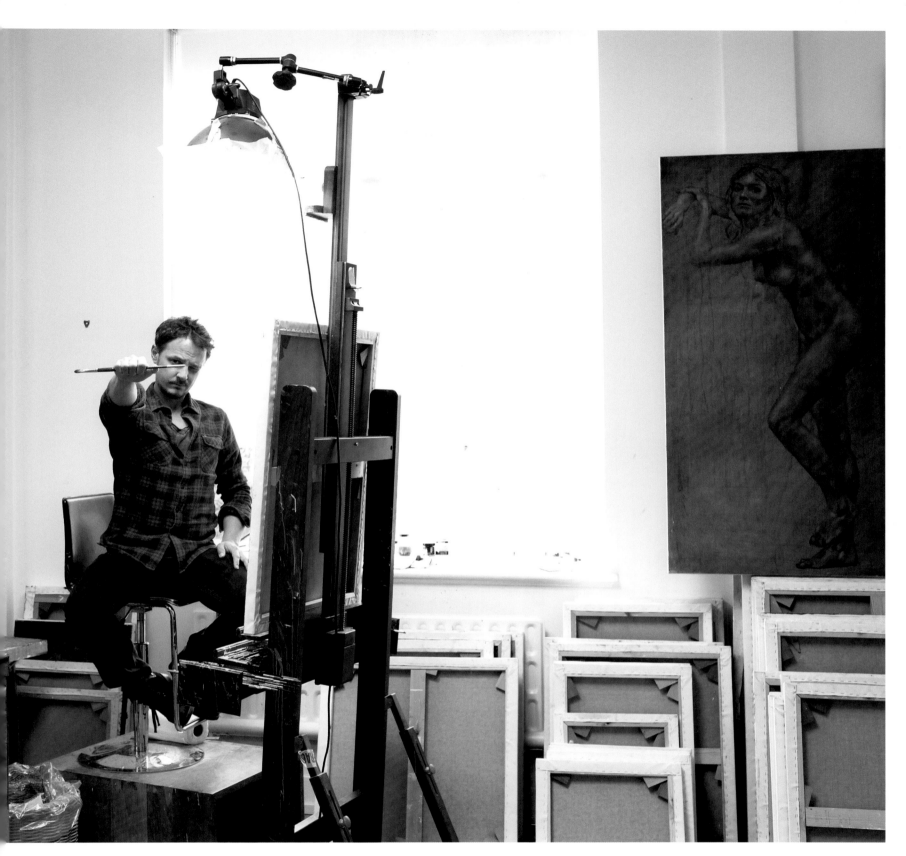

Jonathan Yeo in his Chelsea, London, studio. A nude portrait of Sienna Miller hangs on the wall. The artist, who is famous for paintings and collages of celebrities, originally took on his high-ceilinged workspace from a friend for six months but has stayed there for nearly ten years. 'Human faces are the most interesting things you can look at,' he says. 'We are animals, highly sensitive to subtle variations in movement. We read other people's faces much faster than we read anything else – at a glance.'

Hurvin Anderson (opposite) moving into his new studio in Tulse Hill, London, in mid-June 2011.

Can we start by describing your current studio?
I've had a space at Gasworks in London for five years. At the moment I'm prepping for some new work, but I've also been trying to create some set-ups. So I've been using the studio as somewhere where I can recreate a place; the space has been doubling as somewhere where I paint and develop ideas. Before, I would make drawings at home. I would bring them in and use the studio to make paintings. Since I finished my last show, I wanted to bring all of my practice into the studio. So I'm at this little crossroads. I quite like the idea of the studio as a solitary, private place.

Gasworks is a particular type of set-up inasmuch as there are a number of resident artists as well as visiting artists and an exhibition space. Has being here had an effect in terms of how you want the new studio to function for you?
Yeah. If you're in London and have a space that's fairly cheap, you're thankful. Now that I have to move, I've started to realise that I can do anything. This space came up in Tulse Hill, where I used to have my studio. A group of us bought a section of a mews. It is an opportunity to go back. That familiarity is important ... I'm hoping to have two sections, one storage/drawing area, the other purely a studio. It's become an issue where I put windows in because I just want four white walls lit from the top – a flexible space, a space for possibilities.

Did you have a sense of priorities for the design of your new space?
I need more room. Getting things through doors at Gasworks is difficult. I want to make larger paintings.

I have a sense that you like to have other paintings around you while you are working on a particular one. Is that correct?
Yes. Right now I'm putting together a new series, so if I want to work on a study I just pull things out ... I'll work on a study and that will then be taken into a larger painting.

Do you work on one painting at a time or more than one?
I work on more than one painting at a time. A painting can come to standstill for a while, and, while you're negotiating that, you move on to something else. Momentum is an issue for me. I like the idea of constantly moving. I find it difficult to start again when I come to the end of a series.

So you have an archive of images and photographs to which you constantly refer when you are thinking about the construction of a painting?
Working on a painting generates ideas. At the moment I am mainly working from scenes set up in the studio. At the same time there is a bank of photographs I think about using. Once I finish a series of works, I'll either go back into it, if I think there's something else there, or I'll delve into the bank and see what's happening.

How much of your inspiration comes from memory and how much from imagination?
Memory is the trigger. I will start from an idea about a place. Usually once I've made the first thing, I realise there's a whole new aspect. By the end it's not necessarily associated with the thing you started with. All of what I do is a description of where I see black culture in Britain at this time. Although there is a personal aspect to the work, I see it as a trigger.

I know that you were born in Birmingham of Jamaican parents, but I've never thought of your work as explicitly negotiating your own biography. However, there does seem to be this dialogue between different worlds within the paintings.
I'm interested in where cultures meet or don't meet as the case may be. Where you might see the biography is in the personal photographs or the constructed scenes. Using personal images gives the work something familiar we can all engage with. I've been trying to find a language that explores this meeting point, to create a fluid, uninhibited dialogue.

Can I ask about your last show at Thomas Dane? I remember you describing the idea of presenting paintings together with small works on paper and studies in order to evoke the relationship between studio practice and the final paintings, that sense of articulating the alchemy or magic that goes into studio practice.
Some exhibition spaces can be difficult. That was part of the reason for layering things up. Putting a lot of different works on that wall provided insight into what I have in the studio. I believe in just sitting down and seeing how things trigger off rather than having one rigid idea.

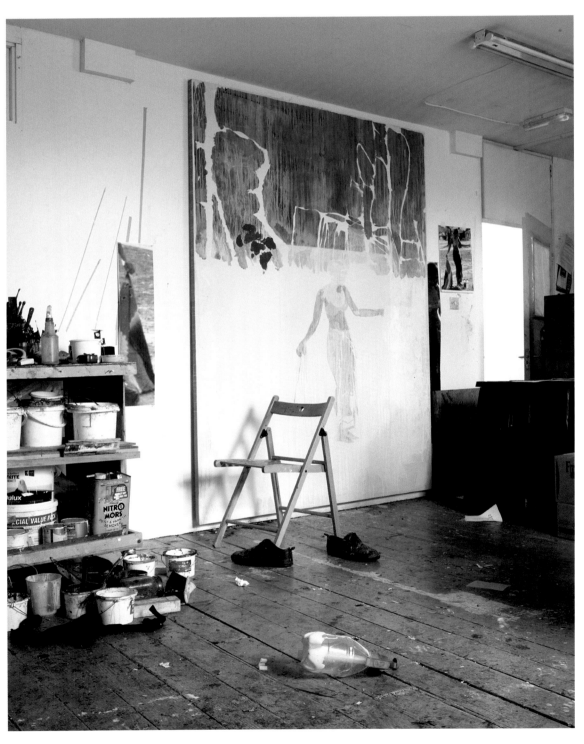

Are there other things you'd like to talk about in relation to your studio?

I did a residency in Trinidad in 2002, at Caribbean Contemporary Arts. It was a strange moment. I had come to a stop and then this idea was put to me that I should try this residency. I tried to work in the studio, but it was just too much, being away and stuck in a studio. So I opted for taking photographs, for seeing what the place was about. What had the greatest impact on me was how I existed there. I was British one moment, Jamaican the next. If they didn't know who I was, I could have been Trinidadian. So I existed in all of these different places, and at any particular moment I could be told off for being British or being Jamaican. It could be used against me ... It was intriguing to not exist anywhere.

Behind where we were staying there was this country club which had this reputation of being for the elite. I don't think I aspired to be in there, but there was this curiosity about the place. You could hear it more than you could see it; you could hear them swimming and people diving into the pool. It was this sense of this other life which intrigued me. There was also a tennis court there. It all became quite symbolic. When I came back to England, I started to make work in my usual way, playing with those photographs. First I painted this open area, but I wanted to see what would happen with chicken wire in front of it, a kind of scarring. From there I went on to make other paintings where you didn't see so much of the chicken wire. They just became dots ... they were speckled all over. At the moment, I'm trying to go back to those things ... I want to try and make a new body of work looking at something else ... it's also to do with the studio and how it's set up.

There's a sense of you working within your own private space or finding a way to make work based in your studio ...

Yes. It goes back to that thing about memory. It feels like something's starting, but it's not concrete yet.

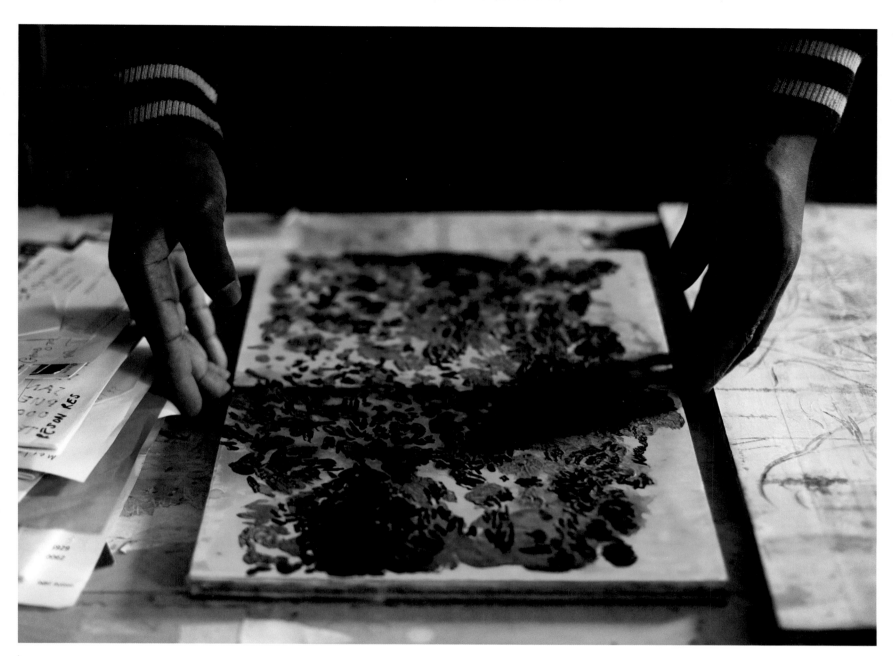

Work in progress in his current Gasworks studio in Vauxhall. Born in Birmingham of Jamaican parents, Anderson's paintings are influenced by black culture in Britain. His current works follow from an artist's residency in Trinidad in 2002. 'I quite like the idea of the studio as a solitary, private place.'

George Shaw

Your work has been described as Larkinesque. Why is that?

Because one of the things I'm interested in is failed ambition. Larkin, who wanted to be a poet, who wanted to be an artist, had a 9.00-to-5.00 job in an office and didn't live the life of a poet, didn't live the life of Kingsley Amis down in London, drinking at Claridge's and all that. Larkin comes home from work, rinses out a couple of dishcloths and wonders what Ted Hughes is doing. I think that's brilliant.

When I was a youngster, I wanted to be an artist, to be famous. My art education was provincial and mundane. I don't really have much to offer despite my bumptious statements. It was slightly like a little man in a little world.

Yet you've been nominated for the Turner Prize.

That's the shocking bit! Why? I still find it odd how my paintings have been in pawnshops and no-one wanted to buy them, let alone nominate them for the Turner Prize!

Is art a kind of banal nostalgia?

Mine probably is. I tend to meet people who are uninteresting, who haven't done anything interesting in their life whatsoever. Yet I'm fascinated by them, or they're the people I love.

Is it disappointing – a let-down – when you meet an artist or a literary personality?

Most of the artists I meet are the same as ordinary people. The only really famous person I met was Lucian Freud. I just shook his hand. It was a bit like shaking hands with the head teacher. I couldn't remember why I was doing it.

Just going back to what we were talking about earlier, I was so convinced by my own role as an artist when I was fourteen, fifteen and sixteen that I still feel that I'm completing the work I began then. I don't feel that I'm making the work of my maturity; I'm fulfilling the prophecy of my teenage years. I'm in awe of that teenager in the same way that I was in awe of meeting Lucian Freud.

What do you mean by 'prophecy'? Who prophesied that you would be an artist?

I did. I was my own prophet. I can remember saving up to buy a portfolio so I could walk through the streets carrying it … so everyone else knew I was an artist. I thought I could reinvent myself in art school, far from home, far from the council estate, far from people playing football. There was nothing to stop me. There were no walls. Open doors all the way.

Was that because of talent or willpower?

No. It was because of government grants.

In terms of the thematic content of your work, there is a lot of referencing of your childhood. Is it mostly memory-based?

A lot of it has to do with my memory being so poor! When I go back to those old places, something – in the same way that it's triggered off in everybody I know who comes from the same background – makes me think in a different way. Everything about your body, everything about your mannerisms, changes, almost like Ken Barlow returning home in *Coronation Street*. He's in his sixties and he's been to a middle-class university. When he goes back to his working-class home life, he can see his own awkwardness and the change in his nature. It's because of trying to fit back into where you want to belong, but you don't.

So your career is all about going back to that source?

Yeah. Something about it has to do with digging. I can't remember much about being a kid. There wasn't much friendship. It was just me locked in a studio, or locked in the landscape, doing this thing. Thinking about going back there unlocks that passion, unlocks that feeling of optimism and love of

the world and the future. I'd positioned everything in my studio like I'd seen it in a book about Francis Bacon's studio. Everything just in the right corner. The first thing I did wasn't really a painting; it was an installation like an artist's studio.

The more I make images of this familiar environment and how it's changing, the more unnerved I am by why I'm doing it. I like Constable because Constable stayed in one place and dug down there. One of the things I'm interested in is finding the roots of my journey.

Are you a social archaeologist?

Not a social archaeologist, no. Society comes along by accident.

But, looking at your paintings, I can imagine you walking home and seeing what you're doing as a half-dark, unexciting experience.

That's exactly right. I'm beginning to feel like a character in my own work. I don't know whether he's me as a painter or whether me as an artist really exists. The last bit of work I'll make will be this fictional film about a fictional artist called George Shaw who's completely obsessed with this other artist called George Shaw. It will pull an Oscar!

Your first studio was your bedroom, which you shared with your brother. It was also the room in which your father died. What impact did that have on you?

At the time it didn't have an impact; it only did when I started to take photographs. I was drawing my dad as he was dying, and then I drew my dad when he'd died. Then the ambulance people came and took his body away. I took a photograph of the bed before my mum came and tidied it up and made it nice. At that moment I became aware that it was the room that I'd had as a child. It had the completeness of a *Play for Today*.

Is there a starkness inside you?

Yeah. My work isn't formulated to be shocking, but I come out with shocking things when I'm out and about, to the point where my girlfriend will go, '*George*!' I just think, Fuck's sake, I'm not *doing* a horrible thing – I'm just *pointing* at a horrible thing. Why should I get the blame?

Today, when you go back, how do you see the room where your father died?

It's been redecorated. It's lost its power. It's like a Gregor Schneider but with carpet and magnolia paint.

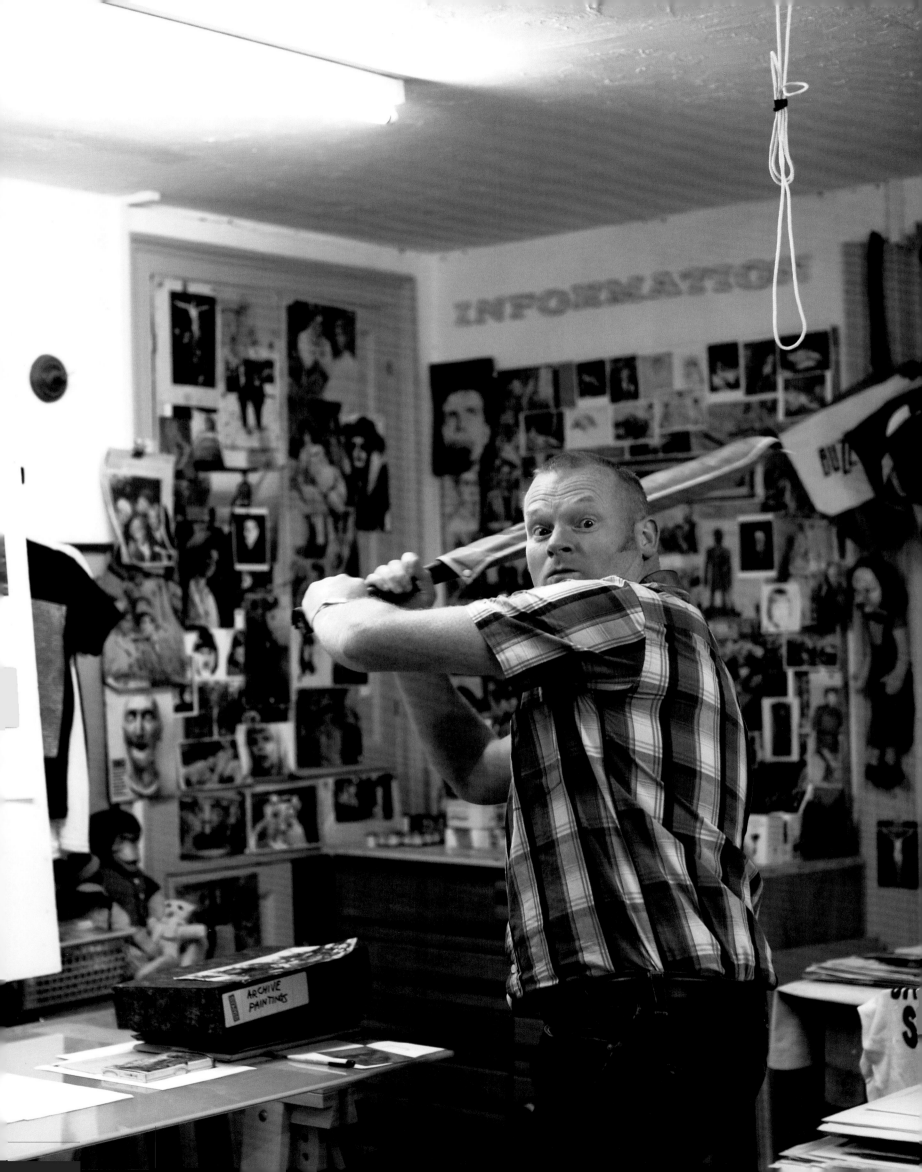

You haven't gone back to do anything there?
No. But I know for a fact that at the end there will be another painting of it. Because one of the things I'm interested in is a circular notion of time. When I'm writing something like a diary or an anecdote, and when I read it back, I confuse tenses. I'm never consistent with how I'm viewing the thing I'm looking at. Quite often I can look at something and see it as it was, as it is and as it will be. That's why the notion of nostalgia doesn't fit. It's not like trying to remember what it was like to watch *Top of the Pops* in 1974. It's very, very non-specific.

Have you ever lived in London?
I lived in London for a couple of years. It was too expensive. I spend twelve hours a day in the studio. I don't give a fuck where it is; I just want it to be a bit cheaper. One thing I can't do is share a studio. I can't stand other people. I don't want them anywhere near me when I'm working.

I pretty much work office hours. I start at 7.00 in the morning and finish at 7.00 in the evening. I go upstairs just before *The Archers* … unless something drastic happens!

Do you ever come downstairs again?
I may pop down, but my girlfriend warns me not to, because she knows when I pop down it could ruin the entire evening. You know, in the break in *Taggart*, I'm whispering, 'I'll just go down and have a look …'

I'd like to return to your obsession with studios. Why did you have a fascination with studios when you were young?
It's about trying to navigate inside my head. I'm trying to make the inside of my head outside, in the studio.

But I don't like the notion of the studio as a mind. A studio's like a house. It's a room; it's interior. When I move into a new space, I put things on the wall which make it feel like it's mine, maybe to get rid of the person who was in the room before? I want the space to be layered, so I can spend ages putting something up or taking something down, hiding something or getting it out … *My* studio has a relationship to a man's shed or garage.

Let's look at the contemporary art market, something that you're not really too enamoured with …
No, I like it! It's good. The money's fantastic.

It doesn't detract from your artistic integrity?
Not at all. It adds to it! I like most of the collectors I meet. Most of the people who've bought my work have an engagement. I could sit with them at dinner and have a chat. They tell me, 'Oh, I bought your painting! It reminded me of this and this and this.' I go, 'I don't care about your suit or the rest of your art collection – I'm having a chat with *you* …' It would be exactly the same conversation I would have with my girlfriend's mum about a painting.

If you were crippled psychologically or emotionally and couldn't make art, what would you do?
I think about that often. Am I defined by moving coloured bits of crap around on a board? Not really. I'd find something else. I found this. What I've got to say is important.

It's storytelling, right?
To me it's not just about storytelling. It's about *telling*.

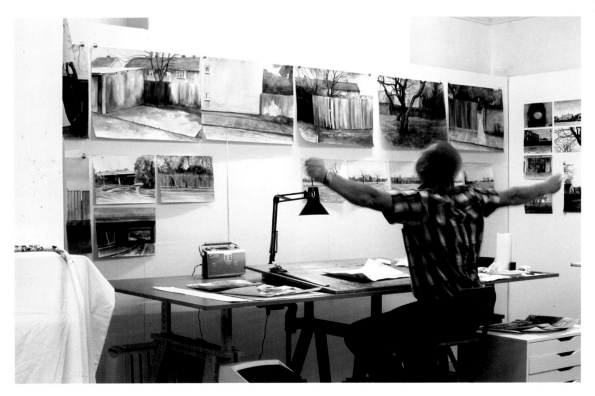

George Shaw (previous spread) paints dilapidated landscapes of his childhood with high-gloss Humbrol enamels used by model makers: 'One thing I can't do is share a studio. I can't stand other people. I don't want them anywhere near me when I'm working.' Shaw lives and works in the same building in Ilfracombe, Devon, working downstairs in an abandoned shop and living upstairs with his girlfriend. The artist (opposite) at his desk, his sketches and photographic images slowly transforming into paintings.

Shaw (above) photographed in 2011 against the spectacular Devon coastline: 'I tend to meet people who are uninteresting, who haven't done anything interesting in their life whatsoever. Yet I'm fascinated by them, or they're the people I love.' Shaw keeps a memory bank and archive of childhood paraphernalia in his studio. 'When I was a youngster, I wanted to be an artist, to be famous.'

Ged Quinn

You've been described as one of the most entertaining artists in Britain. Is this an apt description?

I don't seek to entertain. It's like a complex, layered dialogue, like trying to find solutions to problems I'm setting myself. I don't think of art in terms of entertainment at all. You can have the jest; you can have the serious jest that takes you into different territory. But I don't set out thinking that I'm going to put on a show. I like work that has generosity. Where there's a lot to look at, there's a lot to think about; you can bring a lot to it of yourself.

What I like is to find an intellectual space in which to work. Take Claude Lorrain. There is a lot of artifice in his work because he was transmuting an environment outside of Rome that was quite a hostile landscape. He was projecting his imagining of what Arcadia was like. So there are interplays of reality and unreality going on.

Were they tongue-in-cheek or ...

They were deadly serious. He was painting environments for gods to live in, or biblical characters. That was quite interesting, that he'd alter the landscape to be worthy as a home for gods and angels, that he developed the notion of longing in landscape through his use of light, through sunset or sunrise. I find it interesting that this was artifice, that it was a construct. I wanted to bring this kind of approach back and introduce contemporary imagery into it in a harmonising way, not in a collaged way. Then I got into Romanticism. Again, the ideas behind that are a fertile area to meld with twentieth- and twenty-first-century concerns.

Is there a link between your art and your childhood?

Inevitably. I was the youngest of four, and I lived in a slightly unreal place because of that. I escaped attention, coming at the end. My parents' desires were very much for their older children. That gave me a lot of freedom. My parents were working class, so their desires were for safety and security, nothing more. I recoiled from that. It didn't seem to be fulfilling, the occupations they would have selected for their children: teaching and accountancy, those sorts of things. Which, even from the age of seven, seemed far from where I wanted to be. What I liked was the freedom of the mind to wander, to be left with your thoughts. At school I was the only person in my year who did art. I had this enormous Victorian art room. Inadvertently they'd given me this studio for myself because I was the only one taking art. I spent a few afternoons a week, when everybody else was

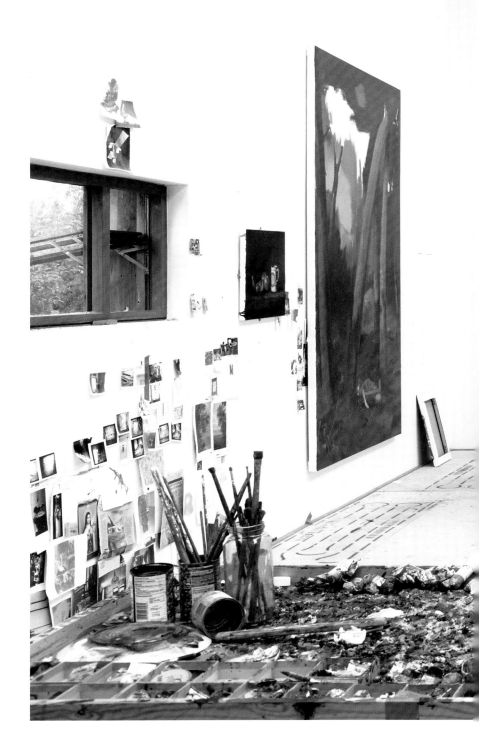

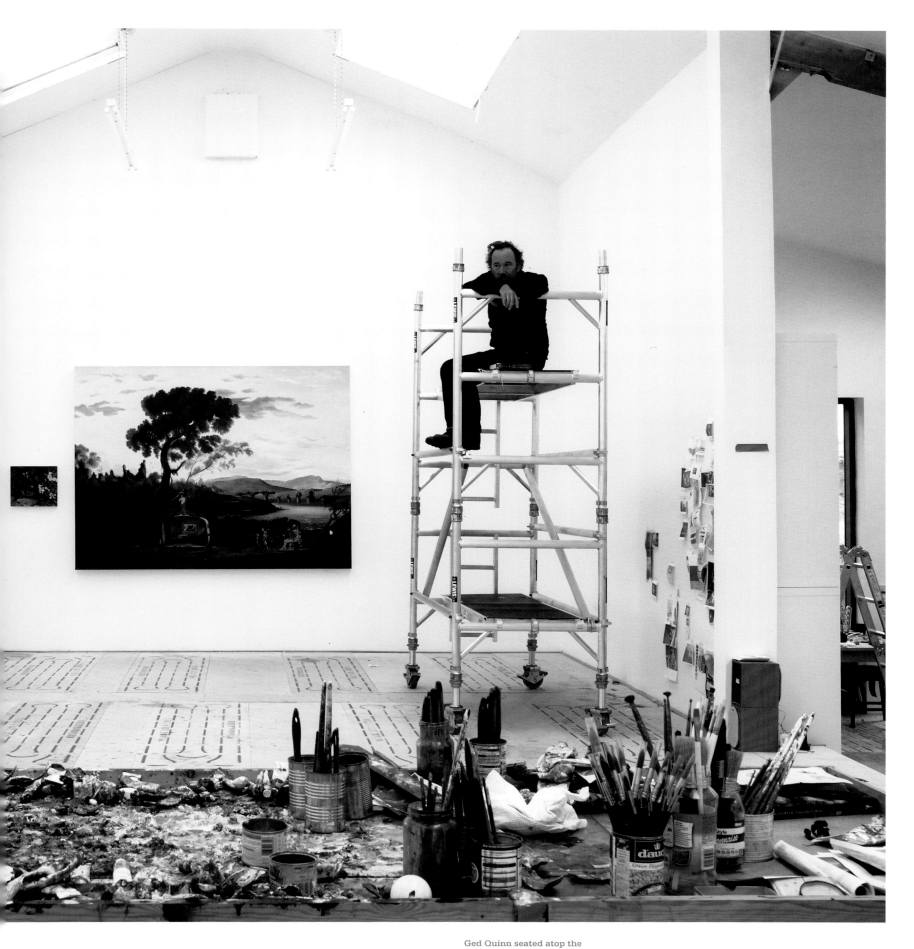

Ged Quinn seated atop the
scaffolding he uses for his
larger paintings in his studio
in Penzance, Cornwall,
photographed mid-June
2011. The studio is a large
converted cattle barn.
'I've had so many studios.
I've worked in bathrooms,
with a board on the bath
to create a desk; I've worked
in sitting rooms.'

doing physics, going through old art books, teaching myself. I became closely engaged with the practice of drawing.

So at home there was solitude, and at school you were in a secluded space. And now you've chosen seclusion in Cornwall.
I've had enough of cities. Art has made me live in cities my whole life.

But why Cornwall?
I'd been there as a teenager, aimlessly hitch-hiking around the country. Cornwall is at the end of the road. If you are just travelling and you don't mind where you're going, you reach that point and you can't go any further. It's got beautiful landscapes all around it. It's quite a gritty environment. There are a lot of extremes – extremes of weather, extremes of light – and that fantastic feeling of being on the edge. It looks out towards America. You've got this endless ocean. The whole idea of the Celtic fringe, of the architecture informed by the early Celtic saints: I thought that was interesting.

Were you ever caught up in the YBA scene?
No. That was just starting when I was in London. It was the trigger that made me remove myself. All of the artists realised that something was happening. They all craved success. It made everybody anxious in case they missed out. There was a lot of intellectual positioning going on. You'd see something, and – rather than just make your own work – you'd think, Should I be doing this, or should I be doing something else because I've seen this?

You mentioned Claude Lorrain. When did you first came across an image of his work?
I'd been aware of him for a long time and regarded him as old-fashioned, brown, unrealistic. The concept didn't have any significance for me until years later. There was this natural period when modernism was digested through Postmodernism, and a lot of artists started to look at utopian orthodoxies and deconstruct them. The visual embodiment of those ideals stretched right back, and that interested me because it brought in the notion of museum orthodoxy and the canon, the way that art history is taught.

Going back to the question of solitude, you've been described as 'reclusive and distant'. How does that inform your art?
I don't know. I was reading about Terrence Malick. He is described as being reclusive because he doesn't live in Hollywood. People who live around him say he's not reclusive at all. I'm not reclusive. I just live where I live and I've got a nice studio. It works for me.

Was mythology part of your fantasy world when you were growing up?
Yeah. Myth is all around us; it's developing all the time. I'm interested in cultures that produce myth and in why they produce them – the needs they have to produce them, to cohere around them, or to order things, or to make them into emblems.

Are you a political artist?
Yeah, but not in a programmatic way. It interests me.

The artist (left) lying atop the Geevor Mine, once one of Cornwall's largest tin mines: 'I've had enough of cities. Art has made me live in cities my whole life.' Art and artifice (opposite) atop the artist's desk, the skull having a central place. It is striking to see the number of artists who display skulls in their studios. 'What I like is to find an intellectual space in which to work. So there are interplays of reality and unreality going on.'

What do you contribute to mainstream thinking? Are you ahead of history?

I don't think so. I'm just somebody on the sidelines saying, 'You're getting it wrong and it doesn't work.'

But you are a recognised artist, your artwork fetches high prices, you are shown internationally. So your voice carries.

Do you not think you can be out there but still stay on the sidelines? I'd be embarrassed if I thought there was a message in my work. There's meaning, but I don't think there's a message.

Do you believe that contemporary art affects political thinking or interrupts it?

It's a hard claim to make. It's one of those questions that isn't answerable because you can't run a control. The best I'd say is that it's a component. Its tenor is generally liberal, imaginative, so it's a good place to start. It's always difficult to use moral terms about work, but if it reinforces good, progressive values, it must be a good thing.

What about your process? Where do you start?

I start with looking at an image and maybe reading about its background in a fairly academic way – I do background research. Initially there is a response to the work. I think, Yes, this would make a good painting.

Do you ever consult others during the process of painting?

Only through text.

And what is the role of your studio? It's rather grand and well built.

It's a hay barn and a cattle barn together. I've had so many studios. I've worked in bathrooms, with a board on the bath to create a desk; I've worked in sitting rooms. I like working from home; I like to get up and go straight to work. I'm up at 6.00 in the morning; I don't like facing the world before I face my art. I remember reading about Gustav Mahler … His maid used to have to use the rough track through the woods, carrying his breakfast the long way round to make sure he didn't meet her on the path on his way to work. I'm not like that! But I do like this to be the first thing I think about each day.

Is your studio a sanctuary?

A sanctuary and cell. It's both, isn't it?

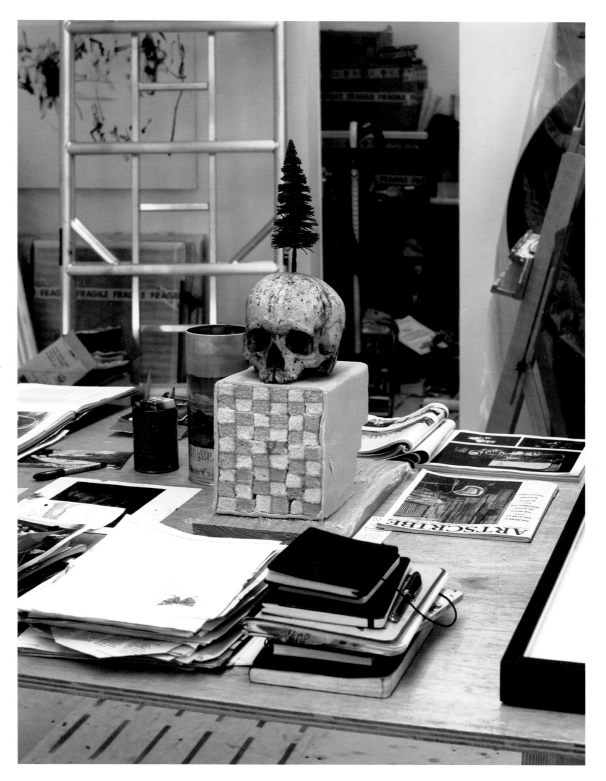

Sarah Lucas

You've observed that 'there's a lot of magic out here' in Suffolk, where you live, and that you find it hard to see things in London whereas here you manage to see more.
There is certainly a lot of magic. I suppose it's being around nature, and being aware of the weather changing all the time. There are things you don't notice in the city, not to the same extent. It's very stirring of the moods. That's the magical part.

How much time do you spend in London?
The last four years have been almost entirely here. I've started a whole other life. Not that my life in London has gone away. I've become involved in Snape Maltings. I've always liked classical music, so that's a developing thing. I suppose I've gotten to know more people working on the music side.

Do you listen to music in the studio?
Yeah. In fact it was music that first brought me up here. The house belonged to Benjamin Britten and Peter Pears. I wasn't actually looking for a house; I came up because I was curious. Having this cultural dimension to life makes a big difference. It's exciting. There are things going on all the time.

Suffolk seems to have been a breeding ground for productivity and artistic effervescence all the way back to Constable. What is it about this place?
I don't know; that's why I describe it as magic. A lot of people do residencies here. A lot of people come here like I did, part-time or for a particular reason, and are grabbed by the whole thing and stay for longer or permanently. It is actually very convenient for London; it's not so far away.

Has Suffolk changed your work?
It's always tricky, that kind of stuff, because most influences are unconscious. It's the question you always get asked, and all the answers seem to be false because the real thing is going on unconsciously. And the work will change anyway.

But you've said that your work is in many ways about your ideas and yourself.
I've always felt strongly that I wanted my work to be a part of my life, to be a way of life, not a job. Everything affects it.

It's interesting because you're part of a gang, some of whom have gone down the commercial route, the production route, with huge industrial units …
And loads of minions!

So there's that, and then there's you …
I do have people help me from time to time, friends usually. I suppose I see that as a more collaborative thing. I'm not comfortable with having authority. I don't get up every day and work in a 9.00-to-5.00 way, so I couldn't put myself in a position of somebody else doing that. It doesn't work that way for me.

How do you mesh with the local community?
My neighbours are farmers, and I get on tremendously well with them. They've been proper old farmers for generations. When we first got the house for weekends, I remember thinking, What the hell am I going to do up here? Well, the whole thing has just unfolded. I feel quite adopted, actually.

One always thinks that contemporary art is in the present or the future, but by being in the country somehow you're reversing the trend. You seem to be nourishing your practice from the past and from your way of life.
My next exhibition is with Gelitin. I got to know them a few years ago. We're making the entire show in Austria. So I've been to Vienna and then they come over and stay here for the weekend. It's very private. You've got the magical thing of having the whole place to yourself, with no distractions, and of being with the people you want to get down to it with. It's a different social scene to London, where you're out all the time, and you're seeing lots and lots of people, but you're not spending that much time with them.

It was interesting to see that Michael Craig-Martin had a big role in getting the idea for *Snap* off the ground.
Yeah, he prompted it! A few other people were here last year who had been students of his at college and who live in Suffolk now. And he's good friends with Dennis Stevenson, who has run Aldeburgh Music for years. They were both trustees at the Tate. Michael told Dennis that he thought it would be a good idea to get something organised with all the people living up here. Dennis was enthusiastic, so the idea took off.

It takes art out of its elitist environment. You can have that connotation in London, whereas here, you're almost democratising, making it available to the rural community and possibly involving them. Do you feel that it's had a positive effect?
I think that it has. There are a lot of small art groups and art spaces. People are quite open-minded here. It's fantastic to have open days for people who come here to shop and who otherwise wouldn't visit unless they were classical music fans.

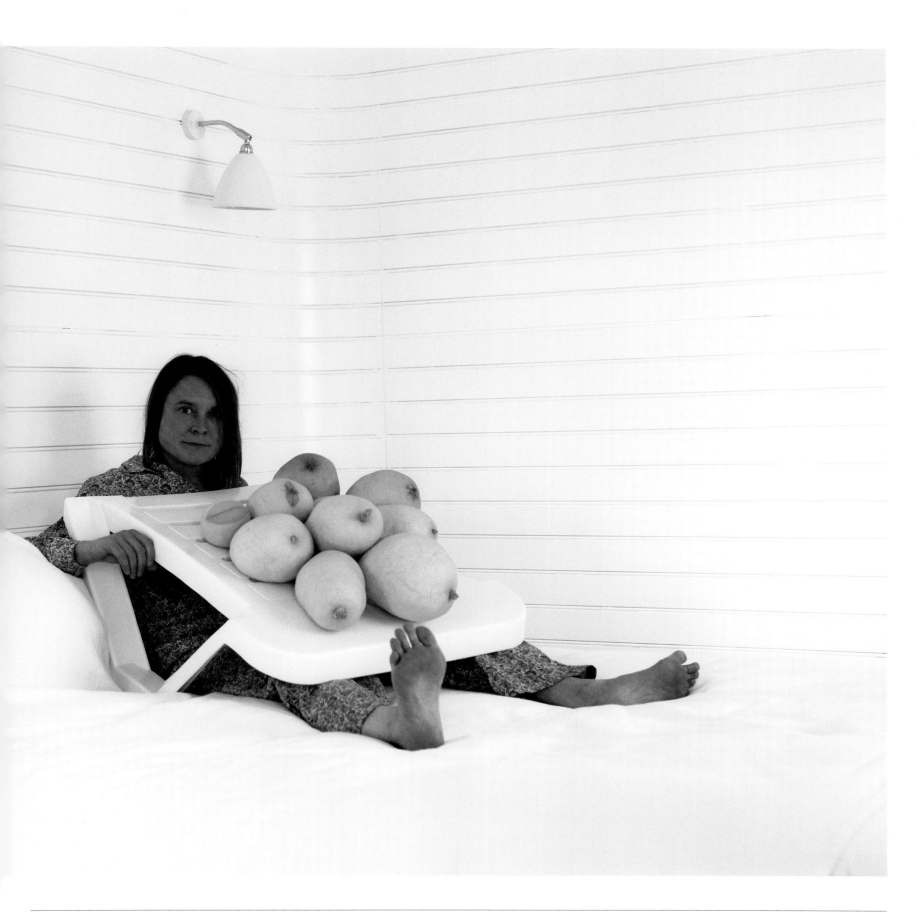

(previous page) **Sarah Lucas** with her work *Artist in Bed* in residence at the St John Hotel, London, during the Frieze Art Fair (October 2011): 'Having this cultural dimension to life makes a big difference. It's exciting. There are things going on all the time.' Lucas has a small studio – in fact it's a shed in the garden.

Where do you actually create your work?

I have a small studio; it's a shed in the garden. But I always tend to work at home, on the kitchen table. From time to time I have studios … I'm thinking I might get something bigger.

What does the studio space mean to you? Is it a sanctuary?

That's why I like to work at home. I like to be doing a bit of cooking, and I like to go away for something and come back. I like to do all the things I do at once. A lot happens when you're making things when you're not being too overdetermined about it. You can have an idea and rigorously try to execute it and you get something, but nothing's really happened. What often happens is that while you're doing something else, it gives you space to think in. Seeing something out of the corner of your eye might trigger something that hours of concentration won't. Those sorts of moments are important.

It's also a domestic environment, and you tend to integrate a lot of domestic objects into your work.

Yeah. I work on a domestic scale generally speaking. Again, that's because otherwise you have to start getting equipment and all these kinds of things. I like to be quite direct.

Having this domestic dimension of course brings up the gender issue …

It's again the circumstance of being in the country, and I unavoidably am a woman, so of course that's got something to do with it!

How important is it to have a woman's voice?

At a certain point, I realised that I'd made it more of a positive thing. Now I've got the option that it doesn't always have to be such a positive thing.

What is your role as an artist?

I thought about that when I was doing my early self-portraits, because I realised that you're making some sort of point by the way in which you present yourself. I didn't want to become some sort of caricature of myself. Which is another thing … moving to the country has allowed me to relax, in a way to be more feminine. It was a necessity, being tough in the city. I'm a bit less clear now, I think, about how this appears to other people than I was then. It doesn't matter so much.

Should art be political?

There's a soft kind of political-ness in everything you do. It's more of a vibration of what you want to give to somebody. Even if you're cooking for someone, there is a message in a way, but it's not a political statement. It's more how you feel.

Do you have an audience in mind when you make your work?

Oh yeah. I think about it, not pointedly, but I like things to be quite explicit, quite graspable by most people. I don't feel that they're actually working until they arrive at that point of explicitness. That's to do with me not coming from an art background. It's important to me that things make sense. Not that I'm for being lowbrow, but it doesn't have to be mystifying or obscure.

Who are your artistic heroes?

I like Franz West a lot. He's probably my favourite. He's generous and democratic about involving other people in his work. I love the work and I love the fact that it has that broader dimension.

And Surrealism?

Of course! But again, that's more sublimated now. It was stronger when I was younger.

Scale and sky and light: are they important to you?

It's all to do with wellbeing. Listening to classical music at home adds another dimension.

You've said that you reconnect with people you know as if by chance. Is that part of the magic?

That's definitely part of the magic.

Lucas in mid-June on the grounds of Snape Maltings (above), near Aldeburgh in Suffolk, where her works (top left) are part of an exhibition. *Snap*, an exhibition organised by Sarah Lucas and Abigail Lane as part of the annual Aldeburgh Festival, has been successful at mixing art and music. Lucas with Michael Craig-Martin, her former tutor at Goldsmiths (opposite). 'Most influences,' the artist claims, 'are unconscious.'

(following spread) Lucas, who is based in Suffolk, walks towards *Perceval*, a life-size painted bronze sculpture of a Clydesdale workhorse pulling two large marrows cast in cement – a replica of a popular mantelpiece ornament. This 5-ton sculpture is the artist's first and only piece of public art; she was encouraged to create it by Damien Hirst. *Perceval*, on display for six months during 2008 on New York's Fifth Avenue, now put to pasture on England's green and pleasant land.

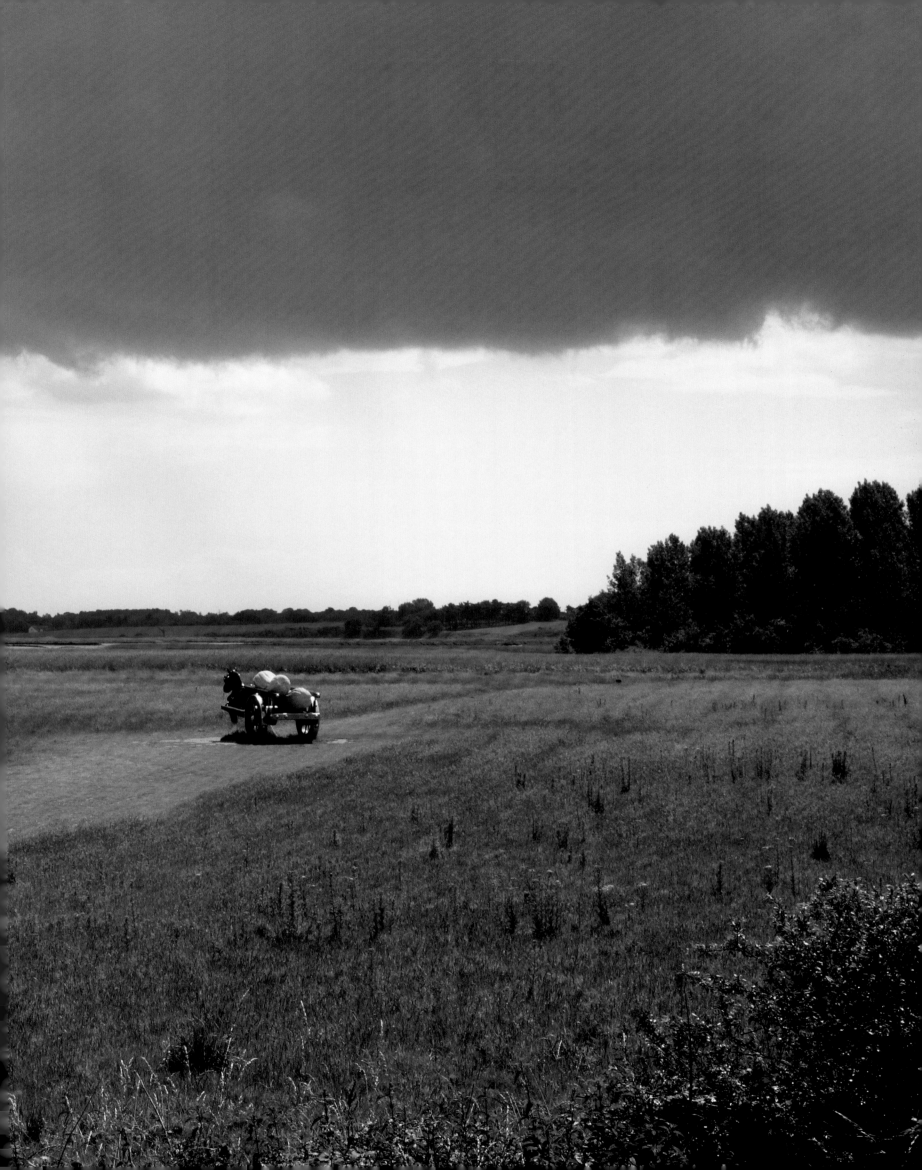

Martin Creed

Martin Creed in his Brick Lane, London, studio, in mid-June 2011: 'I don't mind what people call me, but I wouldn't want to be called one thing in particular. I don't like using the word *artist* because I don't know what art is.'

In an interview, the BBC described you as a 'singer and artist'. Shouldn't the artist encompass the musician?

I don't mind what people call me, but I wouldn't want to be called one thing in particular. I don't like using the word *artist* because I don't know what art is.

But you have been in the art business, or whatever you want to call it, for a long time. You should at least have some sort of idea about it. Or maybe at the end of the investigation it gets more and more unclear, the further you venture ...

It is much more unclear now. When I went to art school, I did question what art was and what it wasn't. Now I think that there is no big difference between making a painting and going to a shop and buying a loaf of bread. Both are involved with moving your body and making decisions.

But not necessarily with making a record of doing so.

That's true. But if you go down the shops and someone sees you, they might remember. That is a record. Everything is a live event because the people who experience it are alive.

You started numbering your work, so there is some sort of record there. What was the number 1 work?

There is no number 1. At a certain point I wanted to take away the need to have titles. I didn't want to have 'Untitled' either, because that is also a title. A simple process of numbering seemed a good thing to do. I took the idea from classical music because I grew up playing violin, so I knew about the opus numbers of composers. There is no number 1 work because I was self-conscious about it when I started out. I thought, I can't have a number 1 because I wanted all the works to be equal.

A number 1 would be too special ...

Aye. Also, I started numbering at a certain point, but before that there were other things that I made when I was a kid and stuff. So I started with number 3.

It is very hard to pin your work down. You seem to move from one thing to the next, so these numbers seem to stabilise the situation.

Exactly. I wanted a way of treating everything the same. I like doing as many different things as I possibly can, because I don't know what I really want to do and feel like I am just looking for things.

As you've done more work, has it become difficult to find things that excite you?

Difficult isn't really the word. The more I work, the more I have to work to make up for the work I have done, because it never seems good enough.

So it's an evolving process ...

It is probably an addiction as well. One thing that I don't want to do is stop. When I stop, I get scared; I feel like a loser; I feel shit. Working is a way of avoiding that feeling.

That pressure seems entirely self-imposed, no?

I feel pressure sometimes from other people, but I want that pressure because I would much rather have someone demand something of me than not. Because I want to be wanted. If you sell work and then people buy further works, there is a natural tendency to want to keep doing that, to give people what they have wanted. That can lead to treading water, doing the same thing and not changing because you don't want to lose the niche. There's nothing wrong with that, but comfort is a great danger. To me, comfort leads to sitting on a sofa, eating biscuits and watching TV rather than doing stuff. When you are comfortable, what do you do? The thing to do is find a cliff, jump off it and start swimming.

Germaine Greer said, 'Martin Creed is the greatest minimalist.'

I really like Germaine Greer's writing, but I think that I am an expressionist because I think everyone is an expressionist. All artworks are expressionist objects.

You are also involved with ballet, aren't you? How did that come about?

Ballet is a mixture of things. In a way 'ballet' is not a good title for the work because although it contains a lot of ballet and dance, there is a lot of music and other things going on. I think of it as trying to make a work that is truly a mixture of music, dance and talking. So it's bits and pieces, it's a bit jumbled up, it's a bit improvised, but the dancers are very, very central.

The ballet came about from the running piece I did at the Tate. If you think that dance is movement, moving your body as fast as you can is a simple dance. That's what the running piece was. The idea was that people moved as fast as they could, sprinting, basically. I got invited to develop a piece by Sadler's Wells. I had the chance to work with some dancers to try out my ideas.

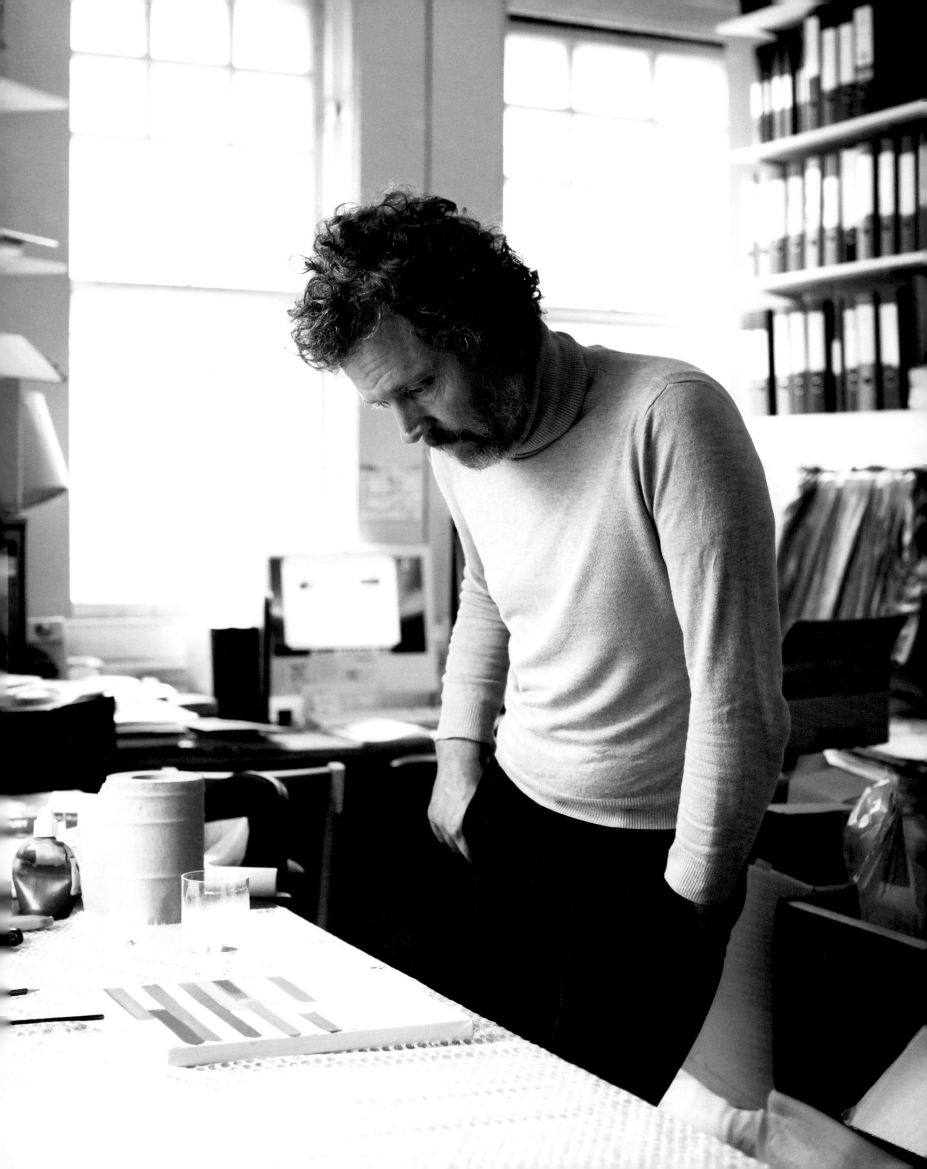

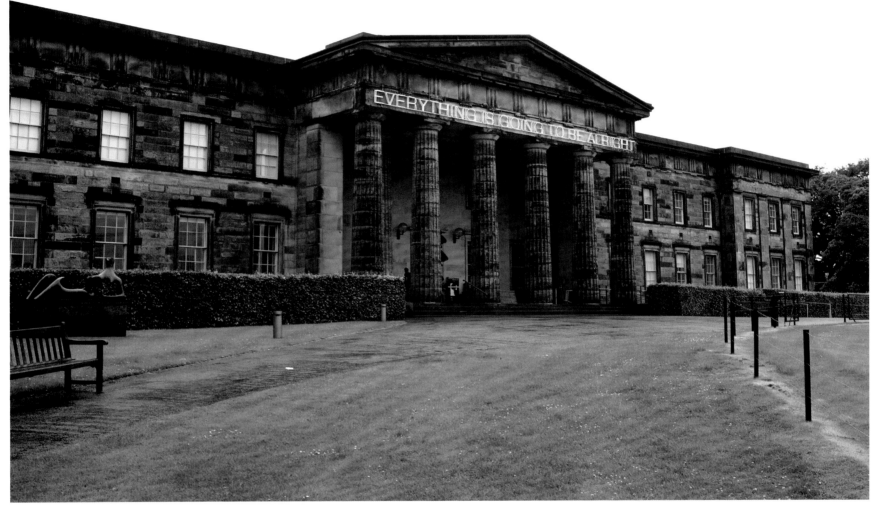

Creed's *Work No. 1086 | Everything Is Going To Be Alright*, an installation at the Scottish National Gallery of Modern Art, Edinburgh.

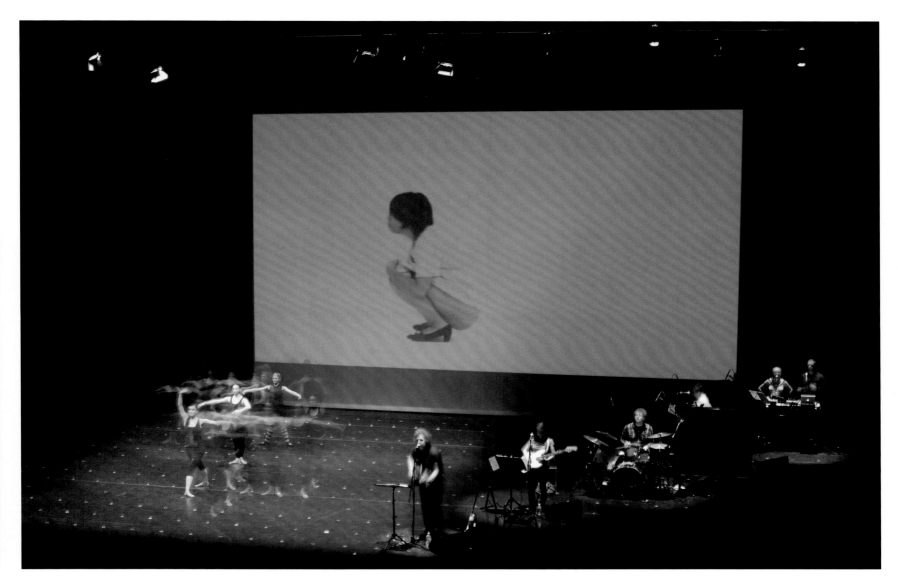

It seems like a natural combination of your art, your music and your interest in movement and performance. In a way, ballet, or doing a dance piece, seems quite a logical step.

It does to me. It is a chance to combine elements that I work with a lot. It also contains film, because I do scenery – well, there isn't really scenery, but I do all the visuals, some of which are film works.

You came to London to go to art school, is that right?

Yeah. I came to go to art school at the age of seventeen in 1986. The people just ahead of me were Damien Hirst and Gary Hume and all that lot. I knew some of them a bit – Gary Hume and Sarah Lucas and Tracey Emin – but I was younger so I wasn't quite in that set. But I benefited from their success, because at that time there were shows of British art all over the world. So being British was an advantage. Things are very different now.

You are very much rooted in London at the moment. Can you imagine working anywhere else?

In terms of places where I'd like to live, I'd like to go to Los Angeles. It feels a bit like the end of the world. I like the people. It's laid back. But everyone – with the movie industry being there – everyone is pursuing this dream. Even so, it seems like in LA there is still an old outback thing, with weird people living in the desert doing what they want, as if it's a bit lawless. It's like everyone can do what they want out there.

And that attracts you?

Aye. I think it's brilliant.

Creed (above) on stage during rehearsals for *Work No. 1020* on 21 June 2011 at Sadler's Wells Theatre in Angel, London. Creed's ballet, a mix of movement, song, talk and film (including some of his notorious vomiting and defecating films), resulted from his study of movement in *Work No. 850*, where runners sprinted the length of Tate Britain at intervals. 'Comfort,' the artist says, 'is a great danger. When you are comfortable, what do you do? The thing to do is find a cliff, jump off it and start swimming.'

Mike Nelson

Does art always reflect the personal experience of the artist?
No. It's important that work engages in something which reflects the world that other people live in as well as one's self.

Is that something that you consider when you make a piece of art?
Of course, even though I am quite careful to try and make works that are not too prescriptive.

You've said that you never visit your own installations ...
I do, but not when they're open. I go back to photograph them, and I spend quite a bit of time in them, but I don't like being inside them when the work is open and populated by visitors.

The work doesn't have any spiritual pretensions, does it?
It depends what you mean. In the '80s it was very theoretical. If you uttered the word *intuition* in college in the '80s you would have been laughed out, yet there is an intuitive aspect to my work. But it's not something that I am deeply concerned with.

When you embark on a piece of work, do you develop it intuitively or do you consider the structure beforehand?
I tend to start off with an idea, and I'll probably develop it both as a narrative and as a physical structure. I will work on that in terms of drawings, but I'll also be collecting and looking for material, finding other stuff which somehow might tie in as well. It's structured and loose at the same time – I know *what* I want to achieve but not always *how*.

So you are physical; you are able with your hands.
Yes. Nothing goes into a show that I haven't chosen. I tend to find every piece of wood, every object, for the exhibitions.

You have been an itinerant traveller. Does world culture inform your work?
I was brought up in the Midlands. I didn't travel until I went on a French exchange when I was a teenager. When I was at college, I went to Turkey. There was a sense of difference then; in a way it's almost disappearing now. I found it incredibly intoxicating, almost disorientating, that level of difference in a place like Turkey then. The immersion in the sounds and the smells, the visuals and the heat of another country: I had never experienced all of that before. Later I travelled a lot in Morocco, Egypt, Syria, Pakistan and China.

Were you influenced by the Islamic world?
In the '80s, when I first went to the Middle East, you were aware of societies based on something seemingly completely opposed to the one you were coming from, on something completely different. In the mid-1990s I described it as a poor man's exoticism, a backpacker's orientalism of sorts, somehow the end of the equation where the colonial impact of Britain and other such nations had been acknowledged. I was interested in making work with this subject matter even in the late '80s for my BA course. It was highly problematic because there was an argument about ownership in terms of who could articulate this sort of subject matter. A shift of sorts has occurred with globalism, making articulation about cultures possible from other perspectives. I found the ability of mosque architecture to move you far more successful than, say, Western church architecture. Then the Gulf War happened, and on a cultural, political level you could see that something was going to shift. For example, while travelling in Pakistan around that time the older men were quite pleased to meet you, but among Pakistani boys and teenagers there was a great deal of antagonism towards the West. It was easy to see why from their perspective.

Shifting back to the present, the contemporary art scene inevitably has its glamour, doesn't it?
If you engage in it, yes, it has.

You don't buy into all that stuff?
Buy is an awkward term. It's not wholly appealing.

You were twice nominated for the Turner Prize and you've had work in the Venice Biennale. Did you ever imagine you'd be here today?
Never. Now it just feels normal. The sad truth is that no matter how glamorous it might appear on the outside, it's almost as if the floor moves up with you. I was more stressed about my first show at Matt's Gallery than I was about Venice. It doesn't really change. You are worried about making sure it works, you are fearful of failure – failure in the eyes of your friends – whether now with the work for Venice or when you are twenty-six and showing in the East End of London.

Have you ever had a studio?
I had a front room that I used as a sort of studio/office when I lived in Balham years ago. I rented a rundown house from a Bangladeshi doctor, Dr Hakim. I always say that Dr Hakim was probably my greatest patron because the rent was so cheap. He came once a year for two weeks and we'd be cooking lots of food,

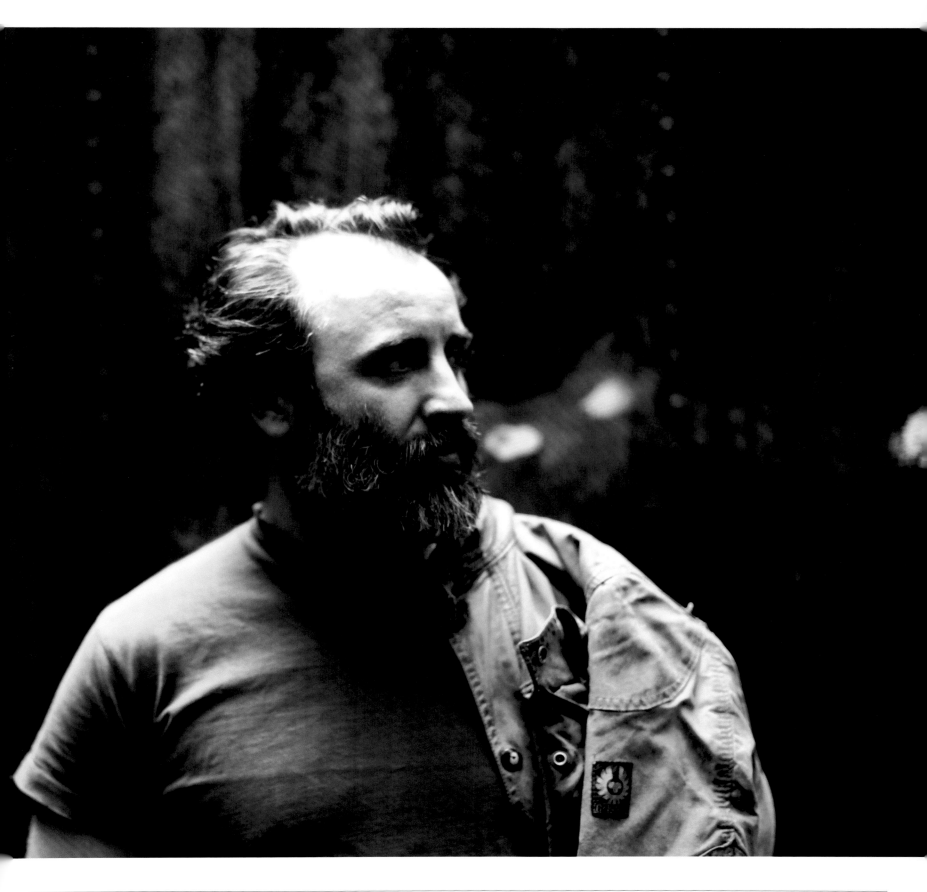

(previous spread) Mike Nelson near his home in Sydenham Hill, South London, in late June 2011. 'I had a front room that I used as a sort of studio/office when I lived in Balham years ago,' he muses. 'I rented a rundown house from a Bangladeshi doctor, Dr Hakim. I always say that Dr Hakim was probably my greatest patron because the rent was so cheap.' Nelson does not presently work from a studio.

(left)
The Coral Reef, 2000
Various media
Installation view at
Matt's Gallery, London
Tate Collection, London
Photo: Mike Nelson
Courtesy the artist; 303
gallery, New York; Galleria
Franco Noero, Torino; and
Matt's Gallery, London.

(below)
I, IMPOSTOR, 2011
Commissioned by the
British Council
Installation view,
British Pavilion,
Venice Biennale 2011
Photo: Cristiano Corte
Courtesy the artist; 303
gallery, New York; Galleria
Franco Noero, Torino; and
Matt's Gallery, London.

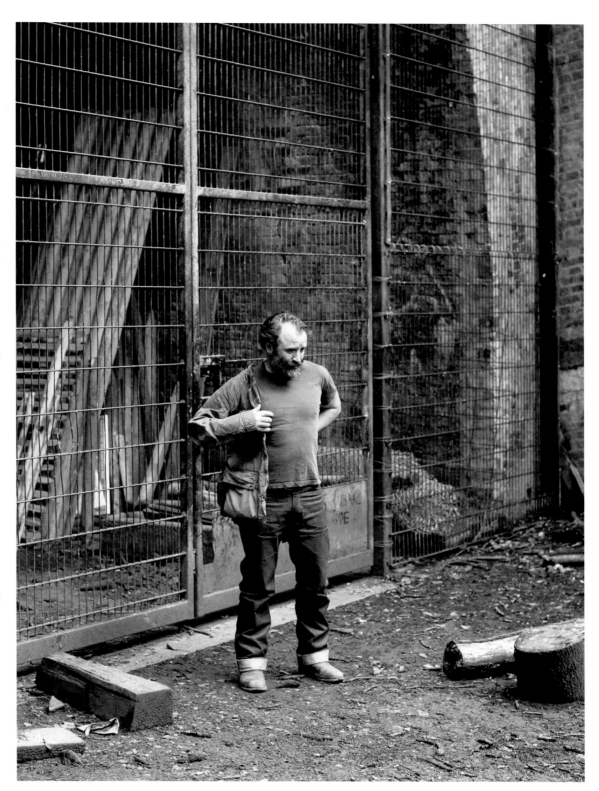

making lots of roll-ups, taking him shopping and being taught the origins of the British Labour Party. He was a lovely guy. When I moved out of that house, I was sad to lose that room even though it really wasn't a studio. I rebuilt it as part of an exhibition in 2004.

I probably will get a studio now because I can't fit my tools into the house any more, or into the garage. They get shipped out to where I am working and then we build on site. Maybe it's just a financial thing, keeping it light in a sense. I have so many friends who seemed to spend their lives working to pay for studios they couldn't afford.

There is great physicality in your work. What interests you most, the physical process or the final product?
A bit of both.

In 2010 the *Guardian* described *The Coral Reef* as being 'blatantly one of the true masterpieces of modern British art' …
That's one person's generous opinion. It's a good work in terms of what I've made. History has been kind to my work when it hasn't been kind, perhaps, to other people. *The Coral Reef* is cited partly because of the events that happened subsequent to its being built. It was built before 9/11 and it's right to be read in that context, but at the same time it's an unfortunate accolade.

Does it requires some sort of obsession to be so convoluted in representing what would otherwise be seen as banal, ordinary, everyday objects or places?
Yes. But some are everyday, some are not everyday. However, you would not say that of a good history painting or still life from the nineteenth century. There is a possibility for formality or poetry with stuff. You can articulate things in a way that makes them something beyond the sum of their materiality.

How would you like to be remembered?
It doesn't really matter. I sometimes think no or little contemporary art will be remembered to a greater or lesser degree. That is, if the prevailing culture continues in the same fashion.

Nelson out hunting in a park near his home. 'Nothing goes into a show that I haven't chosen. I tend to find every piece of wood, every object, for the exhibitions.' He believes that little or no contemporary art will be remembered. 'That is,' he adds, 'if the prevailing culture continues in the same fashion.'

Paula Rego

Is it correct to say that depression has been a force in your life?
Yes, I've been very depressed. Touch wood, I'm not now. It helps when you work.

Are you driven to paint to escape the dark side, the 'black dog'?
I'm not driven to do it, but habit is a good thing. If you pick up a pencil and look at something and draw it, that cheers you up.

At what time do you come in to the studio?
I haven't been very well so I've been coming in a bit late. I stay for nine hours. Not every day but mostly.

When did you start painting?
When I was four. I didn't so much paint as draw. I drew under tables and things, as children do. I drew a lot for vengeance. If you're cross with somebody and you do their picture you can hurt it like you do your dolls, cut off their fingers or whatever, which I did.

As you grew more accomplished, was this still symptomatic of your oeuvre?
No. But sometimes I disagree with things in society and I try to do something to change them.

Do you care if your art is commercially attractive or not?
It's the subject that matters. If somebody said to me, 'Do a really commercial picture,' I probably would paint an abortion.

What is it about cruelty that fascinates you?
It's so unfair.

Surely that's the human condition?
People try and change it a little, and the more you change it, maybe it will change for the better.

Do artists have a role in creating change?
They can do. In the last century there were concerned artists who often were called caricaturists. I like Surrealism; the Surrealists were dissenters. I am very fond of Max Ernst, and I particularly like Pierre Klossowski, the brother of Balthus.

Where does your fascination with fairy tales come from?
They are folk tales from all over the world. I studied for six months at the British Museum, reading all the Italians and also the Grimms. The most violent of all folk tales are Portuguese. It's fascinating, really, because the Portuguese are basically obedient people.

Paula Rego, who uses pastels for most of her works, sits with her model of over twenty years, Lila Nunes. Nunes was brought from Rego's native country, Portugal, to care for the artist's ailing husband and has sat for Rego ever since. They are shown here in Rego's Camden, London, studio in late June 2011.

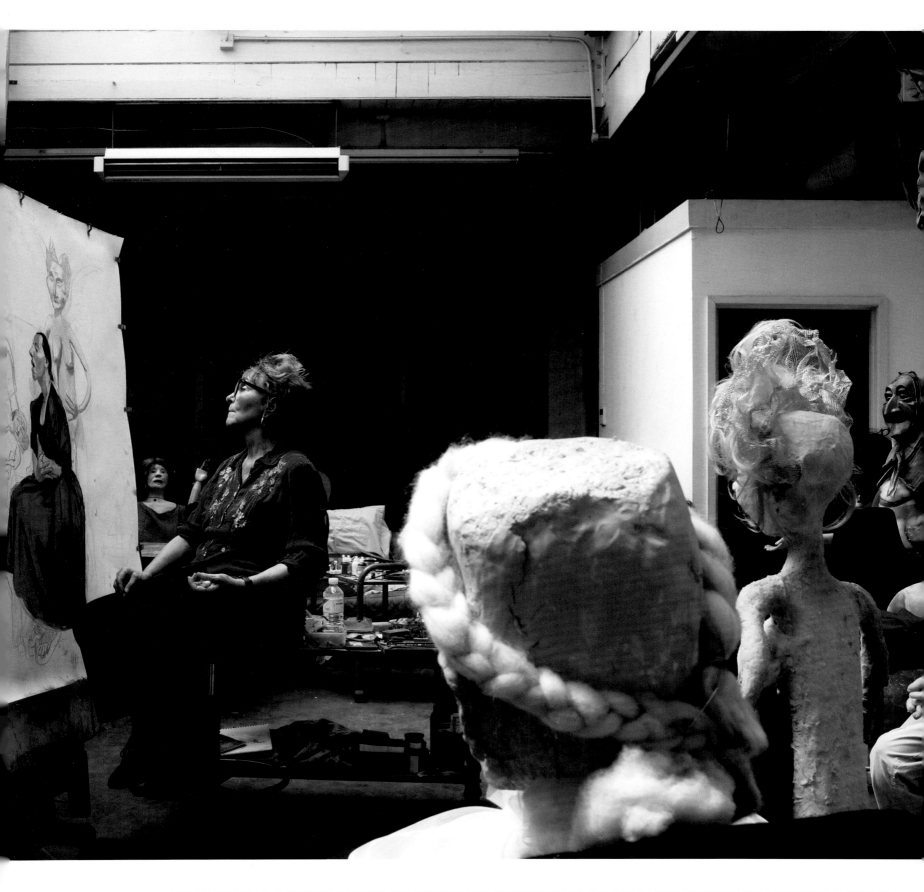

When I was little, I was always afraid of the dark. I had an old lady who had been my mother's nanny, and she came and sat by my bed and told me stories until I fell asleep. I loved that. Then I began to read them myself, stories of women who cut off their breasts to feed their husbands and stuff like that. Which is very Portuguese but is not very nice, is it?

Why did you choose England as a place to live and work?

My father sent me away. He said, 'Go away from here! It's no place for a woman, Portugal.' And it wasn't for men either at the time of the dictatorship; it was disgusting. So he sent me to an English school, and I've been here ever since. I like England. I'm used to it now.

You were married to a painter, and you had to organise your time efficiently. You've said that you had to shut yourself off from your children during the day so that you could paint. How did that relationship work?

My husband was much better than me, and I loved him very much. He helped me, although I already had done several pictures which had won prizes. He taught me about Surrealism. He taught me about all sorts of things, because he was more intellectual than me. Even when he was paralysed – he had multiple sclerosis – he would say, 'That is disgusting! Paint all of that out!' When I was in trouble and didn't know what to do, I could ask him. He knew about perspective. He was always right. When he died, I had to depend on myself.

How did you manage?

I gave up smoking.

The shock of his death must have been traumatic ...

No, it wasn't traumatic; he'd been so fucking ill for so long. It was a relief for him, you see. I spent six months painting a picture called *The Dance*, and I didn't have anybody to ask, 'What do you think?' Then I went to that place by the sea, near London, and threw my cigarettes into the sea. I never smoked again, and I produced the picture, and it's in the Tate now. After that, I went out and did another one, and then I did another one, and then another.

You've been described as one of the greatest living artists. How does that make you feel?

Depends who said it.

Do you feel that you are a bad artist?

No.

Do you feel that you are an artist at all?

Yes. I have good pictures, very good pictures, but I haven't yet done something that is really, really good. I'm hoping that I will live long enough to do something really, really good.

How many artists do you know who have addictive, afflicted souls?

I think that most artists are compulsive.

You've described your compulsion to paint and draw as a release from stress. You also look at it as a life-affirming act. Am I describing this properly?

Of course it is. That is living.

And without it you would be –

I'd be in an asylum.

How would you like to be remembered?

As a caricaturist. I like the obscene, the grotesque – the beautiful grotesque.

You've said that you like figures and the body. Your female figures are not dainty little things; they are present both in their attitude and in their physicality. Is this the portrait of Woman that you like to project?

Of course. Women can be tough if they are not too much in love. They should be tough *and*, if they're lucky, in love.

You haven't had an exaggerated life, and yet your pictures are the epitome of disquiet.

Well, if I had a very wild life, I wouldn't be able to do pictures like this. If I had a very wild life, I'd have to do very, very calming pictures.

So painting is your friend, your lover almost.

It just does what I tell it to do. That's quite good. It tells me things too.

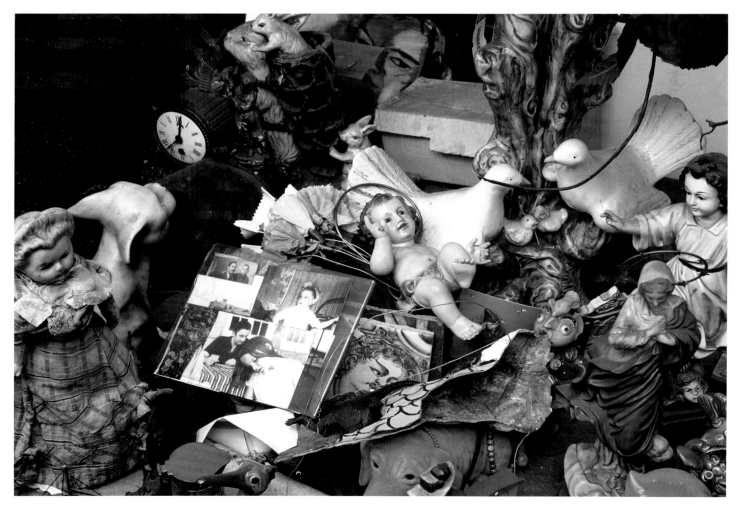

Rego's studio is filled with the papier-mâché characters she uses for models; it has been described as part little chamber of horrors. 'I drew a lot for vengeance,' she says. 'If you're cross with somebody and you do their picture, you can hurt it like you do your dolls, cut off their fingers or whatever.' Most artists, she adds, are compulsive: 'I like the obscene, the grotesque – the beautiful grotesque.'

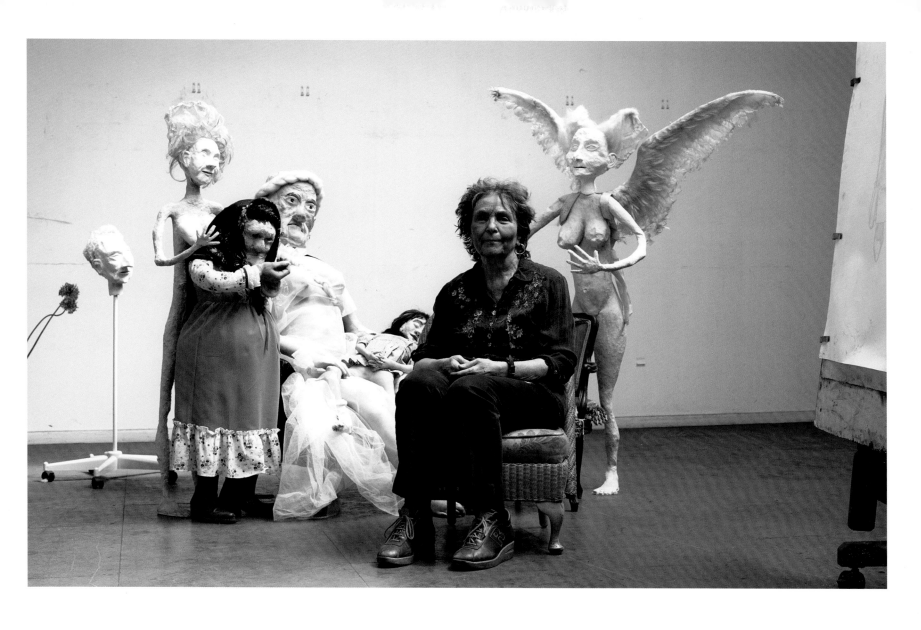

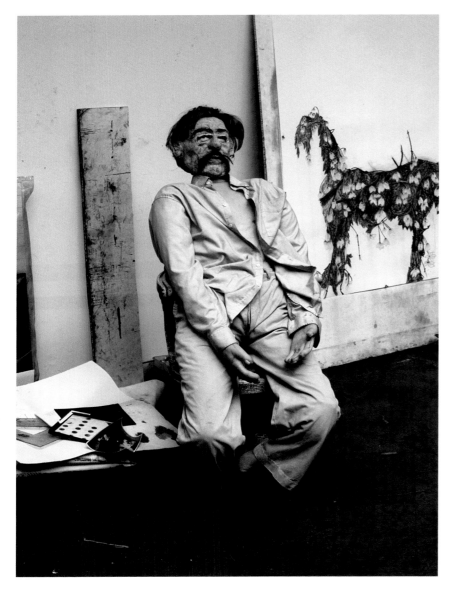

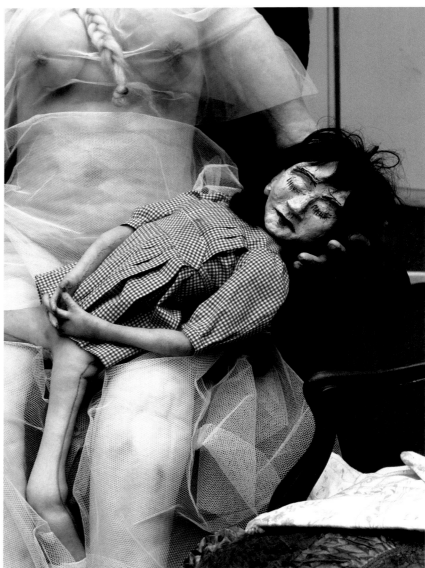

'It's the subject that matters,' Rego explains about her art. 'If somebody said to me, "Do a really commercial picture," I probably would paint an abortion.' Rego with some of her friends: the grotesque puppets, some life-size, which inhabit her studio. 'The most violent of all folk tales are Portuguese,' the Portuguese-born artist says.

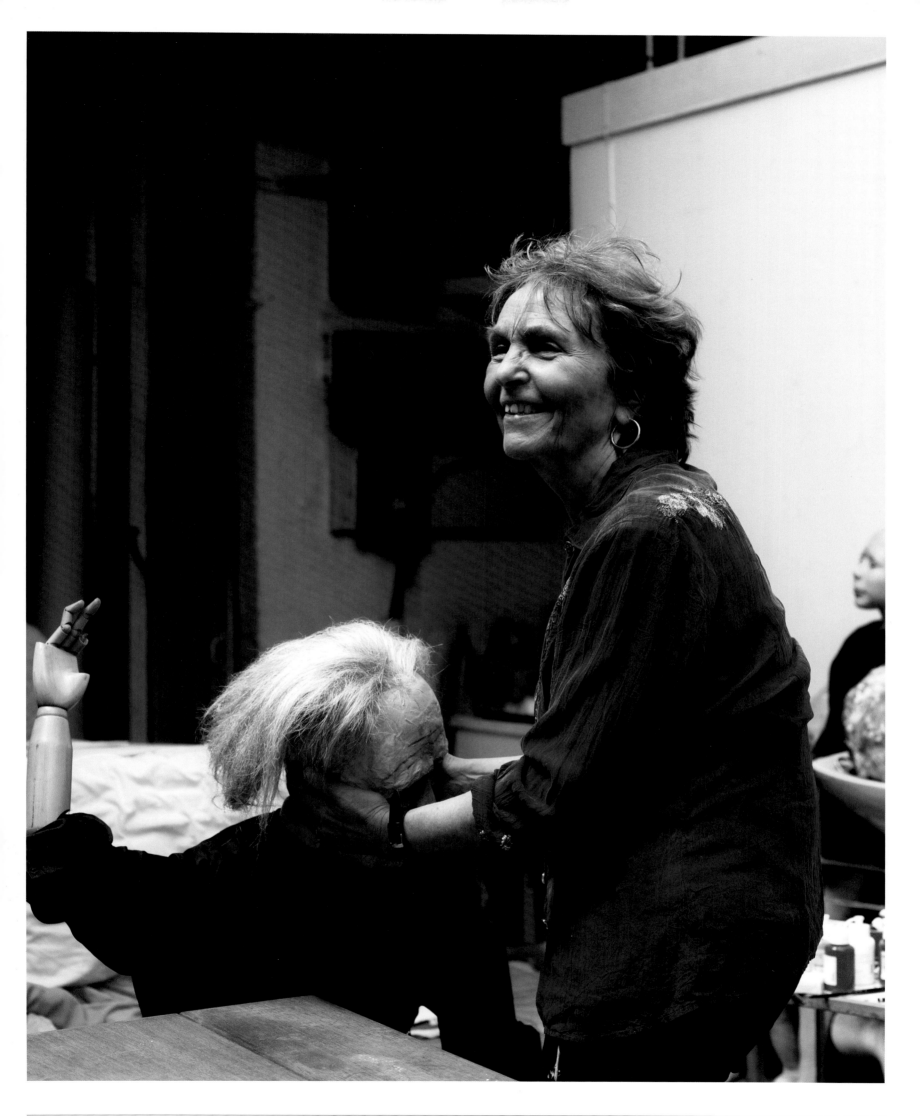

David Noonan

Can you talk a bit about your artistic process?
A lot of my process involves gathering images from various sources and then having them around, looking at them and how they relate to one another. Then there's the process of editing. But most of my work is collage, so it is bringing images together to form a new marriage or new scenario.

Is the selection of these images eclectic or methodical?
Both. I have a limited range of things I look for; otherwise it would be completely overwhelming. Often I don't know what I'm looking for until I see it. It's controlled happenstance. I set up fairly strict perimeters, whether it is my palette, sizes I work with or techniques, and then I look for images that will work within that context. I make one piece and that informs how other pieces are made to relate to it. The viewer bringing their own perspective to the work is quite important. I like how open-ended that can be. The pictures aren't about anything specific.

There's much more choice now for artists to do what appeals to them rather than feeling like they need to adhere to dominant forces in the art world. For an artist like myself, that is quite liberating. However, there is an element of nihilism to making art because it's a temporal thing. If you think about the history of art, so little remains; so much is stripped away. You only have to look through second-hand bookshop catalogue bins and you'll see hundreds of artists you've never heard of. When you think about longevity and your own practice, you can't be too optimistic.

When you create a piece, do you want people to think hard about what it is?
When I look at art myself, I'm thinking about it, but often you're almost not thinking and just letting it wash over you ...

What is the role of the studio in this production process?
It's critical. I start out with an idea and a sort of design, if you like. Then it's a matter of pushing it through processes in the studio. The printing process is incredibly variable, because I work on a large scale and so many things can happen. Aside from the screen prints, all of my other work, whether it be collages or sculptures, is made in a studio and by hand. I do as much as I can myself. I have an assistant who works with me because the pieces are difficult to move. I enjoy working with him; it brings something to the work. It's not collaboration, but it certainly makes the experience better.

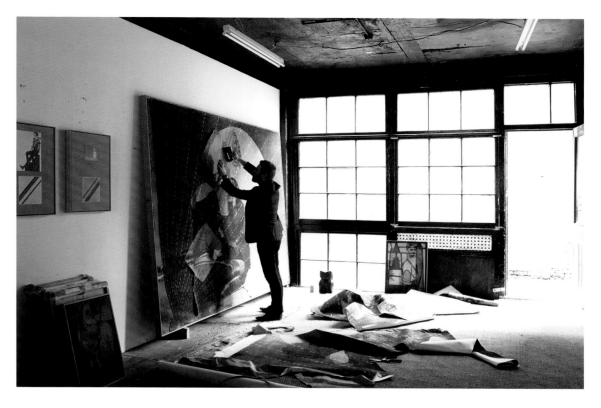

How does the experience of making art in Australia compare with the London scene?
In the studio context they are not very different. In the larger context, it's different because Australia is so far away. Australia has an incredibly interesting art scene, and quite a large one for the population size, but it's insulated. The art doesn't look provincial, but it's not generally noticed abroad. Because it's so far away, curators don't get out there often. Shipping is very expensive, too.

Your work has been described as 'exploring the inter-workings of the expression of memory, connotation, and sentiment'. Where do the engendering ideas come from?
I can see the element of memory. I'm not so sure about sentiment, although the palette I often use is very reduced – black and white or sepia or greys – and can get interpreted in nostalgic ways. Nostalgia and sentiment are often linked. A lot of the imagery is from the past, and people's recognition of that kind of imagery perhaps triggers the element of memory.

Will you ever go back and practise art in Australia?
No. London is a vibrant city for contemporary art, and I prefer it to New York in that respect. I find it interesting and less commercial. I like living here.

Australian-born David Noonan (opposite) photographed at the door of his studio in Bethnal Green, London, in mid-July 2011, and making work (above) inside. 'London,' he says, 'is a vibrant city for contemporary art, and I prefer it to New York in that respect. I find it interesting and less commercial. I like living here.'

Noonan reworks archival photographs, which he collects from charity shops in Australia, antiquarian bookshops in Berlin and basement junk sales along the Charing Cross Road in London: 'Most of my work is collage, so it is bringing images together to form a new marriage or new scenario.' Nostalgia and sentiment, Noonan says, are often linked: 'There is an element of nihilism to making art because it's a temporal thing.'

Catherine Yass

For how long have you been in your present studio?

Since 1990. Before that I was at Delfina Studios, and before that at Red Cow Studios in Bermondsey.

How much of a contribution do you think institutions like Delfina make to the development of an artist?

If an artist can use it well, then an incredible amount. It is up to the artist to take what is there. An institution might offer things with too many strings attached or too many restrictions, or an artist might not be up to taking them productively.

Why has your work been concerned with underground institutions?

I was interested in how a language of art is formed and how you develop your own language in relation to one that has been institutionally embedded. The institution is like another metaphor for the institution of language. You need structure or you wouldn't be able to communicate. At the same time, structure has to be restricted by necessity, and you have to find your own way to undo it or open it up or find within it cracks or ways to express yourself in your own terms. Of course your ideas and sense of self are themselves constructed by language. I can't say that I am The Noble Me and that I have to express myself through this restricted language; it is not like that. It is more like some vain attempt to say something in what you would like to imagine could be your own vocabulary.

So vanity is involved?

It's not about vanity. People need to say something in a particular way. It might be out of desperation, not out of vanity.

Do artists need to be loved?

I'd like to think I don't, that I could just make my own bubble, but I suppose that is a fantasy. If there wasn't an audience and I was on my own on a desert island, I would like to think that I would still make work … I don't know if I worry any more about what art is. I just know that I need to get on with making.

At what stage in your career did you stop worrying?

Usually it is when you are not particularly hoping for anything that something comes along.

Does ambition makes things worse?

Not if it's ambition for the work. If it's ambition for self-promotion without anything behind it, you might worry. I suppose it also depends on what you think success means.

Success in terms of market visibility and value …

Success might be how successful you think your work has been in terms of generating ideas or critical response.

But we are talking about a generalised market concept and auction value …

I wouldn't say that that is a marker of success at all. If I were getting exhibitions in good places with good curators whom I respected, curators who maybe didn't have a financial investment in my work, then I would be delighted if I thought they were interested in me. Money isn't the only measure of a successful work of art.

When you went first to the Slade in 1982, what was your vision for your art?

I had a romantic idea of artists, that you could be discovered in your attic. I didn't realise that you have to interact with the world.

Did that realisation come as a blow? Did it change the direction of your art?

It did momentarily because it made me angry, so I made some work about that which was a rather literal way of dealing with it. Then, reacting to the recession followed by huge interest in the market around the 1990s, I photographed the powers that be – patrons, funders, property owners, gallery directors, anyone who I relied on for space and funding.

Catherine Yass looking out from her Tower Hamlets, London, studio, in early July 2011: 'If there wasn't an audience and I was on my own on a desert island, I would like to think that I would still make work.'

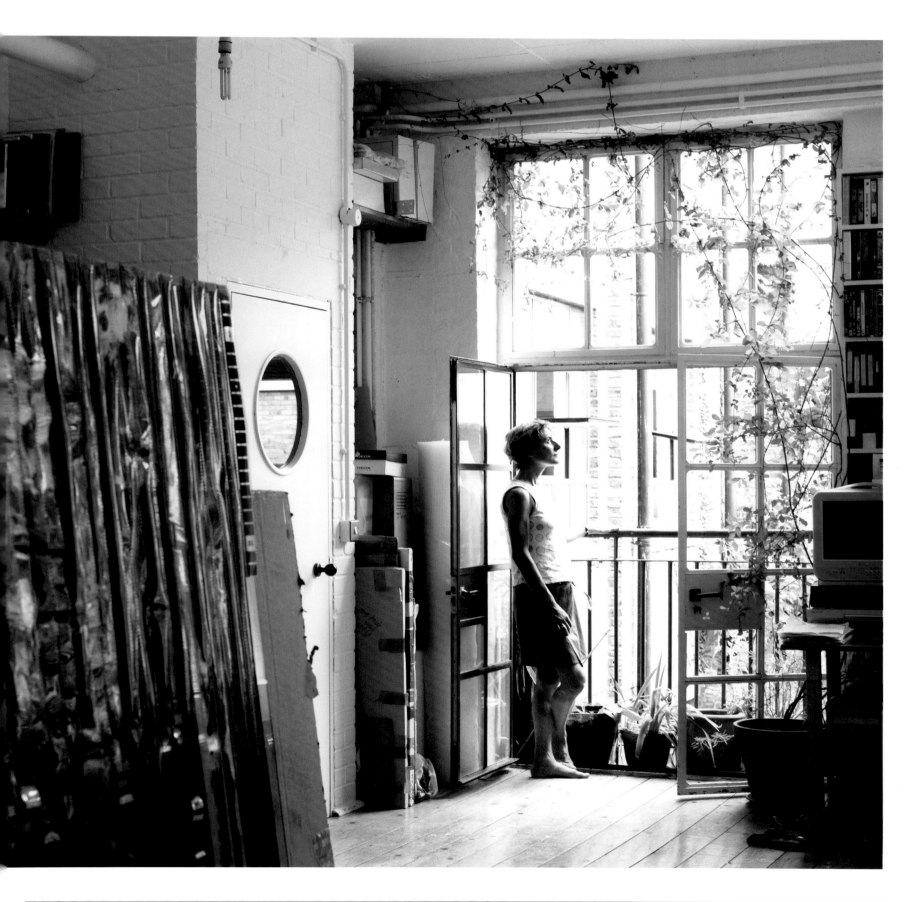

Do you work outside of your studio at all?

Most of my filming and photography is outside the studio though I do test shoots there. I work with printers and editors, so I am often out of my studio for that too. A big part of my work is translating it into a computer scan; I used to print analogue and you can't do that any more. I wish you could. I wish you could just put a transparency into the enlarger and get your print, because that is what I'm used to, and there was an art in dodging and waving and make bits lighter and darker and changing colour. Now it is totally digitised, it is a totally different process though just as skilled. Now I spend a lot of time with the people doing the scanning, correcting the colours, and then a lot of time with the printer, or a lot of time with the editor. The stuff that is done in my studio is compositing, research, planning, sketching, writing; then photographs and offline editing. The light boxes are also wired up and the image put in them in the studio.

How do you come up with a project for a film?

I am not sure. Recently I was having an exhibition at the De La Warr Pavilion, which is by the sea, and I said, 'Are there any odd things in the sea like shipwrecks or planes?' They said, 'Oh, there is that lighthouse.' So I made a film of the lighthouse. It was a combination of knowing that I was interested in filming underwater and the situation presenting an opportunity in the form of a lighthouse which was partly submerged, if you see what I mean.

So an idea lingers for a period of time and then you suddenly feel inspired?

Usually I am looking for some way of doing it and it just seems impossible, and then something comes along completely unexpectedly from behind or the side. Often it is when you stop looking or when your expectations are down. Maybe you are most perceptive then; your lateral thinking comes in ways you didn't expect it to.

Is there a financial component to these things? Are they dependent on others?

Yes. That is one reason why it takes so long to make them.

You have basically to hunt and cruise the market. How does that make you feel? Is it like hawking your wares?

Possibly, yes. You hope that somebody is going to be engaged by the idea and support it. I wish I could make works that didn't need so much money because it is ridiculous that it costs so much, but it does. I have been lucky because I have been able to make all the things I have hoped to make. I make other works alongside on a smaller scale which are less costly and more immediate to make.

How much does your work have to do with fantasy?

A lot of my films have been about having a fantasy, about doing something like walking in the air. I am also interested in the relationship between collective utopian fantasies and people's individual fantasies.

And you are exploring rather than trying to break through boundaries?

Perhaps when you explore a boundary it opens up into a kind of space and it's more a question of inhabiting it than crossing it. If you crossed it, you might find yourself in another place defined by boundaries of its own.

Yass, who primarily uses moving image and photography, experiments with methods of processing and colour, drowning some photographs and burning others: 'A lot of my films have been about having a fantasy, about doing something like walking in the air. I am also interested in the relationship between collective utopian fantasies and people's individual fantasies.'

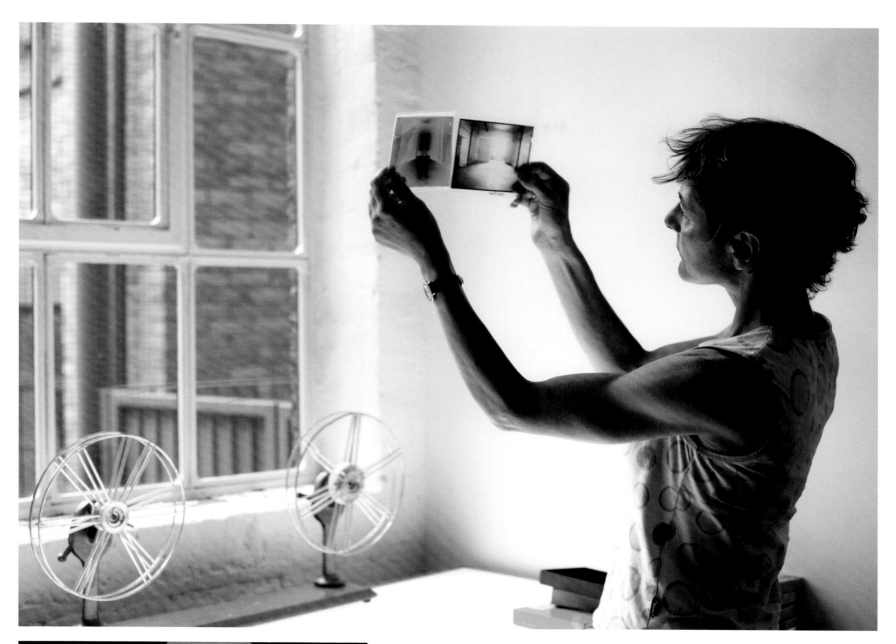

Peter Macdonald

Does it make a difference whether you have your studio in the countryside or in the big city?
There are fewer distractions out of the city, but working in the studio it is much the same wherever I am. I have moved quite a lot over the last two years, and when you do that you can't really afford to wait until you are in the perfect place. You get used to the studio being an extension of your head space. The way I work usually involves concentrated periods of drawing, and I am very focused on the drawing in front of me. So the immediate surroundings tend to melt away.

What is the perfect studio?
Most studios tend to be very hot in summer and freezing cold in winter, so a consistent temperature would be great. Other than that, I just need plenty of good storage so I can clear the decks for new work.

Which comes first, the mind space or the workspace?
The mind space, definitely. Everything follows from that.

Where does the idea come from?
It can begin in any number of places: in the landscape, watching a film, reading a book, going to sleep. The spark of an idea can appear at any time, but the development of that idea usually happens when I am already working. I have always found that the best way to generate and develop ideas is by doing work.

Does it direct you or do you direct it?
It is a sort of push and pull. It has to be like that. I set boundaries in my mind, or make formal decisions regarding technique and media, and then allow myself to be led within that. It's a kind of bounded chaos.

Are you inspired by Far Eastern art?
Yes. I've always been drawn to Japanese woodcuts, Hiroshige's landscapes particularly, and the way they inform the contemporary look of virtual worlds. Also Chinese scroll paintings, which have a different aesthetic but in their meditative qualities may have more in common with my practice.

Do you allow influences to interfere with your work?
They interfere in ways I wouldn't be able to help even if I wanted to. The process I use is about building up an image in small increments, and I am always surprised by what emerges. Often I start a drawing without making any preliminary studies, although I might have the idea in my head of what it is going to look like. Sometimes it doesn't work out that way, but often it does. A lot of the work is about the gap between the imagined image and the finished piece, and the processes that happen in that gap, so interference from all kinds of ideas is important and encouraged – and decoding those influences after the fact is the process of understanding a piece of art, or more generally, of learning.

Is your preference for countryscapes or cityscapes?
I have done very few urban landscapes. The closest I get is probably the decaying suburbs. I suppose I am most often engaged with the post-industrial hinterland and its furniture: electricity pylons, telecommunications installations or – lately – radio telescopes and other communication devices. I have done quite a few drawings about the modified landscape, the huge pine plantations of Scotland and Scandinavia and places like that, where the terrain has been reinvented for a human purpose. I like those landscapes, partly because they remind me of how I work. The process starts with a blank page and develops incrementally. It becomes more and more legible as a landscape drawing and then goes beyond that. It becomes more abstract and difficult to read. When I started using overlaid lines on top of the image, it was to take that approach even further into regions where the image was being destroyed or becoming more ambiguous.

It is not until you step back that you start realising that your drawings are quite conceptual.
Well, I would like my work to have something to say on many levels. It's important to me that the drawings work as engaging images, but the performative aspect of making them, which feels quite experimental and risky to me, and the letting in of randomness, are equally significant. And the subject matter speaks to, or informs, that process, so images of apparent chaos and noise coalescing into readable forms are analogous to the cognitive and performative processes involved when making the work. If I can achieve some kind of holism across different registers, I feel like I'm on the right track.

Is there a childhood element in all this, a particular out-of-the-world experience that you are trying to connect to?
That is reading too much into it. Many of my images are closer to dystopias than to places you'd actually want to be! You could perhaps equate my personal experiences with having faith at a young age and gradually losing it, with a desire to look for meaning and intelligibility elsewhere.

Has art replaced religion in your life?
Yes, but making art is not something that fits easily into a religion-sized gap. And I don't think it provides the kind of solace that some people find in religious practice. For me it's more about exploring uncertainties than finding answers.

Some would argue that institutions like the Tate have become cathedrals of sorts. They have greater attendance than any church, that's for sure.
I wouldn't think that they fulfil the same needs, apart from a certain amount of entertainment. It is difficult to go somewhere like the Tate these days and have enough time to meditate and gain sufficient peace to be inspired. Maybe it is more like a pilgrimage ...

You spent a few years working at the Tate, didn't you?
As a technician, I was very much behind the scenes, initially on the first installation of Tate Modern. It opened my eyes to a lot of the collection that doesn't normally get seen. In terms of approaching art objects, it gave me a more pragmatic way of dealing with them, a less reverent one perhaps, although of course you have to be very careful with those things. You end up recognising them for what they are in terms of their physicality.

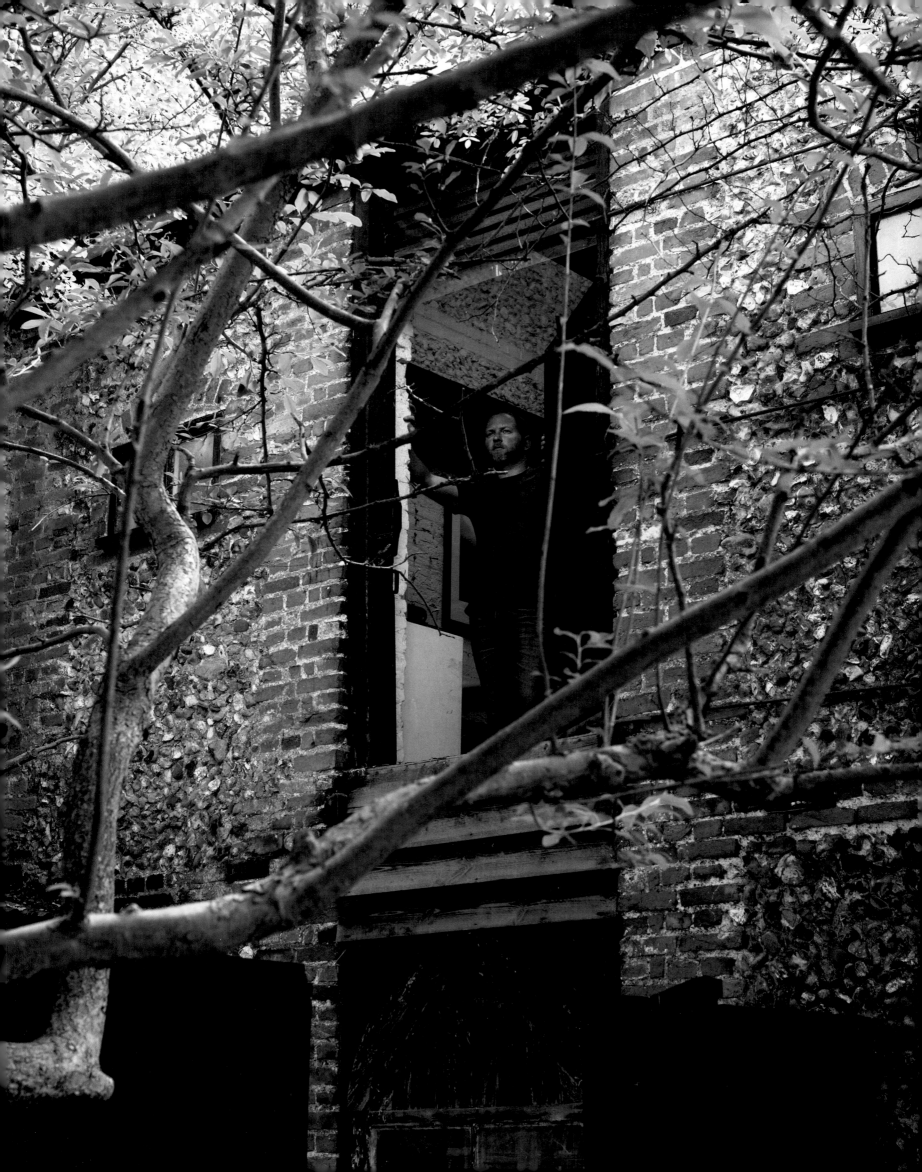

(previous page)
Peter Macdonald in early July 2011 in his studio, a converted barn near the house where he grew up in Ickleton, Cambridgeshire. The University of Cambridge is a mere thirty-minute drive away. 'I suppose I am most often engaged with the post-industrial hinterland and its furniture: electricity pylons, telecommunications installations or – lately – radio telescopes and other communication devices,' Macdonald muses.

Just canvases with some scribblings on?

Absolutely, which isn't demeaning to the art objects – demystifying perhaps.

What influence did that experience have on your own art?

That's difficult to say. But when you are exposed to such a huge range of work, it mostly reinforces the belief that you have to follow your own path, and that art historical narratives are imposed from above and don't necessarily reveal the landscape of art production as it really is. So it made me want to get into the studio more and work harder.

Would you describe yourself as obsessive, given your intricate penmanship?

I don't think that I am obsessive in my normal life; stubborn is perhaps closer. I have this notion that I would like to see work that has been made in a certain way, and I accept that there aren't any shortcuts. And I like the idea of a long process being compressed into a single moment when you apprehend the image for the first time, although, having witnessed the production, this is the one thing that I can never do. It has always got that history, weeks or months when I have been making it, which destroys it for me in part. Often when I have finished a piece of work, I don't want to see it any more.

Some artists argue that there is always something they would like to do differently or come back to …

I don't feel that way. For me there is a point when it is finished, whether I am happy with it or not, and I'd rather move on to the next thing.

Is it almost as if you are testing your own perseverance and perfectionism …

Yes. I want it to be quite an ambitious endeavour. You have to set your sights a bit higher than you think is reasonable. If you feel like you have bitten off more than you can chew and you still achieve it, then you have got somewhere, even if it's not always the place you thought you were going.

Does art help to educate society?

I hope it does, but 'educate' in the sense of expanding thought and experience rather than improving. I don't think that there are many artists who set out to improve people when they make work. On the other hand, once an artwork has left the studio, it has a life of its own with others, and you lose control of it.

You went to school in Cambridge, quite close to your parents' house. Did you ever want to be part of the university?

No. My idea of getting out into the world meant getting away from Cambridge, and I don't regret that. I can see the attractions of academia more clearly now, but I never stop to wish I was a different person, one who would have gone down that road.

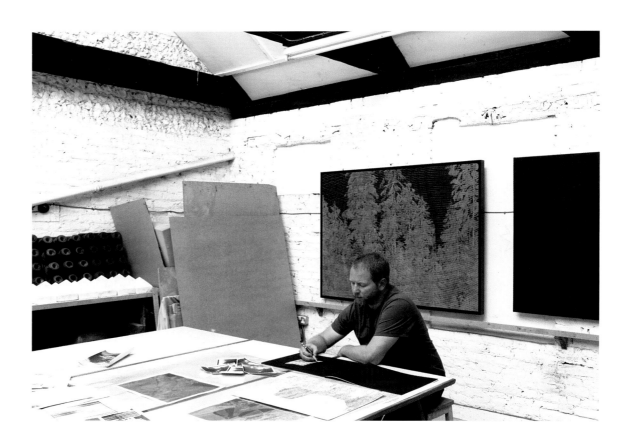

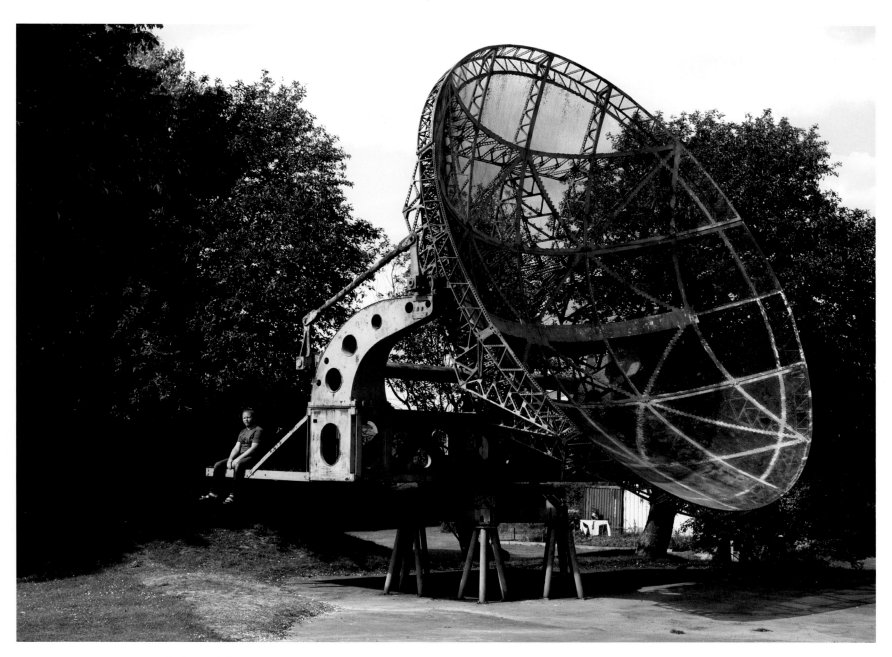

Macdonald, influenced
by imagery from satellite
recovery missions, creates
intensely detailed and
pigmented ink drawings:
'Many of my images are
closer to dystopias than to
places you'd actually want to
be! You could perhaps equate
my personal experiences
with having faith at a young
age and gradually losing
it, with a desire to look for
meaning and intelligibility
elsewhere.' He is shown
(above) with a Second World
War German radar dish
rusting away at the Imperial
War Museum, Duxford.

Phyllida Barlow

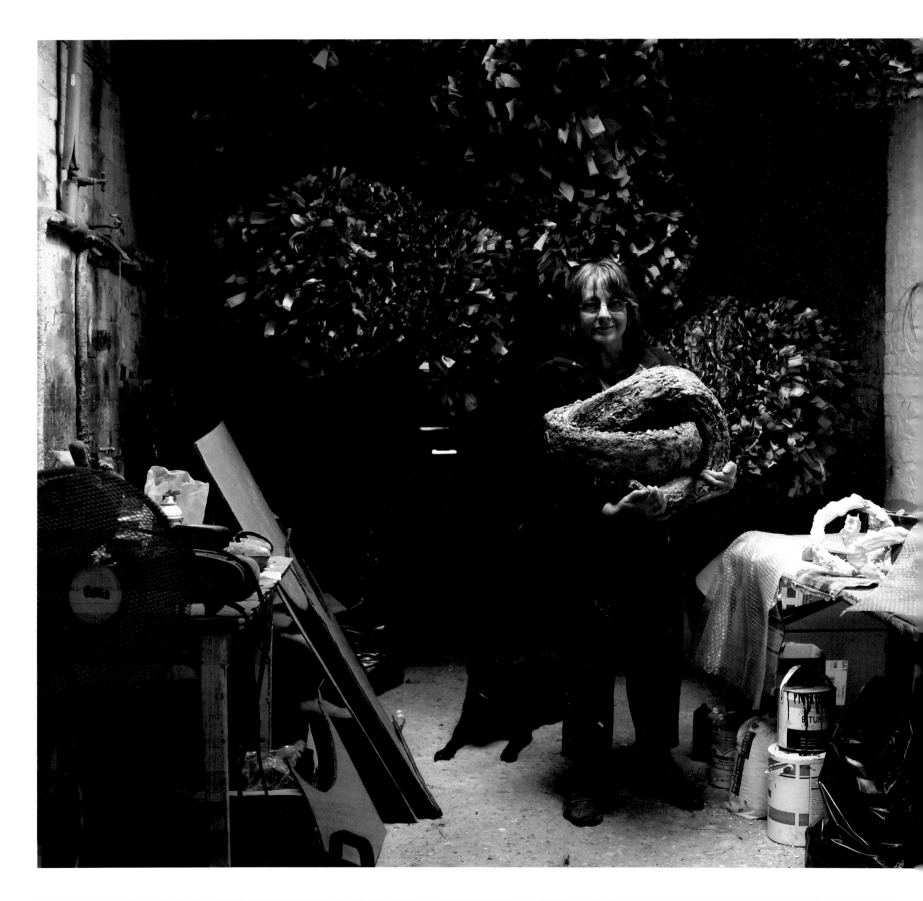

You went to Chelsea School of Art in 1960, then to the Slade in 1963. What was the art scene like in the early '60s?

Chelsea was changing from a traditionally based painting/sculpture/printmaking college into a place where new ideas about art education were beginning to be important. My husband Fabian Peake and I witnessed a huge change in art education, which was then taken up by schools like Saint Martins in the most dramatic way. Chelsea in the early '60s was one of the first art schools to address arts education as a mid-twentieth-century activity.

The new Chelsea School of Art began to be built in the 1960s. It was very radical to build a new art school at that time. The idea of investing public money in an art school was visionary. The philosophy behind it was that industry and the arts could be symbiotic. The design industries were not just isolated phenomena, and painting, sculpture and other forms of art were not isolated from all the new materials – plastics, ceramics and other things – that were being developed. It was only in the '70s that the overt notion of a political subject became important. You got these movements bouncing off each other within three or four years, so by the early '70s you were getting collisions of Minimalism, Conceptualism and Pop art in a very rough debate, and Feminism as well.

Would this have happened without those initiatives by the Labour government?

I don't think that the Labour government was the sole instrument of the changes. Change was coming from creative individuals who were seeing what was happening in Italy, what was happening in France, what was happening in America, that artists were taking their education as a springboard for a critique of the institutionalisation of art.

So your generation broke the mould?

Yes. I wouldn't say that I went in there single-handed, but I was asking these questions when I went to the Slade. Why was I going to be examined on whether I could make a figure correctly? Why did I need to show forty life drawings? I had nothing against working from a figure, but it didn't seem to me that it was the only way of beginning to discuss a work of art. There was an extraordinary range of how you might draw – and drawing has always been incredibly important to me.

Is drawing a science or a natural gift?

The word *skill* comes to mind. We are talking about students in the 1960s being expected to make renditions of the world in front of them. That was judged in a particular way as to whether it was right or wrong. It wasn't so much scientific as based on what I would call a Victorian idea of exactness rather than notions of expression.

You went on to teach for forty years. Do formal teaching methods contribute to static aesthetic interpretations?

I was furious about my education because we were taught sculpture through armature-making, clay modelling, stone carving, welding, construction and casting. I was extremely bad at all of those, apart from working with clay, and therefore using a soft, malleable material is at the root of what I do. But what that education did give me was independence. As education progressed and became a critical forum regarding all that had come before, it was only natural that those ways of learning were ditched. There is a sense now of wanting to bring back some of that in a revitalised form. For about the last ten years there has been a hunger on the part of students to leave art school with something that enables them to set up studios and get on with it. That notion is in complete contention with artists who don't want the same thing, who want to be able to employ a range of individuals who can do the work for them, even remotely. So you have this variety of possibilities now, and there isn't a morality about which is better. It has to do with choices made during the art-school process. My idea of working in an art school wasn't so much as a teacher but more as somebody who could discuss the possibilities of the work, discuss where it had come from, where it was going, what other ways of approaching it might be available.

So you would spend all of your daytime hours teaching and doing administrative work, and then you would retire to your studio in the evenings?

In the evenings and on weekends, yes. On many occasions it was extremely frustrating, but I have never stopped working in the studio.

Where was your first studio?

It was in the basement of a house in Islington and had a very low ceiling.

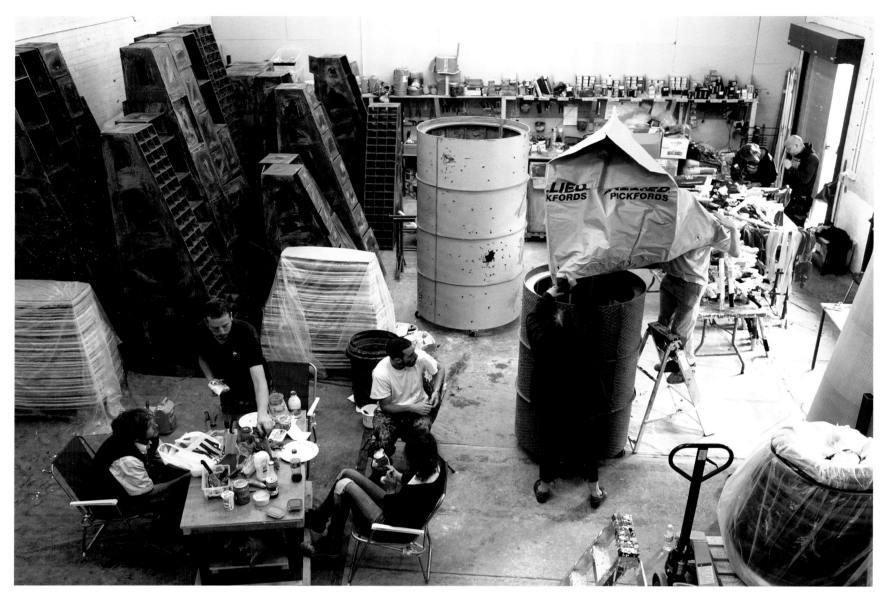

Phyllida Barlow (previous page) in her home studio near Finsbury Park, North London, in mid-July 2011, surrounded by the fabric and paper pompoms featured in her *RIG* exhibition at Hauser & Wirth, London.

Barlow's busy second studio (above and far right), an industrial site in Southwark, South London, is used for making larger works, many of which were displayed in *RIG*. Barlow has a commitment to 'truth to materials' and reuses cheap materials, often recycling works into new ones after exhibiting them. 'There can be an aspect of slumming as an artist,' she says, 'and I could be accused of that.'

How important has the studio of the mind been to you?

When I was about six, we went on a studio visit with my parents. The place was near Brancusi's studio, and it had a huge impact on me. The atmosphere and the yard outside, everything about it was an incredibly intense experience. It was filthy and it was black and it was grimy. My mother was very fashion-conscious, and I remember her being concerned about her dress getting dirty. If anything was an inspiration, that was.

You are the great-great-granddaughter of Charles Darwin. Was that something to live down or live up to?

My mother said, 'You must never mention it or use it in any way; you are on your own.' So he was quite a remote figure. But my father would talk about him, and it was interesting to become aware of Darwin as a man with a great conscience. That struggle always fascinated me, the fact that a human being would find himself in a position of immense vulnerability almost by mistake. And also be hated for something that he had not intended to be hated for, the cruelty of that.

Does art have a moral dimension?

For me, the moral dimension is the need to see what human imagination is. Of course that does sometimes lead to things that are extremely risky and dangerous. At what point do you say that a work of art is unacceptable? How do you give full rein to human imagination, which is an unpredictable, extraordinary force and which can go in any direction?

What conclusions have you come to? Is there a limit to art?

For me there is. There must be respect for human suffering and how that gets used in the visual arts. It is a very difficult area. We have become accustomed to the Christ figure on the cross, but the idea of witnessing the death of somebody in an electric chair is absolutely extraordinary. This has always made me question the role of aesthetics as opposed to documentary. Bringing an intellectual purpose to visuality is very, very difficult. It has something to do with trying to understand the role of decoration.

You have become famous for using ordinary found objects or cheap material to make your work. I was wondering whether poverty has something to do with your vision.

There can be an aspect of slumming as an artist, and I could be accused of that. But the notion of imitation and fakery for a purpose in my case is at the root of something I'm trying to recall. What am I trying to bring back into the world almost as a theatrical moment? I am perhaps interested in the interface between a process which is aggressive and combative and holding onto an action that has some sort of longevity about it.

Oftentimes you destroy your pieces, or you used to.

I used to, but my circumstances have changed now that I have a gallery. I destroy some of them because they are terrible pieces of work! But I do not destroy so many, and that has raised lots of questions for me about work going anywhere other than into exhibi-tions. To me, the making of the work is when I am setting it up. It's as though what you see in the studio is a rehearsal. Then it arrives in the space and suddenly there are parts to be played, there are things that have to be acted out, and that is when the work takes on specific identities. The future of it is something I am still learning about because it is a new experience.

You achieved success late in your career. Do you resent that?

No. I was grateful for the teaching experience. The thing that people need to understand about teaching is that you have to work hard, but you are paid for it, and the paying for it enables you to do your art and bring up your family. It protects you from another layer of professional commitment, which is how you have a gallery, how you sell your work. It is up to each individual to define the gallery for themselves. For me, now, a gallery means an income. It is a different professional commitment.

You once said that the best way to look at sculpture is in the dark because then the 'chill of its presence can be felt'. What is that chill? Is it fear?

Yes. When you enter your house and you haven't turned the lights on, there is a strange way in which you negotiate the familiarity of the space. But if it is not familiar, it's worrying and disturbing. To me that is a sort of sculptural experience. You are on red alert as to whether you are going to bump into something or miss a stair. I don't like the idea of touching sculp-ture. I think it should be a process where you imagine the sensation of materials.

Have some of your pieces taken on lives of their own, become alien species?

I presume they have, yes.

Which one would you choose if you could take just one piece away with you?

I don't think I have made that piece yet.

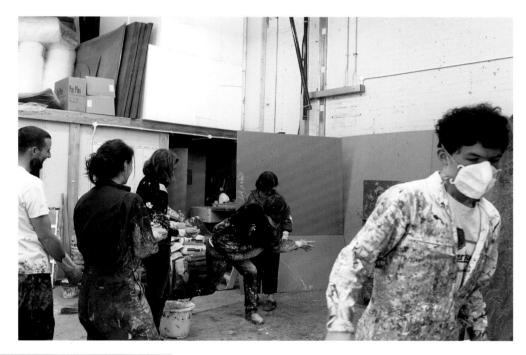

Barlow (left), a tutor at the Slade School of Fine Art for many years, practised her artwork in the evenings and on weekends. Fame came late in her career. She is shown here with her husband Fabian Peake, a writer and artist, and their dog Mimi in the library of their crowded home. 'When I was about six, we went on a studio visit with my parents,' Barlow remembers. 'The place was near Brancusi's studio, and it had a huge impact on me.' Bringing an intellectual purpose to visuality, she says, 'is very, very difficult'.

Douglas Gordon

How important has Scottish contemporary art been in the last twenty-odd years?

The country was gripped by the fear of being an oppressed culture, but at the same time Britain was doing the most atrocious things in India, Ireland and Africa, to name but a few. I was very conscious of the schism between the Enlightenment ideal and this very brutal culture. I wouldn't say that they co-existed happily, but they did co-exist easily.

That's the political, social context. I'm talking about the artistic context.

They're the same. When I was a student in Glasgow, it was expected that you would immediately be lucky if you were going into a teaching context. Despite the fact that history possessed a few Scottish artists who had made an impact post-war, there was almost a cultural expectation to do very little. There can be a certain comfort in being provincial and peripheral because you find your own way to be international. I had a group of friends and teachers who supported me going to study in London and who welcomed me back when I left London. That was the most important thing. Being welcomed back allowed me to leave again.

You went to Glasgow School of Art and then moved to the Slade in London. Why did you do that?

When I was living in Britain, anything that was happening had to be channelled through London. That's changed a lot since the period when I won the Turner Prize.

Where was your first studio?

When I was a student in Glasgow, we had a huge studio space. When I went to London, the harsh realities of life in the bigger city hit pretty quickly. I basically had a time-share on a desk half the size of this table! I would go in and work on Monday, Wednesday and Friday, and a girl I knew would come in on alternate days. Where in Glasgow there was a practical, hands-on experience of learning, London was the opposite. There was very little space to do anything but a lot of time to think about doing things. When I left London and went back up to Glasgow, I finally claimed my unemployment benefit. Like everyone else in Glasgow at that time, I worked in my head or in my bed. Then I had a studio in New York in order to keep my assistants away from my house. I was trying to have a home life.

How did you end up in Berlin?

After the Turner Prize I won a prize in Hanover. Then I came to Berlin to do a DAAD residency and I loved it. This was in '97, I think. I was living in Charlottenburg, which I thought was hilarious because it was full of old people. Never felt safer in my life. And it was *dead cheap*!

How does being in a different city affect your art?

Hanover was pretty isolated. It may be hard to believe, but there were no mobile phones; there were four channels on the TV. If I'd missed anything on British television I had to telephone my dad and hope that he'd remembered to videotape *The Two Ronnies* or *Benny Hill* and send it over. Everything was dead slow. Even though I think I'm living at a slower pace now, it's a thousand times faster. All the satellite events outside of yourself affect your internal orbit.

Can you remember when you switched to a different genre?

I would try to stay away from anything definitive. I mean, when you look around here, it might look like ten different people have been working. That's a type of schizophrenia that I enjoy. I will go through some weeks where all I'll do is paint. When I do a neon sign, I try to work it out, get another artisan to fabricate it, so it's necessary to make drawings. People are here on retainers; other people come in and out whenever they're needed.

Is there a link between your growing up as a Jehovah's Witness and the darker side of your cinema work and your fascination with burnt faces?

I grew up with images of catastrophe on a daily basis; they were called 'Armageddon' and 'Revelation'. Kids today grow up with images of catastrophe all the time, on Sony PlayStation or whatever. And in Scotland we don't get much sun. We get a lot of catastrophic weather on a daily basis. You couldn't watch TV all the time, and we didn't have video games and stuff like that in the 1960s and '70s. So you'd pick up a book. Inevitably I would be into Robert Louis Stevenson. *Dr Jekyll and Mr Hyde* can do terrible things to you when you're young! Oh, and the Bible was pretty rough.

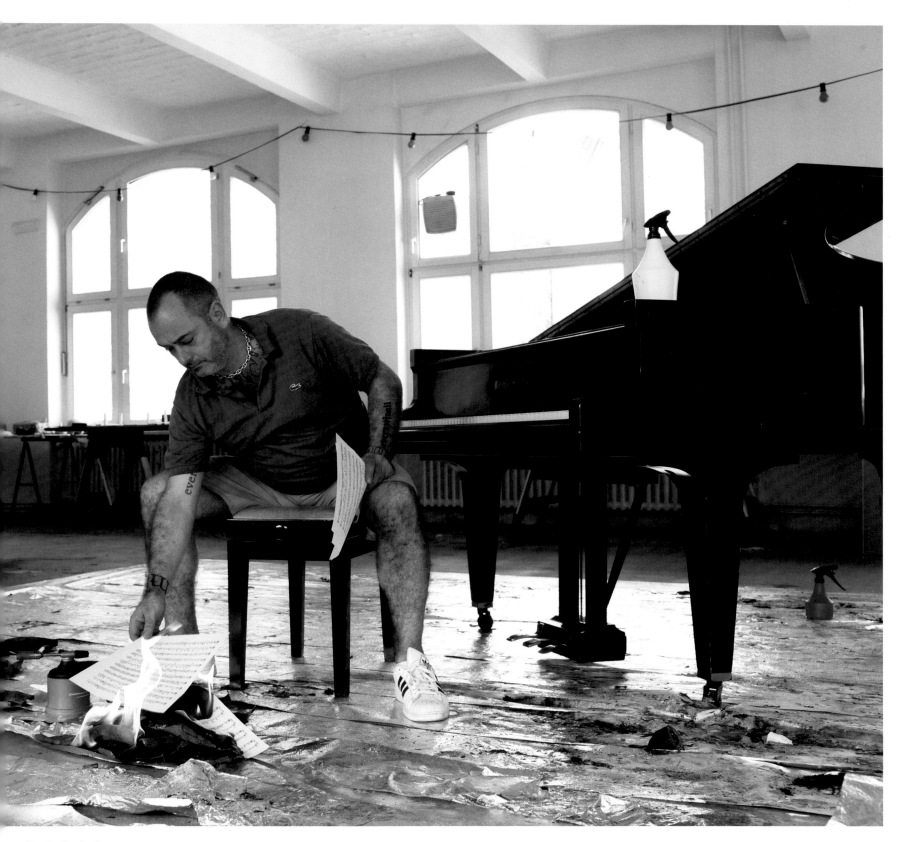

Douglas Gordon burns
Mozart's musical scores
in front of the piano in his
Berlin studio in mid-July
2011. His home is immersed
in contemporary and classical
music in part due to the
presence of his partner Ruth
Rosenfeld, an operatic soprano
from Israel, and in part because
his current oeuvre is organised
around original musical scores.
'I grew up with images of
catastrophe on a daily basis;
they were called "Armageddon"
and "Revelation",' Gordon
says. 'Kids today grow up with
images of catastrophe all
the time, on Sony PlayStation
or whatever.'

Gordon uses wide-ranging media, including video, photography, audio and text, for his artworks, which tackle themes such as love, loss, time and spirituality. A view of his crowded studio (above), and the artist in conversation with an alter ego from the animal kingdom (right). 'Inevitably,' he remembers of his childhood in Glasgow, 'I would be into Robert Louis Stevenson. Dr Jekyll and Mr Hyde can do terrible things to you when you're young! Oh, and the Bible was pretty rough.'

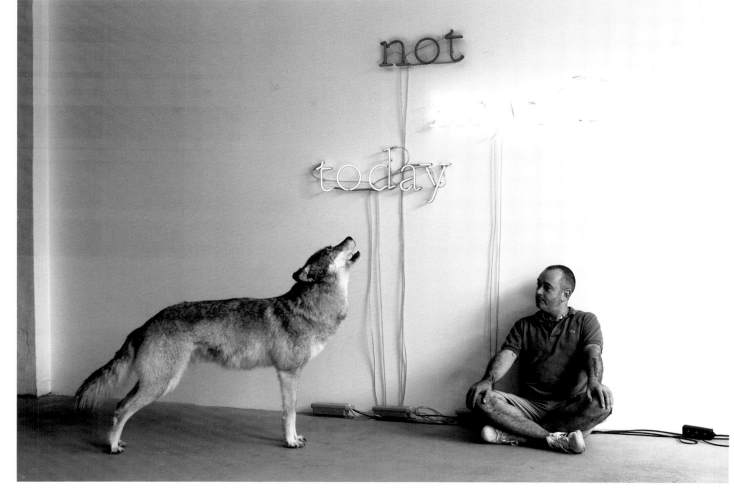

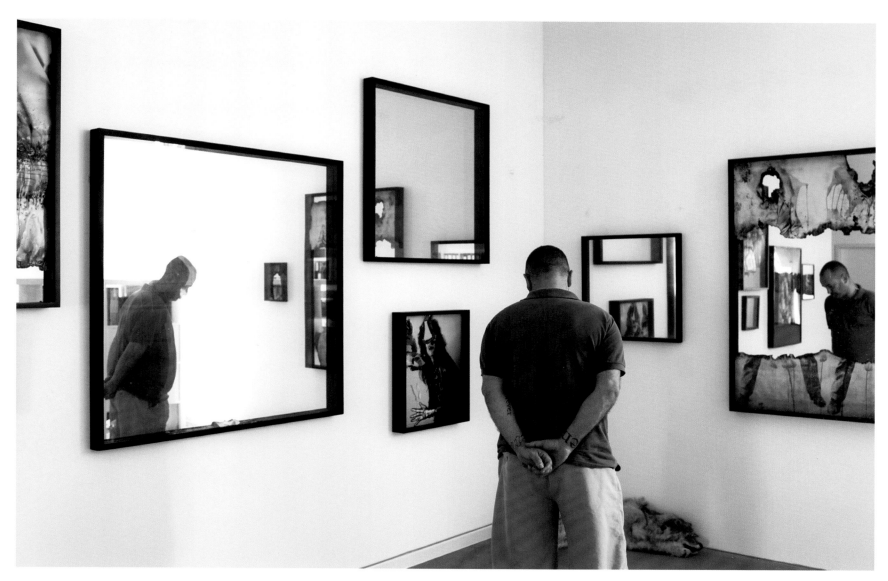

But your mother's liberalism helped in your artistic development?

It wasn't *actively* encouraged, but it was not discouraged.

If you had gone to work in the shipyards, would you ever have become an artist?

I don't know. Someone set up a great conspiracy of circumstances for me. Ironically, what Thatcher did to the economy in Scotland left a lot of people unemployed. That meant that when I went to art school I got a fantastic grant from the government because my dad was out of work. And when I went to London, the Scottish Education Department gave me a bit more money because I was Scottish and in London. I ended up squatting anyway.

Television, cinema or books: which was more important when you were a teenager?

My memory is that I watched a lot of TV, but I always loved the cinema experience. In those days, when people still smoked, that beam of light seemed to be fixed in space. As opposed to now, when it's much healthier, but it's lost a certain romance. The picture actually seems to be coming out of the screen.

One of the great things I remember about growing up in Glasgow was the flea markets and going through suitcases full of photographs. I tend not to throw anything away; it gets a bit ridiculous! My girlfriend came to the studio about a year ago and I had a huge block of paper; it wasn't a block, it was all the paper from sandwiches that I'd been keeping. I'd thought, I won't throw this away. I can use this for a drawing. When I was a kid, my older relatives had been in the war, and there was still that rationing mentality. I led a very excessive life in New York. You know how Americans can be! We own the world! Oil will last for ever! Keep the lights burning! Keep the heating on! Now I'm living in Berlin with a Jewish girl, it's quite the opposite. We don't throw *anything* away!

When you were a kid going to the cinema, did you feel as if you were in an altered state?

I have been in altered states in the cinema but not when I was a kid! You thought that the real world actually existed beyond the screen. There was a parallel reality through the TV and through the cinema, and I'm sure that this was the same for radio. It's not just about the moving image. As soon as broadcast sound started happening, I'm sure there was an idea that even when you switch off it's still around. And it kind of is. There is a romantic idea in there, I think.

If you were to be in an altered state today, either in a physical or in an animal sense, what would it be?

Could be interesting to be a flea on a wolf. Ready to jump ship when … when I've seen enough.

Jonathan Monk

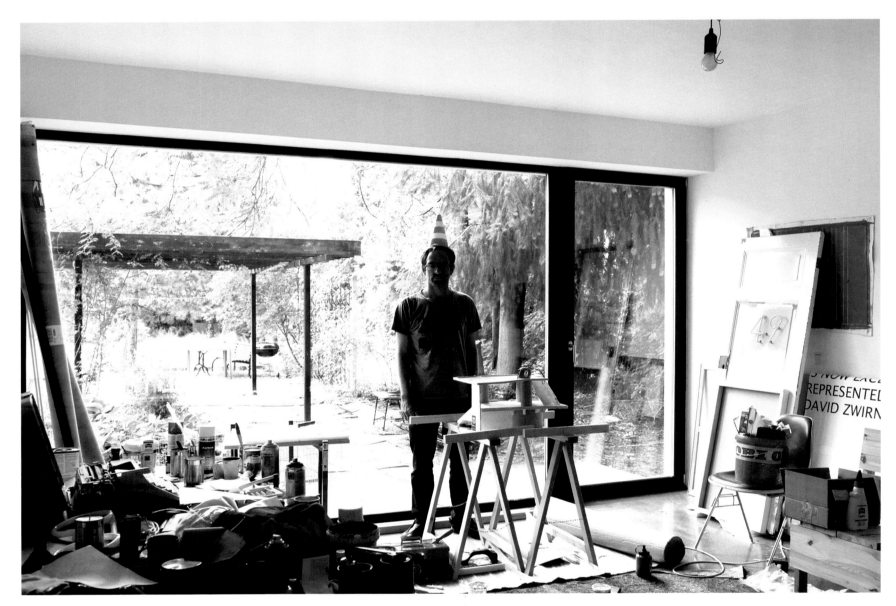

Scottish-born Jonathan Monk, whose work is based on installation, photography, film, sculpture and performance, fooling around in the basement of his home in Berlin, which serves as his studio, complete with drum kit. 'I don't like studios where it's an open house, where everyone is sharing their ideas. A studio is a space not for making anything. I don't really make anything. I don't produce stuff in the studio very often that you would see as being art.'

You've had studios in Glasgow, Los Angeles and, now, Berlin …

I did have a studio in Glasgow and at that time not many people had studios. In the '90s people did, but it would just be a little room or a big shared space. It was never that comfortable for me. I don't like studios where it's an open house where everyone is sharing their space. For me a studio is a space for not making things. I don't really make anything. I don't produce work in the studio that you would see as being art.

Then what exactly do you do in your Berlin studio?

I move things from one side of the room to the other. I don't really want to make it clear. There are a lot of things happening at the same time that slowly find form at the end of the journey. It might be that the work ends up being outsourced and produced somewhere else, and then it comes back here for a brief period before it goes somewhere else to an exhibition. There are moments when I sit and think, but they're not necessarily within the studio confines. It's more a space I can go to and just be quiet, speak to whoever I need to speak to, work out whether an idea functions. If an exhibition is happening in another country, I wouldn't necessarily go about trying to produce the work here if it could be done just as easily there. It's always easier to avoid packing and shipping.

So in a manner of speaking your art is intellectual property transformed into a product by other hands?

Not always. I have painted over the years, not often but once in a while. And I do make things but haven't done so for a while. Maybe it is the studio or the position you find yourself in that will alter the way the work is formed. If you only have a desk and you don't have the option to create large things, you might be confined to making notes on paper. It isn't necessarily any different; it's just about scale. Often the process can follow on if I meet specific fabricators who I think are interesting and who can help me develop an idea.

You started out as a figurative painter.

Almost everyone who finishes O levels thinks that's what art may be about … that you have to paint. I found bits of information in the street and in other people's handwriting that became source material for my work. I even collected thousands of small pen testers from shops; I had a Rolodex full of these things that I would repaint. I'd enlarge them and they'd look like a kind of abstract painting. I collected adverts for holidays and I would repaint them. I also realised that if I wanted to make something like a neon sign, I wasn't going to learn how to do it myself. It's a bit like when your heating system breaks down. You don't learn how to repair it; you call someone else. I guess that's been standard practice in the art world for many years … we need more plumbers!

Are you questioning the meaning of art or the meaning of life in your work?

They're inseparable. I'm not sure I go out of my way to question things, although I do think about how the art world might function. I also think a lot of artists should retire.

Retire or disappear?

Disappear. You're not forced to continue, but it is very difficult to stop.

The hype and marketing that surround contemporary art are so glamorising. Do you sometimes feel as if artists like you are being elevated onto a pedestal?

Maybe. The Venice Biennale is turning more and more into a big, glamorous party for rich people with some art on the side. It's easier to get involved in the art world than it is to hang around with famous film stars. It's another way of people happily spending their money and making themselves look good or clever.

If you think back to the '60s, to the founding fathers of the Conceptual movement, it wasn't a con. They were trying to work out a way of producing things that required more thought. It was just a mental game that you played. Things did change, but it's a lot to do with politics and how work and artists are supported. Britain wouldn't have produced the artists it has, or the musicians, or all the creative elements we take for granted had Thatcher not been in power. I don't think Damien would have been Hirst had Thatcher not walked him through school.

What took you to Los Angeles?

Love. I met someone who lived there. It did also feel like it was the right time to leave Glasgow. The move gave me a chance to look at things I hadn't seen before. I'd known of Baldessari and so on, but it was a chance to look at them more closely. I didn't have a studio, I just had a table. So I wandered around quite a lot, and it felt like it was a time to sit down and think. I'm still thinking. I didn't get involved in the art world there at all. It was in its infancy; now it has expanded a lot.

Generally, as Sol LeWitt would say, the work follows its own course and ends when it ends because that's when it was agreed to end. Occasionally it's not what you expected and you have to twist the ideas so you can get them to function. It's a bit like having a haircut with your eyes closed. You're not sure what you're going to look like.

Jane and Louise Wilson

It's been said that you 'never get sick of the sight of each other, or if [you] do, one of [you] goes to the studio'. Is that what your studio is for?

J: Yes. But even then, there's no escape, as we often use each other in our work. We still keep catching glimpses of one another, even in the studio.

Does the word sanctuary apply here?

J: The studio is a great place to be shut away. It is a space where you can have a focused discussion but also a place to think, not as much escaping each other as escaping everything else outside.

Is it correct that you didn't have a studio to begin with?

L: We started out in our flat in Kings Cross. The flat became the studio. We would stage things in the kitchen, in the bedroom, in the bathroom. So in a way, our living space became our studio, and we treated our studio like a set.

You just upped sticks and left home, got on the train from Newcastle with a one-way ticket?

L: Yes, sleeping bags and a couple of rucksacks: that was it. It was easy to be in a bigger city, but you are also more vulnerable. We actually made a piece of work called *Construction and Note*. When we were staying in that flat, someone tried to smash in the front door in the middle of the night. A week later, they posted a note through the door saying, 'I was the person who tried to smash in your door. I have a psychiatric illness; if you want to contact me, please see overleaf.' The note became an artwork. It seemed to mirror what we were doing in our photographic works, which was staging *mise-en-scènes* that looked like crime scenes.

Your genre is reflective of horror movies, isn't it?

L: I wouldn't say we have a particular genre, but at one time we were looking at certain artists, for instance Cindy Sherman. That's closer to what we are thinking about. It was much more about the film still as a suggestible psychological space.

What was the origin of your fascination with film?

L: It started from growing up together and hanging out with each other and watching films together. You develop a sense of your own world – that's what children do.

Were you rebellious teenagers?

J: We grew up in the North-east of England. We went to our local comprehensive school, and at the time we were the only two people doing A-level Art. It was during the Thatcher years, and the idea of an art career was not really on the radar. I guess you could say it was rebellious in the sense that you had nothing to lose.

You never dreamt that you would become famous?

J: The dream was to keep going as artists and to continue making work.

L: To be studying was a big luxury. Like a lot of our contemporaries at Goldsmiths, we worked part-time on the MA, and that's how we managed to keep our studio going.

You've talked about being classified at school as girls who would become nurses or teachers or whatever. Are you feminists?

J: Of course! We grew up in a strong matriarchal culture. To turn around and say that you don't believe in feminism …

L: … is totally missing the point!

Can you say something about your visual language?

J: We work in film, video, photography, sculpture and installation. We are fascinated by the narrative of the peripheral, particularly when looking at sites of real political power.

Do both of you carry cameras?

J: Yes. It's important to have someone there who is also seeing what you are seeing so you don't miss anything. *It* questions *you*; it's not just about reaffirming things.

L: It brings an emotional and psychological dimension to the work as well, so it doesn't just remain a document.

J: It was particularly important in relation to *Stasi City* because you were looking at a lot of paraphernalia about the idea of surveillance while simultaneously having somebody watching you. It became a very self-conscious exercise. You knew then that something was wrong with that kind of violence.

L: Even though it was a piece that was commissioned and made there, *Stasi City* has never been shown in Berlin.

Jane and Louise Wilson in front of their 2011 collaborative work *Face Scripting: What Did The Building See?*, created together with artists Shumon Basar and Eyal Weizman. The work references the 2010 assassination of the Hamas official Mahmoud al-Mahbouh by Mossad agents in a Dubai hotel.

J: I remember when we were making that work, a lot of the artists we met in Berlin were looking more to connect with what was happening internationally. Something from the recent past like the former DDR probably seemed clichéd, a little obvious. But to us, going there, being allowed that access, was compelling, because we couldn't have done it eight years earlier, when we first visited in 1989.

L: I also think that there was a strong desire in Germany to smooth over the divisions and make unification seamless and meticulous, and that's what they have done.

Can you explain your fascination with pillboxes?

L: We were interested because there is something so brutalist and otherworldly about them. I wouldn't use the word *mausoleum* but …

J: … it's strange. Because of erosion, they have fallen off the edge of the cliff but now look as though they could be emerging from the sea. They're impotent. They look like relics from a different civilisation.

You work in photography, film and sculpture. Which medium do you prefer?

L: There isn't a preference in what we do, really. All of the process is an extension of the ideas.

J: A more accurate way to describe the work is as installation.

As you've been working together, has there been one experience that has stood out for both of you?

J: In 1993 we made a piece in Oporto in Portugal, in an empty warehouse building. Part of a British art show, it ended up being a large-scale video installation. It was the first time we had worked with video projection, not monitors. We used one side of the building to film in, suspending a floor-to-ceiling blue curtain, sanded part of the floor, and placed three chairs and a camera …

L: … it looked like a set …

J: … and we filmed a hypnosis session together, using ourselves as the subjects. We worked with an English and a Portuguese hypnotist, filming one session in English and one in Portuguese. On the other side of the building was a projection screen where you saw the hypnosis session as it had been filmed. That was important because at the point when we go into trance the camera pans away from us as subjects and up to the blue curtain. It is a classic cinematic move. We were looking at how suggestible you can be as an audience, also at the mechanics of cinema and film. It showed that displacement between the filmed and the real event.

Some of your prints suggest to me that that is exactly what you are doing with your photographs.

L: You have to want to enter something, to cross the threshold …

J: A lot of artists want something to have a kind of atmosphere, an intensity, a sense of place, a sense of time, a sense of space. It's important to how you experience something. That is very much about being in a suggestible state of mind, isn't it?

What are you working on currently?

L: It's returning to the forensic, looking at potential crime scenes. Recently we were in Chernobyl visiting the town of Pripyat. The recent photographs are part of a series we made called Atomgrad where we photographed the public buildings, incorporating a yardstick, a measure.

J: It's an obsolete measure, really; no-one measures in yards any more. There is a sense that the image is being measured, but it's also literally been measured many times before. Pripyat was constantly measured for its levels of radioactivity.

L: Particularly in forensic photography, everything is measured in terms of how you take the shot. You have to do the wide shot, the medium shot, the close shot, and it's all marked and timed. You can't do anything from an angle because it looks like you are falsifying the evidence. So there is something about the process of forensics that we are interested in. We recently collaborated with two architects and writers, Shumon Basar and Eyal Weizman, on a film about the assassination of Mahmoud al-Mabhouh, who was a Hamas operative. The CCTV footage of the assassins coming into the country was on YouTube. Many came on British, Irish or Australian passports. Some were in disguise, some were dressed in tennis gear. There was a highly amateur-dramatic side to it, but in fact a man had been murdered, and this makes it truly macabre.

Talking of forensics, how would you measure your own art?

J: We are probably too close to measure it.

L: Conversely, you can say that you're constantly in that position of measuring so it is difficult to step outside of it.

(above) **Louise (left) and Jane Wilson** preparing a photograph from their pillbox series for an impending show. 'The studio,' Jane says, 'is a great place to be shut away. It is a space where you can have a focused discussion but also a place to think, not as much escaping each other as escaping everything else outside.'

The Wilsons and a pillbox on Allhallows Beach, Kent. 'We were interested [in pillboxes] because there is something so brutalist and otherworldly about them,' Louise explains.

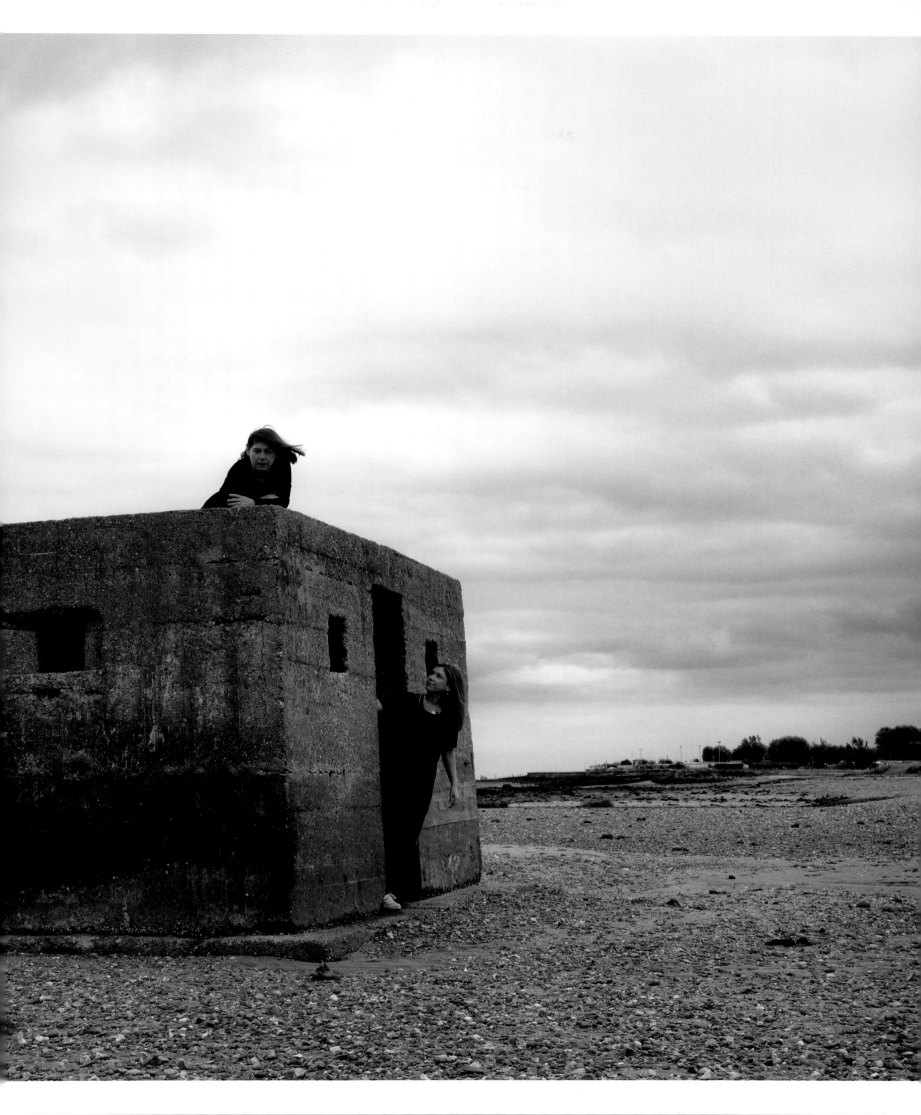

Ximena Garrido-Lecca

You're in the process of leaving your present studio. How does it feel to inhabit a space and then move on?
I get really attached to spaces. Also, during the process of working, I leave little objects behind that are not needed in the work, and they start becoming like a narrative. So by the time I leave, I have an accumulation of bizarre objects. I like going into a new space that's sterile and starting that process again.

When you take on a new, sterile space, what is the first thing you do to make it habitable?
I just set up. I do not intentionally make it happen; it happens gradually. Through the process of making work, the space gets its character.

You were born in Lima, Peru. Why did you choose London rather than New York or another city?
It was all happening here at the time, and I had some friends here too.

How much of your Peruvian heritage did you bring with you?
I use it often as iconography in my work. Maybe if I worked in Peru, my references to my own culture wouldn't be that strong. Because I am outside of my place, it allows me to keep a distance and see it from a different perspective.

So perspective is what you are looking for, culturally, historically and emotionally?
It's more about trying to understand my own culture within a globalised world, how this culture is being lost somehow. I'm trying to register it. It's like a predator or someone who is whispering to history before impressions get erased. There's a general hybridisation between traditional culture and new ideas brought by capitalism.

How much has North American or European contemporary culture and art affected Latin American artistic production?
I went to art school in Peru. They go up to modernism – that's where it stops. That's why I felt I had to leave. It's quite conservative, but it is also about information, I think. We didn't have access to a lot of information, to books, to art books. Now, with the Internet and technology, students have more available information. Back in the '80s and early 90's, when I was growing up, it was hard to find out what was going on around the world in terms of art.

What is the impact of these new technologies and of the aesthetics of other cultures on Peru?
People consume Western culture because you can access it easily and it is portrayed as the model to be followed. They absorb it within their own culture and then manifest it in a strange way. It has a lot to do with trying to find a new identity to keep up with what is going on in the world. It goes back to colonialism, to the idea that people were stripped of their culture when the Spanish arrived. The same kind of thing is happening now with the new reality in which information is everything. People try to keep up with that and get used to it, but they're a bit lost. We are all a bit lost, I guess. It's difficult. I travel a lot for my work documenting this transition.

Does art act as a midwife to this transformative cultural process?
I'm not sure. Something facilitates the transition, something that provokes talk, something that questions what's happening. It doesn't facilitate anything, it just raises questions. It is more about 'Look, this is what is happening. Be aware of where you are.' That's how I see it. That's one of the main reasons why I make art.

On a previous occasion, you said – I'm going to quote you here – 'I would like to think that by making art you are encouraging thought and making people more aware of their environment in order to appreciate more their and other cultures.' Can you give me an example of what you are searching for in terms of lost heritage?
I am working on a project that depicts a traditional celebration. It involves violence, but I think it reflects struggle in a good way. That's one of the important aspects of my work. There are many others to do with practical day-to-day things like traditional clothing that people have worn for generations. Peru is a culturally rich but fragmented country.

This loss of identity you talk about: you don't have that sense of loss living in London?
Lima is a capital city. It's a multicultural place, not as much as London, but it's certainly not a backwater. So it's very Western in a way. It's not that I came here from the countryside and it was a big shock. But yes, culturally I still find it different. There are many things I still struggle to understand and interact with.

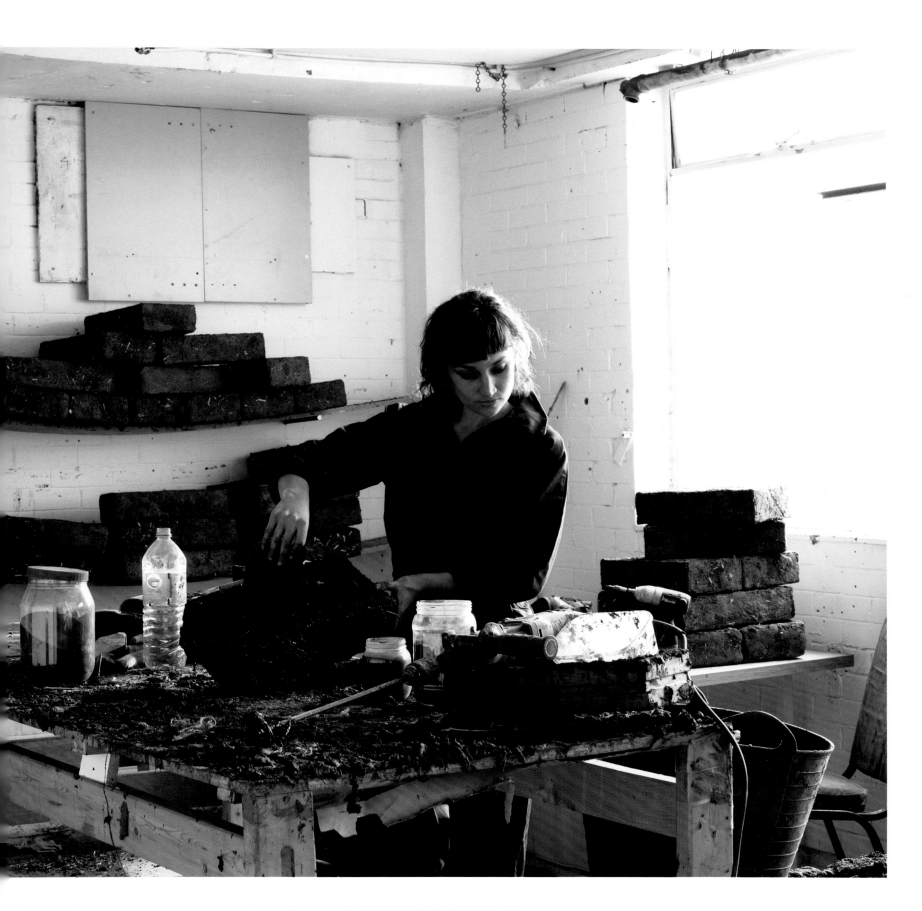

(previous page) Peruvian-born Ximena Garrido-Lecca in her Hackney, London, studio in mid-July 2011, building *Wall of Progress* for exhibition at the 2011 Frieze Art Fair. The work is part of a sixteen-piece series based on the mud walls that can be seen in the Peruvian highlands. 'It's more about trying to understand my own culture within a globalised world, how this culture is being lost somehow,' Garrido-Lecca elaborates. 'I'm trying to register it. It's like a predator or someone who is whispering to history before impressions get erased.'

Garrido-Lecca on the roof of her nearly derelict studio building (right), captured in an unguarded moment, as far removed from her roots as space, climate and time allows. 'People consume Western culture because you can access it easily and it is portrayed as the model to be followed,' she says of her native country. 'They absorb it within their own culture and then manifest it in a strange way.' Her power tools (below) themselves resembling an installation. 'Maybe if I worked in Peru, my references to my own culture wouldn't be that strong.'

Mat Collishaw

You grew up in a strict Christadelphian household, didn't you?

Yes. It was a house religion, like the Plymouth Brethren or Jehovah's Witnesses. They don't go to church. They have a designated meeting area, but they don't really have traditional iconography like the Crucifixion or any of the normal tropes of religion. And they are very insular, very strict. The biggest problem is that it's extremely boring. I didn't want to break out like a rebel, I just internalised everything. I'd sit there pretending that I was listening and think about other stuff. Generally in the church meetings I would be drawing, sketching away, either the back of somebody's head or things from my imagination.

What kinds of things?

War, first of all. Stuff boys are obsessed with: soldiers and wars and, after that, football. I used to make my own comics. Comics were okay; they were deemed a lesser evil than TV, for example. That's what happens when you don't have a TV. It teaches you to imagine. I'd watch other people's TVs through the window, and I'd become enchanted by that moving box of magic going on. Also I used to make wee stick boxes with a stage inside them, kind of 1970s pre-television entertainment. I was interested in escaping through a little window, a portal, because we had no TV.

And this magical movement is reflected now in your light boxes?

Kind of. In a lot of my video work there is no narrative. There is no beginning or end; it is just a moving picture. I found it compelling that someone could reanimate life artificially. It is possible that that is what I carried on to do.

So you create life, animate the inanimate.

Yeah. For me that's a big part of the video thing. I am not interested in video as a medium for telling stories. What it does is take electricity and transform it into something that becomes a visual experience. For me that has enormous spiritual capacity. I try to make my videos look like the fragility of tenderness and the transience of life's ephemeral nature … the spirit of life flittering away.

Is the role of the artist to take the inanimate and turn it into something possible via the imagination?

I don't set parameters on how I operate. I lean instinctively towards what seems natural for me to do. If it feels wrong I generally won't be doing it. I will be drawn to certain subject matter that influences me. I will start reading books or looking at things that I find compelling, so they become the source for inspiration. When I started off being an artist, I was reading a lot of J. G. Ballard. I can't remember what I got out of J. G. Ballard … maybe the meaninglessness, the senseless violence, the atrocity, the exhibitionism, jarring visions of the modern world. But also things like *American Psycho*, Bret Easton Ellis's novel, which was major when I was twenty … that disengagement from emotion and visceral violence, but not playing for emotional impact, just totally emotionless. It was an aggressiveness that I was looking for as a way of getting something over to an audience. I was bored with going to the Lisson Gallery and seeing artworks that didn't engage me.

Is there integrity in contemporary art, or is it just there to make a bold statement to capture our attention?

I like art to be contemplative in a way that at the same time incorporates elements of violence or inhumanity. Cruelty and injustice and debasement have always been driving forces for me, and that is something I try to incorporate into the work. I use thoughts of violence, but you need tenderness to feel the injustice in a situation.

But Ballard and Easton Ellis are very much removed from the everyday, and there is no tenderness in their language.

It's satire, really. They are making satire. When I try to deal with violence, it is not necessarily about violence itself but about the way in which we experience violence.

Do you classify your work?

If someone at a bus stop would ask me what kind of work I make, it would be difficult to classify. The worst thing I could do would be to say that I work with photography and video. Generally I am not a big fan of photography and video, and I don't see myself in that tradition. I come from just looking at paintings for years and years, and at sculpture – essentially traditional media. I just like to give that a bit of edge. I find it too seductive to have canvas with oil paint, too cosy; there's too much liberal charm. Whereas photography and video have a certain anonymous, contemporary feel. If I can inject a bit of spirituality and artistry into a medium that is soulless, that's a challenge. That's where I like to be. It's difficult to explain that to the guy at the bus stop.

You've said, 'The reason I got into art is because I am a really bad communicator, cripplingly shy.'

Yeah, I am. After years and years you get to the point when being shy is a kind of vanity; it's about being self-conscious. I used to think of myself all the time. I got over it. I gained confidence by making work.

Mat Collishaw in mid-July 2011, painting in his Camberwell, South London, studio. He has a strong sentimental tie to the area as he lived there when he was a teenager. It is close to the original site of Goldsmiths, from which Collishaw, one of the YBAs, graduated.

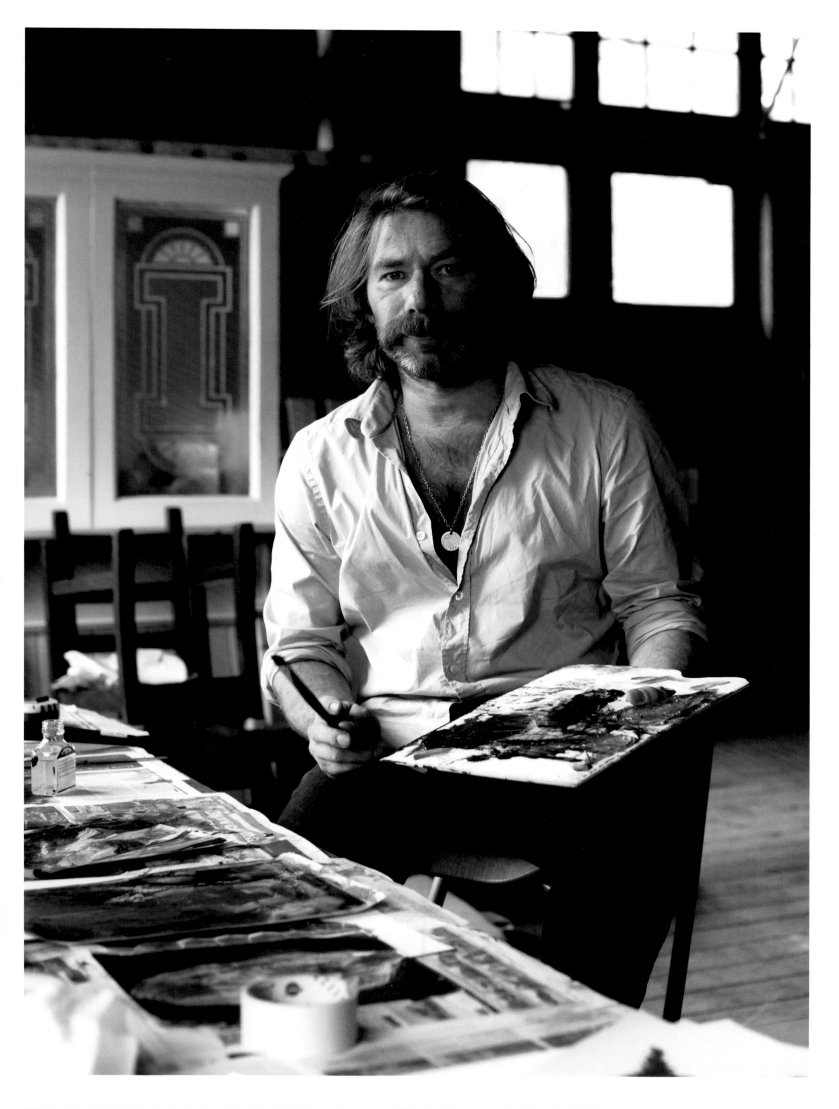

You can't be that shy; you dated Tracey Emin for five years!

Yeah. I was her backseat boyfriend.

I frankly can't see you in the backseat anywhere!

I don't agree with the heroification of drug and alcohol consumption so I wouldn't want to make a thing of it. Again, I get very bored and I am working all the time and I get stressed out so occasionally I go on a binge. But I don't really like going out for a pint, and I don't drink in the evening. Generally you are looking for different sensations; the reason I make this or I make that is because I am desperate for a new sensation. You need something compelling to make, that thing that gives you a buzz.

You have been quoted as saying that art is a modern religion. If so, are you a priest or a prophet?

I'm Jesus – well, not exactly Jesus. As if Jesus came back and said, 'Don't listen to the scribes and the Pharisees. Go straight to God. Forget the collector; just the art and you are enough. There are too many false prophets, too many journalists and curators who put too much of a spin on artwork; they obscure your relationship with it.' Jesus revolutionised everything by saying, 'Fuck the Old Testament! Don't listen to these old men who are trying to be an intermediary between you and God!'

Where does that leave society? What is the next stage in spiritual development? What comes after art?

I hope that nothing comes after art. Without art we become un-human. We could become very dangerous creatures without literature and pictures and music and all of those things that can share tenderness and anger and the complex experience of being a human being.

It used to be that art was a service of the church. Certainly in the Renaissance, art was used to bolster up the importance of the image. It was an advertising show, really. If you were decorating cathedrals or making religious paintings, it was all about promoting doctrine. Since the twentieth century it hasn't been that way. It hasn't been about patrons or religion, it's been about humanity.

Are there any revelations left in the human psyche? Do you explore those inner depths or open up important paths that others may follow?

I like science, in particular evolutionary biology, and I spend a lot of time reading that sort of stuff. Human beings are basically programmed by software inside them.

To fuck, eat and shit?

Pretty much. We tend to see ourselves as being civilised, but beneath all of that there are these programmed instructions telling us what to do. Now we are putting human genes into animals to simulate how cancers grow in humans. There is an extremely exciting change happening and accelerating rapidly, so things are only going to get more and more interesting, probably more and more diabolical. There will be plenty more material for artists.

What is the role of your studio in all of this?

It's where physical stuff goes on. The little nerve centre is my office, where things get made. I've got a few assistants; I use fabrication companies. Some of the things I do are technically complex, but I will generally be there working out how they are made. They are built offsite in a workshop. I edit the videos myself. I do a lot of 3-D creating, so I have two guys working on an animated video for me at the moment.

Do you like living and working in the same place?

I love it. If I get an idea at 10.00 at night, I want to go downstairs and try it out.

I had a studio when I was at college. Then we swapped to a big building not far from here when I was about twenty-three. I moved all the way around London and never imagined that I'd move back to Camberwell. We always lived in warehouse spaces. I quite like a big, open work floor.

You use photography, you use sculpture, you use film. Which do you prefer?

I have a whole arsenal of media. I use other solutions as well, like cylinder-anamorphosis and zoetropes. I also have a list of subjects of interest, pictures in magazines or newspapers or something on TV.

Is there honour in the need to believe in something higher?

Just because we are genetically predisposed to self-preservation doesn't mean that we can't overcome it. For me that is a triumph over how we are programmed to behave. Art is part of that struggle to become more than just a self-interested species.

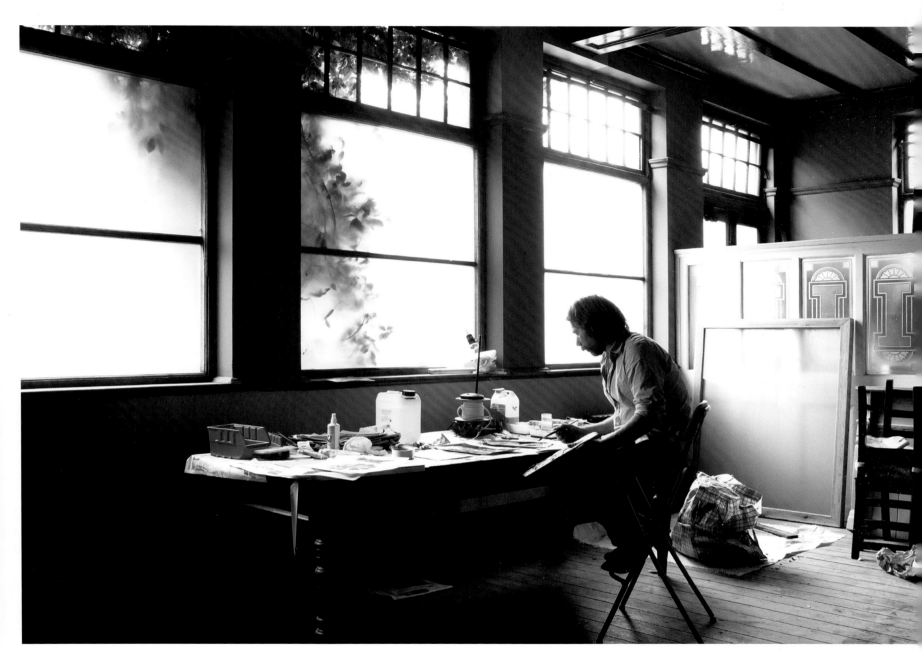

Collishaw lives above his studio, a converted pub in the process of being refurbished. He is shown here working on his exhibition *Sordid Earth*, his various workstations scattered around the cavernous three-floor building. 'We could become very dangerous creatures without literature and pictures and music and all of those things that can share tenderness and anger and the complex experience of being a human being.' The drum set (following spread) belongs to the artist's son, but the empty wine bottle and cigarette ends tell a different story.

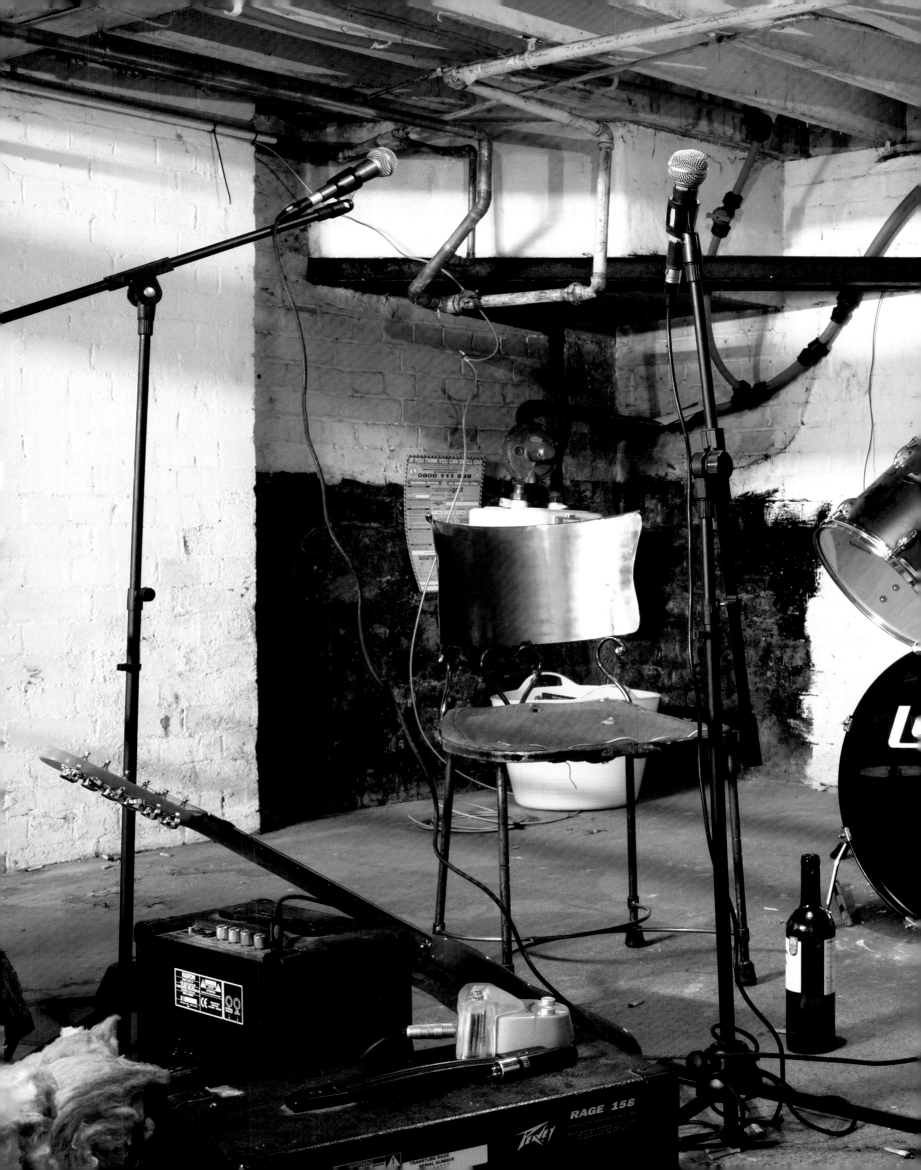

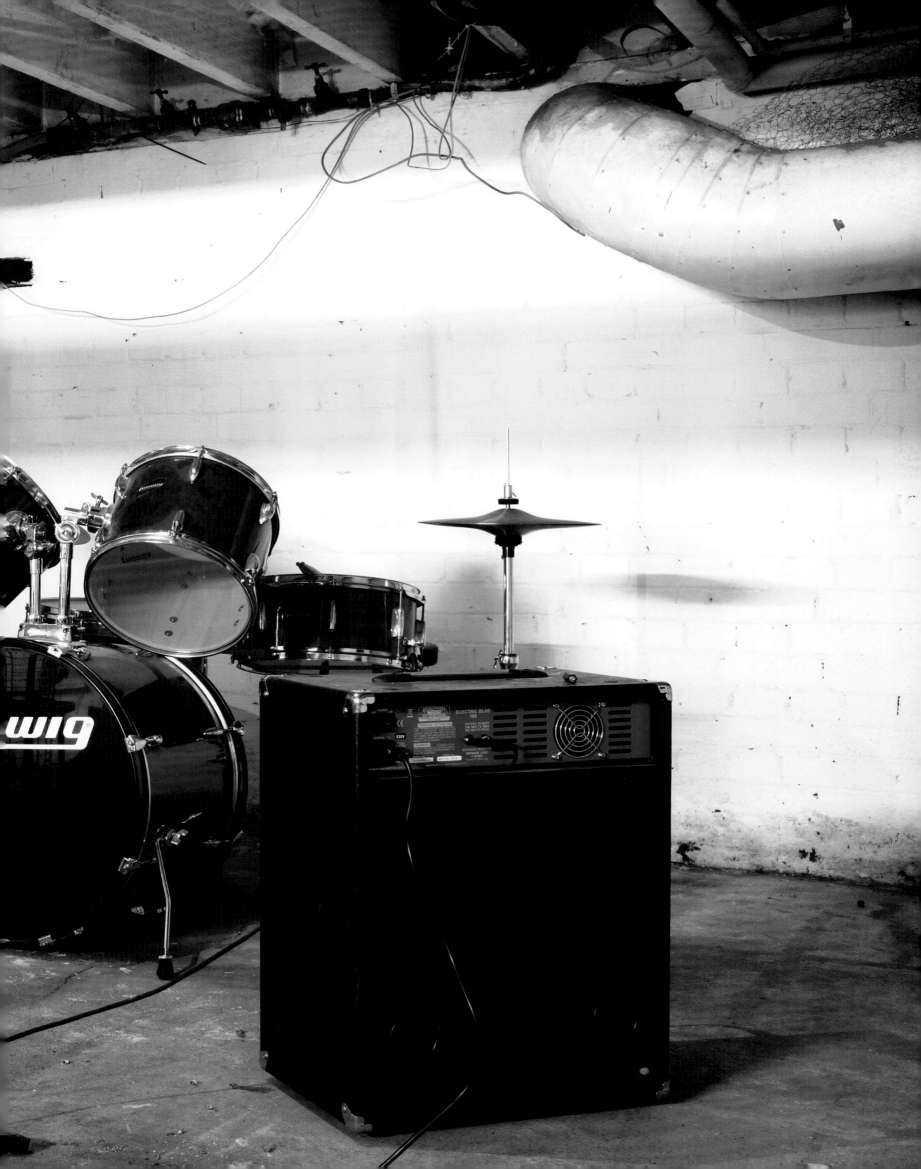

Claire Barclay

Claire Barclay in late July 2011 in her metal workshop in Glasgow (above) and at home (opposite top) working on a new installation. The artist installing her Bloomberg commission, *Shadow Spans* (right), at the Whitechapel Gallery, London, in 2010 (photo: Patrick Lears). 'I was always fascinated by how functional objects are infused with meaning, especially those with a sense of fetishism about them ...'

Would you describe yourself as an accidental artist?
I wouldn't categorise myself in that way, but there are accidental elements in my process.

How did you come to art?
I always wanted to be an artist. Going through a formative art education, however, changes your perception hugely, as there's a shift to asking yourself fundamental questions about what it means as opposed to simply having an aptitude for making.

Is there a Scottish element in your art?
Not overtly, but of course I am influenced by my own culture. I am interested in how contrast exists in a historic and social way in Scotland, but I am also drawn to influences from England, America, Scandinavia or other places where I have made work.

Did a particular type of object capture your attention at an early age?
I was drawn to objects that had ambiguity built into them, museum artefacts and redundant functional objects, for example. I was always fascinated by how functional objects are infused with meaning, especially those with a sense of fetishism about them, because I am interested in the seduction and repulsion of form and material. These kinds of objects pose questions and suggest possibilities. They trigger the imagination through viewers drawing on their own understanding of the material world and its relationship to the human body.

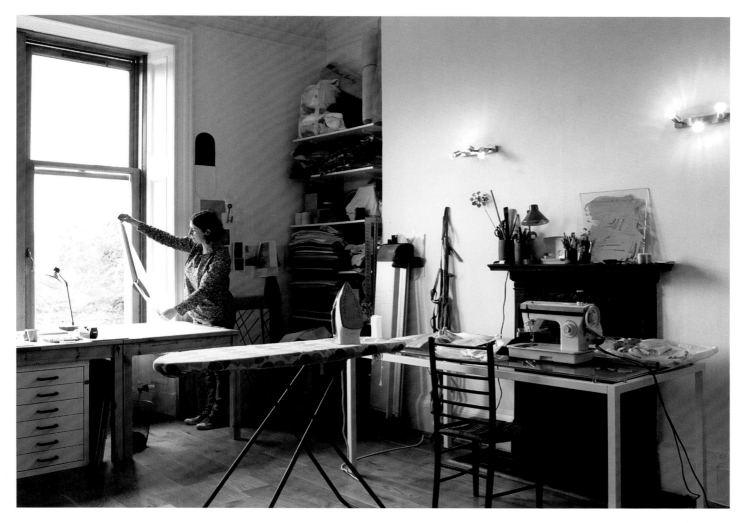

You never use found objects. Is it important that your hand plays a part?

It is either my hand or somebody else's hand. I'm not worried about having other people involved with producing the work. However, I prefer to make as much as possible in order to adopt a more organic process to produce forms. That way you learn through experimentation and the work is allowed to develop less predictably. I try to get away from designing as much as possible, taking raw material and trying to form it as intuitively as I can by using a combination of craft techniques and more industrial processes. To me, 'found objects' have too specific references. Instead I prefer to make my own objects, which are by their nature ambiguous although suggestive of everyday things.

Your studio has two areas, one for 'clean' fabrication and one for 'dirty' making. Does every installation incorporate both aspects, or do you have pieces that are purely clean or purely industrial?

My work incorporates both, because I tend to play with these kinds of contrasts in the sculptures that I make. Often the context will suggest the materials I want to use in order to interact with that particular situation. There is frequently some kind of organic substance which spoils a pristine surface, for example honey poured on aluminium, or mud smeared on cloth.

Are you saying that you start pieces of work entirely without planning them?

Especially when working with sculpture, drawings on paper are always so far removed from giving a true sense of the object in your imagination. Instead, I try to get a sense of a mood rather than a concrete design of the end product. Because I work on a large scale, I fabricate some elements in the studio and also produce other elements within the gallery. The individual pieces don't stand alone; they only become an artwork when brought together in the space.

Then how do you know what the final installation is going to be before you put it together?

I don't. There is a risk that there are things that are unresolved or parts that I don't like, but the installation arrives at a place where you can't take it any further. It has found a natural pause, and that means that it is ready to be seen.

You've described yourself as having an interest in objects 'which convey an ambiguous relationship to nature'…

The body of work I was making a number of years ago was influenced by time I had spent in Australia, where I was struck by the sense of a cultural identity that was so in tune with raw nature and at the same time so concerned with commodification of the wild. I became interested in hunting paraphernalia and romanticised imagery of the wilderness. It seemed to have something to do with placing oneself on that threshold of safety or threat.

Ambiguity seems to be a consistent theme here. Your art appears not to represent actuality and physicality …

I don't see it as representational. What I am trying to do is coax people to interact with the work by making it seem familiar.

Is Eva Hesse an influence on your work?

Back in art school she was. Seeing her pieces gave me the confidence to work with abstract forms within a very conceptual art-school department.

Why do you think that craft is dying out?

It doesn't help that a lot of art schools are closing their craft departments. I would hope that it is not dying out. I believe that it can't really die out because it is a natural aspect of human nature to make objects by hand.

You've explained how the studio works for you. Is it in fact the installation, the place where you display your art?

Yes. Or the gallery becomes an extension of the studio. The more exhibitions I make, the more I get a sense of how people read the work. While I have a certain understanding of the work myself, I don't want to reveal that directly, as I want to allow for openness in interpretation. There tends to be a sense of a collective understanding coupled with an individual's eccentric response to it.

What does being an artist entail for you?

For me it is the privilege of being asked to engage with new contexts. I have been swept along from one project to the next, rather than having had a particular career goal. I think it is healthier not to have expectations but to keep your curiosity active instead.

Anish Kapoor

Can you say something about memory and art-making?

Sculpture is full of the idea that we have memories that aren't verbal, that are if you like lodged in other places. Colour operates like that, too. I insist that my work is abstract even if it toys with meaning. I don't have that much to say as an artist, but that's an important thing because what one's struggling to do is to excavate a meaning or work towards a thing that might come to have a meaning. I'd rather keep things that way because it allows the studio to be a place in which memory and other things can arise.

It would be good to hear about your other epiphanies making pieces.

After making pigment pieces for about ten years, I felt that they were getting compositional and I wasn't really interested in composition. So I spent two or three difficult years in the studio and eventually made a simple big bowl. It had no form, it seemingly had no content, and all I did was to paint it blue. It was a discovery rather than a process led by thought. This thing seemed not to be empty; it seemed to be full of a kind of darkness that led me to ten more years of work which seemed to say that the great adventure in sculpture is space. It's the way that an object both says it's present and, in this particular instance, seemed to say that it was not fully present.

When by chance I made this 'void' piece after making form for all those years, it was just a very, very thin shell. I didn't really know where I was going. It suddenly filled up. It was as if it bore a direct parallel to something that I knew somewhere but never knew I knew.

After making those works for a number of years, I felt that maybe it was time to move on. I wondered if it was possible to do the same thing with mirrored form. I stumbled into the idea that one could make an object that was concave. Suddenly this was not just a camouflaged object; it seemed to be a space full of mirror just like the previous works had been a space full of darkness. That felt like a real discovery. What happened was that it wasn't just a mirror on a positive form – we have that experience from Brancusi onwards. This seemed to be a different thing, a different order of object from a mirrored exterior. It seemed again to be a moment that led me to another ten years' worth of work.

As I've grown up a bit as an artist and felt able to deal with more, at some level anyway, or to allow more things into what the work might be, I've come to see that one of the big concerns I've had over many, many years has been to make whole objects. Of late I've felt that I can for the first time deal with a fragmented object, with a fragmented world. That has to do with confidence.

What would be your advice to a young artist?

What we have to do is to keep inventing ourselves somehow.

How many parallel realities are there?

Thousands. One can concentrate all the possibilities in one area or do the opposite, which is to let them all be together, and that's what I'm interested in. I'm interested in the idea that there isn't one way to be an artist.

Anish Kapoor in his Vauxhall, South London, studio, at the end of November 2011. Kapoor's working model of the ArcelorMittal Orbit for the 2012 London Olympic Park (left). Designed to be Britain's biggest piece of public art, it will be 120 metres tall and use approximately 1,400 tonnes of steel. Devised to provide stunning views of the city, the Orbit, it is hoped, will rival the Eiffel Tower as a permanent attraction.

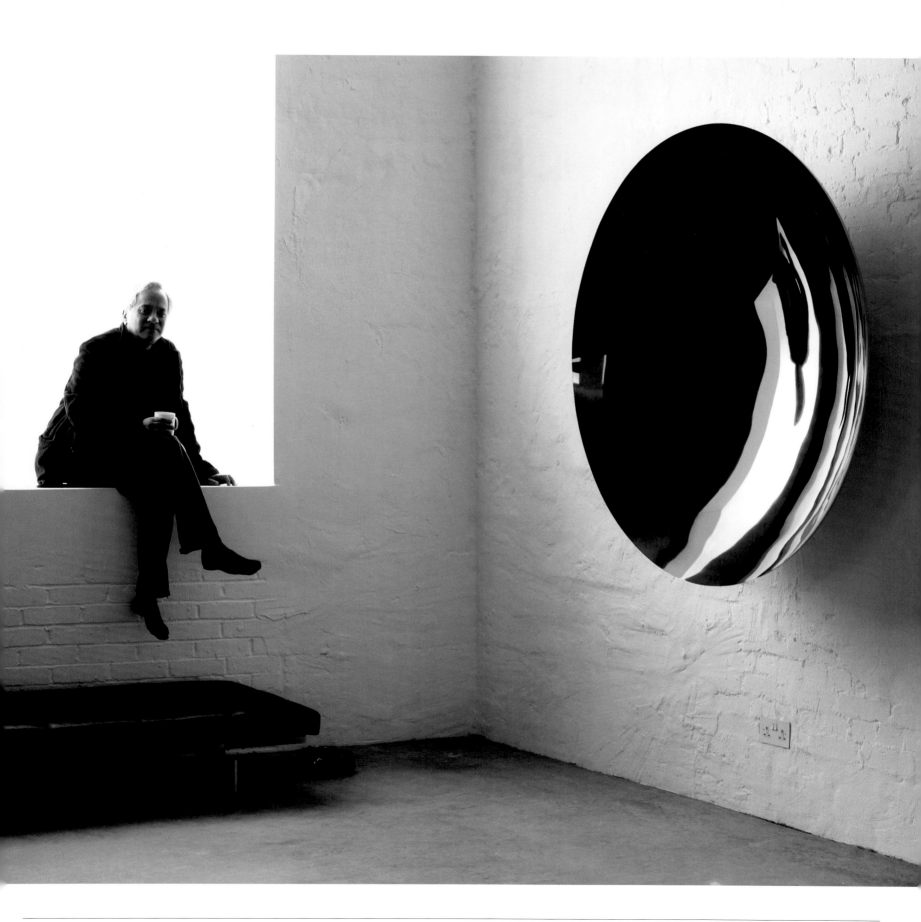

One of the things about a world in which everything is possible is that it's denaturing, first of all, and then de-skilling, which I think is an interesting proposition. Of course many artists have struggled with the de-skilling of the act of making. Think of Cy Twombly and Philip Guston and many others, of this sense that somehow a child could do it. Yes, there is something clumsily idiotic, but also in that sense archaic. It's like playing with shit. It's archaic in terms of its architecture but also in the sense that it's somehow – I'm going to dare to say it – somehow an internal object. It goes back to some primal human thing.

I was also curious about your relationship to science. In your works there is often something related to science, isn't there?

I am, of course, deeply interested in the whole subject. There's a big difference between art and science. Art has always been talked of in mythological terms: an artist discovered something, then some other artists would come along and appropriate it or work with it or use it or whatever the phrase is, so things seemed not to move ahead in a way. In science what happens is that a scientist tumbles upon or experiments with or discovers something at a certain moment. However significant or insignificant, it's properly recorded as something that was discovered, and the next discovery is almost built like

a block on top of it. The mixture, if you like, of the mythological and the 'pyramidal' is eternally fascinating because the two mix with each other.

When I interviewed the scientist Albert Hoffman, he would say, 'In 1937 on that very specific day I discovered LSD.' In some way one can say that scientific invention is an epiphany that happens at a specific moment in time. In terms of art, do you think that one can pin it down similarly?

Absolutely. I think this is vital. I've just described two moments like that, very precise moments, that I've had myself. One is always in search of those moments. Where do they come from? There's no knowing.

What would be your third epiphany?

I don't know. One sort of flows into a notion. I suppose there are two kinds of artists. There are those who discover a possible aesthetic way in the world and then go for it, mine it, if you like, to great profundity and depth. Then there are others who are perennially uncomfortable and looking very hard: is it like this, is it like that? And so on. I expect I'm the second kind of artist. There can be the sense of 'I've never made an object like that. Why not? Let's see what happens.'

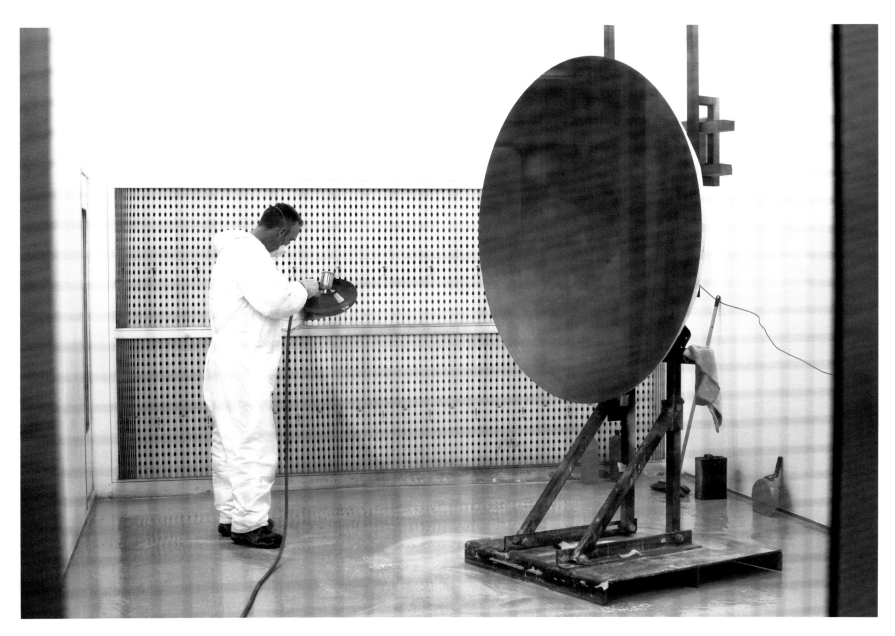

In addition to your different studio-workshops, there is also the studio in the mind, which is the notebook.
Which is a very important thing. Making architecture and drawing are parallel processes. They are both important, and we have to keep coming back to the idea that we don't know where art is going to occur. It has always to be open. That's why I believe that it's important to work on theatrical pieces, to work on dance pieces, to work with architecture, to keep the forum as widely based as possible.

So one can say that your notebooks are your studio in the mind. When do you do your drawings? At home, on your travels?
Travelling, at home, sometimes in the studio itself.

Is drawing a daily practice?
Either in the notebooks or on the walls of the studio, yes. It's a particular kind of mind process because what it continues is engagement with scale. That's the thing, really. There are two things that are truly mysterious: space and scale. But more mysterious than space is scale. Scale is not cultural, space is not cultural. They are to be discovered and rediscovered and reopened. When is a thing big enough to have a sense of awe? It's not because it's huge. We live in a world of big things, but very few man-made things have scale. It's interesting that scale is illusive; it's a mysterious quality, or quantity.

John Cage once said that it's by doing these parallel realities that we can maybe catch something special. He was working on his music; he was working on his drawings.
To catch the little moments because one literally does not know where art's going to occur is not definitive or anything like it; it's kind of an accumulation.

Kapoor's assistants working on the highly reflective, gently curved stainless steel and mirrored artworks for which he is famous. The artist's studio photographed in July, 2011 (top) dotted with prototypes and model renderings for new pieces. 'I'm interested in the idea that there isn't one way to be an artist,' Kapoor says.

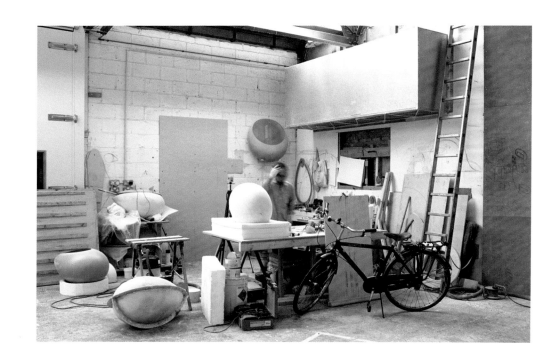

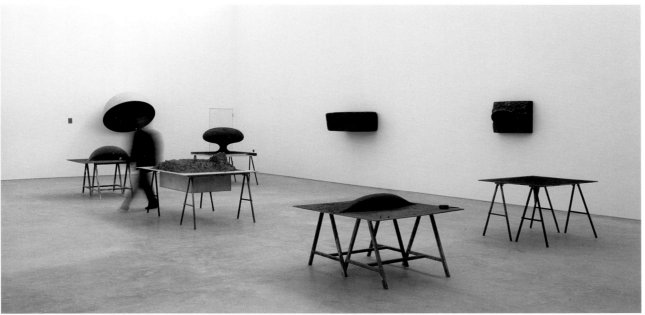

Warehouse, workshop, studio, storehouse. Kapoor behind his desk and inspecting the finish of his artworks. 'What we have to do is to keep inventing ourselves somehow.' Material being reinvented (following spread) formed in the crucible of the studio ... alien objects crafted by human hands. 'We have to keep coming back to the idea that we don't know where art is going to occur. It has always to be open,' Kapoor says.

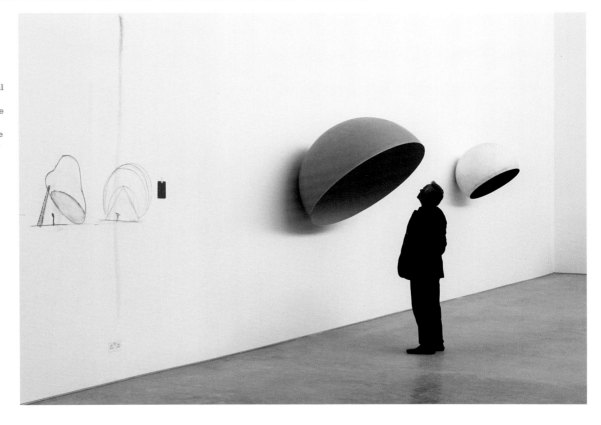

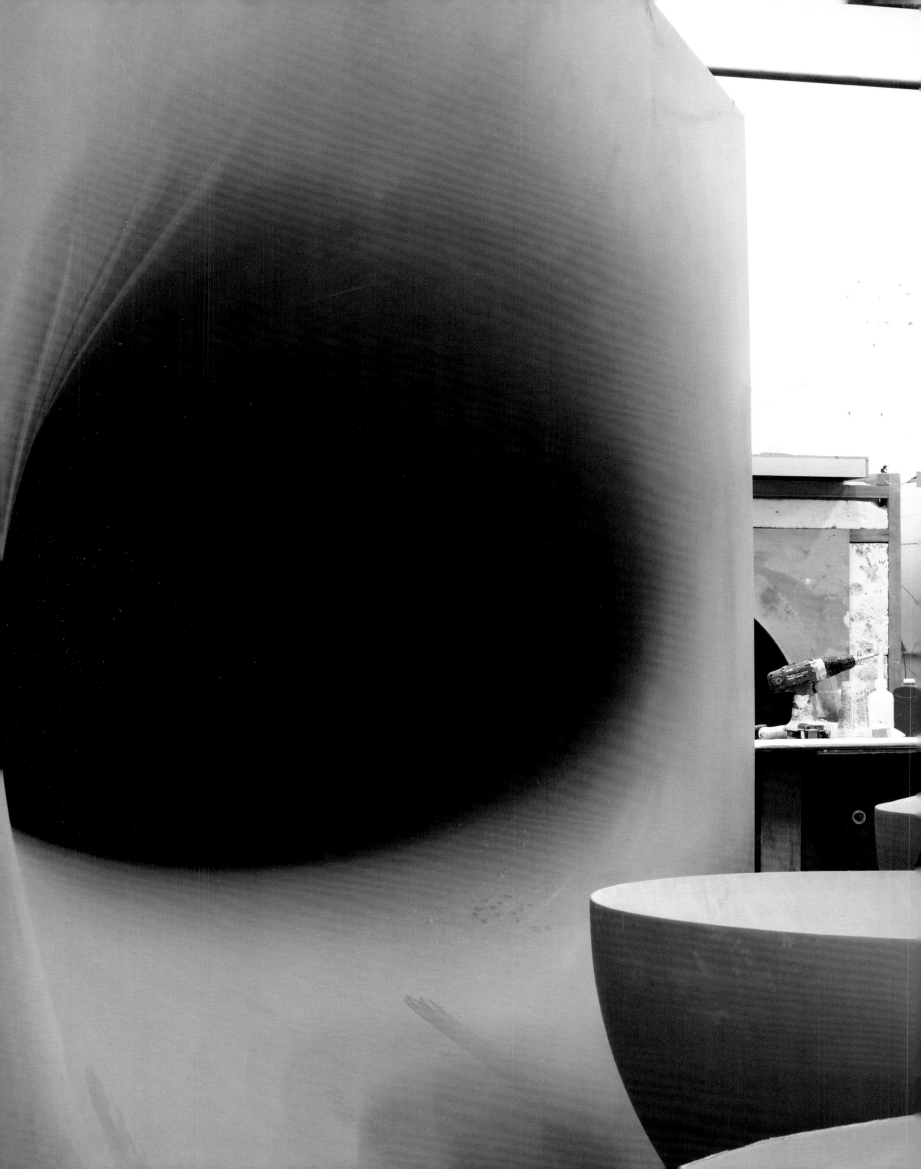

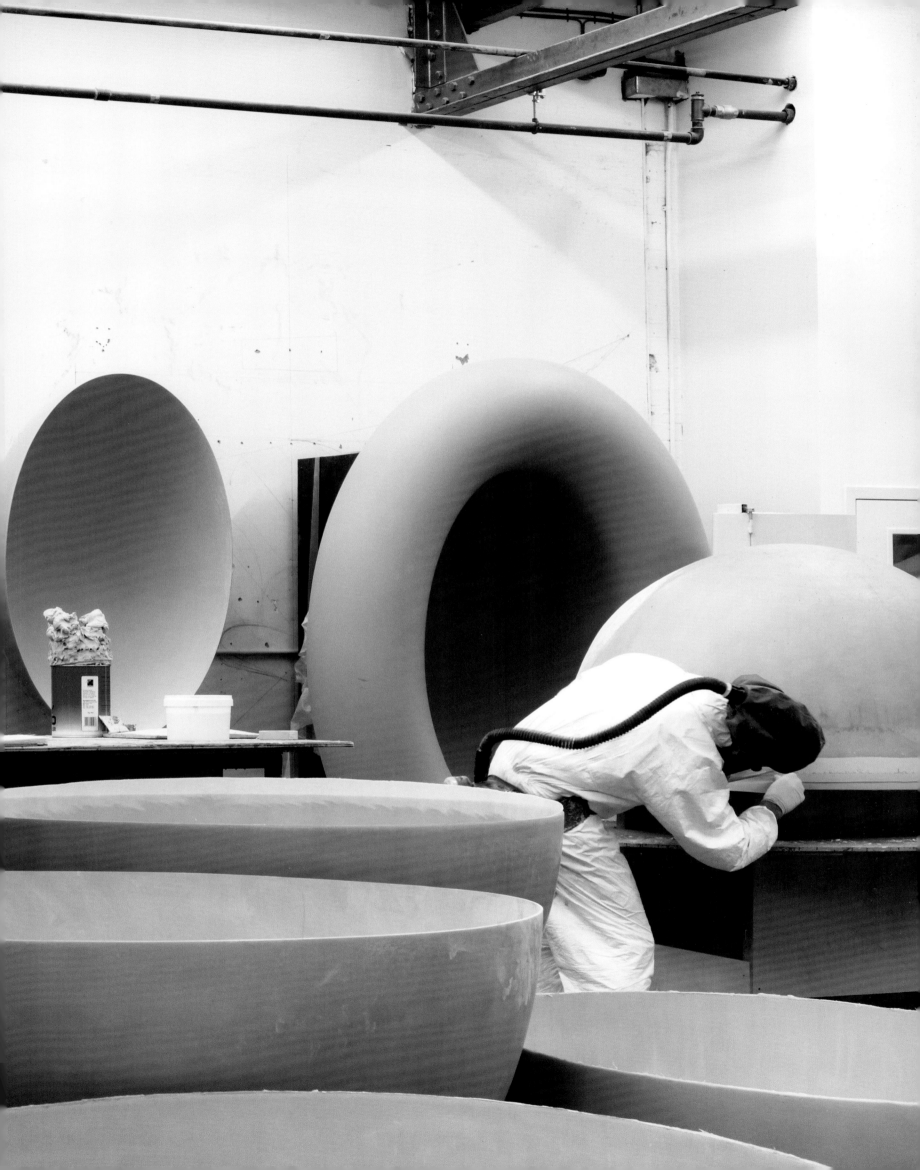

Helen Marten

You were born in Macclesfield and studied at Central Saint Martins in London and the Ruskin School of Fine Art in Oxford. How are these juxtapositions reflected in your art?

I wouldn't say that they are reflected necessarily. Macclesfield's an interesting place because industry is so accessible, but London has a more probing density, is so much bigger.

Are you never drawn back to your roots?

I have a rather unromantic vision of nostalgia. It's not sentimentality about the growing-up part, more a feeling of deep value in the honesty and intelligence of the town's mercantile pace, that what is special is the respect you can have for a place that represents a different sense of time.

Do you inhabit space with your art? Does it grow out of that space, or does it grow that space?

A bit of both, inevitably. You put an object in a space and it changes. You nudge something one way or the other; you've occupied (sometimes quietly) a piece of territory. The idea of inhabiting space has a specific type of emotion. Pieces can work quite differently in the studio to how they speak outside of it. Inevitably there is a shift between the studio safeness and that frightening moment of manoeuvring something into

a white space or a designated context. Fashion is at work too; how cold or laboured something can look when you're not there to prop it up. I'm interested in legacies of objects and manufacturing, but inhabiting a space isn't something I think about first when I'm making work. The relationship to people who have to walk around something drags you into conversations with the size of an object, or into thinking about our desire to look round corners – to consider material quantities that you can see, touch or smell. I'm interested in physical density and in dirty, grubby stuff but also in the sanitised space, the stuff that just becomes 'information', generic winks or redistribution. When you put something into a gallery or a museum, the context of a show necessarily shifts the reading of the result. But I wouldn't say that the building is the starting point.

You've described your methods as 'bouncing between parameters of architecture, fashion, design, history and environmental window-shopping'.

'Window-shopping' is the best way to describe it. This idea of theft, of poaching and re-appropriating stuff you trawl through in books, streets, on the Internet. This method of looking and systematically (or haphazardly) cataloguing stuff you see, then re-forming it into a new vocabulary. Maybe not a new

vocabulary – maybe something that has just shifted, a kind of haptic playing around with stuff when you twist things and flex them in directions that you're not used to seeing. Fashion, design, architecture are these great, encompassing ballparks that you, as an artist, have the luxury of darting around and stealing all the best bits from. It's like, 'I'll take that ... This seat pattern is brilliant' or 'The use of rubber here is really interesting.' Then somehow you mesh all of that into a new system or a new object or a new physical moment of wonder. So the idea of environmental window-shopping is literally just taking your pick. Artists are such magpies; they steal from everywhere.

How original is your art given that you're reinventing vocabulary, whether social or aesthetic?

I'd like to think that it becomes original, but you're always making some universal hook or linguistic reference that can be understood by your audience. I hope I'm not making things that are completely hermetic and self-indulgent, that are not mean-spirited, perhaps. It's always good to have a bit of humour; self-deprecation is quite useful. I look at a lot of things, take a lot of photographs. But those ways of researching or cataloguing are useful for making your own lexicon or index of stuff that you can then refer back to. It's always this building of a pathway, an unfocused map of things, or an elaborate dot-to-dot, really. You're joining up the dots as you move among them.

Helen Marten taking a break in early August 2011 in her Peckham, South London, studio. 'Fashion, design, architecture are these great, encompassing ballparks that you, as an artist, have the luxury of darting around and stealing all the best bits from.' Marten (left) visiting her favourite toolshop.

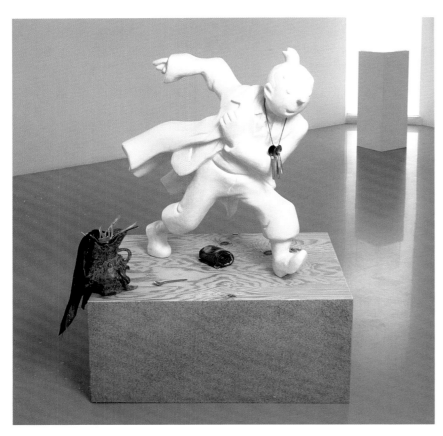

'Artists are such magpies; they steal from everywhere.'

(left)
The advent of a world class economy, 2009
Photo: Ken Adlard
Courtesy Johann König, Berlin

Marten (opposite), who studied at Ruskin College, Oxford, is recognised as a cerebral artist with a promising future. 'I hope I'm not making things that are completely hermetic and self-indulgent, that are not mean-spirited … It's always good to have a bit of humour; self-deprecation is quite useful,' she says modestly.

Are you a reductionist or a contortionist?

Either/neither or both! I would never want to have some kind of reductive strategy for making, or some overblown system of links and twirls that gets lost in private rhetoric. Maybe I have a leaning towards a heavily collaged look, but some works are pared down and un-complex. That again changes from piece to piece. You're always hunting for a new look for yourself – to find surprise or be hit on the head with something very obvious.

Which pleases you more, the process or the product?

Both. The point is that they're both engaged in this continual flex. You're never moving towards one or the other, just passing continually through each stage. I don't think that the work strives for an 'either' or an 'or'.

Your work has been described as resembling the Rosetta Stone, as being like code. Is that accurate?

That's a fun way to describe it. I'm thinking about systems and hieroglyphic ways of reading around things. At some point there's translation, but maybe not everything is translated. Codes and symbols are interesting; they are concerned with what society ultimately breaks down to: how we behave, language, how cars move on the motorway. There are ingrained systems that exchange and manufacture. I'm always surprised by how much humour there is in the everyday: in signs that have an accidental double reading – the breeziness of their satire – or people carrying ridiculous piles of wobbly stuff on a bicycle but with the most deft and articulate of touches. To an extent, putting a sculpture in a room can have the same effect as a stand-up comedian performing on a stage, with those same moments of catharsis and pathos, humour and violence.

You work sometimes with metal and wood, which you've described as being 'hard, lofty boys' materials – unforgiving', as against clay, which is 'relaxing and yielding, feminine and spontaneous'. Is this reflective of a gender division in your thinking?

No. That was a joke. I definitely don't think that metal or wood are 'boys' materials'. It's funny to rub up against 'old-school sculpture' – *heavy metal* – but I can't see now how it's relevant. The casualness or the hardness of materials can lend an object a personality, but I don't think they're definitively gendered or categorised. But obviously there's a formal use-value to clichés.

So artworks, installations, have personalities?

They can have personalities. This idea that you're spinning an emotion into something, not necessarily a narrative … material always has a look, and that look always has a tone, and that tone always has an emotion. So if you make a bench out of wood, the colour of the wood will instil some kind of personality. I don't mean character-based; I mean the pitch of the object. Playing with materials is always wielding some kind of unfixed narrative that you can control by this combining of things.

Is your studio as important as the workshops to which you outsource your work?

Definitely. Wherever possible, I at least start or end things myself. If I don't have access to a machine or don't know a particular process, I might work with people very closely. Things go through stages: I touch something, it moves out to a fabricator, someone who knows how to put a specific radial bend in a sheet of metal or in a tube, for example. People with knowledge! Then this material comes back to me to fiddle around for a bit. Things get dragged around. There are conversations, sometimes misunderstandings. Everything goes through a very 'hot', touched process.

Going back to your obsession with fixings and material seductiveness, when did these materials begin to attract you, or obsess you?

I've always been a collector of stuff. I used to collect washers; I had a wonderful collection of toothbrushes when I was a kid. I used to collect rocks, fossils, bits of metal, stickers, bottle tops, feathers. I'd always have drawers full of things. It was never a strategy; it's just that I was attracted to having *stuff*. I hold on to things in my studio. I'm still collecting; I have books and images, an image bank, lots of ceramic tiles and fabrics … I wasn't one of those people who grew up thinking, I'm going to be an artist, I'm going to be an architect, a juggler, a policeman, whatever. It's just that I somehow quite liked gathering information.

When did you slip into the stream of being an artist?

I don't know. When you reach that point in the English school system where you have to decide that one thing needs to be more interesting to you than all the others and you think, Maybe I'll go to art school? Then you fall into that space, and you meet people who are making, people who are in some way or another composing similar things, making attitudes, reverberations. And you fall into this universe of conversations, of collisions. And somehow you're making shows and you've fallen into this incredibly luxurious way of making a life. Which is almost like making luck.

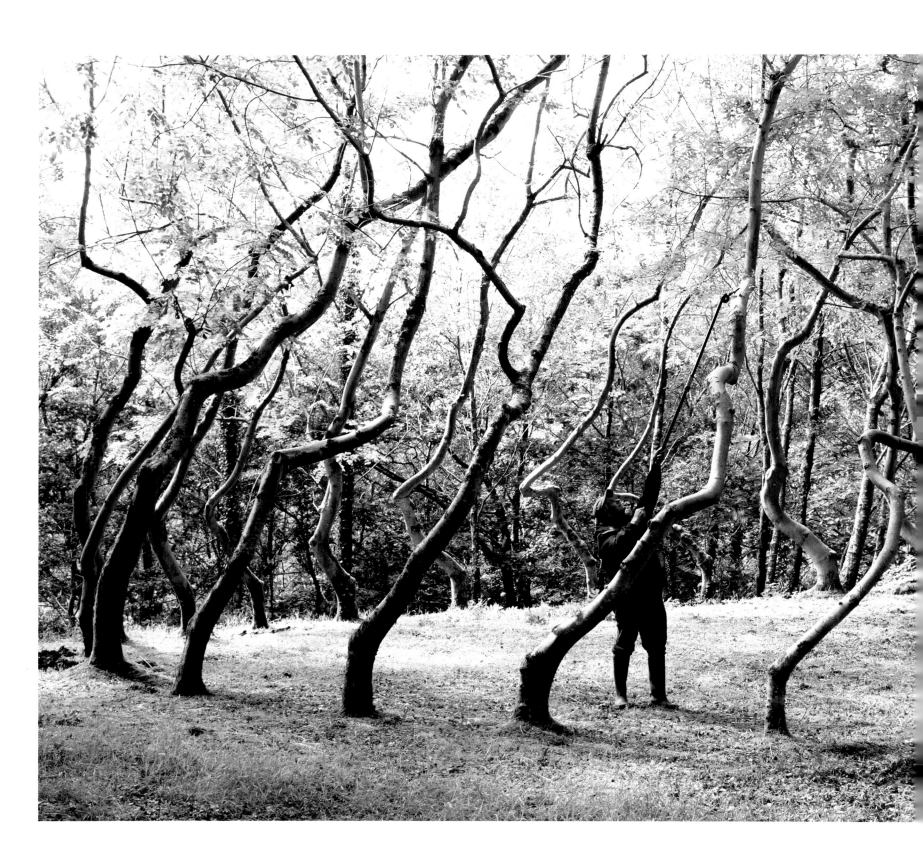

How many studios and workshops do you have?
There's the main chapel, which I used to work in.
Then there's the drawing studio, the second drawing
studio, the industrial units, the drying kiln and some
storage space. And then there is a piece of land
where I am nurturing groups of trees into forms.

Why so many?
Real estate is cheap in Blaenau Ffestiniog because of
the 300 centimetres of rain every year. I first came here
in the '60s, after leaving college. I knew I could live on
next to nothing. My father's parents were pharmacists
– they had shops in Wales. My father was born and
brought up in Wales, and all our holidays when I was
growing up were in this area. What was exciting was
being here in the weather and on the land.

**This love of nature, this relationship with it …
you call it 'skin' …**
Nature is a bland word. These are the forces that we
have to contend with, that we depend upon. Nature
gets us in the end. It is our environment, which is an
extension of our skin. We are the most dominant force
for changing or diverting it.

For good or for bad?
It has been for bad, but it can be for good. People
and nature get along best when people collaborate
with nature and don't try to dominate. There has to
be a system to this relationship, which is what I have
developed with my material, which is wood, which is
from trees, which are living things, which grow out of
elemental forces.

**But you never take life, you never cut down
a live tree, do you?**
There are times to take a live tree: when it's
damaged, when it is out of balance and could fall and
is dangerous. I would never take down a perfectly
healthy tree.

So you don't interfere with nature?
I intervene and I guide as I learn. I've never been
comfortable feeling dominant over the forms that I
am making. I've wanted dialogue. I thought I could
find that by following a material. Then I saw a big
retrospective of David Smith's work at the Tate which
was all made from steel in the 1960s. This was a
man who spoke steel; it was like clay in his hands.
I realised that I had to learn a material so I could be

fluent with it. Wood is my material. I 'speak' wood,
and it speaks to me. It's not like scavenging; it's more
like being a hunter-gatherer.

**Is there any other artist whose practice is
similar to yours?**
Brancusi, who was quite private, is the grandfather of
modern and contemporary art. He made his gesture
not only in his work but in how he lived. Apparently
he wept when he sold a piece. Other artists who have
touched me deeply include Rothko. I didn't get his
work at first, then an artist friend told me, 'Go and sit
in front of a Rothko for five minutes. Do this for me.
Then you'll probably get it.' And I did. It really touched
me. When I heard that he said that his pictures were
moral statements, I understood that too, because when
you make something and you put it into the world it
represents an attitude or behaviour.

Brancusi said, 'Good art heals.' That is what I
want. I want my work to have a tenderness to it.

**So your main display area is the old chapel …
Looking at these totemic pieces against the
stained-glass window makes me wonder whether
you are reinventing religion through art.**
Yes. Each individual has to become their own temple.
We have to take responsibility for ourselves, not give
our egos away to religion or allow another ego to
dominate us, especially artists. Rudolf Steiner said
that artists are at the cutting edge of the evolution of
consciousness. They'll make a lot of mistakes, they'll
get it wrong, but they challenge accepted thinking.

**When did you realise that you had to become
an artist?**
When I was fourteen, I was sent to an English public
school. I realised that they were trying to mould me;
they were trying to destroy all the confidence I had
built up within myself and trying to replace it with
someone else's ideas. I realised that I was at war
with anything that was trying to mould or control
me. I was always good at art. We had wonderful
neighbours; the father was a graphic designer and his
kids were the same age as me. I was always in their
house. I drew, I painted. So when I went to school,
I was already doing it and I was praised for what I
was doing. When you are praised, you flourish. I was
always playing with materials, particularly bits of
wood, building camps and huts and carts. I've always
been a maker.

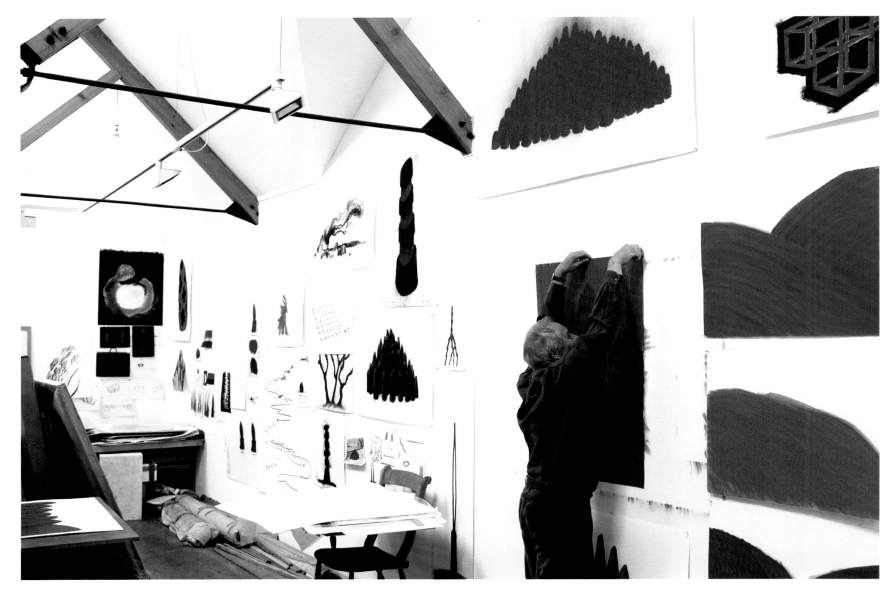

David Nash (previous spread)
tending to his *Ash Dome*, a
ring of twenty-two saplings
he planted and has been
pruning and guiding into
shape for many years. Playing
with ideas of growth, decay
and natural transformation,
Nash classifies his works as
either 'coming' or 'going'. *Ash
Dome* is a classic growing, or
'coming', work, intended to
create a space for the twenty-
first century. Nash has never
fully revealed its location,
taking crews via circuitous
routes to its secret Snowdonia
site in North Wales.
Nash (above) often uses
natural materials for his
drawings. Here he is shown in
his drawing studio in Blaenau
Ffestiniog. 'Nature gets us in
the end. It is our environment,
which is an extension of
our skin. We are the most
dominant force for changing
or diverting it'.

Nash next to the tent (above) set up in woodland he owns in Snowdonia, where family and friends gather to celebrate each New Year. 'Time is a part of my work; it an essential part of wood as a material.'

Nash with his wife Clare, who is also an artist, photographed (left) in their picturesque garden in the foothills of Snowdonia in the Welsh mountains. Originally from Surrey, Nash moved to Blaenau Ffestiniog in his early twenties, purchasing a disused chapel to turn into a studio and home. 'Brancusi said, "Good art heals." That is what I want. I want my work to have a tenderness to it,' he muses.

Nash uses petrified wood (below), sometimes casting nature's work in bronze.

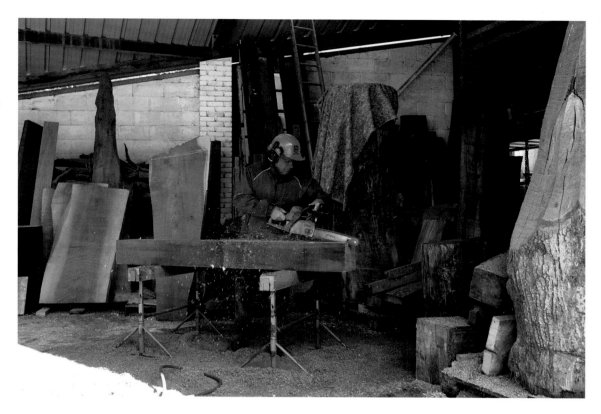

Artist and tree surgeon, he does all of his carving himself (right) while occasionally employing finders in his search for fallen or dead trees. The artist in his inner sanctum, previously a chapel (following spread), viewing completed work, some of the wood sculptures waiting to dry out naturally.

At secondary school there was an art teacher, Gordon Taylor. He taught at the Royal College in graphics and design, I think, and found that he could survive at this private school because he loved to be subversive. People interested in art tended to be subversive. He took us under his wing, taught us about being free human beings, about being adults. So he wasn't just teaching us how to pass exams. And he taught the history of art in the most amazing way.

Can you say something about *White Cube: Seven x Seven*?

In 2000 I planted forty-nine trees in seven rows of seven, seven feet apart on a slope in a square. Everything about a square is in balance, but everything about this square is out of balance. Seven is the most odd number; seven cubed is even more odd; and the work's on a slope so it's a rhomboid. The trees are very white birches. I am just keeping them all growing, bringing them along to become white poles. Each year I need to prune them, but there'll be a point when I'll have to stop. Those trees want very much to survive. If you look in farmers' hedges where they have been bent and slashed, they keep coming back. They adapt to what happens to them. They want to survive.

Is that a metaphor for the human condition?
I think so.

Did you use other media at the beginning of your career?
I started out as a painter, lost my way and also found that I didn't want the forms I was finding flat on the wall at a distance from me. I wanted them to exist in real space.

When did you make your first piece?
When I was a kid at a nursery. It was autumn; there was Virginia creeper on the building. The stalks were about 6 inches long, bright pink. I collected a handful of them and found an elastic band to hold them together. I remember standing the stalks upside down. They looked like some of the works I do now. I can remember being thrilled. My teacher liked it too.

So you were essentially standing things on their heads?
Yes. Standing a tree upside down with all of the branches going out works like a perfect piece of engineering.

And the first piece that you sold? Was it made out of wood?
The significant sales were from a show at the Serpentine Gallery, London, in 1976. I got a lot of sales directly to museums. I wasn't with a proper gallery until 1984.

And do you cry when you sell a piece?
No. I love my works going out into the world, particularly going into someone's home. That is where they are meant to be. But I do keep pieces.

Your work is allowed to deteriorate and change with time, isn't it?
Time is a part of my work; it is an essential part of wood as a material. Some woods are resistant to rotting. I know how to make a piece that won't rot; it's all to do with water. But only 10 per cent of what I do is for outside.

And you have a former tree surgeon who works with you?
Yes, he helped me cut down a big tree for a project in Sussex. I was also doing a project in Rouen and he found some trees for me to cut and shape. Ever since then he's been my main source for wood.

So you have a wood doctor ...
Yes. Sourcing the wood is important. In the '80s and early '90s, most of my work was made on location. For a museum show I'd make all the work with local wood from near the museum, which became fascinating. In Barcelona they took me to what they called a tree hospital where they take sick trees and nurse them back into health. They have an 80-per-cent success rate, so I was able to have any of the trees from the 20 per cent that were dead.

You've been described as seeing your art as part of the community and as being very conscious of your viewers.
I give enough, but you mustn't give too much. You have to put enough there for the viewer to complete it. This is pure Duchamp: the artist does one half, the viewer does the other half. If you over-explain, there is nothing for other people to do. That is dumbing down. It's why I'm careful in museum shows that the education department doesn't overdo it with explanations. You've got to trust people to sense what's in the work. People recognise truth; it is one of our twelve senses.

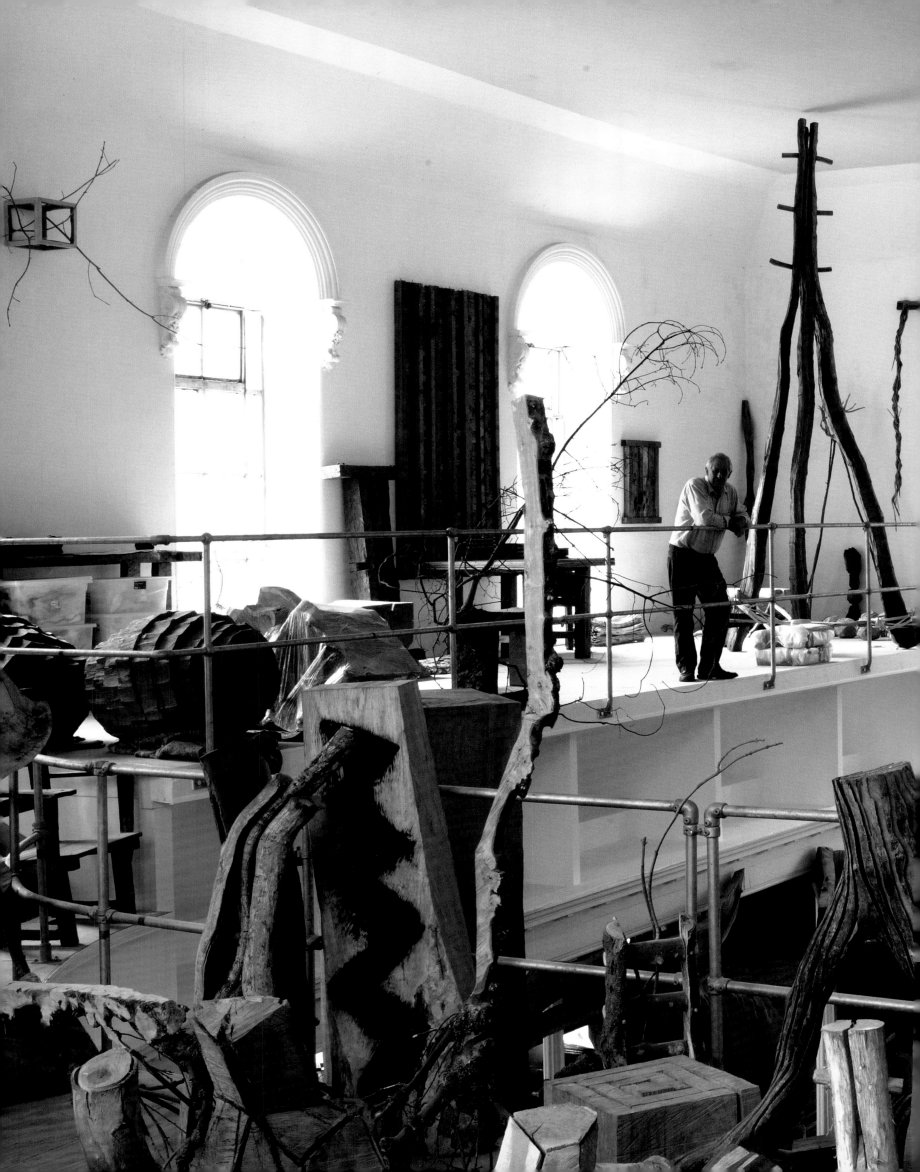

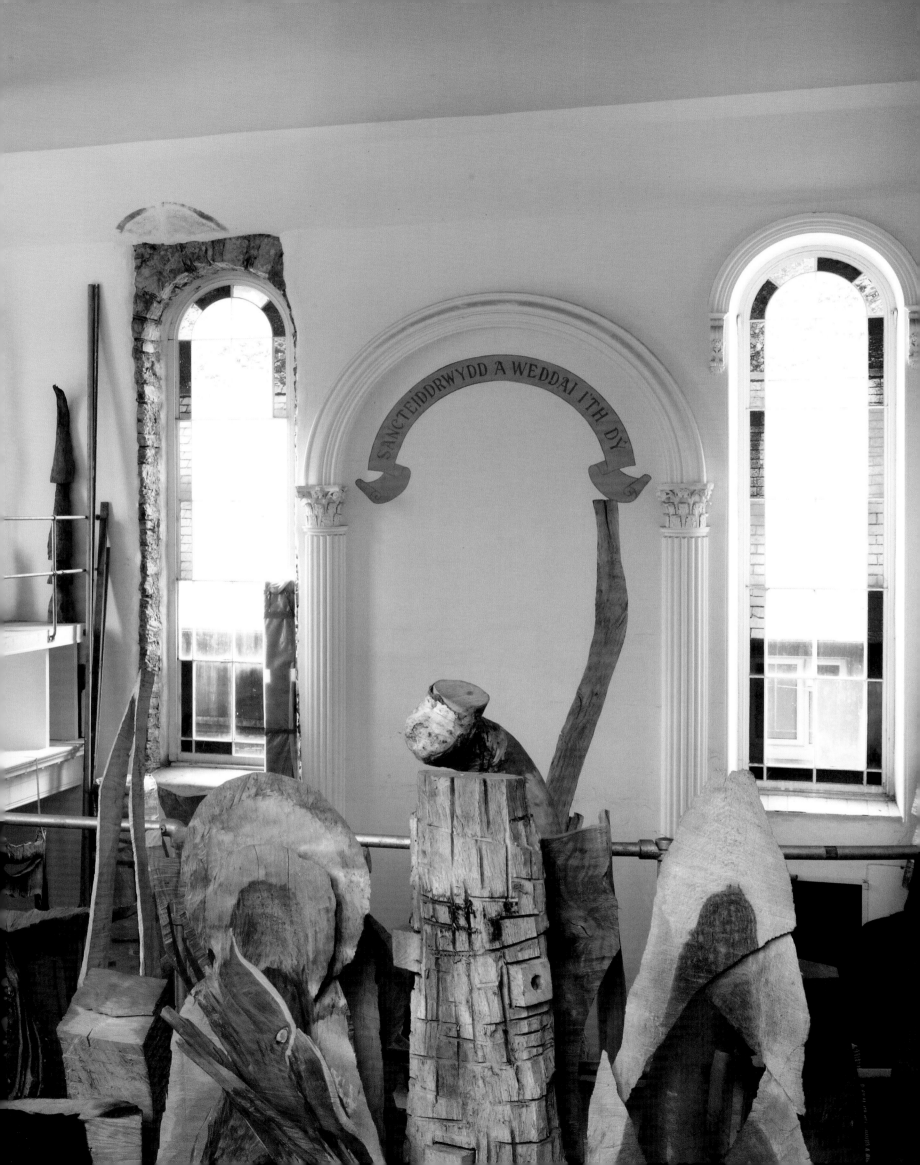

Jananne Al-Ani

When you start a project, are you concerned with its effect on an audience or are you just doing it for yourself?
Audience and context are important to me but tend to be among the considerations that arise nearer to completing and exhibiting a work.

The word *intervention* is frequently used when people discuss contemporary art. What does it mean?
Artists often use the word *intervention* when talking about making works that have an impact beyond the space of the art gallery.

But 'intervention' implies getting in between things, perhaps between an audience and an object. Is that what your art does?
No. I wouldn't generally describe my works as interventions. Maybe someone like Grayson Perry is creating a kind of intervention when he appears in public as his female alter ego Claire. Another example might be Emily Jacir's brilliantly witty work *Sexy Semite*. Jacir adopted the guerrilla tactic of placing ads for an Israeli husband in the lonely hearts column of a New York newspaper in order to claim her right of return as a Palestinian through the back door.

But what does that have to do with art?
It generates a discussion. It also raises the whole question of what art might be.

Your mediums are photography and film. Have you ever been interested in painting or drawing?
When I started my undergraduate studies, I was committed to the idea of being a painter. At one point I was photographing and painting from my photographs, and one of my tutors said, 'I don't understand why you are doing that. The photographs are interesting enough!' At that time – the late '80s – I was concerned that I would be pushed away from painting because it wasn't seen as an appropriate medium for 'political' work. I was making work that was overtly feminist and felt that if I was being critical of the history of European painting, I had to paint. When somebody else said, 'Actually, quite a lot of feminist artists of the '60s and '70s worked with photography and film,' I was like, 'Well, there is no reason why I can't also make political work as a painter.' I hung on to painting for longer than necessary.

Do you regret abandoning painting? Would you ever go back to it?
No, I have no regrets, and I can't see myself painting ever again.

You've talked about the 'language' of art. Who controls this language, and where does it come from?
People have been making images for ever. If you think about hieroglyphs as bringing together image and text, I would argue that this is a tradition with which contemporary artists are still engaged today.

You were born in Iraq. Are you Kurdish?
No. My father comes from Ana in the west of Iraq. He met my mother, who is a second-generation Irish immigrant, when he was studying in England. I was born in Kirkuk, where my father worked for what was then the Iraqi Petroleum Company.

You are based in Britain now. Do you ever go back to Iraq?
I haven't been back to Iraq since I left in 1980. Not once. I have missed it terribly and am deeply connected to it, but when the Baathist regime was in place it was very, very difficult, and with the collapse of the regime in 2003 it became more dangerous than ever. However, in the last ten years I've been back and forth to neighbouring countries such as Palestine, Lebanon and Syria, where I have made new work and exhibited. Last year I was filming and photographing from the air in the south of Jordan, which was extraordinary. I did quite a bit of research finding the locations I wanted to shoot by looking at maps, photographs and of course Google Earth. The one thing I couldn't bring myself to do, though, was to look at the place where I was born. When I finally plucked up my courage, it was incredibly shocking because it was so familiar, with buildings and roads exactly where I remembered them despite my never having seen the place represented on a map. I suppose that was the point at which I realised I could never go back. On the surface it appeared to be the same place, yet in reality everything about it had changed for ever.

Yet your subject matter is very much based on those initial memories – the veil, for example.
No, not at all. Coming from a Muslim culture, the veil is ordinary and ubiquitous, a non-event. The reason I made work about the veil was because I was astounded by how fascinated everyone in the West was with it. Those works had nothing to do with the Middle East. They were to do with the West's fantasy about veiled women. I became interested in early European travellers' experiences of encountering veiled women and how often their reaction was one of anger or frustration. Men were furious that they couldn't see these women and fantasised about unveiling and undressing them.

How did those observations relate to your artistic viewpoint?

One of the things I'd been interested in was the way ideals of feminine beauty have been constructed through the image. I was looking at Western painting of the eighteenth and nineteenth centuries, when Orientalism became fashionable. I was trying to understand what inspired the fantasies that were constructed in painters' studios and how they fed into the images produced by Western photographers who travelled to the region and established studios in which they replicated the sets and motifs that appeared in the paintings. Somehow the medium of photography itself became a collaborator in verifying the existence of this fantasy.

Do you accept that the veil is an imposition, or is it just a cultural condition?

I think it is impossible to make generalisations about an issue as complex as the veil.

But what about the crass hypocrisy with which people live in the Middle East, the hypocrisy that religion imposes, for instance? Are you not conflicted about that, given that you live here safe from its corrosive effects?

Sadly hypocrisy seems to be a universal phenomenon, and unfortunately there aren't many places in the world where women's bodies are not a site of conflict and contentiousness.

At the end of the day, do you consider yourself a British artist or an Iraqi artist practising in Britain?

I am an artist.

Iraqi-born Jananne Al-Ani (above) uses photography and film (created in her studio and at the VET post-production lab) to explore topics related to conflict, loss and displacement. Shown here in mid-July 2011 in Shoreditch, Al-Ani has not been back to her homeland since 1980. 'I have missed it terribly and am deeply connected to it,' she says. Her new work revolves around aerial imagery of borders in the Middle East. The artist (opposite) checking a proofing press at Book Works near Old Street, London.

Juergen Teller

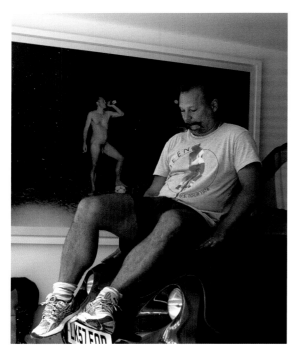

Juergen Teller (above) in front of a self-portrait from his 2003 exhibition *Daddy You're So Cute* at Lehmann Maupin, New York. The series featured images of Teller drinking and smoking naked over his father's grave; his father, a volatile alcoholic, took his own life in 1988. Teller (opposite) shopping for razor clams at his local fishmonger in Notting Hill, London, early August 2011.

Where does fashion photography end and art photography begin?

I never ask myself that question. I just want to do good work. Obviously if you are involved in fashion photography, you have to please the client. You can't photograph a tree when you have to photograph a handbag! It's important in the sense that it's a big industry and it is very much part of our lives. Whether you like it or not, everybody is vain and fashion-conscious, and you can make some sort of cultural comment on it. You can acquire influence, comment on society, within that framework.

Are you cocking a snook, then, at the very people who feed you?

I did this book called *Go-Sees. American Vogue* asked me to fly on Concorde to New York and photograph Christy Turlington and Linda Evangelista, things like that. I became more and more famous as a fashion photographer. I got model agencies calling me up and saying, 'We've got this great girl in town for three days. You have to see her!' And I thought, I have no idea for a story. And then I thought, Hang on a minute. I'm going to let the world come to me. And it did, literally. To my doorstep every day, different faces, all of them models.

All these people with aspirations to be transported to the Neverland of fame, and you held the key ... How did that make you feel?

I can use my power to do exciting things. If I have a client I can convince, I can go anywhere. I just want to have fun with it. I want to explore things, and I want to use it for my own advantage.

That power allows you to infiltrate and inhabit a world that is contrived in every way, isn't it?

Well, it's very staged.

But you've said that you try to get at the naked, un-staged essence ...

That's quite a hard thing to achieve. I want to show the beauty of it but also the ridiculousness of the fashion, you know?

You've been described as the *enfant terrible* of fashion photography. Is that a position you developed intentionally?

I'm very much *in* the system, but I don't necessarily play by their rules. I have a natural talent for photo-graphing people and *showing*. With a lot of other fashion photography, you don't even see the clothes. It is a serious business where a lot of money is being made. But some of the clothes are just ridiculous, and I want to show the ridiculousness. And I want to show the fantasy of it, the theatre of it.

You arrived in England with two or three cameras as your only asset at the age of twenty-two. Where did you go from there?

I used to make bows for violins; my dad made bridges for violins. I had an apprenticeship and studied for one year. But I had an allergy to wood dust, so I had to change jobs. With my cousin, who was two years older than me, I drove to Tuscany. He was a hobby photographer; I always looked up to him. At the end of every day, we had to find a camping ground. And he always stopped the fucking car and put up his tripod. I was thinking, Why the hell is he doing that, day after day, waiting for the right light? Jesus, it's so bloody boring! We've got to put this tent up! Until I thought, Let's have a look. And I grabbed this thing, and for the first time in my life I looked through it. And for the first time in my life, I thought, Actually, I see something. It was the first time I felt that I was actively *looking*. That was the key moment. I thought, I want to be a photographer.

I went to Munich to study photography between '84 and '86. My parents couldn't afford the tuition, so it was the German health system that helped me find another occupation. After two years of studying I was supposed to go into the army. But I was so driven about wanting to do photography that I left Germany. I couldn't go back as a loser. That was very much what drove me to make it here, and make it in photography. I could not have gone back to my village and said, 'It didn't work out.' The first thing I did was sell my cameras, except for the 35-millimetre one. I was able to live off the money I got for about nine months.

Where do you start?

I was very much into music at the time, and record covers were important to me. So my visual educa-tion was not really from an art background; it was from TV, movies and record sleeves. I started making record covers here. I felt it was an honest way for me to make money. When I liked somebody's music and made their record cover, it made sense.

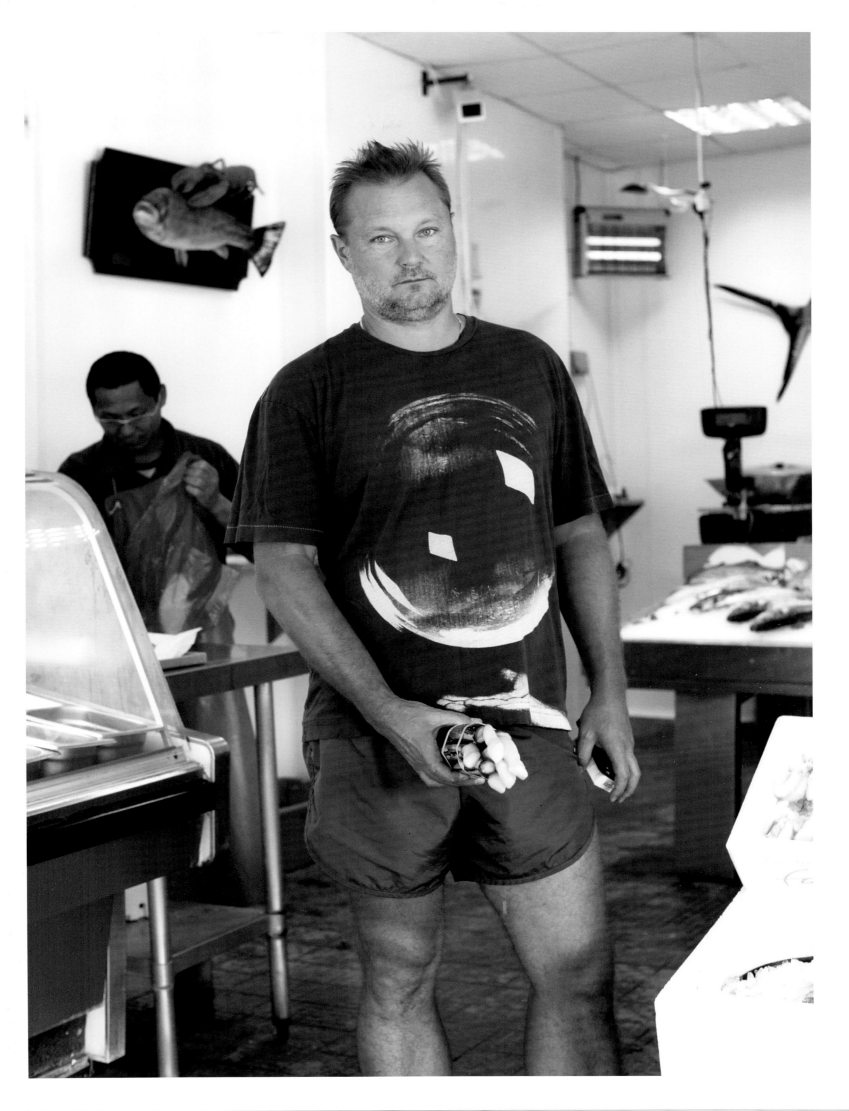

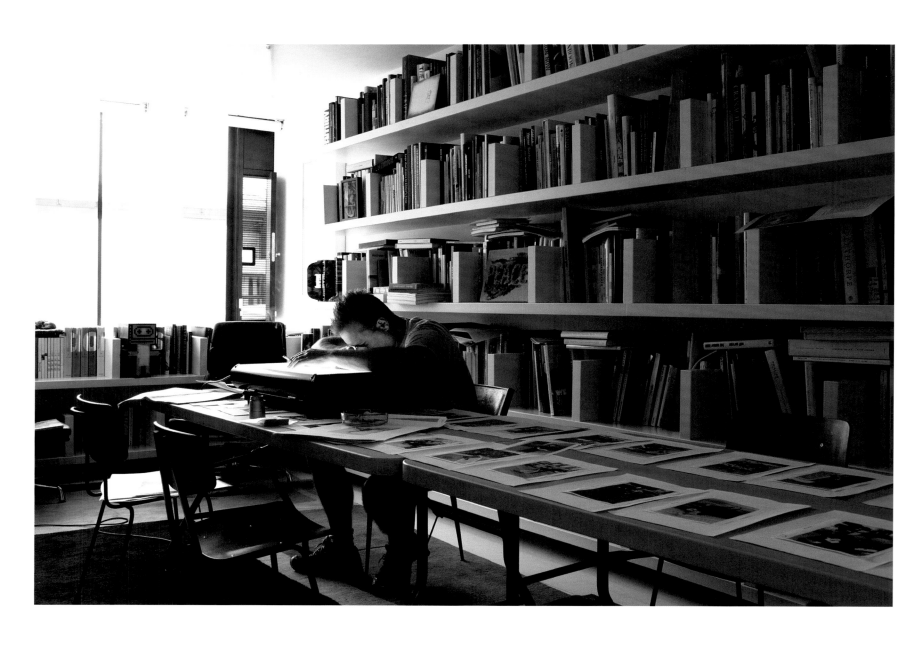

What constitutes great art photography?

When you feel the person behind it very, very strongly, when you feel their inner self coming through. Great photographers are great artists: William Eggleston, Boris Mikhailov, Robert Mapplethorpe, Nobuyoshi Araki. It's when you really see their instinct and their intellect, and when nobody else could have done that.

You work exclusively with Marc Jacobs. How did that start?

I don't think any photographer has worked with a designer for that many years. Normally in fashion they always chop and change. It started in '97, when my girlfriend at the time, Venetia Scott, got asked to be the stylist for Marc's collection. She turned it down because we had just had our kid. They were very determined in a calm, sweet way, and they invited me and Lola and some help to work in New

York. We stayed for three weeks, and a friendship developed from there. We discuss who we're going to use, and then Marc leaves it up to me. He says, 'Juergen is so shameless!' But I don't work exclusively for Marc Jacobs.

How straightforward is it to create your photographs?

I work very, very hard on them. I shoot a lot of film. I'm like an animal that catches his prey in the way I photograph. I don't let go until I've got it. So it's not like I'm just lifting a camera and thinking, Yes, okay, let's do this. And with my assistant we spend a long time over the light box. Then I go to my colour printers, and I don't just give them the things, I'm there. I love it in the darkroom. I'm very concerned with whether this picture goes next to this picture – in a book or an exhibition – and which size it should

be. There's a lot of hard work involved, and obviously the thought process, what and how to photograph is very well thought through.

Charlotte Rampling said of you, 'He gets the raw part of you out, the animal part.' Is that what you're looking for?

Yes. I'm looking for something exciting. I'm looking for an adventure. I'm looking for something new. I'm looking for something I've never seen before. I'm looking for something I've never done before. Photography gives me pleasure, takes me where I normally wouldn't be able to go.

But is it art?

I'm completely unconcerned about whether it's art. I'm just a photographer. I'm just producing work which I believe is good.

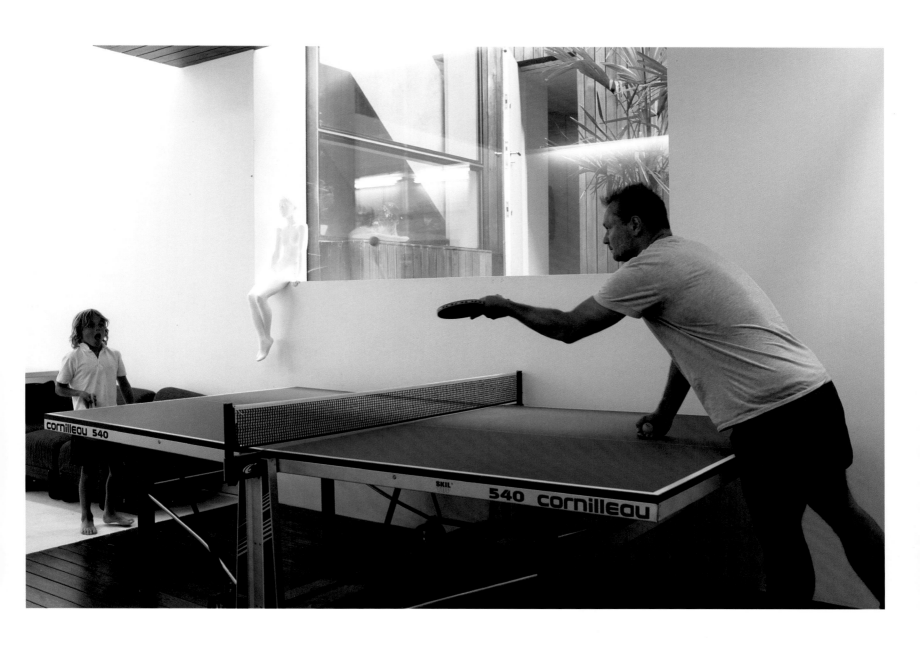

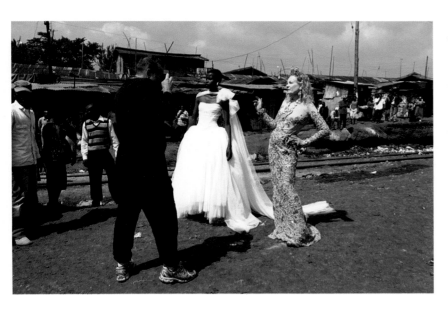

Teller reviewing images on his lightbox (opposite) in his Ladbroke Grove, London, studio, which is also his home: 'I'm just a photographer. I'm just producing work which I believe is good.' A Don Brown sculpture watches over a game of table tennis (above) between Teller and his son Ed. Teller at a fashion shoot (left) in Kibera, Haiti, for Vivienne Westwood (photo: Chloe Mukai): 'I'm like an animal that catches his prey in the way I photograph. I don't let go until I've got it.'

(following spread) Teller taking a break from the summer heat in Ladbroke Grove, the famous 1970s Brutalist landmark Trellick Tower (designed by Erno Goldfinger) rising in the background. 'I'm looking for something exciting,' the artist explains. 'I'm looking for an adventure. I'm looking for something new. I'm looking for something I've never seen before. I'm looking for something I've never done before. Photography gives me pleasure, takes me where I normally wouldn't be able to go.'

Polly Morgan

Polly Morgan, a self-trained artist and member of the Guild of Taxidermists, works on an owl cadaver in her Hackney Wick, London, studio, careful to use as little artificial light as possible.

Banksy apparently called you Britain's hottest bird-stuffer. Does that make you an artist?

No. To use taxidermy in art is quite new as far as I know. A lot of contemporary artists have used it in their work but not consistently. It does challenge people, whether they view me as an artist or as a taxidermist. I just see it as a medium.

Is it correct to say that you fell into this practice almost by accident?

The taxidermy wasn't so much an accident, but I found calling myself an artist difficult to start with. I never set out to become an artist. It was more that I always felt these creative urges to do various things: photography, a bit of sculpture, a bit of drawing. I did a bit of freelance writing, I started making films. Nothing ever really stuck. With taxidermy, as soon as I hit on it, that was it.

Does the fascination with dead animals come from your childhood?

I don't think it's to do with dead animals, it's just animals. I would be happy if I was surrounded by live animals and if they were happy about it. But they're not, so I have to use them when they're dead. It's the only time they don't run away from me. Taxidermy is a way I can access animals without upsetting them. I can hang on to them. They're never going to disappear.

We had hundreds of animals when I was a kid … I'm sure my interest comes from that. Then I came to London and I didn't have animals … and suddenly felt their absence. I came to London when I was eighteen. I studied English at university. I got a job at a bar to help fund my way, and that became a much more influential area of my life than university ever did. I made a lot of friends at this bar in East London where there was a big art crowd. It was one of the first bars to open up in Shoreditch … I just walked in and asked for a job. A lot of the YBAs were drinking there. The White Cube used to have their after-parties there sometimes. I hadn't gone to art college, I hadn't had a big group of artist friends, but I gravitated towards the same sort of places.

When did you feel confident enough to call yourself an artist?

Probably after I exhibited in the Zoo Art Fair in 2005. The work I showed there sold before the fair actually opened, and the guy who sold it said he could have sold it twenty times over. It seemed like a weird dream that was just happening to me. Channel 4 News put it in a little package they did about the fair, and it snowballed. It felt terrifying, but at the same time I was excited. I felt vindicated because my mum

would always call me morbid. I had this voice in the back of my head that said there was something wrong with me, that everyone was going to find these things disgusting. It was nice to know that all of these people were looking at my work and seeing the same things that I had seen. I hadn't experienced that before.

What inspires you to go out and find dead things?

I always have my eyes peeled. If I see something, I'll pick it up. But I don't go around with the express intention because I know I'll be disappointed if I do that. It's rarely me that finds things. It's normally people I know who contact me, friends of friends or someone who's read about me in the paper or found my website. The way I 'hunt' is to put an advert in bird magazines. Once I did drive to Stratford because I heard there was a bird fair there. I asked for dead birds and by the end of the day I had ten. I keep in touch with a lot of those people. When things die they keep them in the freezer and call me when they've got a bundle. My stuff is off the road or flies in the window or the cat brings it to me.

How does the process work once you get a bird?

Normally the first thing I do is freeze it. I disconnect the bones at the shoulders and the hips and peel the skin over the neck, keeping the body for as long as it takes to make measurements. Then you can throw the body away. Unless you're doing an animal that has been run over or it's got maggots on it, it's not disgusting. It can be quite clean and surgical. My knowledge of animal anatomy is very good. I couldn't name you a part or anything, but I have an innate understanding of it now.

What's the biggest animal you've contemplated working with?

I'm going to start doing a stag soon.

Have you ever imagined what it would be like to 'ornamentalise' a human being?

Not really, because I have to identify with my subjects. I need to see them as inanimate objects. I need to have that dispassionate view.

What is the ultimate message in your work?

It varies. I'm not trying to be didactic. I'm not trying to comment on our treatment of animals or anything like that. It's more a contemplation of life and death. It's quite an optimistic thing, new life coming off from death.

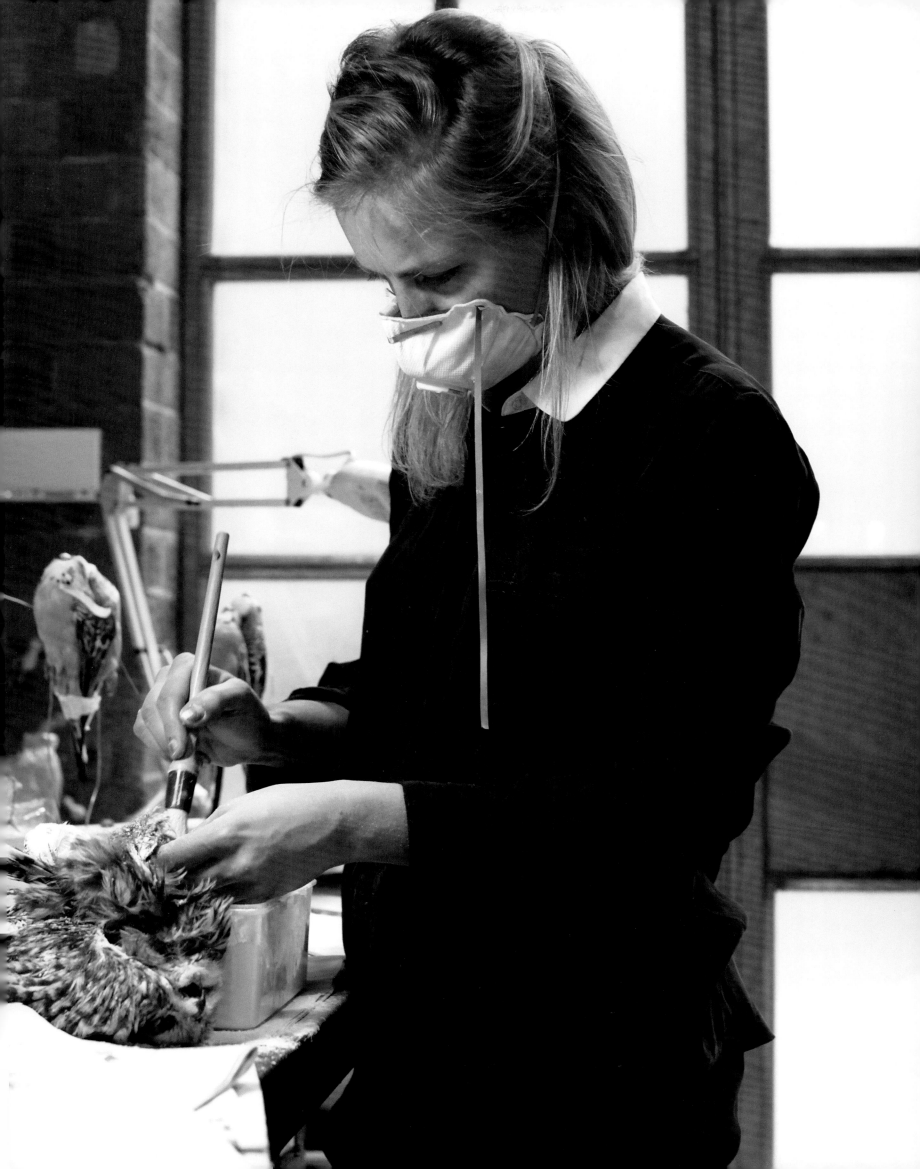

Morgan's kitchen fridge freezer (above) filled with biodegradable artwork. She uses animals that have died of natural causes or by accident. The chicks and fox form part of a series entitled *Still Birth*. 'I'm not trying to comment on our treatment of animals ... It's more a contemplation of life and death. It's quite an optimistic thing, new life coming off from death.' Morgan (opposite top), by the glow of her freezer, inspecting her corpses – most given to her by gamekeepers, vets and quail farmers. Two lovers captured in death (opposite), budgerigars brought back to life through art. 'Taxidermy is a way I can access animals without upsetting them. I can hang on to them. They're never going to disappear,' the artist claims.

You've said that you're drawn to the delicate and the fragile. But you're not fragile yourself, are you?

No. I used to help my dad out with animals when they died, so I developed a thick skin when I was young.

And you've never lost any sleep?

I have weird dreams if I'm doing something repetitive. My old place was this small studio with a bed. I would work till midnight and then try to go to sleep, but I couldn't unwind. As soon as I opened up the bedroom, everything was everywhere … it was all work.

This is the first decent studio I've had. When I started doing taxidermy, I worked in a flat above the bar where I was working. I set up two trestles and a bit of wood in my living room. Then I moved to another place and had a desk in the corner. And then the studio started taking over. Life had sort of shrunk. I was working really hard because I had an end in sight. I wanted to have a better studio; I wanted to have a separate living space and just work in the studio from 9.00 in the morning till midnight, Monday to Saturday …

You've shared a studio with one of your boyfriends. Have you had difficulty living with men and dead animals?

No. My boyfriends have always been artists; they've generally been quite open-minded. They get a bit annoyed if they go to the freezer to get some ice cream or something and there's a headless chicken in there. Occasionally if I haven't cleaned up after myself I get some exasperated remarks.

What do you hope to achieve as an artist?

I'd like to think that I've contributed to modernising taxidermy, to rescuing it. When I first started out, a lot of the taxidermists I spoke to were troubled by the fact that the skill was dying out.

You were taught by one of the best …

Yes, by George Jamieson. He does traditional hunting trophies and big cats. The exposure of my work has given a lot of younger people who are maybe going through what I went through ten years ago another subject that they can think about.

Thomas Houseago

Is happiness conducive to making good art?

Yes, it is. I don't agree that artists have to suffer or be poor; artists can make fantastic art, rich and comfortable, and artists can make fantastic art, poor and miserable, but mostly when you are poor and miserable, it exhausts you. The ones we know of who survive it are rare exceptions. But if you talk about making work that's angry, sad, lonely or frightened, that's important, of course, as you are still adding to the beauty of the world. You are talking about what it is to be human.

Is there a difference between being normal and being an artist?

No, but I generally find artists to be the most normal of people. I had a hunch that I was born with a propensity for the artistic side of things. I didn't know what being an artist was; I couldn't describe it for a long, long time. In my opinion, all children are artists; it's the most natural state, to be creative. I wasn't interested in doing anything else. The problem was handling the pressure to be an economic creature, which as an artist is hard.

How old were you when you recognised that you were an artist, and how did you feel about it?

I think I probably was like four or five – I loved to draw – you couldn't take pens out of my hand; it was like a painful thing to be removed from that state. I was aware of this activity called drawing that I was comfortable with, that I was good at and that I felt I needed in my life. In exactly the same way that I do now – there's no difference, none at all.

Were you withdrawn or outgoing as a kid?

I was a scared kid, and I was a happy kid. I was a wholly emotional kid! I loved dreaming, looking at things, spacing out. I grew up in a very tough, grey, cold kind of climate – everyone seemed to be drinking heavily and there was quite a bit of violence. There was a palpable sense of danger that when mixed with my desire to draw and dream and be soft and inquisitive made for a weird kind of development.

You've talked about growing up under Thatcher and watching the transition happen, the culture of physicality being lost.

The North is the industrial heartland of England, and you had all the mines closing down, you had all the systems that were changing. Everyone was being pushed into the service industries, and you were having this rebranding of everything. I could still feel inside me this other, probably more tactile, Northern English sense of being. I didn't have TV, we didn't have computers at home or in school. It was a different time.

Your sculpture is very physical. Is it emblematic of your lost childhood?

Sometimes I make things quite big, and I often wonder, am I trying to make the viewer into a child? When you come across a huge foot, something strange happens, something about the relationship to the body, which is very childlike. Maybe my work makes the viewer into a child ... As I go further into it, I am aware that my relationship with the body has some early human qualities to it.

Are they primitive? Primeval?

Not primitive, no, because it is quite complicated to do it. I think Britney Spears is primitive! I am an absolute realist; my work is super-realistic. It's about focusing on what happens when you look at someone. To me, your parts can look monstrous; if I focus on your hand, it becomes bigger than your head. I am impressed by that. I can't look at a hand without thinking of memories of hands, my father's hands, my grandmother's hands …

Well, looking at something is a spiritual experience; reading is a spiritual experience – music of course too – these activities help you handle, look at, relate to the world. Help you handle this crazy situation of being born – of popping out of your mother's body – to have been given life.

Do you ever regret popping out?

No. I am so grateful to have been given a life. I regret sometimes not getting into my groove more quickly. I sometimes regret wasting time – but then that's probably stupid – the journey was very important.

Where do you feel you wasted time?

I wasted a lot of time not trusting in obvious facts and things. The mysteries of the world are trying to talk to you all the time, but you block them off. My hunch is that everybody feels this, or else they wouldn't care about art.

Are you saying that an artist reflects society like a mirror?

An artist reminds you that you are human.

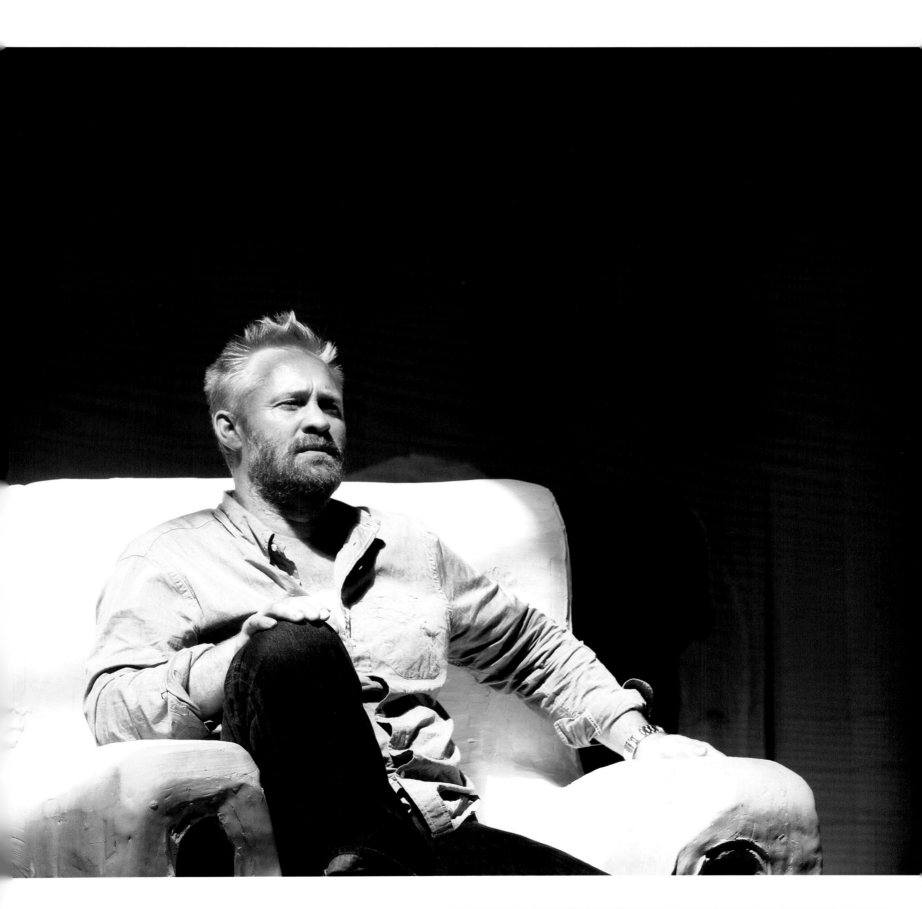

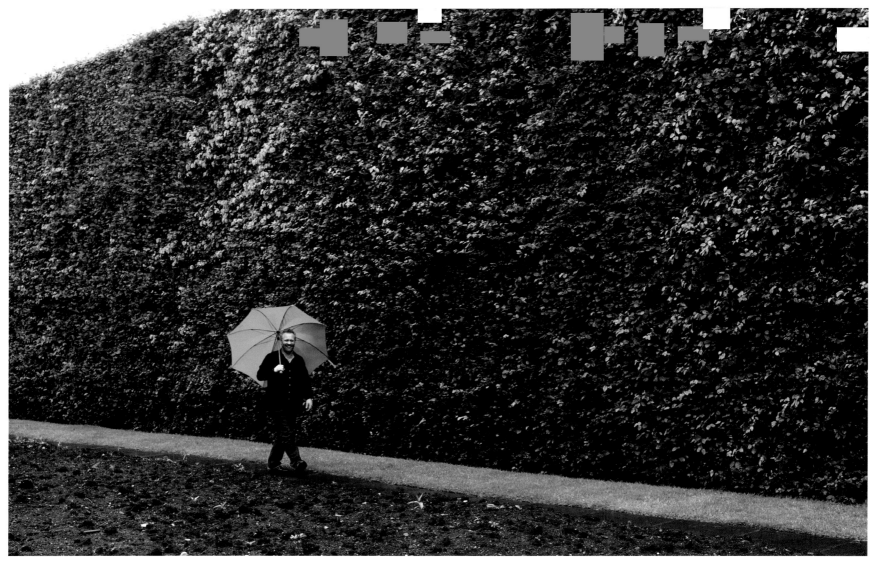

Where is the depth in art? I can see the physical presence on the wall, but –

Depth in art? – It is one of the only activities that allows us to muse upon who, why and where – to really explore what it is to be alive and die. Rodin made a great statement –'Clay is life – plaster death – bronze rebirth' – such a beautiful summation of the process.

If you hadn't had the opportunity to become an artist, what would you have become?

I would have loved to be a musician, be in a band. I love music, but I am not really motivated enough. My energy didn't flow that way.

Do you think that your art is dangerous?

No. I think the reaction someone can have to art can be quite upsetting for them. It can be dangerous for them in some senses as it provokes change. But I really, really believe in the positive power of art. I believe in that intimate experience with an object, with music or with poetry, that it can be a positive thing even though it shocks you. I was very shocked by movies, too. I saw Werner Herzog's films when I was very young and they just shocked me. Bob Dylan shocked me and woke me up too.

There's a new film, *Cave of Forgotten Dreams*, that reveals this unopened prehistoric cave and the symbolic gesture that is art ...

It must be a secret place because, as I said, looking at art can be dangerous. You have to be careful with it. The ancients got it right. Art should be in a cave, it should be in a museum, it should be in a specific location. Speaking of Herzog, just this summer, after a screening of his new documentary, I crashed my car driving home in the hills above Malibu and spent the night wandering around in the darkness. I guess art *can* be dangerous!

So it's dangerous, as well as sacral, and the cave has been transformed into a church, which has been transformed into a museum or gallery?

Sure, the room that has no practical meaning. Say you have a religious sculpture from Japan. You put it into a museum, and you curate it and write a blurb about it. But if that thing gets into your system, if you are ready for it, there's nothing anyone can do about it. You might misunderstand it, you might not get the Buddhist meaning of it, but it will get inside you. That is a very interesting thing.

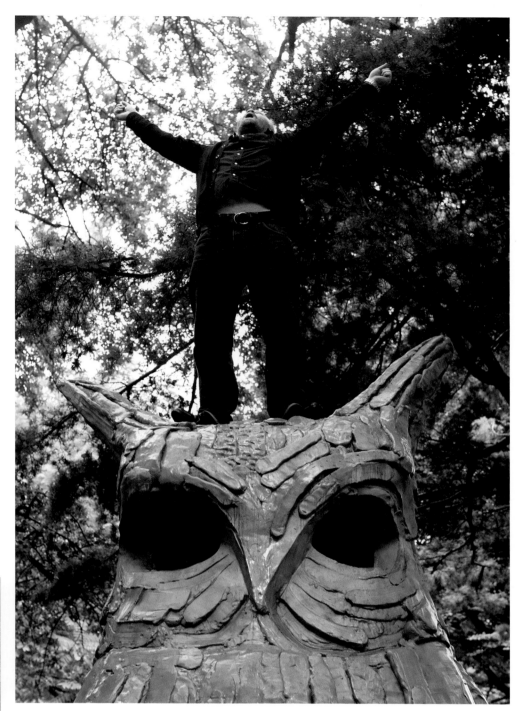

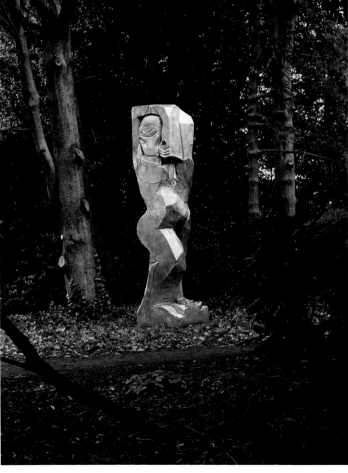

Houseago, his personality
as big as his sculptures,
having fun at his exhibition
The Beat of the Show at
Inverleith House, Royal
Botanic Garden, Edinburgh,
in late July 2011. The artist
stands atop one of his bronze
sculptures, *Large Owl
(For B)* (2011). Housago
singing in the rain (opposite).
Also photographed (left)
is another recent work,
*Rattlesnake Figure
(Aluminium)* (2011). 'The
mysteries of the world are
trying to talk to you all the
time, but you block them off.
My hunch is that everybody
feels this, or else they
wouldn't care about art'.

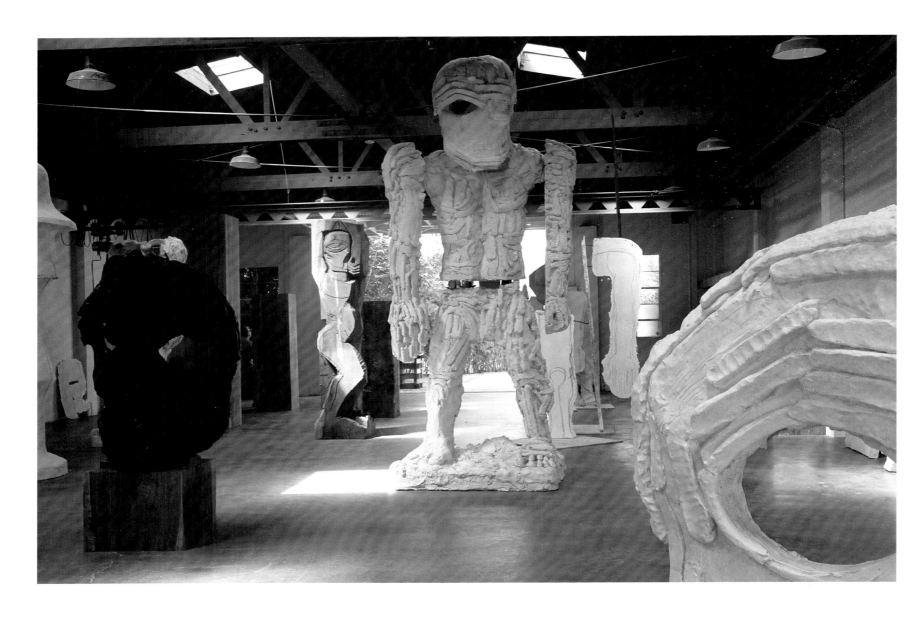

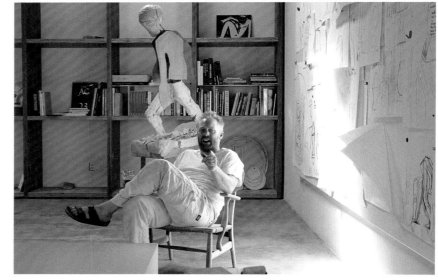

Houseago, after a string of misfortunes and bankruptcy, arrived in Los Angeles in 2003 with only $200 to his name. *Ars gratia artis*. That artistic fortunes change is evidenced by the monumental works housed in his 1,800-square-metre, purpose-built Los Angeles studio spread over three buildings. Fifty-five people are employed there. Houseago in his private studio study (right) surrounded by drawings, models and books.
(Photo: Hossein Amirsadeghi)

Is the artist the arbiter, the spiritual guru, for this transformation?

There is always that possibility and an exciting thing, that an artist can do that.

For how many years were you a starving artist?

If I'd died four and a half years ago and it had turned out that my work was important, I would have been a tragic, classic artist of the nineteenth century. Penniless, struggling, miserable, all my work destroyed. I wasn't part of the generation that thought you could make money out of being an artist. I was heartbroken, of course, but it was all part of the pain and plan of events.

You had a studio in Belgium, didn't you?

I had a studio in Belgium. After Belgium Amy and I came here to Los Angeles. We lost some things in Belgium; I lost everything. I arrived here with just a few objects and about $200. I started from nothing, slept on friends' floors, got a job doing construction, etc. – but Amy and I had each other and our work, which was all we really needed.

How has success transformed you?

It's made me a lot calmer and given me a lot more energy. It's allowed me to do things I dreamt about for years and years. So I was completely ready, and I think probably I paid my dues when I wasn't ready yet. If I'd been making the kind of money I am making now years ago, I would have done something stupid. Now I use every inch of it. I put back into the work, my family, my employees, and I am very, very focused.

How many employees do you have in the studio?

Between fifteen and twenty. Then I have the foundry, so if you count everyone, you've got fifty or sixty people. Sixty families if you think about it. So art is a huge economic generator.

When you were sitting, starving, on a floor in Belgium or Leeds, what kept you going?

I've never, ever, doubted what I was doing in terms of being an artist. I never thought in terms of 'keep going'. During the most miserable, weird times, I never thought, I should stop making art. It's not a thought that even crossed my mind. I couldn't stop it anyway even if I wanted to.

How many hours do you work each day?

I work seven days a week and almost all the time. You can be with your family a bit, and this and that, but you are still working. As soon as I come back to America, I am on. Something about California does that to me. LA has a magic effect.

Talk me through your routine in the studio.

I wake up quite early because my kids wake me up. I hang out with them and then I come in here and deal with the business end of the studio. The guys have usually made some progress on things, and then at night they leave and I take over. I work alone until about 1:00 in the morning. The best work is probably produced between about 8:30 p.m. and 1:00 a.m. Then I start the whole thing again.

Your work has been described as 'monstrous and threatening', as 'part man, part animal'. Which attracts you more, the human part or the animal part?

What are humans? Often people ask, 'Why is your work so violent?' I say to them, 'Are we living in the same place? Are you watching what's happening in the world? What world are you seeing?' I want to make things that seem the most truthful, the most realistic.

This sculpted head (above) sits incongruously in the small studio garden situated in the Westlake district of Los Angeles, near MacArthur Park, made famous by the late Richard Harris singing Jimmy Webb's lyrics. (Photo: Hossein Amirsadeghi)

Varda Caivano

What constitutes a bad painting?

If we're talking about my own paintings, a bad painting is one that is predictable or over-familiar in some way. I feel enthusiastic about art that questions me, work that acts on me somehow.

What does the practice of painting mean to you?

The practice of painting in my case is the search for the image, so the practice of painting is very important. The process of making the work is sometimes more important than the final result.

Is this process a lonely one for you?

I don't feel lonely at all. Because the studio works on a symbolic level like a big head where you have all of these thoughts in progress, the relationship with the paintings is like a conversation or monologue. In this environment things happen, make sense and ultimately belong.

What is the role of the studio?

The studio is a very particular private space. Philip Guston said that the studio is a court where you are judge and jury, prosecutor and defendant. As an artist, you occupy these roles in different moments. This is why the sofa is important here. With the sofa I am outside rather than in the scene on the stage, where the painting is done. After working on an individual painting for a time, I turn it to the wall. After a while it becomes a stranger again; the attachment to it is almost lost. Then I'm able to see it with new eyes.

So you have bits of your fairly small studio which are little islands separate from the rest of the space, like the sofa?

Yes. I have the room where I have work on paper, and I have an archive. I have a storage area, and I have the coffee shop around the corner, which isn't part of my studio but which is where I have breaks, as well as meeting friends, writing or reading.

At what time do you arrive in your studio?

Sometime in the morning. I have a few days when I only paint all day. Other days I do everything else that is part of my life and is not painting.

You said that pieces interest you because of the dialogue they create. Is this what you want to create with the viewer, a dialogue?

I don't really think about the viewer when I work. During the time in the studio I think about the dialogue between paintings and certain texts or pieces of music.

Are you interested in the dialogue between paintings?

Yes, very much so. I'm obsessed with it. What they do to each other.

Do you have a lot of anxiety around your work?

No, not really. I enjoy making the work although some works are not easy to resolve. My mood may change during the process of making a work. There is a certain vulnerability that is needed to allow me to make the work.

What do you love most about painting?

I am not sure. I'm not bored yet!

Why do you think there are so few painters among the younger generation?

There are some good ones! However, painting can be a hard and demanding practice, both technically and emotionally. It can be difficult to look at painting, unpleasant even. Perhaps this goes against the grain of how we look at images today.

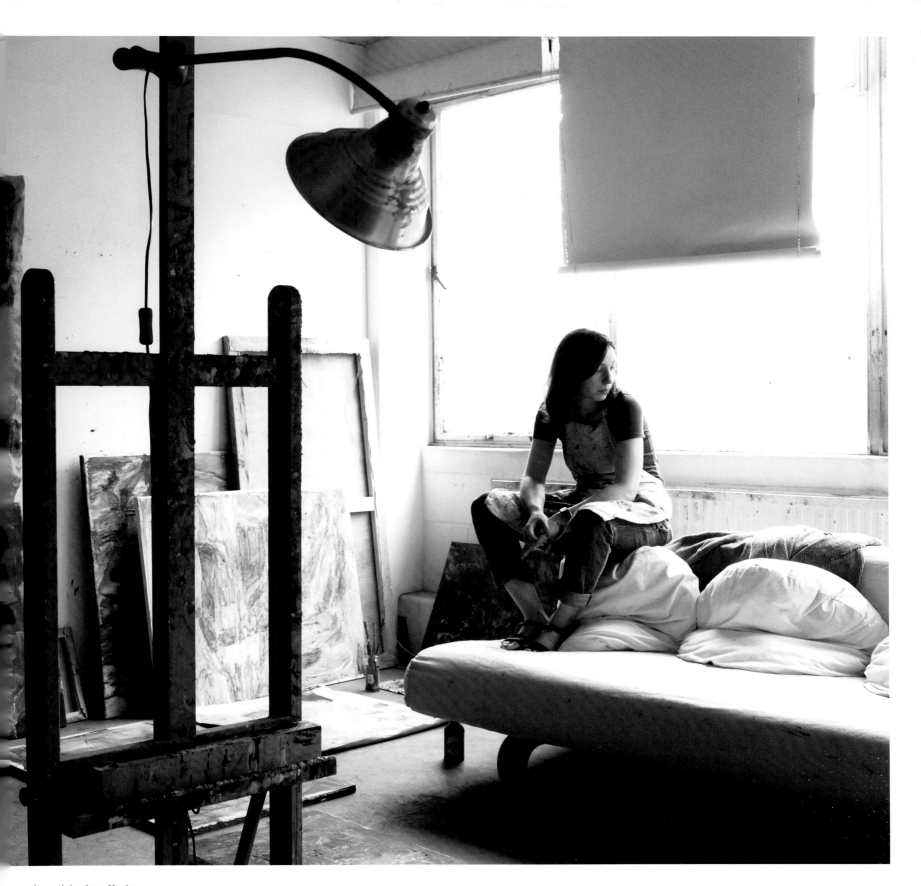

Argentinian-born Varda
Caivano takes a break from
painting in her Hoxton,
London, studio across from
the Geffrye Museum. Caivano
employs a muted palette in
her small-scale paintings,
the surfaces of which she
scratches to expose the weave
of the canvas. 'After working
on an individual painting for
a time, I turn it to the wall,'
she explains. 'After a while it
becomes a stranger again; the
attachment to it is almost lost.
Then I'm able to see it with
new eyes.'

Caivano, coffee in hand, leaving Columbia Road's famous Sunday flower market in October 2011. The image encapsulates the mood of people living in the megapolis, a mix of traditional cultural references (the Pearly Kings) with the brisk pace of change, yuppies and puppies all together in a throng. The windows in the background reveal snapshots of lives immortalised, including a preoccupied young man in a state of undress seen through his open window, graffiti (follow your heart) scrawled on a window pane. Hitchcockian, Balzacian or the symmetry of metropolitan lives lived together, separately.

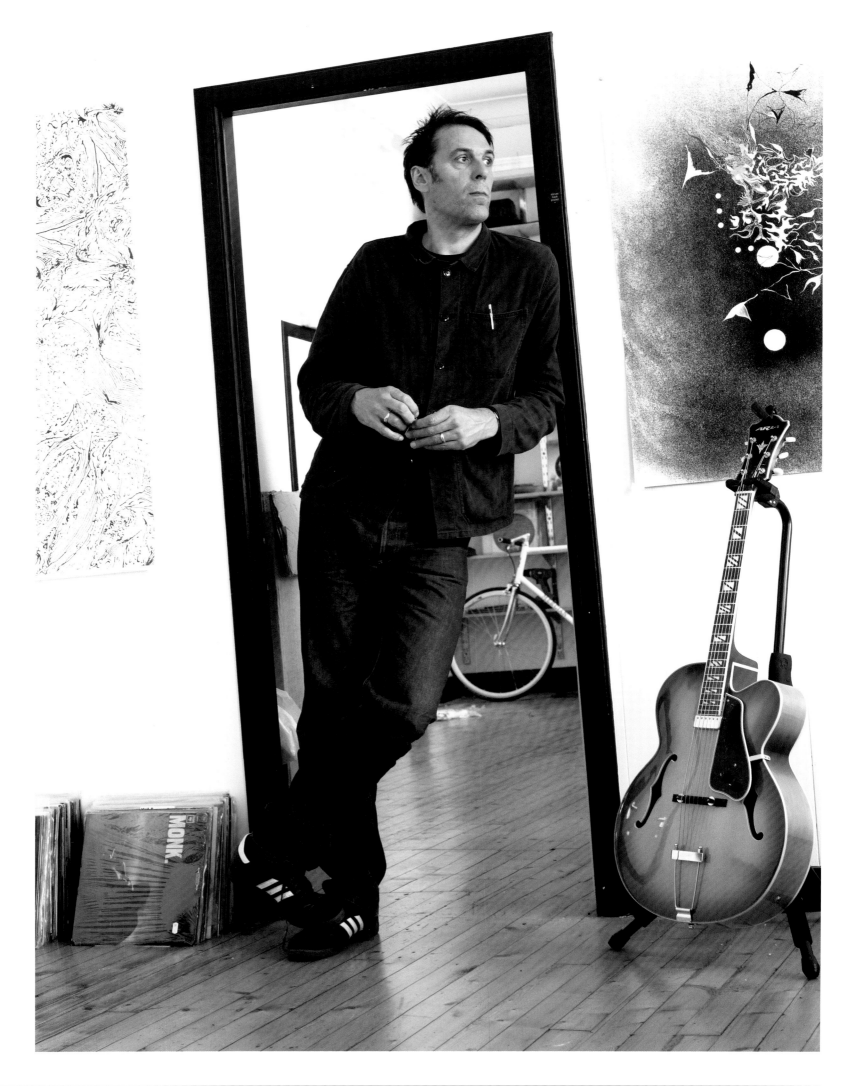

Richard Wright

You were born in England, yet you've chosen to live and work in Scotland. Why is that?

I wouldn't say that *I* chose *it*. *It* chose *me*. My family moved up here when I was a boy. I have lived in America and Europe, but I always seem to come back to Glasgow.

What's the attraction?

Glasgow isn't a city in which it's easy to be an artist. There is no infrastructure that supports artists, only a few galleries, and there isn't really a market. It seems a little more edgy, a little more nervous, because it doesn't have that stability. There are a lot of artists initiating projects, a lot of people working and exhibiting in their houses or studios. People have to create their own situation here, and that gives it a certain energy. And there is a good music scene. My work is influenced by music and I've played for many years. So I find it's the right balance. If I am away in London or Berlin, I always think I have to go to things. I like the fact that here, I can just disappear.

The studio is an escape, if you like. The work for which I am known is very public. The activity itself is very public. I put myself in a position where I have to make a work out of nothing, and there are always people looking over my shoulder, or coming or going. The studio allows me a space in which I can waste time. It's also a place where I imagine I can see the world.

What is the purpose of art in this process of looking at the world?

Art has no purpose. It is not just what I do; it is one of the things we all do that we don't need to do. It is the way we dress, the way we speak about nearly everything. It is not so much what we are, but what we would like to be. Is that a purpose?

Have you ever felt guilty about wasting time?

Every day I think I should have done more. So I do feel guilty, but what appears to be useless turns out to have a use. To become a different person, sometimes you need to get away from yourself. But that can seem aimless.

I don't want to give the impression that I just come to the studio to look out of the window. I come here with the intention to resolve something. The problem for me is that the path is not straight. I tend to start a lot of things and then abandon or destroy them – then I put them away and pick them up later. This activity seems obscure, undefined and has no end. But without it, I wouldn't be able to do what I do.

Do you destroy a lot of your work?

I hate pretty much everything that I do. That's partly why I waste a lot of time, if you see what I mean, because there is no product. But of course I am actually working – that's the point. Many days one has to rub a lot of sticks together before any kind of fire appears. Sometimes working enables me to become a different person.

How did that marry up with your teaching career?

It was difficult. Teaching demands a lot of energy, a lot of concentration, and in some ways you do give the best of yourself. I found that very stimulating. It was great to be forced to perform in a way. There is an aspect of persona in that performance. In the studio, on the other hand, a lot of time is spent trying to become the person who *could* do something that they cannot do.

Is contemporary art connected in any way to the real world?

Absolutely. *How* it's connected is a more complicated question. On the one hand, painting is a discourse and has to do with the exchange of ideas. But painting is also a fundamental language. What painting tries to do is somehow to slow down the process of engagement, to stop time. Marcel Duchamp sometimes used the word *delay* instead of *painting*. This has to do with consciousness, or presence. When I first looked at paintings, I always wanted to touch them. Painting is deeply connected to this act of touching, and in this it concerns itself with the fundamental proximity of reality. Of course painting is also concerned with a reality which is more super-real than concrete. Perhaps that has to do with a condition that is more unconscious than what you might call real, but in both the material and immaterial modes painting addresses being here now.

Richard Wright in his Glasgow studio, which is also his home, in late July 2011. A keen musician and collector of 45s, Wright believes that art has no purpose. 'It is not just what I do; it is one of the things we all do that we don't need to do. It is the way we dress, the way we speak about nearly everything.' Wright painted recurring black fleurs-de-lis over the walls, windows and ceiling of Modern Two (right) at the Scottish National Gallery of Modern Art as one of three artworks commissioned by the 2010 Edinburgh Art Festival.

(above) 'The studio,' Wright
says, 'allows me a space in
which I can waste time. It's
also a place where I imagine I
can see the world.' The artist
(opposite) outside a Scottish
cultural landmark, the
1896 Glasgow School of Art
designed by Charles Rennie
Mackintosh, from which the
artist received his MFA.

Given the transitory nature of your art, have you done installations that still exist?

Not many.

Which one do you feel the most connected to?

That is a difficult question. One of the beauties of this way of working is the relief that they don't come back and haunt you. They are gone. But there have definitely been times when a work has been destroyed and I felt its loss. I felt that I could never be the person who made the work again.

Was it a conscious decision to make a piece and then break it up?

Initially it was a solution to a problem. In the '80s there had been a massive boom in the market, mainly for bad paintings, and this led to a reaction against painting. *Painting* was a dirty word. But I was looking for a way of working with the things I was still interested in. I was interested in Mondrian in particular, and this idea that painting becomes part of architecture and also that perhaps art even disappears by becoming part of everything else. At the time, making temporary work was like believing and not believing at the same time. It was a way of being able to do the work or give myself permission to do it by freeing myself of the responsibility of the past. It was also a way of making the action somehow more significant than the object.

Does art need to hang on the wall to be permanent? What is the relationship between art and memory?

A person doesn't really die until the people who knew them die. It's possibly the same for a painting or a piece of music. I suspect that my paintings might belong more to the world of memory than to the world of art. This is an area I find very interesting. Some of the works of art of the past that I adore the most have been significantly repaired or reworked, and that has happened largely out of love, because we need them to exist. There are other motives, of course. Some objects are devotional or religious and are still used (like tools). Sometimes you might even say there was the economic motive of tourism. All of these factors play a part. But in the end it is something to do with need.

Why is there this desire to be connected to the past?

I don't know. Painting is an extremely exact language. It is just possible that a picture like Leonardo's *Last Supper* is so unique that it is like a chemical formula for something that we couldn't rediscover. So we've had to keep it somehow.

But commercial value has something to do with it as well, hasn't it?

It's definitely a factor. But with this issue of preserving the past, commercial value may have something to do with fundamental need. There is a connection between the history of a work and its value, but it is a fragile connection. What really matters is that it means something; otherwise it's still Granny's painting regardless of how much you paid for it. When a fresco falls off the ceiling into thousands of fragments, it takes more than commercial value to make us want to put it back together again. We are less without it.

Isn't some contemporary art based on sensationalism and publicity-seeking?

That is a complicated question. On the one hand, we expect our artists to be saints; we want them to live outside the baser motivations of our world. If they dare to participate in the ignoble world of organised theft that is the market, they are somehow damned. But the fact is that art can only be what we are, and it is therefore not surprising that some art is little more than an advertisement for something that does not exist. I don't think we should blame artists for this; they are just people like the rest of us. On the other hand, it is necessary to criticise art. That said, in this country we have a political agenda to make art impotent and valueless by rubbishing it. This is a reactionary, anti-intellectual tendency. For this reason I would tend to stand by contemporary art even when it is bad.

Your favourite artists from the past seem to be people like Turner, William Blake, Piero della Francesca, Mondrian. Are they your gods?

Are they gods at all? What I love about Mondrian is that when you look at the work, you think, Anyone could do that. But it turns out to be *so* particular that if you could do it, you'd become Mondrian.

Enrico David

What is your purpose as an artist?
Art can change a lot of things, but we live in a time when there is little respect for the timing these changes need to take place. We live in a society that is quite numb; it has been numbed by consumption. Society creates stimulus by reminding us that desire is connected to the way that work operates.

Do some contemporary artists manufacture art with a view to consumption?
It's not only manufacturing with a view to consumption; it also reminds you of what society tells you a work is worth economically.

I thought that artists were supposed to be outsiders.
I thought so too.

When did you realise that that's not the case?
There isn't really a moment when you come to that realisation. You might experience it seeing how the younger generation responds to the possibility of being in a creative space, the way that they mimic aspects of society knowing exactly what society expects, what the viewer expects, what the audience expects. People don't really want to know who they are. They are driven towards being told who they are, they are not driven towards finding out who they

are. Art isn't a conflict that shuts down the discovery of who you are. Art that discusses the topic, that discusses politics, tells you things that you can find out for yourself outside of the art space. The art space is for magic. It is for spiritual, evolutionary, soul-enriching experiences that make it possible for you to know better who you are.

Is there drama attached to the production of art?
Part of the process of creating is a series of events. For me it is about observing contradictions, about how different emotional and cultural agents exist within myself. Therefore the internal drive is important. From there you gather materials and images and try to formulate a dialogue between those elements, in order to crystallise that into a finished image.

You are famous for being a crazy surrealist. Do you have to be extreme or an extrovert to be recognised as an artist these days?
You need to strive to be truthful to yourself and to celebrate that, to embark on that journey. If that brings you to places which are not familiar to the mainstream, that's a good thing. As artists we spend a lot of time thinking about things which the majority of people who are not involved in that process don't spend a lot of time thinking about. So I can imagine that the perception is of people developing traits that are eccentric or marginal.

So the 'we' that you reference is a community of spirits-as-artists or a community of thinking that is marginalised by choice but choreographed to some extent?
Yeah. I am talking about an artistic community bringing changes to the world in the best possible way or, more simply, evolving to allow us to move on.

Is the job of the artist to bring change to society?
The job of the artist is to provide an example of how to deal with being in the world. I often ask myself what it is that people look for in art. Are we looking for entertainment? Are we looking for something beautiful that pleases us, or something that disturbs us, or something that surprises us? You can group all of these different discoveries together by saying that we are looking for a better understanding of who we are. In a sense, making is a metaphor for learning. Making is finding out. Making is getting a better handle on where we are, where I am.

Does society take a lead from art, or is it interrupted or challenged by art?
People have been encouraged to become more familiar with art in greater numbers over the last twenty years. The audience has expanded; it is huge. It is an enormous voice for a nation or for a city to have places for art. I can only imagine how economically big it is.

Enrico David, who moved to London from Italy in his early twenties, in his Berlin home and studio in late August 2011. A picture of his father (left) lies amid odd possessions on a table, an impromptu shrine to art and family. 'Making work means bringing to the world things you feel are missing,' David says.

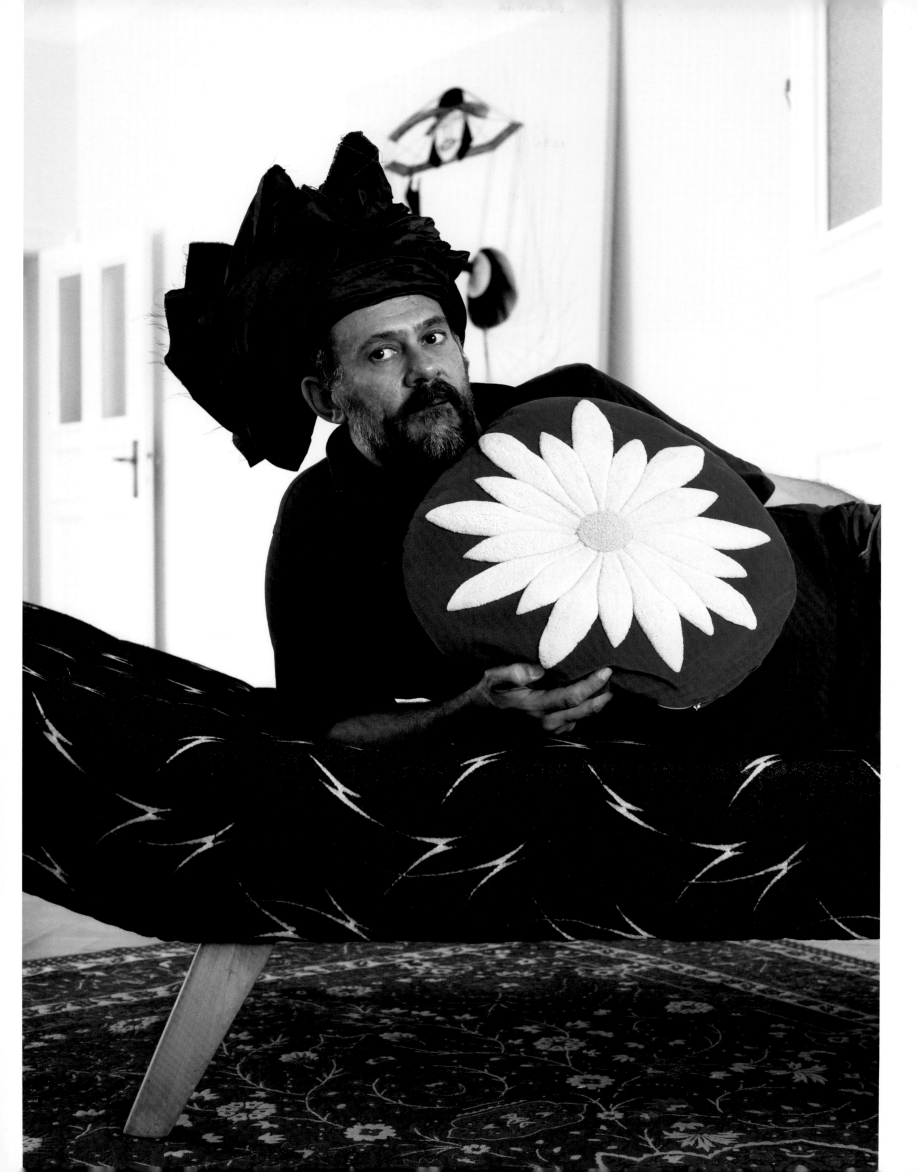

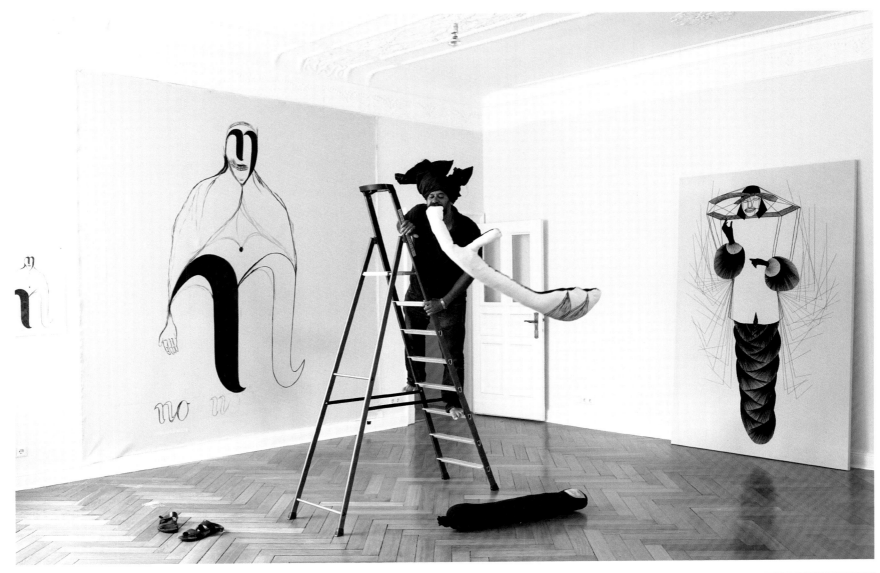

David (above) making hay with his art and (right) in the Paris Café in Berlin, a favourite haunt for international artists, some of whose works (including works by Sarah Lucas) hang on the walls. (The restaurant used to accept art in lieu of payment.) 'The art space is for magic,' David asserts. 'It is for spiritual, evolutionary, soul-enriching experiences that make it possible for you to know better who you are.' Even while lunching.

(following spread) Italian cheek and German pre-war architecture go to make dramatic interplay in this irreverent image of David on the balcony of his Berlin apartment.

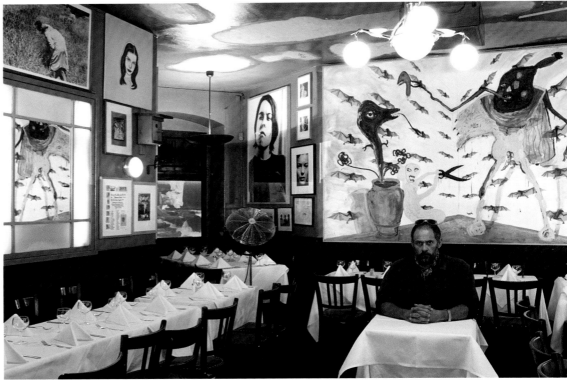

Which is more important, the intellectual integrity of art or its political, economic complexity?

Everything has its economic aspects, so there is no reason why the arts should not be a part of that exchange. I don't think about the value attached to my work because that's connected to laws of economics and laws of the market. I don't have anything to do with that. My job as an artist is to make my work.

At what age did you start out?

I moved to London when I was twenty years old. I was at Saint Martins in the early '90s. It was not an activity that allowed me to make a living, but I always had a studio. My first studio was in a yard in Brixton with a number of other artists around me. Then I moved to Brussels, and then back to London, where I worked from home. I got a studio and then I moved back to working in my flat. It has been nomadic even to this day, a very de-gentrified activity. My first real studio was at London Bridge between 2001 and 2008. It was the first time I had a substantial environment where I could work. I had rats everywhere, it was a disaster, but I remember going into that space every day and feeling absolutely joyous about the possibility of being there. It was a real achievement.

So the studio is a joyous place, a place for thinking, a sanctuary?

All of those things.

Do you work outside of the studio?

At the moment I am working from the place where I live, so the boundaries have become elusive again. These days a lot of creative activities seem to be taking place in studios that are more like agencies or offices. I am a maker; I am a handler of things. It is in the physicality that I encounter myself, so a desk is inappropriate for my research. It's not enough.

Are you a happy man?

I don't think it's relevant to know whether I am a happy or an unhappy man. What is interesting is the idea of exploring or tapping into a resource, a dark and often uncomfortable side of our experiences that I believe is often disregarded and unaccounted for. In that lack of accountability lies a lot of injustice and suffering. It is a proposition that looking into that dark stuff is better than not looking.

Is this part of the narrative of history?

It is a fundamental component, almost like an alternative source of energy. It's grief, it's fear, it's pain, it's loneliness. But it is also joy, also celebration; it's about the inclination to try and create a better relationship with that part of ourselves.

Does contemporary art reflect reality?

Yes, it does. Sometimes it mirrors it so well that it becomes a footnote to reality. Think about an artwork that could propose a 'what if' scenario rather than a 'look, I am giving you what you already know' scenario … an estimate of what things *could* be, of how you could change reality, perhaps.

Does that make drama a component of contemporary art?

The process of making art is quite dramatic.

Where do you pick up your ideas?

It feels like everything is in an archive that I can pull out and combine with things that I find. It is like composing a sentence or a phrase. That is of course affected to a degree by things I find walking down the street in Berlin, but I would say that it is mostly internal stuff.

Is the basis of that language the same whether you are in India, Cuba, London or New York?

Yes. Especially when you work in an alien environment, you end up improvising a lot because you have to construct your self just like you construct an image. You come to a place you don't know anything about and you need to face your own reality in that place. That brings you close to the method of building an image.

You've said that the way you work is to use language or representational rhythm as an opportunity to give physical form to your 'discontinuity, disruption and misuse'.

What I would say today is to try and be a realist. Making work means bringing to the world things you feel are missing in the world. Look for things that don't allow you to do the work.

What are the things that are 'missing in the world'?

Every time I make a drawing, I find out what is missing in the world.

Do you remember the first piece of work that you created as a child?

I remember the first work that I created when I was in art school. I thought I was in the presence of something that felt like it had a different energy than stuff that had come before it. I was faced with an object that had an aura, that had an energy that was new to me.

What was that energy?

It was like seeing myself in a way I'd never thought of. It was about trying to position myself in the universe. It was about searching, and locating, and experiencing.

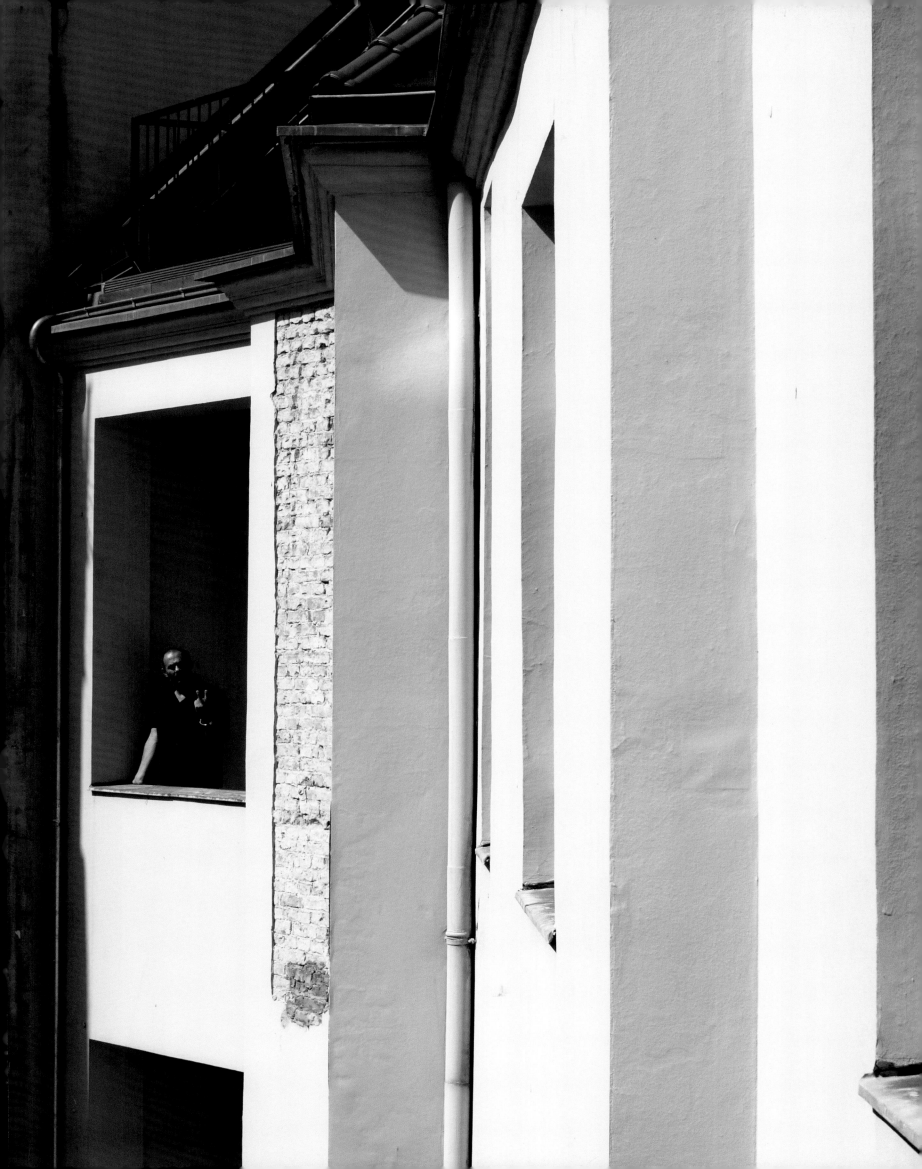

Tacita Dean

Your current work for the Turbine Hall at Tate Modern pays homage to real film. You have also done a work, *Kodak*, about the closure of a Kodak factory, haven't you?
Yes. The idea came about because I found I couldn't get black-and-white film any more. So I decided to try and film the factory where it had been manufactured and use its own obsolete stock on itself. The Kodak factory was in Chalon-sur-Saône in France.

What do you think people watching your film at the Tate will have taken away from the experience, given that we are living in an increasingly digitalised world?
Film is a different medium from digital, still full of beauty and potential. *FILM* was made entirely using analogue constraints and techniques, and was formed through them. It is a work that would never have happened using digital because I made decisions that directly resulted from wrestling with early cinema techniques. It was about returning to the innovation and invention when cinema was beginning, and I didn't want to rely on post-production, which is how digital cinema is made these days.

Have you ever worked with digital yourself?
I use digital the whole time; it is an important tool. The aperture masks that were crucial to this project were made digitally. I don't reject or eschew digital; I would just prefer to work with film. The assumption is that you have to use one or the other, but artists always seek out the mediums they require and, of course, completely understand the differences between them, and want to continue to use both. It is the industry that is hell-bent on seeing one replace the other; they are trying to persuade us culturally that it's fine to lose film, but of course it isn't: it's a tragedy. My sound is recorded digitally; it has been for a very long time, but then it returns to analogue. Sound is always separate from the picture. That's why you have a clapperboard: to sync the sound to the image later on. Film itself is mute.

Is your sound invented or ambient?
It is a combination of sound that I record simultaneously and sound that I invent. For example, when I filmed *Craneway Event*, of course it had voice in it, which was synced, as well as footsteps, but when there were gaps I had to invent it. I often play with sound to create atmosphere. What people don't understand is that sound is as much a construction as image.

Can you imagine experimenting with digital film?
My language isn't digital. I don't have the desire to use it as my primary medium. I use it when I need it.

Sometimes you work on your own and sometimes you work with a crew. What does that depend on?
It depends on the size of the project and on whether or not I need to hire cameras and lenses. Increasingly I work with a crew.

Are editing and working in the studio very much part of your practice?
Of course. They are the heart of my practice.

Am I right in thinking that you started off as a painter?
Well, no. I never started as a painter, but as an art student I was in Painting departments, which is different.

Some of your films have the qualities of still lifes. They are quite painterly, still and poetic ...
I always feel that my films are closer to painting than to cinema. My roots are in visual art. I use film as an artist.

What are your influences?
A lot of people: I love the work of many artists, I love the work of many writers, I love the work of many film makers. I can't say I'm influenced by them, though. It is not so simple.

You moved to Berlin about ten years ago and never came back. What is it like being a British artist abroad?
I love being in Berlin; it was the best thing I ever did. Although it is changing rapidly; sadly, it is becoming a normal European capital city. For the last ten or eleven years, it has been my sanctuary. It has been wonderful.

Is that kind of energy what attracted you to Berlin, its having been completely isolated for such a long time?
What attracted me to Berlin was to suddenly find an empty and forming city. London is very frenetic. Berlin gave me a place to be. I just loved it.

Did you learn the language?
Not much. I didn't have any German when I first went there.

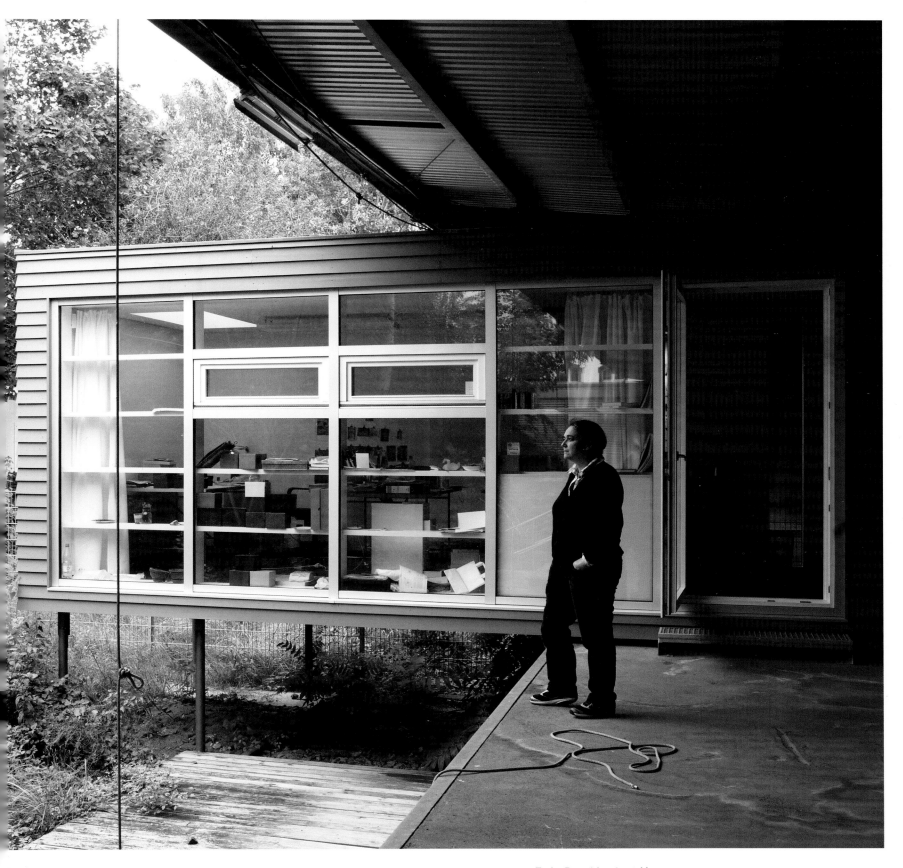

Tacita Dean (above) outside
her home and studio in
Berlin in early August 2011.
The artist says that she never
knows what will happen
when she is filming, 'and
I court the unexpected'.

Cans of film stacked in Dean's studio (above). The artist works at her Steenbeck cutting table (opposite page), where she edits alone. Dean's work *FILM* (right) in the Turbine Hall of Tate Modern was an homage to 35mm film, which the film industry is quickly replacing with digital. Shortly before the opening of the exhibition, Dean's film was revealed to have suffered a major error in the cutting room, the result of a loss of skill in the Dutch laboratory that had worked on it. A desperate search ensued for a skilled technician; only one individual in the entire UK, Steve Farman from a Tonbridge-based company, could be found to help. He and Dean drove to Amsterdam to recut the film, driving back through the night in time for the opening.

I know a Mexican artist who lives in Berlin. He made a conscious decision not to learn German so he can just stay in his space.

Yes, I am a bit like that too. Berlin does allow you that. I am easily distracted, so if I'm in a café, I will happily eavesdrop on conversations. But I can't do that in Germany; I have to concentrate to understand German, so I stay more in my own thoughts and can read amid people.

Tell me about your studio.

My studio is relatively small. I share it with Thomas Demand. It was Thomas who encouraged me to build a hut, a box, in the garden. There was a dark little storage space and we knocked the door through. That became my 35-mm cutting room. I have a 16-mm cutting room upstairs, an office and a small studio. I have just taken on another room, so actually I am expanding.

Do you do the editing with a team?

No. I edit alone on my Steenbeck cutting table. That's really where I make the work. That solitude is primary.

Do you develop the film yourself?

No. That is all done in a lab.

How much time is spent shooting and how much is spent editing?

Well, every project is different. For example, with the Tate project I only started thinking about it in March. Then came a long period when I had no ideas, but I had to deal with a lot of technical issues. We filmed in late July, which shows you how tight it was. I filmed for nine days. Normally I film for one or two days, or a maximum of three. I edited for two months.

Do you prepare in advance or not?

Yes and no. I never know what will happen when I'm filming, and I court the unexpected, but of course I need to be technically prepared. I have a film crew that I've worked with for many years, so we share a language. I don't need to direct them too much. I can only really work on one exhibition at a time. For example, just prior to the Turbine Hall, I had an exhibition in Vienna at MUMOK for which I made five new works, which was why I couldn't start work on *FILM* until March.

Where do the ideas come from? Do you have them in the pipeline or do they happen spontaneously?

They all come from different places, so it's very difficult to answer that question. I don't have a stock of ideas. After every exhibition there is a moment of paralysis.

Are you now in a moment of paralysis?

No, I am just about to have some rest. There has to be a bit of a break now because my work schedule has been crazy. When I get home tomorrow I have to clear up the mess that has been left, and I have got to work on another project quite soon as well. So I have a lot of stuff to catch up with.

So you pick up ideas while you are on the go ...

When you are open to it, that sometimes happens. The idea for the Tate work was a struggle to get to. I am so relieved that it worked! It was a challenge on every level because it is so different from what I normally do. I've been working very hard for a very long time.

Jim Lambie

Is there a connection between creative output and extreme thinking induced by alcohol, drugs or emotional excitement?

I've never believed that there was a connection. The real thinking I do is never induced by any of those things. So I wouldn't say that art-making hinges on any of that at all. What art needs is sober thought.

When you start creating a piece, how does the process unfold?

It depends on the piece. My initial thinking around a recent piece, for example, was an observation I made in the street of pop posters peeling off walls. I took that idea and tried to make my own sense out of it by using painted metal. I layered up the metal sheets, then painted and bent them by hand, pulling them into the room. That developed into what you see now.

How long would all that have taken?

Before I actually made that piece, it probably hung around in my head for about three years. After first observing something and thinking about it, I try and work out what to do. I'm not a draughtsman. With that first metal piece, after a while I thought the way to go would be to do it in metal because then I could bend it. To get the boring technical stuff over with: it needed to be 2-millimetre-gauge metal because it's thin enough to work but holds its position when I bend it. I thought metal might be a great way to suspend that image, almost like a suspended photograph.

But that's just one piece. Works come in from different areas. Sometimes it's something that I've observed; sometimes it's a problem that I set myself. It could be simple image-making. It's all up for grabs, and I enjoy that.

So as an artist you have the privilege to choose which direction you wish to go in as long as your abilities allow you to do so. What about the market; what about marketing?

Marketing is the furthest thing from my mind when I'm making a piece. When people say, 'That looks like a Jim Lambie piece,' I haven't got a clue what a Jim Lambie piece looks like, honestly! I don't try to create an image in that way. I just do it. Thankfully, somehow, it seems to be gelling.

But there has always been hype around art, ever since Michelangelo, even before him. Artists become celebrities, stars in their own time.

If something resonates, it's unavoidable that people want to know who made it. There was probably a twenty-year period where the romantic notion of 'pure art' was born. The rest of the time there was always patronage; the Church was doing it, royalty were doing it. Artists have always tried to make money. I'm comfortable with that if it means that I'm free to continue to make art and support art being made around me.

Do you make a good living?

I'm absolutely surprised by the fact that I can support myself and also sustain a small studio where other artists can help me. I pay them, and that frees up their time so they can pursue their own stuff. That's really important to me. I have a studio manager and three full-time employees. Other people come in depending on the project. They can choose their times as long as they give me a bit of advance notice.

Do you take advice from people who work in your studio?

All the time. I ask everybody when I'm making a piece. Sometimes I've thought so long about it that maybe I can't physically get it to work. At the end of the day, though, whatever decision's made is my decision. But I love hearing what people have got to say.

It's been said that you prioritise 'sensory pleasure over intellectual response'. Is that an accurate description of your method?

Some of the works may appear more sensory than others, but I'd like to think that all of them have a strong conceptual grounding. The enjoyable part for me is thinking about colour, form and all that. Then it opens up for me. I feel much more comfortable dealing with a real idea. Of course, when you start introducing colour, you start introducing emotion. Then music and rhythm and beat come in …

Speaking of concepts, do artists need to be intellectuals?

No. For me it's just about getting at interesting ideas. My concern is trying to understand the world.

Jim Lambie in the mews (opposite) beside his studio in Glasgow in mid-August 2011. Lambie often gathers material from secondhand shops, markets or even dumps to make work with. 'Works come in from different areas,' he says. 'Sometimes it's something that I've observed; sometimes it's a problem that I set myself. It could be simple image-making. It's all up for grabs, and I enjoy that.'

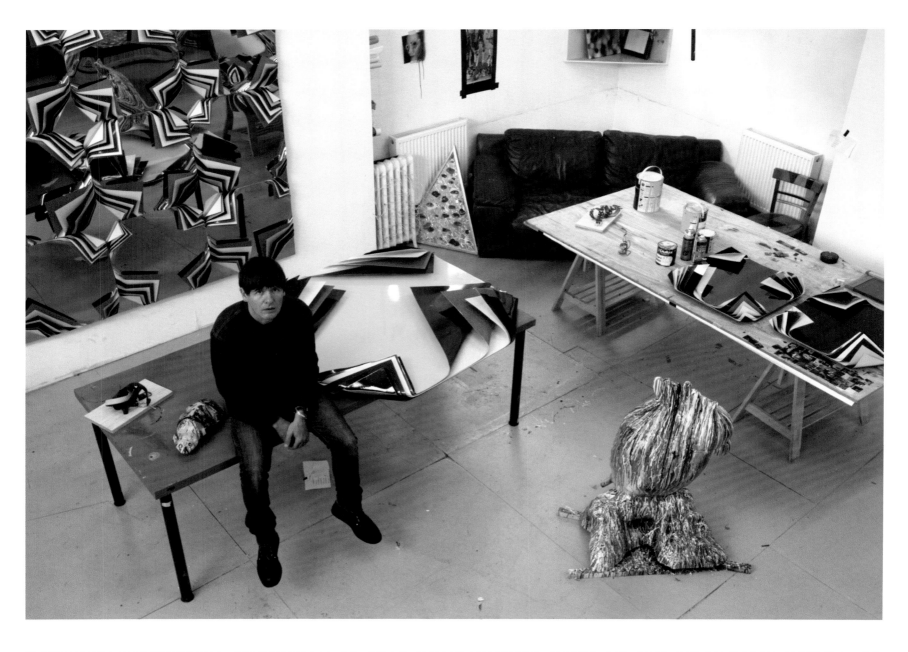

Lambie in his studio among his signature pieces, the idea for which came to him over years of observing torn posters on Glasgow streets. 'The enjoyable part for me is thinking about colour, form and all that,' he explains. Music is another major influence, Lambie having joined a rock band as a teenager and later played with *The Boy Hairdressers*. He still plays bass guitar and DJs at events, though he admits to being a 'terrible musician'.

Is anger part of an artist's palette?

I'm not interested in anger. Art is about opening up discussion and getting people talking to each other.

Do you mean that it's almost democratic?

Absolutely. The various voices are always valid. It just depends how far we want to take it. For me it's like music. Anybody can tell you whether they like a song or not. Of course there can be a higher intellectual level to music too, but I like the idea that it's quite democratic.

But anybody can go out and buy a CD. Not everybody can go and buy a Jim Lambie!

Ah, but anybody can go and *look at* a Jim Lambie. That's really all you need, you know?

It's said that some of your work is like 'the ephemera of modern life'; you 'take … found objects and transform them into vibrant sculptural installations'. How does a pile of rubbish turn into a piece of art?

I use a lot of found objects and things that I find in junk shops. For me, initially, that came from a way of working. For many years, if I had an exhibition I would turn up without any materials, without any artwork, a week to ten days beforehand and go round the city to find material. All of the works in a show would be made that way. For instance, one piece I did in Nîmes was about pushing myself a little bit. Two or three days before the exhibition opened, I realised

that the walls separating the spaces were *this* thin. The only things that I had with me were my duty-free cigarettes. So I ended up drilling through the walls and pushing cigarettes in. Then I got somebody into the room next door to give me a light, and I smoked the cigarettes down through the holes in the wall. It made a kind of constellation of cigarettes. Now, if I'd brought work with me already made, I may never have realised just how thin the walls were in the gallery. It was in the South of France, and they seemed to really enjoy the work because it reminded them of Jean Genet taking the piece of straw from his mattress in prison, feeding it through the wall and sharing cigarettes that way. I thought that was amazing, and all this conversation started coming off about this thing. It was only because I'd pushed myself into that position.

So you in effect scavenge for product. Do you also scavenge for ideas?

Absolutely. That's a great way of putting it! But I can only do that by challenging my thinking and my physical position in the world.

So art is a challenge for you?

Always.

And if it stops being a challenge?

I would like to think that I would always keep pushing myself.

Are you naturally good at sculpture, or is it something that just came to you? Are you equally good at painting or drawing?

I went to art school, you know. I can do it. I got my degree. But I stopped thinking about it in those terms many years ago. It very quickly became just about ideas. I abandoned the technical sort of art. If I couldn't do it, somebody else could do it for me, you know? If I couldn't make something, I could find somebody to help make it and get the idea out.

The phrase 'transcendent profundity' has been used to describe your work. Is that what you aspire to?

I came up with that Zen quality in terms of emptying a space and filling a space at the same time. That was something that was revealed to me through thinking and making work simultaneously … Some of the pieces have that quality about them. Others are more high-impact, while still others are slow burners – you have to find them a bit, work with them a bit harder. But it's not like I'm a priest or something! I'm making work and the work's revealing itself to me while I'm making it. After it's been made, it reveals stuff to me that I wasn't aware of. There's always a sense of alchemy in it.

Maggi Hambling

Maggi Hambling in her Rendham, Suffolk, studio. The walls (above) drip with paint, the floors are covered with cigarette butts, but the wonders of the Suffolk countryside are a mere step away. A fierce protagonist in any debate, Hambling lives up to her reputation, her bonhomie hidden beneath a tough demeanour. 'Victor Musgrave once said to me that there is this balance between remaining vulnerable, so that you can respond to things in life, and having this backbone of steel that makes you carry on regardless of what anybody says about your work.'

How do you feel when you're in your studio?
However big it is, no studio is ever big enough. This new series includes the largest canvases I've ever worked on. Practically everywhere is already full of them. If I'd designed the building myself, the walls would have been taller and I'd have had less slope to the roof because I paint on the wall. It would be nice to be a poet. You only needed a few exercise books in the old days, or a computer nowadays, I suppose.

Do you ever regret becoming an artist?
Not for a minute. I like the thing Brancusi said about it not being difficult to make a work of art. The difficulty lies in being in the right state to do it. That is so true.

If I'm doing a portrait, I try to be a channel so that the truth of the person can come through me onto the canvas. It's the same with my work with the sea. That's why it's important, this emptying of yourself. Quite a lot of artists dictate *to* the subject. For me it's the other way round: the subject has to be in charge of me. When I was fourteen, the art teacher at school said that a subject chooses you. As the now dead poet, writer and art person Victor Musgrave once said to me, there is this balance between remaining vulnerable, so that you can respond to things in life, and having this backbone of steel that makes you carry on regardless of what anybody says about your work.

There seems to be a fascination with death not just within your painting but within yourself.
Well, Bacon always said that he thought about death every day. Any serious artist bears it in mind most of the time.

George Melly talked about your painting this way: 'Artists plan every brushstroke, but Maggi lets the brush take its own path. So there is a marvellous balance between realism and automatism.'
Good old George! I miss him a lot. He used to try his jokes out on me, and if I didn't laugh he didn't use them. That was quite a responsibility. As he became more and more deaf, he'd say, 'I can't hear if you're laughing, Mag.' When all my work of George left for the Walker Art Gallery a couple of years ago, I went back into my London studio and looked round and said to myself, 'Accept it. He really is dead.'

What is your process? Do you plan?
No, no, no. If I knew how it was going to look at the end, I wouldn't bother doing it.

Drawing's a vital part. I get up early, about 5.00. Most mornings when I'm in Suffolk, I drive out to the sea with the jolly old sketchbook and a lump of graphite, the spookily old-fashioned way. Make some drawings. I don't look at the drawings. It's a way of getting into the rhythm, the energy of the water.

Like jogging?
If you like. I'm not as fit as a jogger, but … yeah. To get into that rhythm. To try and find the marks.

How long does that take?
At most half an hour. I come back here and have a first cup of coffee, and I paint. In a way when I'm sitting there drawing the sea, that bit of beach I'm on is my studio. And of course, because I dream about my work, the studio can be in my head. The studio is wherever you are.

What memories do you have of your first studio?
This strange thing happened when I came top in an art exam at school when I was fourteen. I'd done nothing but flick paint at people and generally draw attention to myself, because I was in love with the biology mistress who was invigilating the exam. Suddenly I saw the clock – it was 3.20, and at 3.30 I knew I had to hand in a painting. So I did one, okay? Ten minutes. And when the results came out, I was top of Art. Soon after that exam, my mother bought me a work table which I had in my bedroom. So my bedroom became my studio. That's where I could be dealing with the truth. The rest of life can be a lot of charades, can't it? The only reality in my life is the work.

Lett-Haines, who ran the East Anglian School of Painting and Drawing, where I worked with him in the kitchen, said the best thing that any teacher said to me: 'You must make your work your best friend.' That's how I've lived my life.

Do you ever get upset with your best friend? Do you tell him off?
Oh! Drives me mad, man!

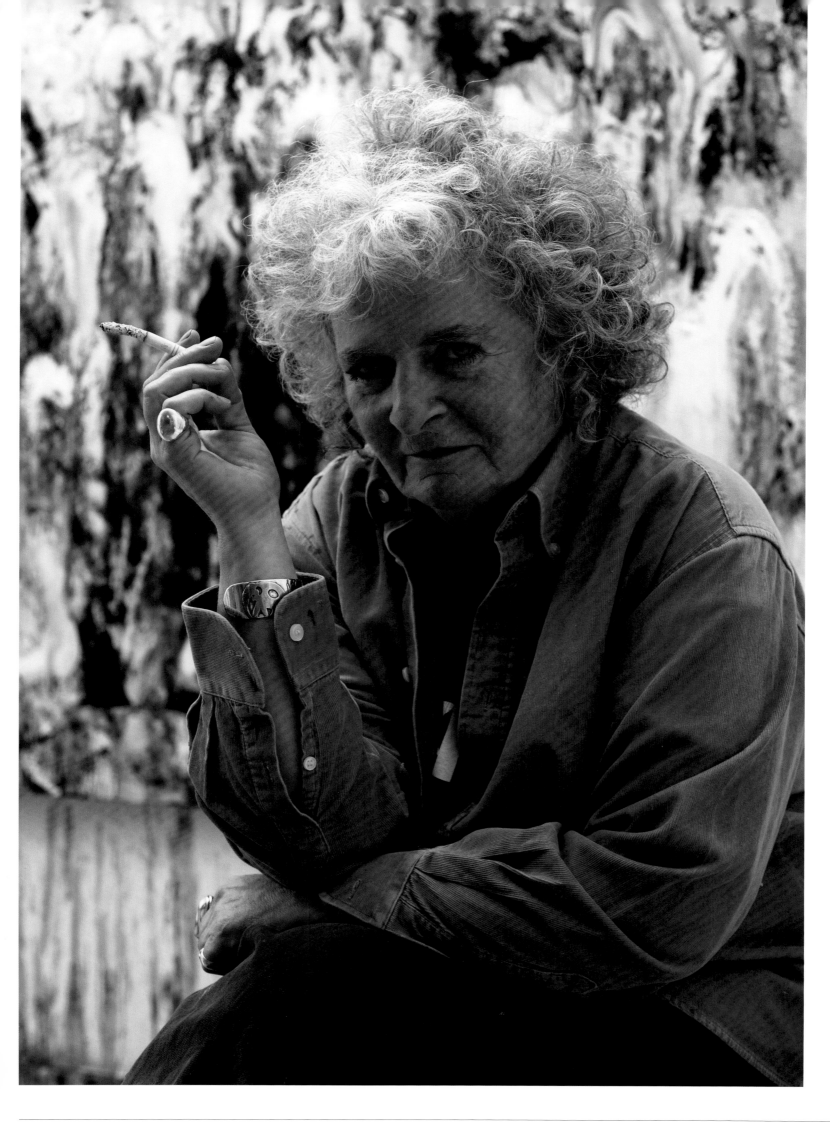

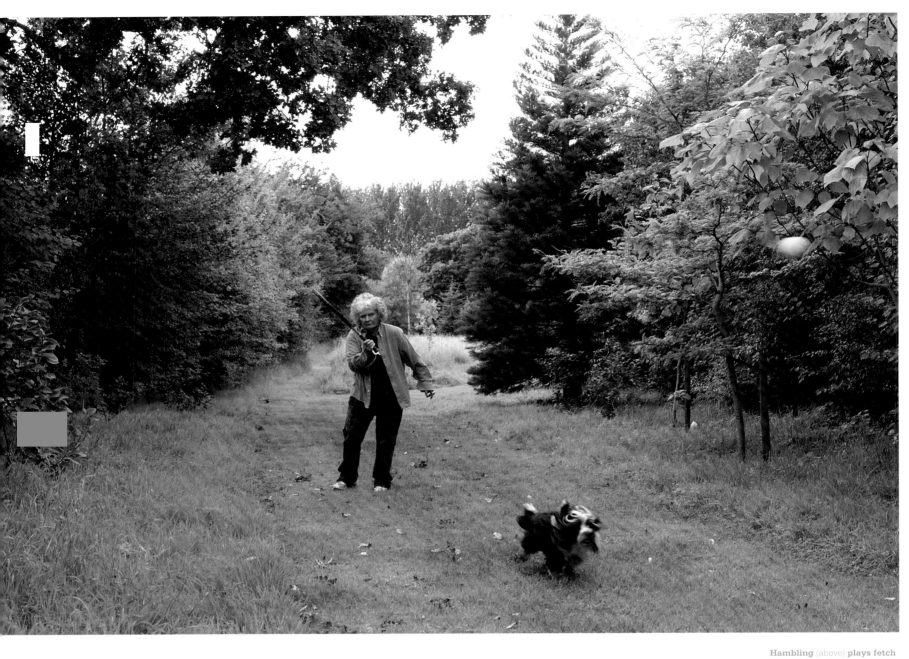

Hambling (above) plays fetch with her dog Lucky on her Suffolk estate. An animal lover since childhood, she once allegedly jumped ship in Egypt in order to rescue a cat being tortured by locals. (One wonders what happened to the locals?) Hambling in the drawing room of her house (opposite) next to her studio, with the odd tiger for company. An early advocate of gay rights and open about her own sexuality, she poses next to her Chrysler, named Marilyn (far right); the number plate reads 'HI O GAY'. 'The rest of life can be a lot of charades, can't it?' muses Hambling. 'The only reality in my life is the work.'

How important are mental, emotional and physical stimuli for an artist?

I'm pretty manic-depressive. I'm either absolutely on top of the world or in the pits of despair.

Are there times when you just want to chuck it all in?

I certainly don't think of chucking life in. Artists are lucky. They can go on in the hope that they might get a little better. I mean, look at Titian. We don't have to retire like tennis players.

Does sexuality have anything to do with your art?

Of course it does. That's why I like oil paint. It's live, sensual, sexy stuff to work with, compared with acrylic, which I can use on paper but is like concrete on canvas. The physicality of the paint, as I hope you can see, is very, very important to me. It's the same kind of urge, if you like, to make love with paint as to make love with a person.

I remember at Ipswich Art School one of the teachers saying to me that at first the girls look a lot more talented than the boys because they have a natural feeling for paint and colour, but they are not always too hot with the drawing. The boys, who can draw, more often catch up with the paint and the colour than the girls do with the drawing. As Picasso said, we're all partly male and female, and you have to bring the whole thing together to make a work of art.

Talking of art schools, do you think they have much relevance? Do they make artists, or stop artists?

There's no rule. I was lucky: in the '60s, when there were grants, I managed to be an art student for seven years. I mean, look at the poor buggers now! Having to find £9,000, and if they're very lucky they see a tutor for half an hour during the week. The terrible thing – this will sound very old-fashioned – is the lack, quite often, of models. The discipline of drawing from life, drawing the human figure, is essential. Working from life trains the eye and the hand to be *one thing*.

What about your own experience as a teacher? You don't teach any more, do you?

Not in art schools. I do a class at Morley College once a week. We have a model. I have one or two young people that I am bringing along, together with the others who are a bit older. I can draw from the model if I feel like it. I don't go to any meetings and I refuse to fill in bits of paper.

And how much are you still involved with literature?

The fact of the matter is that I get up so early in the morning – I work as long as possible – that in the evening I tend to have a drink, I never miss *Coronation Street*, and I fall asleep. I don't read as much as I used to. You have to realise as you get older that you *cannot* drink and dance all night and think you can be up at the crack of dawn and work all day. Energy – which is what all of these paintings are about – is the important thing.

Where does that energy spring from?

I don't know. I just say, 'Thank the Lord!'

Have you ever had 'artist's block' in the sense of not being able to paint?

That's a lot of rubbish. I work every day. I'm never on holiday. Occasionally something goes right, but a lot of the time it doesn't. A lot of the time you're lost, you're fed up, you're full of doubt, of despair – all of that. But you've got to do it every day, for when Madame Muse chooses to arrive and something goes right!

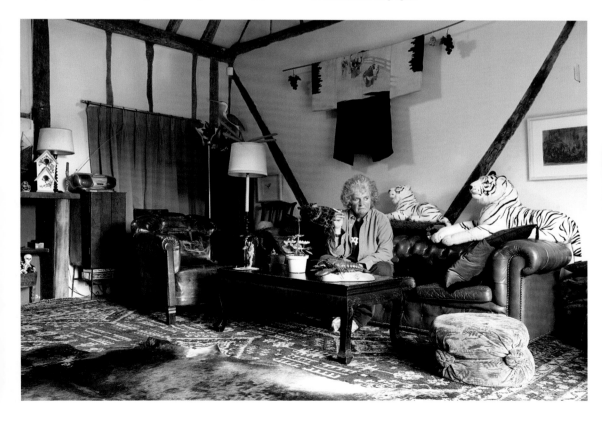

Is an artist born with creative genes, or does she adapt and grow into them?

Well, they must be inside me somewhere. My father discovered that he had them. He'd worked in a bank all his life. I gave him some paints when he was sixty and retired from the bank. Suddenly, one morning, he started to paint. He painted for the last thirty years of his life. It poured out of him. On the telephone I'd say, 'Have you done any paintings, Father?' And he'd say, 'Well, I've got a couple of things on the go.' And then he'd say, 'Your mother likes one of them.' We'd both laugh, saying, 'Oh dear!' Meaning it wasn't going to be much good! Because she didn't have any art inside *her*. She was a pretty good tennis player. She loved the theatre and films. And she was very churchy. Running flower festivals and Mothers' Union and all that sort of thing.

You've been described as 'famously scary, friendly but fierce'.

That's all right. All we have in this life is time, isn't it? As you get older, you become more and more aware of less and less time. So you don't want interference. I don't let many people in *here*. Keep them away, keep them away! If they find me scary, that's a good thing.

What is your ambition as a painter?

To get a bit better.

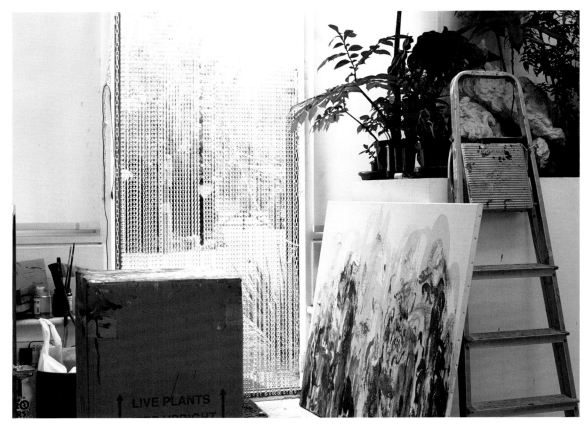

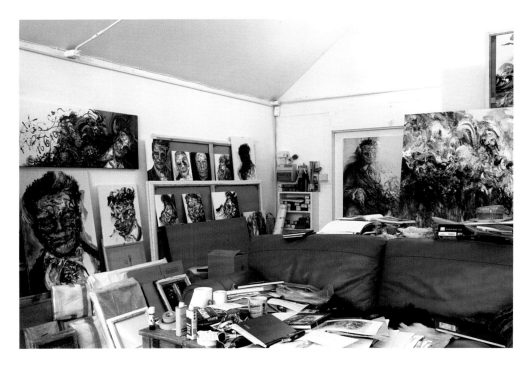

Nicknamed Maggi 'Coffin' Hambling by her late friend George Melly, the artist has a habit of painting portraits of close friends who have died, something she started to do after the death of her father. Featured here are paintings of Sebastian Horsley, who died of an overdose in 2010. 'Bacon always said he thought about death every day. I think any serious artist bears it in mind most of the time.'

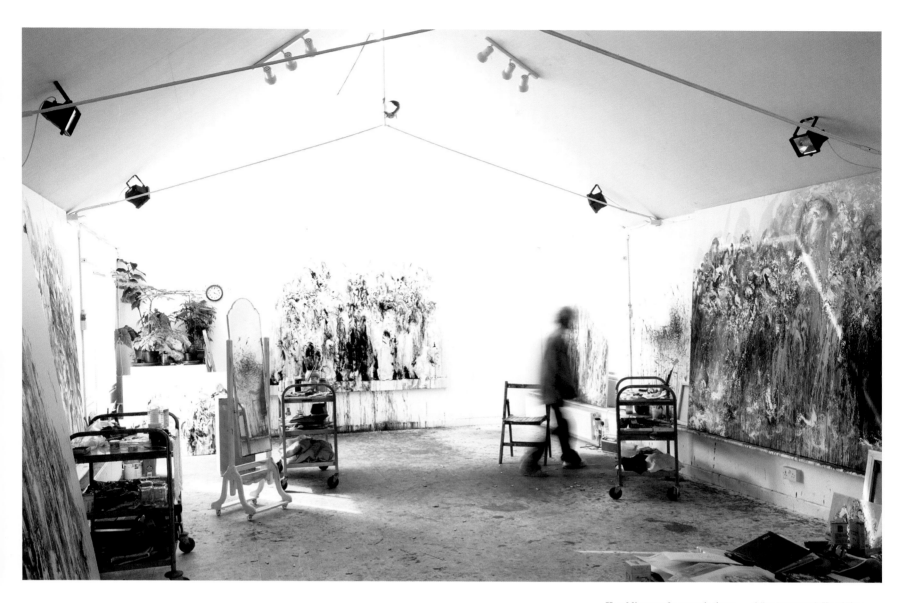

Hambling works on paintings from her *Walls of Water* series, finished and half-finished works scattered around the place. 'The physicality of the paint, as I hope you can see, is very, very important to me. It's the same kind of urge, if you like, to make love with paint as to make love with a person.' Hambling has a studio in London too, but she tends to avoid the big city, preferring the quiet of the English countryside. 'A lot of the time you're lost,' she says. 'You're fed up, you're full of doubt, of despair – all of that. But you've got to do it every day, for when Madame Muse chooses to arrive and something goes right!'

(following spread) **Hambling** photographed in early September 2011 with her 3-metre-high stainless steel sculpture, *Scallop* (2003), located on the northern end of Aldeburgh Beach, facing the North Sea. The edge of the shell is pierced with the words 'I hear those voices that will not be drowned', a tribute to the composer Benjamin Britten (who founded the Aldeburgh Music Festival) and his opera *Peter Grimes*. Hambling visits the beach early every morning to sketch: 'In a way when I'm sitting there drawing the sea, that bit of beach I'm on is my studio.'

Eva Rothschild

The very private artist Eva Rothschild (opposite), who often uses varied materials such as leather fringe and incense sticks, working in her Hackney, London, studio in mid-September 2011.

How are mysticism and magic related to your work?

I am interested in how an inanimate object can be read as having a quality separate from its material reality. That respect, I suppose, chimes with the idea of a religious or magical object whereby the materiality of the pieces exists in parallel with ideas that surround them. I've always been interested in a non-practical way of thinking. If there is a story around something or a possibility for something to be out of the ordinary, I am always interested. Groups of people invest objects with power, and artists tap into that a lot of the time.

Art is a way of making objects which aren't necessarily functional. I am interested in the transformation of material that can bring associated meanings together. The human body as a whole is what I am least interested in. The eye interests me, the hand interests me, the head … but the idea of the complete body doesn't interest me. Sculpture is about the collapse between subject and object, where they become confused. The act of making is often pragmatic, but the end result is not necessarily a pragmatic or practical object.

You've been quoted as saying that you're 'interested in un-systems of belief'. Can art become an un-system?

For some people it can. Art fulfils a role in contemporary culture, a role it has always fulfilled by providing a place for thinking or seeing things beyond the day-to-day things that people think and do.

Would one of your sculptures receive the same interpretation if it were seen by an Amazonian tribe as it would in a New York gallery?

No, but hopefully it would have a resonance for any set of viewers. Obviously people will have different ways of seeing that they bring to objects. If you show in a gallery in New York, you have a certain assumption that the crowd are aware of what you do. But then you have places like the Tate where you don't know who comes to see the art; they have millions of people through their doors. Public galleries in the UK have done a lot to bring art to young people. I come from a background where I did go and see things, so for me there are real possibilities that can be brought about by horizons being broadened.

I'm trying to explore what underpins the acceptance of contemporary or Conceptual art …

Art is contemporary because it is happening now, but art has been happening since somebody painted a stick. Art is a human impulse to make something that has no function except for looking and experiencing, something that you can't express in any other way.

Your work radiates a sense of unsettling energy. Is that reflective of your personality?

It would be good for it to be unsettling! I don't want it to be inert. Everyone wants their work to have power and tension and the ability to connect with the viewer.

What influences have there been on your work?

When I was at art school I became aware of the work of Cady Noland; that was a critical point. I hadn't been aware that people could make work that was so tough and that combined ready-made objects. I was also aware of Barbara Hepworth and Henry Moore; recently I've been interested in Hepworth as a female artist working in a male-dominated environment. The most interesting artist working at the moment is Cathy Wilkes; I find her pieces raw and emotional and related to the body. I worked with Phyllida Barlow; she is somebody I respect. I like the way she works with materials. People who interest me have multiple approaches to making and there isn't a sense of limitation.

How many people assist you in the studio?

I work with three people on a regular basis, although they are usually not all here at once. They are all artists.

Is your studio your principal thinking and doing place?

The studio is really, really, really important for me. This week I had to go and check on some things that had been broken and I was really unsettled. I like to be here and involved in the practicality of making. To me that feels like work.

When do you get here in the morning, and when do you leave?

Quarter past nine and quarter past six.

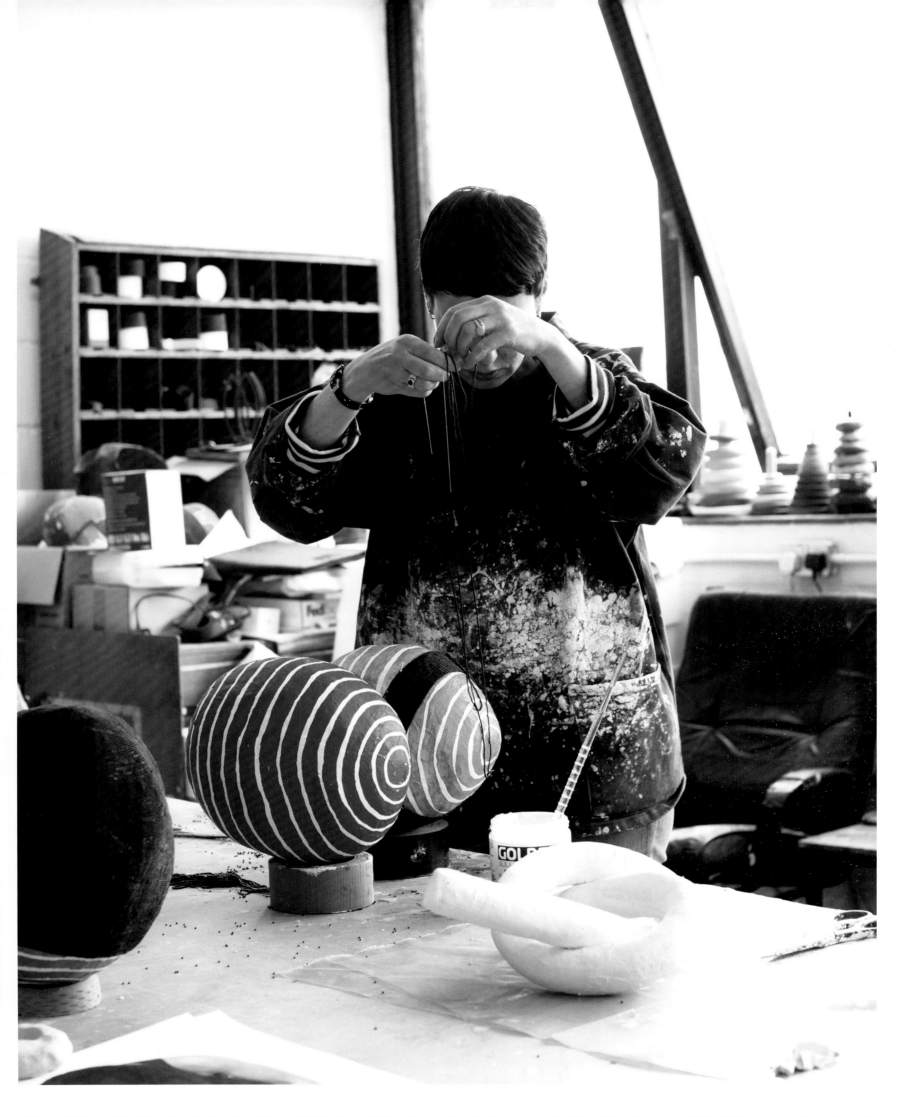

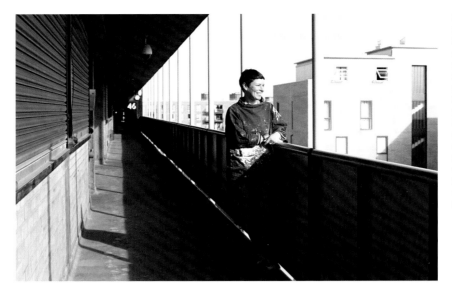

Rothschild (left) on the balcony of her studio near Broadway Market: 'Art fulfils a role in contemporary culture, a role it has always fulfilled by providing a place for thinking or seeing things beyond the day-to-day things that people think and do.' Rothschild working in the studio, a large Persian carpet, dyed jet black, in the process of drying. 'Sculpture,' she says, 'is about the collapse between subject and object, where they become confused.'

As regular as clockwork?

Yes. While I am here, I think about other things I might have to do, and when I am at home, I think about things that have to do with the studio. The two do cross, but they are quite separate. I might do email, but I don t work at home, ever.

Do you visit other artists' studios?

I have friends whose studios I've been in but not recently. I used to have a studio in Bermondsey, and that was great because there were lots of people working there and you sensed that people were busy. Since that's closed, people are dotted all over the place. It's always interesting coming into other people's studios. It sounds pedestrian, but so much of making, especially with sculpture, is about problem-solving. If you go to somebody else's studio and they've got an area where they are casting or mould-making or something, you might go, 'Oh, that's a good way of setting that up.' It's about seeing how different people work, like being a mechanic and visiting a workshop and seeing the organisation of tools or materials. So there is quite a practical thing about seeing other people's studios. Also it's interesting to see work being made because normally you just see finished objects. I used to teach a lot and I was in a studio situation all the time. There were all these artists making work and I really did enjoy that. We all engage in the same process but in different ways.

Taking that a step further, how much appropriation of ideas is there among contemporary artists?

People are always interested in what other people are doing, and sometimes people come to the same conclusions. You see that in all aspects of culture, even in science. I can't think of appropriation that seems truly contemporary; people tend to look back twenty or thirty years.

Looking back in terms of your own work, was there a moment of critical transformation?

Doing the 2009 piece at the Tate, *Cold Corners*, was important for me because it was large-scale and singular as well. I'd never done anything like that. My sense of the possibility of sculpture was realised in that moment. The jumps that you make in the studio are also very important, though. The artists I like very much tend to have vast, profound practices. I can't imagine that I would ever make a painting because I have no ability in that area, but I am interested in artists who make collages, who make paintings, who make films. In a narrower sense, within my own process, I feel that when you make a jump in a way of making or using another material, it opens another path within the work that expands your field as a maker.

But if you were locked away and told to paint, what would you do?

I'd paint.

And you'd be happy with the product?

I suppose I wouldn't have a choice. But I would always rather make sculpture.

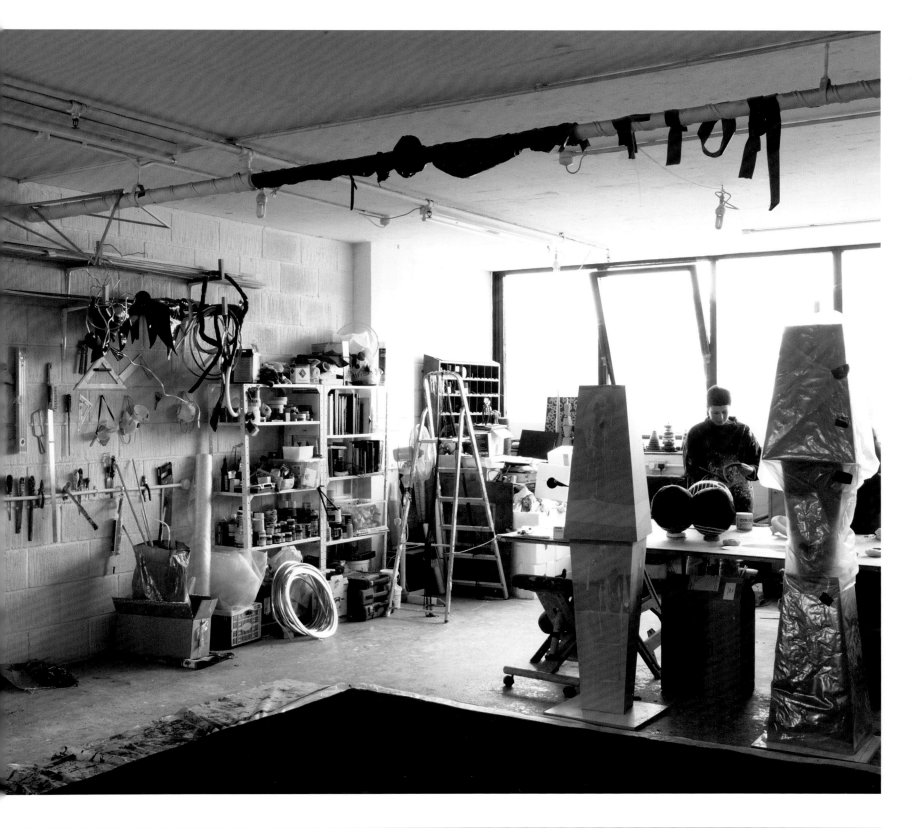

Sir Anthony Caro

Do you have a routine when you go to your studio?

I get to work around 10.30. I hate going to my office and answering letters and seeing what's on the email and so on, but I *do* do it. I work through to lunchtime, have a snooze, get going again around 3.00 and get home at 5.30. More or less. Lots of cups of tea all the way through.

Are you more inspired at some times of the day than at others?

Inspired isn't the right word. I was an evening person in the old days. But I've had to learn to be a morning person because that's when things happen – steel comes, practical things. As far as stimulation is concerned, if I've had a long weekend in the country or something, and I come back and see the work afresh, it does something for me. Getting one's time-table right and knowing what's going to work for you are almost more important than each individual work, because somehow you can build on that.

Do you always want to leave the studio with a sense of what you might do the next day?

Yes. I'm much more interested in the things that are not right than I am in the things that are already right.

Are you always working on a number of sculptures simultaneously?

Mostly, yes. Because they need each other, and they criticise each other.

And how do you know when a work is finished?

As Larry Poons said, 'When it says yes to me.' I think that's a very good answer.

Do you find fundamental differences between working at actual scale and with actual materials and having to work with models or maquettes?

I like to work with actual materials. I want the real thing. I want to be able to go up and move it and say, 'Let's try that one.' Since we got a fork-lift truck, it's made an enormous difference, because we can take a very big thing and try it just like we would a small thing. In the old days, lifting big things would take a morning. Now it takes ten minutes.

Do you often have a clear idea about where something will go when you're making a sculpture? Or will you only understand how it works when you physically see something next to something else?

It's very much the latter. But there is an idea, there is *something*, some direction that one's aiming for. It was interesting yesterday when Will Fawcett, who used to work here and is now working at the AA, said it's difficult talking to architects because when they're trying something out, they call it 'testing'. 'Testing' is what it *isn't* in sculpture or painting. You're *making* it. You're making a *thing*, you're not making a *test*.

How important is drawing to you?

I love to draw for fun. But it's nothing to do with my making sculpture.

So if you're away from the studio, you never make sketches or notes?

No. When I go to Venice, I draw gondolas or the view from the window, or sometimes the odd palm tree, that sort of thing. When I've got no possibility of making sculpture, I'll draw a bit. I draw my grand-children. Sculpture's so three-dimensional. For me it's got to be real. A drawing would be a shorthand version. I don't want that.

Sir Anthony Caro in late September 2011 in his Camden, London, studio, where he has worked for forty years, here seen sharing a joke with art historian Tim Marlow. A painting by Sheila Girling, Caro's wife, hangs in the background. Caro and Girling, whose studio is next door, have lunch together every day at the oak table pictured here.

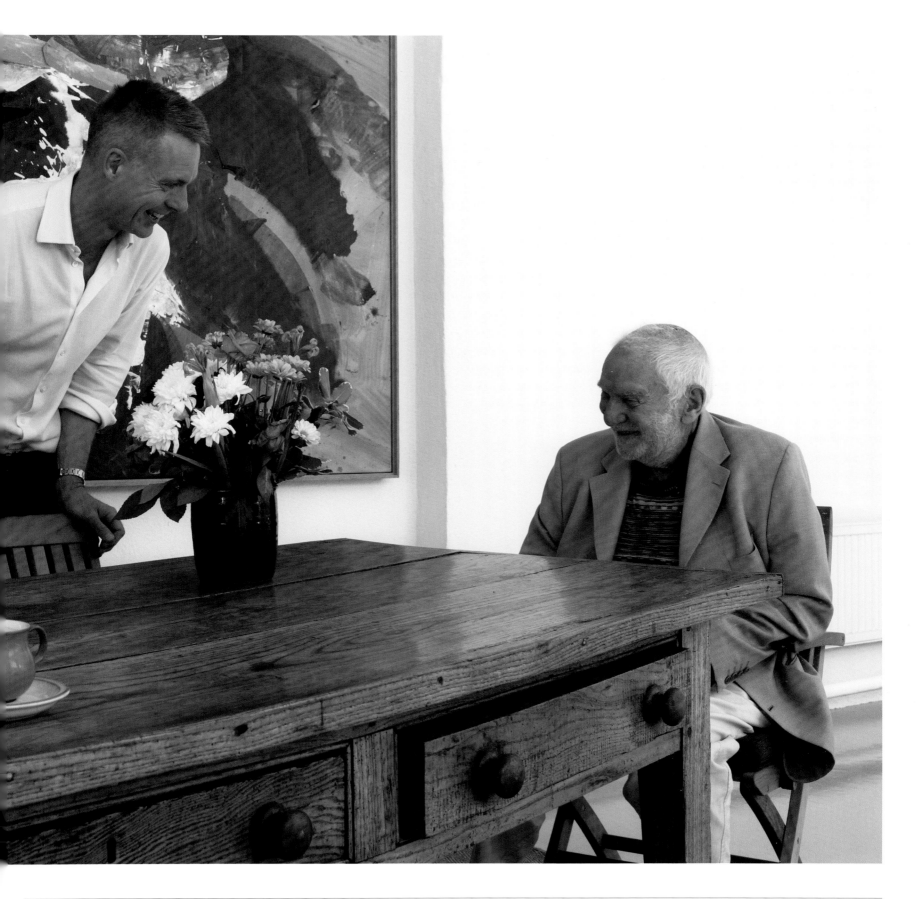

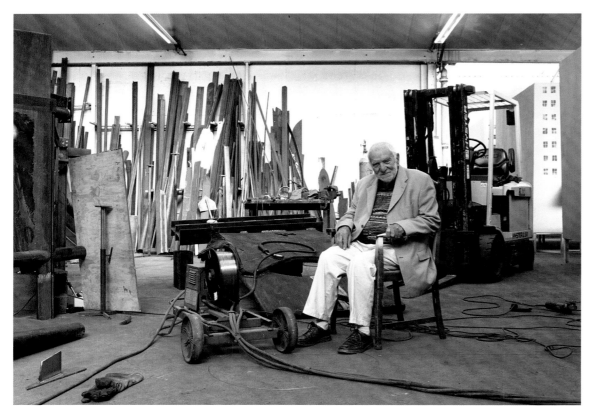

Caro works primarily in steel in his small-factory-sized studio. 'I like to work with actual materials,' the artist says. 'I want the real thing.' 'The real thing' can be anything from scrap metal sourced from junkyards to expensive materials and alloys.

You've made work that has been interpreted as being in dialogue with paintings by Monet, Manet, Duccio, even Picasso and Matisse. What's the nature of the relationship between those paintings and your finished sculptures?

You get different things from different sorts of pictures. They can be just a springboard. Or why not make them looser? Or something could be much bigger. There are a hundred different ways of getting excited by the Old Masters, by paintings that you love.

When you look at paintings, do they suggest sculptural possibilities to you?

No. I enjoy them. I could be looking through a book and suddenly say, 'How about that? That's a thought. Look at the way those shapes are interlocking.' Or the colour. Or whatever. You're lucky when you hit something like that at the right moment, that it can stimulate something.

If you think about an artist like Picasso – one of your heroes – or Matisse, both of them painters, but they also made sculpture, they also drew. Is it liberating to be drawn to different dimensions or media, or would you find it daunting?

It took me a long time to learn to make drawing sculpturally. I think I got there. I learned that from talking to Henry Moore, although I don't now follow his way of making form look sculptural. I was completely uncomfortable with drawing from the figure, say, until I went to Moore's. It may have made me beware of drawing. I rather wish I did do more of these different things. But it's never worked for me. I'd be interested to design an opera; I've done a little bit of three-dimensional work with paper. I've got awfully taken up with the problems of sculpture.

You've worked with a considerable range of materials, particularly in the last three decades. What is it about steel that still appeals to you?

Well, it's easy! You take a bit of steel, you stick it somewhere, and if it's not right you cut it off. Steel is very available. I've endeavoured to do the same thing with expensive materials like bronze, silver, even gold. You have to treat it all like stuff, really.

Are you still ordering all manner of scrap steel that in itself suggests how you might do interesting things?

Yeah. Terence was down at the scrapyard the other day and said, 'I've found some stuff you might like, so I've brought it up.' Fine, fine! Thanks! Put it in the pile! In ten years' time I might use it. Or I might use it tomorrow.

There's a consistency over the last four or five decades in the way you've treated steel. You try not to let it be anything more than 'stuff', yet at the same time it allows you to do things that almost any other material doesn't.

As I never could understand how things worked, it was easier for me than if I'd have said, 'Oh, that really is a machine.' I would only think, That's a shape. I own a little painting by Hans Hofmann. When I had it in my barn in America, I could have sworn it was an abstract painting. When it came back to England and I put it on a wall in my house, it was a head. I don't know what caused that. Maybe it was something to do with thinking, American thinking? Or maybe it's something to do with the sky or the landscape?

That is very interesting, because at the beginning of your career, in the early '60s, abstraction was central to what you did. Many would argue that it's remained central.

I think it has done.

A mini model of New York's Park Avenue (above) serves to position Caro's plan for a sculpture installation on a three-block traffic median. 'People make sculpture like they make painting. Mind you, now the tendency is to want to make monuments. That is mostly a step backwards,' he reflects. Caro works with a handful of assistants who cut and weld most of his work and who also discuss art with the master: 'The critic's job is to be like Ezra Pound was for T. S. Eliot, you know? Another eye, another hand.' Caro (opposite) taking the autumn sun in the scrapyard of his studio, where found metal is brought to rest until inspiration transforms junk into art.

But you have also played with codes of representation. Are you relaxed about the interplay between what is perceived as representational and abstraction, or do you think of your work as abstract?

No, no. Some of the work is definitely representational. I shocked myself when I first made work that had narrative – heads and things – in it. I didn't expect myself to be doing that. The trouble with abstraction is that it is hard to swallow. Yet I probably love the abstract things best in the end.

You famously said that you wanted to try to 'learn to write fuller sentences' in this abstracted language of sculpture. What kind of language have you evolved?

I would like to push the envelope. We can do all sorts of things, even abstract things, which haven't been done yet.

So sculpture still seems to you a territory of considerable possibility?

Oh yes!

What impact has the communications revolution had?

An enormous one, but not in my case, unfortunately, because I'm not comfortable with computers. I'm not comfortable with anything virtual.

Do you not worry that there is a generation growing up now for which so much is virtual? Does sculpture have a role to play in the reassertion of physicality?

I can't say what's right for people of twenty-four, or thirty-four, or forty-four. I can only say what's right for people of my age. I can't even say that! I can only say what's right for me. I have to have the real thing. I'm working with this graspable stuff. I am going to try and give it expression. I don't want to make stipulations for anybody else, because they're going to see sculpture differently.

What's the biggest change that's happened sculpturally in your lifetime?

It's become much more available. It's something a lot of people can enjoy and not feel it's just a damn nuisance when they really want to look at pictures! It's become an intimate thing. People make sculpture like they make painting. Mind you, now the tendency is to want to make monuments. That is mostly a step backwards.

What about people coming to your studio? Do you still feel that a regular dialogue between artists and critics is possible?

No. I wish there were more of that. I love it. There are only two or three people with whom I have a good time in the studio. We spend the day looking at work and suggesting possibilities. I'm all for that. The critic's job is to be like Ezra Pound was for T. S. Eliot, you know? Another eye, another hand.

So is creating in the studio essentially a solitary thing for you?

Yes and no. I have to have somebody here some of the time, but I have to have some thinking time as well.

Your wife Sheila Girling is a painter, and her studio is next to yours. How is your creative relationship?

Very good. I will say to her, 'I've done something. Tell me what you think.' It's very lucky that we have that relationship. But I don't go up and look at her work without being asked, and she doesn't come into this studio without being asked.

Do you ever dream of sculptural possibilities?

I don't know what I dream.

I remember you once said you dreamt of Picasso.

That's different. I stopped dreaming of him after I had a long conversation with his ex-wife. It cured me a bit. I understood him better.

Jenny Saville

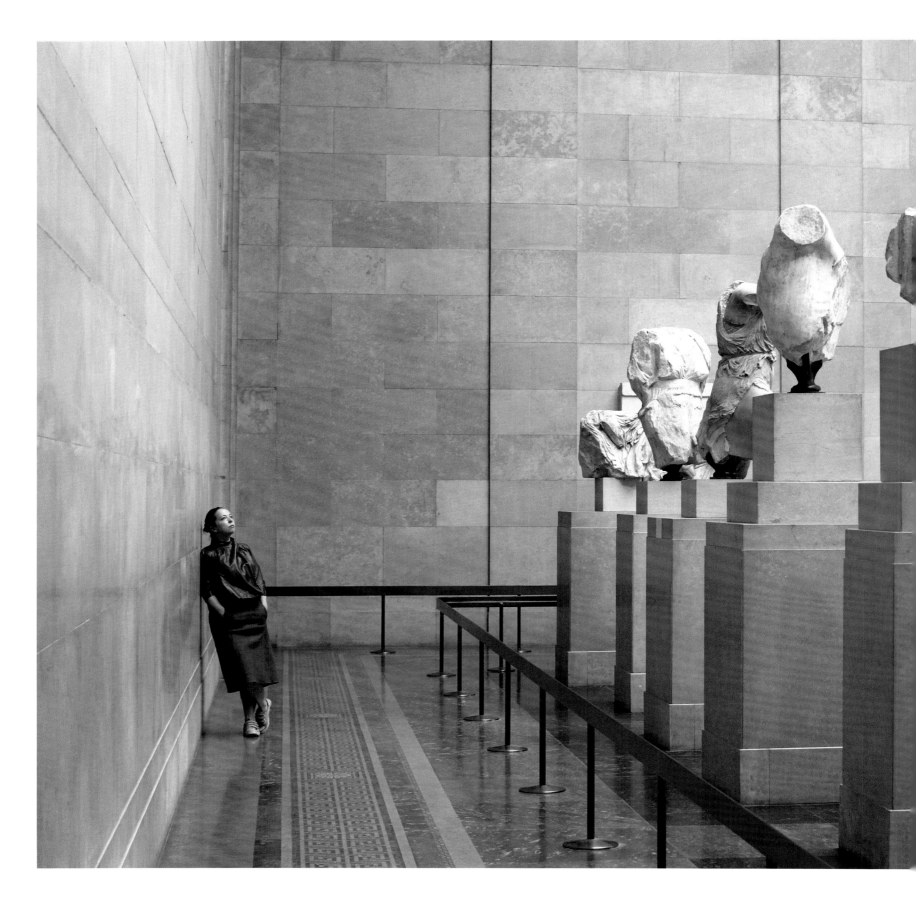

You've said that you were fascinated in childhood by Giacometti's and Bacon's studios. What did they evoke?

The built-up, layer-on-layer existence inside a space struck a chord. I had a sort of studio from the age of eight. My mother gave me a cupboard in the hallway; I used to spend all day in this cupboard making work. I have weird recollections of having my sandwiches on a plate. I would paint directly on the walls, and, as the seasons changed, I would change the paintings. I remember summer holidays of waking up and wanting to get into that room.

Giacometti's studio was like a work of art in itself. The way he worked extended to the walls and back to the work. In a way, the studio was a mass exhibit. When you looked at the black-and-white photographs of his studio, you got this incredible sense of civilisation and history.

Is a studio a congregation of ideas or a cemetery of lost thoughts?

A studio changes depending on what you need at a particular time. It can be a laboratory of ideas; it can be a safe haven; it can be somewhere you don't want to go because the work's not going right. If I'm not in the studio, I feel a magnetic pull back to it. It's been like that since I was quite young.

You've changed spaces many times. Have they affected your work in different ways?

My studio does affect my work but not the core element. When I get in there, I find my feet quite quickly. I learn different things from different spaces. In my studio in Palermo, Sicily, I had about twenty rooms which were incredible – frescoed, falling apart, like being in a film – and I loved the idea of working on a different series of paintings in each room. But I missed having a big, white, open space with skylights. The darker the space – I mean psychologically darker – the more violent or dark my work becomes. In a more airy space, I notice I'm a little light-footed.

When I was working in Palermo, it was such a different place that I felt like I was slightly in exile. Funny things like shadows became very important to me: the violence of light when I saw it cutting shadows on balcony walls outside my studio, also the battle of the heat. I worked above a meat market, with these innards of cows, this internal animalism, visually apparent in my everyday life. That was beautiful for the work. I've worked in a slaughterhouse; I walked in and there was this steaming beast, and that was just about paint. I was literally mixing paint in my head. The same thing is true of plastic surgery. I see possibilities for making art and it excites me.

You spent six months in New York working with a plastic surgeon. What did you learn?

I learnt about anatomy, about women's perception of their bodies, about what flesh is. Most profoundly, it gave me a model of how to paint. I saw a surgeon literally re-sculpting flesh, and that became something to think about in terms of mixing colours and moving paint around. I was interested in how when you go into surgery, you become a patient, and then you come out and the world sees you before and after. That's what painting's like.

How do you, as a woman, treat with blood and gore?

There is an assumption that women are not associated with violence. I've given birth twice and I've seen a lot of violent things and looked at a lot of medical images. Women are associated with violent acts and blood; every month they're used to having blood in their life. It's social conditioning to think that violence has nothing to do with women. I think there's a sort of social cover-up. Women are interested in those things and have them in their daily lives.

I've always wanted to show women in a potent way as active people, not as passive people to be looked at. That idea of being looked at versus being the observer, that power relationship, has always run through my work.

Would you describe yourself as a powerful woman?

It's not something I've thought about. I often feel shocked, when I'm photographed in front of my paintings, by how small I am in relation to them. When I'm making them, they seem to be the size they should naturally be.

I definitely exist in a time period when women have an ability to be taken seriously. I don't want to take that opportunity lightly.

Do you always work from photographs, or do you have sitters as well?

I worked from life when I was younger. I started using photographs when I got frustrated when someone didn't turn up. And it's very difficult to paint yourself naked! With photography I am able to pin a body down in a position it couldn't hold for very long in life. That gives me the scaffolding of an immediate moment.

I'm not a portrait painter or a painter of life, trying to bring out something of a sitter's personality. With a lot of the work I've done, I didn't even know the person. I like that personal/impersonal relationship.

How do ideas come to you?

It tends to be the case that I have a few ideas roaming around inside my head. When they come together, three or four of them, it tends to make a piece of work. Then I have other work that is just instinctive. Sometimes they can be better, the ones I've least planned. But most of it comes out of previous work.

Working in Palermo, I got very interested in the history of civilisation. The history of architecture is this big mutant body. Sicily's been invaded by so many people and they've all left their marks, scars on everything from food to architecture. I used to look at all this architecture and think of the hybridity of it. We think pluralism and hybridity are modern phenomena, but they're absolutely ancient.

Recently I started looking at ancient texts and I found the Pythagorean Theorem translated by a Persian scholar of the twelfth century called al-Tusi. Arab culture had preserved all this information after the destruction of the Library of Alexandria. I started projecting this text onto a pregnant woman's stomach, and it became this carrier of history.

You get free passage if you're lucky enough to make a living from being an artist. I can look at anything. I can look at ancient texts; I can look at medieval mosaics, from scientific stuff to surgery. I can live anywhere in the world and make my work. I find that an incredible privilege.

What took you to Palermo?

I'd done a show in New York, which was a lot of pressure for two or three years. A friend said, 'I've got a house on an island between Sicily and Africa.' I went there to recuperate for a week or so and ended up with an architect on a bus to Palermo. I felt completely connected to the place. He happened to know of an old palazzo that was for sale; it was the price to build a shed in London. So I went there and started doing a few drawings.

Now I don't go so much; my kids are at school. There are good and bad sides to working in Sicily. It's very difficult to get work out; it's hard to get materials. You never know when the electricity is going to come back on. I love the romance of working in a place like that. And all the stories: Caravaggio made a famous Nativity painting there. It suited me. I lived very minimally:

no materialistic things, only my work. I enjoyed being able to work outside of an art world. I found that I had much more of a connection to history than just being a contemporary artist who wants to be doing what everybody's doing right now. Exile is the only way.

You describe yourself as British, yet you've delved into the innards of dead animals in Palermo and worked with plastic surgeons in New York.

I'm British in the sense that I was brought up with Bacon, Freud, that greyness. I'm used to the low sky and the low light. In Palermo, there was a clear sky every day. For a Neapolitan that's nothing, but for me! But I'm also very attracted to that grey light in which flesh and shadows are lemony yellow and grey.

Were you formed as an artist more by nature or by nurture?

I didn't think, What should I do with my life? It's just what I've been. It felt so fundamental to who I was from a very young age. I'm grateful to my uncle, who went to art school and then became an art historian. He guided me quite a bit when I was younger. He took me to Venice; he showed me fantastic paintings; he got me to watch how nature mutates through the seasons. It was an incredible gift.

You never considered a medium other than painting?

I've done some sculpture and photography, but I feel absolutely myself with a paintbrush and paint. I like drawing, but painting … It's like someone who says, 'I like to drink wine.' It's very much your whole life.

I want to try oil painting in order to get to a certain level. I know it's going to take my entire life. My aim is to make painting have contemporary relevance by using the figure, which is not an easy thing to do. Painting is great in that it can't be anything else. I used to get frustrated by that when I was younger; now I think it's painting's power. Because when you have a photograph, it can exist in many areas of the world, whereas if you want to see a painting, you have to take time out of your life to look at *that painting*. I find the unique surface quite powerful.

I'm almost religious about painting in the sense that I believe in it. When I'm in my studio, especially at night, I do sessions of painting. If it goes terribly badly, I have to pull it back. And all of a sudden it takes on a sort of life. That is the pinnacle of experience.

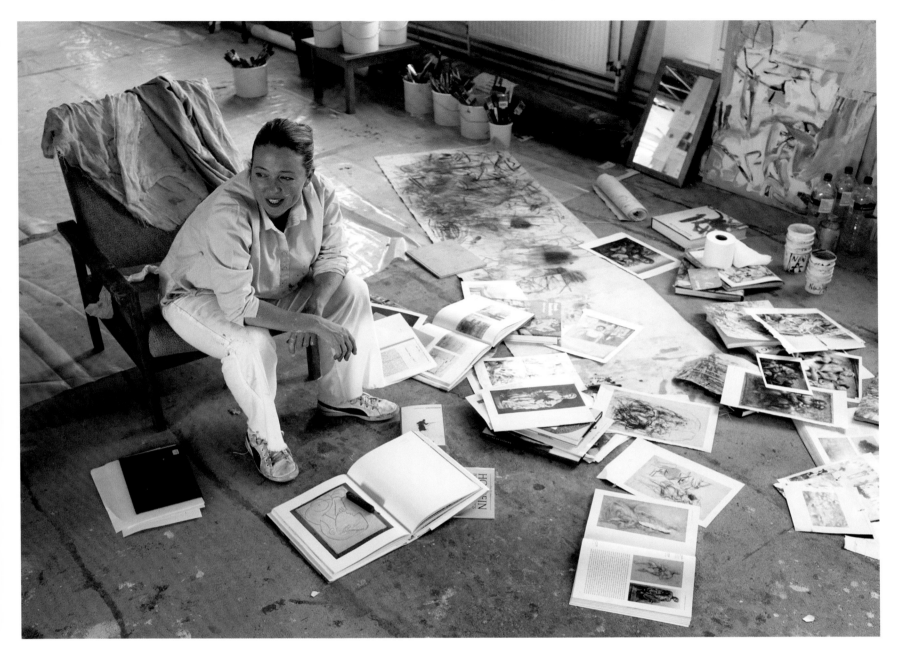

How long do the paintings usually take?

It depends. The longest took two and a half years. I produce about ten pieces of work a year, but not all paintings.

Do you feel a particular allegiance to American modernism?

It was the last great movement in painting. I'm able to steal from De Kooning and people like that. You can't steal from Bacon, to be honest; you just can't touch him. The same goes for Giacometti. De Kooning did something really special because he made painting that was abstract but which felt completely bodily and not decorative. That's no mean feat in painting. I always get excited in front of a De Kooning; I always want to go to the studio.

What is Jenny Saville looking for?

I would like to be as acute as I possibly can be, and precise about the ambiguity of being human.

Jenny Saville (previous spread) admiring marble sculptures at the British Museum, London, in mid-May 2011. The life-size statue of Iris, goddess of the rainbow, from the west pediment of the Parthenon in Athens, is of particular interest to the artist.

Saville with reference materials (above) strewn across the floor of her Oxford studio, photographed in early October. She also has a huge studio in Palermo, where she lived for many years. 'A studio changes depending on what you need at a particular time,' she says. 'It can be a laboratory of ideas; it can be a safe haven; it can be somewhere you don't want to go because the work's not going right. If I'm not in the studio, I feel a magnetic pull back to it.'

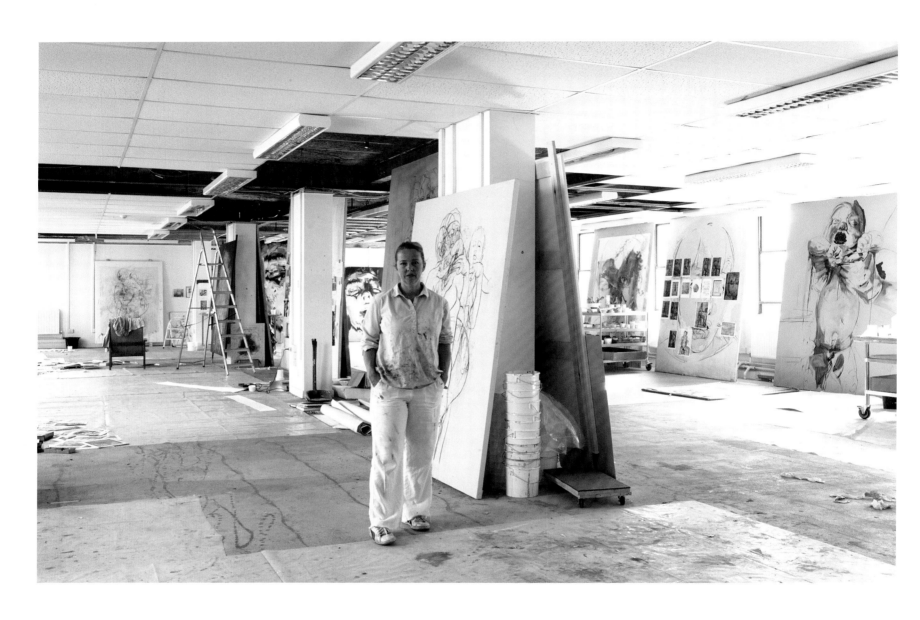

Saville (above) at the Bodleian Library, Oxford, one of her favourite buildings in the university city, and the place where she goes to work, think and research. 'I'm almost religious about painting in the sense that I believe in it,' she explains. Saville tends to work on canvases (left) several times her own size. Her busy mind is reflected in her busy studio, where finished work competes with half-finished canvases, life studies and drawings.

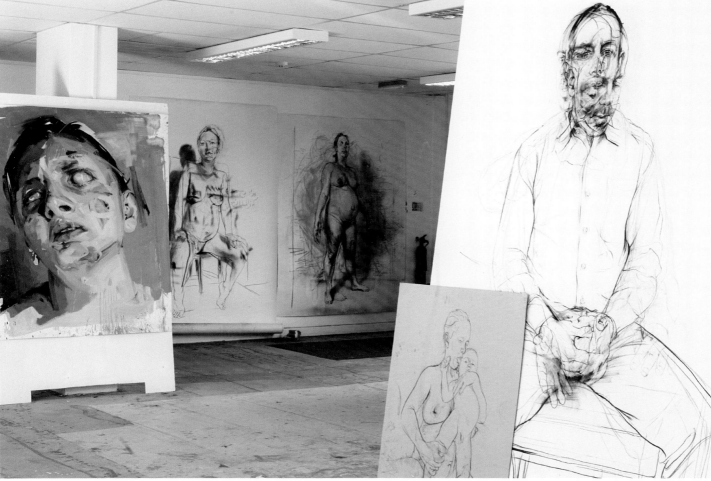

Saville is deeply interested in bodies in transformation; bodies that have endured beatings or undergone plastic surgery are of particular interest because of her work in support of battered women. She spent months with a plastic surgeon in New York to see at first hand the transformation that can be (cruelly or otherwise) engineered on the human body.

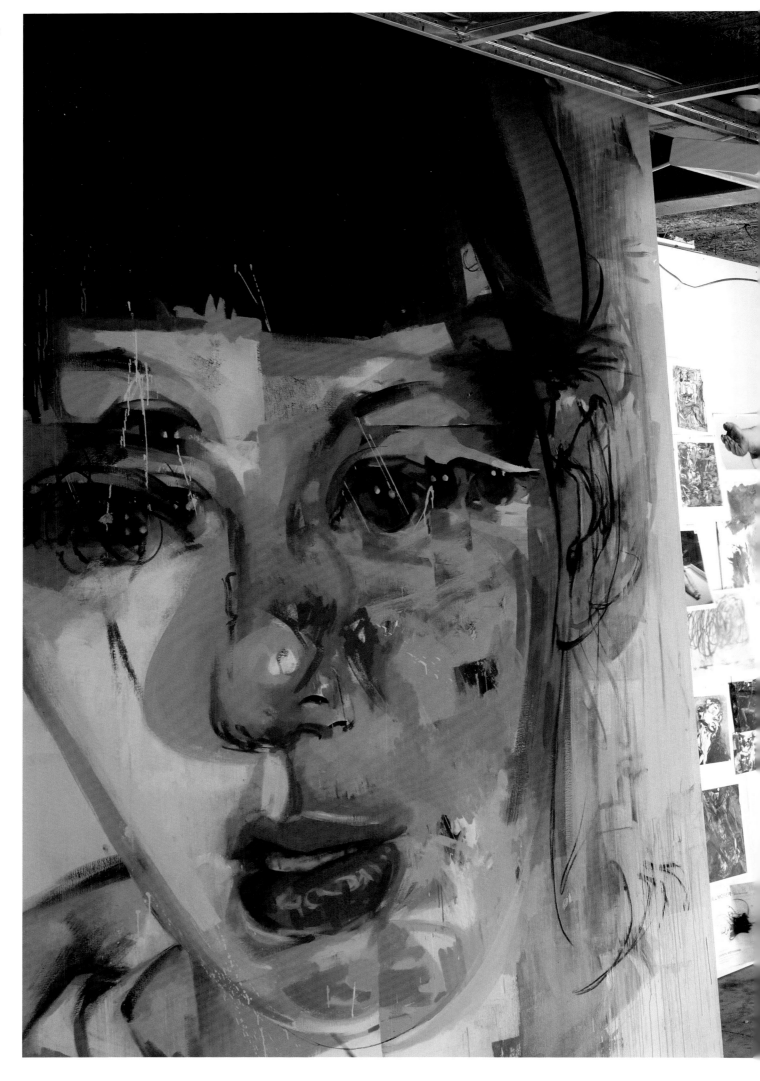

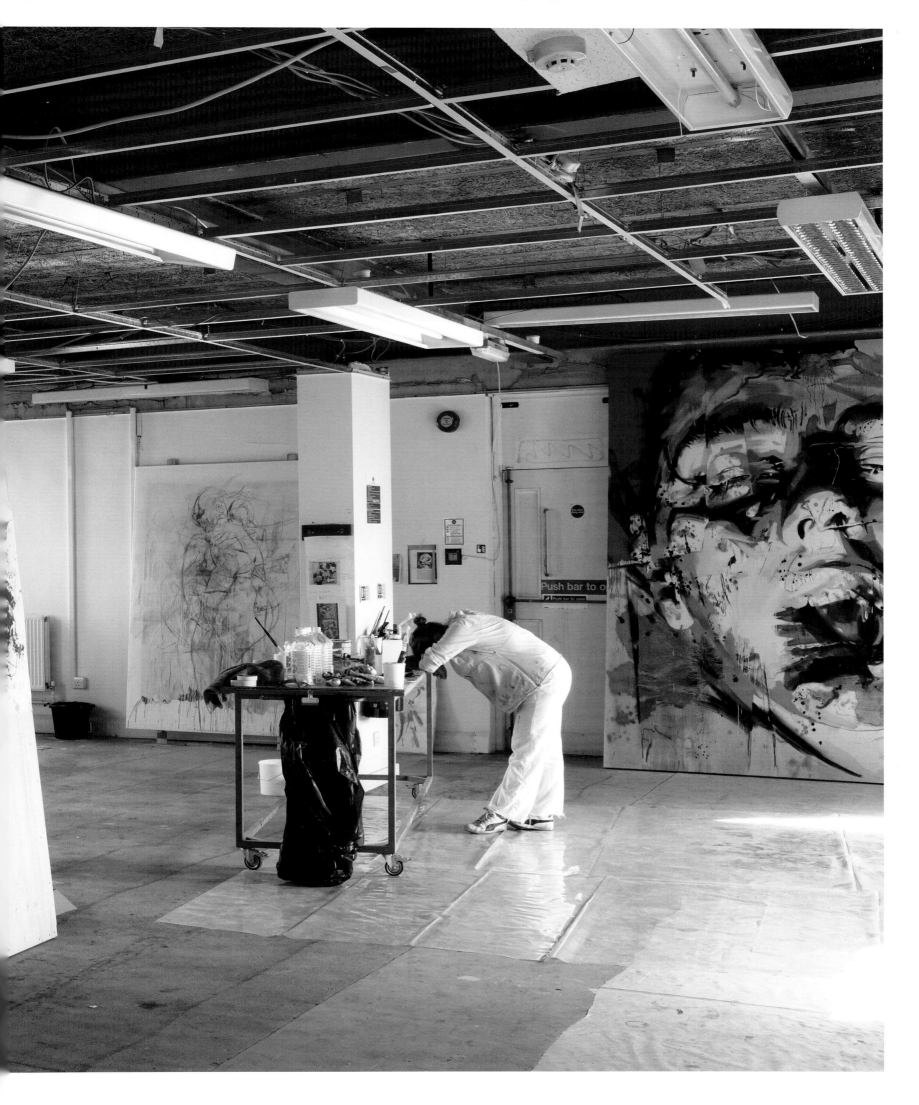

Rachel Whiteread

How much does good health have to do with making good art?

Good mental health is useful, but complicated mental health is also good for the creative process. As an artist you often have to delve deep, and often delving deep is a bit uncomfortable.

So the stereotype of the mad artist is qualified by the necessity to dig deep, or erupt?

Maybe 'erupt' is the better way of putting it. You have to be in touch with your dark side; otherwise you'd just be making pretty watercolours.

Have there been periods in your life when you have been terrified of not making art or making bad art?

That hasn't happened in a while, actually. But there are periods when you get stuck. I had a freezing-cold studio in the middle of nowhere, which was very difficult, because you would go there and you couldn't be comfortable; you could only be there and work. Now I am very fortunate. I make my living as an artist, I'm in a great studio, I am very comfortable, and if I can't work, I do something else. But I can still be in my working environment, which is helpful, because it's like you have this itch and you have to keep scratching it until it feels better.

You've spoken of your methodology, which involves repeating things …

Yes. I work in series, and sometimes I go back to things again and again and again through drawing or by making sculptures. But every time something different happens.

So when you had a freezing studio, you had to just get on with it. Was that a necessary step on the ladder of success?

Yes. I lived in a tiny council flat at the time. I'd make drawings on the kitchen table when it was cold, and when it was warm I'd make drawings in the studio. I also had to do other things to earn money. Life was much more fractured; the creative process was much more fractured. As you get older, as you are more experienced, you develop your own art language. I draw on that all the time.

How old were you when you figured out what you were doing?

It was the year after post-grad, so I was maybe twenty-three.

You won the Turner Prize in 1993, the first woman to do so.

By the time I won the Turner Prize I had been working, exploring ideas, for over a decade. I had made *Ghost*, *House* and a number of smaller-scale works. *Ghost*, made in 1990, was a 'eureka' moment for me. I'd say that it influenced my work from then up to the present day. It was made off-site in a building in Archway Road, North London, and then relocated to my studio. *Ghost* was an ambitious and complicated work to make for a penniless, unknown artist. *House* came about two years later and brought me to international attention.

How did you find the money? Did you have to knock on doors?

Well, at the time I was completely unknown. I got a grant from London Arts and another from the Elephant Trust.

How have money and success affected your art?

They've enabled me to make pieces I've wanted to make without worrying. They've enabled me to have other people help me make things; that makes a big difference. A lot of the work I did in the beginning when I didn't have any assistants was based on my size. The casting was based on how much I could physically manage. It helps to have a great studio, a great house, to feel comfortable, to get on with it. I am not very good at being flamboyant with money. It is just there, and it is a useful tool.

But flamboyance seems to be the flavour of the day in the art world. Is that really about art, or is it about theatre?

Occasionally it works extremely well. Jeff Koons's *Puppy* was extremely flamboyant and wonderful. My version of that is a shed, or rather a boathouse, which I made in the middle of nowhere in Norway, hidden away and very quiet.

Rachel Whiteread in Rome for her exhibition *Looking On*, photographed at the Galleria Lorcan O'Neill in late September 2011.

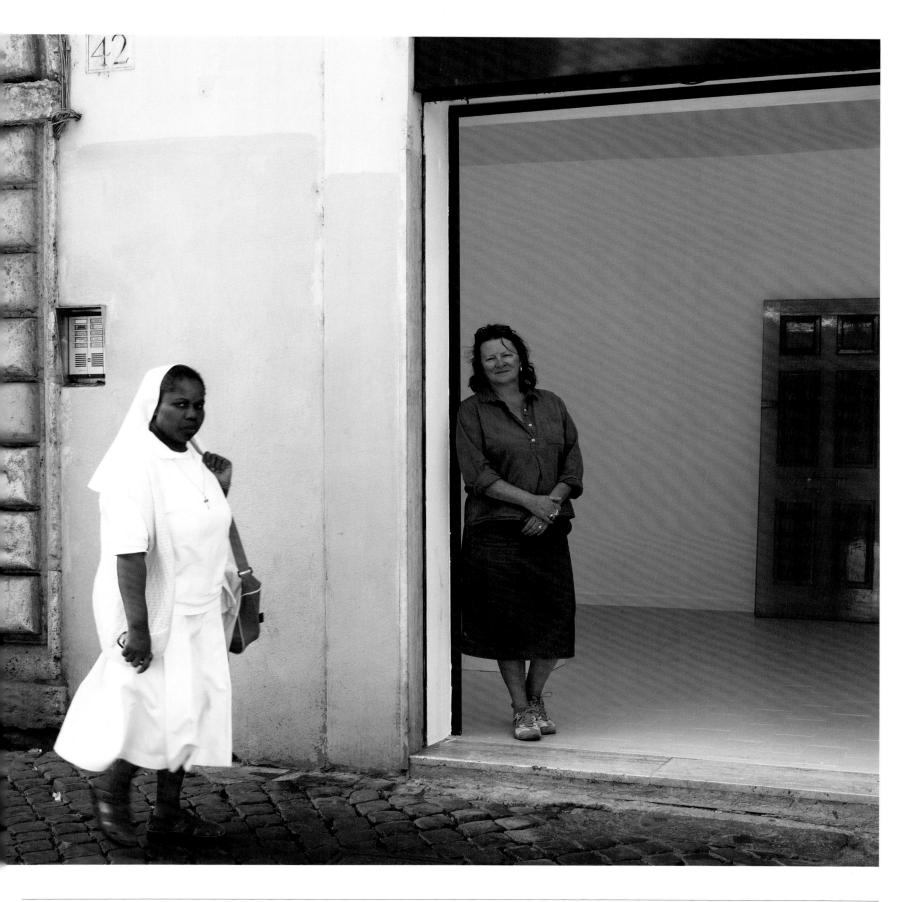

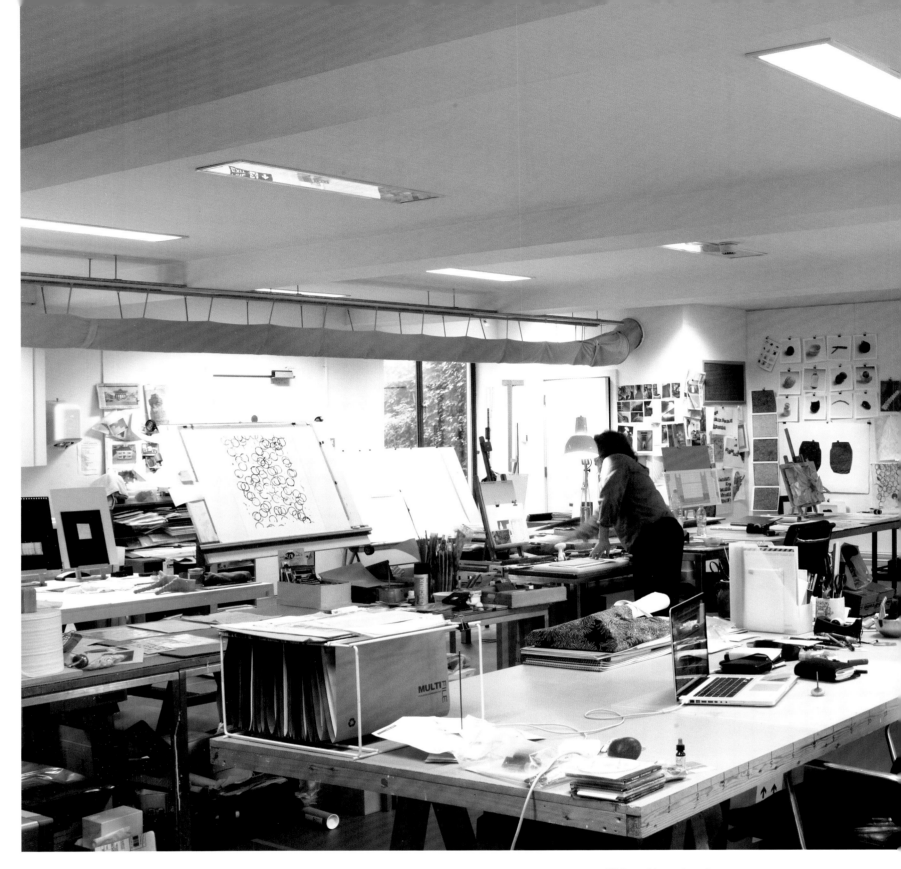

Whiteread busy at work. The print displayed on the easel was commissioned for the London 2012 Olympics. Colour drawings and the odd artwork add contrast and relief to this cluttered tableau.

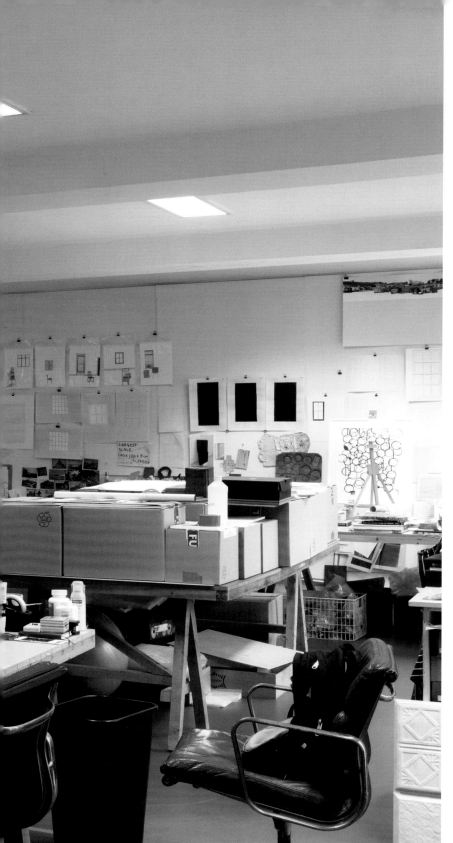

So are you communicating with nature or a higher force? Is there no public audience?

There is a small public audience. The boathouse is not going to get articles written about it. It isn't flashy. I have this idea that I am currently working on, casting small derelict buildings in all kinds of locations. I'm considering sites in California and the UK.

A little like mausoleums?

I would say that the connection is to someone like Smithson, to going out to see *Lightning Field* or all those fantastic sculptures in the middle of nowhere. It is about the journey as well, about the time it takes, about the experience, about slow art.

Has the YBA label been hard to live up to?

Well, we are all pretty old now! It was a label a lot of people found useful. I didn't particularly, and I didn't play with it very much. I suppose it became a market-able product. I did what everybody else did, but I didn't quite do it so loudly.

Have you reached a plateau with your art, or do you expect to go on refining until you move on to the ultimate refinery?

I hope it will be a while before I go to the ultimate refinery! Occasionally a little smile comes across my face and I think, Ah, I can do that. For instance, with the pieces that I am trying to make in the middle of nowhere, not going to a gallery but trying to find really quiet places and work like that.

Whiteread in the back
streets of Rome (above)
and on the roof terrace
of her Shoreditch studio
overlooking London's East
End. She describes her
view as her 'sketchbook':
'It's like you have this
itch and you have to keep
scratching it until it feels
better.' Whiteread often uses
photographs (opposite) to
explore space and prepare
ideas in the solace of
her studio.

We've alluded to pilgrimage. Is art replacing religion?

Art is never going to be a religion. I don't think people want that. I think people want a god.

You get more attendance at Tate Modern than you do in the entire worshipping community in London.

Tate Modern is a wonderful museum. Art has become extremely popular. It's on a cultural high. This can be a little frustrating if you want to have a quiet museum experience.

I used to go to museums when I was a student to pick up girls. Now I go to galleries to look at people looking at art. What is that about? Meditation? Mediation?

It is a kind of mindfulness. People can also be very pretentious and pretend that they are looking when in fact they're thinking about their shopping. People like to pose – but looking at great art can stop you in your tracks and make you think about nothing else.

Is your art meditative in some respects?

It is quite confrontational, I suppose. *House* was a perfect example. I made something, it stood on the street, and people became enthused by it, liked it, hated it, loved it, thought it was fantastic, terrible, thought that anyone could do it, thought that a child could do it ... The reactions of people and the way they talked about it were the complete opposites of one another. I thought I was making the equivalent of *Ghost* but bigger. It didn't occur to me that it being on the street would cause such a row, that it would have a different audience and a different reaction. But yes, to answer your question: Much of my work could be considered meditative or contemplative.

How old were you when you had your first studio?

I was probably about twenty-two. The first studio had no windows – and it had friendly mice. I just let them get on with it.

Can you describe your production process within the studio?

I make a lot of things off-site now. I make a lot of drawings here. I'm working more often with computers to plan complicated sculptures. The big mess is made somewhere else. I also have a very hands-on approach and make smaller works in the studio.

How many engineers worked on *House*?

One. For one of my current projects there are hundreds of drawings, and some engineering company is working on it. Some of the large-scale pieces are exercises as much in engineering as in sculpture.

Do you have any desire to be memorialised as a great British artist?

I'd rather be seen as a great artist. But I am not in the game of trying to have my work everywhere.

It's been said that your work gives materiality to 'sometimes unfamiliar spaces of familiar life, bath, sink, mattress or chair ... Transforming the domestic into public, it fossilises ordinary objects in the absence of human usage ... It allows the objects to stand anthropomorphically for human beings themselves'. Is art then a metaphor for modern humanity?

I made a piece of work many, many years ago ... it was a mattress cast in orange rubber. Eventually I propped it up against the wall. It is the most anthropomorphic sculpture I've ever made. It looked like a homeless person slumped against the wall, tired, forgotten and in need of a helping hand.

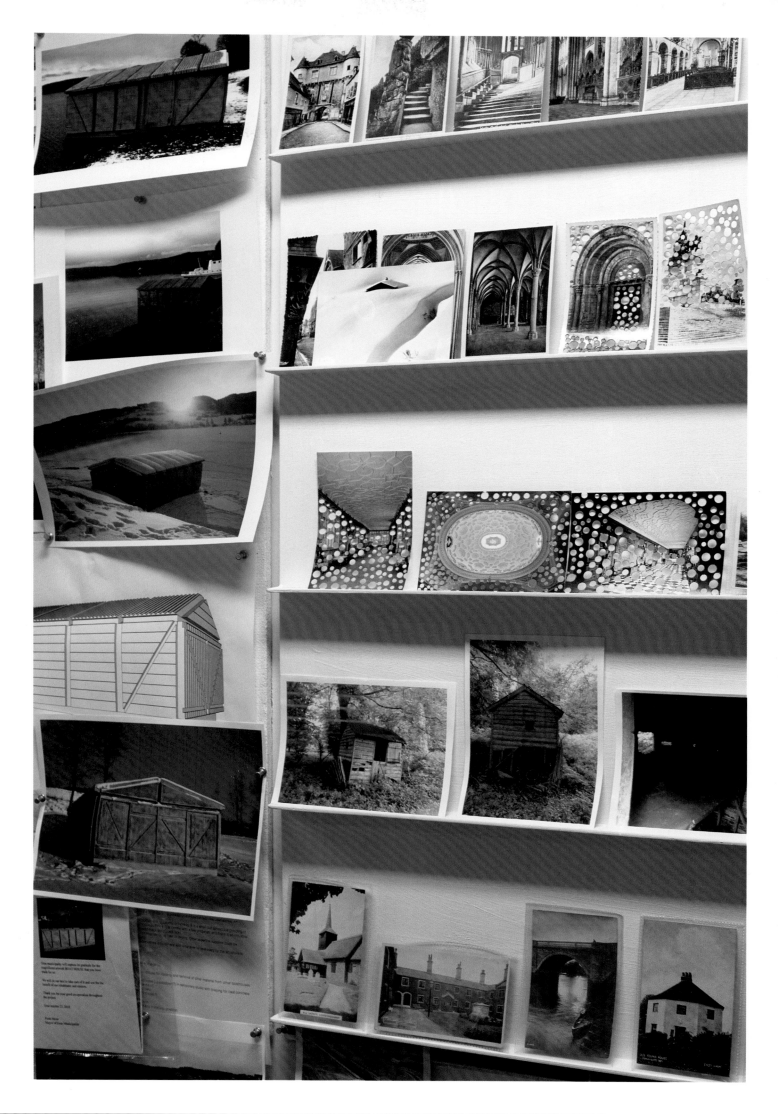

Whiteread is known for using dental plaster to cast private and domestic spaces. *House*, a concrete cast of the interior of a Victorian terraced house, was derided by some and heralded by others as the best piece of public art ever created by a British artist (winning the Turner Prize in 1993). *House* was ultimately destroyed.

Frank Auerbach

Is, or was, God an artist?
I've never for one moment believed that there was such a thing as God in the sense of a figure controlling everything. I think that life is a sort of artist … or not an artist, but it's so incredibly inventive under the pressure of millions of years of time that we're presented with the extraordinary gift of a million-petalled flower that we can never get enough of.

I do believe in luck, and that people who don't believe in luck and fortune and charm are in a sense irreligious. Sometimes people suggest that everything can be organised and logical – and it can't be. There's something out there that's bigger than anything we can understand. I think that's my answer.

It seems to me that, especially in cities, religion is being replaced by art.
It is for some people. But I'll tell you a secret: for artists it always has been. When they asked Matisse whether he believed in God, he said, 'Well, I do when I'm painting.'

Every painter will tell you that sometimes something seems to take over and make them do things. Matisse also said – and he never said a stupid thing – 'I do what painting wants me to do.' So in a sense there's something bigger than art.

And what does your art want you to do?
In the sort of painting I do, there is a permanent and insoluble problem, and every time it's solved it becomes a formula. Then you have to find a new way of doing things. The problem is that it is impossible to make compatibility between the three-dimensional object that has a particular expression, like a portrait has, and a flat presence like a flag. To get these things together in the same image is impossible. People try and find three-dimensional perspective; they find Cubism. Every time they find a formula, it becomes dead and stale.

Art has persisted for hundreds of thousands of years. Survival comes first; animal ingenuity has mostly to do with survival. Art after all goes slightly beyond survival. It goes to understanding. When we stopped having to use every ounce of our energy to survive, we began to have to entertain ourselves. We began to make art.

Is there a moral dimension to this higher calling, this urge that humans have for artistic expression?
There is. To see great art reminds one of what matters. In some ways it cuts away the trivia of life. For artists, it's walking a tightrope. The artists I admire are the ones who have this inner core of integrity – they're the ones we remember – and who do the things that seem to them, and to no-one else, to be right. They never deviate from that path. My friend Lucian Freud said that never once in his life (which was fraught, often in danger from debt) did he ever let a painting go for the sake of money. I don't think I have either. There's something that goes deeper than utility.

Did modern artists – Warhol, for example – not put themselves out there to make money? Is their art valid or invalid because of that?
We're all different; I'm reluctant to comment on my colleagues. There's something fairly brilliant in the move that Warhol made to engage with the world that had been secretly lurking under the art world for centuries. When Warhol started replicating pictures in enormous numbers, starting what he called a factory to make art, he caught on to something embarrassing that hadn't been mentioned before. It would be impossible now to think of art without it, but it's not my way because of my particular history. What matters to me more than anything is the individual experience rather than the public one.

Would you call this quest an obsession?
It seems to be an obsession. When I stray from it, I feel I'm not myself.

You work fourteen or eighteen hours a day sometimes, don't you?
Yes, but I don't do anything else. I work seven days and five evenings a week. I lie down a little more these days.

Apart from lying down, are there other things that attract your interest or engage your mind?
I've read all my life and I love poetry. I used to be interested in film. I never watched television until the last twenty years or so, when I've become an insomniac.

You're known to be a recluse. Are you completely disconnected from real life out on the street?
I don't think so. After fifty-seven years in Camden Town I've become a local character. Lots of people say hello to me on the street. But, apart from my wife, my son and my sitters, I see very few people indeed.

Is that a matter of choice?
It's a matter of time, as all too many of my friends have died. I used to go to Soho, and then the energy ran out. I found I didn't need it any more. I found it more interesting to be in the studio with a brush in my hand.

Are you interested in the work of younger contemporary artists?
I find them of interest and I wish them well – and I can sympathise with their impatience with oil painting and gold frames hung in galleries because I felt a little impatience myself and dealt with it in my own way. But I wouldn't dream of passing judgement on them.

Do you believe you have been privileged by being given this gift of art?
I didn't think it was a gift. My history makes me feel privileged in the sense that I am doing something that I love.

Is it true that you destroy a good number of your paintings?
I often destroy them in the sense of scraping them off; that's my way of working. Somebody comes and sits for me and then I turn the painting to the wall. If I look at it three or four days later and it isn't good enough, I take the paint off so that I can start again on a manageable surface. When I was young, I would let the paint pile up notoriously.

I believe that you've bought back some of your paintings?
I've done it once or twice.

To keep them, or …
To destroy them.

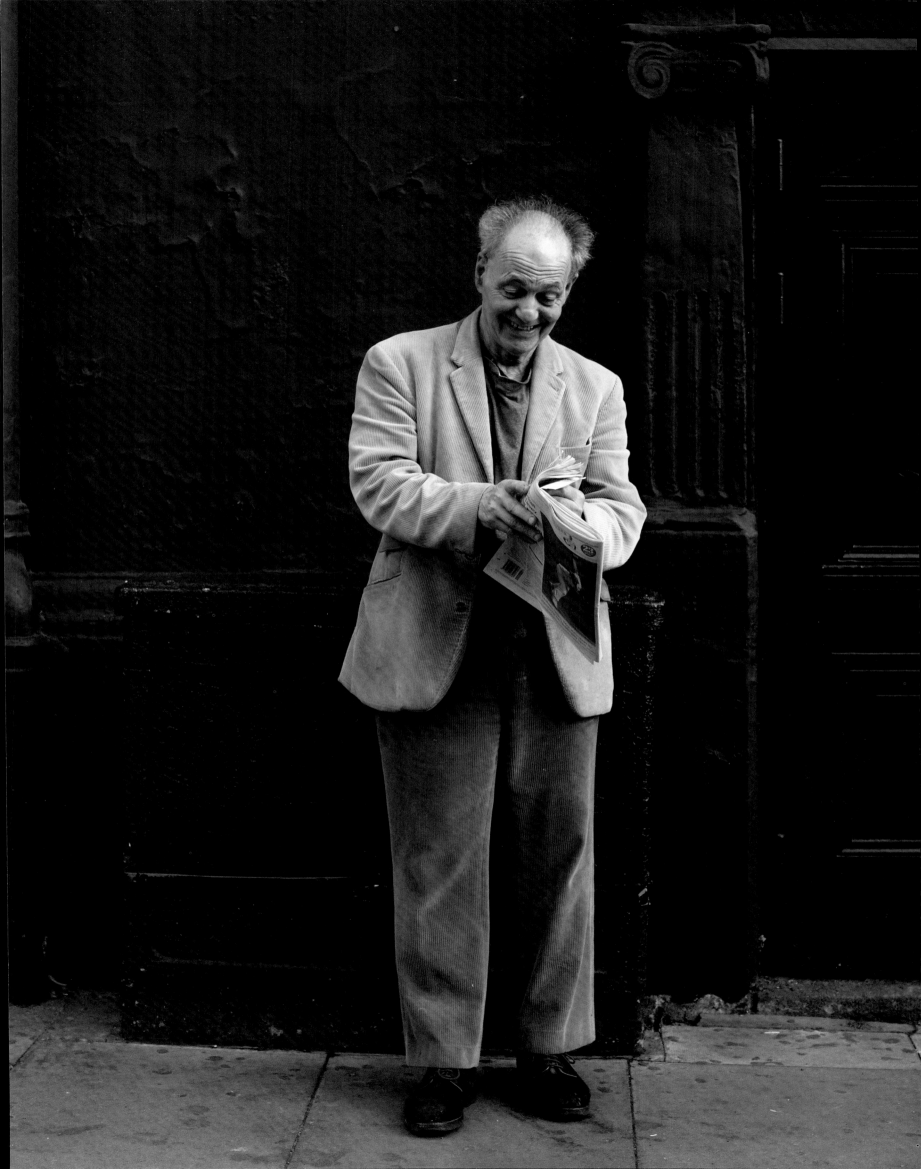

How did that feel?

I never talk about it … it's an impulse of the moment. I wouldn't be able to do it now. When I did it, I was just happy to get rid of the pieces that annoyed me. I didn't think they were good enough.

It would seem that you have little interest in the commercial aspect of art …

Well, I've had an overwhelming interest for a very long time. I never had any money until I was in my fifties. I used to lie awake at night being afraid that I would run out of paint or that I would run out of space to work in. I never owned a place to work in. Now I own my studio.

Who is the best judge of a work of art, the viewer or the artist? Or is the market the final arbiter of value?

The best judges are people who, without any commercial interest at all, find that they have an overwhelming love for some sort of painting.

Do you respect the sort of personality who is hopelessly in love with art?

That is what creates taste: the people with the most intense attachment.

When did you move into your current studio?

I've had the same studio for years, but it didn't belong to me until I was in my fifties, when I was able to buy it. That did make me feel rather more secure.

And for how many years have you been here?

Since 1954 – you do the sums.

This is a one-room studio. Do you never get tired of working in a small space?

I'm quite happy. I do my washing-up and stuff, but I never get tired of the space. I don't like people visiting. The idea of anything going on except painting makes me feel really, really uncomfortable.

Is it a sanctuary, a refuge?

It's both of those things. It is where things happen.

Do you remember your first studio?

I had a room off the North End Road in Kensington, the first floor of a house. I did my first paintings there and totally messed up the room. I lived in a cave of paint. I had to fetch my water and pour it away again. It was a tiny room and I was obsessed – possessed in a way. Then I moved out and the landlord sued me. I tried to scrape the paint off the walls and cover it up, but they were absolutely outraged. The very nice people downstairs wouldn't tell them where I was and who I was, so I was saved.

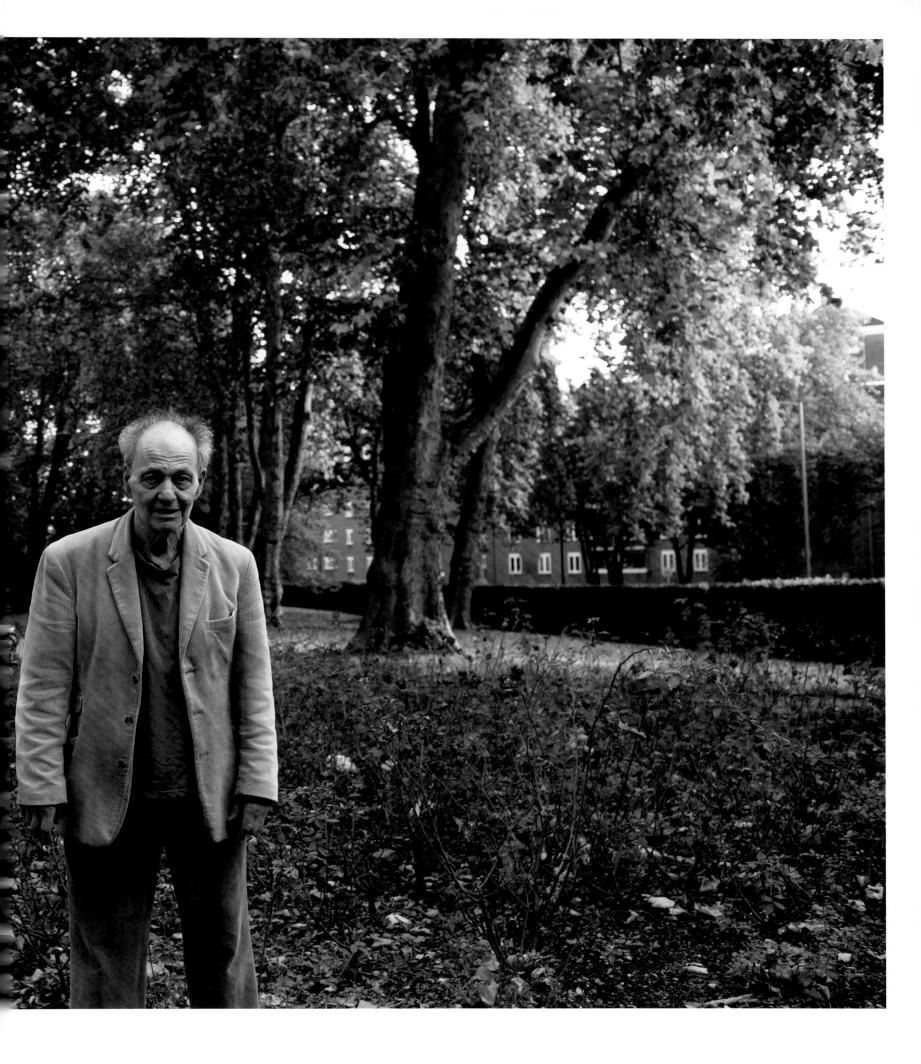

Auerbach (previous spread) has spent over fifty years in his Camden, London, studio, the Mornington Crescent landscape featuring in many of his paintings. These are the first official portraits of the great artist-recluse taken in many years. 'What matters to me more than anything,' he insists, 'is the individual experience rather than the public one.'

Auerbach (above) crossing the road in front of the Art Deco Carreras Cigarette Factory, October 2011. 'I'm frightened of everything – water, dogs, anything you can think of,' he says. 'The only risk I take is when I'm painting.'

Do you have any assistants?

No. I couldn't possibly work with anybody else except a sitter who is quiet and thinks their own thoughts.

Talking of sitters, you've had very few in the course of your career …

… and they've been marvellous. They're people I'm involved with. They all seem to me to be not only admirable but very busy people, and for all I know they may sometimes feel like it's a benefit to them to sit quietly for two hours. They come once a week at a certain time, fifty-two weeks a year.

Do you speak with them?

I didn't used to speak at all, but now I speak for twenty minutes towards the beginning. Then it's silent when I get really caught up.

For many writers there's always a dread of having to face their inability to write. Does a similar fear haunt artists?

Writers are lucky in the sense that they don't need a studio and gallons of paint to do it, but they're unlucky in the sense that a writer can use up their themes. For painters there is no definitive image. If there's something that's very important to them for making an image, it's absolutely valid to make another image of the same subject. It can be just as genuine, just as fresh.

Have you ever courted danger as a muse for your art?

I'm frightened of everything – water, dogs, anything you can think of. The only risk I take is when I'm painting.

Are there particular artists to whom you still look for inspiration?

There are many. I've lived with these people all my life – they are my friends – and if I started giving you a list there would be literally hundreds and hundreds.

You mentioned Lucian Freud. Did you criticise each other's work?

We knew each other very well for a long time. We never had a serious discussion on art, but these things happen by implication so are involuntary.

And he had one of the biggest collections of your work, didn't he?

He did have some of my pictures, yes.

Do you have any of his works?

I don't collect at all.

So the commercialism that has transformed the art world dramatically in the last few decades hasn't affected your lifestyle?

No, but I'm grateful for it. It's marvellous not to worry about money, absolutely marvellous, but I haven't done anything myself. I just let it happen.

Has your life been an important life?

I never think of it like that, but anybody who does art thinks they're doing something important. I'm still trying to do something that is in me somewhere.

(above)
Carreras Factory at Mornington Crescent, 1961
Oil on board
Private collection
© Frank Auerbach,
courtesy Marlborough
Fine Art, London

(left)
Mornington Crescent with the Statue of Walter Sickert's Father-in Law, 1966
Oil on board
Private collection
© Frank Auerbach,
courtesy Marlborough
Fine Art, London

Tracey Emin

Is it important for an artist to have a particular national identity?

Not for all artists, no. But it is important to have cultural identity.

Does that affect creativity?

I know it does, because when I am in France I make really different work. I think differently. I don't know whether it is because in France I have more peace and quiet? Recently I tried to make a series of paintings there and the colours were really lurid, so bright that even when I painted them over with white the green kept coming through. In London I would never do that. London is so frenetic and so crazy that I am more passive with colour, whereas in France everything is more peaceful. I am surrounded by nature and feel I can fire it up more.

So is the art that you produce in France more vivid?

No. It is about being lonely, about being alone.

Why did you end up in France?

I bought the house because I'm tired of being a guest of other people. I'd worked out that being a guest means that you have to be at their breakfast table, at their dinner table, at their lunch table, and I am too old to keep doing that. I need to have my own table.

When do you get up in the morning?

I usually wake up at about 6.00 or 7.00. Then I might listen to Radio 4 or watch BBC World News, otherwise I'd be completely cut off. I make myself breakfast and might have a swim. Usually I am thinking about writing something. So I lie in bed and think about words and then think, I've got to get a pen and paper and write all of that down! And I never do.

Are you more a writer or an artist?

It depends. Some people think they're artists and they've never made a piece of art in their lives. When I'm old I'll probably just write and draw pictures because I won't have the energy to keep it all going.

Where does your energy come from?

Mostly my energy is used talking, talking, talking, talking, talking, talking, talking and talking to different people and thinking about twenty different things at once. I find it really exhausting. I think I've had enough. My voice is even going.

Would you pack it in – making art, I mean?

No, because it's what I am.

And if nature were to take it away from you?

I'd be dead. I'd probably die. I'm with the arts like a lover. No matter how bad I am to it, it always comes back.

Is it very demanding?

Well, you wouldn't want to have a lover who is really lazy and boring and uninteresting.

Does being different mark an artist?

An artist has to be different because you have to be able to think existentially. You have to be able to see the world from outside to be able to create something.

From my reading of it, you have delved inside and then poured your life outside.

Yes. But now I am dealing with the future.

Does the future seem attractive to you?

It seems unattractive. The future seems darker than the past was.

How do you lighten up the day once you've gone into that dark place?

I don't. I don't want to lurk in the dark, but I understand that it is there.

You've described your childhood as 'living like a princess'. Has the princess label stuck in some sense?

You nearly fell off your chair when you heard that I could make my own breakfast! I am just particular about the way I like things. I am very clear with people.

Tracey Emin in her
Spitalfields, London, studio,
mid-October 2011.

Is that clarity reflected in your art?

I have clarity in my art because you can see immediately that it is mine. It doesn't matter what materials I work in, or how I do it, or what the subject matter is. I've created a language and that means there is clarity about it.

Is that language unique to you?

No. Many artists have used personal experience. Van Gogh painted what he witnessed, for example. I'm not saying that I've invented something. I am just saying that for each artist who uses a personal language, it is their own.

Is the theme of sexuality in your art a spur to your creative output or just an addendum?

It is another thing on the list. You have God, you have sexuality, you have home, you have emotions. The sex bit is maybe 30 per cent.

And God is how much?

About 25 per cent.

Would you describe yourself as a woman who needs a lot of love, or are you self-contained?

I am very self-contained, very independent.

The theme of children has come up often in your most recent interviews …

Yes. That's because I'm not going to have any.

And that bothers you?

It does bother me, but it bothers me more that no-one has ever wanted to have them with me. I've never met the right person. And now I don't think there will be anybody. Also, being creative and making so many things, there's not always been room to have children.

Would you call yourself a martyr to your art?

Yeah. I've lost out a lot because of it. But because it's like a pact, the art has given me so much that I haven't been able to enjoy the things that other people do.

Are you a great artist?

I don't know yet.

Would you be insulted to be called an intellectual?

No. I am an intellectual in the fact that I am an artist; I have an expanded intellect visually but not academically.

Hang on! You get up in the morning, you think about a couple of words, you put one line up in neon, and you sell it for £50,000 or £100,000!

It doesn't matter how much it sells for. It has to do with the fact that the sentence is in neon. I can justify it. I have the conviction and the courage to do that.

What kind of courage does it require to create a neon sentence?

Well, I don't know anyone else who is doing it.

Is it the courage of bolshiness, do you think, or is it intellectual courage and conviction?

I'll tell you what: a lot of people go to art school and then want to be artists. But after a few years they haven't got the determination or conviction to carry on, or they have much easier options to do something else. That never happened to me. I have only ever done one thing and that's art.

You have never faltered in your faith in your ability to produce art?

No. But last week when I was trying to make a series of paintings, I suffered terribly from it. Normally, with anything that I want to do, I push it and manage to do what I want. But last week I just couldn't, and that made me feel sick and terrible and ill.

You have massive attention being paid to you. Together with a few others, you practically created celebrity art.

No, I didn't. Andy Warhol did, Frida Kahlo did. In the nineteenth century you had people like Turner, many people who had a high profile. The Bloomsbury set were instantly recognisable. Art is celebrated in the UK. It's the zeitgeist, isn't it? Art now is the same as eating in good restaurants. Twenty years ago there weren't any good restaurants. Now London is becoming a food city the same as it is becoming a city for art. The zeitgeist of the nation is also to do with the fact that contemporary art is taught in schools now, and the contemporary artists whom they are teaching about are myself and Damien Hirst. That makes a big difference because it means that young kids can actually go, 'Wow, that's an artist, that's someone we see walking down the street, that's someone's exhibition we can go to!' It is not like you are teaching about art and it's someone in New York who lives 6,000 miles away and is twenty years older and who you haven't seen grow up.

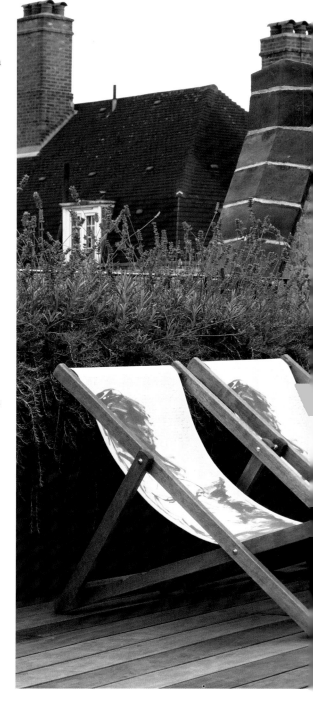

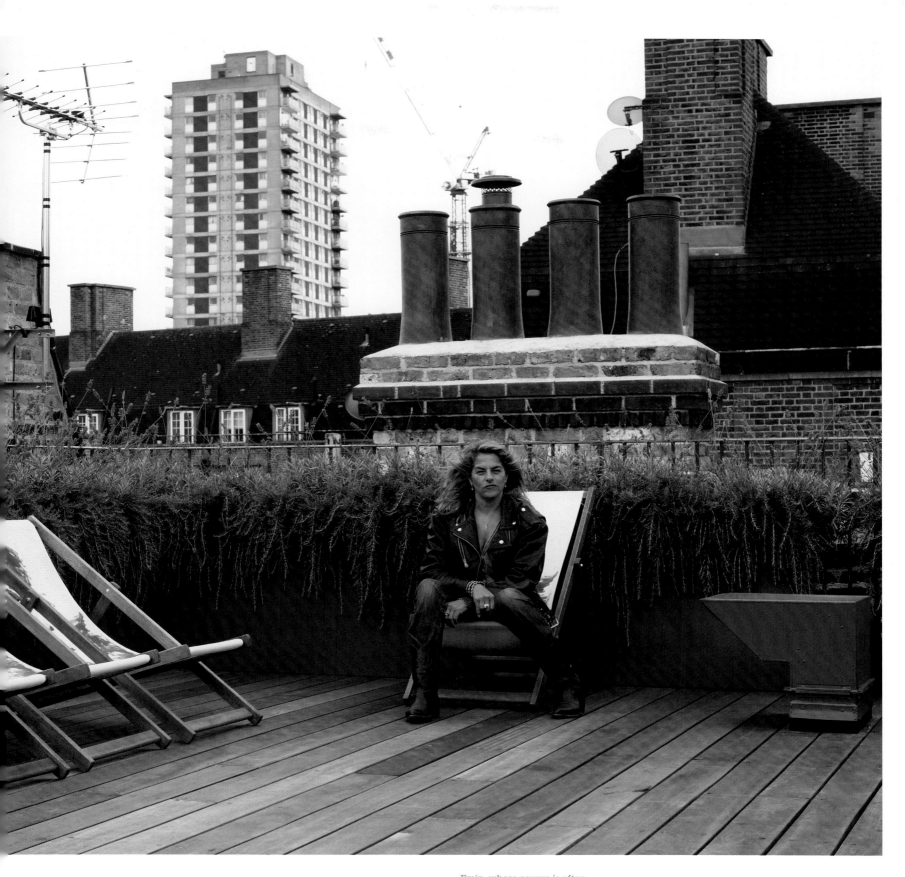

Emin, whose oeuvre is often autobiographical, highly narrative and sometimes humorous, works both in London and at her house in the South of France. She says she gets more inspired by colour in France. 'London is so frenetic and so crazy that I am more passive with colour.' Emin seated in one of her screen-printed deckchairs on the rooftop of her studio. The scent of Provençal lavender fills the space. The plants will eventually be recycled and dried to make potpourri.

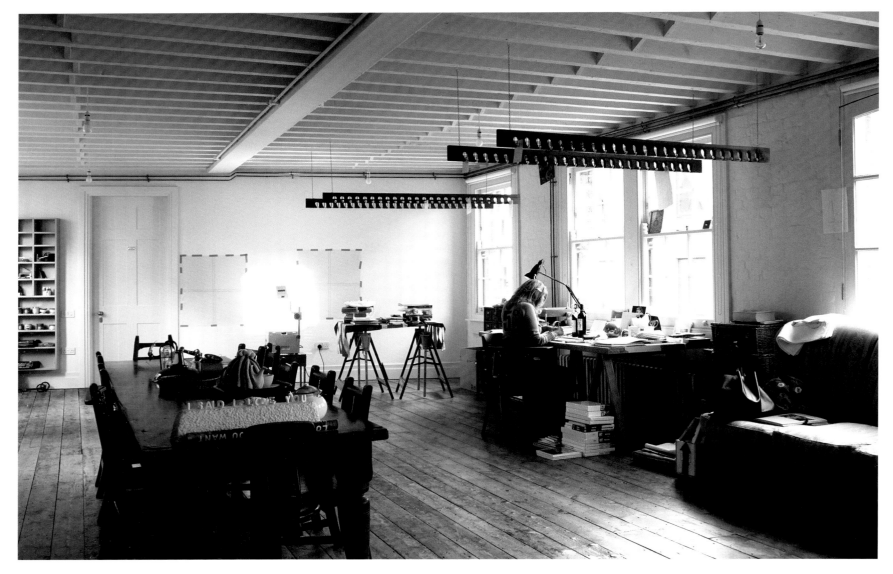

I am talking about economics. The money was there for art ...

No. The art was there first. Then people went and bought the art. You can't have the money and then people invent the art. It wouldn't be genuine art, then, would it? Tate Modern wasn't built and then they filled it with shit! It's like having a good wardrobe. You don't go out and have a really great wardrobe and then fill it full of crappy clothes, do you?

Is there a pull towards art as a replacement for religion these days?

Yes. Not just religion but somewhere to go, metaphorically or literally.

Do you go to galleries yourself?

Not as much as I should do. When I was younger, I'd get on my bike and travel around looking at exhibitions.

When you were a student, it was said that you wanted to make paintings to be hung in prisons, in courthouses and in hospitals, not in people's homes ...

I said I wanted my work to be hung in public places and guess what? It is! I get letters from people in prison, from people in the army, from people who are terminally ill. The Tate has a large room of my work. I'm in the school syllabus.

How does that make you feel?

I hope it shows other people what you can do. I haven't conquered all the odds, but I've definitely done well for someone who left school at thirteen.

Let's talk about critics. Does it hurt when ...

Yes, it does, especially when it is factually incorrect. They should check their facts before they attempt to be derogatory about me.

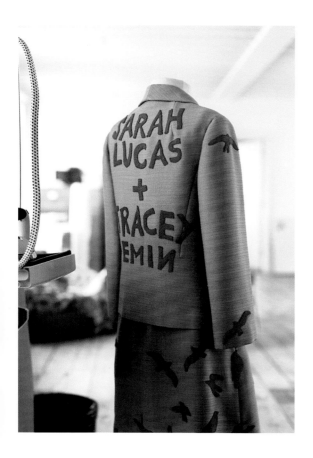

Emin and her close friend, fellow YBA artist Sarah Lucas, ran *The Shop* in Bethnal Green Road selling arty-facts for six months during 1992. Lucas was one of the names featured in Emin's famous *Everyone I Have Ever Slept With 1963–1995* (destroyed in the Momart warehouse fire). Emin's present studio was totally gutted and reconstructed from the shell of a Victorian building. Approximately 800 square metres, 500 of which she uses herself, it is a dream-come-true for the controversial artist. (following spread) Emin lost in her own shadows, the studio revealing bits of her character: organised yet random.

Do you remember your first studio?

Yes. It was when I left the Royal College of Art. It was £22 per week, a small classroom divided in half. I shared it with someone else.

And now you are sitting in this purpose-built building … How many square metres is it?

790 square metres.

Do you ever reflect on that little studio in Elephant and Castle?

No. What I think more about is my tiny, tiny, co-op flat at Waterloo, about how things have changed. That little flat kept me safe, actually. Without that little flat, I wouldn't be sitting here today, that's for sure.

Is the studio a sanctuary for you?

The studio is where I work. I would never work at home. France is a sanctuary too. But then sometimes just being on an aeroplane 35,000 feet in the air is a sanctuary, because no-one can get to you.

What will be your defining legacy?

The things I'll be remembered for are *My Bed* and *Tent*. If I die tomorrow, it will all be about *My Bed*, everywhere.

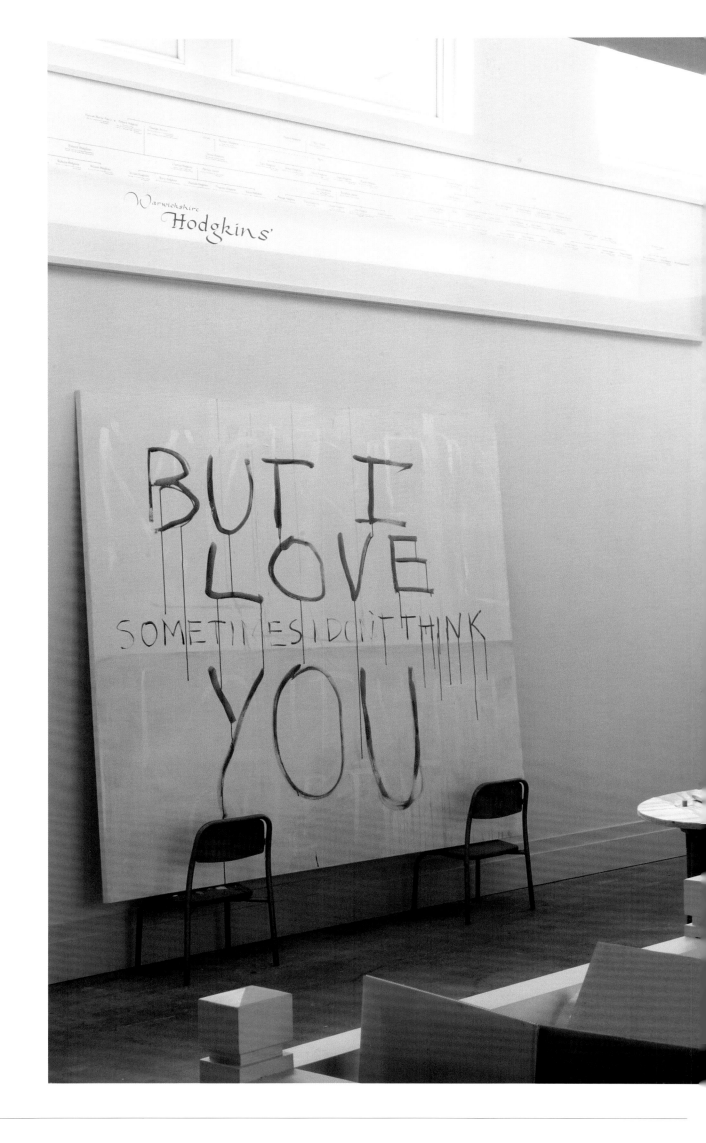

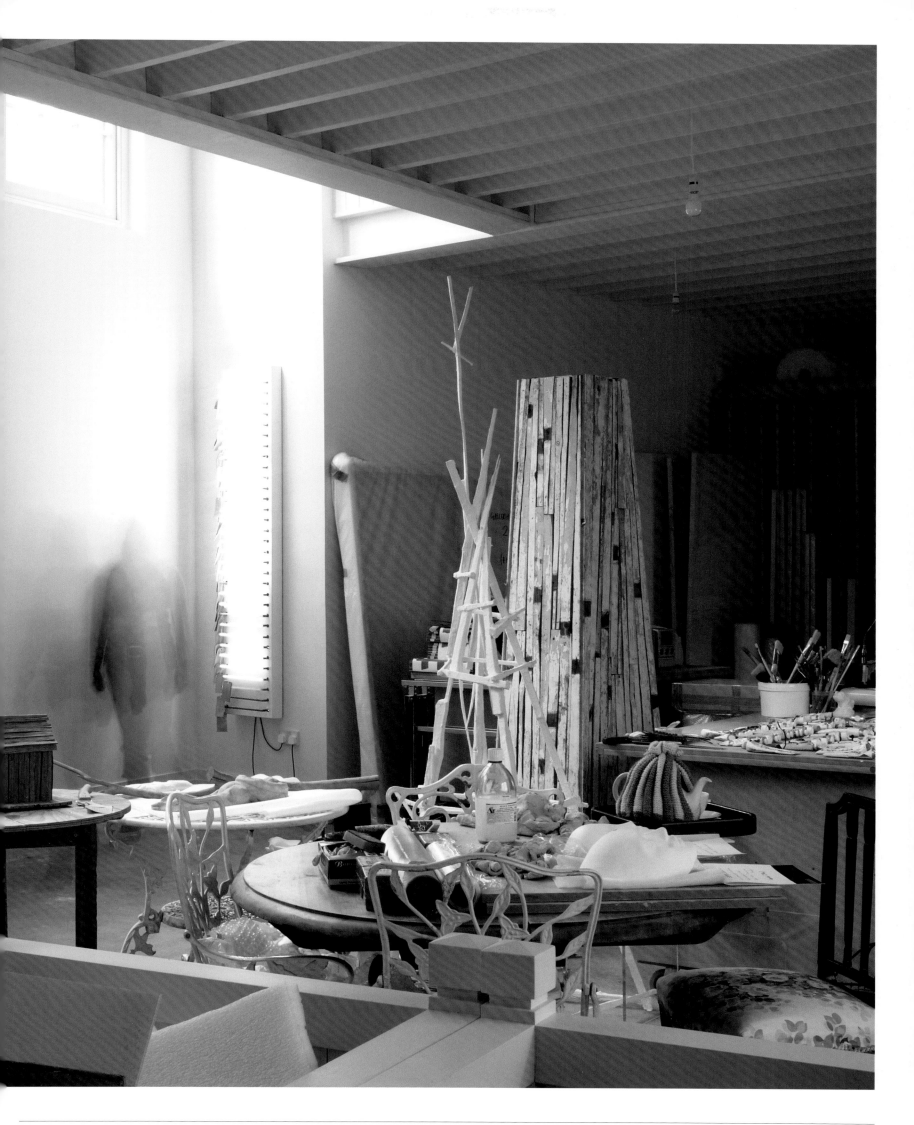

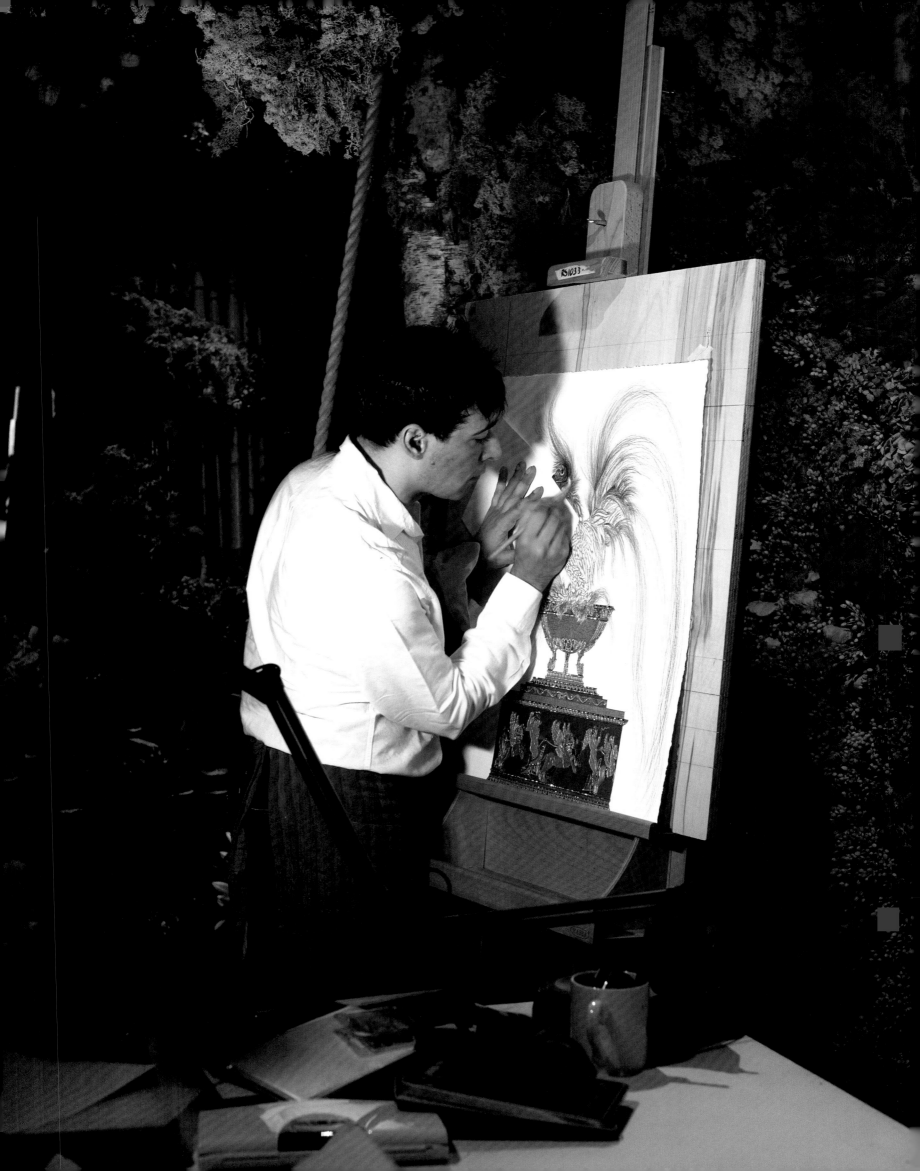

Raqib Shaw

What is the significance of art, in your opinion?
You have to *live* art. Art is not a product; it is not something that you make. It is a consequence of your way of painting your life. It is the extraction of your internal bits and your experiences, your time on earth. It is a nightingale singing. Why does a nightingale sing? To attract mates. Even if it's instinctive, if you're a bird you sing because that is the way you express yourself: song!

At what age did you start singing?
According to my ex-mother, it was when I was in her womb. She still tells me, 'I wish everyone had a son like you because you have always given me only pleasure.'

Why 'ex-mother'?
Because I don't do family and friends.

Then how do you survive?
Oh well, my darling, one has to transcend animal qualities. We are devotees. We worship aesthetics. That's all we do. Because it is *my* life only. Friends, family, someone has a child – give me a fucking break! Domestic, domestic! Let's do aesthetics! Let's do art! Let's do beauty! And you know what? It is the hardest thing in the world to do because you never get it right and you *suffer*! But that is the driving force. It's not money or society. Do we do society? Fuck society! What is society? We need money to do art, and we have lovely dealers who look after that. And that's where it ends.

But if the money wasn't there ...
I probably might ... Oh, my dear! I was a squatter in the East End for seven years. I got two bruised ribs because from 1998 to 2003 I slept on the cheapest sofa bed; that's all I could afford.

And yet four years later, in 2007, you sold a painting for $5.5 million!
That was only a secondary market drama. I don't give a shit about that.

But doesn't it hurt when you sell something for £5 and somebody makes £50,000 out of it?
No, because I believe that artworks have a life beyond. In a hundred years, 150 years, hopefully our art will survive. We leave something for humanity. We leave beauty, contemplation, thought, psychological engagement and – I really, really hope – inspiration for future generations of artists. I don't give a shit about what it's bought and sold for. That's trade.

Can you name an artist who has approached perfection?
I don't think so. That is why you make the next painting. Perfection is a concept; it's like nirvana. No-one reaches it. If you feel that you have made your best work, then you know what, sweetie? Fuck off!

Your process involves working in near-darkness. Do you not see the product until it's finished?
Sad that you call it a 'product', but that's what it becomes when it leaves the studio. While it is here, it is prayer, something that transcends, something that is beyond society. It's almost like philanthropy. You're making your life absolutely fucking crazy and shit and really working hard so that you can leave something for the next generation of young thinkers.

You live in Islington; you are about to move to a very large space; you are surrounded by phantasmagorical flower settings, by dark, hidden space divorced from reality. That is a purposeful act, isn't it?
The new place is a bigger version of this. You go in there and that's it. I need a bigger canvas because this canvas is so small. We have more works to do, and I need to justify myself to myself.

You know what? We never have black because I don't like black. So the accountant always tells me, 'Raqib, you're in the red.' And I say, 'You know what? Roses are red and violets are blue. It is true, I love you!' He's like, 'Raqib, do you know that you have no money? You have debts. Why?' And I go, 'Excuse me! I might be dead tomorrow, but one has to please the Goddess of Art.'

So is this a temple to art that you have built for yourself?
Is it not? And when the Goddess of Art is here, she tells me, 'Oh, that's amazing!' We have to wait, worship the Goddess of Art, and, when the Goddess descends, one becomes an instrument for the Goddess of Art.

In other words, a vessel for the transfer of creative ...
Abso-*lutely*, sir! I have come to the conclusion that my whole life was, is, orchestrated around getting these fucking pieces of wood and these fucking pieces of paper ready. Sir, what you are looking at is an atelier. It's not a fabrication studio. It takes two and a half years for the meanest of the mean to get up to scratch.

So what is the purpose of your studio? Is it a sanctuary, a hiding place?
No. I put my feelings in a bin bag inside a leaded wall. It's all about aesthetics.

How many assistants do you have, on average?
We do not talk about that.

At what time do you start work in the morning?
The last time I had a holiday was thirteen years ago. The last time I had sex was thirteen years ago. What time?! Does time exist?

You never wear a watch?
What is a watch?

No matter what, you never get it right. And that's the beauty of it. I call it 'the run'. My dear, the ladies do rather respect me because I'm the only fucking bitch who survives for forty-eight hours without food and still goes on without sleep. Just shower, change clothes, and I'm there. To do that, it can't be fashion, it can't be whim, it has to be your fucking DNA.

What about celebrity in the contemporary art world?
Oh fuck art! Who cares? I am so glad that I only have to deal with the contemporary art world once every two years, when I have a show. And that fucks me up. You know, three days and I'm dead! And people get really pissed off because I never answer their emails. I am not going to read them. Who cares?

Shaw's technique is painstaking and time-consuming. Drawings produced on tracing paper are transferred onto board, where every motif is outlined in embossed gold. He then applies fast-drying enamel and metallic industrial paints with a porcupine quill before adding beads and precious stones.

'My darling, one has to transcend animal qualities. We are devotees. We worship aesthetics. That's all we do.' Shaw at full throttle (above), laughing his signature laugh while hugging one of his assistants: 'I really feel that it's not about me. The work needs to be made, and everyone serves the work.'

You were a loner, by your own account, as a child?
Always.

And you've remained alone by choice?
I don't know what choice is. Maybe fate? I know it's an outdated idea, but I believe in fate. Perhaps it's like Brownian movement? But even in that disorder there is order.

Would fate have made you an accountant?
My mother wanted me to be a doctor. I went to medical school and it was the most horrific thing ever. I was drawing and painting, and my mother said, 'My God! How much paper do you consume in a night?' I really feel that it's not about me. The work needs to be made, and everyone serves the work. It's Proustian in a way, you know?

You were born in Calcutta; your family dealt in carpets, shawls, jewellery …
That's irrelevant, isn't it?

I want to find the sequence or the connectivity between the art and that initial experience …
My grandfather was a keeper of the Sufi shrine in Kashmir. His family actually built all those things. When I was a little kid, he said, 'Wherever you go, wherever you are, always remember that the Sufi saints of Kashmir are always going to be with you.' Years later, he was dying of cancer and I went to see him; he was on morphine and he had not spoken for three days. He said – ah, such a tragedy! –'Don't ever come back here. Go, because the mentality here is not going to suit your mentality. My only worry is – what a shame! – you will always have to carry an umbrella. It rains there [in England] all the time.'

My grandmother always used to tell me that her father worked in the administration of Kashmir. Nothing pleases her; she's a *grande dame*. When I was little, she said to me, 'May you write with a golden pen on paper made of silver.'

So you took that to heart?
No. I just think it's bizarre that that's exactly what I do!

It's been said that painting provides a means for you to channel your fantasies and create alternate universes. Do you prefer fantasy to reality?
Look around you! It's not a fantasy; it's a reality. Where does life end and art start?

Do you care about the critics?
I don't give a fuck!

Does it bother you if anybody says negative things about your work?
Absolutely not!

Do you think you are an easy person to work with?
I'm not an easy person to work with. The only people who are able to stick around are absolute motherfucker gold shit. One hundred per cent perfectionists. It's not easy.

Do you gain satisfaction when taking an art student and making them into something different?
We do not do 'art students'. We have absolutely fabulous MA professionals who want to come to the studio and learn. We train the best of the best, of course. That resonates, according to Norman Rosenthal, back to the real, proper, internal essence of an atelier. People here don't come to work; they come to assist me in creating art for eternity.

How long does it take you to finish a piece?
Some take two years, some take three years, some take seven years, some take eight years. You have to make studies and go back to them, you know?

My whole life is *Paradise Lost*. The first chapter is in White Cube, and the second chapter is going to be at Space Gallery. We are looking at a 3-metre-by-40-metre painting. It is going to be a chronology of the way I have experienced life. So I'm making paintings for myself. I'm not making them for others, because they're always fighting! Give me a fucking break!

What inspires you the most?
A broken heart. It's like a piece of porcelain; it can never be sutured again. And realising that things can be broken and that there is beauty in broken things.

Are you a martyr to your art?
No, that's too … I'm just a boy from Kashmir trying to make work.

(following spread) **Shaw in his very own Garden of Earthly Delights, which is made up of mirrors, fabrics, artificial rock, birds and butterflies, and thousands of flowers that bloom and decay according to the particular season. 'Perfection is a concept; it's like nirvana,' the artist declares. 'No-one reaches it. If you feel that you have made your best work, then you know what, sweetie? Fuck off!'**

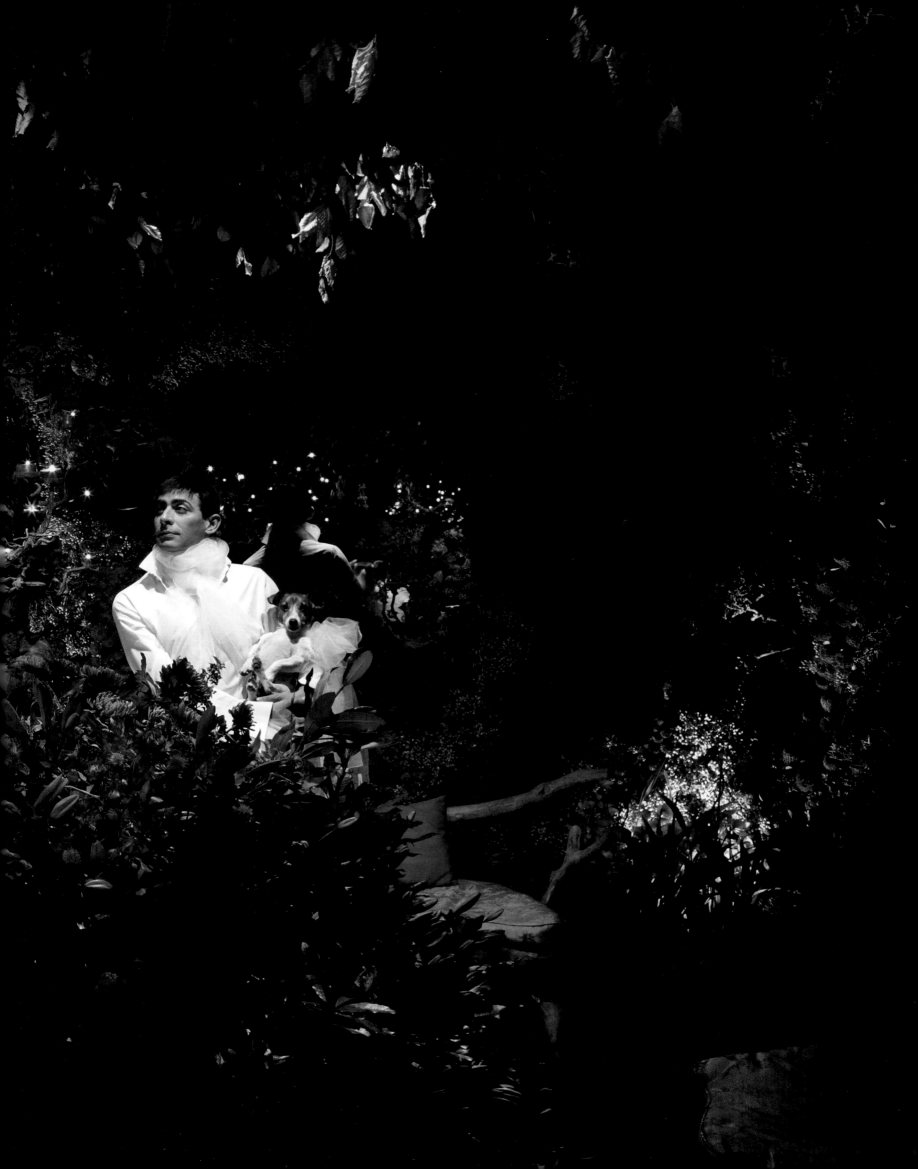

Gilbert & George

Is contemporary art more to do with performance than with art as such?

Geo: Art has never been such a big practice since the middle of the nineteenth century, when everybody sketched including every member of the royal family. In the early 1970s you couldn't get a person on the street to name a living artist. Now everybody knows the names of living artists all over the world.

You live in Brick Lane. You have a church on one side, a mosque on the other …

Geo: It's very good. We can hear the call to prayer; we hear the bells on Sunday.

Does religion still have relevance today?

Geo: We don't believe in the cynical modern artist who thinks that religion is over and done with.

Do you think that God is the ultimate artist, or con artist?

Geo: He is the ultimate criminal, I would have thought. It is a criminal organisation, the church in general. If you think of the number of people dying every day, committing an act of murder or torture because of religion, in that way it is a criminal activity. In around 1890 artists started to ask, 'What do I want to say to the world today?' instead of painting the horses of aristocrats or propaganda for the church.
Gil: I think the most important part of the Enlightenment was to be able to be human without believing in God, to be able to judge and rule ourselves. You don't need a Pope to tell you what is a mortal sin. We don't know why we are here, but we are here, so we have to live.

You've cited morality as an aspect of your art or your aesthetic. What did you mean?

Geo: We formally believe that people who go to see our exhibitions are slightly different from the ones who don't. That's why we like to take shows to different countries. We think that they can affect people's lives.
Gil: We never make art for art's sake. We always try to make art that addresses the human person. The sky doesn't tell you anything, but your neighbour does.
Geo: We think that our pictures open doors. We know that from our fan mail from children, from elderly people. People go to museums and galleries to see what they feel, what they think. Even if you just read detective books, you will side with the crooks or the police. You have a choice.
Gil: Like the new pictures that we are doing now: we don't even have to have a view about it. The view – what do you call it? – creates itself. You don't have to invent it. It is there. That's what we like. And we don't have to preach. We just want to show it in some way.

You fell in love, George, with the idea of being an artist at an early age. What does that mean, to fall in love with art?

Geo: People have innate abilities. It is a fact that some people are more gifted. I bought a second-hand copy of *The Letters of Van Gogh*, a very early edition. Rather odd, you know, miles away in the country. I read it with great fascination and realised one single thing, and that is that you didn't have to go about it the right way to become an artist. He went about it all the wrong way; it was very unpleasant. He trained to be a priest. His neighbours disliked him, but he managed to get through that. He gave something to us all.
Gil: Even that is a moral dimension.

Would you then describe your art as representing some kind of record of hypocrisy in the contemporary world?

Geo: No. We are not critical in that way. We are not anti-establishment in a way that many other artists are.
Gil: We have never been part of the establishment, ever, but we are not against rich people or whatever. We are only interested in ourselves. I sometimes think you could even take the word *art* away, because we don't know that art is special in some way.
Geo: We have two main privileges. We leave our house, come into the studio and do exactly what we want. The second set of privileges is to take those pictures out into the world. We are saying things that you cannot say on the street. You cannot shout, 'Paedophile, pervert, police, strangle, murder' on the street; you'd get arrested. But with art you can get away with it. The final privilege is that, on the day the pictures are finished, they are in the gallery, it's a private view, and we are surrounded by teenagers licking us all over. It is the ultimate privilege. We have so many young fans.
Geo: I think the young people see us like when I was a baby artist, a teenager, and my heroes were Picasso and Henry Moore. It didn't occur to me that they were old people. They were just my trendy heroes.
Gil: We don't need big studios; we don't have to go up ladders. It is all very close to our brain.

Back to the question of art. Gilbert, weren't you a woodcarver?

Gil: I was a woodcarver.

And now you are a superstar.

Gil: Who says? No.

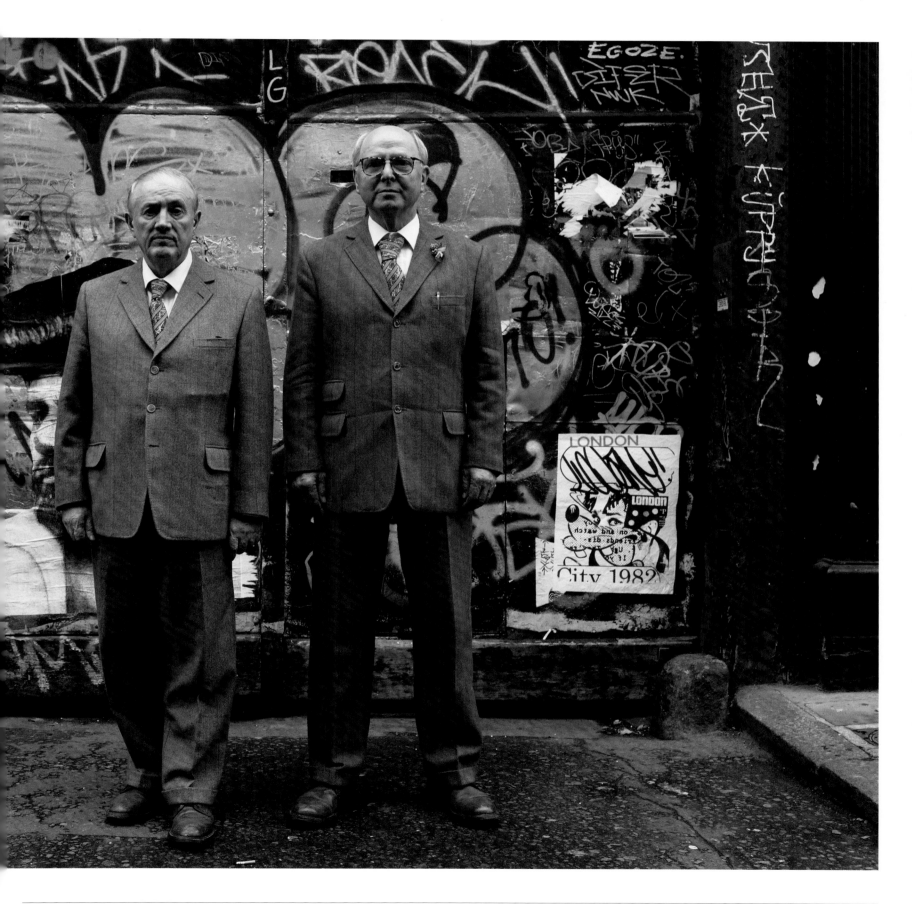

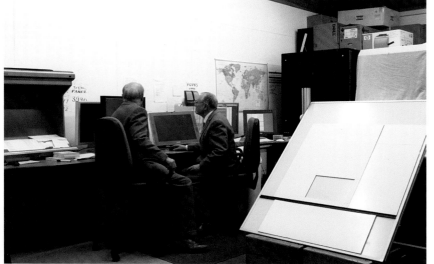

Is there no in-between feeling, no moment of euphoria, after the first million dollars?

Gil: No. Never. We don't have money; we spend it all. We don't like it because the struggle is still there. Every time you finish a group of pictures, you have to start all over again.

How draining is that?

Gil: Extraordinarily draining, don't you think?
Geo: Yes, but very rewarding.

You've spoken of living in sin. How much has sin to do with the creative impulse?

Geo: There was an article in the *Telegraph* today which said that creative people are more tortured than other people.

How important is it to you that your art is admired more by a public audience than by an elite?

Geo: We have a public, but sadly we don't have pictures in public museums in a way or on the scale that we would like to. All the people who stop us on the street from abroad tell us they just got back from Tate Modern and didn't see our art, and that is very disappointing.
Gil: That is why we are setting up this touring show ourselves. The establishment in the museums is difficult.
Geo: We also feel that we suffer from being original.

Where are you going to be in a hundred years' time?

Gil: We have a foundation, all our studios and the archive. We still have all the designs for every picture we ever did. We have all the negatives, all the letters.

What do you do for fun?

Geo: Fun? Would you trust an artist who liked fun? Would you trust a happy artist? To be an artist is not an easy thing. Culturally we are all very privileged because of this amazing stuff that people did and we ended up like this. We are here in this privileged room being interviewed for a book about art and artists because of the suffering and hard work all these guys did before. It wasn't an easy path. A lot of them got bumped off for having bright ideas in 1500.

Gil: We have struggled at lot. At the beginning we did extreme art. We were able to keep us together because we were two people. At the time of Minimal art, we were humanistic artists who suffered, who were against the grain. We bought this little house very cheaply, and we restored it ourselves day and night. We did everything ourselves.

When was that?

Gil: It was 1972. George was here in '64.

At which time, George, this would have been a slum.

Geo: Yes. Not that the people who lived here thought that. For them it has always been trendy. The Jewish people when I first came here as a student thought it was very trendy. They had a posh shop for fruit, and their own newsagent and tobacconist. Compared to where they came from, it was almost luxury.
Gil: All the rich people came here from the West End to buy fur coats.

Were you ever painters or sculptors?

Geo: We trained in painting, sculpture, architecture, history of art.

Getting back to your studio, you rented your first space for £12 a month …

Geo: We only ended up here because it was the cheapest part of London. Nobody wanted to come here. For years, journalists used to say to us, 'Now that you are successful artists, wouldn't you like to move to a nicer part of London?' Now they say, 'Your neighbourhood has become so trendy! You don't want to stay around here any more, do you?'

Would you say that the neighbourhood has become trendy because of you two?

Geo: Yes.

Gil: In the summer we had to go to a place where they had different art and an auction, and we had a picture there. We had a peep and we came away. All the other art was arty-farty.

Geo: Ours was the only picture that didn't have the smell of art, you know? You show an elderly aunt all the other objects – all this modern art, darling! – she wouldn't know what to make of it.

So that's the smell of art. What about the taste of art?

Geo: In a way it is the content.

And the process starts with you watching the news or in the local shop …

Gil: We always take images that interest us. Feeling what we feel, taking thousands and thousands of images, and then maybe, three or four years later, Ah yes, now we can use it, make art out of it.

Geo: The best example is the net curtains. We went around for years taking images of lace curtains in windows, not knowing why and not wanting to know why. One day we suddenly realised that it was the house burqa, the burqa for a building rather than for a person. The moment we found this moral dimension, we could use it.

This experimentation starts when? At 6.30 in the morning?

Geo: We get up at 6.30, buy a newspaper and go to a little café around the corner. At 11.00 we have lunch. We used to have this fantastic place, the Market Café. We went there for thirty years. The gentleman who used to run it was a genius.

Talking of genius, who are the geniuses of the British art scene?

Geo: We are generally supportive of art. The world needs artists. There are many countries that don't even have one. Terrible. If you go to a country where there is no museum or opera house or public library, you will almost certainly see dead bodies on the street on the way from the airport or the hotel. And the hotel will probably tell you to have a bodyguard. We would like to show in more difficult places.

Don't you care about criticism or art-world gossip?

Geo: We follow our press. We get invitation cards every day. We know roughly what is going on in the world. Of modern art, we always say, 'Never before have we shown such good-looking artists.' We have a minute circle of friends whom we trust entirely, who are very discreet and very nice. We love them and don't need to expand our …

Gil: … and they know what we don't like. We don't like art gossip.

Your personalities have been described as occasionally unsavoury and strange. Is this an accurate description?

Geo: We've been described in worse ways. What's the point? I don't understand. I am not un-amused by that.

Why are you always at the centre of your artworks?

Geo: When we were baby artists, we were socially involved with a group of artists in London, Paris and New York. So we partied in nightclubs and things. We didn't understand why their art was entirely separate from their lives. You would dance the night away with people, get drunk and talk of everything you could think of, and the next day they would go to the studio and do a perfect pencil line on a sheet of paper. We didn't understand why that was because we were always trying to find ways to include our art in the life and the life in the art.

Rembrandt is a good example. When you look at nearly all of his important portraits, you don't need to know who the sitters were. You just feel the humanity of people. Just connect with life.

Gil: It is his view. It is his personal living sculpture. He is in there.

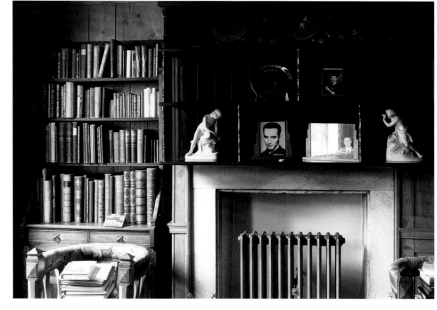

But Rembrandt never called his works *Gilbert the Shit and George the Cunt*. When did you lose your innocence?

Geo: When we went to Thailand in 1973. We had an exhibition with a young man who wanted to bring art to Australia. He did Christo and then us. It was an enormous success, on national television every day, and he was so pleased. He said, 'I am going to give you a little present.' And we said, 'How kind!' And he said, 'I am going to pay for a stopover for two weeks in Bangkok, including the hotel and everything else.' We had never been to a place where the pressure was on to have sex all the time. The opposite of London! You couldn't get into a taxi and go to a temple. They would say, 'You want to have sex!' They pressurised you the whole time. That was new to us. It was marvellous.

Are you martyrs to art?

Geo: Why shouldn't we want a better world?

Are you devotees of your own art?

Gil: Yes. We are strange monks …

Geo: We are pioneers of a different kind. When we first showed in galleries, all the things that we wanted were taboo. We wanted sex, happiness, thinking, feeling. The galleries weren't interested in that. We wanted colour. They didn't do colour. Everything we felt and wanted wasn't permitted.

Gil: That has changed.

Gilbert & George
originally painted their
house themselves, every
detail a reflection of their
characters, each memory
sanctified with little objects
(left). Photographs on a
mantelpiece (above) include
a graduation picture of their
Chinese assistant Yu Yigang.

Gilbert & George in lockstep in front of the now-defunct Market Café, where they ate together for thirty years. The artists do not have a kitchen at home, preferring to eat, regular as clockwork, in an Italian restaurant in Spitalfields Market with colleagues and anybody else that happens along. 'We have two main privileges,' Gilbert says. 'We leave our house, come into the studio and do exactly what we want. The second set of privileges is to take those pictures out into the world. We are saying things that you cannot say on the street.' And saying it with verve.

David Batchelor

David Batchelor in his Hackney, London, studio in early November 2011, testing colours and light. 'Art, for my money, is an invitation to look,' he says.

Your studio has been described as 'a treasure trove piled high with an endless variety of fluorescent plastic objects'. Is it like an Aladdin's cave?

When you first got in touch about interviewing me, I was thinking about this term *sanctuary*. I don't think of my studio as a sanctuary. The studio is part office, part laboratory, part playground and part, I don't know, padded cell. Activities that are usually separated in everyday life can sometimes come together in the studio.

What kind of laboratory do you mean?

Not the great intellectual powerhouse kind. I spend quite a bit of time trying out various materials, objects and colours. I'm interested in these materials as facts of our everyday lives, not in terms of what we may take them to symbolise. They are everyday things that we often tend to overlook – because they are ubiquitous, mundane or un-aesthetic – and that's what makes them interesting to me. I try to adapt them and abstract them, to make them a little less familiar. Sometimes it works, sometimes it doesn't.

So you're anti-aesthetic?

Not at all. I don't think you can be anti-aesthetic as an artist. To make art, a bit of you has to be anti-art, but not all of you. Certainly you need to be wary of good taste, but that's not the same as being anti-aesthetic.

I've been fascinated by the subject of colour for nearly twenty years now, particularly as we experience it in the city. Not so much the colours of nature as petrochemical and electrical colours. I've been trying to find ways to use some of those colours in three-dimensional work, drawings, photographs and, more recently, paintings.

Going back to the padded cell concept, what does that imply?

Well, I'm already beginning to regret that phrase, but you have to do some stupid things sometimes. As often as not when you're making something, you have all your fine ideas that you bring to the studio – and it all goes wrong. You have to accept that. Sometimes it can be a good thing because it means that you have to lash out a bit to try to recover it or make sense of it. What you end up doing – if you're lucky – is making something you hadn't anticipated, something that is genuinely new to you. So you have to make leaps in the dark from time to time. That's all I'm really saying.

You've talked about 'the post-studio world of art'. What do you mean by that?

Since the '60s there has been a lot of talk about getting rid of the studio, mainly because of its traditional craft connotations. A lot of artists don't work in studios these days, which is fine – it's horses for courses, and some of them are very good artists. I'm just not one of them. The studio remains a complex, difficult and strange place for me, although there is very little of what you might call craft that goes on in it. But I like the fact that, as well as having to think about things, you have to physically stick things together and often they don't stick.

Following along with that image, is art an idea that 'sticks' in somebody's memory for some unexplained reason?

I'm not sure that art is an idea. Works of art are things that have physical or aural or optical or whatever properties. Even the most conceptualised of Conceptual art is still a configuration of materials at some level. And that's pretty much unavoidable. What the viewer is usually faced with is a *thing* or an *event*. You can learn from those things and events, and you can generate ideas from looking at them, but what you are looking at is not an idea.

So how do they stick?

I really don't know.

You don't set out with the objective of making them stick when you're experimenting in your laboratory?

You always have ideas in mind, but most of those ideas come crashing down at some point and you end up with something else.

Crashing down or spurting up?

You're being way too melodramatic.

Isn't art meant to be melodramatic?

Why? Who says that? Art, for my money, is an invitation to *look*.

You're a critical theoretician, aren't you?

I've written a couple of books on colour. I don't know whether you'd call them critical theory or not. I wrote them because some of the stuff I was thinking about colour was better expressed in text than in the work of the studio. But I couldn't have written the books if it hadn't been for the studio. And it couldn't be the other way round. The books don't make the work; the work makes the books, if you see what I mean.

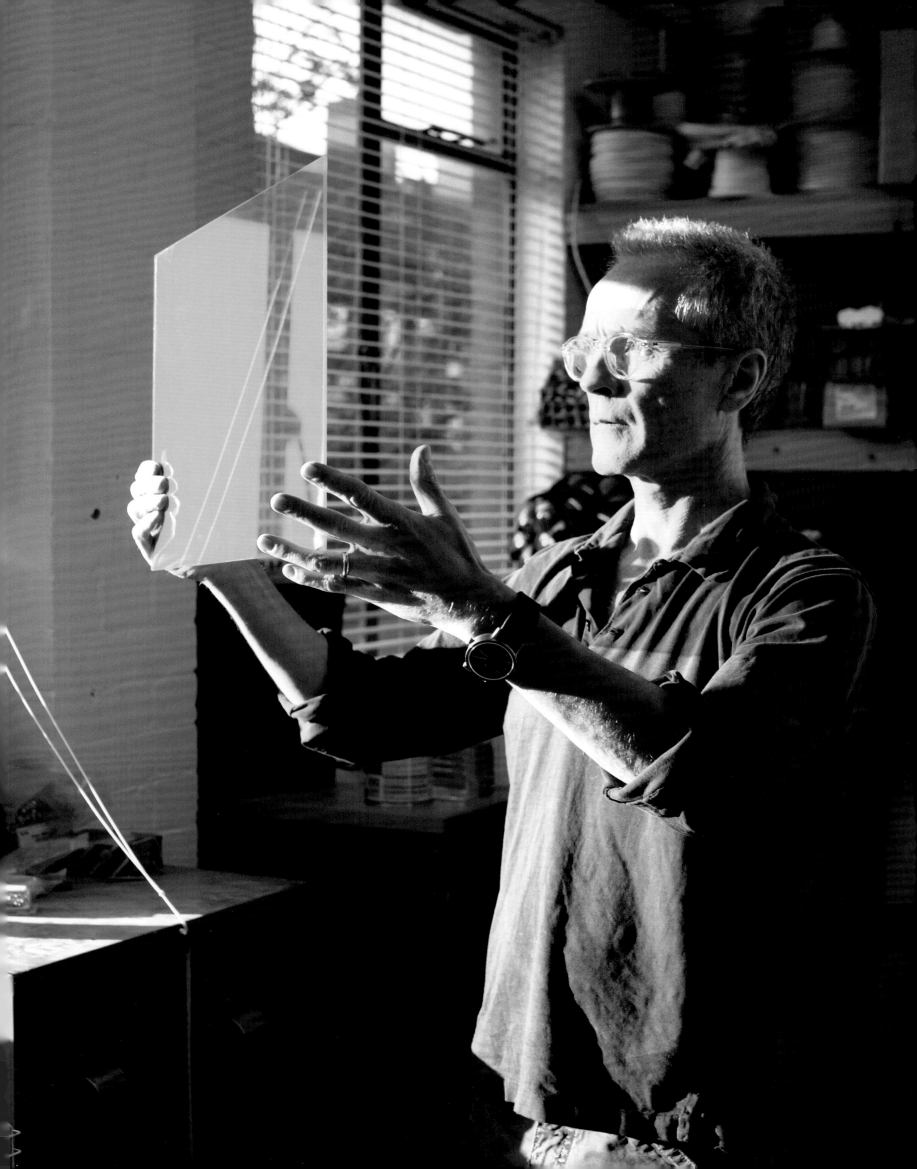

Are you primarily an artist and then a writer?
Absolutely. These days I spend 90, 95 per cent of the time making work in the studio and probably 5 to 10 per cent writing. Although recently I have begun to feel another text coming on.

When does your working day start?
I usually do an hour or two emailing in the morning. I'm in the studio at 9.00 or 10.00 and usually leave around 6.00 or 7.00. A regular working day.

How much of your work never sees the light of day?
It's really hard, that one. Sometimes you don't know whether what you've made is any good. The minute you've finished a work is absolutely the worst time to make a judgement about it. You have to let it lie. Then you come back a week or a month or a year later and think, Actually, maybe there is something there. So you're not your own best judge, at least not immediately. A lot of my earlier work still hasn't seen the light of day, and I'd like it to. Some of it has and I wish it hadn't.

Does your art talk back to you? Once you've created it, does it take on its own life?
It's certainly the case that, when you've been around for a number of years as I have, you find things that recur. Some things you were doing ten years ago, you thought you'd put them away, you thought you'd done with certain ideas or themes or motifs. You can find them recurring, without your having consciously planned it, ten or fifteen years later. That's quite strange. You stand back and think, Oh, right, *that's* what I'm doing. There's what you *think* you're doing, and there's what you've actually *done*. They're often two quite different things.

Do you ever get angry with your art?
No. I get angry with myself when things don't work, when something I'm working on is patently awful.

You taught Critical Theory at the Royal College of Art. Is art criticism a bit like economics in that they're both overrated?
Well, I didn't teach Art Criticism, and I've never read Economics, so I can't answer that question. I did once write art criticism for a couple of magazines, late *Artscribe* and early *Frieze* mainly, but I haven't done that for a very long time. I stopped because I didn't have much left to say in that particular format. There's an idea of the critic as someone who has an instant 'that's good/that's bad' function. I never had that. I think it's a myth, anyway.

How much is the hype and glamour around the art scene in London to do with creating value for art itself?
I don't think it has anything to do with art. At the end of the day, I'll be dead, you'll be dead, and the only thing that will be left is the work. That's what will get judged. That's the only thing you can depend on.

But some well-known or well-hyped artists earn a lot of money ...
That's always been the case. In the nineteenth century, William-Adolphe Bouguereau was the most famous and successful painter in France, but, a few art historians apart, hardly anyone's heard of him now. The most famous, the most successful artists are not necessarily the most interesting artists. At the same time, being unsuccessful also isn't an entirely reliable indication of your greatness.

You've been described as being provocative or ironic.
Really?

What roles do provocation and irony play in contemporary art?
In my work, none. My work is about joy and love. Though it's possible other people may see it differently.

And do other people's interpretations surprise you?
Yeah. If you're lucky, people describe your work to you in ways that you haven't imagined yourself. That process gives it a different life, a life outside of your own head.

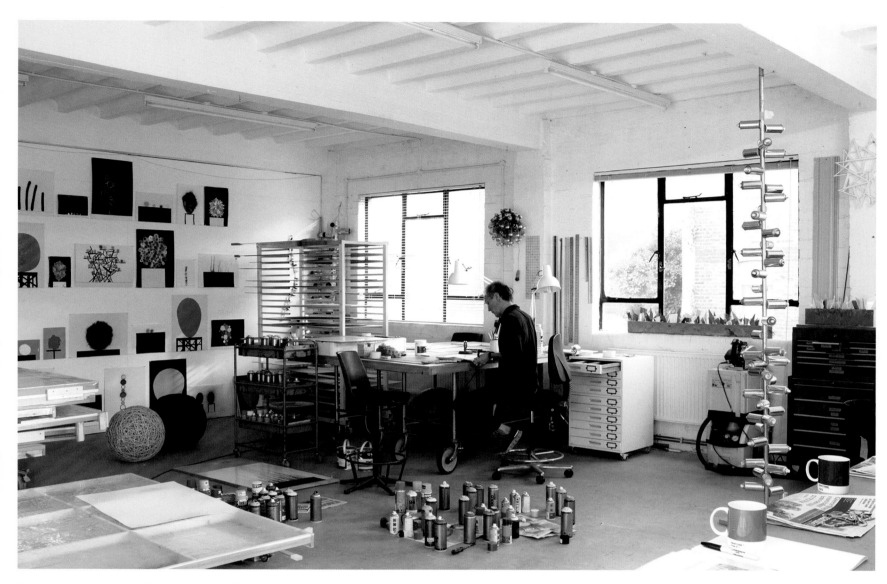

Here's another quote: 'It seems to me that the practice of art when it was at its most dynamic and most vivid, was when it was doing exactly the opposite; when it wasn't a refining and purifying medium.' Can you expand on that?

I think that's a fragment of something I wrote in my book *Chromophobia*, and I was referring mainly to the art of the '60s. I was trying to say that, in spite of certain theories of artistic 'purification' that were around at the time, much of the best work was more about forms of contamination. It was about messing up the boundaries between painting and sculpture, between image and text, between art and non-art, in a spirit of creative self-doubt. And, for me, that doubt, that uncertainty, always has a presence in the studio.

Leaving theory to one side, you have the body of work, the body of evidence of your aesthetic experience and existence. Where would you like that to be displayed, if at all, once we are all dead and gone?

Somewhere, rather than nowhere, probably. You can't come to the studio every day of the week for twenty or thirty or however many years without caring deeply about what it is that you're making. At the same time you have to let it go lightly and not be too self-absorbed. You hope that at the end of the day you've produced something that other people find worth looking at. That's all you can say.

Batchelor uses found objects from the urban environment to create structures and apply colour. His much-lauded book *Chromophobia* (2000) dissected the Western world's fear of seductive colour. Meanwhile his studio is full of colour and paints. 'I don't think of my studio as a sanctuary,' he muses. 'The studio is part office, part laboratory, part playground and part, I don't know, padded cell.'

Humphrey Ocean

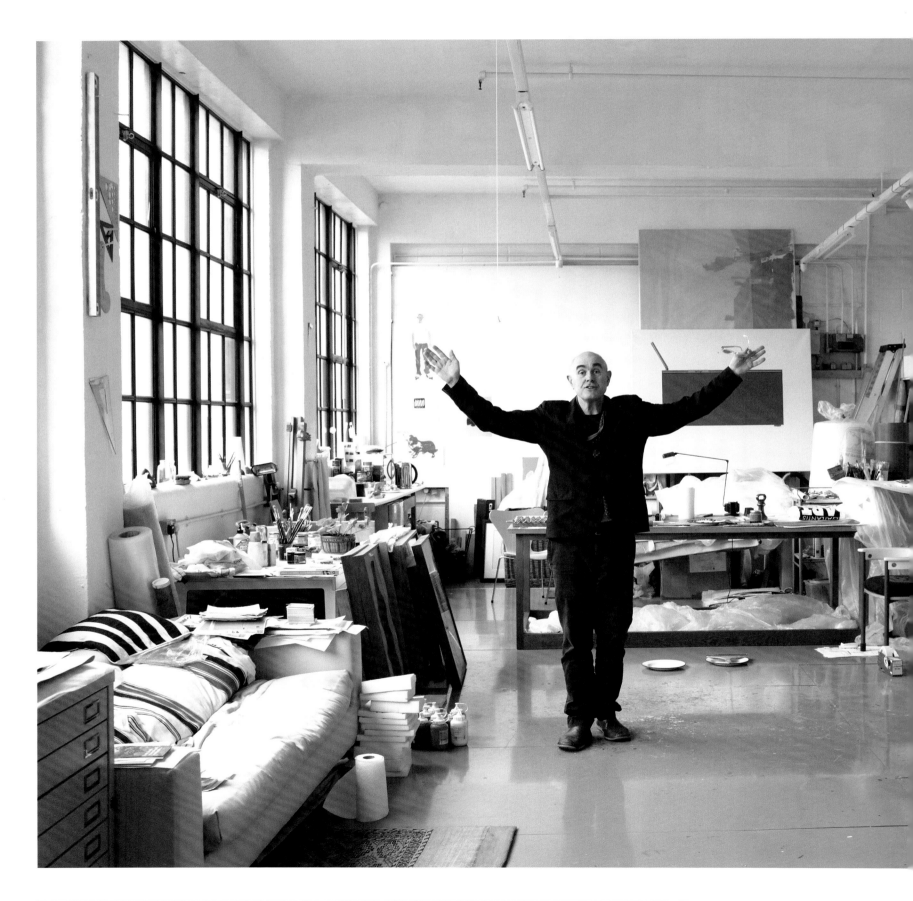

Does an artist need inspiration to produce art? It may seem a rather banal question, but nobody seems to address it.

I live on excitement. And one of the reasons I do art is to see what other people think. I want to say, 'I've seen something.'

Where does art come from? Which inner space?

One of the reasons why artists are strange beings is they have the head of, say, Isaiah Berlin and the hand of a farmer or a bricklayer, welded together. We categorise mental intelligence – that's Oxford and Cambridge – and we know what manual work is – that's mending roads and growing crops. To have both within one body: that's what an artist is.

A piece of art is 50 per cent thinking and 50 per cent doing. It's not a balance, it's a collision.

What attracts you to your sitters?

The same thing as anything I want to paint: because for some reason they make an impression. There's nobody who is entirely uninteresting. If I do think they're dull, it is probably me overlooking something. I paint things that are near me, physically, but I was sent onto this Earth to do pretty much what you and I are doing now, sitting 3 feet away from each other, or closer. And instead of just talking, making a graven image.

What relevance is there in a piece of art which is necessarily static? I'm thinking about painting, obviously.

Well, it's what somebody thinks. It is an image made by a person which you in turn look at and think about. That is why we set such great value on painting, something that at least sits still long enough to look at, for a lifetime if necessary. But even the highest-priced painting – say a Van Gogh – which affirms life, people pay much less for than a nuclear submarine, which takes away life, so the equation is not quite right yet.

Is portrait painting the creation of a 'lateral' reflection, if one can use that word? Do you dress up your portraits?

One hundred per cent not. That's what I don't do. In the same way that I accept a house whether it's made out of concrete or whatever, whether it's a bad planning move or a good planning move, it's just there. I, in a completely non-judgemental way, record not only that it was there but that I was there too.

You've been described as seeming 'too enthusiastic and way too gentle and polite to have talent'. Is that accurate?

No. An Englishman uses manners to get what he wants.

But manners are not what get you noticed in the art world, are they? How many well-mannered, good-natured, unassuming, modest great talents do you see on the British art scene?

I can mention absolutely none at all. I am interested in art. And one of the reasons I keep myself rather to myself is that I don't want people to find out what I'm really like. I do what I do because if I wasn't allowed to, I'd get – I don't know – I might not be able to answer for my actions.

So is art a means of controlling uncontrollable urges, of quieting the tremors of the soul?

Well, all artists are control freaks. When I'm offered a show, I think, That's nice, that's lovely. And then I think, Oh God! I get worried because I know I'm going to start trying to get involved in aspects like catalogue design, for instance, that other people are probably better at than me, although it pains me to say it.

I used to be interested in the collective consciousness, in being in a group or doing collaborations. But I am a solitary, really; that is why I went into art. I did collaborations for ten or twelve years, from the middle of the '80s. One night about ten years ago I rang a friend in despair at the fussing and fighting, and my friend said, 'It's time for you to cease your collaborations. When you show me your own work, you beam. When you talk about projects and associations, you are dark and taciturn.'

So is this process of 'backing off', as you've described it, a kind of social disassociation?

It's a disassociation from what the world expects of me, even, sometimes, from what I might expect from myself. That helps my work.

Does it help you in marketing terms?

No. But I'm in a very unusual position. I am independent. Not financially; I mean I'm not with a gallery. Yet. I'm sixty now and I'm just getting going. My contemporaries were where I am now, in their heads, when they were thirty. It's taken me a long time to get to where I'm doing the paintings I wanted to do when I was twenty. I wanted to do those pictures, but I couldn't. I just couldn't.

Do you feel that this blooming of Humphrey Ocean at the age of sixty has been recognised by the art world?

I wouldn't put it as strongly as that, no.

And that makes you angry?

Yeah, but not so angry that it stops me from wanting to make another picture. It's not that I'm trying to prove something, but the more I have to say, the more I want to say it. And I feel less inhibited than I did twenty years ago.

In what sense?

Because I don't give a fuck. Or – how should I say it? – I concentrate my energy on the important things. That's another thing about being sixty.

People say to me, 'You should do a book.' I'm not ready for a book. I don't want a tombstone.

Speaking of tombstones, what single word would you like inscribed on yours?

'Now what?' I know, that's two words.

I believe that you work out of a studio that is essentially a garden shed.

That was many years ago. My father was in the navy and I think I inherited cabin mentality. I used to work well in quite small spaces. When I broke out into the room where I am now – huge in comparison – I was ready for it.

And how old were you when you had your very first studio?

Fourteen. I had a hut near our house; it was separate, quite separate. To me that is the most important thing: to be able to close the door so that I can think my own thoughts.

So the studio is sort of a potting shed of ideas?

Absolutely, a place of germination. It's a bed. It's a shoe as well, that you walk in.

You know, being an artist is not linear. Nobody has done a better picture than the cave drawings of bison. Art is circular. More and more circular, quicker and quicker; you drill down through your shoes into the ground. All you're saying with your body of whatever it is that you've done is: 'I was here.'

What is the worst criticism you could receive from a critic?

If they didn't say anything. If they just walked past.

Are arts institutions today too controlling, too dictatorial? Do they stifle talent? Are we ruled by 'trend-ism'?

There's always been 'trend-ism'. The Renaissance probably began it. With English *milordi* and artists going like lemmings to Italy to see great art …

What, in your opinion, constitutes modern or contemporary 'great art'?

It's really difficult to say. Warhol was the most intelligent colour man of the twentieth century. His colour was aimed differently than the colour of Matisse and Picasso. Mind you, he said he wanted to be Matisse, it's just they came out as Warhols. I believe him. He depended on colour as much as image to contain his intelligence. His orange is never just an ordinary orange; he uses it to make you think about the electric chair. So you look at the most horrible thing: man's inhumanity to man, state-sanctioned revenge. You look at that electric chair and you think, How can people do that? You realise the full horror and you are repelled, so you walk away. But that particular red, or green or purple, gets you. So you come back and you look at it again. You're being repelled and attracted. You can do that with art.

Talking of masters, who would you consider to be the great master of British portraiture?

I didn't go into portraiture because I admired portraiture. I went into portraiture because of people. You, for instance, are more interesting than that table, by at least a mile. You can tell a joke to the cat, but the cat won't laugh. Lucian Freud is not my completely favourite painter in the world, but what I like about him is that he came as a foreigner and saw our light, our colour, and thought it was an exotic thing. Which it is. English light is really beautiful, and he saw that. And when you see one of his paintings next to somebody whose colour isn't that good, Freud's painting outclasses the other one. So I admit I've looked at a Lucian Freud because of the colour – and I've felt jealous.

Humphrey Ocean (previous spread) in his West Norwood studio in South London, autumn blues wiped away by his charming personality. 'One of the reasons why artists are strange beings is they have the head of, say, Isaiah Berlin and the hand of a farmer or a brick-layer, welded together.'

Primarily a painter, Ocean shows off a lithograph (left) from one of his print series. His brain was studied by researchers with a Wellcome Trust grant to research how artists produce work. The scans revealed that Ocean uses the visual cortex but also the front of the brain, which deals with emotion and cognitive thinking. This confirmed what the artist already believed: that two minds are at work simultaneously when good art is being created.

(following spread) **Ocean, who has been a Royal Academician since 2004, hails a black cab in front of the Burlington Arcade, Piccadilly, a most iconic setting for a true Brit. 'An Englishman uses manners to get what he wants,' he jokes. Not if the contemporary art scene is anything to go by.**

Alison Wilding

You are from Lancashire?

I was born in Lancashire, but I grew up outside of Cambridge. My dad had an apple-packing company in the Fens.

And how has your background affected your work?

Only insofar as the landscape is concerned. It is very flat; there are big skies, long distances, lots of water. I am still drawn to that kind of place, but it doesn't have an overt connection with the work that I do.

You've been described as a sculptor who is not as well known as you deserve to be. Assuming that's true, would it be a matter of choice or market dynamics?

When my work was emerging in the '80s, the Lisson Gallery was pushing a lot of artists of my generation. There were lots of group shows and I was in many of them. But because I was never with the Lisson Gallery, I was always slightly sidelined. You could say that I wasn't with the right gallery, but I wasn't very good at playing the game either. I've never been very good at playing that game.

What do you think defines your work?

Sometimes what you see is very much what you get, sometimes not.

How is the art world today different from when you were at college in the 1970s?

It is completely different. Art was marginalised then; it was tough to be an artist. It's tough again now because of the times we live in, but it was really tough, particularly for women, in the '70s. There were very few role models; in fact I don't think there were any for me. I was the only girl in my year at the Royal College. It was a completely male-dominated atmosphere. When I started teaching, there were many more women students than guys. Now it is no more difficult for a young woman artist than for anyone else.

What made you decide to become an artist?

I had no idea what it meant to be an artist. I actually wanted to be a beatnik when I left school. I went to a very academic school in Cambridge; if you weren't a high flyer, they weren't interested in you at all. I was rubbish at art, but I would paint and draw obsessively at home. What I did there had nothing to do with anything I was doing at school. The art lessons we had were laughable, really. There was a long art room, a classic art room; there might be twenty-four easels in two lines on each side. We did life drawing, we did imaginative composition, and there was no talking, and small sheets of paper. There was no discussion about what art was and what it might be. We didn't even go to look at anything. We didn't go to the Fitzwilliam Museum! It was laughable.

Was it perhaps also thought that art could corrupt, so girls were kept away from it?

I don't think so. I just think it was a marginalised activity.

At what age did you up sticks and become a beatnik?

I never was a beatnik. When I did evening classes in pottery, I started modelling small figures, nothing of any interest, but I was quite passionate about it, just feeling the clay and making things. I was between sixteen and seventeen, I think.

And you went from Cambridge straight to London?

No, I went to Nottingham to do a foundation (pre-diploma) course.

Did the art teaching you received at that time help or hinder your progress?

It was absolutely fantastic. Actually, last summer I had a show in my gallery of drawings that I did in my foundation year. I found one of my old tutors and went to see him, and he wrote a piece for the catalogue. It felt great.

Did your parents encourage you?

They were a bit worried when I never got a job, and I had no money for years and years and years. But while I was at art school, they were always supportive.

So you had to climb the ladder, right? There was no shortcut to fame or fortune.

No, there wasn't.

Today it is a different story …

It is and it isn't. There are many more opportunities for young artists. People are much more aware of them.

Do you feel envious?

No. It's too late to feel envious, but I regret that it wasn't more like that then. It would have been easier.

When did you achieve recognition?

Probably in the early 1980s.

How did it feel the first time you sold a piece for a good price?

I sold a piece of work when I was a student, in fact. I got £20 for it. It felt good. That would have been in 1970. After that, I didn't sell a piece of work until 1980, I don't think.

This romantic idea of the artist being poor and living in a garret, having to struggle, freezing … is it part of the process of growing up and doing art, if you will?

I don't think you have to be poor or struggling. I don't think it makes you a better artist. I remember when I was living in my studio in Wapping. It was during the winter, it was very, very cold and unpleasant, and I suddenly realised that I really wanted to make work. I was really, really excited by the idea of working. Being poor, which I was, had nothing to do with it. If you want to make work, you will do it whether you can buy the materials or have to use what you find in the streets. It doesn't make any difference.

Alison Wilding in her new studio in Bermondsey, London, in early November 2011. The area is becoming increasingly hip, not least with the opening of White Cube Bermondsey.

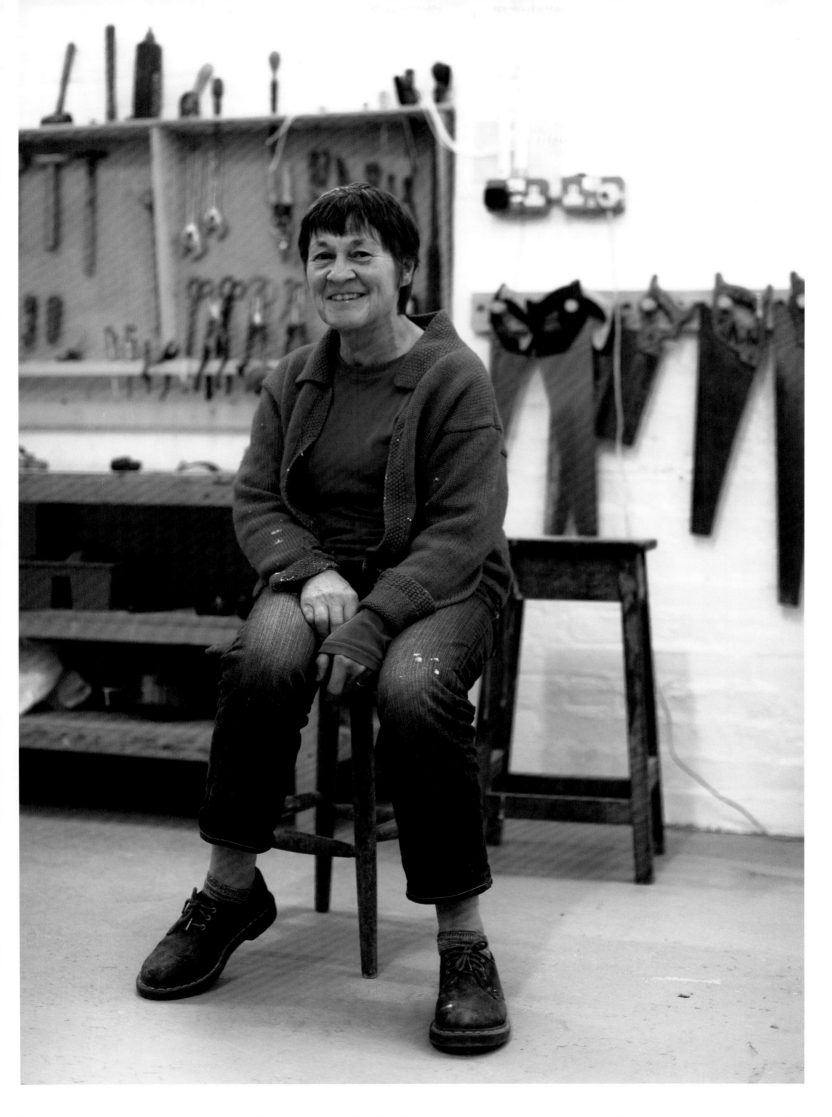

Is engineering involved in the making of your work?

I don't always use engineers, but if I do I know I have to be clear about what it is I want from them. They have to be both intuitive and pragmatic – and some of them are fantastic at that.

You talk fondly of engineers ...

Yes, because I think they are wonderful. This country used to be stuffed full of engineers – I mean guys in small workshops who loved problem-solving. Now they are having such a hard time. I have worked with a couple who have made the most incredible things for me. They love rising to a new challenge, making something when they have no idea, really, what it is.

And do they appreciate it for what it is in its completed form?

Absolutely.

Does their appreciation derive from the fact that they were involved in the process?

I think so. They become part of the work.

Moving on from that idea, how does a reviewer, an audience, an ordinary Joe at a gallery, engage with your art?

The work has to draw them in. Why would you waste your time looking at something which is completely dead? Once the viewer is drawn in, they have to make some sort of sense of what they are seeing. In the case of my work, there is never any narrative. They don't have to unpick or understand or read a caption before they get into it. In a lot of art, there is so much back-story; I resist that kind of thing. I hope that with what I do it isn't necessary. The work itself provides all the information you need. It is *there*.

How would you define your genre?

I don't know. I don't think that is my job, actually. I used to say that I make abstract sculptures, but I am not sure that I do. Because I think the work is connected to figuration even if the figure isn't there.

But it's there in your mind ...

But there is so much stuff in a piece of work that is there at the beginning but not there at the end.

Is it lost in translation?

It is edited out and actually doesn't matter. It is what is left at the end that matters.

Is art a primal urge or is it a social aid demanded by economics?

It is a primal urge. It is also a market. We are all part of it; we couldn't survive without it.

In a 1996 interview you said that you've 'always been interested in dissonant materials'. What did you mean?

I meant bringing together two materials that seem to have no compatibility. I was referring to a piece where I used lead and beeswax because I had in mind what they both would taste like. I thought that by bringing those two materials together, something of that would come through.

What does art evoke in terms of the bigger picture?

It doesn't have any purpose.

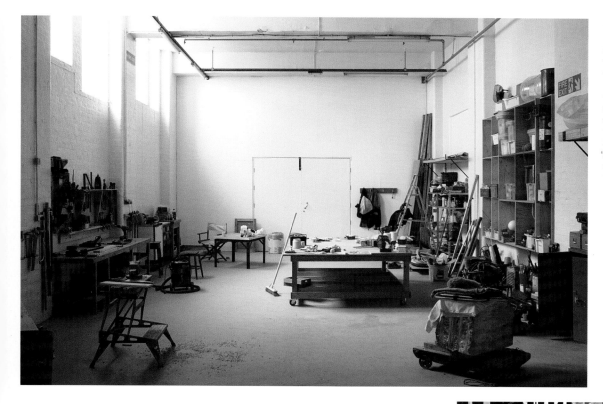

Wilding creates sculptures by joining unconventional materials together: 'If you want to make work, you will do it whether you can buy the materials or have to use what you find in the streets. It doesn't make any difference.' The artist on her walk, pictured outside St Mary Magdalen Bermondsey. 'In a lot of art there is so much back-story; I resist that kind of thing.'

Then are you a servant of an ideal without any purpose?

Art does everything that the rest of life doesn't do. You'll stop and look at a piece of art – whether it is a painting or a piece of sculpture – that is so not like anything else you do in your day. I don't know what your day is like, but what most people do is very far from what we see in a work of art. Especially if you live in London, you racket about from here to there; things are flashing in front of you; you never stop to look at anything.

So art stops you for a moment.

Good art will stop you, take you out of where you are and put you somewhere else.

Bill Woodrow

Can an artist be a wasting asset in the sense of being forgotten? Are artists who aren't really in the public eye wasting their time?
No, certainly not. Apart from anything else, they are keeping their heads together.

In the same sense as when you are a doctor and you retire, you get struck off, or is it something deeper?
You could say it's a need. There is a need to extract from one's inner self, one's mind, whatever you want to call it, that which you can't quite understand. A visual artist does this by creating visual art in a similar way to a musician composing and playing music. I understand my position in the world, or try to understand it, by making art.

And what is your position in the world?
I am not sure that I have discovered it yet. Your relationship with the world can change from day to day. One is an observer and one is also a commentator, though not directly, because if you comment directly, you are not necessarily an artist. Things seem to come in a roundabout way. You discover that actually you have said something about something when you didn't intend or realise that you were going to do it.

Are artists different from normal mortals?
No. Most people have passions, but not all are lucky enough to have the chance to connect with those passions in the way that artists do.

Is there a socio-biological process that triggers passion and then makes someone a devotee of art?
I don't play football, but I could be passionate about it. In that situation I am an audience. I don't have the skills, but I can be involved and enjoy the whole thing by watching it. People who get passionate about art are in a similar position.

But art is a very individual aesthetic action. Sporting events are primeval, tribal propositions.
It sounds like you are describing art ...

But isn't art elitist?
I don't know how interested I am in that argument. One of the interesting things about art today is that there are so many artists, so many people wanting to be artists; it's so natural nowadays for people to be artists; it's not a problem. Your parents wouldn't stop you wanting to be an artist; they wouldn't want you to go into another job. But if that's true, then how is it possible for an artist to be radical? When there

were fewer artists, it was possible – maybe because of what you are calling 'elitism' – that art was more radical. There may be things that lose their edge when they get big and multiply.

When I talk about being radical, I am not thinking about audiences, about who is going to look at the work. I am thinking of myself, about how I can make something that is radical for *me*. It has to start with *me*. Whoever sees it after that is not my primary concern.

Do you mean that it is not your problem or not significant inasmuch as you can't control it?
You can try. But that's not my initial interest. My enjoyment, my passion and my drive, if you want to use that word, is to make pieces for myself, in a very selfish way.

When I did an interview like this during the summer, a similar issue came up, and people were surprised when I said, 'If I had my way, I would keep everything I made, and if I had enough money, I would buy back all the things I have sold.' What I feel is that I make these things and they are for myself and I like and want to look at them. Thinking about it afterwards, the process of making art is like writing a diary of your life. When you sell something, it is like ripping pages out of that diary. What you are left with is this book with lots of bits missing.

You went to Saint Martins and Chelsea School of Art between 1968 and 1972. How has British art been transformed since then? Whose work were you looking at?
To answer your first question, there has been an incredible change, which I picked up on before, in how to be radical, because of the numbers, the sheer expanse of everything. When I was at Saint Martins, there was very little talk about exhibiting work or about how to manage yourself as an artist. Even the notion that art existed outside of London and was international was something you only understood because you looked at magazines. It wasn't played out in the same way as it is now. The people I noticed showed that you could make different work and it could be shown and appreciated internationally. Those people were Gilbert & George, Richard Long, Bruce McLean and others. They were just beginning to get recognition in a way. They showed that you could step outside of the mainstream, that there was an appetite for that. The positive thing about them was that they were very, very professional even at that age, and they didn't compromise. I am not saying that the mainstream formalist art of Saint Martins was worthless, far from it, but as a student you have to react against something; you have to try and not do what they want you to do; you have to be

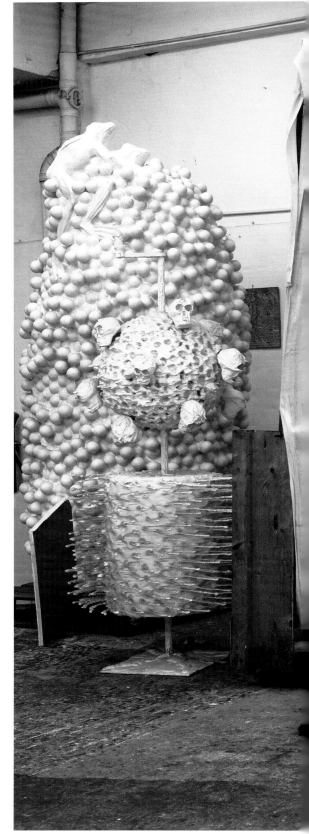

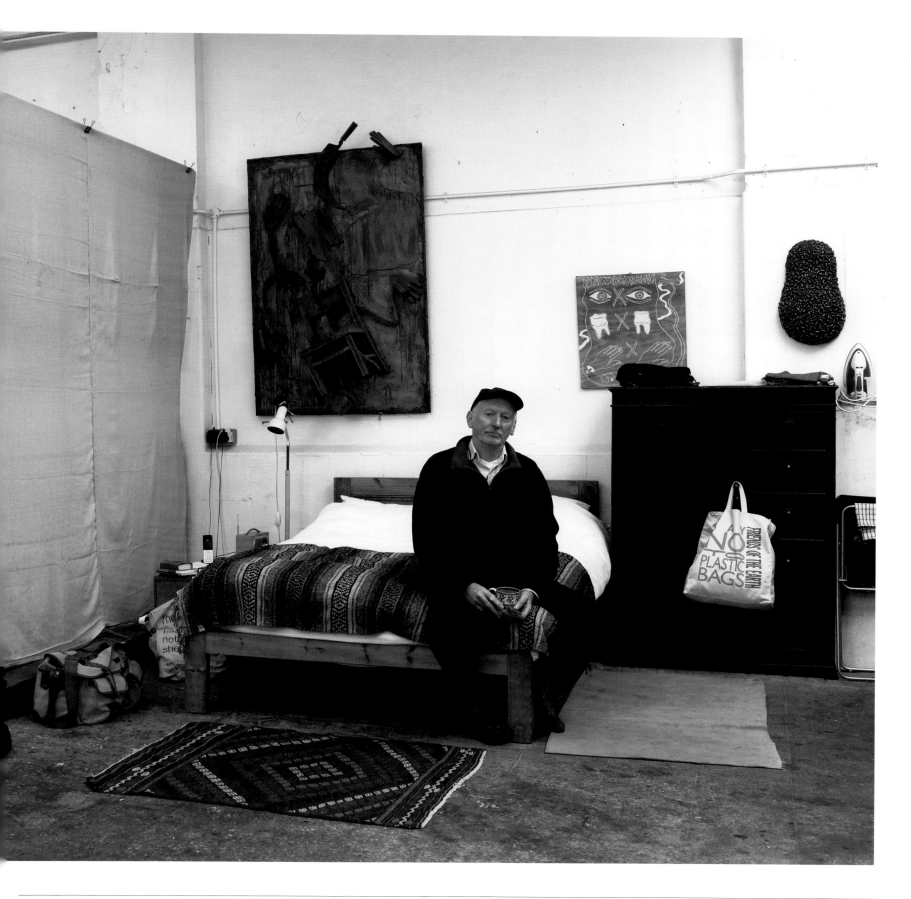

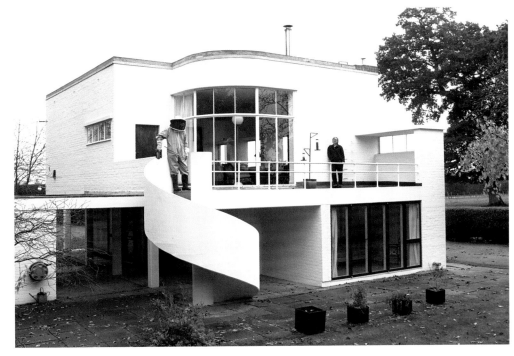

Bill Woodrow (previous spread) photographed in early November seated on his studio bed. The artist lives four days of the week in part of his Oval, London, studio, returning to his Hampshire home at weekends. Woodrow, who is very keen on apiculture, pictured (right) in his beekeeping gear standing on the stairs of his modern home set in the heart of the English countryside. Pauline, his wife, stands to his left. The Woodrows have restored the 1934 house, originally designed by architect Christopher Nicholson.

Woodrow prefers his studio (above) to have no windows or columns, as they distract him from his work. The artist signing a new work at the AB Fine Art Foundry (opposite), where most of his metal fabrication is completed.

(following spread) Beekeeper, artist, part-time philosopher: Woodrow at his home in Salisbury, where he and his wife moved four years ago: 'The process of making art is like writing a diary of your life. When you sell something, it is like ripping pages out of that diary. What you are left with is this book with lots of bits missing.'

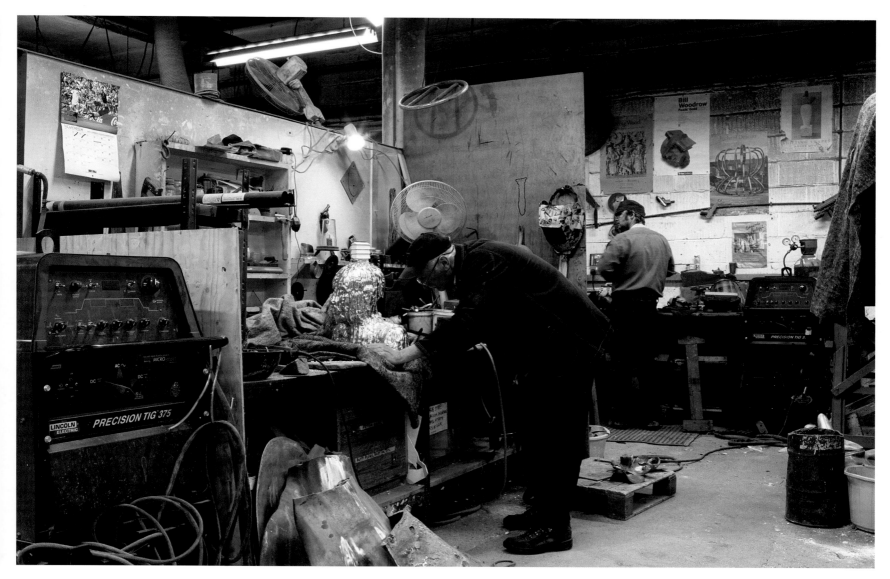

bloody-minded. That is what makes it interesting. Good teachers recognise that and organise you to do it, and if they are really good you don't understand that it is happening.

What sets London apart from the rest of the art world today?

I might have difficulty answering that question because I don't travel so much at the moment. There is so much out there right now that I cannot keep up with it all. I am primarily a producer, not so much an audience.

There is much more attention being paid to public art today than in the recent past. Is this a manufactured phenomenon, or is there an actual yearning on the part of the public to be educated?

I am not sure. Public sculpture intended to educate people is an abysmal concept. I am not sure I understand it. Although I have been involved with public art on one or two occasions, it is not something I am that interested in. There can be too much of it, and probably most of it, including my own, isn't very good.

You have used a lot of junk and scrap in your work. Do you still do that?

I would still use that kind of material if I needed to but not in the same way as before. When I first started using scrap in the late '70s or early '80s, it was out of necessity, because it was free. If I was living in the countryside I could go outside and cut down a tree, dig up some clay and make something from them. When you are living in a city, scrap is the natural material. It is what surrounds you, what is lying in the streets. That's how it started.

What is your preferred material today?

I work with anything that does the job.

Is painting a dead art or is it being revived?

I think you'll find that there are a lot of young painters. There are even old painters! How many times has painting been 'dead'?! I'm quite interested in painting myself at the moment, because it has some sort of substance.

Do you think of your studio as a sanctuary?

Your use of the word *sanctuary* is interesting, because when I come in here, the rest of the world stops …

Stops at the doorstep, or is locked out?

That depends on what you need.

Do you sleep in your studio in London?

Yes, sometimes, because I don't live in London any more. We moved to the South of England about four years ago.

So the studio can be an emotional space as well as a workspace and a sanctuary?

Of course. Most artists spend the majority of their lives in the studio and most of them are on their own. If you said to somebody, 'You are going to spend most of your life in a room on your own,' they'd think they were being sent to prison!

When you go home to the South, do you work there at all?

I draw sometimes.

Does taste change or remain the same within or outside of the art world?

There is always taste and there is always fashion. You can waste a lot of time if you think about that too much.

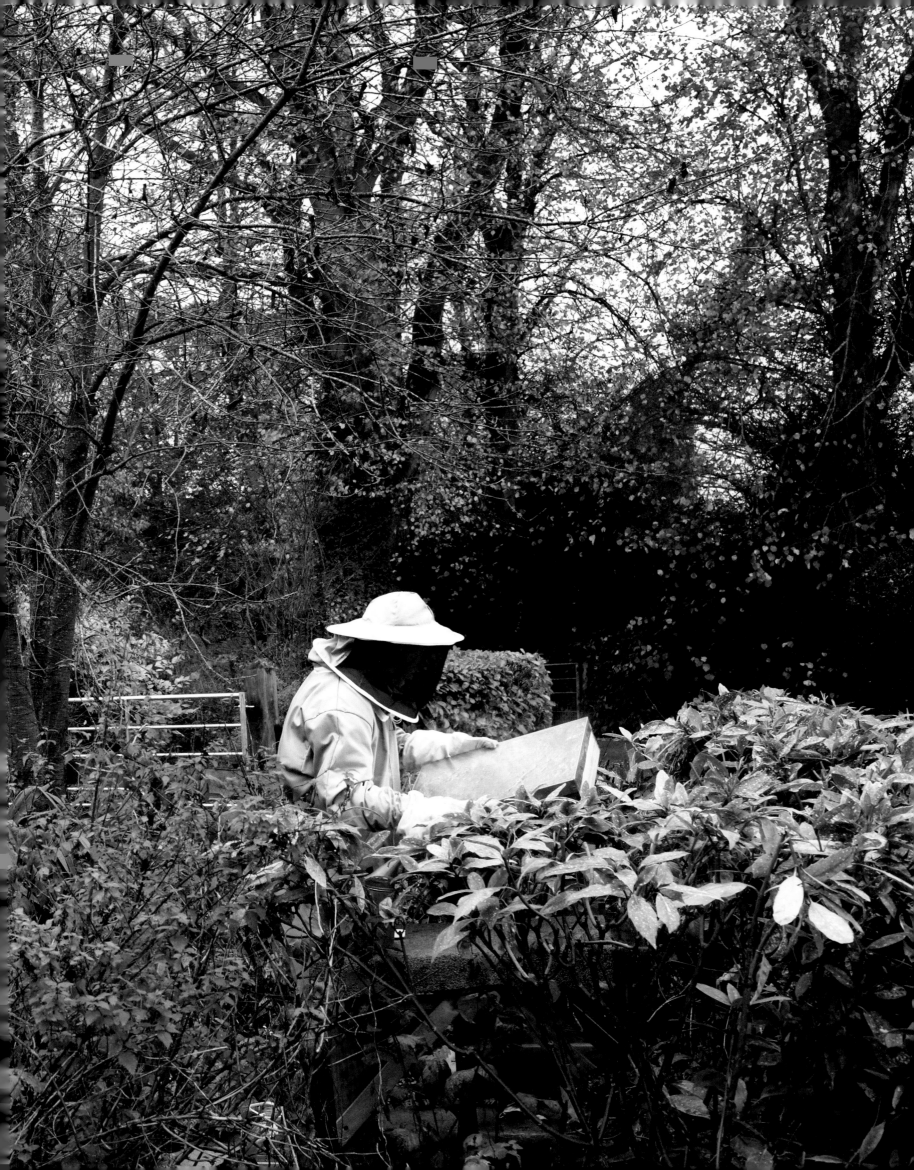

Sarah Morris

Is it possible for a nation to invent an art scene?
I don't think you can 'invent' art. That's an impossible task. It just becomes propaganda. That's like asking, 'Did Margaret Thatcher invent anything to do with the British art world?' Absolutely not. If anything, it could be argued that it happened in spite of her.

But many artists working today say that they were able to grow during the Thatcher period, because of the largesse as well as the challenges, because the state allowed them to be on unemployment benefits.
Yes, there was a support structure, and they were able to use the loopholes. There are no loopholes for American artists. You move to New York City at eighteen and basically you have to have a job. There are no rent subsidies; there are none of the structures that exist in England.

Were you born in England?
Yes. My mother was American, my father was British. Both were in medicine.

Were you born an artist?
I don't think anybody's born an artist. It's a choice you make.

Who, then, determines that you've achieved your goal of becoming an artist?
With any good art right now, you have rhetorical play. Anybody can co-opt and empty out the meaning of one's work. I can't control who buys my work and what they do with it.

As an artist, there are always these challenges of being in control and not in control. You have to know when to let go, but you also have to know when to fight about the meaning of your work. This is a dilemma that every artist faces: how to become powerful and have a platform in society.

What are the defining characteristics of a Sarah Morris film?
It can actually be anything. I made a film about Robert Towne, who created the role of the script-doctor. He wrote *Shampoo*; he wrote *Chinatown*; he did a lot of important screenplays. What he does is take reality, or somebody else's script, and tweak it. He gets paid enormously to do this slight adjustment. I thought this is a very interesting model. Most people think that the film industry in Los Angeles is a pile of crap, but in actuality there are some interesting people there working in a way that parallels the way artists work. I thought, Why not examine this? Maybe there's something to be learned from this model of film-making and collaboration. Artists are only now starting to talk and utilise some of these subjects.

As to what characterises a Sarah Morris film, it can be about production, pre-production, municipal pathways, travel, broken narratives, architecture, politics, the commercial, graphic design. The films are schizophrenic. There are many, many points of view in them. And there is an automated view of how all these things fit together. That's where it all goes back to somebody like Towne, who was proposing the city-as-conspiracy in *Chinatown*.

A bit like the art world today?
Possibly.

In terms of the art world, where do you fit in?
It would sound incredibly arrogant to map that out for you. I didn't go to art school. I just read, read, read, and watched a lot of film. I was reading Chomsky when I was thirteen or fourteen. I was very nerdy. My friends studied human behaviour in grocery stores …

And what triggered you to become an artist?
I'm not discounting reading, but by the time I was twenty I realised that our cultural position was an endgame that had to be brought into a tangible, three-dimensional form. I started realising that that was the turn I was going to make.

Sarah Morris photographed by her husband Liam Gillick at their home in New York in late November 2011. 'As an artist,' she says, 'one of the most difficult things is that you're constantly thinking about the future. That is a painful state to be in.'

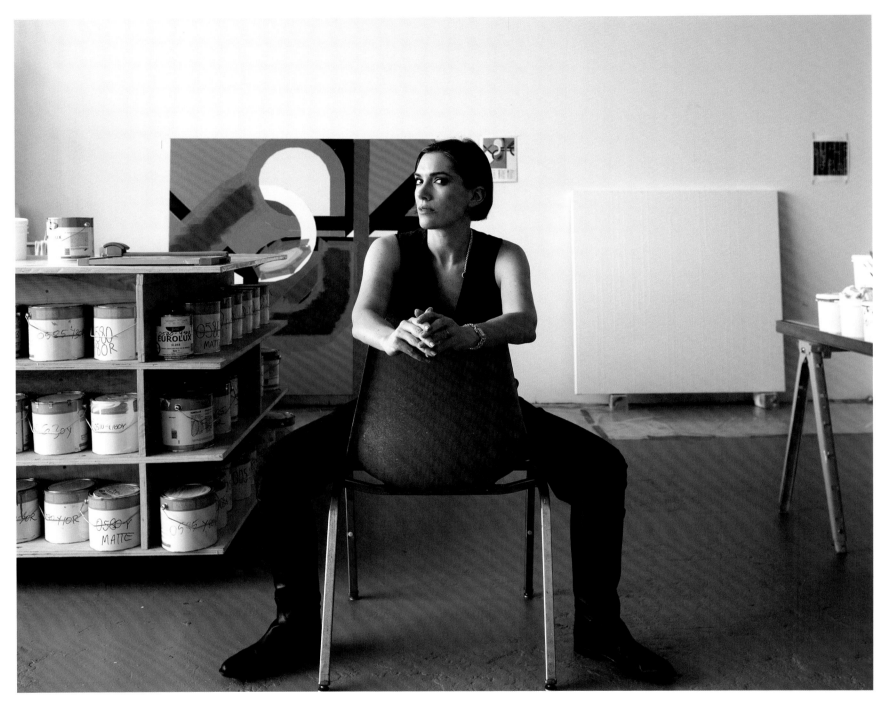

Morris in the studio, finished
and blank canvases in the
background: 'I don't think
you can "invent" art. That's
an impossible task. It just
becomes propaganda.'
(photo: Jason Schmidt)

Before that, where had you been going with your life?

I'd been reading Political Philosophy at Brown University. Then at Jesus College, Cambridge, I read Social and Political Sciences. A friend of mine gave me *The Anti-Aesthetic*, which was edited by Hal Foster; I found a lot of issues that I had been thinking about in that book. I contacted Foster and suddenly found myself at the Whitney Museum of American Art, in the Studio Programme.

Were you never drawn to drawing and painting?

Of course I was. I always drew and painted.

Were you any good?

I knew that I had a strong sense of colour. I also knew I had a strong sense of ideology. I knew that I did not want to have any evidence of the hand. I was very taken with the idea of materialistic form that comes from the tradition of Frank Stella to Warhol to Donald Judd to Dan Flavin, and by the critique of the institution, which comes from, say, Broodthaers or Hans Haacke. There are many references that come into my work.

In terms of actual politics, what was the defining moment for you?

Watergate was probably the most formative political event of my young life. The whole thing about Nixon was interesting because you learned very early not to trust the news and not to trust the impulse for documentation. You learned very early not to trust how things appear on the surface.

But the role of the artist is to dig beneath the surface, isn't it, and to be trusted for doing so?

I don't think you should ever trust a narrator, even if the narrator's an artist. You shouldn't trust artists either. Once art starts becoming didactic, I lose interest. We all know that the artist isn't the possessor of truth. The artist is like any other citizen, complicit in their society. We know that the avant-garde to some extent is a fiction. The avant-garde might rip certain things to shreds, they might create certain gestures, but it is a complicit form within a system. One has to understand that and try to avoid being simplistic.

But popular opinion has it that the artist is an outsider.

That's bullshit. If you look through art history, you'll see that the avant-garde was never an autonomous group. It was always promoted and part of a system. That's why all of this talk about the art market is really boring. The point is, what are you going to do about it? How are you going to direct viewers to engage with the society they live in? I want them to be able to see the forms of power and understand how unresolved power is, also how power can turn on a dime.

Talking of power, art and artists have grown substantially more powerful in recent times.

In England the artist is quite powerful because it's a small society and there's a lot of crossover between fashion, art and music, and because the idea of a contemporary art scene doesn't have a long history.

Is it a good thing for artists to have power?

Absolutely. It's always going to be better than people making arms and pharmaceuticals having power.

But arms and pharmaceuticals command the byroads and the high roads ...

Obviously guns and pharmaceuticals are important elements of capitalist society. But I would rather have a Gerhard Richter selling for whatever than a pharmaceutical company making chemicals.

Are you more American or more British?

I'm fifty-fifty. My British grandmother always said I was American because of my lips. In terms of the contemporary art that I'm interested in, I'm probably mainly American. Or German. Or Belgian. But I love Richard Hamilton. Hamilton and Stanley Kubrick influenced a whole generation of Americans who were either film makers or artists. It's impossible to avoid those two people.

What is your daily routine?

I have a serious routine, very structured in some ways but very unstructured in other ways. I'm very diligent: I go to the studio. The studio is usually wherever I am. My computer is there and I'm controlling what's going on. My physical studio at the moment is in New York; it used to be on Columbia Road in London. I've always produced everything at the same time. There are parallel productions: there are paintings, there are films, there are site-specific pieces. There are a lot of different practices going on simultaneously. Because the films are very fast, very expensive, very collaborative, they involve a lot of people. And the paintings are extremely slow, very precise. Both involve the plotting of co-ordinates. The paintings are literally mapped out with a precise type of Swiss automotive tape. I like the process of my work. I don't like talking about it so much, because I think some things should be left as a mystery. The films also are a set of co-ordinates of specific places and people whom I want to somehow meet or engage with. In a way, the films are an excuse to create a fantasy or engage with a set of things that I might find quite repulsive. I might also be captivated by them.

Given that your studio is nomadic, what does it represent to you?

Headquarters. A safety zone. 'Sanctuary' might be too strong: that makes me think of birds or something. Some sort of place of respite. A place you can go where you can think calmly and where time slows down. You can think about the future, you can think about the past, you can think about your plan. As an artist, one of the most difficult things is that you're constantly thinking about the future. That is a painful state to be in. All of my work to some extent involves states of alienation, states of failure and states of complicity. That would therefore presuppose my own involvement in those failures. I do believe that it's better to be engaged than to be separate. I'd rather be engaged with a subject, even if it's very problematic, than not be involved.

You are clearly passionate about ideals and ideas. Do you care about the human race?

Of course I care about the human race. That's a very strange question. But I'm not like Angelina Jolie. I don't view it as my role to be engaged with issues in a practical, political manner. Art can be political in a sneaky, covert way.

Jake and Dinos Chapman

When did you get into art?

J: We were exposed to art when we were kids. I went to art school because I wanted to be in a band.

D: Everything else demanded an actual decision-making process, whereas if you were going to art school, you didn't make that decision; that's where you ended up. Also it was the most attractive proposition. Why study some sober subject in some university somewhere? When we were at school there was a class called 'Career Opportunities' which basically meant you sat there and filled out forms, learned how to make job applications. The idea was that all you needed was five GCSEs and you could go to art school. If you went to art school you could do whatever you wanted.

J: The model for production when we were students was life drawing and really provincial, English, kitchen-sink modernism. Some of the time we were taught by people with dementia and tutors with alcohol problems; they'd lost their brains at the foundry. That was the notion of what an artist was, the Romantic structure. You could go through art school doing life drawing and feeling slightly hung over.

D: The YBA thing was the first time artists made allegories with political interests. It had some purpose to it other than some self-searching catharsis. You could make art as an act of resistance.

J: Also, it was about localisation. It wasn't a grandiose statement; people were making art for their immediate friends.

D: No-one expected anybody to be interested. It was a form of amusement as well.

Where is the romance in art? What drew you in?

D: The activity of making art is an experiment in itself. It is a way of deciding how you view and interpret the world and what you want to put back into the world. But there is something clearly different about our work than about that of someone like Frank Auerbach, say. His work is about soul-searching. It is a manifestation of an internal torment. Our work is a conversation about what the work does, about how it works with the world.

Some critic said that you like 'rubbing our noses in our own excrement'. Are you training people to look at your aesthetic? Are you puppyfying your audience?

D: I don't think that there is an act of training going on. Our work is about power. When people see our mannequin pieces, they assume that they have something to do with sexuality. They have nothing to do with sexuality; they are all to do with relations of power.

Do you care how your art is viewed when it goes out into the commercial sphere?

D: We can't be held responsible for what it is seen as. Once it is outside of our studio, it isn't ours anyway. It becomes an object in its own right.

J: It is a given mode of interpretation of art that it is confessional. When you look at a work,one of the conventional questions is, 'What was this person trying to do?' What we are saying is that it has nothing to do with the person who made it.

The Chapman brothers, workmates for over twenty years, photographed in front of their warehouse studio in Hackney Wick, London, at the end of November 2011. The Chapman brothers have created three versions of their iconic *Hell*. The first version was lost in the infamous Momart art warehouse fire. Here another *Hell* (left) rises from the ashes.

Dinos at work in the
studio (right). Jake displays
recent work (below) while
Dinos shares a joke with a
friend (opposite) at White
Cube's Mason's Yard,
London, showrooms. The
brothers also produce work
in separate studios, in
isolation from one another.
'Everything you make,'
Dinos says, 'is a massive
disappointment because it
is not the thing you wanted
it to be.'

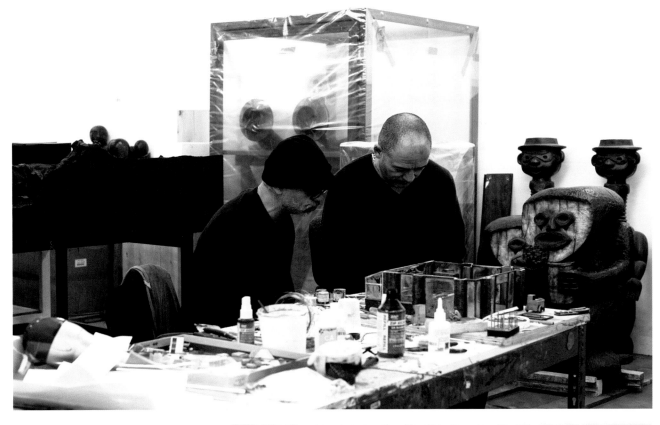

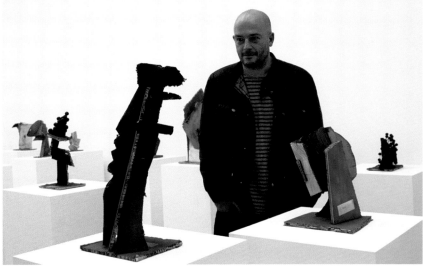

Would you describe your aesthetic as one of horror and disgust?

D: It's more about laughter and hysteria.

J: The laughter and hysteria side of horror as opposed to the weepy, cry-y bit.

But there are a lot of tears, a lot of drama.

D: Drama is mostly melodrama; it is mostly pathos towards the point of no return. Of course you can't see your own work; it is dead. And people have unexamined, unmitigated, compassionate reactions to the things they are seeing.

What about fear?

D: Compassion and fear.

You say that your art becomes dead to you. Does it not mean anything at all?

D: Once it's finished it is completely alien. I can't look at *Hell* at all. In ten years' time I'll be able to look at it and have forgotten all it is. There is a frenetic desire on our part to make the work we make. Get it all done and then get rid of it.

J: The work in the gallery is not the work in the studio. You can't go back. You think about it in a very different way.

D: It is not a question of disappointment. The idea that making a work of art is about loading up something which may dispossess you. On the up-side, you can sometimes observe your work as if it had nothing to do with you.

J: When something is successful, it disassociates itself from us. That is the measure of the work having its own kind of evil force.

Are your art pieces concrete symbols?

D: They are, I suppose.

J: I am going to contradict myself. They are objects that represent a quota of curiosity, of experimental investment. With two people working on the same things, the emotional content is not the most important part of the work.

Who wins the arguments you have?

D: Neither of us. The argument is the same argument that has been going on for twenty years. The objects are indications that the argument is still going on. Everything you make is a massive disappointment because it is not the thing you wanted it to be.

Do you think carefully before making a work of art?

D: No.

J: No.

You don't plan it out?

D: Yes and no. In a sense the momentum delivers all the appropriate ideas and all the appropriate material to us.

As a double act you started out with Gilbert & George, didn't you? They seem to talk almost in tandem, while you seem like contrasting characters …

J: Working with them or for them taught us not to be like them.

When the *Hell* piece that Saatchi bought got burnt, was that some kind of religious poetic justice?

D: Of course. The funniest thing was that when it was burning, you had journalists calling and saying, '*Hell*'s on fire!' When is it not?

How did that make you feel?

J: The comedy of the situation outweighed everything else.

D: On the morning of the fire, someone came by and said, 'Have you heard about the Monmouth fire?' We said, 'No, no, no!', jumped in the car, drove up there and looked at those flames. We were just pointing and looking at all that fucking art. That was the funniest thing. Drove back and sat there laughing at the misfortune of others. Later we got a phone call: 'Your work is in there as well.' In a sense the fire opened our eyes to the idea that actually it isn't about the work, it is about the performance, that we become subordinate to this central task of remaking this nasty thing over and over.

Jake and Dinos outside their studio (above) overlooking the stadium being built for the London 2012 Olympics. Jake has two new Staffordshire bull terrier puppies, which he is training, or trying to train. 'When something is successful,' he remarks, 'it disassociates itself from us. That is the measure of the work having its own kind of evil force.' The brothers (opposite) on the second floor of their large studio. One can make out the corner of an artwork that is a spoof on Tracey Emin's infamous *Tent*, which, like *Hell*, burned in the Momart warehouse fire. 'The same thing, only better,' Dinos jokes. 'Edition of 500 offered at cost price,' Jake adds.

How much discipline is there, intellectually or philosophically, to maintain continuity and excellence?

D: I don't know. The reason we do things is that there is a kind of speed involved, but by speed I mean that the work seems to be moving very fast, not blinking. We are always in a hurry with our work. It is kind of like a death-drive, a suicidal shock, an impulse where you try to do everything you can to test tolerance. It might be the last thing that says you can't do art any more.

J: It is the kind of excitement of running with scissors.

What drives you? Is it money?

J: No.

Then how do you relate to commercial success?

J: Spend the money as fast as we can. Borrow, spend, crash and learn.

D: Crash and burn.

Your art has been characterised as 'scepticism, parody and irreverence'. Was or is God an irreverent creator, do you think?

J: Why? He fucking hates us, hates our guts. Make demons.

Your art is aggressive in many ways, right?

J: It is more funny than aggressive.

Didn't you just mention that art has been reduced to a level of ridiculousness?

D: Yes, I did. Look at the Tate – what is modern about it?

J: No, Tate Britain.

D: Tate Britain's got fucking escalators in it. The idea of getting on an escalator to go and see art …

J: You are not even prepared to walk to go see it! You should just stick it on the side of vans and drive it around town …

D: They should have this amazing ramp that if you walk past it, a gust of wind lifts you up and you find yourself looking at Mark Rothko.

Do you have a grudge against the Tate?

J: They had engineers working out the flow dynamics of the gallery, the same guys that did the flow dynamics at Bluewater shopping mall. If you work out how people walk, you can divert them. You get these eddies where people act like water. They have these people to work out flow dynamics … horrible.

How much is your work reality or augmented reality?

D: *Hell* is the best example for that. You could ask, 'What does this work have to do with representations of the Holocaust?' Nothing, nothing. There is nothing in *Hell* that shares any kind of realistic fidelity with images of the Holocaust. The critical difference is that not one Jewish person is killed, and all of the death pits and the piles of bodies are Nazis. They could not be more poles apart.

J: What is interesting about this is that we make these things over and over again. Yet the commentary that magnifies the work is always the Holocaust, which is an interesting idea. It is not revisionist; it bears no credible relation to the work. The people who have been exterminated are Nazis, but still there is discussion going on that it is about the Holocaust. A Russian collector came to look at *Hell*, a prospective buyer. He came in, pointed at the pits and said, 'That is exactly what happened in Russia.'

D: A simple fact might be that it is Hell. It's where bad people get punished,

So is the ultimate, pure essence of art somebody's handprint in a cave?

J: I used to teach at Goldsmiths. One of the things that seemed a problem was having young students sitting in rooms thinking, Fuck, what generative seed is there in me that makes me go? I used to take *Flash Art* and *ArtScribe* and *Artforum*, put them all on the floor and say, 'Just pick out four that you like and make something like them.' Art is about processing something that is already in the world rather than coming up with some sort of momentous self-representation that is only about you. The conditioning of art is not something that is a negative aspect of it; it is something that is a positive aspect of it.

So art is positive?

J: Shit, I walked into that! You didn't hear anything else I said. No: it is positive in its chaos. It is chaotic.

D: I don't see why art should be positive. I don't see why that is even an adjective applicable to it. It's just art.

Hell in progress: an army of dark forces comes to life.

Milena Dragicevic

How would you describe yourself in terms of your nationality?
I am Canadian Serb.

How does that define you as an artist?
To be Canadian usually means to have dual nationality. Coming from somewhere else, you are always seen as an outsider. It is a good position for an artist because you are always having to observe and focus and try to connect. That is a strong position from where to make work. When I came to England I still felt like an outsider. Even though the language is the same, the culture is very different. Because of that you are more able to interject, to be seen, to be heard.

Is that a disadvantage or an advantage?
It's definitely an advantage. It makes you more of a survivor

Is art about survival?
Absolutely, 100 per cent.

Which is more important, feeding your mind or feeding your stomach?
Your mind doesn't work without nutrients, so both are important.

What about the Romantic idea of the starving artist?
It hasn't to do with the starving artist; it has to do with survival within your own work. How to maintain a focus, how to create rules for yourself, rules to live by, to work by in order steer a journey. During the recent war in the former Yugoslavia, my identity was put in question. Only then do you learn to negotiate different realities with a sense of urgency. Survival within your work should necessitate a similar sense of urgency.

After living here for years, how British do you feel?
When somebody asked at my gallery in Vienna last year and was told that I was in the British Art Show, they said, 'But she's not British!' I laughed about that. What does it mean to be British any more? So many people from different cultures live here. I had the same thing when I was in Canada, but it is different here. Canadians celebrate multiculturalism in a different way. My work is being seen now, and very little of it has to do with being British.

So is there nothing distinct about British art?
I don't think so, not any more. I was intrigued by the art scene here because of the chance to leave my family behind and explore the world for the first time on my own. Those are the reasons why I came here. It hadn't been in my mind to be British.

Growing up in Canada, what was the appeal of London as an artistic centre?
There was a choice between New York and London. It had to be a strongly multicultural area, a big city. Because I was already living in North America, and London is part of Europe, I thought that would be more interesting for me.

But surely New York is as much of a melting pot as London?
It is, but I know the history of New York art because my first experience of painting was Abstract Expressionism. I had very little knowledge of figurative painting, and it wasn't until I came to England that I began to discover that side of making art. New York, as I found by reading interviews with various British artists out there, is a very raw place; they don't give you any support.

Did you receive support in London?
Only when I was at the Royal College of Art, but after that nothing.

Milena Dragicevic in her Hoxton, London, studio in late November 2011. 'I came to realise – after living in Canada, living here, living in San Francisco, living in Barcelona – that I don't feel loyalty any more. I am not as patriotic as I was twenty years ago'.

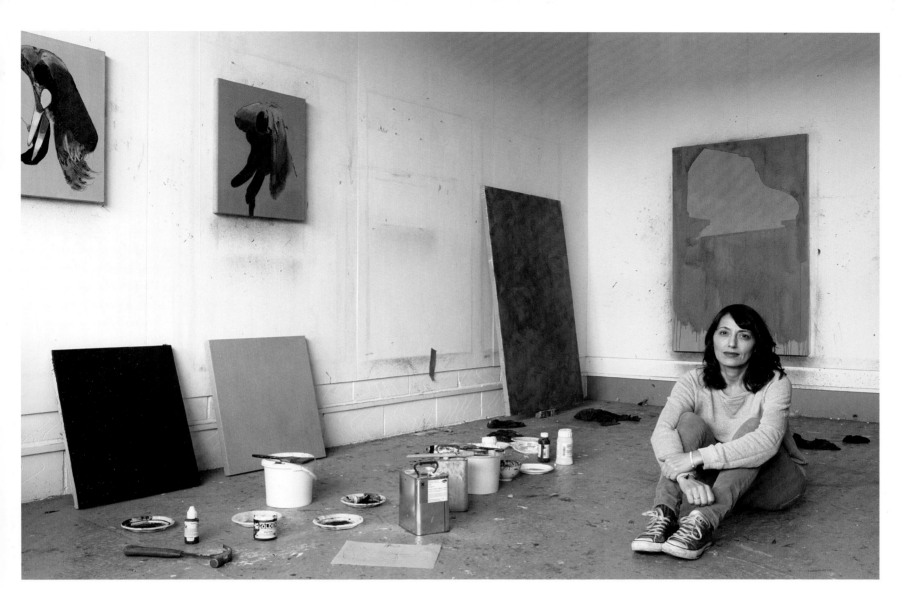

So when you came here, did you become immersed immediately?

I got involved in student life immediately; that is different from the actual art community, which is to say the market or galleries. There is no pecking order yet, or vetting or anxiety about being seen and heard.

Is there a big Serbian art community?

Sadly I never had any affiliations or connections with the Serbian art community. It is curious because people in Canada don't seem to know my work and people in Serbia don't seem to know my work.

Then who does know your work?

The British and other Europeans find me interesting because I come from a broken country.

Do they find you interesting because of your art or because of your broken background?

Hopefully because of the art, but that question always comes up. One of my galleries said, 'Forget the Canadian side! Not as interesting as the Serbian side! No-one cares about you being Canadian!' I thought that was very funny.

I came to realise – after living in Canada, living here, living in San Francisco, living in Barcelona – that I don't feel loyalty any more. I am not as patriotic as I was twenty years ago.

Is it common among the younger generation that the idea of nationality is less pronounced or marginalised? Have you all been globalised, or Hollywood-ised?

Yes. Globalisation could be seen as 'Frankenstein-ation. I can't say that borders opening is a bad thing, but sometimes it extends to rewriting history, and that's a bit scary.

Does your art attempt to address any of these issues?

Not in an overt way. I don't think that art can display political action or events. I want to be more indirect. I'm interested in ways of seeing, and part of respecting ways of seeing involves dealing with different references in my work. I use those references as a way of understanding the parameters of painting, and the structure. So I borrow from various places, including my own background.

What are you most proud of from your time living and working in the UK?

That is a really hard question to answer. Having a sense of humour really helps me to be able to conduct day-to-day business, and I think the British have a great sense of humour. I connect with them on that level. That is important as an artist because your work has to have a sense of humour somewhere within it.

You've been quoted as saying that 'the raw energy in London comes from the place itself and artists; the galleries have less to do with that' …

What I meant was that there is still a strong clique mentality here. That clique mentality can keep people on the outside, and that's not a good thing. There are some great artists who have never had a chance for a gallery here. In the past on many occasions I have had to deliver my work to somebody's house in the West End so that they could look at it. They couldn't be bothered to come to my studio.

How did that make you feel?

It happened a long time ago. I would never let that happen today, never.

Even if you were starving?

I'm not starving, and my work is edible.

Matthew Darbyshire

As an artist, do you have a sense of Britishness? Is there such a thing?

It's something I try and avoid. Due to the fact that I exist and work in Britain, I can't help reflecting on or examining the British phenomenon. It's become more of an issue lately. I'm keen to travel now, having made eight or so substantial shows that couldn't help but reflect on Britishness.

I'm trying to get to a sense of essential Britishness, a sense of the power of being British …

That's about a bygone era. The world in which I work is a more international, globalised context. I'm physically in Britain, but I'm looking at more global aspects. Occasionally in among them I see bits of dubious history. As a British person I share the guilt and discomfort over most of that shameful past, so it finds its way into the work occasionally.

I'm also trying to see whether exceptionalism – there's a lot of talk today about American exceptionalism – exists within the British cultural mind-set as exemplified in, say, Tracey Emin trying to be more British than British, or in the Britishness of the YBAs.

They're not things that I would aspire to be part of. Although last week I was very flatteringly invited to a lunch reception at my local Turner Contemporary gallery to see the Queen unveil a plaque; Tracey Emin sat next to her and I was on the lowest table of course! There was obviously a huge sense of pride in Tracey Emin. She was there in a brand new Vivienne Westwood suit, specially made I imagine, and she was happy to take the centre seat. Whereas I don't share that sense of pride or patriotism. It's never occurred to me. I feel affection towards the Queen because she's in her eighties, she has that strength, and she's a role model. But it's not something I try and reflect within my work or imbue it with. And I'm certainly not interested in 'Cool Britannia' – in fact I find it quite cringeworthy now. I look back at New Labour trying to jump all over that, and I find it all very suspicious.

Who decides what is art and what is not? And what is British art?

I really can't answer about British art. As to what art is, for me the key ingredient is the critical dimension. It's not just about trying to propagate or uphold or facilitate; it's about trying to reflect critically, and of course it has to have an inherent aesthetic dimension.

Explain to me how your artistic process begins.

It usually begins with an invitation. I get invited to make an exhibition or an intervention within a building. I go there, and it's quite a lot of reconnaissance just being there. So there's a degree of social history involved. Then I go back to the studio and start conducting research and thinking about how I can personalise the invitation. What I arrive at is something less accountable and less academic, but hopefully there's some validity to it in terms of factual and theoretical accuracy.

You use the word *intervention*. That's rather aggressive language.

Maybe it's a term whose aggressive nature we've forgotten. I don't see it as aggressive in this context. Perhaps the term *intervention* came about in the arts when we were thinking about institutional critique. An 'intervention' for me is just an injection, like an addition or a gesture. When artists are encouraged to intervene in the sense of social outreach, that's when I'm suspicious. When the artist becomes a social worker, things get very dangerous.

So art has to be almost cruelly neutral?

Well, I used to be ashamed to use the word *intuition*. Now I'm realising that actually all I have to offer is something inside of me that I'm not even aware of, and that has been instilled over a long, long time through different experiences that I probably can't recount at all. For me, art's about that. It's not about trying to think consciously and cerebrally and trying to 'do the right thing' as a politician or social worker might do, because that way you end up just pedalling learned and patronising mottos.

Gustav Metzger told me that he has chosen to assume the mantle of poverty as a way of maintaining the purity of his art. Do you subscribe to that idea?

I'm not trying deliberately to embrace that idea, no. Just by default my partner and I live hand to mouth. It's not something that I resent. If I can make work, I'm happy, and my partner's happy, and that's it. If there's any excess, I don't know what we're going to do with it. Perhaps we're just going to make more work. I'm teased by the gallery I work for, and by my friends as well, that every time I get any money it goes straight into a project. And I'm constantly phoning, borrowing another £5,000 to make that project. For a lot of artists today, that's all we want money for, if there is any money.

Darbyshire's studio (left), a converted brewery where he works most of the day: 'As a British person I share the guilt and discomfort over most of [my country's] shameful past, so it finds its way into the work occasionally.' Darbyshire (opposite) at home with his daughter Dot in Rochester.

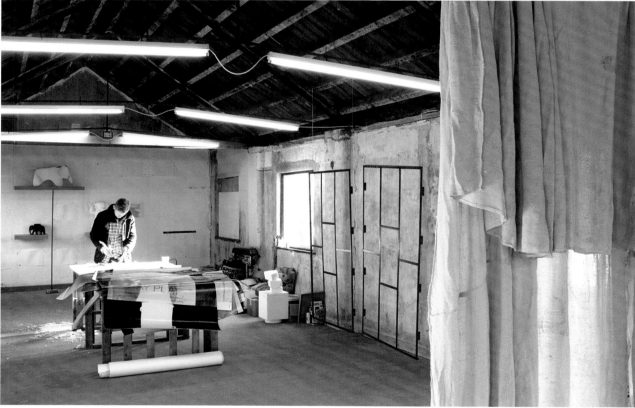

(previous spread) Matthew Darbyshire at Restoration House in Rochester, Kent, in late November 2011. Named to honour the stay of King Charles II on the eve of the Restoration, this beautiful English Heritage building was also the Satis House of Dickens's *Great Expectations*, the home of Miss Havisham. Darbyshire, whose studio is in the grounds, walks to the natural spring to fill his water bottle each day before work.

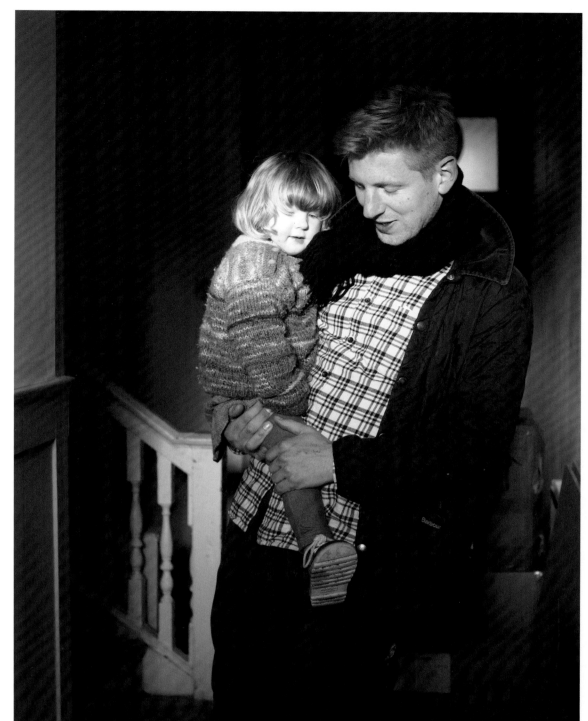

So essentially you're driven to do what you do …
I suppose so. For the last few weeks I've been wondering if I'm becoming tired, whether I just want to get a more conventional nine-to-five job, see more of my two-year-old daughter, hang out more at home, not be working seven days a week and panicking every time we get a bill through the door. But at the moment I'm still driven enough to persevere.

A great many of the successful artists that I've come across almost have manufactories to make art: huge staffs, huge offices in the form of studios, big PR teams, big egos. How big can art get before something goes wrong?
That is the reason I've been thinking of trying to retreat. You get to the stage where you start wondering if you're just becoming another agent. For me it's becoming a moral dilemma. I'm starting to think maybe I should just do less, just teach, take on one project a year … Or do you just keep on racing and racing – and why?

It's been said that one of the most interesting issues raised in your practice is the 'polymorphous role of the art institutions'. Can you explain what that means?
I can cite two examples where my work might've highlighted this. One was a Frieze Project I made and the other an intervention at the ICA. The piece of work I made for Frieze last year was a very soulless, generic mobile phone shop environment. I was trying to show that even at Frieze it looked scarily comfortable. When you go to the Tate, you're at times encouraged to interact and play and bop and dance with the objects in the way that you would if you went to a phone shop and had a play with some new app. Whereas for me art is about quiet

contemplation, about a difficult sort of engagement, about things that are problematic, things that might rupture your expectations or prick your conscience to make you feel awkward. For me the fear is that in the cultural sector, they're having to tick every box and be everything to everyone, so they are compromising their autonomy. I wonder if those institutions should be holding on to their autonomy, not to become elitist and inaccessible, just so they don't compromise so much that it becomes like visiting the new Westfield Shopping Centre. They go to artists now as well to help educate, regenerate, enlighten – suddenly the artist is the facilitator of everything. I think I prefer the Gustav Metzer model, where I hear you can only get hold of him once a week in a phone box. It's a romantic model, but I can't help wondering if it's a better one.

So where does British art stand today?
For me British art no longer exists. We can see national traits in other art, perhaps. In German art you see a heightened degree of formalism for example. In Polish art you see a huge social empathy on the back of social realism; now that's become more personalised. As for England, I'm afraid I'm still ashamed of Britishness. For me the future of British art should be to undo and unlearn and delete and move forward and start afresh.

Acknowledgements

A good book is the sum of its parts. Sanctuary has had as many parts as a fine Swiss watch, each movement benefiting the overall structure that has brought it to press. But there are a few key movers we could not have done without, the most noteworthy being the executive editor, Maryam Homayoun Eisler. Her dedication, hard work, imagination and energy have been instrumental in making Sanctuary the book it has become.

Roger Fawcett-Tang, the creative director, must not only be commended for his design skills but also for his patience: working with me is not easy. The young and, time will confirm, brilliant photographer Robin Friend has fully lived up to the challenges with which he was presented. Andrea Belloli, the managing editor, has played an important role in bringing together the book's editorial parts, especially the interviews, whose historical significance will become increasingly obvious over time. Siobhan Loughran Mareuse, the project director, was a new recruit to our inner sanctum but has proven worthy of her role, while Anne Field, the project coordinator, is a more experienced all-rounder after Sanctuary, except that she's aged by ten years. Press officer Kate Burvill is also to be thanked.

Thames & Hudson, my co-publishers, have been very hands-on during this journey, and I would like to thank Jamie Camplin, Maria Blessing, Jackie Klein and Natalie Evans for their contributions. While Caroline Campkin, the production director, and her team at CS Graphics must again be commended for their excellent collaboration. But of course the real stars of this book remain the artists themselves, all 120 of them. Truth be told, it was a major challenge organising, re-organising and sometimes cajoling reticent artists to face the challenges of intrusive photography and frank inquiry into their inner lives (and thoughts) through the interviews.

Essayists Iwona Blazwick, Richard Cork and Tom Morton deserve particular mention, their contributions making Sanctuary a livelier and more informative read. There are many in the art world whose help we have sought, and others who have offered their time and expertise freely, without care or agenda. Sir Nicholas Serota inspired us to add a few extra names to our artists' list, while leading critics and curators helped with comments and guidance. Some shall remain nameless, but others, including Hans Ulrich Obrist, Achim Borchardt-Hume, Tim Marlow, Stephen Deuchar, Phillipa Adams, Frances Morris, Ziba Ardalan, Anne Gallagher, Simon Grant, Jessica Morgan and Judith Nesbitt have given freely of their time and expertise. Edward Eisler and Colin Grassie must also be commended for their valued support for the project.

Tim Marlow, Achim Borchard-Hume, Hans Ulrich Obrist, Bina von Stauffenberg, Maryam Homayoun Eisler, Anthony Downey, Clarrie Wallis, Catherine Pettigas and Siobhan Loughran Mareuse also undertook several of the interviews, while Maryam Homayoun Eisler assisted on many more.

In many cases access to artists' inner sanctums would not have been possible without the engagement and cooperation of the galleries that represent them, here in London and abroad. Most have been exemplary in their support from the outset. We would therefore like to thank the following: Alan Cristea Gallery, Alison Jacques Gallery, All Visual Arts, Annely Juda Fine Art, Anthony Reynolds Gallery, The Approach, Artangel, Ben Brown Fine Arts, Blain Southern Gallery, the British Museum, Corvi-Mora, Edel Assanti, Elms Lesters, Frith Street Gallery, Gagosian Gallery, Hales Gallery, Haunch of Venison, Hauser & Wirth, Herald St, HOTEL, James Cohan Gallery, Karsten Shubert, Kate MacGarry, Lazarides, Lehmann Maupin Gallery, Lisson Gallery, Lorcan O'Neill Gallery, Marlborough Fine Art, Mary Mary, Matt's Gallery, Maureen Paley, Michael Werner Gallery, Modern Art Gallery, National Portrait Gallery, Other Criteria, Paradise Row, Parasol Unit Foundation, Sadie Coles, Serpentine Gallery, Simon Lee Gallery, Stephen Friedman Gallery, Tate, Galerie Thaddaeus Ropac Gallery, Thomas Dane Gallery, Timothy Taylor Gallery, Victoria Miro, Waddington Galleries, White Cube, Whitechapel Gallery and Wilkinson Gallery.

Our personal thanks are due to many individuals within the art world, and outside who have helped along the way, including: Sabine Abasser, Lucy Adams, Martine D'Anglejan Chatillon, Miranda Almond, Charlotte Artus, Martina Aschbacher, Emma Astner, Nick Baker, Corinne Bannister, Mark Barker, Chloe Barter, Julia Baumhoff Zaouk, Lucy Beech, Florian Berktold, Dominic Berning, Harry Blain, Valerie Blair, Erica Bolton, Elena Bortolotti, Juanita Boxill, Ben Brown, Tarikh-Oliver Bull, Nathalie Burgun, Fran Burrows, Katharine Burton, Emily Butler, Philip Byrne, James Cahill, Bridget Chew, Susanna Chisholm, Rowena Chiu, Susie Clark, Vicky Clements, Sadie Coles, Cristina Colomar, Stuart Comer, Emma Cook, Tommaso Corvi-Mora, Helen Craggs, Nicholas Cullinan, Pauline Daly, Thomas Dane, Elizabeth Deegan, Tom Dingle, Leanne Dmyterko, Stephanie Dudzinski, Jeremy Epstein, John Erle-Drax, Neil Evans, Charlie Fellowes, Jess Fletcher, Mark Francis, Bella Freud, Hannah Freedberg, Ann Gallagher, Victoria Gelfand, Rola Grant-Gordon, Jorie Grassie, Jessica Green, Grant Greenaway, Louisa Guinness, Claire Gylphé, Nick Hackworth, Jessica Hamblett, Christiane Hardt, Nicola Hayes, Paul Hedge, Alastair Hicks, Whitney Hintz, Marcus Hoffman, Jens Hoffmann, Duncan Holden, Jessica Holland, Alexandra Jacobs, Rukhsana Jahangir, Rob James, Robert Jaques, Glenys Johnson, Matt and Kate Jones, Paul Jones, Jay Jopling, David Juda, Robyn Katkhuda, Catherine Lampert, Tabitha Langton-Lockton, Clodagh Latimer, Jimi Lee, Simon Lee, Marcella Leith, Andreas Leventis, Hannah Liley, Alex Logsdail, Nicholas Logsdail, Honey Luard, Sara Macdonald, Elliot Macdonald, Kate MacGarry, Fatima Maleki, Louisa Macmillan, Rachel Mapplebeck, Carolyn Mason, Zoe Maxwell, Kirk McInroy, Fiona McKinnon, Laura McNamara, Lucy Meakin, Reynaldo Mercado, Jake Miller, Victoria Miro, Hugh Monk, Paul Moorhouse, Annie Morris, Michael Morris, Marianne Morrow, Kylie Bloxham Mundy, Catherine Murray, Megan O'Shea, Louise O'Kelly, Shireen Painter, Maureen Paley, Lord and Lady Palumbo, Sunita Pandya, Nicola Parsons, Camilla Paul, Anne Marie Pena, Inigo Philbrick, Deborah Phillips, Venetia Porter, Victoire de Pourtales, Patricia Pratas, Lindsay Ramsay, Maya and Ramzy Rasamny, Anthony Reynolds, Gina Richmond, Olivia Rickman, Kadee Robbins, Emma Robertson, Galerie Thaddaeus Ropac, Paula Feldman Sankoff, Danny Saunders, Michael Schenk, Frances Scott, Harry Scrymgeour, Stuart Shave, Lesley Shearer, Patrick Shier, Heather Shimizu, Louise Shorr, Holly Slingsby, Anna Smith, Graham Southern, Flavia Souza, Michelle de Souza, Graham Steele, Joanna Stella-Sawicka, Lillian von Stauffenberg, Kathy Stephenson, Maria and Malek Sukkar, Roger Tatley, Timothy Taylor, Fru Tholstrup, Joanna Thornberry, Laurence Tuhey, Cassie Vaughan, Gordon Veneklassen, Rute Ventura, Nicky Verber, Xaver von Mentzingen, Sophie Walker, Helen Walker, Alice Walters, Jessica Watts, Katy Wellesley, Neil Wenman, Stephen Wentworth, Patricia Wheatley, Anthony Wilkinson, Catherine Wood and Yu Yigang.

Finally, Xaviera Alvarez Nordström and Jessica Marr, our research interns, and the Sanctuary transcribers deserve our thanks, including Amanda Bryan, Elizabeth DuBois, Francesca Frediani, Susan Jones, Ruth Knox, Masa Al-Kutoubi, Tyler Perfect, Rebecca Spiro and Carol Warner.

Hossein Amirsadeghi
London, 1 December 2011

Additional interviewers:

Hurvin Anderson
Clarrie Wallis

Sir Anthony Caro
Grayson Perry
Tim Marlow

Gordon Cheung
Phoebe Unwin
Maryam Homayoun Eisler

Martin Creed
Mark Wallinger
Toby Ziegler
Bina von Stauffenberg

Mona Hatoum
Anya Gallacio
Achim Borchardt-Hume

Anish Kapoor
Hans Ulrich Obrist

Sarah Lucas
Maryam Homayoun Eisler and Catherine Petitgas

Jason Martin
Susan Hiller
Bina von Stauffenberg and Maryam Homayoun Eisler

Yinka Shonibare
Anthony Downey

Jonathan Wateridge
Siobhan Loughran Mareuse

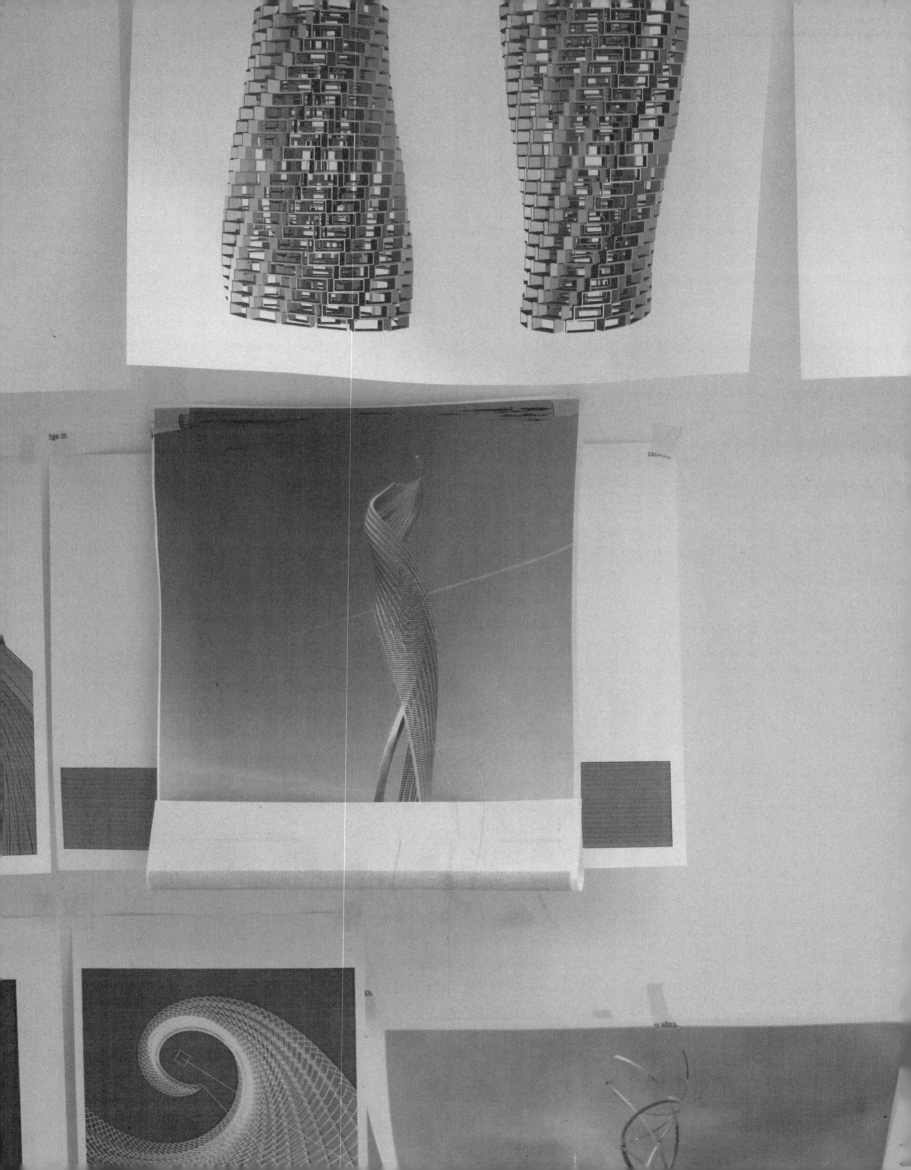